THE BOOK OF PHOTOGRAPHY

THE BOOK OF PHOTOGRAPHY

TEXT BY ANNE H. HOY

NATIONAL GEOGRAPHIC

Washington, D. C.

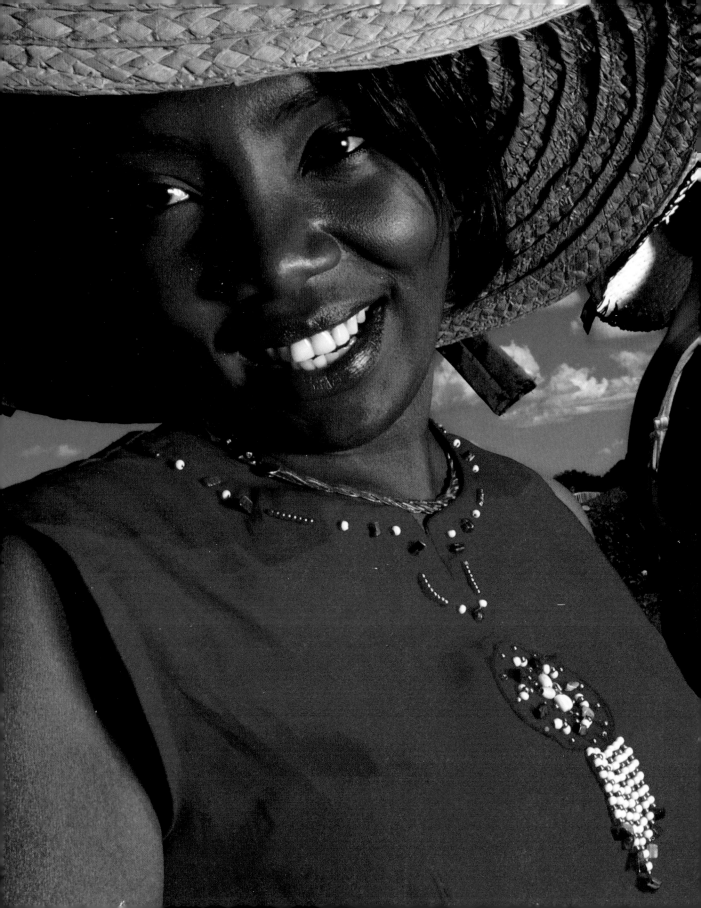

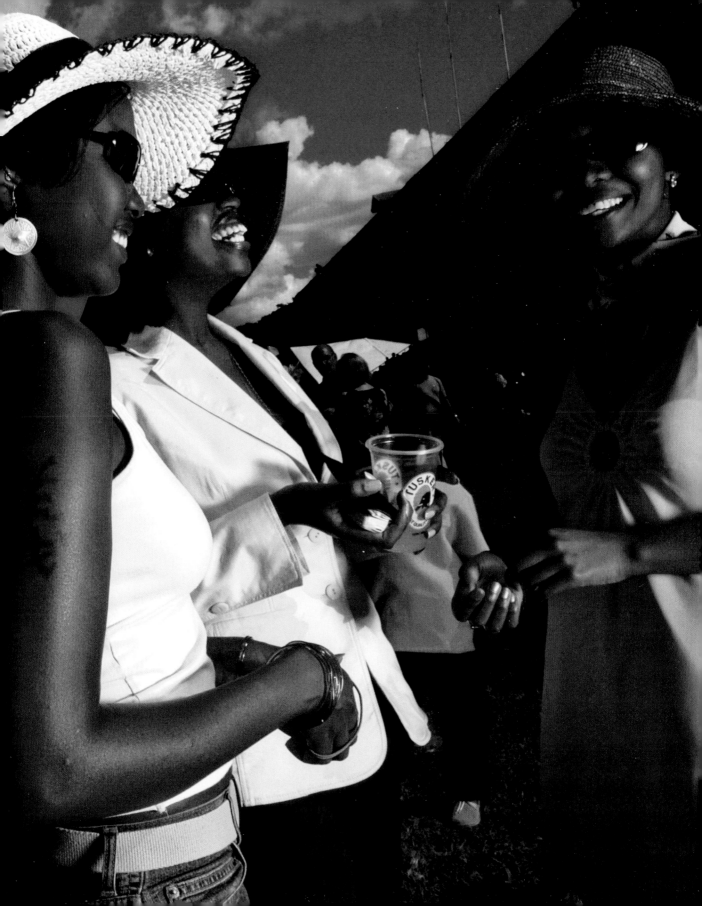

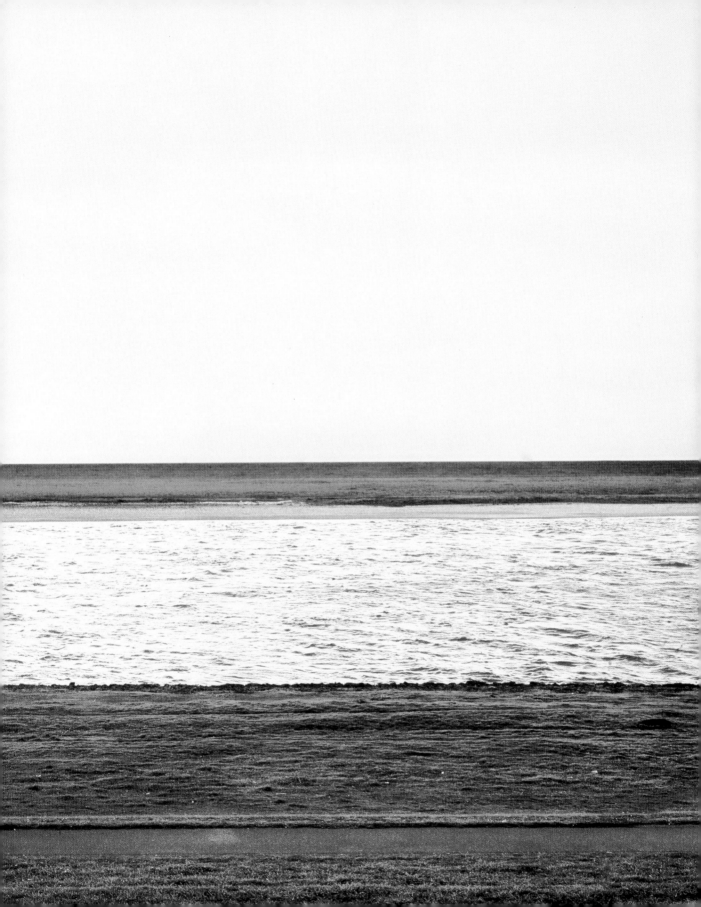

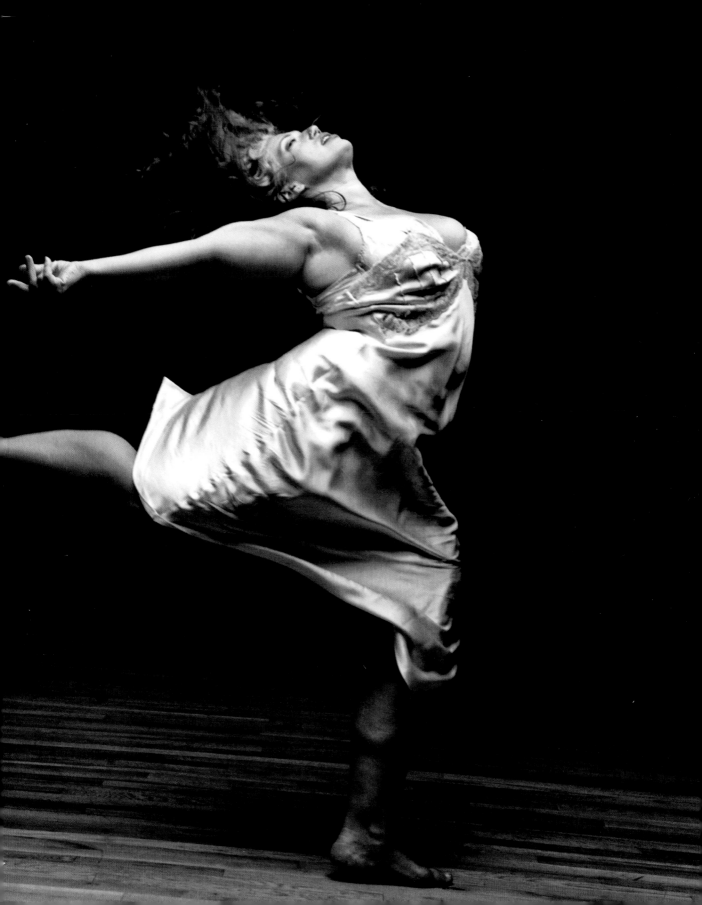

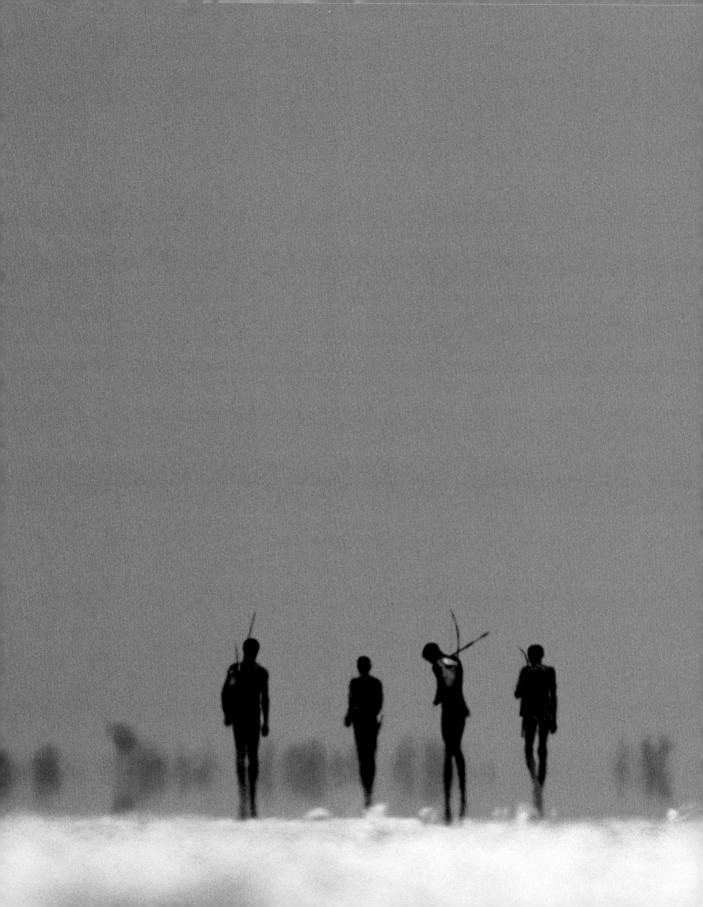

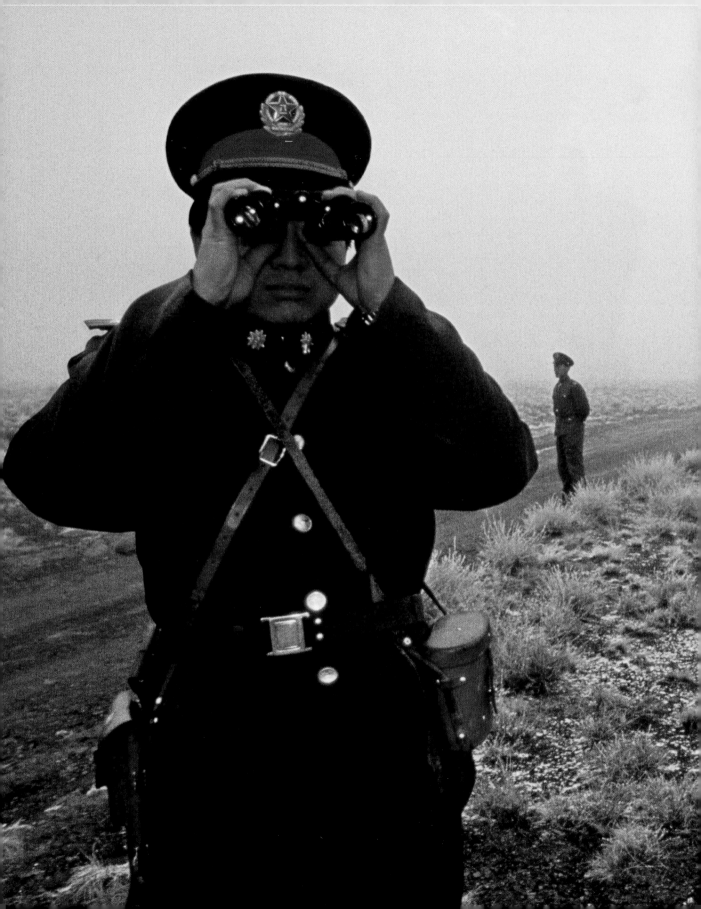

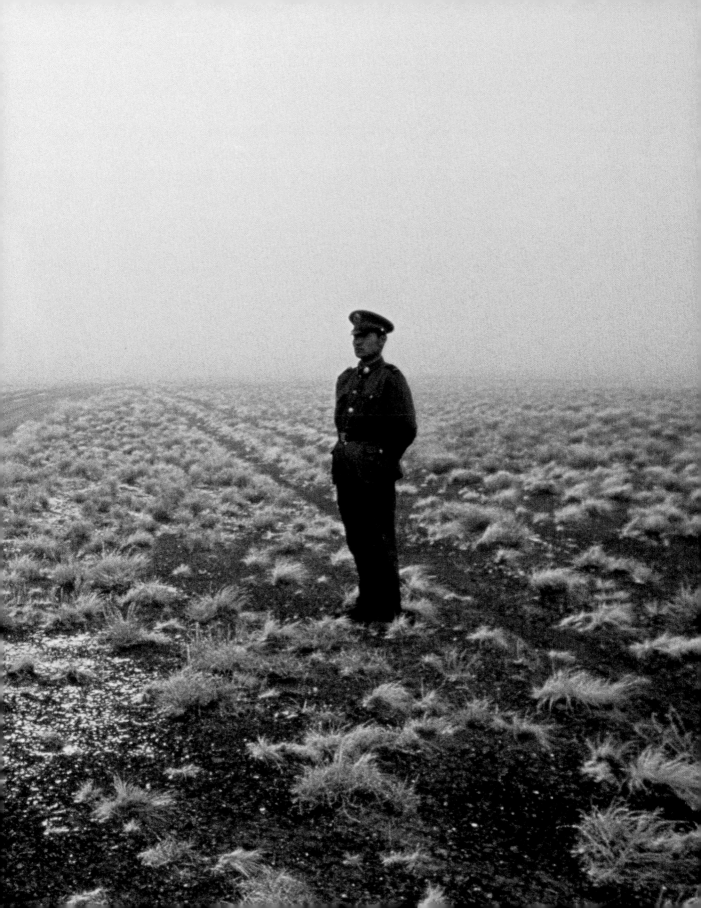

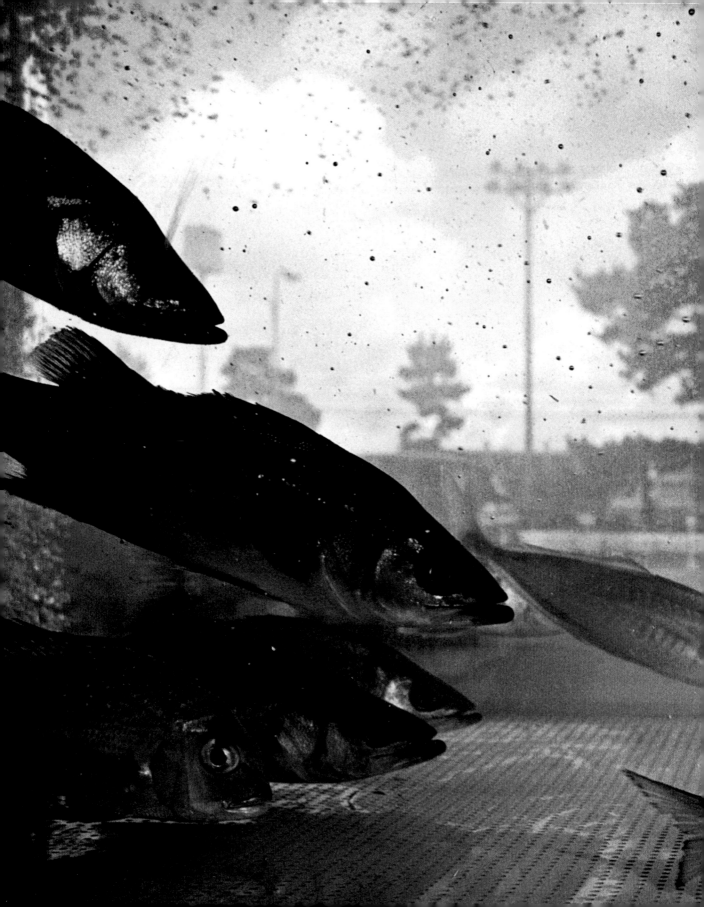

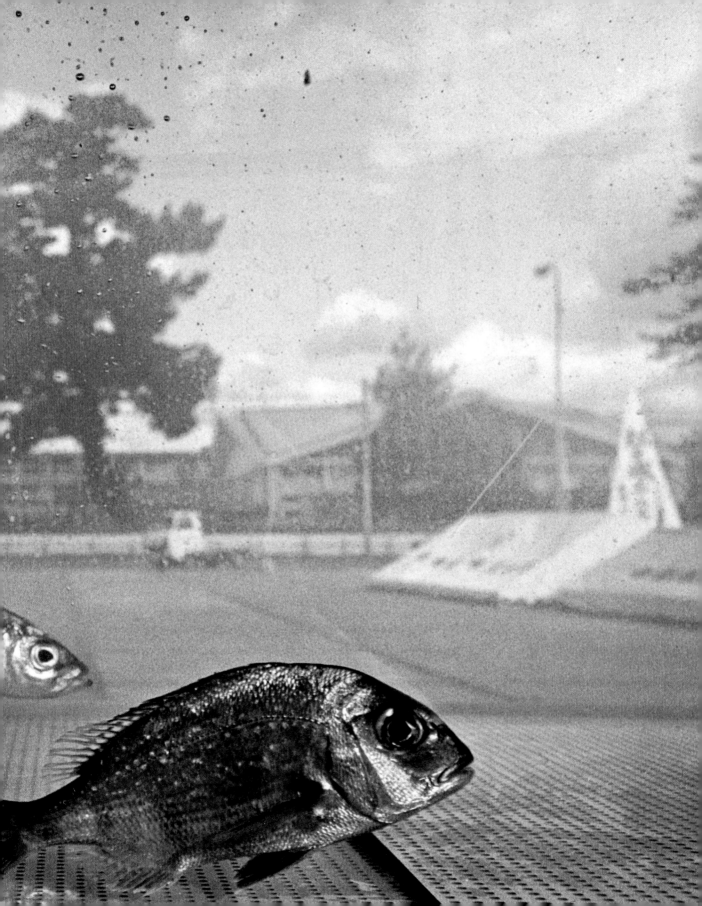

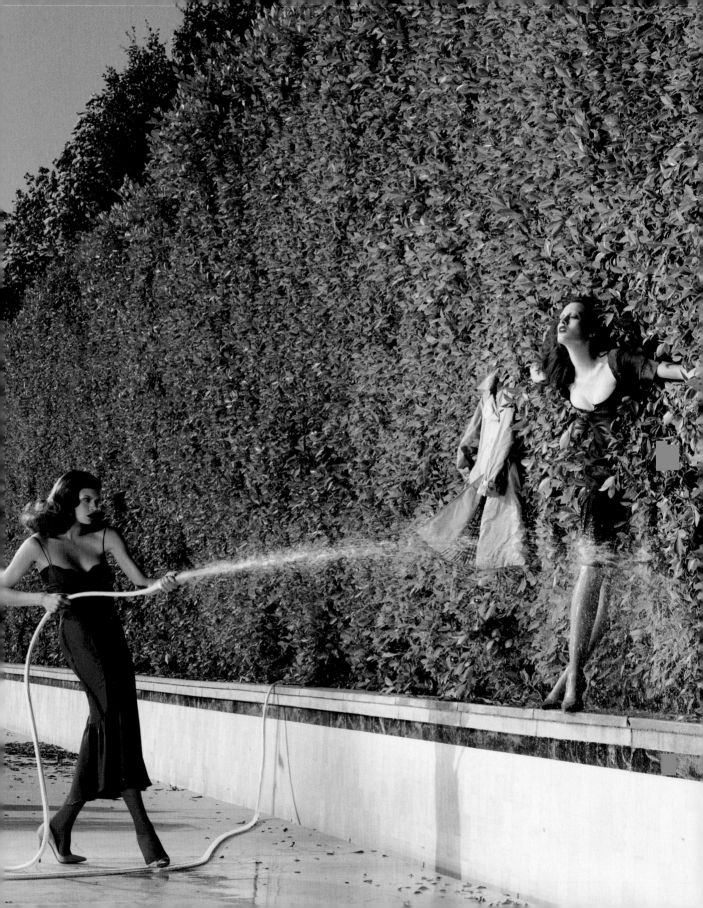

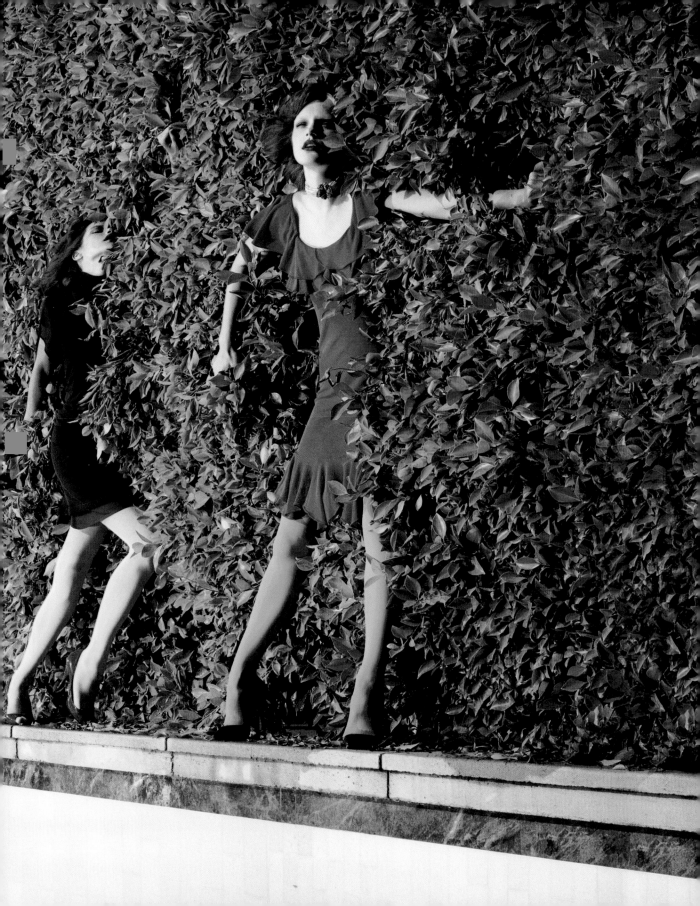

FOREWORD

On September 10, 2001, in the late afternoon, Steve McCurry returned to New York from a photographic assignment in Tibet. He was tired and jet-lagged. He unpacked, cleaned up, and went to sleep. The next morning, September 11, a neighbor told him the World Trade Center was on fire and he ran up to the roof of his apartment building on Fifth Avenue and Eighth Street to have a look. From there he had an unobstructed view of lower Manhattan. He took a few pictures and saw first one tower then the other collapse. He ran back to his apartment in a state of disbelief, grabbed more film and cameras, and headed downtown. Chaos and barricades made threading his way to what has since been called Ground Zero difficult, but he wasn't the only one doing this. Quite a few other photographers in New York were doing the same thing. They didn't check with anybody, they just went. They couldn't help themselves.

About 24 hours after returning from Tibet, McCurry stood in a lobby in the World Financial Center across Manhattan's West Side Highway from the World Trade Center, and took this picture. The late afternoon light glancing off miscellaneous surfaces made the surreal scene eerily calm. The photograph is about what you don't see—the calamity that caused the devastation, the life that's not there—as much as it is about what you see in the frame.

In the days and weeks that followed, despite all the TV coverage, all the film and video, the still photographs of 9/11 held us spellbound. Now they lodge, immovable, in our common memory.

Photography had barely been announced in 1839 when it entered people's imaginations and intellect and began to make its way into every sphere of life. And despite today's profusion of modern media our appetite for photographs hasn't diminished. In fact it seems insatiable.

THE INTERIOR OF THE WORLD FINANCIAL CENTER ON SEPTEMBER II, 2001, AROUND 6 P.M,. BY STEVE MCCURRY

Photographs take hold of particulars and make us look at them—individual suffering and specific instances of violence, wildness, beauty, devastation, ordinariness, and the enormous diversity of humanity. Photographs contemplate civilization and record far-flung fragments of the physical universe. We treasure pictures of people we love and save them, with pictures of ourselves, for posterity. We create photographs to record our innermost thoughts and to sell just about everything.

So how can all this fit into one book? Of the billions of photographs that have been taken and the tens of thousands of photographers who have taken them, what makes one photographer or picture worthy of this or any other book on photography? Not surprisingly, there isn't a formula for selection. This book is the outcome of a collaboration among professionals from diverse photographic fields who have taken up the immense challenge of looking at photography as a whole. The resulting judgments and viewpoints, along with a plethora of facts and information, fill these pages.

The volume is organized so readers can approach topics in historical and thematic context. Each of nine chapters is devoted to one or more photographic genres. A detailed timeline lets the reader consider major photographic milestones chronologically. Multiple entries in each chapter recount the history of the genres and offer concise definitions. Others identify key players, describe their world, elaborate on their technical and aesthetic accomplishments, and explain how they built upon those of their predecessors.

Photographers and their pictures usually can't be pigeonholed. Many photographers work in more than one genre and some appear more than once on these pages.

Full profiles of close to a hundred important photographers are featured in the main text. A dictionary of photographers at the end adds another 74 names to enrich and round out our coverage. An important key to this book is the index. Rely on it to navigate through stories and subjects that fit together in multiple ways and you will be rewarded.

We've chosen familiar, classic pictures and also pictures that are unknown or rarely seen, with the aim of contributing to the literature and to the continuing reconsideration of photographs. In quotation sidebars scattered through these pages photographers speak directly to readers. William Henry Fox Talbot, Ansel Adams, Diane Arbus, and others talk of aspirations, methodology, and idealism. Technical sidebars explain breakthroughs in processes and equipment.

The history of photography is short and the study of it is still evolving. The world continues to change and so do our tastes. Changing technologies keep transforming the way photography is done and how it is seen. Today's digital revolution is merely the latest major case. It is daunting to publish a book like this, to attempt to sort out photography and reflect upon it, but it is important to do so because of the impact photographs have on all of us daily.

A unique feature of our book is the sidebars on gatekeepers. Gatekeepers are curators and editors of magazines, museums, galleries, and photo clubs—those who identify the few photographers whose work will be widely seen. Though viewers often assume curators and editors unerringly identify great work, some artists and critics may disagree at times. Some choices made by gatekeepers are controversial. Does significant work exist that will never be known? What if worthy photographers have been overlooked? The repeated and continued reevaluating and re-appreciating of photography is, among other things, a safeguard.

In this volume the work of more than two hundred photographers from a dozen countries is considered in light of cultural and chronological origins. We had to leave many out due to lack of space, and we are grieved by this, but we console ourselves a little with the knowledge that photography bookmaking will continue, that this book is part of an ongoing story that has a long future.

A great photograph is endlessly interesting because it is both fact and fiction, dated and timeless, explicit and mysterious, unforgettable yet impossible to fully remember. Photography's ultimate paradox is, perhaps, that it can help us see while simultaneously preventing us from knowing—this is true of the 9/11 photographs, and of all photographs to one degree or another.

We have high aspirations for this book: We hope readers will be almost as involved reading it and considering the photographs as we have been preparing it. We want to inform and entertain, and also to contribute to the ongoing conversation about photography, its history, its achievements, and its expressive possibilities.

— LEAH BENDAVID-VAL

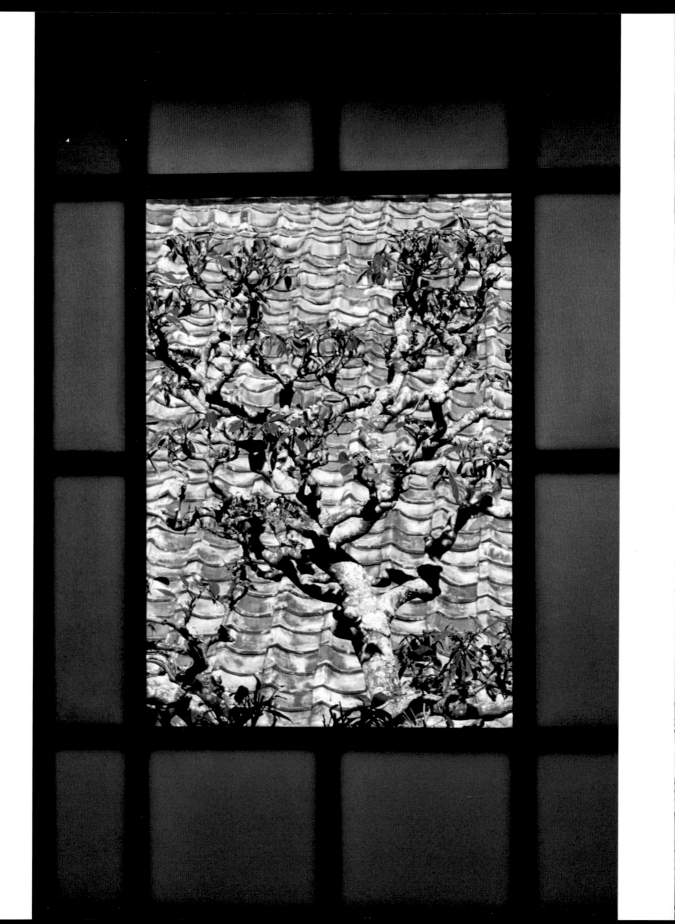

ARCHITECTURE & STILL LIFE

The earliest photographs, taken in the 1820s and '30s, are of buildings and still lifes—often the photographers' own homes and possessions, which obligingly stood still for the long exposure times required by photography in its infancy. These subjects were static, convenient, and free. But they were also warm with human use and personal and cultural meanings—as almost all structures and objects tend to be. Even after exposures were shortened enough to allow portraiture (by 1840) and unblurred images of people and animals moving (by the 1880s), architecture and still life remained camera subjects. These themes have thrived as specialties for commercial camerawork and as opportunities for artistic expression, mirroring the changes in approach of photographers over time. In the last two decades, for example, some of the most dazzling art photographs have been made of contemporary architecture. They reveal the individualities of both the architect and the photographer, transcending reportage. In still life—*nature morte* in French—photographs are far from dead.

EARLY PHOTOGRAPHY

Architecture is built into early photography, and helps frame a discussion of how this revolutionary image-making system was invented. Not one but two very different kinds of photography were announced in 1839 (see pp. 30-31), and both ultimately relied on the camera. In Latin, *camera* means "room." And photography, as it is popularly understood, originated in the *camera obscura*, or *dark room*, an artist's device for capturing illusions of nature that was described by Leonardo da Vinci, Vitruvius, and others in Italy and Northern Europe in the 16th century.

In the first versions of the camera obscura, a room large enough to enter was completely darkened except for a tiny hole in one wall. Via light rays entering that hole, the image of the world outside was projected upside-down and backwards onto

ESTABLISHING A SENSE OF PLACE HAS BEEN ONE OF SAM ABELL'S STRENGTHS DURING HIS PERIPATETIC LIFE AS A PHOTOGRAPHER. THIS VIEW IS THROUGH THE WINDOW OF THE TOMOE RYOKAN IN HAGI, JAPAN.

the opposite wall. There the artist could trace it, confident of the picture's correct spatial relations and freed from labor otherwise needed to translate three dimensions into two. For his 1996 photograph using the phenomenon, Abelardo Morell turned a New York apartment into a camera obscura and photographed the wall opposite the little hole. The result, for both Morell and ancient draftsmen, was black-and-white magic.

The camera obscura became a studio tool in the High Renaissance, as artists sought shortcuts for accurate rendering of one-point perspective—the visual experience in which receding parallel lines appear to converge at a single point in infinity, like railroad tracks receding into the distance. Respectable Italian artworks depicting architecture and nature had to obey the laws of one-point perspective around 1425, when Leon Battista Alberti first published the formula. And so Giovanni della Porta included a detailed description of a camera obscura in his writings in 1558, indicating it was well known to artists and scientists by then. Armed with these devices, Western artists would labor continuously, and in various directions, for the next four hundred years to "rationalize sight," to create artwork based on how the eye sees. Theirs was an appetite—not found in other, more

FINE-ART PHOTOGRAPHER ABELARDO MORELL USED THE SIMPLE TECHNOLOGY OF A CAMERA OBSCURA TO CAPTURE AN IMAGE OF A MOST COMPLEX CITY IN "MANHATTAN VIEW LOOKING SOUTH IN LARGE ROOM, NEW YORK, N.Y." 1996.

idealizing cultures—that photography would truly satisfy.

In the interim between the Renaissance and the announcement of photography in 1839, the camera obscura gained a lens, to keep light rays focused through a larger opening that brightened the image, and sometimes an internal mirror to turn the projected image right-side-up. And the room was miniaturized. Portable versions of the camera obscura were sold in the 17th century, especially in the Netherlands where opticians were producing microscopes and telescopes to aid optical possession of the near and far. In Delft, the painter Johannes Vermeer was known to have owned a camera obscura, and he incorporated some of its distortions of proportions and light effects in his work. In the 18th century, when English lords began completing their educations with a Grand Tour of Italy, Antonio Canaletto and artist-colleagues satisfied their demand for souvenir views (or *vedute*) of Venice with paintings reliant on the camera obscura for their accurate depiction of architecture. By the early 19th century, the vogue for keepsake pictures of beauty spots, whether man-made or natural, was so wide that the *camera lucida*, a prism on a stand, was invented by William Wollaston in 1807, primarily for amateur artists. The prism superimposed the view on their sketchpads, to which it was attached, so artists could simply trace what they saw.

Handwork was still required, however, to transcribe the images seen in the cameras obscura and lucida. And some skill in sketching was expected of upper middle-class and wealthy travelers through the early 19th century. William Henry Fox Talbot had none. In 1833, honeymooning at Lake Como, the Englishman was frustrated by his inability to draw with either the camera lucida or the camera obscura, and he wondered, "how charming it would be if it were possible to cause these natural images to imprint themselves durably, and remain fixed upon the paper!" Talbot, who invented the fundamentals of photography, would call his experiments "the art of fixing a shadow."

The chemistry Talbot pursued depended on the light sensitivity of silver, which had been observed in antiquity but never exploited. In 1725 the German medical professor Johann Schulze discovered by accident that silver nitrate

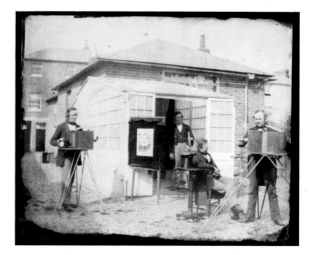

WILLIAM HENRY FOX TALBOT PHOTOGRAPHED MEMBERS OF THE READING ESTABLISHMENT PRODUCING CALOTYPES FOR *THE PENCIL OF NATURE*, CIRCA 1843.

darkened on exposure not to heat but to sunlight. Independent writings on the phenomenon and publications of experiments became known in England, and they doubtless intrigued Josiah Wedgwood, the English pottery manufacturer. When Catherine the Great of Russia commissioned a dinner service to be decorated with over a thousand images of country mansions and views, many generated with a camera obscura, Wedgwood was probably motivated to find a photo-chemical transfer process. In 1802 his son Thomas and the chemist Sir Humphrey Davy attempted to print paintings on glass and record botanical specimens by placing them on paper and white leather sensitized with a solution of silver nitrate. These and other chemical experiments succeeded in producing light silhouettes within darkened grounds. But the reversal of normal dark–light values displeased the inventors, as did the impermanence of their images. After an exposure was made, the silver solution remained light-sensitive and the materials continued to darken, causing the image to soon disappear.

Talbot contributed, in 1835, by his choice of paper as his light-sensitive surface; his breakthrough was his realization around 1839 that the translucent paper he had sensitized,

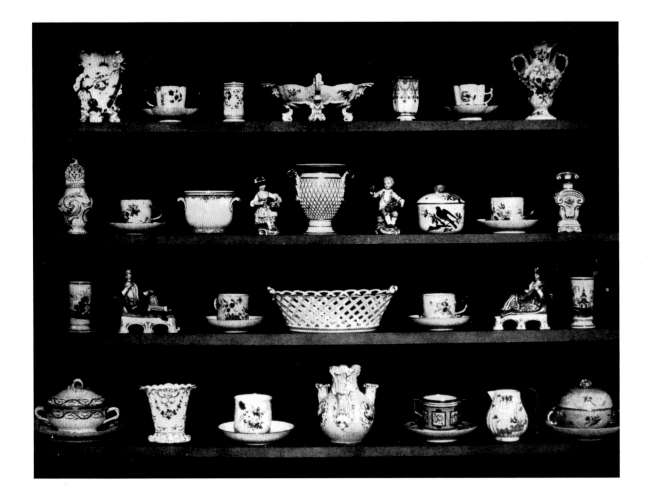

once exposed and washed clean of unexposed silver parti-
cles (or "fixed"), could be used as a "negative"—a term
coined in 1840 by his friend, the scientist Sir John Herschel.
Laid on top of another light-sensitized paper sheet and
exposed, the "negative" produced a "positive," in which the
light–dark values were reversed again and thus normalized.
Talbot's "negative–positive" process became the world's
most widely used photography.

It is revealing that Talbot's first surviving photographs
depicted his estate, Lacock Abbey, outside London. Though
he was reared in comfort and expensively educated, financial
reverses for his family meant that he could not take posses-
sion of this ancestral home until 1828. His early photograph
of a Gothic Revival oriel window there demonstrates by its
very existence his access to the handsome property. Talbot's
subsequent photographs around the estate, showing its rus-
tic charm but also its agricultural economy, are evidence of
his position among England's landed gentry. Likewise, his still
lifes of tables set with crystal and silver, and his photographs
of shelves of books, porcelain, and glassware are more than
demonstrations of photography's rendering of detail. His
chosen objects appear to be possessions that display his
knowledge and good taste, in an era when mass-production

PHOTOGRAPHY AT YOUR SERVICE FROM 1844

William Henry Fox Talbot's *The Pencil of Nature*, 1844-46, described or illustrated the wealth of purposes that photography can serve. The camera is a "royal road to drawing," Talbot claimed, and art novices "will find themselves enabled to enter the field of competition with Artists of reputation, and perhaps not infrequently to excel them in the truth and fidelity of their delineations and even in their pictorial effect, since the photographic process when well executed gives effects of light and shadow which have been compared to Rembrandt himself."

Photographs of everyday life could be artworks in 17th-century Dutch style: "A casual gleam of sunshine, or a shadow thrown across his path, a time-withered oak, or a moss-covered stone may awaken a train of thoughts and feelings, and picturesque imaginings." Portraiture was "one of the most attractive subjects of photography," and a gift to posterity. "What would not be the value to our English Nobility of such a record of their ancestors who lived a century ago?" And photography's record-making was impartial; it documented items even the photographer had not noticed: "Sometimes inscriptions with dates are found upon the buildings, or printed placards most irrelevant, are discovered upon their walls; sometimes a distant dial-plate is seen, and upon it—unconsciously recorded—the hour of the day at which the view was taken." Between the posters covering the hoardings around London's Nelson Column, under construction when Talbot photographed it in 1845, one can read the stenciled warning, "No Bills."

was beginning to make bad taste cheaply available. Architecture and still life, so conveniently inert, became emblems in the photographs of this learned gentleman.

WILLIAM HENRY FOX TALBOT (B. WILTSHIRE, ENGLAND, 1800–D. WILTSHIRE, 1877)

Talbot evolved the negative–positive process, the core of almost all photography (until the digital era), and was also the first in related areas: he discovered the latent image and how to speed its appearance through development, photo-enlargement, micro-photography, halftone screen reproduction (vital for printing photographs along with text), and a *cliché-verre* process. His *The Pencil of Nature*, 1844-46, was the first book illustrated with photographs (pasted in), and one describing multiple applications for photography, all of which are still current. His oeuvre of some 600 prints was the first body of photography with a distinctive aesthetic. A scientist-inventor, artist, and theorist of camerawork, he was the epitome of a Victorian genius. And photography was just one of his interests.

Talbot studied at Harrow and then classics and mathematics at Cambridge University. At 22 he was elected a Fellow of the Royal Astronomical Society, and he went on to publish on mathematics, physics, botany, Bible studies, Assyriology, and the deciphering of cuneiform. His friendships with the scientist Sir David Brewster as well as Sir John Herschel encouraged his interest in optics and chemistry, the key ingredients of photography. In 1834 he discovered how to make paper light-sensitive by coating it with alternating washes of silver nitrate and potassium iodide. The resulting silver iodide darkened where exposed to light, producing photographic silhouettes, or what Talbot called "photogenics"—light drawings or photograms—of objects such as leaves or lace placed on the paper (see pp. 60-1). He also placed the sensitized paper into little lens-fitted cameras (which his wife called "mousetraps") and exposed the sheets for up to 30 minutes. In 1835 this resulted in the first surviving negative in photo-history, of a window at Lacock Abbey. His caption read: "When first made, the squares of glass about 200 in number could be counted with help of a [magnifying] glass." He had not yet learned to "fix" the negative (Herschel's term). Later in 1835 Talbot learned to stop the darkening of the unexposed silver salts by washing them with potassium iodide. He also arrived at the cliché-verre process by coating a glass plate with soot, into which a picture could be scratched, and then laying the glass upon sensitized paper and exposing the two to light.

For the next three years, Talbot pursued other interests, but on hear-

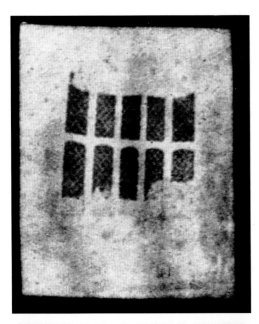

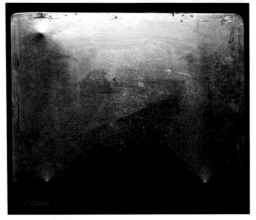

"ORIEL WINDOW" BY WILLIAM HENRY FOX TALBOT, CIRCA 1835; AND "VIEW FROM THE WINDOW AT LE GRAS," BY JOSEPH NICÉPHORE NIÉPCE, CIRCA 1826

ing in 1838 the first report of the success of Louis-Jacques-Mandé Daguerre with his own photography process, he rushed to publish his photogenics of 1835. When both processes were detailed later that year, their differences were obvious, but Daguerre had the edge, with publicity and his government's support. For the next 12 years, the

Frenchman's "mirror with a memory" would be the world's favorite photography.

Meanwhile Talbot concentrated on his negative–positive process, and by 1840 he had discovered the latency of images on negatives and how to speed up their development chemically and thus shorten exposure times. In 1841, after he had reduced times from minutes to seconds, he published on the "calotype" (from the Greek *kalos* or "beautiful") and patented it. Its ramifications for publishing images were enormous, and Talbot realized them from 1843 in a studio set up to mass-produce photographs. These were pasted into *The Pencil of Nature*, a subscription serial publication. In image and text, it demonstrated that photographs could be artworks in their own right and faithful copies of art and printed matter—sculpture, paintings, engravings, book pages, and handwriting; they could depict individuals; aid artists; foster science by providing accurate and comparative data about specimens; capture history in the making as monuments were erected; recall natural and architectural wonders from one's travels; and inventory one's valuables for insurance purposes.

Capitalizing on growing leisure travel among Victorians, Talbot's second book was *Sun Pictures in Scotland*, 1845; and he also photographed on the Continent. His photographs were often picturesque, with a British Romantic nostalgia for fast-disappearing agrarian life (the source of his income). He protected his patented commercial rights doggedly, and so the calotype remained primarily a hobby in England. When, in 1851, it was superseded by the wet collodion glass-plate negative, which produced a much sharper print, free of paper texture, Talbot stopped photographing. Instead he explored photo-engraving to ensure the permanency of photographic prints, and patented such processes in 1852 and 1858.

Talbot's photographs of architecture—whether in London, Paris, or Scotland—reveal his thoughtful temperament, interest in traces of time, and awareness of the differences between high and mass culture. Distanced and artfully selected from the urban fabric, without human figures, his calotypes of man-made structures reveal his differences

from the chief contemporary inventors of photography, Daguerre and Niépce.

LOUIS-JACQUES-MANDÉ DAGUERRE (B. CORMEILLES, SEINE-ET-OISE, FRANCE, 1787–D. BRY-SUR-MARNE, 1851)

The inventor of the first widely usable photographic process, Daguerre was a show-business entrepreneur and hack Romantic painter who knew how to entertain a crowd. His rival, Talbot, inventor of the more important negative–positive process, was a learned and well-connected aristocrat, and Daguerre's partner in photography, Joseph-Nicéphore Niépce (1765-1833), was an amateur engineer and chemical experimenter fallen on hard times. But the self-made Daguerre thrived as a popular image-maker and a master marketer. No wonder the daguerreotype—which immodestly bore his name—electrified the world when it was announced in 1839.

Raised in a petit-bourgeois family in a small town near Paris, Daguerre was apprenticed to a local architect and then to a stage designer in the capital; later he became an assistant to Pierre Prévost, master of panoramic painting, and worked for him during 1807-16. Daguerre contributed illustrations to the twenty-volume series *Picturesque and Romantic Travels in Old France*, and in 1814 he began showing his Romantic landscape canvases at the Salon. His scenery designs of 1816-19 for a theater specializing in melodramas were so successful that he was invited to design for the Paris Opéra. In 1822 he opened the illusionistic theater he called the Diorama, winning a Legion of Honor award two years later for its popularity. There, changing lights on his huge scenic paintings (executed on both sides of gauze), rotating seats, and props that extended the illusion of the art into the viewer's space, gave customers the impression of touring the Swiss Alps, Gothic ruins in Scotland, or sunny Spain. The success of these entertaining and instructive fool-the-eye paintings depended on their convincing perspective and detail. Daguerre's profits depended on presenting new virtual tours as often as possible.

Daguerre used a camera obscura, like many artists, to aid his drawing of landscapes and architecture, and he doubtless wondered whether the images appearing in it could be made

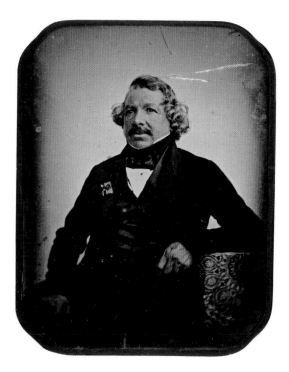

A PORTRAIT OF LOUIS-JACQUES-MANDÉ DAGUERRE BY JEAN-BAPTISTE SABATIER-BLOT, 1844

permanent and thus save him work in scenery painting. In 1826 he heard from his optician that a fellow customer for camera obscura lenses had made successful "sun-drawings" or heliographs: he quickly wrote to Niépce, who visited him in 1827 and was enchanted by the Diorama. Niépce had begun experimenting in 1816 and had mastered the chemical component of photography, but his optics were disappointing. Daguerre, on the other hand, claimed to have improved the camera obscura. The two formed a partnership in 1827.

Daguerre could build on Niépce's invention of photoengraving in 1822, a success with results that survive from 1826—a photographically made copy of a 17th-century engraving of Cardinal d'Amboise, minister to Louis XII. On a metal plate Niépce had spread a layer of bitumen (a kind of asphalt) dissolved in oil of lavender and then covered it with the portrait engraving, oiled to make it transparent. After a two-to-three-hour exposure to light, the bitumen beneath the pale

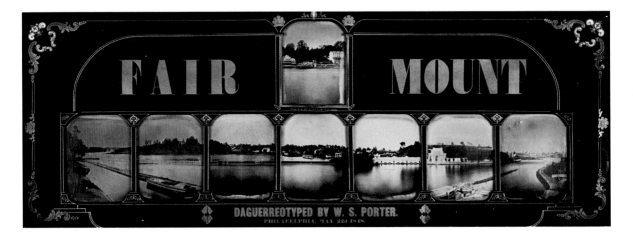

WILLIAM SOUTHGATE PORTER ASSEMBLED EIGHT DAGUERREOTYPE PLATES INTO ONE MOUNT TO CREATE THIS IMAGE OF FAIRMOUNT WATERWORKS IN 1848.

parts of the engraving hardened, while that under the dark lines stayed soft and could be washed off. The plate could then be etched and used to generate new prints. With the camera Niépce was less effective. In what the photo-historians Helmut and Alison Gernsheim consider the world's first extant photograph, a pewter plate shows a dim view of rooftops from Niépce's studio window, taken over eight hours in 1826. The scene includes a dovecote at one side and a barn's slanting roof in the middle: it represents his modest rural home, comfortable enough to allow experiment in photography, but plain.

Niépce tried applying iodine to silver-coated plates to speed up exposure time, but he died suddenly in 1833 and left Daguerre to achieve lasting results with Niépce's "heliography." In 1835 the painter also discovered that the faint image on an exposed plate could be brought out by fuming it with mercury vapor, also shortening exposure time; and by 1837 he found how to make his images permanent, by dissolving the unexposed silver iodide in salt water.

Daguerre's first surviving daguerreotypes express his notions of what photography could do. Shelves displaying fossil shells inform scientists about a new means of exact comparative study, and collectors about the benefits of documentation. A classically composed still life of plaster casts of Renaissance sculpture demonstrates that a photograph can be art and serve

art simultaneously. (A flask amid the images of females suggests the intoxicating pleasures of photographs.) A window view over the Boulevard du Temple in Paris is eerily unpopulated, but for a man who stopped long enough for a shoeshine (and therefore long enough to be captured by the long exposure) and the worker who served him. Yet the photograph describes shingles and street signs—more details than the eye could see from Daguerre's window—plus perfect perspective and consistent light. Though portraits and color escaped Daguerre, his 1837 daguerreotypes showed that nature and the man-made (at least their motionless parts) could be precisely and permanently recorded. In a broadside of 1838, he asserted that exposures could be made in 3 to 30 minutes and that the process would allow the "leisured class" to depict their country houses and "form collections of all kinds."

Daguerre's efforts to profit from his invention by selling subscriptions failed, but the politician and scientist François Arago—a progressive member of the Chamber of Deputies—recognized its usefulness to science, industry, and art. Believing that supporting inventions would glorify France, Arago convinced the French government in 1839 to award Daguerre and Niépce's son with lifetime pensions in return for making the details of their process public. The American painter and inventor Samuel F. B. Morse was in Paris during the excitement, and he bought the necessary photographic equipment and invited Daguerre to see his own new invention, the telegraph. While the Frenchman was visiting Morse, his Diorama burned down. It was a melodramatic symbol worthy of Daguerre, of the death

of one popular imagery as another was being born. He stayed in Paris, giving daguerreotype demonstrations, but in 1840 retired to a village outside Paris. His last significant artwork was an altar painting for the town church, which extended it illusionistically into a Gothic cathedral.

When Samuel F. B. Morse returned to New York, he quickly tried out the equipment, chemicals, and instructions he had bought from Daguerre and his opticians. It is revealing that while the French entrepreneur depicted a boulevard famed for its theaters of popular melodrama, the civic-minded Morse photographed City Hall. Among the world's daguerreotypists, Americans especially delighted in depicting urban settings reflecting local history, architects, and city growth. Samuel Bemis photographed King's Chapel Cemetery and its surrounding buildings in Boston in 1840-41, while around 1853 the firm of Southworth and Hawes portrayed Cambridge's new Mt. Auburn Cemetery, a picturesque "garden of graves" according to contemporaries. John Plumbe recorded the construction of the Capitol's dome in 1845-46; and panoramas—images much wider than tall—were made of impressive municipal facilities, like Philadelphia's Fairmount Waterworks by William Southgate Porter, 1848, or of burgeoning development, as in Cincinnati's waterfront, also by Porter, with Charles Fontayne, 1848. Whole-plate daguerreotypes (6 1/2 x 8 1/2 in.) were exposed contiguously and framed side by side: the Cincinnati panorama was over five feet long. Otherwise, panoramas were made on extended, flexible, single plates, which moved on a rail as the camera turned slowly in the opposite direction. As photo-historian Naomi Rosenblum points out, such vistas were built on the early 19th-century popularity of dioramas (like Daguerre's), and they let townspeople enjoy locating landmarks while officials could boast about their regular street plans and public amenities. For scientists, the city was to be seen from afar, as an organism with a circulatory system of goods, services, and social classes. Panoramas and aerial views, initiated in 1858 by Nadar, embodied this idea.

Not just local loyalties but the boom in travel fostered by the new railroads and steamships helped establish the profession of architectural photography. This may be dated as early as 1840-44 when the French publisher N. M. P. Lérebours launched his multi-volume *Excursiens Daguérriennes*, and hired photographers to document views and monuments from Paris to Moscow, from Spain to Greece. Though their daguerreotypes had to be translated into engravings for printing, the photographic origins of the pictures—and therefore their topographical accuracy—was publicized by Lérebours's title. New architecture and engineering feats also interested educated amateurs, thanks to relentless building during the Victorian era and to debates about proper

PARIS, AUGUST 19, 1839: DAGUERREOTYPES REVEALED!

Between the announcement of Daguerre's magical process and the publication of its ingredients, seven months passed and popular excitement picked up steam. Quoted by Helmut and Alison Gernsheim, an eyewitness described the public's response to the presentation: "Enthusiastic cheers resounded from the grave benches even of the Academy. Truly a victory—greater than any bloody one—had been won, a victory of science Gradually I managed to push through the crowd and attached myself to a group near the meeting-place, who seemed to be scientists After a long wait, a door opens in the background and the first of the audience to come out rush into the vestibule. 'Silver iodide,' cries one. 'Quicksilver!' shouts another, while a third maintains that hyposulphite of soda is the name of the secret substance. Everyone pricks his ears, but nobody understands anything. Dense circles form round single speakers, and the crowd surges forward in order to snatch bits of news here and there An hour later, all the opticians' shops are besieged, but could not rake together enough instruments to satisfy the onrushing army of would-be daguerreotypists; a few days later you could see in all the squares of Paris three-legged dark-boxes planted in front of churches and palaces. All the physicists, chemists, and learned men of the capital were polishing silvered plates, and even the better-class grocers found it impossible to deny themselves the pleasure of sacrificing some of their means on the altar of progress, evaporating it in iodine and consuming it in mercury vapor.

styles fanned by such critic-theorists as John Ruskin and A. W. N. Pugin. Among politicians, the competition between European countries for industrial and colonial power, seen in the world's fairs begun in 1851, gave public buildings additional weight as national symbols. Meanwhile architecture professionals were banding together for self-education and promotion of the field: in 1834 the Royal Institute of British Architects, the Société Française d'Archéologie, and the Commission des Monuments Historiques were all founded; and in 1842 *The Builder* magazine first appeared, designed for a general audience. Daguerreotypes of architecture answered all these curiosities, while they spread information about world cities and their monuments. Having a daguerreotype, Ruskin enthused, was "very nearly the same thing as carrying off the palace itself."

THE MISSIONS HÉLIOGRAPHIQUES, 1851, AND CONTEMPORARY FRENCH PHOTOGRAPHERS

The year 1851 was a good one for European architecture and photography. Napoleon III, Bonaparte's nephew, gained the French throne by a coup d'état, and he rapidly moved to affirm his legitimacy and broaden his support by sponsoring massive public works projects, vast demolition and reconstruction in Paris to regularize and glamorize its plan, documentation of the national architectural heritage, and restorations across France. Photography was a witness to all these operations, and a propaganda tool intended to assert Napoleon's progressivism. It was the year of the Great Exhibition in London, the first world's fair, called the Crystal Palace Exposition for the giant greenhouse-like pavilion by Joseph Paxton that housed it. There the industrial products and arts of all nations competed for medals and sales. Photography was among them, and prints made with Frederick Scott Archer's collodion wet-plate (or wet collodion) process were displayed. The painstaking process, published in 1850 and 1851, involved suspending light-sensitive silver salts in collodion, or guncotton dissolved in alcohol, then coating a glass plate with the fluid, and subsequently exposing and developing it while still wet. The process recorded detail as minutely as the daguerreotype, yet allowed a near-endless duplication of prints like the calotype.

Combining the best of the original photographs, wet collodion made them both obsolete.

Also marking 1851 was the first photographer's association, the Société Héliographique, founded in Paris with its own magazine, *La Lumière*, the first journal with serious coverage of aesthetic and technical issues in photography. That year in Lille, the publisher Louis Désiré Blanquart-Evrard began mass-producing photographic prints from paper negatives and using them for book illustration and for sales, priced as reasonably as etchings and lithographs. France was fighting to catch up with England as a modern industrial power, and its cultural inheritance, especially as known through images of landmarks, was a locus of patriotic feeling.

Giving unprecedented official recognition to camerawork, in 1851 the state-funded Commission des Monuments Historiques formed a team of five photographers known as the Missions Héliographiques. Gustave Le Gray, Henri Le Secq, Hippolyte Bayard, Edouard Denis Baldus, and O. Mestral were assigned to document the key monuments, sacred and secular, of the main regions of France that were slated for restoration by the architect Eugène Emmanuel Viollet-le-Duc. The latter's goal was to erase the decades of neglect and damage to French architecture since the Revolution. He recommended photography to establish the extent of restoration needs and then to measure his improvements.

For the Missions, photographers made calotypes, not daguerreotypes—a choice that may seem surprising at first glance. But most of the team had trained as painters, in the studio of Paul Delaroche, who encouraged photography as an aid to drawing, and they had gained an affinity for the broad massings of tone and the painterly quality of prints made by the calotype process. When **Gustave Le Gray** (1820-1862) invented the waxed-paper negative in 1851, which considerably sharpened the calotype's details, the team adopted it, and could remain indifferent to both the daguerreotype and Archer's new collodion process on glass plates. At the same time, the ease of using a paper negative, relative to glass or

HENRI LE SECQ POSED FOR CHARLES NÈGRE WITH A GARGOYLE ON PARIS'S NOTRE DAME IN 1853.

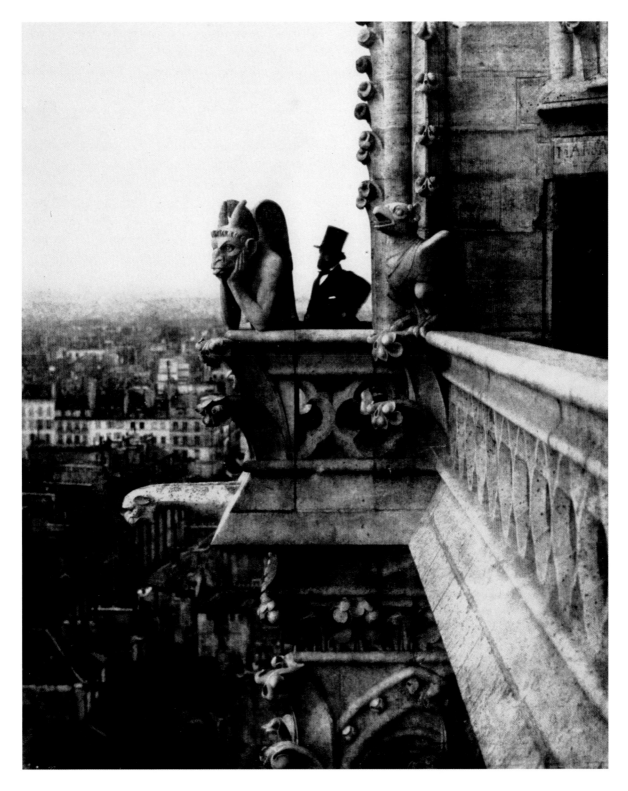

the daguerreotype's metal plate, made larger prints feasible. Darkroom enlargements were impossible until the 1880s, and so the 20 x 28-in. photographs produced by **Charles Nègre** (1820-1880) around 1850 were impressive. Dominating all architectural photography at mid-century were historic façades, while interior views were few owing to poor light.

Of the Missions photographers, **Edouard Denis Baldus** (1813-1882) was the most classical in style, favoring distanced, head-on vantage points, taken where possible from second-story windows opposite his buildings. His balanced views, produced when the light best revealed structure, proportions, and ornament, purposely resembled the architectural drawing type known as the elevation. **Henri Le Secq** (1818-1882), on the other hand, was almost as experimental as his teacher Le Gray (see pp. 115-6). Le Secq's stress on forms modeled with soft shadows created a sense of mystery at cathedrals such as Chartres and Amiens, but also at a Seine bathhouse.

Le Secq was the center of a witty photograph at the cathedral of Notre-Dame by his friend Charles Nègre, which sums up the consciousness of these architectural photographers in 1851 (See p. 35). Le Secq's dapper, top-hatted silhouette contrasts with that of a gargoyle emblematic of medieval Paris in popular etchings by Charles Meryon and others. The paired figures might represent France, old and new, while the camera, raised on high at the cathedral, captures both in the grip of the building's perspective. Nègre did not privilege the camera over the canvas in general, however, and he used some of his photographs as bases for paintings of cityscapes or anecdotal figures in apparently spontaneous movement.

Hippolyte Bayard (1801-1887), who contributed to expressive self-portraiture (see pp.68-9), also pioneered in portraying work scenes in Paris and the city under construction. Even before joining the Missions, he made panoramas and studies of streets, individual buildings, and a laborer. He can be seen as an artistic ancestor of Eugène Atget, the great turn-of-the-century chronicler of the buildings and trades people of Paris. Another ancestor of Atget was **Charles Marville** (1816-1879), who, working apart from the Missions,

photographed architecture, especially around the ancient Ile-St.-Louis, where he lived. Marville showed the unsettling speed of demolition in Baron Georges Eugène Haussmann's reconfiguration of Paris, as dark old quarters were leveled to make way for the straight, parade-width boulevards beloved by Napoleon III. Though Marville was employed by the city in the late 1850s and named official "Photographer of the City of Paris" in 1862, his photographs conveyed ambivalent messages about the destruction of medieval Paris, where crooked streets were readily barricaded in uprisings, but where time and need had generated natural evolution. He showed these streets without people, but from pedestrian level and as urban spaces, with signs of vital commercial life and occupation. (For Thomas Annan's photographs of Glasgow streets, which are superficially similar (see pp. 158-9).

Were preservationist views influential then? They may explain in part why the Missions team's photographs were never published by the Ministry of the Interior, but simply archived without comment. More than 300 were generated, recording the range of French architectural history, yet their fate was not explored until the early 1980s, as 19th-century photography came under scholarly scrutiny. In Napoleon's France, demolition and building pressed on without interruption, however, and *La Lumière*, the photography magazine, recognized the artistry of Missions cameramen and the particular demands of architecture as a photographic genre. Baldus, for example, continued in the field, printing on albumen papers, and was commissioned by Baron James de Rothschild in 1855 to document the railroad line he helped finance for the government between Paris and Boulogne. Baldus's sense of crisp linear design suited the engineering, and an album of his photographs was presented to Queen Victoria by the baron. In 1851-61 Napoleon was investing an estimated 7 percent of the gross national product in railroad building, and so the gift was a gilt-edged token of French competition. Others who photographed for the railroads in this age of expansion included the Bisson brothers in France in the 1860s, and in the United States, Andrew J. Russell and Alfred A. Hart in the 1860s and '70s (see pp. 118-20) and William Herman Rau in the 1890s.

THE GRAND TOUR OF ITALY

In Italy at mid-century, tourists with varied budgets surged in from across Europe, determined to bring back photo-filled albums of the trophy sights they had seen. Until the 1880s when they could snap photographs themselves, travelers bought views or albums from commercial firms founded by Italians or English-speaking expatriates. Wet collodion negatives were almost universally used for their detail and reproductive capability. Conventions that persist to this day for showing the Duomo of Florence, the Bridge of Sighs in Venice,

ROBERT MACPHERSON SHOWED LUSH FOLIAGE SURROUNDING THE "CLOACA MAXIMA," CIRCA 1859.

St. Peter's in Rome, and the like were locked in by the long-lived firms of Fratelli Alinari in Florence, Carlo Ponti in Venice, and **Robert Macpherson** (1811-1872) in Rome. In the topographical tradition of rendering full details, these photographers presented the maximum information about famous structures (which also served architects), while showing them entire, within their cities. Figures were rare, in part owing to long exposures, or they were shown back-to, as posed stand-ins for the tourists who bought the photographs and could say, "we were right there." The histories of architecture and art were taught with such photographs through the 1960s, with little recognition of the craft or aesthetics of their makers.

Macpherson's industry typifies that of Victorian entrepreneurs

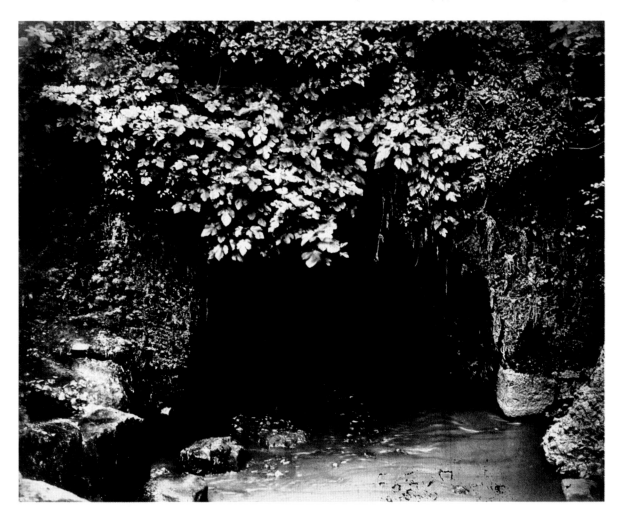

as well as period photography businesses. A member of Rome's anglophone art community since circa 1840, this landscape painter adopted the camera in 1851. By 1863 his catalogue listed over 300 views at modest prices, and the year before he exhibited more than 400 photographs at the Architectural Photography Association in London (a group founded in 1857 to support the profession). Macpherson worked all over Italy, but he was identified with the Holy City. A reviewer of his 1862 show asserted that from it "the collector may obtain everything he wants of Rome, from the Coliseum to a cameo." Though others imitated his signature images, Macpherson added expression to certain examples through reflections, wide-angle distortions, and asymmetrical compositions.

Leopoldo Alinari (1832-1865) opened his first photography studio in 1852, and two years later his brothers Romualdo and Giuseppe joined him to found Fratelli Alinari. In this decade the Uffizi Gallery awarded them valuable permission to photograph its painting collection; and in the late1860s they became official government photographers after Florence was named capital of the newly independent Italy (a position it held from 1865 to 1871). Today the firm owns 3.5 million historical photographs of Italian culture, having acquired the archives of Anderson, Brogi, Beato, and many others; and it functions as a photo-agency and a book and print publisher, while it operates a museum of photography in Florence in the Renaissance Palazzo Rucellai.

STILL LIFE IN THE WET COLLODION ERA

Studies of abundant fruit and flowers, tabletop arrangements of deluxe or quaint objects: these subjects let photographers explore effects of light and imitate still-life paintings, as they sought the respectability accorded artists. In the wet collodion era, from the 1850s through the 1880s, photographers and Realist painters influenced one another, and both reflected the period's optimism and its wholehearted pleasure in possessions, whether from nature or craft. Painters such as Gustave Courbet and photographers of still lifes shared the enthusiasm for 17th-century Dutch and Spanish art (France's empress was Spanish), but they ignored that tradition's use of still life as *vanitas*—a reminder of life's transience—to concentrate on its potential for opulent display.

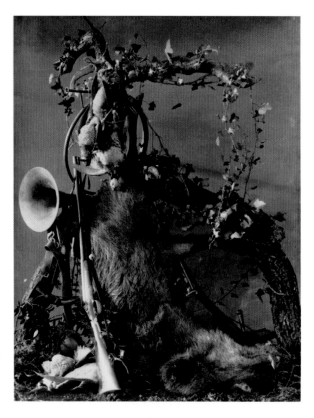

ADOLPHE BRAUN CREATED "STILL LIFE FOR A HUNTING SCENE" IN 1860.

In Great Britain in 1860, Roger Fenton confirmed his status as official photographer to the royal family with still-life photographs bursting with noble abundance. Gigantic grapes, heavy heirloom roses and lilies, punctuated by plaster cupids, filled his albumen prints edge to edge, bragging of nature's bounty, the gardener's skill, and the luxurious taste of the photographer. His compositions were obviously artful, recalling his efforts to raise photography's status from 1853, when he founded the Royal Photographic Society with Queen Victoria's patronage.

In Paris in 1854, **Adolphe Braun** (1812-1877) exhibited an album with 300 of his photographs of flowers to great acclaim. His venue was the Académie des Sciences, and he had made the albumen prints as design sources for the Alsace textile manufactory where he worked. But the album was hailed as more than a tool for designers of porcelain, wallpaper, and fabric. Cut

flowers, herbs, grasses, and shrubs of great variety were silhouetted against plain grounds, their containers minimized to allow concentration on the plant forms. The generous bouquets looked fresh from the greenhouse (Braun's second wife was the daughter of a horticulturalist), and they witnessed his technical skill, since the plants risked wilting in the sunlight necessary for detailed recording. Braun asserted that his album was the first series in a "Natural History of Flowers," and though he never finished this, he soon produced additional flower photographs in stereo cards and formats up to 16 x 20 in. Commended in 1854 magazines as "likely to tempt all people of good taste" and exhibited in 1855 at Paris's Exposition Universelle, Braun's still lifes bridged commerce, science, and art. He was recognized as a photographer on a par with Baldus, Le Secq, and the Bisson brothers.

Braun's career now began in all sorts of commercially attractive photography. Through the 1870s he and his family members produced prints of the Alps, provincial monuments, and sights of Rome and Egypt; railroad construction; museum collections (including the Louvre's); and Swiss costumes—which they generated in various sizes to suit different wallets. The photographs pasted into stereo cards were so small, at about 3 x 2 1/2 in., that they required no retouching; but Braun also made 32 x 24-in. carbon prints in 1867, suitable for framing. His theme in the latter case was "Trophies of the Hunt," for which he artfully arranged shot game birds, deer, foxes, and so on, with hunter's gear. His sources lay in 18th-century paintings by Chardin and Oudry; his intended buyers were wealthy print collectors who enjoyed (or aspired to) the privileges of the aristocracy, such as the hunt.

In Great Britain, Fenton and others photographed comparable hunt still lifes. And in France, Braun's flower albums inspired **Charles Aubry** (1811-1877), who in 1864-69 arranged leaves with fruits and flowers as studies for art students and industrial designers. The static quality of Aubry's often symmetrical compositions derived in part from his custom of dipping his ingredients in plaster of Paris. Of course his monochrome photography did not reveal this. (For early attempts at full-color photography—where flower pieces were favorite subjects—pp. 258-9).

THE TURN OF THE CENTURY

The halftone plate, introduced to newspaper and magazine printing in the late 1880s, changed the fortunes and looks of architectural photography. As architectural photographer and author Cervin Robinson notes, halftone reproduction was cheap, and so it encouraged illustration of vernacular buildings and monumental ones through details, in addition to series of photographs where a single image had once sufficed. Most architects now chose photographs over drawings as records; and images of contemporary buildings were more frequently published than they had been, relative to those of historic landmarks. Magnesium flash powder made photographs of interiors possible; and in the Gilded Age, when the profession of interior designer emerged, photo-illustrated books of "Artistic Houses" included such documents of their craft. In the popular market, picture postcards with their soon-clichéd views undercut the business of firms such as Alinari. This and the rise of amateurs wielding cheap Kodak cameras on weekends and holidays drove art photographers to evolve new approaches to the built environment. The international movement known as Pictorialism arose in the 1890s in response to such commercial and popular pressures. Dedicated to personal expression and exquisite printing, groups formed in various cities, of which The Linked Ring in London (founded in 1891) and the Photo-Secession in New York (founded in 1902) were the most famous (see pp. 237-57). The differences in style of the Englishman Frederick Evans and of his colleagues in America—Alfred Stieglitz, Edward Steichen, Alvin Langdon Coburn, and Karl Struss—reflected the new importance of aesthetics in the photography of architecture.

FREDERICK H. EVANS (B. LONDON, ENGLAND, 1852– D. LONDON, ENGLAND, 1943)

The demands of architectural photography met those of Aestheticism in the person of Evans, a London bookseller who became familiar with the circles of Oscar Wilde and Aubrey Beardsley (one of his greatest portrait subjects)—of F. Holland Day and other Pictorialists, as well as William Morris of the Arts and Crafts Movement. Evans was unusual among members of The Linked Ring in upholding "pure" unmanipulated photography,

THE ARTIST AND THE CATHEDRAL DEAN

Frederick H. Evans's infinite patience and fastidiousness in pursuit of his vision inspired this only slightly exaggerated description by George Bernard Shaw in a 1903 publication on Evans: "He has been known to go up to the Dean of an English cathedral—a dignitary compared to whom the President of the United States is the merest worm, and who is not approached by ordinary men save in their Sunday-clothes—Evans, I say, in an outlandish silk collar, blue tie, and crushed soft hat, with a tripod under his arm, has accosted a Dean in his own cathedral and said, pointing to the multitude of chairs that hid the venerable flagged floor of the fane, 'I should like all those cleared away.' And the Dean has had it done, only to be told then that he must have a certain door kept open during a two hours' exposure for the sake of completing [the] scale of light."

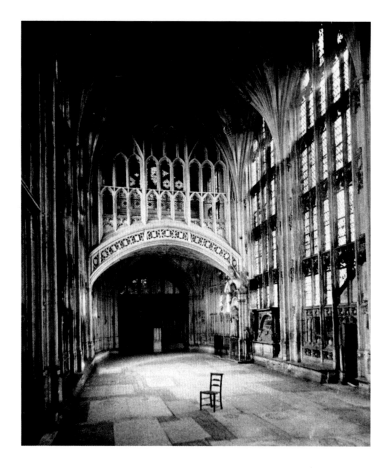

FREDERICK EVANS PAINSTAKINGLY CHOSE TIME AND PLACE TO PORTRAY MONUMENTS SUCH AS "GLOUCESTER CATHEDRAL, LADY CHAPEL, TO WEST" IN 1890.

and his lapidary platinum prints—especially of English cathedrals and French chateaux—are poetic both in their sensitivity to nuanced light and awesome scale and informative about hallowed monuments, relative to the fuzzy architectural photographs by Pictorialist contemporaries.

Evans first attempted photography around 1885 with a series of micro-photographs to illustrate a scientific text, and his studies convinced him of the existence of growth principles underlying and unifying creation. These ideas were shared by supporters of the Gothic Revival in Victorian arts—by Morris, critic John Ruskin, and others—who saw Gothic structures as organic and longed to recreate the union of art, artisanship, and spirituality in the Middle Ages. With such convictions Evans began to photograph British architecture in 1896; in 1898 a small annuity let him retire from his bookshop to devote him-

self to "the lifelong study of the beautiful." He joined The Linked Ring in 1901 and was the subject of the fourth number of *Camera Work*, the first British photographer so distinguished by the demanding Alfred Stieglitz. In 1928 the Royal Photographic Society awarded him an honorary fellowship.

Evans's best-known photographs are of such great churches as York Minster, Wells Cathedral, and Westminster Abbey, where light filtering through stained-glass windows and edging ancient stones creates a hushed and reverential atmosphere. These repositories of British history, faith, and building skill are free of people and any signs of present-day use, thanks to Evans's persistence in pursuing desired shots. His perspectives enhance the grandeur of the architecture, yet the warm shadows and worn details suggest the centuries of human presence. "Try for a record of emotion rather than a piece of topography," he advised the beginning photographer. "Wait till the building makes you feel intensely … then try and analyse what gives you that feeling …." One reads his photographs not to reconstruct their cathedrals or locate their details but to absorb his interpretation of a Gothic spirit.

In 1905 *Country Life* magazine commissioned Evans to photograph French manor houses; and in 1908–9 he made a series of landscapes for a memorial edition of the poems of George Meredith. In 1916 his photographs illustrated *Twenty-Five Great Houses of France*. When platinum papers were taken off the market after World War I, owing to loss of access to Russian sources, Evans stopped photographing. He demanded the delicate tones, transparent shadows, and matte surfaces of what were commercially known as Platinotypes. Gelatin silver papers did not satisfy him.

Evans and the French photographer Atget were born in the same decade and shared the belief that architecture was civilization's richest repository. But they worked unknown to one another, and Atget—unlike Evans—was widely celebrated for his artistry only after his death.

JEAN-EUGÈNE-AUGUSTE ATGET (B. LIBOURNE, NEAR BORDEAUX, FRANCE, 1857–D. PARIS, 1927)

Recording Paris occupied Atget for 20 years—its medieval cobblestoned streets, its Beaux-Arts façades reflected in modern, manikin-filled shop windows, its environs with deserted, once-royal parks, its vendors and trades folk, its quaint amusements and open-air markets—subjects that he sometimes labeled "destined to disappear." The theme that critics have discerned in his huge oeuvre is time and French culture, found in a given cityscape with its accreted marks of human presence and in the encyclopedic portrait composed by his career's over 10,000 negatives.

Atget turned to photography to earn a living at age 40, after working as a sailor, actor, and painter. In 1897 he began cataloguing Paris. He advertised his prints as "documents for artists," making them as aids for illustrators and painters, sources for artisans, such as stage and decorative designers, and records for national archives and historians of the city, in an industrializing period with a renewed concern for architectural preservation. The urban historians' market and his old-fashioned equipment connect him with the photographers of the Missions Héliographiques of 1851 and commercial view makers then: like Charles Marville he trained his bulky view camera on picturesque neighborhoods, and he got street people to pose in the early 19th-century genre tradition of journalistic "Cries of Paris" sketches. Municipal institutions such as the new Musée Carnavalet commissioned some of Atget's gold-toned contact prints; he made the majority in hopes of sales. His clients' interest in detailed information about his subjects, and relative indifference to photographic art, helps account for some of his stylistic trademarks: his shadow falls into some pictures; he used a slightly wide-angle lens to embrace more data, a lens that sometimes contributed to drastic perspectives and vignetting in the upper corners of prints; and his long exposures and slow plate film could produce halation and blurs from moving elements. To avoid people, he chose to work at sunrise or dusk: his worlds are sometimes dreamlike in their depopulation. (These traits, insignificant to Atget, have come to endear him to modern collectors and photographers.)

In 1920 Atget sold 2,500 negatives of old Paris to the Caisse National des Monuments Historiques, a financial coup that let him photograph more personally in his last years. The domestic interiors of people of various social classes entered his

ABBOTT ON ATGET

In *The World of Atget*, 1964, Berenice Abbott presented some of the Atgets she had saved after his death, and she connected the professions of the photographer, who was a small-time actor before devoting himself to documenting Paris and working Parisians. "Interrelation of actor with audience developed a psychology for human exchange and sympathy, evident in his pictures of people, who appear to have cooperated with the photographer To Atget the visible world became the stage; man himself and the effects of man, the great drama. Men and women in the Paris streets became the cast of characters. He knew how to dramatize his subjects, but his photographs were never merely theatrical. The stage was now transformed to the larger scene in front of his lens, and the photographs repeatedly suggest the stage setting which one beholds after the curtain goes up."

repertory. Photographed in a more subjective and simplifying light, gnarled trees and neglected statues became personal metaphors. And he returned to favorite motifs for more close-up views.

In 1926 his neighbor Man Ray published a few of Atget's photographs, including a shop window, and claimed his spatial complexity, uncanny dummies, and occasional chance effects for Surrealism, the artistic movement of which Man Ray was a part. On Atget's death, Berenice Abbott acquired 7,800 prints and some 1,400 negatives with help from the dealer Julien Levy, and she acclaimed Atget's documentary lucidity to modernist friends, publishing a book on him in 1930. She tirelessly promoted his work and its purely photographic qualities until it was purchased by New York's Museum of Modern Art in 1968. In the 1980s, the museum published four catalogues of it, establishing the authority of Atget's elegiac artistic vision. At one extreme, his photographs can be dry archaeology; at the other, they are haunting poetic scenes that the Rococo painter Watteau might have imagined after his actors left the stage. Their impact has been felt by numerous photographers, from Walker Evans to Lee Friedlander.

At the beginning of the 20th century, New York was racing Chicago to build the world's tallest skyscrapers, using America's immigrant labor. The Photo-Secessionists cared nothing for engineering or economics, however, and when they photographed landmarks, such as the Brooklyn Bridge or the Flatiron Building, they simplified their motifs into silhouettes and portrayed people for animation and scale, not as representations of work or class. Romantic evocations of atmosphere, the views of Stieglitz, Edward Steichen, Alvin Langdon Coburn, and Karl Struss distinguished themselves by their self-conscious artistry from commercial documents, which were multiplying to serve the picture press. While Joseph Byron and his family, for example, produced nearly 30,000 views of New York in 1890-1910, the Photo-Secessionists labored lovingly to make unique prints from a few choice negatives. Though they shared the widespread conviction that the city was the locus of progress and American achievement, they described its gutsy harbor and thrusting new skyline lyrically, veiled by mist, rain, snow, or twilight. In so doing, they underscored their technical achievements (under conditions believed impossible for photography) in association with those of city builders.

In 1899 Alfred Stieglitz wrote that he was searching the city for "picturesque bits ... homely in themselves" to which he would give "permanent value" through his "poetic conception of the subject." New York was as photogenic as Venice and Paris, he indicated, and through his photographic beautification its rough reality (the squalor and suffering seen by Jacob Riis

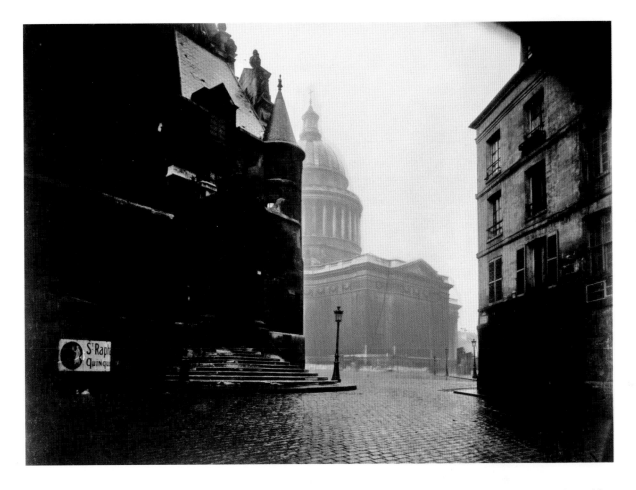

WHILE DOCUMENTING THE ARCHITECTURE OF PARIS IN 1924, EUGENE ATGET USED LONG EXPOSURES TO RENDER THE MOOD SURROUNDING BUILDINGS SUCH AS THE PANTHEON.

and Lewis Hine) could be transcended. In 1910 Stieglitz titled a New York harbor photograph "City of Ambition," encapsulating his feeling for Manhattan. He later stated that "my New York is the New York of transition.—The old gradually passing into the New" (a subject that Abbott would later tackle in her book *Changing New York*). In the 1930s, in hard-edged, sharp-shadowed photographs from his midtown apartment, he presented the latest icons of Gotham—the towers of Rockefeller Center in construction, notwithstanding the Depression. The city, he had written in 1914, "is like some great machine, soulless, and without a trace of heart …. Still I wonder whether there is anything more wonderful than New York in the world just at present."

MODERNIST CONSTRUCTIONS

Modernism in photography grew out of the pre-World War I art movements of Cubism, Futurism, and other "isms" that shattered conventional perspectives and pioneered abstraction. Chapter 7 of this book deals with the broad responses of international art photographers to the pictorial revolution; here, it is illuminating to see how readily the mute subjects of still life and architecture reflected the explosion of Renaissance norms in art.

Paul Strand adopted the view-from-above of Coburn in 1916 for his ground-breaking series titled "Abstraction—Porch Shadows." But instead of ascending Manhattan skyscrapers as Coburn did, he pointed his camera down and at an angle on a

tilted table and chair beside a porch rail. His vantage point and close-up on the simple fragmentary objects defied conventional spatial reading. The chevrons of shadows and solids patterned his print surfaces and challenged recognition. Yet these and all Strand's photographs are "straight"—unmanipulated in the darkroom. His abstraction, inspired partly by Synthetic Cubism, is generated by purely photographic means. Made around the same time, his photographs of New York structures stressed their geometries, especially in relation to the picture edges. And his close-up studies of his Akeley movie camera in 1921-22 (he was also a cinematographer) paid rapt homage to this precision machine.

In 1912 Charles Sheeler began commercial architectural photography to help support his painting career. On weekends at his Bucks County farmhouse, outside Philadelphia, he photographed the plain Colonial buildings as private experiments, and in 1917, through close-ups and unusual angles, he produced camera equivalents for the geometric simplifications of vanguard painting and the found objects of Dada. Even at Chartres Cathedral in 1929, he found geometry and structural principles and chose to photograph the buttresses from a vantage point on the roof, as repeated proto-mechanical forms. In an ironic inversion in 1927, he documented the Ford Motor company's River Rouge plant like a secular cathedral, using a worshipful low angle to photograph its smokestacks and crisscrossed conveyor belts. The title of an industrial painting by a colleague could apply to Sheeler's series: it showed "The Incense of a New Religion."

In Germany in the 1920s, sharp-focus images of manufactured items, slices of nature, and people were identified with the New Objectivity in both photography and painting (see pp. 275-6). In the early part of the decade, **Albert Renger-Patzsch** (1897-1966) became known as a commercial photographer, and in 1925 he made his publishing debut with *Das Chorgestühl* (Choirstalls) *von Cappenberg*. The discipline of precisely recording medieval architectural carving went into his best-selling *Die Welt ist Schön* (The World is Beautiful), 1928, which proved the camera's ability to isolate pleasing related patterns in the manufactured and the natural. Critics favorably compared Renger-Patzsch's lucid style to that of architects' technical drawings. In the 1930s he published more books on German architecture, which identified medieval churches with the German landscape, a trope of patriotic 19th-century Romanticism.

"CHASE NATIONAL BANK, 1928": A LONGTIME CURATOR AT GEORGE EASTMAN HOUSE AND MOMA, BEAUMONT NEWHALL WAS ALSO AN ACCOMPLISHED PHOTOGRAPHER AND AUTHOR.

CHAPTER ONE

August Sander also photographed native architecture and landscapes after 1934 when the Nazis prohibited his encyclo-lifelong project to portray the German people. Before the War, SANDER photographed Cologne in anticipation of Allied bombing, and afterward he documented its ruins.

Between the wars in the United States and Mexico, Edward Weston, Tina Modotti, and Imogen Cunningham homed in on plants and made lambent close-ups with their large-format cameras and long exposures. They too dispensed with settings, like Renger-Patzsch and his countryman Karl Blossfeldt in their plant studies, and they revealed the structure of their subjects, but without mechanistic overtones. For **Weston** and **Cunningham**, who became known as members of the Group f64 in the early 1930s, nature radiated the life force.

In interwar Europe, the "New Vision" of vertiginous vantage points and angled framing was seen in photographs of building parts and still-life compositions by practitioners as diverse as the German architect Erich Mendelsohn, who published *Amerika* in 1928; the 35mm cameraman André Kertész; the architectural photographer Werner Mantz; and artists associated with the Bauhaus school of architecture and design, including László Moholy-Nagy and his first wife Lucia; Andreas and T. Lux Feininger, sons of the American expatriate painter Lyonel Feininger; Herbert Bayer; and Walter Peterhans, who taught photography there in 1928-32. Skewed angles looking upward at buildings made a virtue out of the inevitable optical distortion of tall verticals known as parallax, when a structure is observed from ground level. The titled images expressed the dynamism of modern glass-skinned, steel-skeleton architecture. Lucia Moholy-Nagy, Mantz, and the Feiningers also exploited reflections and the graphics of shadows to stress the transparency and geometry of International Style buildings.

An American citizen, **Andreas Feininger** (1906-1999) trained and worked as an architect in Germany in 1925-31, and in 1927 took up photography. In 1933 it became his occupation in Sweden, to which he fled when Nazi and French restrictions made it impossible for him to find work. In 1934 he opened a photographic firm to serve Swedish architects, and the following year he built his first camera with a super-telephoto lens. In

New York from 1939, he improved on the long-lens camera to capture the hurly-burly of city streets, Sundays at Coney Island, and rush hour at the Staten Island ferry terminal. Such photographs were published in *Life* magazine, where he began a 21-year career in 1941. There his highly detailed and graphically vivid horizontal photographs were so often printed across two pages that colleagues admiringly dubbed him "Double Truck Feininger." After leaving the magazine, he photographed American landscapes with ecological concern and made quasi-scientific studies of leaves and shells—a kind of extension of the organic structures he saw in his cityscapes. From 1939 through 1998, he published more than three dozen books, many on photographic technique.

As for still life, the impact of the introductory "Foundation Course" at the Bauhaus was felt by Bauhausler and non-student alike. The *Vorkurs* assigned exercises demonstrating the properties of materials and techniques: art, photography, and cinema, as Moholy-Nagy defined them in his 1925 Bauhaus book, *Kunst* (Art), *Fotographie, Film*, were united by their dependence on light. So students concocted photograms of scraps of fabric and metal screens, celluloid fragments, and the like; played with the shadows and reflections of studio items; and tried various illuminations of geometric solids in tabletop arrangements. Intersecting planes, cones, and spheres populated photographs by Florence Henri in Paris, Herbert BAYER and Walter Peterhans of the Bauhaus, Paul Outerbridge in the United States, and the Czech Jaromir Funke.

When the New Bauhaus opened in Chicago in 1937, these devices were pursued and multiplied in Gyorgy Kepes's Light and Color Workshop, with experiments using a light-box construction devised by Nathan Lerner, prisms, cut-paper shapes, negative prints, multiple exposures, superimposed images, and solarizations. If the calla lily was a prime still-life motif of interwar modernists, the egg was a close rival. "Modernistic photography is easily recognized by its subject matter," the art director M. F. Agha had already sniffed in 1929 (probably at the huge "Film und Foto" exhibition in Stuttgart). "Eggs (any style). Twenty shoes, standing in a row. A factory chimney seen through the iron work of a railroad bridge (modernistic angle). The … eye of a fly enlarged two thousand times."

AMERICAN ARCHITECTURAL PHOTOGRAPHS OF THE 1930S

In Depression-ridden America, Walker Evans's photographs of rural and small-town architecture and Berenice Abbott's documentation of New York were related to American Scene painting with its popular, nationalistic, and sometimes nostalgic appeal. Though very different in mood from one another, their large-format camerawork showed the country's vernacular culture and the marks of changes over time. Their photographs were commissioned for architectural history, but soon appreciated for their personal expression.

Walker Evans's first important project was photographing Victorian buildings in New England and New York State in 1930. Selections from the group composed his first exhibition at New York's Museum of Modern Art, in 1933, and they appeared in *American Photographs*, the influential retrospective and book he organized for MoMA in 1938. The task of architectural photography led him to the archer's stance that became typical of his work: he faced his subject at ground level and at a distance sufficient to let it appear whole. Through photographs of buildings, he commented on popular American tastes (fantastic Victorian gingerbread and bold Coca-Cola signs) and native practicality (typologies of country stores and frame houses recur across the South), but also on lost illusions (a Tuscaloosa mansion has become a car wrecking company) and industry's oppressions (a cemetery cross looms over the steel town of Bethlehem, Pennsylvania). In 1945-65, when he was staff photographer at *Fortune* magazine, his 40 portfolios and photo-essays included portrayals of cities through their buildings alone.

BERENICE ABBOTT (B. SPRINGFIELD, OHIO, 1898– D. MOSEN, MAINE, 1991)

Abbott makes several claims for attention: her incisive portraits of Paris intelligentsia in the 1920s; her preservation of the lion's share of Eugène Atget's negatives and prints in 1927; her comprehensive architectural record, *Changing New York*, 1939; and her dedication to scientific photography in the 1940s and '50s. Linking these achievements is her clear-eyed devotion to

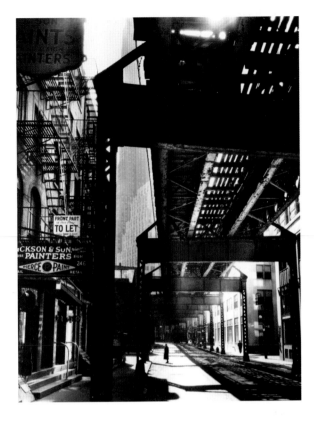

"EL SECOND AND THIRD AVENUE LINES LOOKING WEST FROM 250 PEARL STREET, MANHATTAN," 1936, BY BERENICE ABBOTT

the descriptive power of documentary photography.

In New York by age 20, Abbott met Marcel Duchamp and other Dada artists, and then went on to Paris to study sculpture in 1921. Out of money in 1923, she became Man Ray's studio assistant and by 1926 was technically assured enough to have a solo photography show and to open her own studio. Writers James Joyce and Djuna Barnes and heiress Peggy Guggenheim sat for her Nadar-like portraits. In 1927, following the death of the then-little-known Atget, she bought 1,400 glass-plate negatives and 7,800 prints from his estate (with the help of dealer Julien Levy), and she began to exhibit and promote his sharp-focus views of Paris. In 1929, she returned to New York to find a publisher for his work, and was overawed by the city's skyscraper boom. She determined to stay in New

ABBOTT ON PHOTOGRAPHING NEW YORK, PAST AND PRESENT

As she planned *Changing New York,* the most comprehensive photographic record of the city to that time, Abbott asked: "How shall the two-dimensional print in black and white suggest the flux of activity of the metropolis, the interaction of human beings and solid architectural constructions, all impinging upon each other in time?" She would ignore fleeting human gestures, and instead "show the skyscraper in relation to the less colossal edifices that preceded it … the past jostling the present." When questioned about her research plan, she replied that her "photographs are to be documentary, as well as artistic, the original plan. This means that they will have elements of formal organization and style; they will use the devices of abstract art if these devices best fit the given subject; they will aim at realism, but not at the cost of sacrificing all esthetic factors; they will tell facts … [b]ut these facts will be set forth as organic parts of the whole picture, as living and functioning details of the entire complex social scene" (quoted in Bonnie Yochelson, *Berenice Abbott, Changing New York,* New York: The New Press, 1997).

York to "preserve for the future an accurate and faithful chronicle in photographs of the changing aspect of the world's greatest metropolis." Her project would evoke "an intuition of past, present, and future" in New York. With a salary from the Federal Arts Project of the WPA (Works Progress Administration), she made hundreds of negatives, and published 305 of them in *Changing New York,* with a text by her companion, the critic Elizabeth McCausland.

Like Atget, Abbott used an 8 x 10-in. view camera for maximum detail, and she too portrayed signs of popular culture and favored juxtapositions of old and new, grand and humble, in conveying time and urban life. Both ignored obvious landmarks; she chose the Manhattan Bridge over the Brooklyn Bridge. But while Atget's vision was nostalgic, hers was upbeat and modernist: she ignored the Depression's tent cities, as well as its bourgeois apartments, and concentrated on shooting buildings in dazzling sunlight, sometimes from above or below, with New Vision drama, or head-on, with a sense of the pattern the skyline makes at the picture edges. Old-time bakers and barbers gaze directly at us; office workers hurry from ferries and elevated subways in overhead photographs. She caught the tension between the fragile ecology of street vendors and the glamour of mercantile progress. Her unsentimental, crisply graphic images show her appreciation, and that of her generation, for 19th-century photographic records.

In the late 1930s Abbott began experimenting with ways to show such scientific phenomena as gravity, electricity, and kinetic energy in photographs. She later became photography editor of *Science Illustrated,* and in the 1950s she illustrated high-school physics texts and scientific books, and generated "The Image of Physics" traveling exhibition of her science photographs. In 1956 she published a portfolio of prints she made from Atget's negatives; in 1968, the Museum of Modern Art bought the work by Atget that she and Levy had rescued.

MID-CENTURY ARCHITECTURAL PHOTOGRAPHY

In the United States in the 1940s and '50s, architectural photography reflected diverse aesthetics and served different audiences. For example, the Midwesterner **Wright Morris** (1910-1998), who became a writer and photographer at the same time in 1934, attempted to convey American identity through photographs he made of anonymous structures and objects on a 10,000-mile cross-country trip. In *The Inhabitant*s, completed in 1942 and published in 1946, he combined his laconic head-on photographs of buildings with his fictional texts imagining those who occupied them and their

thoughts. In *The Home Place*, 1948, he evoked his own Nebraska heritage through homely objects, from worn books to family photographs. Though the publications sold poorly, they were admired by such photographers as Robert Frank.

A STUDENT OF ARCHITECTURE, EZRA STOLLER CREATED LASTING IMAGES OF MODERN DESIGN, AS IN THE OFFICES OF UNION CARBIDE IN 1960.

In *Ghosts Along the Mississippi*, 1948, the Southern Gothic imagination of **Clarence John Laughlin** (1905-1985) found objective correlatives in musty, once-glorious, pre–Civil War plantations. In *Time and New England*, 1950, on the other hand, Paul Strand used austere colonial buildings and monuments to recall founding American values of freedom of expression and assembly. These three photographers treated architecture as a metaphor for regional culture and a means

to engage the survival of the past in the present. They demonstrated the increasing role of finely produced books in the appreciation of photography as art.

In New York City in the postwar period, **Todd Webb** (1925-2000) photographed unpretentious façades to reflect human use and community values. "Every window, doorway, street, building, every mark on a wall, every sign, has a human connotation," he wrote. "All are signs and symbols of people—a way of living—living in our time." His quietly affirmative approach—distinct from postwar boosterism—was evident in his most ambitious project, his document of Sixth Avenue between 43rd and 44th streets, 1948. His panorama of the store fronts, combining eight individual photographs, was nearly 24 feet long, and allowed reading of each shop sign.

In this period, commercial architectural photography also flourished. Responsive to the surge of building in modern style, Ken Hedrich (1908-1972) founded the Chicago firm of Hedrich-Blessing, which used limpid description and respectful distance to describe important new public structures. **Julius Shulman** (b. 1910) and **Ezra Stoller** (1915-2004) also won support for contemporary architects through their technically polished depictions, in which light and the occasional additions of attractive still-lifes and discreet figures humanized the lean, unornamented lines and glass walls of American modernism. The firms they established are still operating.

John Szarkowski (b. 1925), who went on to become director of the photography department at MoMA in 1962, made the photographs for *The Idea of Louis Sullivan*, 1956, a book characteristic of the period's interest in progenitors of modern architecture. This had led Aaron Siskind in 1952 to direct his students at the Institute of Design (the New Bauhaus descendant) at the Illinois Institute of Technology to photograph anything conceivably by Sullivan in the Chicago area. The photographer Richard Nickel became so obsessed with preservationist issues that he lost his life in 1972 in Sullivan's Chicago Stock Exchange Building, which he entered after hours during its demolition. In his books on 1940s and '50s construction in Brazil (1943), Sweden and Switzerland (both 1950), and Italy (1955), **G. E. Kidder Smith** (1913-1997) compared old and new buildings to suggest what the first could teach the second, and he captured figures with his small camera to convey lived experience in these countries.

CONCEPTUALISM AND COLOR

The biggest changes to architectural and still-life photography occurred in the late 1960s and '70s, as Conceptual artists, especially in the United States, adopted the mute documentary style of real estate photographs and tool catalogue illustrations, and full color became acceptable among art photographers (see pp. 314-19). Rejecting the rhetoric of photojournalists such as W. Eugene Smith and Henri Cartier-Bresson, California artist **Ed Ruscha** (b. 1937) published *Every Building on Sunset Strip*, 1966, an accordion-fold sheet that reached about 25 feet long; and *Thirtyfour Parking Lots in LA*, 1967, 34 aerial views that made the oil-stained lots look like Minimalist paintings. These astringent comments on the emptiness of both California car culture and current abstraction set the scene for the 1975 exhibition "The New Topographics: Photographs of a Man-Altered Landscape, " organized by William Jenkins for the George Eastman House in Rochester, New York. Most of the photographs were dry black-and-white landscapes showing the shocking distance between Ansel Adams's idyls of the West and the bleak contemporary reality of tract houses and trailer parks (see pp. 133-4). Among the photographs focused on anonymous architectural types were works by Joe Deal and Bernd and Hilla Becher.

BERND AND HILLA BECHER (BERND, B. SIEGEN, GERMANY, 1931; HILLA, B. POTSDAM, GERMANY, 1934)

Minimalist sculptors and Earthworks artists were among the first to appreciate the deadpan serial photographs that the Bechers began making of ordinary industrial structures after

BERND AND HILLA BECHER EMPHASIZED THE SHARED BEAUTY OF INDUSTRIAL SITES, SUCH AS GAS TANKS, WATER TOWERS, AND SILOS, BY PHOTOGRAPHING THEM FROM SIMILAR ANGLES AND HEIGHTS.

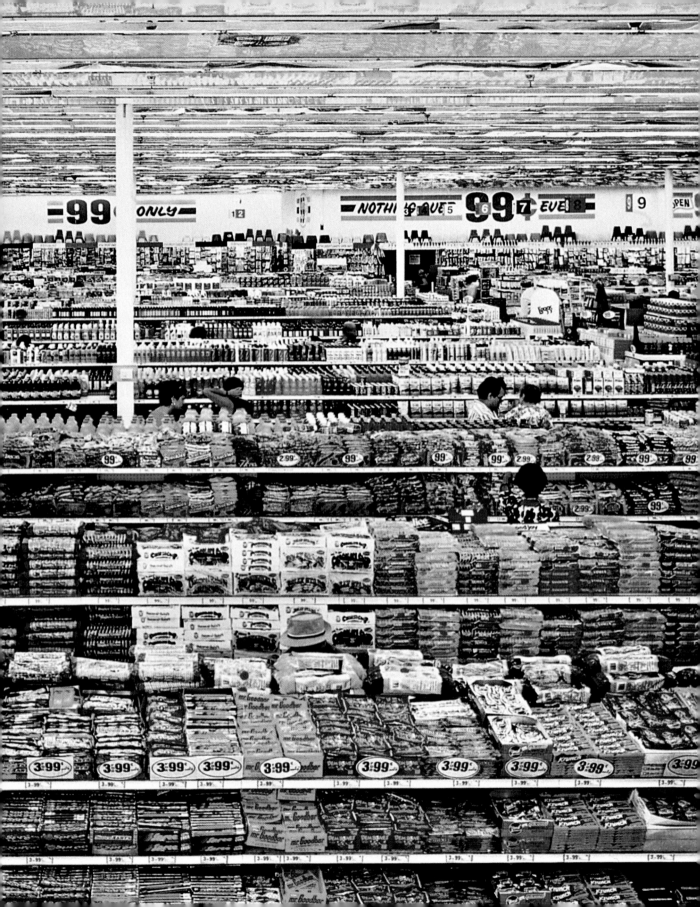

CHAPTER ONE

PRECEDING PAGES: "99 CENT," 1999, WAS ONE OF MANY LARGE PHOTOGRAPHS IN ANDREAS GURSKY'S FIRST MAJOR RETROSPECTIVE AT THE MUSEUM OF MODERN ART IN NEW YORK IN 2001.

their marriage in 1961. Their water towers, gas tanks, blast furnaces, silos, and the like, in rows or grids of same-size, black-and-white images, were "anonymous sculpture" in their phrase. The typologies these series formed looked back to the New Objectivity movement in German photography in the 1920s and forward to Minimalism, the art of "primary structures," and to Earthworks, constructions made or found in the landscape, movements that emerged in the early 1970s. The Bechers have spent the last 40-odd years on their cumulative project of photo-documentation, classifying the artifacts of the waning machine age across Europe.

Karl Blossfeldt's plant specimens in his book *Urformen der Natur* (Art Forms in Nature), 1928, are the closest ancestors for the Bechers' project, and their many publications likewise equivocate between documentation and art. They photograph their subjects similarly, head-on in an even, shadowless light, without signs of human presence, and present them in an identical, anti-hierarchical format: the subjects are the same size and so are the prints in a series. The simplification and grid presentation draw attention to the Platonic shape they share, yet also to the individual formal variations in the type and the huge number of these variations. If "form follows function," in architect Louis Sullivan's credo, how can one explain why none of these water towers, for example, looks the same? At the same time, the abandoned industrial relics seem somewhat unworthy of quasi-scientific scrutiny—not to speak of conventional aesthetic concern. Yet the Bechers' work, despite its punctilious objectivity and its avoidance of modernist abstracting, exudes a melancholy grandeur for some, and a dry humor for others.

Bernd Becher found his lifetime's subject during his youth in the Ruhr Valley, once the heart of Germany's steel and mining industries. After studying painting and lithography in Stuttgart, 1953-56, he returned to draw a favorite ironworks

and found it being torn down. The photography he began as note-taking seemed better than his artwork, and soon after he met Hilla Wobeser, a technically proficient photographer, while studying at the Kunstakademie (Art Academy) Düsseldorf in 1957. They became collaborators with a view camera, graduated in 1961, and had their first solo exhibition in 1972 at "Dokumenta V," the prestigious triennial exhibition of contemporary art in Kassel, Germany.

Their first books, from 1970 and 1977, concerned industrial typologies in Germany; in the 1990s they ranged from western Pennsylvania to Great Britain, France, and Belgium. Their *Industrial Landscapes*, 2002, breaks with their usual serial presentation by showing huge factory sites one by one in their natural settings.

The Bechers taught at the Düsseldorf Art Academy in 1976-96, marking a generation of cool documentary photographers including Andreas Gursky Candida Höfer, Thomas Ruff, and Thomas Struth.

ANDREAS GURSKY (B. LEIPZIG, GERMANY, 1955)

Commercial photography meets Postmodern minimalism in Gursky's trademark images of global capitalism, which describe mega-stores, stock markets, glittering hotel atriums and apartment projects, and cast-of-thousands techno-music raves with the hard-sell vocabulary of the phenomena themselves. Super-size (up to 16 feet wide) and super-slick (brilliantly hued, obsessively detailed), these photographs are digitally altered to regiment locales in European, American, and Pacific Rim cities into graphic patterns, all equally sharp-focus, that fill the frame and thus seem to expand without limits. Human figures are interchangeable or molecular when they appear in the banded or all-over compositions of evenly distributed motifs; the glamorous, soulless world they inhabit is a kind of totalitarian paradise.

The only son of commercial photographers, Gursky learned the conventions and techniques of that field at an early age. In 1978, the young German studied at the Folkwangschule in Essen, where Otto Steinert had established his subjective interpretation of photojournalism. In 1981, Gursky transferred

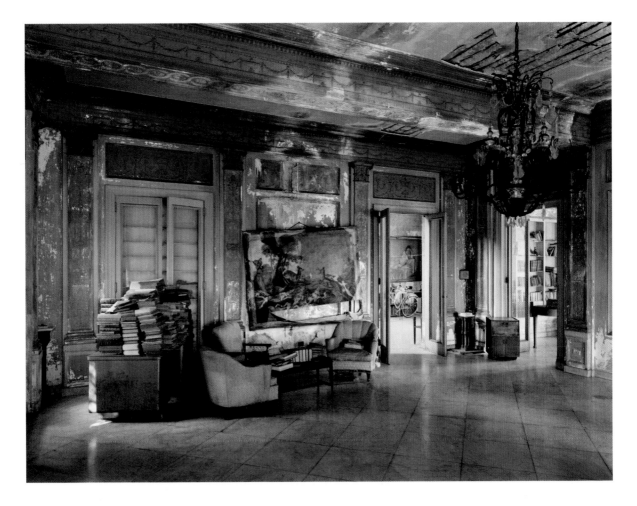

ROBERT POLIDORI CAPTURED THE MELANCHOLY
BEAUTY OF CUBA INSIDE THE SEÑORA LUISA
SAXAS RESIDENCE IN MIRAMAR IN 2001.

to the Kunstakademie in Düsseldorf, which artists Joseph Beuys, Sigmar Polke, and Gerhard Richter had turned into a major locus for vanguard, culturally critical art in Europe. Until his graduation in 1987, he studied under Bernd and Hilla Becher, whose head-on photographs of disused industrial building types combined aspects of the Minimal and Conceptual art of the 1960s. While their black-and-white documents seemed faintly elegiac by comparison, his full-color series—notably a student project on security guards in office buildings—had an Orwellian edge. A sense of blank-

faced menace would underpin Gursky's work: he was in school in 1984, the year that Orwell chose to title his bleak futuristic novel of the state as "Big Brother," and he observed U.S. president Ronald Reagan's launching of the "Star Wars" missile buildup against the USSR, at a time before the Berlin Wall had come down.

A cheerier vision informed Gursky's first series after graduation, on the leisure destinations of his countrymen—the big public pools and parks underwritten by Socialist programs and a rising economy. At the same time, his photographs of nature, also seen from afar, led critics to associate his viewpoint with that of the 19th-century German painter Caspar David Friedrich, who evoked the sublime in his meticulously rendered landscapes. The notion of awesome boundlessness

associated with the sublime grew more explicit when Gursky began digitally manipulating his images in the 1990s, and the irony in his allusion to German Romanticism became plainer. He removed elements in his scenes that detracted from their immediate legibility and extended the patterning, which flattened the space without sacrificing detail. Like many digital interventions, his were undetectable, yet the final results were obvious phantasms. Saturated with information, his photographs called attention to the ploys of commercial art and especially advertising photography, using the tools of the medium—as Andy Warhol had used Mylar and silk screening—to critique it.

Gursky intends his pictorial structures to contain political commentary, and he remarks: "You never notice arbitrary details in my work. On a formal level, countless interrelated micro- and macro-structures are woven together, determined by an overall organizational principle. A closed microcosm which, thanks to my distanced attitude towards my subject, allows the viewer to recognize the hinges that hold the system together." In a panorama of 2001, he superimposed images of the VPs of fourteen multinational corporations on a cliff side, with an audience of stockholders below, and above them, in the sky, where Friedrich would have painted a moon and stars, he printed the company logos. New York's Museum of Modern Art, which had given Richter and Polke retrospectives, honored Gursky with one in 2001; his work has received international recognition since the late 1990s.

With a similar interest in public spaces as emblematic of mass humanity, **Candida Höfer** (b. 1944) has photographed empty meeting halls, huge lobbies, amphitheaters, and similar tourist destinations across Europe since the 1990s. Their grand architecture is the more evident as a result of their depopulation, while they gain an air of vague anticipation mixed with a sense of loss: are they expecting crowds or have they been suddenly abandoned, and why? The anonymity of the modern citizen, privileged and nomadic but characterless, is figured in these large interiors for relatively passive mass activities.

The aura of threat in emptiness is more obvious in the large color work of **Thomas Demand** (b. 1964), who constructs the banal settings he sees in news and other photographs, paints the lifesize cardboard constructions, and then photographs them. His imitation of generic interior design, desks, office machines, and various lighting is convincing at first glance; his deception is revealed mainly by his objects' lack of details. When captioned, the interiors—like the hallway leading to serial killer Jeffery Dahmer's apartment—become portentous. But Demand's handsome compositions underline the impossibility of conveying the meaning of events in images. He mocks the Romantics' pathetic fallacy about places and shows the distance of photography from any sort of truth.

With an irony like Demand's but in the Postmodern 1980s, the Americans **Zeke Berman** (b. 1951), **James Casebere** (b. 1953), and **James Welling** (b. 1951) constructed similarly fictional tabletop arrangements, all in black-and-white, but in order to call attention to image-making conventions. Berman parodied art school analyses of good composition by "diagramming" his still-life objects with string, and he defied perspective laws by masking his table edges with black cloth to prevent them from appearing to recede. Thus he questioned the reliability of both photography and perception. Casebere's constructions evoked Hollywood's old signifiers—the clapboarded main street for the Western, for instance, the tower with searchlight for the prison drama—and through nocturnal lighting and oddities of scale he gave these locales a dreamlike spirit. His more recent photographs, of empty classical structures, are even more haunting in their simplicity, as they underline the poetics, sign language, and cultural associations that architecture can have. In his 1980-84 work, Welling deconstructed the mannerisms of product advertising and art photography by focusing on crumpled aluminum foil, soap flakes on black velvet, and gelatin chunks on white seamless paper. In their compositions and fine printing, these images recalled Group f64 photographs, but their identifiable kitchen

ingredients lampooned the rhetoric of art. Like linguistic analysts, whose theories fueled Postmodern art (see pp. 319-20), he asked viewers to ponder not *what* his works meant but *how* they conveyed meaning.

Among recently emergent photographers, **Robert Polidori** (b. 1951) is notable for his appreciation of architectural history and how it can express world cultures. He has made his color photographs for *The New Yorker* magazine as a staff member since 1998. With a contemporary social awareness and sense of the sardonic, he has shown the outlandish new skyline of Shanghai with the scavengers of the old buildings it displaced; and he has won prizes for his series on Brasilia, Oscar Niemeyer's capital for Brazil, and on Havana in all its subtly hued shabby grandeur. His fascination with the human impact on the built and natural environments motivated his book, *Zones of Exclusion*, on the abandoned sites of the nuclear disasters at Chernobyl and Pripyat. His color ranges from nuanced atmospherics to cartoonish saturation, as at a Dubai hotel he photographed on assignment and recognized as a "jewel-fantasy" for the architects and guests. For himself, he also photographed the workers' housing around the hotel, commenting, "This is not a product shot. This is a sociology shot …. Nobody wants a backstage shot. Nobody wants to pay for lessons in the possible class upheavals occurring around luxury projects."

Color is a significant expressive tool for **Jan Staller** (b. 1952) and **Alen MacWeeney** (b. 1939), who take commissions as they pursue personal work, as most architectural photographers do. MacWeeney's eye for the nuanced hues of worn upholstery and faded wallpaper conveys time's passage with slightly melancholy charm, especially in British interiors. Staller, at the opposite pole, finds the excitement of the surreal in night photographs of unpopulated semi-industrial sites around New York City, his residence. The weird hues of artificial light are intensified in his often square-format photographs.

The dreamlike unreality of industrial sites also intrigues **Vera Lutter** (b. 1960), who has made wall-size camera obscura photographs in New York, London, and other metropolises since the 1990s. Choosing abandoned factories with historic associations, such as the Battersea Power Station in London, she turns darkened rooms facing them into camera obscuras with a wall of photo-sensitive paper opposite the small aperture opening onto the site. After exposures of a day or even weeks, the paper becomes a unique negative, inverting the dark-light values of the subject and registering no sign of human presence. The monumental scale of the prints summons up the stature of these relics of Machine Age power, while their ghostly pallor and emptiness witness the powerlessness of such places today.

CANADIAN CENTRE FOR ARCHITECTURE

Museums of architecture have sprung up since World War II—in Washington, D.C.; Rotterdam; and Paris, for example. Of those collecting photographs as part of their documentation, the Canadian Centre for Architecture in Montreal, founded in 1979 by architect-heiress Phyllis Lambert, is one of the most active and knowledgeable. This museum and research center has collections of works from the Renaissance to the present, from models to oral histories of individual architects, and more than 55,000 photographs from 1839 onward. Lambert began collecting photographs in 1974, and she and her then-chief curator, photographer Richard Pare, have sharpened appreciation of the genre as cultural texts through exhibitions from the collection, commissions, and choice publications.

PHOTOGENIC DRAWINGS
FOUNDATIONS OF PHOTOGRAPHY

In the first three decades of the 19th century, a handful of talented men in England and in France laid down the basic technology of photography in an astonishing burst of inventiveness. Working independently for the most part, these men brought together the principles of optics and chemistry that made photography possible—specifically, the use of a glass lens to transmit light and focus an image, coupled with a light-sensitive medium to record the image. Their work was a blend of old and new technologies, their successes accomplished through patient trial and error.

The optical knowledge required for photography had been around for centuries in the form of the camera obscura, a device used by artists to project an image from life that they could trace. Originally the camera obscura was a darkened room with a hole in one wall to admit light. The light cast an image of the outside scene onto a wall or screen inside the room. In the 16th century, a lens was substituted for the hole, which brightened and focused the projected image. By the 18th century, the camera obscura had been reduced in size to a portable wooden box with a mirror inside that reflected the image onto a glass top where it could be conveniently traced onto paper.

ADAM FUSS, "UNTITLED (DETAILS OF LOVE)," 1993

The knowledge of chemistry necessary for photography was a more recent discovery. Prior to the 18th century, alchemists and other observers had noted that certain mineral and organic substances were subject to changes in color under light, but they were uncertain about the causes. Then in 1727, German professor Johann Heinrich Schulze determined that silver nitrate turned dark through exposure to light. Other 18th-century scientists conducted experiments on the light sensitivity of silver chloride.

In the late 1790s, Thomas Wedgwood, son of British potter Josiah Wedgwood, became the first to attempt to use the camera obscura to record permanent images on light-sensitive material. Though he failed at this, he and his friend Sir Humphrey Davy did produce "shadow images" in 1802 by soaking sheets of paper and white leather in silver nitrate, then placing objects such as leaves on top of these sheets and exposing them to sunlight. The result was a negative image, since the area covered by the object remained white, while the rest of the sheet turned dark from exposure to the light. However, Wedgwood and Davy found no way of making their images last, and these photograms, as they came to be called, gradually turned completely dark unless protected from light.

In the spring of 1834, English scientist William Henry Fox Talbot began his own experiments with photograms, which he called photogenic drawings. In the process, Talbot perfected one of the most significant principles of photography—the creation of a stable negative image from which multiple positives can be made. Talbot soaked writing paper in a salt solution, then brushed on a solution of silver nitrate, resulting in a coating of silver chloride on the paper's surface. Like Wedgwood and Davy, Talbot placed an object atop the paper and exposed it to light, yielding a negative image. Talbot then bathed the negative in a strong salt solution to remove unexposed silver chloride and halt further reaction to light (his early efforts to stabilize the image were only partially successful). Talbot waxed the finished negative to make it translucent. By placing a second sheet of treated paper beneath this negative and exposing it to light, Talbot produced a positive print.

Talbot made a few improvements to his process, notably building a camera in 1834 to hold the sensitized paper. But his other interests diverted his attention from his work in this area. It was only when French artist Louis-Jacques-Mandé Daguerre unveiled his own photographic process, the daguerreotype, in 1839 that Talbot hurriedly publicized his discoveries.

Initially, Daguerre's creation proved more successful than Talbot's. Nevertheless, Talbot forged ahead with his own system. Thanks to the advice of his friend John Herschel, Talbot improved the sta-

ANNA ATKINS, "DICTYOTA DICHOMOTA," 1849-50, FROM *BRITISH ALGAE*

bility of his prints by fixing them with hyposulfite of soda (sodium thiosulphate), which removed all unexposed silver chloride. In 1840, Talbot made one of his most important discoveries when he found that a shorter exposure created a latent image that could be brought out with a chemical developer (a phenomenon independently discovered by Daguerre). Talbot achieved this by treating paper with silver nitrate, acetic acid, and gallic acid, exposing it for a short time, then bathing the blank paper in gallic acid until the image appeared. Suddenly Talbot was able to reduce the time needed to expose an image from minutes or hours to as little as 30 seconds. He termed the resulting print a calotype, which also came to be known as a Talbotype.

Although Talbot patented his process, in the end it brought him little income, and in fact his patents slowed the adoption of his paper-based process. Despite such setbacks, Talbot's principle of negative-to-positive imaging paved the way for modern negative-based film. In addition, the early experiments of Talbot and Thomas Wedgwood with placing objects in direct contact with sensitized paper spurred an art photography movement after World War I, when avant-garde photographers such as Man Ray and László Moholy-Nagy created surreal photograms. The technique of cameraless imagery is still used today, a tribute to the discoveries of these founding fathers of photography.

PORTRAITURE

W hat is a portrait? Recent book titles promise photographic "portraits" from railroads to champion chickens to Rhode Island. Portraits as defined by some editors are any pictures in which people dominate. Painter John Singer Sargent quipped that a portrait "is a likeness in which there is something wrong about the mouth." Artist Maurice Grosser wrote that a portrait is a representation made "at a distance of four to eight feet of a person who is not paid to sit." The art historian Richard Brilliant proposed that a portrait attempts to answer the subject's questions: "What do I look like?" "What am I like?" "Who am I?"

Among these possibilities, this text supports Brilliant's appraisal, and it assumes that a portrait results from a compact between an individual and a photographer sharing the same broad culture. Verisimilitude, definition of status and role, and characterization are the subject's usual goals. The photographer's interest in the subject's ethnographic differences or social condition is less evident, if at all. (See Chapter 3 for ethnographic studies and Chapter 4 for figures of social concern.)

There's no debate about the fascination of portraits. Each one states "I am" and seeks the viewer's response. That assertion and the sense of particular identity that powers it have motivated portraiture since the Renaissance, when the genre emerged to suit the vanity of self-made individuals. Toddlers recognizing themselves in mirrors, romantics eager to know themselves through knowing others, anyone curious about human nature—all are candidates for portraits, to view them and to sit for them. This is one of the few artistic genres in which both the subject and the artist insist on our attention. Each image refers to a real individual and documents a relation between two people. Each picture reaches out to a third person, the viewer. In the resulting sense of actuality lies much of the portrait's force.

"The history of portraiture is a gallery of poses, an array of types and styles," art critic Harold Rosenberg wrote, "which codifies

"SELF-PORTRAIT, 2000": FOREMOST A PAINTER, CHUCK CLOSE CONCENTRATES MAINLY ON TIGHT FACES AND SELF-PORTRAITS IN HIS PHOTOGRAPHY.

the assumptions, biases, and aspirations of the society." Put four or five choice portraits together, and they can reflect changing social values and notions of identity over time. With these convictions, this text explores portrait photography chronologically, concentrating on professionals in the field and those for whom the portrait represents a primary focus. Mention is made of bodies of work that enrich the definition of portraiture.

THE EARLIEST PORTRAIT PHOTOGRAPHS

No matter how mediocre the photograph, it has an edge over the painting or sketch. The photograph has an *indexical* relation to its subject: it is chemical proof of the presence of its subject in past time under light, a trace of existence like a thumbprint or DNA evidence. In modern culture, where "just the facts, ma'm" have their own value, photographs—and especially portrait photographs—quickly supplanted their handmade antecedents for the masses. Through the 1830s the popular appetite for records of appearance had been somewhat satisfied by miniature paintings (sometimes on ivory mounted in lockets and brooches), silhouettes and physionotrace renderings (tracings from cast profile shadows), and camera lucida sketches. But their lifelikeness was limited or dependent on considerable artistic training. "Sun pictures" with their aura of truthfulness presented a fascinating alternative.

Exposure times in 1839, however, were too long for portraits in either daguerreotype or calotype. Blur was unacceptable in 19th-century likenesses, but movement was inevitable in exposures measured in minutes even in bright sun. By 1840, exposure times were reduced to three or so minutes, thanks to lens and chemical improvements and the arrangement of mirrors to bounce more light onto the subject. The world's first portrait studio, operated by Alexander S. Wolcott and John Johnson, opened in New York that March, advertising "Sun Drawn Miniatures … with an accuracy as perfect as nature itself." A month later the portrait painter Samuel F. B. Morse and the chemist Dr. John W. Draper opened their own firm, where they made portraits in as little as five seconds. Their teamwork would be a model for such successful early partners as Southworth and Hawes and Hill and Adamson. Morse taught portrait daguerreotypy to Albert S. Southworth, as well as Mathew Brady and Edward Anthony.

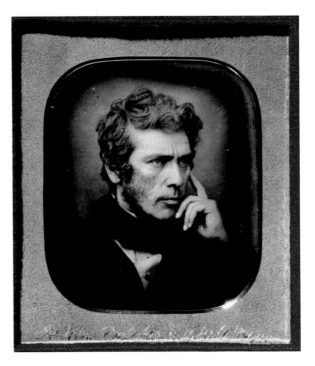

AN 1843 DAGUERREOTYPE OF ANDREW PRITCHARD BY ANTOINE FRANÇOIS JEAN CLAUDET

The year 1840 also saw the introduction of a lens invented particularly for portraiture by the Viennese Josef Max Petzval and produced by the opticians Voigtländer & Sohn: it was twenty times as "fast" as the lenses Daguerre used, and it paved the way for German ascendancy in camera equipment (which lasted through the mid-20th century). In 1841 Voigtländer boasted that exposures were possible with only four seconds in the shade and one second in sunlight. That year **Richard Beard** (1801-1885) opened a daguerreotype portrait studio in London, followed shortly by **Antoine François Jean Claudet** (1797-1867), while by 1845 **John Plumbe** (1809-1857) owned a chain of 25 studios in the United States, from Boston to St. Louis. At this point every large town in America and Europe had at least one portrait business or was visited by a traveling cameraman, according to the photo-historians Helmut and Alison Gernsheim. When the daguerreotype was announced in 1839, the artist Paul Delaroche had cried, "From today, painting is dead!" But in

reality, photographs drove only some miniature and silhouette artists out of business, while they lured opticians, chemists, tinkers, engravers, artists, and entrepreneurs to learn the trade. Sitting for a daguerreotype portrait became the rage in the 1840s, and with competition among portraitists, prices dropped to within reach of all but the poorest sitters.

The vanity of the masses and their urge to memorialize themselves and their loved ones enraged French critic and poet Charles Baudelaire, while their insistence on realism led him to despair for the future of French art. In 1859 he looked back, sneering: "During this lamentable period, a new industry arose which contributed not a little to confirm stupidity in its faith … the present-day Credo … is this: 'I believe… that Art is, and cannot be other than, the exact reproduction of Nature …. Thus an industry that could give us a result identical to Nature would be the absolute of art.' A revengeful God has given ear to the prayers of this multitude. Daguerre was his Messiah. And now the faithful says to himself … 'photography and Art are the same thing.' From that moment our squalid society rushed, Narcissus to a man, to gaze at its trivial image on a scrap of metal."

Yet this "multitude" correctly recognized the unequaled recording capacity of "the mirror with a memory," as the brilliantly detailed, silver-coated daguerreotype was then called. The 19th century marked a new age of physical and social mobility, in which families migrated from farm to city and from country to country in record numbers, under the pressures of political and industrial revolutions. When a youth enlisted to serve in Europe's far-flung colonies, sailed for the New World, or took off for the California gold fields, portraitists urged, "Catch the 'shadow' ere its 'substance' fades." In 1846 the Hartford, Connecticut, daguerreotypist **Augustus Washington** (b. 1820/21-1875) advertised: "A cheap and beautiful Christmas present. A durable memento. Daguerreotype miniatures taken, colored, finished, and neatly put up in cases (see pp. 104-5) for $1.50 …. Portraits and engravings correctly copied. Miniatures fitted in. Bracelets, Lockets, Rings & c ….Instructions given in the art." This African-Asian entrepreneur was promoting the usual range of services of the middle-market photographer. Photographers some-

times doubled as jewelers, and they copied hand-rendered portraits in daguerreotypes for relatives to share. Jewelry pieces containing daguerreotypes were popular tokens of affection, sometimes embellished with locks of the beloved's hair. In his book *The Camera and the Pencil*, 1864, the daguerreotypist **Marcus Aurelius Root** (1808-1888) argued that photography benefited society, and portrait photographs of family members, for example, "perpetuate domestic and social affections" by bringing the "valued originals" near.

Portrait daguerreotypists continued to practice into the mid-1860s, and with some distinction in the United States, well after the wet collodion process, introduced in 1851, had outmoded the unique positive. Today scholars are identifying more practitioners and distinguishing their work. But from the estimated ten thousand firms that operated at mid-century in America, one is still regarded as outstanding.

SOUTHWORTH AND HAWES: ALBERT SANDS SOUTHWORTH (B. WEST FAIRLEE, VERMONT, 1911–D. CHARLESTOWN, MASSACHUSETTS, 1894); JOSIAH JOHNSON HAWES (B. EAST SUDBURY (WAYLAND), MASSACHUSETTS, 1808–D. CRAWFORD NOTCH, NEW HAMPSHIRE, 1901)

A Who's Who of mid-19th-century North America sat for portraits by Southworth and Hawes: philosopher Ralph Waldo Emerson, jurists Oliver Wendell Holmes and Daniel Webster, authors Nathaniel Hawthorne and Henry Wadsworth Longfellow, and soprano Jenny Lind, to name a few. The Boston partners charged almost triple the going rate for their medium-size daguerreotypes—a minimum of $5 for what Mathew Brady charged $2. In the firm's lifetime, 1843-62, over 1,500 celebrities and lesser mortals patronized the partners for insightful interpretations of individual character and technical excellence. While most daguerreotypists purveyed routine literal likenesses, Southworth and Hawes aimed to capture "the spirit of fact that transcends mere appearance." In 1871, Southworth philosophized to the National Photographic Association: "An artist is conscious of something besides the mere physical, in every object in nature. He feels its expression, he sympathizes with its character, he is impressed with its language; his heart, mind, and soul are stirred in its contemplation.

HOW TO POSE PORTRAIT SUBJECTS IN 1854

Did Southworth and Hawes, Mathew Brady, and Marcus Root consult W. S. Haley's 1854 guide for daguerreotypists in posing their clients? There were numerous how-to books, serving the huge profession of portraitists, with recommendations based on conventions from Titian to Sir Joshua Reynolds. "The eyes should be directed a little sideways above the camera, and fixed upon some object there, but never upon the apparatus ….Stout persons should be placed at a certain distance from the apparatus, turning towards it a little sidewise; whilst people of slender make should be made to sit full in front, and nearer the apparatus …. The hands should rest easy on the lap, neither too high nor too low; or one hand may be placed on the table, the other holding a book or some other objects …. In the case of ladies, a shawl or boa, or similar article of dress, thrown lightly over the shoulders, and arranged in a manner to hide some defect, and to properly distribute light and shadow, will mostly tend to produce a pleasant impression."

It is the life, the feeling, the mind, the soul of the subject itself." Early in the medium's history, Southworth and Hawes raised photography to art.

Southworth learned about daguerreotypy in 1840 at a lecture by J. B. F. Fauvel-Gouraud, a representative of the company that Daguerre had licensed to sell his manual and camera. Meanwhile, Southworth's former roommate at Phillips Academy, Joseph Pennell, was helping Samuel F .B. Morse experiment with the daguerreotype and the telegraph in New York. Pennell invited his friend to visit; and Morse taught him the daguerreotype process. Later in 1840 Southworth and Pennell opened a daguerreotype studio as partners. The technology available forced them to begin with three-minute sittings, but they were determined to shorten exposure times and to enlarge their photographs, and so they explored ways to improve lens designs, chemistry, and plate preparation. Knowing New England's elite would value the quality they aspired to, they established a Boston studio in spring 1841. In 1843, when Pennell moved South, Southworth found Hawes.

Hawes was a self-taught painter and an itinerant portraitist in oil and on ivory. He too had witnessed Gouraud's 1840 demonstrations, and was converted to daguerreotypy, which he practiced before meeting Southworth. Together, they attracted numerous customers, yet they rarely repeated a pose or lighting device. To subordinate detail to overall effect, they appropriated vignetting from another daguerreotype portraitist, Marcus Root. Their props conveyed character, from a potted flower beside demure Harriet Beecher Stowe to a cigarette flaunted by courtesan Lola Montez. The fierce Judge Lemuel Shaw, looking craggy beneath a skylight, resembled "Jove himself" to a period journalist, and made "beauty in a man seem paltry and almost contemptible." Sensitive hand-coloring was provided by Nancy Southworth (who married Hawes in 1849) for flesh tones, details of dress, and backgrounds. Infants (dead and alive), children, couples, families, and school groups all were posed in the studio.

Southworth and Hawes were also unusual in experimenting—picturing clouds and frost on windows, for example—and in making daguerreotypes on location: they shot an eclipse, the suspension bridge over Niagara Falls, and a reenactment of an early operation using ether at Massachusetts General Hospital, among other newsworthy subjects. Some of these images were stereoscopic daguerreotypes, pairs of pictures replicating the depth percep-

"ALICE MARY HAWES," 1852, IS A DAGUERREOTYPE MADE BY THE MASTERFUL TEAM OF ALBERT SANDS SOUTHWORTH AND JOSIAH JOHNSON HAWES AT A TIME WHEN PHOTOGRAPHY WAS FIRST BEING ESTABLISHED IN AMERICA.

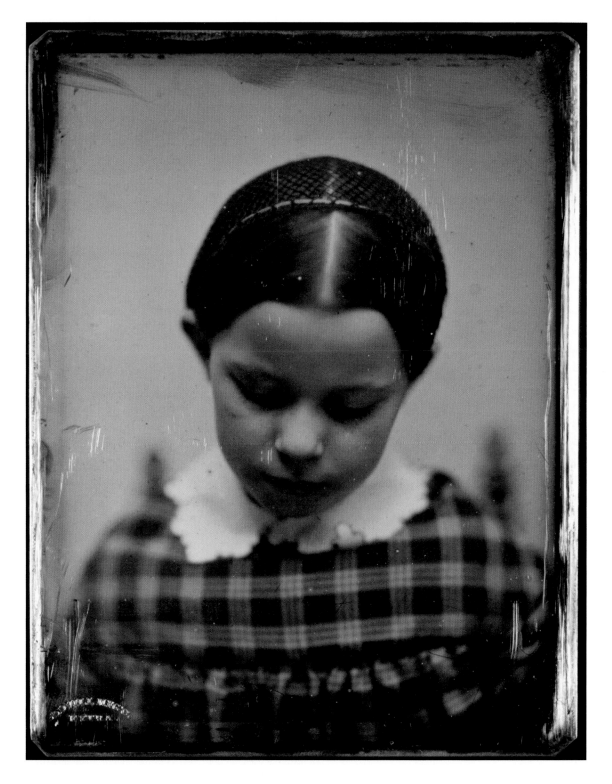

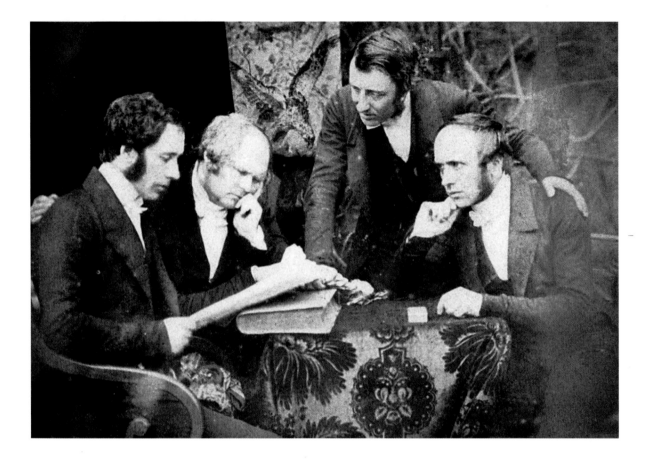

DAVID OCTAVIUS HILL AND ROBERT ADAMSON
PRACTICED THE NEW CALOTYPE PROCESS WHILE
MAKING PORTRAITS OF MINISTERS CONGREGAT-
ING IN EDINBURGH IN THE MID 1840S.

tion of binocular vision when seen in a stereopticon viewer. Southworth and Hawes made them for their own invention, patented in 1855, the "Grand Parlor Stereoscope," which was unique in scale. While other stereoscopes could take only sixth-plate daguerreotypes, full plates—at 8 1/2 x 6 1/2 in.—could be viewed in the firm's device. Bostonians bought season tickets for such viewings.

After the partnership ended in 1862, Hawes maintained his own portrait studio, while Southworth studied and lectured on photography and graphology. Because their clients took away the best examples of their unique-positive portraits, the firm's portrait collection—now in museums—was formed of second choices and duplicates (daguerreotypes made of daguerreotypes). One wonders what got away.

There are few portraits among calotypes. Though the paper negative allowed for countless reproductions, the fibers in its makeup interfered with sharp description—the universal criterion then for photographic excellence in portraiture. Nonetheless, some haunting portrait calotypes survive.

Take the *Self-Portrait as a Drowned Man*, 1840, by Hippolyte Bayard (1801-1887). This unique positive image on paper is unusual as a self-portrait, as a product of yet a third early photographic process, and as a faked document. Bayard went on to become vice-president of the Société Héliographique (see pp. 34-6), but in 1839 his process was refused recognition by the French government, and so he photographed

himself as a suicide. An estimated 24 inventors can lay claim to conceiving photography and realizing some of its optical and chemical steps by the 1830s, but Bayard came closest to Daguerre and Niépce in his invention. Upon hearing the early announcement of their process, he produced his own unique direct positives—but on paper. François Arago, the deputy responsible for elevating Daguerre and Niépce, feared that a third inventor would weaken their claims, and so he bought Bayard's silence with a minor subsidy. The daguerreotype's wildfire success killed Bayard's hopes—but not his creativity. He launched the staged self-portrait as a type.

In England calotypes are rare of any kind, much less of portrait subjects, because Talbot zealously protected his patent and made commercial use of his process too costly. In Scotland, however, he did not restrict calotypes, and the process became the making of a remarkable firm.

HILL AND ADAMSON: DAVID OCTAVIUS HILL (B. PERTH, SCOTLAND, 1802–D. EDINBURGH, SCOTLAND, 1870); ROBERT ADAMSON (B. BURNSIDE, SCOTLAND, 1821–D. ST. ANDREWS, SCOTLAND, 1848)

A turning point in Scottish church history created one of the most productive partnerships in the early history of photography. In May 1843 some 450 ministers—one third of the Church of Scotland—seceded from the Church of England, a revolutionary event that they decided should be memorialized in a giant group portrait. They commissioned Hill, a well-regarded painter and secretary of the Scottish Academy of Painting, Sculpture, and Architecture, to do the job. Sir David Brewster, a friend of William Henry Fox Talbot, wanted to promote Talbot's calotype in Scotland, and he encouraged Hill to use the infant invention for making preliminary portrait sketches. Hill and Robert Adamson, an Edinburgh calotypist, met in June and formed a partnership to work on the painting. The calotypes they made of the Free Church ministers were the first portraits of protagonists in a significant contemporary event. And they led the pair to establish the prototype of a modern portrait photography studio, where they satisfied independent clients for some 3,000 or more calotypes.

Hill, the eighth child of a Perth bookseller and publisher (hence his middle name, Octavius), came to Edinburgh at age 16 and became a recognized landscape painter and lithographer by the 1820s. He published early lithographs of Scotland in *Sketches of Scenery in Perthshire*, 1821, and picturesque illustrations for *The Works of Robert Burns*, the Scottish poet; and in the 1830s he produced artworks that were used as the bases for illustrations to Sir Walter Scott's popular Waverly novels. He was active in Edinburgh art and publishing circles, which doubtless enriched the partners' client base and encouraged them to make calotype landscape and architectural views around Edinburgh. (They planned to publish bound volumes of calotypes, but their pioneering projects came to nothing.)

Adamson trained as an engineer, learned chemistry, and by 1842 knew how to make calotypes. Though he shouldered the technical aspects of the partners' portraits—exposure, development, and printing—he apparently also had a lively aesthetic sense, since the photographs that Hill made after Adamson's premature death in 1848 lack the spontaneity and eye for dark–light patterns of their teamwork. Hill, for his part, adopted the conventions of late Romantic English portraitists, such as Raeburn, Etty, and Lawrence: relaxed conversational posing, Rembrandtesque lighting, simple backgrounds, and props such as pens and books that conveyed learning. The one- to three-minute exposures required by calotype led them to favor downcast eyes and to suggest gestures that stabilized the sitters while appearing graceful and fond: relatives embraced one another, and Hill held his hand to his heart in a flattering self-portrait. The rough paper employed for the prints softened details and increased the enveloping chiaroscuro; the various chemicals used in printing added tints of reddish brown or purple. Such variables and subtleties appealed to Scottish connoisseurs: indeed, Hill was the first photographer to produce a body of work distinctly aimed at equaling painting.

In addition to portraits, Hill and Adamson made figure studies that haloed Victorian maidens as tender innocents. They also photographed the opposite, the sturdy fishing families of Newhaven village, in a series that was early in its anthropology and sympathy for a lower class. Sailors posed beside their boats, and fishwives displayed their picturesque striped skirts and rough kerchiefs. Their way of life was harsh, and danger-

ous for the fishermen: the partners called attention to it.

After Adamson's death, Hill continued to photograph, but only briefly. He founded the Photographic Society of Scotland in 1856, and partnered with a wet collodion photographer for a period. In 1866 he finally completed the Free Church's *Signing the Deed of Demission*, which at four feet, eight inches, by twelve feet, was no match for the eight-by-six-in. calotypes that he and Adamson made for it. The Pictorialist J. Craig Annan rediscovered the partners around 1900, which led Alfred Stieglitz to reproduce their portraits in three numbers of *Camera Work*. The American thus claimed the pair for the history of art photography.

THE ILLUSTRIOUS AND THE COLLECTIBLE

Explosive commercialization of photography followed Frederick Scott Archer's invention of the wet collodion process in 1851 and its application to paper prints sensitized with a silver-and-albumen emulsion. Portraitists could now offer the detail of the daguerreotype and the multiple prints possible with the calotype; they could compete with a wider range of prices, and "improve" their sitters' appearance by retouching their negatives. Portraits of the famous could be purchased by their anonymous admirers, while the anonymous could

ANDRÉ ADOLPHE EUGÈNE DISDÉRI PHOTO-GRAPHED THE DUC DE COIMBRA AROUND 1860.

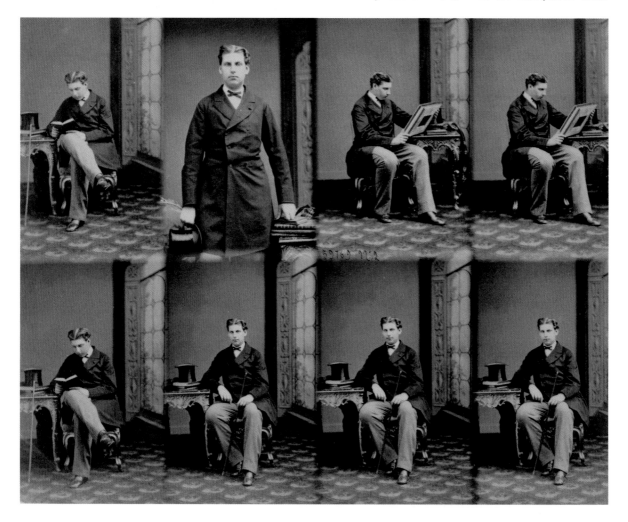

immortalize themselves in albumen prints for their families and social circle. Merely viewing the portrait of a virtuous individual was thought to be educational and uplifting. According to Marcus Root, photographs of "the great and good" would have a "moulding effect" on "impressionable minds," as they recalled the merits of those depicted. At the same time, collections of such portraits were sources of nationalistic pride. A permanent exhibition of Mathew Brady's collected portraits, wrote a congressional committee, would "exert the most salutary influence, kindling the patriotism as well as the artistic taste of the people."

In 1846 John Plumbe had published his *National Plumbeotype Gallery*, lithographs based on his daguerreotypes of distinguished Americans. Four years later Mathew Brady followed suit with his *Gallery of Illustrious Americans*, 12 lithographs based on his daguerreotype portraits. Through these reproductive means, the one-of-a-kind nature of the early photography was transcended. In Paris in 1859 Pierre Petit published *Galerie contemporaine*, portraits of French notables largely based on albumen prints; in 1866, photographs of 50 French artists were reproduced in *Galeries des artistes contemporaines*; and from 1876 through 1884, the publisher and art dealer Goupil and Company issued *Galerie contemporaine, littéraire, artistique*, with a total of 241 photographic portraits of French intelligentsia, some by Nadar and Étienne Carjat and most accompanied with biographies. In the drive to indicate Gallic cultural supremacy and to establish American identity, such projects were impressive tools.

All these portraits embodied the notion that moral character and intellect were reflected in face and expression. This ancient notion had been codified with greatest influence by Johann Caspar Lavater in his *Essays on Physiognomy* of 1789. Did broad brows signal genius? Large eyes a sensitive nature? A prominent jaw strength of will? By contrast, could criminals be identified by their outward features? Lavater's and his followers' pseudo-science offered tools to help identify character in a fluid society with fewer guideposts. Some believed that photography itself could reveal a subject's true nature. The portraitist James T. Ryder personified his Voigtländer camera: "What he saw was faithfully reported, exact, and without blemish. He could read and prove character in a man's face at sight. To his eye, a rogue was a rogue; the honest man, when found, was recognized and properly estimated."

Whether of rogues or heroes, portraits of public figures attracted customers to photography firms, and portraitists often photographed the famous for free or paid them for the privilege of displaying and selling the images. Brady and his neighbor on Broadway, P. T. Barnum, and Tammany Hall politicians all saw the mutual advantages of attractive depictions. Barnum planned a beauty contest

NATIONAL PORTRAIT GALLERIES

The early age of hero worship was Victorian, and London's National Portrait Gallery, founded in 1856, embodied it. Likewise, America's National Portrait Gallery, a division of the federally funded Smithsonian Institution, was set up to collect and display famous faces in the nation's history. The original and still-guiding idea was that great people direct politics and culture and their portraits are potent teaching tools. A bonus (though not a requirement) was that great national painters and photographers often made the depictions. The treasures of the British and U.S. National Portrait Galleries are paintings (by Hans Holbein, Gilbert Stuart, et al.), but the more modest cost of camerawork and its popularity assure the growing proportion of photographs in each collection. Portrait photographs have gained stature by their display cheek by jowl with canvases, first in London from 1859, and by their architecturally distinguished homes and central locations. The London museum is steps from the National Gallery of Art; and its American counterpart occupies a Greek Revival structure that poet Walt Whitman called "the noblest of Washington buildings." Both galleries sponsor annual portrait competitions and consistently circulate their exhibitions (consistent with their federal funding). The U.S. museum offers a virtual tour of "Mathew Brady's National Portrait Gallery," acknowledging (a bit late) that photographer-entrepreneur's achievement in portraiture of the 1840s-'60s. The British museum administers three permanent displays outside London—in Wales, Yorkshire, and Somerset—and in 2005 began a book series on portrait groups chosen from its holdings.

or pageant to be conducted with photographs of contestants (never realized); Brady sent photographs of personalities to the new pictorial journals, *Frank Leslie's Illustrated Weekly*, founded in 1855 as the *Frank Leslie Newspaper*, and *Harper's Illustrated Weekly*, begun in 1857, for publication as wood engravings. The customer and the idly curious were free to visit the richly decorated public rooms of his firm; staring at the famous—questionable in real life—was expected to instruct and entertain, as customers waited for their portraits to be processed.

Introduced in 1854, the *carte-de-visite* or photographic calling card was another technical development that encouraged the already lively cult of celebrity. The *carte* was patented by the Parisian photographer **André-Adolphe-Eugène Disdéri** (1819-1889), who invented a multi-lens camera that could make eight exposures on the same glass plate. The resulting portraits were small—2 1/2 x 3 1/2 in.—but this limited the need for complex lighting of the sitter and retouching of the image. The prints themselves could be cut and pasted onto calling-card stock by assembly lines of semi-skilled workers. Most subjects chose to be pictured full length in their finery (or in the firm's for-rent apparel), on a set with ornate furniture and often a scenic backdrop. The uncut sheets, in which the sitters can be seen trying out different poses and expressions, forecast the charm of filmstrips while they revealed the fashion sense and comportment of upper-middle-class Parisians.

The *carte-de-visite* became a mania of the 1850s and '60s. In 1859 Emperor Napoleon III went to Disdéri's studio to be photographed for a *carte*, which crowned the photographer's career. By 1861 Disdéri had a staff of 90 cranking out some 2,000 photographs a day. Exchanged like conventional calling cards, *cartes* spurred recipients to make collections and to fill albums. Queen Victoria and Prince Albert were the most prominent collectors, amassing over a hundred albums of *cartes* of their relatives and European dignitaries. They also allowed cartes to be made of the Royal Family for mass sales, notably by **John Jabez Mayall** (1810-1901), which helped to build sentiment for the Crown. When Prince Albert died, some 70,000 *cartes* portraying him were bought within one week as mementos.

After the craze for *cartes* peaked, new sizes for portraits were introduced, such as the cabinet card (5 1/2 x 4 in.) and the Imperial (22 x 18 in.). And in some cases, dress, posing, and sets became more elaborate. The New York–based **Napoleon Sarony** (1821-1896), for instance, staged his Broadway stars so extravagantly that a contemporary mocked his studio as "a dumping ground … for unsaleable idols, tattered tapestry, and indigent crocodiles." In all these collectible portrait forms, the famous became commodities like Sarony's bric-a-brac; their images were bought cheaply and traded, fostering the public's sense of intimacy with the famous, and the tendency to interpret current events through the personalities involved. In everyday albums, royalty, statesmen, and theater personalities cohabited with Aunt Emma and Little Jo; *carte* portraiture was a leveler, making public figures familiar, and blurring the boundaries between public and private images. Multiple photographs of a given individual and more rapid exposures led to portrayals of more sociable selves, replacing the stiff formal poses of early photography.

Such portraits could be powerful. It was a portrait reproduced in *Harper's Illustrated Weekly* and available in a *carte-de-visite* that Abraham Lincoln credited, in addition to his 1860 Cooper Union speech, with winning his election. Looking presidential in the campaign photograph, he stands beside a column (which normalizes his height), with one hand on a book (the self-taught lawyer), gazing at the viewer (honest Abe). His long neck is concealed with a retouched collar. Mathew Brady, whose firms would photograph him 40 times, signed the column. Brady's photograph is not a character study nearly full length figures rarely are—but an icon of Lincoln as statesman.

MATHEW BRADY (B. WARREN COUNTY, NEW YORK, C. 1823–D. NEW YORK CITY, 1896)

Brady believed that character and war can be understood through photographs, and he shaped both portrait photography and photojournalism in mid-19th-century America. As a youth he learned the basics of portraiture from the painter-inventor Samuel F. B. Morse in New York. In the early 1840s Brady painted miniatures and made jewelry cases as well as daguerreotypes. In 1844 he opened his

MRS. GEORGE EVANS, MATHEW BRADY'S SISTER,
POSED FOR HIM AROUND 1890.

"Daguerrean Miniature Gallery" in lower Manhattan and started winning prizes for his daguerreotypes; in 1845 he began exhibiting portraits of famous Americans, thus attracting customers to his studio and beginning his own climb to celebrity.

In 1849 Brady opened a studio in Washington, D.C., and photographed President Zachary Taylor and his cabinet, portraits that were among those in his *Gallery of Illustrious Americans*. At the 1851 Crystal Palace Exhibition in London (the first World's Fair), he won the top medal for daguerreotype portraits; and in 1853 he followed the growth of New York northward when he opened a new, more fashionable studio uptown. By 1855 he adopted the ambrotype and wet collodion processes and introduced oversize Imperials to his stock; the following year he displayed portrait photographs printed on canvas and colored in oils. In 1858 he upgraded his Washington

studio by moving it and naming it "Brady's National Photographic Art Gallery" (with Alexander Gardner in charge). In 1860 he opened his most lavish New York studio, at Broadway and Tenth Street, the "National Portrait Gallery," and he photographed the presidential candidate Stephen Douglas as well as Abraham Lincoln.

By the time the Civil War broke out, Brady and his firms had made over 10,000 portrait photographs, including the celebrities of the United States. *The New York Times* enthused: "Future generations would know us better through looking into our very eyes [in Brady's photographs] than through all our books, newspapers, private letters." During the war Brady's employees at the various fronts sent photographs of officials and battlefields back to E. & H. T. Anthony and Company for reproduction and sales. Brady had himself photographed while directing group portraits: this stressed his conceptual and administrative skills in his business, and minimized his poor eyesight, which limited his actual camera work.

As Brady was portraying "illustrious" Americans in the 1850s, Nadar began photographing the leading lights of France, as well as the heights and depths of Paris. This colorful showman benefited from the boom in portraiture in France. The more people with portrait photographs, the more the rest demanded them. In 1861, an estimated 33,000 Parisians were making a living as photographers or their aides, but Nadar was rivaled only by **Étienne Carjat** (1828-1906), best known for his mesmerizing portrait of the poet-critic Baudelaire, and **Antoine Samuel Adam-Salomon** (1811-1881). All three were distinguished by how well they illuminated and posed their personages, sometimes adding a discreet prop.

NADAR (GASPARD-FELIX TOURNACHON, B. PARIS, FRANCE, 1820–D. PARIS, 1910)

Nadar's portrait subjects spanned the bohemia of France's Second Republic (1830-1848) and the celebrities and parvenus of the Second Empire (1852-1870), when Emperor Napoleon III restored France to its position as a world power. His career flourished as the country did in the 1850s and '60s, when Paris doubled in size, France's world trade increased 270 percent,

NADAR AND THE ART OF LIGHTING

In an 1857 court case in which he defended his exclusive right to use the professional name "Nadar" against his brother's claim to it as his former partner, the photographer distinguished himself from everyday portraitists by his use of lighting to penetrate character. "The theory of photography can be taught in an hour; the first ideas of how to go about it in a day," Nadar asserted. "What can't be taught … is the feeling for light—the artistic appreciation of effects produced by different or combined sources; it's the understanding of this or that effect following the lines of the features which required your artistic perception. What is taught even less, is the immediate understanding of your subject—it's this immediate contact which can put you in sympathy with the sitter, helps you to sum them up, follow their normal attitudes, their ideas, according to their personality, and enables you to make not just a chancy, dreary, cardboard copy typical of the merest hack in the darkroom, but a likeness of the most intimate and happy kind, a speaking likeness."

and the finance minister advised an assertive bourgeoisie, "make yourselves rich." Portraiture was not Nadar's only field, but simply his largest claim to fame in the wet collodion era. In this visually oriented consumer culture, Nadar knew that success lay in staying in the public eye.

Nadar began his career in Lyon as a freelance journalist and drama critic, and then moved to Paris where he joined the leading circle of liberal artists and writers. This led him to conceive the "Panthéon Nadar," a group portrait in which he planned to caricature all the intelligentsia of France (his pseudonym "Nadar" derives from *tourne à dard* for his caricature's "bitter sting"). He completed only a third of the thousand-figure lithograph, but it made him famous and exposed him to photography, the source of some of the portraits. With the new craft, which he and his brother Adrien learned, the two men opened a photography studio in 1853. With his shrewd sense of character, Nadar soon overshadowed Adrien as a portraitist and began to operate independently, launching a new studio by 1860 on the top floor of one of the capital's first elevator buildings. This Rue des Capucines site, with his signature emblazoned on the façade, became his salon, with activities climaxing (at least for art history) when he presented the Impressionists' first group exhibition in 1874.

Though his sitters included the Romantics Franz Liszt, Eugène Delacroix, Antonio Rossini, Alexandre Dumas, and Sarah Bernhardt, Nadar's style was closer to the late idiom of the Neoclassical painter Jean-Auguste-Dominique Ingres. Eschewing the elaborate props and full lengths of Disdéri, Nadar posed his subjects with natural dignity, seated and slightly turned, against plain backdrops; and for dimensionality he illuminated them from various side sources, including mirrors reflecting light into lushly dark areas. Their fame as artists enhanced his own.

But Nadar did not rely on portraiture for his self-promotion. In 1858 he was the first to take aerial photographs from a hot-air balloon, and he spent three months in 1861 photographing in the catacombs and sewers of Paris to produce a hundred negatives. The technical difficulties and dangers of these feats made good copy, and the photographs themselves gave Parisians wholly new perspectives on their proud capital, then undergoing Baron Georges Eugène Haussmann's massive demolition and reconstruction. The aerial views of the city's new broad boulevards and buildings were thrilling, while the subterranean pictures, made with artificial light, included deliciously ghoulish images of medieval and Revolutionary-era bones.

POET AND FRIEND CHARLES BAUDELAIRE SAT FOR NADAR THREE TIMES. THIS WAS THE FIRST TIME, IN 1855.

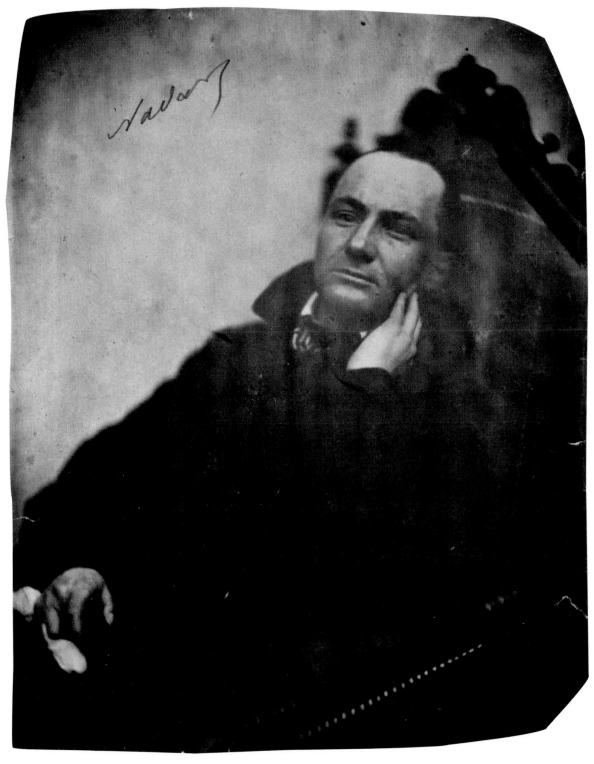

JULIA MARGARET CAMERON SPECIALIZED IN
THE ALLEGORICAL PORTRAIT, SUCH AS
"PRAYER AND PRAISE," 1865.

Nadar's friend Honoré Daumier pictured him at work in the balloon, floating above other photography studios, and captioned his cartoon, "Nadar Raises Photography to the Height of Art."

In the 1880s, although Nadar continued to work, his son Paul took over much of the business. Nadar's last novel project was the 27-picture series that father and son made of the color theorist and scientist Michel-Eugène Chevreul on his hundredth birthday. Shown seated in the studio while being questioned by Nadar *père*, as well as in animated half-length, the voluble old man was quoted in the captions, and a number of the pictures were published in *Le Journal illustré* in 1886. This was probably the first photo-interview, and a fitting climax to Nadar's career of making newsworthy photographs.

"FAMOUS MEN AND FAIR WOMEN"

In England in the 1860s, Mayall, Beard, and Claudet were Nadar's counterparts in commercial portrait photography, but a different, more expressive photography flowered among camera artists and "amateurs"—those who did not depend on camera work for their living. **William Lake Price** (1810-1896) staged historical tableaux and published "Portraits of Eminent British Artists" in 1858, the same year he wrote the first treatise covering the aesthetics of photography, in addition to its techniques. **Lady Clementina Hawarden** (1822-1865) posed her beautiful daughters as becalmed and romantic "Studies from Life" beginning around 1858 and won medals at Photographic Society of London exhibitions. **David Wilkie Wynfield** (1837-1887) made close-up portraits of Royal Academy artists, including Pre-Raphaelite painter John Everett Millais, whom he depicted as Dante. Wynfield may be best known as the teacher of Julia Margaret Cameron, who has been called the 19th century's greatest portraitist, with hyperbole matching her own about her subjects. Cameron, like her artful contemporaries, competed with aesthetic figure studies and tableaux. While she supplemented her family's income with sales of her prints and portrait commissions from Queen Victoria, she disdained commerce and insisted in her autobiography that she always chose whom she wished to portray.

JULIA MARGARET CAMERON (B. CALCUTTA, INDIA, 1815– D. CEYLON [SRI LANKA], 1879)

At age 48, Mrs. Cameron was given a camera by one of her five children, "to amuse you … during your solitude in Freshwater," on the Isle of Wight. Five months later, in 1864, she began exhibiting her large-scale, soft-focus, close-up portrait heads and literary and biblical figures, and for the next 11 years she devoted herself to immortalizing those she called the "Famous men and Fair women" of her privileged social circle. Her passionate, transforming imagination and original, often uneven technique immediately stood out in Victorian art photography, as they do today.

Choosing up to seven-minute exposure times and a short focal-length lens, Cameron may have arrived at her signature selective focus accidentally, but she persisted with it, despite the greater popularity of consistently sharp detail in photography worldwide and in Victorian painting. In emulation of Rembrandt's chiaroscuro, she used dramatic side lighting, and glass plates up to 15 x 12 in. for life-size scale. Her images, she proclaimed, were neither enlarged nor retouched; her artistry, in other words, was genuine and transcended mere manual skill with the wet collodion process.

MRS. CAMERON'S HEROES AND HEROINES

Poet laureate Alfred, Lord Tennyson, astronomer Sir John Herschel, social critic Thomas Carlyle, scientist of evolution Charles Darwin, painter George F. Watts, poet Robert Browning: these eminent Victorians were among Mrs. Cameron's guests and subjects. "When I have had such men before my camera my whole soul has endeavored to do its duty towards them in recording faithfully the greatness of the inner as well as the features of the outer man …. The photograph thus taken has been almost the embodiment of a prayer." The men she portrayed, she said, were "great thro' genius, the women thro' Love—that which women are born for!" Alice Liddell, who inspired *Alice's Adventures in Wonderland*, sat for Cameron as she did for Lewis Carroll, the book's author; Cameron's niece, Julia Jackson, became one of her ethereally beautiful portraits, also inspiring her daughter Virginia Woolf's portrayal of her as Mrs. Ramsay in the novel *To the Lighthouse*. To those who damned her technique, Cameron retorted: "What is focus and who has a right to say what focus is legitimate focus? My aspirations are to ennoble photography and to secure for it the character and uses of High art by combining the real and the ideal and sacrificing nothing of Truth by all possible devotion to Poetry and beauty."

Cameron's lofty goal was to make photography serve high art, that art of moral uplift and sublime beauty continuous from the Renaissance. In her portrayal the wild-haired Sir John Herschel was not just an aged friend but her "Teacher and High Priest," and a type of scientific genius. In *George F. Watts: Whisper of the Muse*, the Pre-Raphaelite painter of allegories was a creative genius, holding a violin, as well as being a type of St. Matthew inspired by an angel. Thus her portraits were intended to halo their individuals with the grandeur of their antique and biblical prototypes, while establishing exemplars of character for modern emulation.

Making pictorial equivalents for great literature—classical and Christian writings, Dante, Shakespeare, Milton, and the Romantic poets—was Cameron's chief ambition, and that of contemporary art photographers, but their storytelling with posed models in tableaux has had uneven receptions. The illustrations that her friend and neighbor Alfred, Lord Tennyson commissioned for an edition of his *Idylls of the King* were turned into woodcuts, with results that disappointed her, and so in 1874 and 1875, she self-published her photographs of servants and townsfolk dressed as Tennyson's Arthurian characters. The latter year she began her autobiography, *Annals of My Glass House*. When the Cameron properties in Ceylon required the family's emigration there in 1875, she slowly discontinued photographing. But successive generations have rediscovered her: that of Peter Henry Emerson in the 1880s; Alfred Stieglitz and the Photo-Secession around 1900; the Bloomsbury group in the 1920s; and scholars from Helmut and Alison Gernsheim, proponents of "straight" photography from the 1940s, to feminists and Freudians since the 1980s.

FAMILY SNAPS

For 19th-century portraitists and their subjects, the Kodak camera marked a significant change in photographic history. Marketed in 1888 to a broad public by George Eastman (1858-1932), the camera made everyone a photographer. The Kodak slogan, "You press

the button, we do the rest," summed up the simple operation of the hand-held, fixed-focus camera: you exposed a hundred frames of film by pointing (there was no viewfinder) and pulling the lens cap string; then you sent the camera to Eastman in Rochester, New York, where the film was developed and printed. The round prints (2 1/2 in. in diameter) were mounted and returned with a freshly loaded camera. Photographing was so easy that a child could do it—and many did, using Kodak's Brownie, which was introduced in 1900 expressly for them. "Take a camera with you," urged the Kodak girl, shown standing at the beach in advertisements from 1901 on.

The success of Eastman's invention depended on ready-to-use gelatin dry film, which was marketed in celluloid sheets in 1883 and turned into roll form by Eastman in 1888. This film ended the messy nuisance of wet plate processing forever. Commercial photographers were no longer distinguished by their dexterity and arcane chemical knowledge; amateurs could record family milestones and social events for themselves. By 1904, the film was made equally sensitive to all colors (freckles no longer registered as black spots), and, most liberating, it permitted faster exposures. Movement could be captured. Gelatin dry film and Eastman's Kodak created the snapshot—a term credited to Sir John Herschel and originating in the hunter's shot from the hip, snapped without sighting down the shotgun. Amateurs immediately took millions of photographs, mostly of ordinary things. Often freezing people in action, they created a taste for spontaneity in portraiture and in the human interest pictures printed in newspapers and magazines. A new range of expressions and gestures entered photography. People grinned. Fashionable ladies were photographed promenading. Lovers were caught spooning in the park. "Fleeting effects," first seen in stereograph photographs of 1859, could be seized by everyone. The authentic was identified with the impromptu.

JACQUES-HENRI LARTIGUE (B. COURBEVOIE, FRANCE, 1894–D. NICE, 1986)

Lartigue was one of the first "snapshooters," and probably one of the youngest to begin photographing. His father, a successful banker, let him photograph at age seven and gave him

a hand camera at age ten; he took photographs regularly for the rest of his life. Action attracted him, and the antics of his invention-loving family provided subjects, as they raced bicycles, bobsleds, and cars; flew kites and the kite-like planes they constructed; or performed for his camera. In the Bois de Boulogne and on the beach at Villerville, he chronicled the Belle Epoque as his family enjoyed it, in the palmy days before the Great War. His eye was quick for small comic moments and stylish women in the era's fantastic hats. His intuitive sense of pattern and unconventional composition gave his pictures vitality beyond their recording of a lost gilded epoch. Every camera buff makes a few great lucky shots. Lartigue made many over his long life, suggesting that camera vision can be a gift, like perfect pitch. Though he served as an officers' driver in World War I and lived through the Occupation in World War II, he documented none of it. "I don't photograph anything I don't like," he said. "I do the flowers, I don't do the weeds."

Lartigue kept his photographs in albums, like any hobbyist, while he focused on his painting. He never attempted art photography. In 1962 a small show of his photographs at New York's Museum of Modern Art was his first recognition in the United States. In 1970 the fashion and portrait photographer Richard Avedon arranged the publication of his *Diary of a Century*. Camera aesthetics had finally caught up with Lartigue, and the acclaim given to Henri Cartier-Bresson, André Kertész, and other small-camera masters was extended to him. Between the harsh documents of photojournalism and the stylization of camera art, the elliptical insights of the snap-shot—into people and epochs—were now fully ratified as a third possibility. Photographers emergent in the 1970s and '80s, such as Emmet Gowin, Nan Goldin, and Nicholas Nixon, would create bodies of diaristic photographs based on their intimate relations, with the spontaneous air and informal technique of Lartigue's amateur tradition. Around the same time, "vernacular" or anonymous snapshot photography would come to be collected by witty connoisseurs, who delighted in picking through yard sales and flea markets for photographs with animated period figures like Lartigue's and the tilted framing, blur, and novel vantage points of Modernist camerawork.

"BICHONNADE, 40 RUE CORTAMBERT, PARIS," 1905, EXPRESSES JACQUES-HENRI LARTIGUE'S LOVE FOR LIFE AND FAMILY.

EARLY 20TH-CENTURY COMMERCE AND ART

Eastman's inventions did not enchant every photographer. Now that any child could make photographs, how could they be art?

JAMES VAN DER ZEE STROVE TO PORTRAY
THE BEST SIDE OF HARLEM IN HIS STUDIO
AND ON LOCATION, HERE IN 1932.

To answer the philistines, art photographers banded together in the 1890s to distinguish themselves from both snapshooters and commercial photographers (see pp. 237-57). Generically known as Pictorialists, they made portraits with the soft focus, unusual formats, darkroom manipulation, and aesthetic presentations that typified all their work. Portraits, in fact, were a speciality of certain Pictorialists because the styles of both the portraitist and the subject could be provocatively displayed, and elaborate printing processes made each portrait virtually unique. Vanguard artists were sympathetic sitters, while self-portraits let the photographer create artistic manifestos.

With his self-portraits in gum bichromate of 1901-03, Edward Steichen demonstrated his allegiance to the Pictorialist goals of the Photo-Secession group. Depicting him-self as a Titianesque painter with palette and brushes, as an aesthete in a tall Japanesque format, and as a charming new-lywed in a large, close-up, soft-focus portrait with his bride, he flaunted his stylistic range and technical mastery (as well as his good looks). In his portraits of the great French artists Auguste Rodin (1902) and Henri Matisse (1909), he displayed a soulful sympathy for the creative process. With astonishing simplifica-tion, he photographed Rodin's scandalous *Balzac* in moonlight, reduced to a silhouette; and in a number of manipulated prints he combined Rodin's brooding profile with his *Thinker*, identi-fying the sculptor with his famous heroic nude and himself as an artistic photographer with both of them. Closer to charcoal sketches than conventional photographs, these were Symbolist evocations of the famous figures, not descriptions.

In the Renaissance tradition of portraiture of literary and artistic heroes, Alvin Langdon Coburn published *Men of Mark* in London in 1913, which gave presence to such contempo-raries as George Bernard Shaw through dramatic lighting and

simplified composition. In Germany **Hugo Erfurth** (1874-1948) photographed Expressionist painters from Käthe Kollwitz to Max Beckmann: the subtlety of his use of gum bichromate and oil pigment printing added a velvety softness to each image, which did not weaken the impact of the artists' large staring faces and clear flattened shapes.

Frances Benjamin Johnston (1864-1952) deserves note as an early magazine photographer (see p. 168), a champion of women photographers (she collected 142 works by 28 "feminine contemporaries" and exhibited them in France and Russia in 1900), and as a sharp-focus portraitist of turn-of-the-century politicians and personalities. In her *Self-Portrait (as New Woman)*, circa 1896, she showed herself with cigarette, beer stein, and photographs of six men, mocking the stereotype of the suffragette. In her portraits of women, she sometimes elicited expressions of amused self-assertion.

Also flattering sitters but with a range of styles, from detailed to soft-focus, was the gift of a remarkable African-American portraitist who extended Pictorialism into the 1920s and '30s.

JAMES VAN DER ZEE (B. LENOX, MASSACHUSETTS, 1886– D. WASHINGTON, D.C., 1983)

The eclipse of Van der Zee's career after World War II made its art-world discovery in 1969 all the more dramatic. The occasion was "Harlem on My Mind" at the Metropolitan Museum of Art in New York, an exhibition early in focusing on black culture in the United States but one that managed to offend almost everyone except Van der Zee. Amid the controversy (critics thought there were not enough black artists or curators represented, and that there were anti-Semitic remarks in the catalog), one of the few things praised was Van der Zee's portraiture of Harlem's luminaries and middle class in the period between the wars. Through the 1940s white photographers—with a few exceptions—had shown American blacks as social victims or comic stereotypes. Van der Zee, a successful African-American commercial photographer, showed his race

GEORGE HURRELL EXCELLED AT MAKING CELEBRITIES OF THE 1930S AND 40S, SUCH AS JOAN CRAWFORD, LOOK ALLURING.

and class as it wanted to be seen, and the picture was powerfully affirmative.

Van der Zee was the eldest child of parents who had worked for President Ulysses S. Grant, and he grew up in Lenox, Massachusetts, a summer spa for New England's wealthy. Raised in an atmosphere of music and art, he bought a mail-order camera in the fifth grade and learned to photograph. In 1906, at age 20, he moved with his father and a brother to Harlem, on the northernmost edge of Manhattan, and worked as a waiter and elevator operator while performing with a band he organized. In 1915 he relocated to Newark, New Jersey, for a job in a portrait studio, where he began as a darkroom assistant and became a portraitist. He returned to Harlem in 1916 and opened his own studio. World War I made his success, for the soldiers he portrayed recommended him to their families and girlfriends. In 1918 he and his second wife opened the Guarantee Photo Studio.

When black infantrymen marched up Fifth Avenue to Harlem in 1919 as decorated heroes of the War, one could say the Harlem Renaissance began. A self-assured and urbane African-American culture flourished there through the 1920s, personified by Van der Zee's sitters—writer Langston Hughes, black nationalist leader Marcus Garvey, singer Florence Mills, heavyweight champion Jack Johnson, and dancer Bill "Bojangles" Robinson. He also made engagement and wedding portraits, "mortuary" photographs of open, flower-bedecked caskets (some with montaged images of angels and the deceased while alive), and group portraits of athletes, musicians, and the like, in his studio or on location. Like a 19th-century portraitist, he provided painted backdrops, ornate props, and stylish clothes and jewelry, and he liberally retouched to produce the most pleasing images. "I tried to see that every picture was better-looking than the person," he stated. In 1932 he showed a handsome couple in matching raccoon coats with their streamlined Cadillac as if there were no Depression. In "My Corsage," which may have been calendar art for the African-American market, he produced an exquisitely lighted, high-fashion study with the early 1920s conventions of Baron de Meyer and Edward Steichen. "The conventional ideals of the bourgeois portrait studio served him

well," writes scholar Deborah Willis, "as a means to capture the culturally integrationist aspiration of his black clients." There were other commercial studios in Harlem then, but Van der Zee's was the best known.

After World War II, however, Van der Zee's fortunes faltered along with Harlem's as its middle class left for the suburbs, and his style was outmoded. On the day after "Harlem on My Mind" closed, he was evicted from the brownstone he owned. Yet a new generation of prosperous African-Americans discovered him, and in his eighties he photographed actor Bill Cosby, prize-fighter Muhammad Ali, and artist Jean-Michel Basquiat, among others. He died in Washington, D.C., on a trip to receive another honorary degree.

As Pictorialism was eclipsed by Modernism in the work of **Alfred Stieglitz** and his circle during World War I, a new portrait subject revived his drooping spirit. In 1917 he would close his influential gallery, "291," and stop publishing *Camera Work*, which was down to 32 subscribers. But the year before, he saw the lyrical, nearly abstract watercolors of Georgia O'Keeffe, and met and fell in love with the young artist. The two energized one another's art and collaborated in advancing their careers. Stieglitz began photographing O'Keeffe, eventually making over 300 images of her strong, voluptuous body and expressive face and hands, sometimes in dialogue with her paintings. He stated that the ideal portrait would be a photograph made every day of the subject's life. Together, his depictions of O'Keeffe reveal her emotional depth and chart the course of their passionate rela-tionship. His exhibition of some of his portraits in 1921 colored the sexualized interpretation of her intense close-up paintings of flowers (an interpretation he fostered and she always denied). Other of his portrayals of O'Keeffe present a handsome, assured woman; still others the elegant hands of the artist.

In the same years, Stieglitz's former friend **Edward Steichen** was picturing the era's intelligentsia, celebrities, and fashions for Condé Nast magazines. Steichen's women, by contrast to Stieglitz's, presented their glittering social selves in his studio setups. His elaborate lighting and bold background shadows dramatized everyone, even those with nondescript looks, while his ability to stimulate engaging responses con-

firmed public opinion of his sitters' characters. His Chaplin was droll, his Thomas Mann thoughtful. He made indelible images of certain film stars: Gloria Swanson glaring through a veil of lace, Greta Garbo with her arms up framing her face like an icon. These are public portraits, made for mass consumers of fame. Yet the women's ambiguous expressions hint at the indi-viduals beneath the masks and at their consciousness of the artifice of posing.

Steichen's lighting and that of fashion photographer George Hoyningen-Huene (see pp. 360-1) apparently inspired **George Hurrell** (1904-1992), whose breakthrough as Hollywood glam-our portraitist took place in 1929. A happy portrait client of Hurrell's, the silent-film hero Ramon Navarro, introduced him to Norma Shearer, who wanted to prove to her husband, head of production at MGM, that she could play the sultry lead in *The Divorcée*. The portraits not only won her the part but led to Hurrell's appointment as chief of still photography at MGM. Through the 1930s, at MGM, Warner Brothers, and Columbia Pictures, Hurrell's highly stylized portraits furthered the studios' construction of such outsize screen personas as Joan Crawford, Clark Gable, Rita Hayworth, and Marlene Dietrich. They literally glowed under his multiple lights (one light on a boom haloed their hair); while his poses for the women have become stereotypes of theatricalized seduction: the come hith-er look with moist parted lips, bare arms, and raised shoulders accenting cleavage. Men emerged out of dark backgrounds, often smoking; the women's props included a bearskin rug for Jean Harlow and a pistol for Jane Russell, who lay in the hay (in the studio) to promote *The Outlaw*. Prints were exhaustively retouched and scoured with graphite powder to remove blem-ishes and pounds. The marmoreal results fit the movie fan's Depression-motivated dream of perfected beauty. Only a god-dess would have eyelashes so thick they cast shadows.

A rival to Hurrell in black-and-white glamour photography was **Clarence Sinclair Bull** (1896-1979), while a master of color in interwar commercial photography (alongside Paul Outerbridge) was **Nickolas Muray** (1892-1965). Muray, a Hungarian, emigrated to the United States in 1913 and began photographing for *Harper's Bazaar* in 1921. The rich saturation of lifelike hue in his use of the carbro process gave his beau-

AUGUST SANDER PORTRAYED A GENERATION OF
GERMANS IN HIS LANDMARK STUDY.

theater and dance, and the vast picture press were mutually beneficial clients, and she supplied them with candids. Working rapidly and disarmingly, Jacobi made what became signature images for Berthold Brecht's star, Lotte Lenya, actor Peter Lorre, and later in the United States, Albert Einstein, whom she had known and photographed in Germany. She showed these personalities at ease and with the modernist devices of close-up and strong graphic forms. An émigré to New York in 1935, she photographed Robert Frost and J. D. Salinger, among others, for book jackets and the news media. Her lighting and the quality of her prints, unlike Hurrell's, did not have to be exquisite: her audiences wanted the actuality of her public figures and associated her unobtrusive style with truthfulness.

Another commercial portraitist of interwar Germany was August Sander, but his extensive, dogged work challenges the definition of portraiture. Does his photograph of a woman artist in men's clothes, for example, represent an individual, a type of woman, a profession, a German, or all these and additional possibilities? The variable interpretations (from his to ours) of each portrait and of his prints as a whole are part of Sander's continued influence.

AUGUST SANDER (B. HERDORF, GERMANY, 1876– D. COLOGNE, 1964)

At the peak of his reputation during Germany's Weimar Republic (1919-1933), Sander developed his influential portrait work, for which he is well known. He continued working with the methods and equipment of professional photographers instead of switching to 35mm cameras. In line with his subject matter and his goals, he remained loyal to his large-format camera on a tripod with glass-plate negatives. While "New Vision" photography offered dizzying perspectives, photograms, and photomontage, he preferred to produce meticulously executed works in line with 19th-century portrait conventions. Since he believed that physiognomy revealed class and occupation and that a compilation of depictions of Germans of all walks of life could form a collective portrait of the nation, he developed his famous oeuvre *Menschen des 20. Jahrhunderts* (People of the 20th Century), with its various

teous stars, models, and still lifes (for advertising commissions) a startling impact within their obviously artificial compositions of the 1920s and '30s.

EUROPEAN SUBJECTS BETWEEN THE WARS

The differences between Muray's and Hurrell's stars and those of **Lotte Jacobi** (1896-1990) reflect the differences between salaried Hollywood studio work and the rough competition of free-lance celebrity photography in Europe in the 1920s and '30s. Jacobi, a fourth-generation portrait photographer, thrived in Berlin from 1927 during the culturally electric Weimar Republic. The vigorous film industry, the worlds of innovative

groups. His life work documented a Germany that was actually in flux, through an encyclopedic depiction of its citizens. His astonishingly ambitious endeavor, which he regarded as an ongoing project, has inspired cultural observers and Conceptualists alike, from Walker Evans and Diane Arbus to Bernd and Hilla Becher.

Sander was one of nine children of a tradesman's family in the Westerwald region near Cologne. He bought his first camera and outfitted a darkroom at age 16; in 1899-1901 he traveled to Berlin and other German cities as a photographer's apprentice. By 1901 he had also learned Pictorialist styling and processes, and the following year he opened a commercial portrait studio in Linz, at first in cooperation with a partner. Over the next eight years he exhibited and won prizes; in 1910 he opened his new studio in Cologne. In the Cologne area and at the farms of nearby Westerwald, he solicited new clients. Gradually he began to drop Pictorialist artifice and pursue what he advertised in the 1920s as "exact photography"—straightforward, sharp-focus, and formal. Elements of his mature style appear in these portraits before and after World War I: his rural folk, shown in their habitats, offer their self-image as they gaze out at us with dignified self-possession.

Around 1924 Sander conceived his comprehensive concept, *People of the 20th Century,* with the encouragement of the Cologne Progressives, a Socialist artists' group that demanded an art "of collective informational signs." In Sander's project, the German population would be classified in seven groups by "type": the Farmer, the Skilled Tradesman, the Woman, Classes and Professions, the Artist, City Dwellers, and the Last People—those on the social fringe, the homeless, the impaired, the dying. The subdivisions of each section would total 45 portfolios; together they would illustrate the rise of society from earthbound man to "representatives of the highest culture" and then its decline to "the idiots." In 1927 Sander exhibited a group of these portraits, and was hailed as "a Balzac of the lens." In 1929, as a preview of his compendium, he published 60 portraits as *Antlitz der Zeit* (Face of our Time), and in 1931 he gave five radio broadcasts on photography, indicating his high critical status.

Sander's typology of Germans was new only in its scale and form; since the 19th century, quaint illustrations of "types" and occupations had been popular as means of social definition and classification in a mobile society. Physiognomic theory held that faces revealed character and even soul. With more sinister consequences, eugenics for humankind, or genetic engineering, was gaining scientific interest in the early 20th century. At the same time, Germany's transformation from an agricultural to an urbanized, industrial economy lent interest to disappearing ways of life and to volatile groups emerging in the city. Sander often photographed his peasants in their countryside, his tradespeople with their tools at work, but also alternated these settings with neutral backdrops in his studio. Some images verge on caricature, others show his restrained but profound sympathy, but in principle all share his democratic viewpoint. His preference for even lighting and crisp and revealing detail is apparent in his work, as is the subject's full cooperation with his long exposures. In 1934 the Nazis destroyed the printing plates of his book; he had shown that there was no typical German, and no dominant, ideal Aryan type. Instead, he pictured a diversity that included outcasts. In fact, his search for occupational typologies was sometimes undercut by his love of particulars. In many of his photographs, the depiction of social occupation pales before the portrait of individual personality (particularly in examples of ambiguous sexuality). His notion that people could be classified by a single social or job identity and thereby understood was a provocative failure.

During World War II, Sander remained in Germany where he photographed people, landscapes, and plant specimens. A bombing raid destroyed his studio, and then in 1946 a fire destroyed 30,000 of his negatives., which were stored in a cellar. Living in the small village of Kuchhausen, he carried out commissions, prepared prints and portfolios for his own purposes, and organized his archives. One of Sander's most

AFTER HIS FIRST COVER ASSIGNMENT FOR *LIFE* MAGAZINE IN 1941, YOUSUF KARSH PHOTO-GRAPHED THE CENTURY'S LEADING CITIZENS, SUCH AS ERNEST HEMINGWAY, SHOWN HERE IN 1957.

impressive photographs showed the death mask of his Socialist son, Erich, who died of untreated peritonitis during his imprisonment by the Nazis.

In France in the 1920s, **Berenice Abbott** extended Nadar's sober style in her portraits of Left Bank intelligentsia. Beginning a few years earlier, her teacher **Man Ray** served commerce and art simultaneously and clouded the distinctions between them with his portraits and fashion photographs: the socialite and the Surrealist both became mysterious solarized images. For a composite portrait of the art group, he photographed each man with his eyes closed, defying portrait conventions, while underlining the group's shared insistence on the primacy of the interior life and the dream. Realizing Marcel Duchamp's transgressive self-conceptions, he photographed the Dadaist in drag as Rose Selavy (a word play on the phrases "la vie en rose " and "c'est la vie") and made the image into a fake label for the imaginary perfume Belle Haleine (a pun on "beautiful breath / beautiful Helen"). His smudgy head shots of Duchamp became part of a "Wanted" poster the artist contrived, and his image of Duchamp with Pan-like horns of shampoo adorned a fake Monte Carlo banknote, supposedly redeemable for francs. As images of Duchamp, these were all portraits. But they mocked usual uses of the human face and ideas of identity—through gender distinctions, advertising, crime control, even currency.

In her self-portrait photographs and photo-collages of the 1920s and '30s, **Claude Cahun** (1894-1954) also explored sexual difference, gendered traits, multiple identities, and role playing. Her stepsister, who was her lover and lifelong companion, collaborated in making most of her almost 300 surviving photographs, in which Cahun showed herself as a crewcut boy, a Buddha with shaven head, an angel, a courtesan, and so on—the gamut of sexual possibilities. "Under this mask, another mask," wrote the sometime actress and associate of the Surrealists. "I will never finish removing all these faces." She published ten photo-collages in 1930 in her book *Aveux non avenus* (Cancelled Confessions). But the photographs remained private until they were published in France in 1992 and then claimed as precedents for postmodern deconstructions of received gender definitions. They were different from Cindy Sherman's mediated women, however. Within Cahun's cultivated, leisured life (her family members were prominent publishers and writers), her small prints related to her translations of Oscar Wilde and Havelock Ellis (the latter proposed a third sex, of homosexuality). In the 1920s, Cahun could also be identified with the emancipated New Woman, who looked for self-worth outside of domesticity and found support from lesbian subcultures in European capitals. Gender, as she enacted it so variously, was not innate but assumed; her self-portrait photographs, which she began in 1912 and continued making until her death, expressed a protean self.

PORTRAIT PROFESSIONALS AT MID-CENTURY

Faces of Destiny, the title of a 1946 book by **Yousuf Karsh** (1908-2002), suggests the grandiloquence of the portrait style favored for certain *Life* covers, especially in the war years. *Life*, and the other picture magazines that proliferated after World War II, were the primary customers for studio depictions of statemen, artists, stars, and other personalities by Karsh, Philippe Halsmann, and Arnold Newman through the 1960s. Such mass magazine commissions required their creation of lofty but flattering images that enriched preexisting conceptions of their sitters. While all three labored to make handsome prints for independent sales, they knew that strong dark–light contrast and graphic forms would survive web press reproduction and catch the eye at the newstand.

Karsh made arguably his most famous photograph, of Winston Churchill, relatively early in his career, in 1941. A studio portraitist for ten years, newly experienced with lighting through theater work, he was given two minutes to photograph the wartime prime minister of Great Britain. When Karsh took away his cigar, Churchill's glower seemed to sum up his bulldog will to defeat Hitler. Made with an 8 x 10-in. camera, this portrait and those of other backlit personages emerging from inky shadows monumentalized their subjects. The executive who sat for "Karsh of Ottawa" joined an august company including

U.S. presidents, some popes, Ernest Hemingway, and the like. More light-hearted, and more effective with actresses, was **Philippe Halsman** (1906-1979), who was voted one of the World's Ten Greatest Photographers, along with Karsh, in a 1958 poll conducted by *Popular Photography* magazine. (Others known for portraits were Richard Avedon, Irving Penn, and Alfred Eisenstaedt.) Such recognition for Halsman, who shot more than a hundred covers for *Life* (a record), suggests the power of the weekly magazine. Halsman, who had a successful portrait and fashion studio in Paris in 1932-40, beguiled or startled his subjects into character-revealing expressions. His *Jump Book*, 1959, compiled portraits of public figures, such as Richard Nixon and the Duke and Duchess of Windsor, whom he persuaded to take off their shoes and jump for his camera. A more elaborate gag was his 1948 portrayal of Salvador Dalí jumping with three flying cats, thrown water, and suspended furniture, in the spirit of his Surrealist painting and the atomic age. The cats and water had to be thrown and Dalí had to leap

28 times before Halsmann was satisfied. (Today the seamlessness of digitized special effects would limit the impact of such gravity defiance.)

In the portraits of **Arnold Newman** (1918–2000), choice accoutrements and careful, often Modernist compositions enhanced the characterization of artists. Newman frequently showed his subjects in their habitats, and found the spirit of their work there: painter Edward Hopper in a bare room with a pot-bellied stove, composer Igor Stravinsky with his grand piano, in a photograph that Newman cropped to stress its black shape.

RICHARD AVEDON (B. NEW YORK CITY, 1923– D. SAN ANTONIO, TEXAS, 2004)

Slightly younger than Newman, Avedon, whose portraiture is more celebrated than his fashion photography (see pp. 376-7), innovated in both genres, and first in fashion. In the late 1940s, while Avedon photographed couture for *Harper's Bazaar*, he also photographed actors for *Theatre Arts Magazine* and made animated "street" photographs for himself. This personal work was supported by his commercial photography, and the two were indistinguishable, thanks in part to the encouragement of the brilliant art director of *Bazaar*, Alexey Brodovitch. Avedon's first book of portraits, *Observations*, 1959, was designed by Brodovitch, with commentary by Truman Capote. His second book, the ironically titled *Nothing Personal*, 1964, was designed by Marvin Israel, Brodovitch's successor at *Bazaar* and a mentor to Diane Arbus. Avedon's figures here, silhouetted against white seamless backgrounds in his studio, were a rainbow of Americans, from former president Eisenhower to an elderly ex-slave. They suggested August Sander's Germans crossed with the subjects of Arbus, whom Avedon may have influenced and who influenced Avedon in turn.

Confrontational, weighted with the detail that a Rolleiflex camera can record, these portraits inverted expectations by giving anonymous people dignity while capturing the famous letting their guard down.

Further expansions of Avedon's portraiture included a series

DEBBIE MCCLENDON, CARNEY, THERMOPOLIS, WYOMING, JULY 29, 1991, BY RICHARD AVEDON

of his father in the last two years of his cancer, shown at the Museum of Modern Art in 1974; and a 1979 commission from the Amon Carter Museum in Fort Worth, Texas, which became the exhibition and book, *In the American West*, 1985. Debunking the Western myth of heroic loners, Avedon photographed drifters and hard-bitten day laborers with an 8 x 10-in. camera, like the political and business leaders he had profiled for a *Rolling Stone* magazine portfolio in 1976—enlarged beyond life-size, their silhouettes etched against his signature seamless background, their smallest feature recorded in brilliant light.

Celebrity as subject matter prevailed in Avedon's career. In 1985-92, his editorial photography appeared only in *Egoïste*, the French literary and art magazine; and in 1992 he became the first staff photographer for *The New Yorker*, while he continued to take advertising commissions. More books and traveling exhibitions followed: the *An Autobiography*, 1993; *Evidence, 1949 to 1994*; *The Sixties*, 1999; *Made in France*, 2001; and crowning his career, the retrospective *Portraits*, 2002, at the Metropolitan Museum of Art, his second exhibition there, following the 30-year survey of his fashion photography in 1978. Such recognition by the Met, where modern painting was tepidly shown, demonstrated his power in photography, art, publishing, and fashion—all primarily New York–based fields. On assignment for *The New Yorker* to photograph Democrats and Republicans emblematic of "Democracy" during the presidential election year of 2004, he died suddenly in Texas.

PORTRAIT ART OF THE 1960S AND BEYOND

The portraiture of Diane Arbus and Andy Warhol electrified American observers in the 1960s, and in that decade Chuck Close and Lucas Samaras began the photo-based portraits and self-portraits that would dominate their careers. The vast differences between these artists reflect the vigor of American art then, when "street" photography, Pop, Photo-Realism, and surrealizing figuration coexisted with other directions.

DIANE ARBUS (B. NEW YORK CITY, 1923– D. NEW YORK CITY, 1971)

Dwarfs, transvestites, nudists, anxious suburbanites, and a matron in pearls: they were all "freaks" to Arbus, yet also inti-

ARBUS: "FREAKS—I JUST USED TO ADORE THEM"

"Freaks was a thing I photographed a lot," Arbus told a class of photography students in 1971. "It was one of the first things I photographed and it had a terrific kind of excitement for me. I just used to adore them. I still do adore some of them. I don't quite mean that they're my best friends but they made me feel a mixture of shame and awe. There's a quality of legend about freaks. Like a person in a fairy tale who stops you and demands that you answer a riddle. Most people go through life dreading they'll have a traumatic experience. Freaks were born with their trauma. They've already passed their test in life. They're aristocrats." She went on to describe her motives in approaching people on the street and asking to photograph them: "My favorite thing is to go where I've never been …. The camera is a kind of license [in getting people to open up] …. There are always two things that happen. One is recognition and the other is that it's totally peculiar. But there's some sense in which I always identify with them …. [Yet] it's impossible to get out of your skin into somebody else's … somebody else's tragedy is not the same as your own."

DIANE ARBUS DISCUSSED HER "CHILD WITH TOY HAND GRENADE," AT THE RHODE ISLAND SCHOOL OF DESIGN IN 1970.

mates. In her best-known photographs—square-format black-and-white images of circa 1963-69—they returned her stare, and thus implicated viewers in the intense intimacy of the subject–photographer relation Arbus created. With her documentary realism yet astonishing selection of subjects, she broadened the conception of portraiture, and in the 1960s, a decade of colliding social forces, her images were sensational in upending conventional definitions of normalcy. That she committed suicide at age 48 seemed to confirm the Faustian legend that the artist must pay for plumbing the depths of experience for her audiences, even though Arbus viewed her bouts of depression as "goddam chemical."

Arbus complained that as a child "I never felt adversity": her family owned a chic Manhattan department store; and she spent 12 years at the private Ethical Culture School (where Lewis Hine taught in 1904-08), and then married at 18. Her husband gave her a camera, and in 1945 her father hired them both to shoot advertisements for the store. Moderately successful, the couple worked together until 1956, when Diane took classes at the New School for Social Research with Lisette Model (1901-1983). Earlier she had studied briefly with Berenice Abbott and Alexey Brodovitch, *Harper's Bazaar*'s art director, but Model's impact was almost instantaneous. The Viennese émigré took her students into the streets to find themes, and photographed for herself at Sammy's Bowery bar, Hubert's 42nd Street Flea Circus, and Coney Island. These raffish haunts were worthy of Brassaï and beloved by the tabloid photographer Weegee, whose work Arbus admired, while the well-born Model became an example and friend to her. Model

described expressive types through sharply focused gesture and detail, and taught her, Arbus said, that "the more specific you are, the more general it'll be."

Divorced in 1959, Arbus soon met the art director Marvin Israel, who became another mentor, and he showed her the classically composed typological portraits of August Sander. By 1962 she put aside her 35mm cameras in favor of flash and the Rolleiflex and used its 2 1/4-in. square format for its symmetry and capture of data. *Esquire*, *Harper's Bazaar*, and later the London *Sunday Times Magazine* became her commercial clients, while she won two Guggenheim fellowships, in 1963 and 1966, to record American manners and customs. In 1967 her personal work was exhibited by curator John Szarkowski, with that of Garry Winogrand and Lee Friedlander, in "New Documents" at the Museum of Modern Art, announcing the new subjectivity in social documentary. For more income, she taught at Parsons and Cooper Union in New York and the Rhode Island School of Design in Providence, Rhode Island, between 1965 and 1971.

Arbus's most controversial photographs, made in homes for the severely retarded, were her last. Taken with flash in sunlight, most of the patients were in motion and did not look back at her. Although Sander had depicted the disabled, it was to complete his encyclopedic portrait of German society. This "Untitled" series, on the other hand, reveals Arbus's private identification with the extreme of mental and social isolation.

ANDY WARHOL (B. PITTSBURGH, PENNSYLVANIA, 1928– D. NEW YORK CITY, 1987)

Of all his media sources—Dick Tracy cartoons, Campbell Soup cans, tabloid pictures—photographs most fascinated Warhol, and engaged him, in one form or another, throughout his career as the paradigmatic Pop artist. He had collected publicity photographs of stars from childhood; and celebrity photographs were the core of *Interview*, the tell-all magazine he founded in 1969 and directed till his death (it is still published). The nature of fame as channeled by photographs, both posed and candid, was the subject of his major silkscreen paintings of the early 1960s, while his photo-based portraiture defined and flattered the café society of the 1960s and '70s.

Jackie Kennedy, Liz Taylor, and Elvis Presley attracted Warhol—as they did popular audiences of the 1960s. By silkscreening found photographs of each luminary in serial compositions, he commented through repetition and uneven color registration on their ubiquity in the culture, yet also on their degradation and stereotyping as images, images with ambiguous relations to the originals. In *Sixteen Jackies*, 1964, newspaper photographs of the smiling First Lady, the shattered witness, and the stoic widow were screened to form a narrative around JFK's assassination, underlining how most Americans perceived the national and personal tragedy. With these different appropriated photographs, Warhol commented dryly on the mechanization of portraits in consumer society and on the tenuous relation between public and personal identity, while being original in insisting that originality was impossible. In the 1970s he revitalized society portraiture by screening overexposed photographs of his subjects onto canvases, then surprinting the schematic features with a few flat plastic colors. His women looked like his Jackies, icons of themselves; they were Warhols and therefore superstars. For more on Warhol, see Chapter 7.

FOR "PHOTO-TRANSFORMATION," 1974, LUCAS SAMARAS MANIPULATED THIS POLAROID.

EMMET GOWIN'S PORTRAITS OF FRIENDS AND FAMILY ARE HONEST, BEAUTIFUL, AND DIRECT, AS IN HIS SERIES, "DANVILLE, VIRGINIA," 1967.

LUCAS SAMARAS (B. KASTORIA, MACEDONIA, GREECE, 1936)

Samaras's approach to identity through his many media—including photographs—opposes Warhol's in many ways. Obsessive in his self-exploration through portraits, he has used all the Polaroid cameras, most richly on himself, and manipulated their "instant" color prints in exploration of both the

process and his image. He is an unrepentent romantic artist, seeing the unique but kaleidosocopic and evolving self as his prime source of expression.

Samaras's interest in psychoanalysis, brief study of acting, and performances in Happenings and art films in the 1960s gave him expressive range. The early black-and-white Polaroid camera, that device for the hobbyist and home pornographer, let him record himself playing roles, including females and monster types. With small prints from the Polaroid SX-70 instant color camera, introduced in 1973, he manipulated the emulsion expressionistically before it dried, turning the image of his nude body into that of a primal crea-

ture. Graduating to 8 x 10-in. Polaroid color film in 1978, he photographed himself clothed with nude friends. In 1983 he began cutting his one-of-a-kind prints into strips and assembling them into space- and body-warping "Panoramas" over four feet wide. He also photographed himself life-size with the room-size Polaroid camera at Boston's Museum of Fine Arts, a machine invented to make same-size photographs of artworks. In these and his subsequent self-portraits, Samaras promoted free articulation of extreme emotional and physical states and used photography for its revelatory power, a shaman with a camera. Narcissism is "not an isolated, neurotic thing, but positive, outer-directed," he said. "It's a process of sharing intelligent delight with others."

This artist's Baroque expansion of photography's potential has not had wide influence, however. In the "body art" of the 1970s—of Bruce Nauman, Vito Acconci, Chris Burden, and Hermann Nitsch, for example—and in Photo-Realism, artists valued the mute documentary capacity of the camera, in reaction to histrionic abstract painting.

CHUCK CLOSE (B. MONROE, WASHINGTON, 1940)

Close is a painter, printmaker, and photographer who has made photographic representation central to his work since the mid-1960s. "Mug shots" are his almost exclusive subject—frontal, staring heads of his friends, family, and himself, in black-and-white or in color. From this unpromising material, which seems to be the Ur-portrait form, neutrally recording an individual physiognomy, he has created an oeuvre of zesty pictorial variety, sustained exploration, and world acclaim. Of the Photo-Realist painters, with whom he was grouped when his work was first widely exhibited, he is unusual in his ongoing innovation. In his approach to the face, he is unique among figurative artists.

It was the dumb, omnivorous recorder's truth of the camera that first appealed to Close. At the University of Washington in Seattle, from which he was graduated magna cum laude in 1962, he had painted like an Abstract Expressionist. When he later met Willem de Kooning, he told the artist he was glad to meet someone at last who had painted more de Koonings than he had. Close's growing disdain for "art handwriting"—the glib facility of modish abstraction—was not unique in the 1960s. While Conceptual artists like the Bechers and Ed Ruscha turned to vernacular photographic forms like real-estate pictures to escape rhetoric, painter-colleagues of Close's such as Richard Estes and Ralph Goings aped full-color snapshots of diners and neon signs—the cityscape of popular culture.

At Yale University, where he earned an MFA in 1964, Close started mak-

CLOSE ON BECOMING A PHOTOGRAPHER

"The main reason I started making photographs was that I knew that I wanted to do very sustained paintings," said Chuck Close. "I wanted to work for literally months on a piece and I didn't want to have the model around I wanted something that was a frozen moment in time that would have some of the urgency of a split second even though I was going to spend in some cases up to twelve to fourteen months working on one picture. I wanted the paintings to look like they just happened I didn't want people to think about, 'Oh my God, look at all that work this guy did' At first I never thought of my photographs as end products I remember trading one for a couple of kitchen chairs. So I didn't think of myself as a photographer." Close taught himself to print black-and-white film. Then, "around the mid-70s, I was invited to work in Polaroid. The minute I started ... I began to take photographs that I had really no intention of making a painting from. So I reluctantly began to accept the fact that ... golly, I must be a photographer."

NICHOLAS NIXON PHOTOGRAPHED THE BROWN
SISTERS ANNUALLY, ABOVE IN HARWICHPORT,
MASSACHUSETTS, 1978, AND RIGHT,
IN BROOKLINE, MASSACHUSETTS, 1999.

ing portrait photographs and painting from them in black and white. To build "landscapes of the face," he gridded and enlarged the shots, square by square, to nine by seven feet, and used airbrush execution. The scale exaggerated the differences of focus in the original photograph, as well as every blemish and odd feature of his subject.

When he moved to color, Close also rejected his art school training, now by imitating the mechanics of four-color printing. After taking color photographs, he enlarged them and transposed them to canvas or paper by filling his gridded field with black dots for the head's tonal structure. Then he overlaid dots of magenta, then cyan, and finally yellow. The results replicat-

ed his originating snapshots but dramatized by sheer scale the intense saturations of commercial color reproduction. They made the artifice in what was commonly considered "realistic" inescapable. Close's painstaking, incremental painting process was anti-hierarchical, in his view: the dots were the same all over and they satisfied him with their craftsmanly discipline. Seen close up, the dots are visible; from a distance, they cohere; in both cases, the image calls attention to photo-mechanics—despite or perhaps because of its warts-and-all representation of a living person.

Since the 1980s Close has used different grids in his paintings, including diamonds and a format of radiating circles; and he has experimented with virtually every sort of printmaking process—from linoleum cuts, mezzotints, and molded paper pulp prints to spit-bite aquatints—in collaboration with expert technicians. He has also explored large-scale face and figure studies, since 1978, with the Polaroid Corporation's 20 x 24-in.

camera and room-size apparatus, which produces 40 x 90-in. images. In these unretouched, brightly hued, one-of-a-kind photographs, he underlines the impact of physical size on representation and its transformation of facial features and indicators of age. Like all his work, these commanding but nearly clinical images are not commissioned: he doesn't want to flatter.

In 1999 Close made self-portraits and nudes of a model in daguerreotype. Working with photographer Jerry Spagnoli, he produced 5 x 7-in. plates with dense loads of detail. The images' illusion of physicality on their highly polished, mirror-like surface fascinated him; these daguerreotypes are "keepers of the light," like holograms, he says. With their magical reflectivity, the plates "involve us intimately in the poignancy and elusiveness of seeing." The format of the self-portraits is the same he used on himself in the 1960s; but the subject is now an art world celebrity, a survivor of a collapsed artery that left him partially paralyzed in 1988, and a man of late middle

age. "Like a lab experiment, if you keep some things constant," he remarks, "you see change better."

VARIATIONS ON THE SNAPSHOT

The 1960s launched exuberant hybrids of photography, painting, and other media, and inserted photography into art world practices as a neutral recording device and a source of culturally laden found images—all used with great fanfare by New York and West Coast artists. Meanwhile, back in rural Virginia in 1964, Harry Callahan's photography student **Emmet Gowin** (b. 1941) got married. The intimate, poetic, seemingly spontaneous photographs that Gowin subsequently made of Edith Morris and her relatives built on the snapshot tradition. Their unpretentious form is the basis for much personal expression to the present, including that of Nicholas Nixon, Nan Goldin, and even Annie Liebovitz, who applied it at the beginning of her career photographing celebrities.

PRECEDING PAGES: JON STEWART OF "THE DAILY SHOW," 2004: FOR THREE DECADES, ANNIE LIEBOVITZ HAS COMMENTED WITTILY ON CELEBRITY THROUGH ELABORATE STAGE SETTINGS OR A SPONTANEOUS DYNAMIC.

The example of Callahan's limpid photographs of Eleanor and Barbara, his beloved wife and daughter, encouraged Gowin to depict "home truths"; and like Callahan, he employed an 8 x 10-in. camera on a tripod, with which, he said, "both the sitter and photographer become part of the picture." Unlike Callahan's formal, frontal images, however, Gowin's often had the action, odd lighting, and oblique angles of small-camera work. He seemed to let his family go on living while he captured chance felicities. He also welcomed chance in his "circular" photographs, which resulted from using a lens designed for the 4 x 5-in. format apparatus on his 8 x 10-in. view camera. The lens did not cover the film sheet but vignetted the scene while the periphery went black. The soft-edged image—an effect seen in some Atgets—underscored the camera's presence and its role as a keeper of poignantly fleeting moments in private life.

In 1970 **Nicholas Nixon** (b. 1947) began what became an annual tradition of photographing his wife and her three sisters looking into his view camera. This built on the amateur's custom of recording family reunions, but gained emotional resonance through attention to the women's gestures and warm interaction, as well as beauty through the exquisite detail of contact printing. As a series, the "Brown Sisters" became more universal by its reflection on time and on aging as physical and psychological Nixon also extended the empathy family pictures to portrayals of nursing home residents, children in a school for the blind, and in 1988 to AIDS patients.

CELEBRITY PORTRAITURE

Commercial magazine portraits from the 1970s to the present have taken energy from the 35mm photography found in art circles. The most successful in this genre is **Annie Liebovitz** (b. 1947). In the 1970s she began contributing her 35mm color photographs of rock stars to the counter-culture magazine

Rolling Stone; three years later she became chief photographer for the publication, and in 1975 she was concert tour photographer for the Rolling Stones band. In 1983 she started photographing for the revived, celebrity-oriented *Vanity Fair* magazine. Her performers' and the publisher's willingness to shock was one key to the success of her early photographs. The images showed recognizable stars performing with startling self-revelation, as if they were pleased to confirm the gossip about them. In fetal position, the nude John Lennon embraced his fully clothed wife, Yoko Ono, in bed; the guerrilla graffiti artist Keith Haring cavorted naked, covered only with his signature markings. From the late '70s, Liebovitz's increasingly glossy production values indicated the degree to which such depictions were collaborations. Indeed, they recalled the colorful animated cover photographs for *Esquire* that Herb Lubalin conceived as art director in the 1960s. Liebovitz's advertising commissions increased in the 1980s, and she produced prize-winning campaigns for clients such as American Express. Adapted from her editorial work, her full-length subjects acted with momentary spontaneity on carefully lighted locations. Similarly upbeat, her books have focused on women and Olympic athletes, among other broadly attractive subjects.

EXPRESSIVE BODIES AND BLANK FACES

Scholar-curator Keith Davis has observed that portraits since Victorian times have devolved from evoking the soul to probing character to expressing personality to describing the body. At least the body was an inarguable fact. The theorists of the 1970s had attacked conceptions of fixed identity, calling the nature of the portrait into question, while women's and gay rights groups drew attention to the connections between the body and the construction of self. In the 1980s the plague of AIDS demonstrated humanity's vulnerability, while natural and man-made disasters since then have heightened anxieties

"ODESSA, UKRAINE, AUGUST 4, 1993": IN HER "BEACHES" PORTRAIT SERIES, RINEKE DIJKSTRA PORTRAYED YOUNG PEOPLE MAKING THE TRANSITION FROM CHILDHOOD INTO ADULTHOOD WITH SIMPLE DIGNITY.

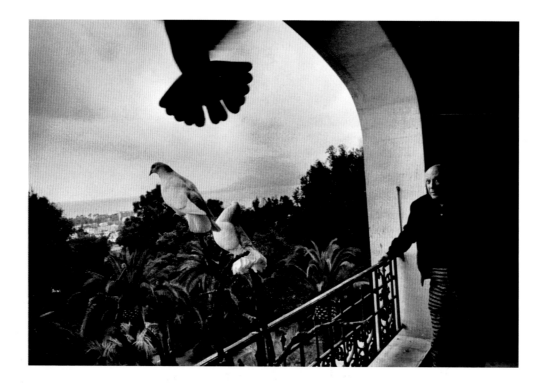

DAVID DOUGLAS DUNCAN SAVORED HIS FRIENDSHIP
WITH PICASSO BOTH PERSONALLY AND VISUALLY.

about physical survival. Simultaneously, multicultural forces and global communications have made faces of diverse ethnicity familiar and significant. The body has in fact seemed a rich subject for photographers.

Portraying his own body since the 1970s, the Finn **Arno Rafael Minkkinen** (b. 1945) explored the relation of human to nature, animals, and space in half-humorous, half-disturbing images, in which unlikely vantage points initially made distinctions among them difficult. With impressive lack of vanity, **John Coplans** (1920–2003) used close-ups of his aging flesh, beginning in 1984, to meditate on mortality while exaggerating the resemblance of his body parts to monumental weathered rocks and elephant skin. Encountering adolescents on the beach and in parks, the Dutch photographer **Rineke Dijkstra** (b. 1959) has portrayed them since the late 1980s, displaying their touching awkwardness in large-scale and full-color prints. How they cope with presenting themselves to the camera—a

concern in the portrayals of vulnerable children and youths by the American **Judith Joy Ross** (b. 1946)—is part of these pictures' content. Though of different generations, using different styles, these four large-format photographers locate identity in metamorphosing physical states and defy the packaging of appearance in media images.

That identity may be impossible to define—or at least that its definition depends more on the observer than the subject—is one conclusion to be drawn from the billboard-size head shots by **Thomas Rüff** (b. 1958). One of the "Dusseldorf School," a student of Bern and Hilla Becher in 1977-85, Ruff adapted their industrial typologies to his young friends in the late 1970s. His format was the passport photograph, the expressionless frontal face, evenly lighted against a blank ground. His enlargement turned viewers into Lilliputians, who became uncomfortably aware of the physical flaws of Ruff's subjects—as well as their own. The identically made portraits were neutral in affect; and, especially when shown in groups, they asked observers to think about physiognomy, age, hairstyle, makeup, and bits of dress as the bare elements of identity.

Ruff's later series included "Stars" (altered from observatory photographs), "Nights" (banal streets photographed with the infrared glow of wartime imaging), and "Machines" (manipulated images from a factory's cache of advertising negatives). These series all originated with documentary genres (like passport pictures) or actual documentary photographs. "Photography can only reproduce the surface," he has insisted. And he adds, "What people see, eventually, is only what's already inside them." How does photography inform us about the world—its youths, skies, streets, and products? In the three-part communication of portraiture (and photography in general)—artist, subject, viewer—Ruff stressed the viewer as receiver and interpreter of material framed by camera conventions.

ANNIE GRIFFITHS BELT PORTRAYED THE LIVES OF ISLAMIC WOMEN, SEEN HERE AT MORNING PRAYERS AT THE DOME OF THE ROCK IN JERUSALEM.

Celebrity portraiture has boomed since the 1960s, reflecting the prominence of celebrity entertainers and sports figures and the media dependent on them. As always, the portraitist plays with the subject's persona, but now with farther-ranging references and mixtures of styles. The elegant silhouettes used by Robert Mapplethorpe and **Peter Hujar** (1934-1987) for their sitters, who looked poised whatever their social tier; the confident sexuality in star portraits by **Herb Ritts** (1952-2003); the good-natured gags in high-key color by Liebovitz; and the exuberant movement in Avedon's early portraits are part of the repertory. But some celebrity portraitists are as dubious as "personal" photographers about the possibility of evoking character, much less seizing a defining feature of personality through their work. They may deal with image itself. Nearly invisible in a portrait by **Inez van Lamsweerde** (b. 1963) and Vinoodh Matadin (b. 1961), for example, the aged Clint Eastwood squints out at us from a shroud of smoke.

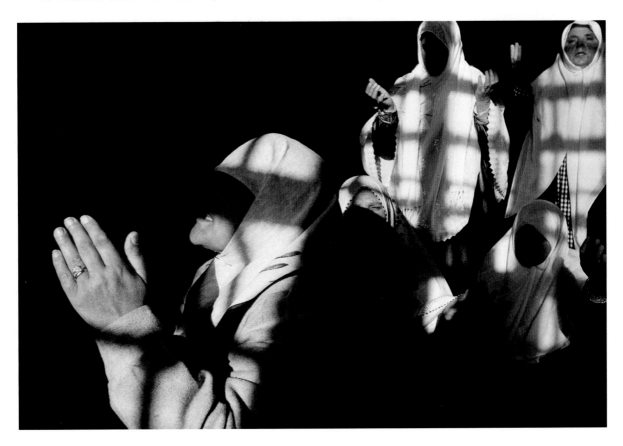

DAGUERREOTYPES
THE BIRTH OF MASS PHOTOGRAPHY

When Louis-Jacques-Mandé Daguerre died in 1851, his photographic innovation, the daguerreotype, was at the height of its popularity. Its creator might well have thought that his invention would set the course of photography for decades to come. After all, by 1851—just 11 years after Daguerre had unveiled his revolutionary technology—millions of daguerreotype portraits had been made in Europe and America. Ironically, despite its huge initial acceptance, the world's first widely used photographic process would turn out to be a fleeting success.

Born outside Paris in 1787, Louis Daguerre grew up to be a painter, making his mark as a commercial artist working for the Paris Opéra. Later he ran his own theater of illusions called the Diorama, which featured large scenic paintings he executed on a transparent background. Through the use of lighting effects, Daguerre could alter the appearance of the scenes, turning day into night, simulating changes in weather, even suggesting motion. An interest in creating these scenes from real life led him to begin his research into photography.

In 1827 Daguerre partnered with scientist Joseph Nicéphore Niépce. In 1826, Niépce had become the

MATHEW BRADY, 1845,
PRESIDENT ANDREW JACKSON

first to successfully record a permanent photographic image when he captured a picture of a barnyard on his estate on a pewter plate coated with light-sensitive bitumen. The image, which Niépce called a heliograph, had required an eight-hour exposure. Ten years earlier, Niépce had used a camera obscura to cre-

ate a negative image on paper sensitized with silver chloride, but since he wasn't able to make a lasting positive print of the image he abandoned the process. Because bitumen hardens and becomes insoluble when exposed to light, the images he made on pewter were more permanent. After exposure, Niépce washed away the unexposed areas of bitumen, leaving a direct positive image.

The partnership of Daguerre and Niépce was short-lived, for Niépce died in 1833. By then Niépce had switched from pewter to silver-plated copper, which he treated with fumes of iodine to produce a light-sensitive coating of silver iodide. Unfortunately, like the heliograph, these silvered copper plates required a long exposure. Continuing his experiments with Niépce's son Isidore, Daguerre found that images could be captured with a shorter exposure, then be made visible by treating them with mercury vapor. He stumbled upon this technique of developing the latent image by exposing the plates to the fumes of various chemicals. Daguerre found that

mercury bonded with the areas of silver iodide exposed to light, forming a white amalgam. He then fixed the images with a salt solution, which removed the unexposed silver iodide. An application of gold chloride hardened and enhanced the image. The resulting pictures were direct positives, with the mercury amalgam forming the lighter areas and the bare silver plate appearing dark when viewed from the proper angle. The images were laterally reversed, as if the subjects were looking at themselves in the mirror.

Images made with this new process, which Daguerre named the daguerreotype, were startlingly detailed, a vast improvement over the fuzzy renderings thus far produced by other experimenters. And because a daguerreotype was made of metal, it would virtually last forever if properly protected. When Daguerre felt that his methods had been perfected, he presented his discoveries to the French government. In exchange for lifetime pensions, Daguerre and Isidore Niépce gave up their French patent rights, and on August 19, 1839, the government publicized the process, making it free to the world.

The world enthusiastically accepted that gift, and early practitioners immediately began to improve Daguerre's original process. Better cameras and lenses and the use of more effective chemicals for sensitizing the silvered copper plates reduced required exposure times from as much as 20 minutes to a matter of seconds, making it easier for subjects to sit for their unblurred portraits. The daguerreotype was especially successful in America. Photographers roamed the

MYERS, CIRCA 1840
PORTRAIT OF A PEDDLER

land, not only bringing portraiture to the masses, but also capturing images of the American West, which were reproduced as newspaper illustrations. By 1850, New York City alone boasted more than 70 daguerreotype studios, the most famous being that of Mathew Brady, who photographed notables for his "Gallery of Illustrious Americans."

Despite the frenzy of activity the daguerreotype produced, the process was soon eclipsed by cheaper and easier to use technologies, including the ambrotype, tintype, and albumen print. Much of the reason for the daguerreotype's fall from popularity stemmed from its inherent drawbacks: The system required a number of complicated steps, and the processing of daguerreotypes exposed the photographer to toxic chemical fumes. Once sensitized, a daguerreotype plate had to be used immediately. The images were extremely fragile, requiring that they be sealed between a backing and a sheet of glass, and mounted in a holder. If viewed from the wrong angle, a daguerreotype looked like nothing more than a blotchy mirror. Finally, since it was a direct-positive process, with no negative, additional prints of an image could not be made.

Nevertheless, the daguerreotype was a signal development in the annals of photography: the first practical process to enjoy widespread commercial success. During the two decades or so of its popularity, the daguerreotype recorded images whose beauty and fidelity we still marvel at today.

CHAPTER 3

EXPLORATION

Deep, even primal feelings are aroused by exotic landscapes and encounters with peoples of race and ethnicity not our own—whether in fact or in photographs. For human survival can depend on "Mother Nature" or the "Other," and on whether faces are foreign or familiar, benevolent, indifferent, or violent. Such feelings may be milder today, in a world of few uncharted frontiers and apparently no unknown peoples. Nonetheless, the appetite for images of nature remains, as does curiosity about humankind. This chapter examines how photographers have answered these evolving interests, and how they have expressed changing definitions of the natural world since the 1840s.

"Nature imitates art," said Oscar Wilde, wittily insisting that we see landscape through pictorial conventions and cultural expectations. Pictures of the land, of its diverse inhabitants and wildlife, are unavoidably symbolic. Projections of their makers' wishes and fears, they reflect particular vantage points and points of view where photographers stand literally and ideologically and when and where they live. In this chapter, images of exploration, ethnography, and wildlife merge with artistic traditions of depicting nature, and different proportions of information and artistry mark such photographs, as they do earlier representations.

The land was always there; the landscape appeared in the late 16th century. Commodities of oil and canvas, landscape paintings by the 17th century depicted the country properties of city dwellers and quaint rural scenes for townhouse decoration; they let armchair travelers imagine trips in space and time (Italian ruins were favorite details), and they appealed to the poetic and the devout with vistas of wilderness and grandeur seen as God-given. These motives for landscape representation—record-keeping and ornament, amusement and escapism, lyrical and spiritual uplift—were strengthened in the 18th and 19th centuries with the philosophies of Jean-Jacques Rousseau and the American Transcendentalists and the aesthetic categories of the sublime, the beautiful, and the picturesque. In attempting to draw Lake Como on his 1835 honeymoon, William Henry Fox Talbot was a typical tourist and

souvenir hunter. This inventor of photography believed topographical knowledge was valuable; that the good and the beautiful were united in the landscape; and that Nature could arouse the most exalted passions of the Romantic heart. The earliest explorers with cameras agreed with him.

EUROPEAN EXPLORERS AND ARTISTS, 1839-1880S

In November 1839, just three months after Louis-Jacques-Mandé Daguerre published his unique-positive process, there were, reportedly, two daguerreotypists already in front of the Sphinx. In January 1840, daguerreotype cameras could be bought in Calcutta. In 1847 aboriginals were first pho-

JOHN BEASLEY GREENE PHOTOGRAPHED
THE NILE RIVER IN EGYPT IN 1853.

tographed in Australia. Photography was a tool of empire, and Europeans were thrilled by the sights of "first peoples" and the signs of ancient civilizations, and of their own colonials and nationals amid mysterious monuments and wonderfully strange scenery. In 1840-43, N. M. P. Lérebours published volumes of *Excursions daguérriennes* showing beauty spots and landmarks from Spain to Greece (see Chapter 1). His employees' travel photographs had to be copied as engravings, but by 1851 the Lille publisher Louis Désiré Blanquart-Evrard (1802-1872) began mass-producing salted paper prints from paper negatives and albumen prints from wet-collodion glassplate negatives and had them tipped into books. His example inspired the founding of other photography printing firms, and the travel book (which originated in the 15th century) took a new lease on life.

A ROAD IN THE VILLAGE OF SAN MARTÍN NEAR
TEOTIHUACÁN, MEXICO, PHOTOGRAPHED BY
DÉSIRÉ CHARNAY IN 1880

In 1852 Lérebours presented *Egypt*, *Nubia*, *Palestine*, and *Syria* with photographs by **Maxime Du Camp** (1822-1894) and two years later *The Nile—Monuments—Landscapes—Explorations* by **John Beasley Greene** (1832-1856), and three volumes by **Auguste Salzmann** (1824-1872) on Egypt and the Holy Land. In their devotion to entire regions, these were publishing firsts, and they responded to a spectrum of curiosities, from French and English politicians jockeying for power in the Middle East, to archaeologists eager to decipher hieroglyphs and to date structures, to potential or returning tourists hungry for mementoes.

The Near Eastern photographs in Greene's and Salzmann's volumes appear proto-modern in their bold compositions and simplification. Though trained as an archaeologist, Greene made mirage-like images of distant settlements along the Nile, sacrificing information for evocative effect. Some of the photographs by Salzmann, on the other hand, were commissioned to settle an archaeological argument about the age of certain ruins in Jerusalem and whether they were Greek or Judaic in origin. These pictures are all patterns and shadows, framed with elegance and directness.

Made in 1849-50, Du Camp's 125 published photographs set the standard for later depictions of such Egyptian sites as Abu Simbel and the Pyramids of Giza. The same Nubian sailor provides a human yardstick in these salted paper prints, sponsored by the French Ministry of Education, and the notion of the paltriness of present-day Egyptians compared to their heroic forebears was implicit in the contrast between live and carved figures. At the same time that Du Camp and his traveling companion, the young author Gustave Flaubert,

were sampling the fleshpots of Egypt's Europeanized cities, **Ernest P. Benecke** (1817-1894) was photographing the natives who were willing to pose. Together, they contributed to the photographic extension of "Orientalism," as defined by the cultural historian Edward W. Said. This was the Christian Westerner's description of the East as "Other"—irrational, lascivious, unchanging, and "primitive," despite its obviously rich cultural past. While satisfying the scientific goal of recording comparative anatomies and physiognomic types, the ethnographic photographer entertained European viewers with types and costumes already established in 18th-century explorers' sketches: thinly veiled odalisques, picturesque rug peddlers, Bedouin warriors glittering with their scimitars. The young women of Madagascar, photographed nude in 1863 by **Désiré Charnay** (1828-1915) in profile, rear, and frontal views, were only a continuation of this tradition, which survived into the 1950s with various degrees of science, sympathy, or salaciousness.

Napoleon's Egyptian campaign in 1799-1800 had asserted the French presence in Egypt long before Du Camp's photographic mission came. But the more powerful nation there was Great Britain, as it pursued trade and traversed the country along the way to India, "the jewel in the crown" of British colonial possessions. The fabled English romance with the desert, epitomized in the early 20th century by "Lawrence of Arabia," was fostered in the 1850s by a Quaker born in Derbyshire. In an age of intrepid explorers and salesmen-entrepreneurs, he combined aspects of both types as he made and marketed photographs to the masses with astonishing success.

FRANCIS FRITH (B. CHESTERFIELD, DERBYSHIRE, ENGLAND, 1822–D. CANNES, FRANCE, 1898)

Frith began his working career as a grocer and spice dealer, and did so well that he could sell his companies for a significant sum in 1855 and devote himself to photography. He was already knowledgeable about the field and about printing, and

FROM 1856-60, FRANCIS FRITH TRAVELED THREE TIMES TO EGYPT WHERE HE PHOTOGRAPHED THE HALL OF COLUMNS IN KARNAK.

in 1853 he was a founding member of the Liverpool Photographic Society. In 1856-60 he made three expeditions to Egypt and Palestine.

On his first venture, Frith sailed up the Nile, as far south as any traveler had, to Karnak, Luxor, and Thebes. On his third trip, he traveled over 1,500 miles up the river, farther than any photographer. Though his collodion fizzed in his darkroom tent as temperatures topped 110 degrees in the desert, and flies and blowing sand continually stuck to his unwieldy 16 x 20-in. glass plate negatives, he was determined to rival in photography the best-selling, six-volume publication of David Roberts's 1838 lithographs of Egypt and the Holy Land. As the photo-historian Gus Macdonald points out, Frith tapped the popularity of scriptural stories and the appeal of retracing Christ's steps in biblical landscapes, as well as the scientific interest in finding the sources of religions. Frith sent his negatives back to three different British publishers, who made him famous, and he sold prints in every format, from stereo cards to luxury albums. His impact was such that tourists at Luxor in 1869 complained of the crowds.

Not only were Frith's Egyptian and Near Eastern views beautifully produced and priced for all wallets, but they also struck a poetic chord with the English. The British Empire, "on which the sun never sets," was the largest in history. Yet Victorian thinkers, such as Edward Gibbon, had pondered the decline and fall of empires, and the evidence of ceaseless conflicts seen in Egypt's defaced monuments and rifled tombs. More than one photograph by Frith could illustrate Shelley's poem "Ozymandias," in which a traveler finds "a shattered visage" in the sand and a pedestal inscribed " 'Look on my works, ye mighty, and despair!' / Nothing beside remains. Round the decay / Of that colossal wreck, boundless and bare / The lone and level sands stretch far away."

Frith returned to England, married in 1860, and started the F. Frith and Co. publishing house in Surrey, which supplied photographs for albums and book and news illustration. By the 1870s, when railroads were crisscrossing the country and half-day Saturdays were obligatory for workers, he recognized the day-trippers' market for local views and picture postcards. His 1886 catalog ran to 670 pages, listing thousands of scenes in

PRECEDING PAGES: THE BISSON BROTHERS , AUGUSTE-ROSALIE AND LOUIS-AUGUSTE, MADE SPECTACULAR IMAGES OF FROZEN LANDSCAPES DURING THREE CLIMBING SEASONS IN THE ALPS BETWEEN 1859 AND 1862.

the British Isles, as well as the United States, Canada, China, and Japan. By 1890, he had more than 2,000 outlets for his cards, and when his firm dissolved in 1970 it owned a third of a million photographs of 7,000 cities, town, and villages.

While Frith was struggling with the wet collodion process on the edge of the Sahara in the 1850s, other explorer-photographers were, too, where the British had interests or government outposts. In Constantinople in 1850, James Robertson (1813-1888) opened a studio with his brother-in-law, **Félice Beato** (1825-1908), and they published an album of city views in 1853. Later both men covered wars (see pp. 152-3), while Robertson became a partner of the gifted **Samuel Bourne** (1834-1912) in India in 1862-63. Bourne made portraits of maharajahs and nobles on commission, rural and urban scenes, and topographic views, in addition to native types on his expeditions to Kashmir and the Himalayas, where he photographed on hair-raising ascents of the mountains. The most prolific photographer in India, he sold thousands of prints in the subcontinent and Great Britain. Others at work in India included **Dr. John Murray** (1809-1898) and **Capt. Linnaeus Tripe** (1822-1902), who was hired by the British East India Company to photograph striking monuments and landscapes, published in 1857-58.

In the Far East, **John Thomson** (1837-1921) photographed the people and made portraits of types from peasants to bureaucrats—enough to fill his four-volume *Illustrations of China and Its People*, 1873-74. It prepared him well for his anthropological *Street Life in London*, 1877-78. (see pp. 159-60), in which he depicted his countrymen making a marginal living.

Among the French, **Félix Bonfils** (1831-1885) opened Maison Bonfils in Beirut, Lebanon, in 1867, and eventually ran branches in Jerusalem, Alexandria, and Cairo, which period guidebooks called the finest sources for photographic sou-

venirs. Locals commissioned portraits, which may have been a source for the costume studies he sold to Western tourists. Such photographs of indigenous peoples in traditional dress were a popular if unreliable form of ethnography. Travelers collected these decorative images, as they did of peasants back home in holiday garb, while ethnographic museums acquired them, alongside more scientific studies. Ethnographic photographs were displayed at such world's fairs as the 1867 Exposition in Paris, in addition to folk crafts, tribal artifacts, and even "specimens" of the colonial peoples, who were presented in reconstructions of their villages. In the photographs, the conventions of full face and profile view (also introduced in criminal mug shots in the 1870s) reflected the importance of physical anthropology in period science.

A major contributor to exploratory photography was Désiré Charnay His archaeological expedition of 1857 to Mexico was the first made with a camera. Looking for development opportunities there, the French government sponsored his photographs of the ruins of Chichén-Itzá, Uxmal, and Palenque, which were published in 1862-63 and sparked interest in the pre-Columbian cultures. Charnay's attraction to wild and remote landscapes later led him as far as Java and Australia.

At the opposite pole of climate, **Auguste-Rosalie Bisson** (1826-1900) and 25 porters reached the nearly 16,000-foot peak of Mont Blanc in 1861, and photographed from the Alps with the wet collodion process (though the cold crystallized the silver on their glass plates and they had to melt snow to wash them). The resulting mammoth-size albumen prints celebrated Napoleon III's annexation of Savoy—of which Mont Blanc was a part—and Nice, and these were spectacular tributes to mountain climbing in a white world above the clouds. Bisson and his brother **Louis-Auguste** (1814-1876) had been appointed official photographers to the emperor in 1860, and they were already distinguished as daguerreotypists, as a firm, established in 1848, and as founding members of the Société Française de Photographie, 1854. Their studio was a chic meeting place for the Second Empire's intelligentsia, and this aided their portraiture and photo-reproductions of artworks. Views of historic architecture were their most frequent commissions, but their technical and aesthet-

ic achievement in the Haute-Savoye secured their fame.

The awe-inspiring tradition of mountaineering photography founded by the Bissons would grow to include the Italian **Vittorio Sella** (1859-1943); the American **Hiram Bingham** (1875-1956), who photographed Machu Picchu for the first time on his National Geographic Society–Yale Peruvian Expedition of 1915; and the American explorer and aviator **Bradford Washburn** (b. 1910), who set records in photographing Mount McKinley and across Alaska. Even today, the spectacle of jagged peaks and wind-sculptured expanses of snow, punctuated by antlike figures of climbers, retains its allure. In the Victorian era, mountains and images of them were "sublime," as the philosopher Edmund Burke defined the concept in 1757. The viewer was dwarfed, even frightened, by the evidence of divine omnipotence and eons of geological violence. Human measure was lost in a vast, alien universe blazing with light. In the Antarctic in 1911, **Herbert G. Ponting** (1871-1935) captured a similar sublime when he photographed the Roald Amundsen expedition to the South Pole.

Below the tree line in the 19th century, however, how different were photographs of exploration and those of landscape? Not very. Photographers knew artistic traditions for presenting vistas—wedges of foreground located the viewer, for example, and alternating planes of light and dark led the eye into depth. And many of the best photographers had trained as painters. One of the most celebrated of these in France was **Gustave Le Gray** (1820-1862).

Le Gray began and ended his career as a painter: he studied under the academician Paul Delaroche in the 1830s, and he returned to painting and teaching in the 1860s in disgust with the commercialization of camerawork. But in the interim, he

pursued photography, opening a studio in 1848, where he taught Du Camp and Roger Fenton and some of those who would become Missions Héliographiques photographers, Charles Marville, Henri LeSecq, and Charles Nègre.

Le Gray's radiant seascapes at Sète of circa 1856, made with the wet collodion process, are his claim to fame. Full of romantic admiration for the power of rolling waves and clouds, some of these were printed (and gold chloride-toned) from a single glass-plate negative, rather than the separate negatives for sky and sea printed successively in register by rival landscapists. Collodion landscapes usually required two negatives because the process was not equally sensitive to blue and green. Clouds were wanted in artful nature photographs: as the landscape painter John Constable said, "the sky is the chief organ of sentiment." Le Gray devised a kind of sunshade to limit blue light and probably chose times of day when the sky and sea were more equally blue. In Fontainebleau, the once-royal preserve, his lush photographs of ancient trees were counterparts of Barbizon School paintings. In 1857, however, at the imperial army camp at Châlons, he depicted dawn maneuvers from afar—as mirage-like as Greene's images along the Nile. The "beauty of a print consisted in the sacrifice of details," he said, thus separating himself from the mechanical recorders of detailed topography.

Le Gray's simplification was unusual in his day: most landscape photographers sold abundant information about pretty places. **Camille Silvy** (active 1857-1869) rose above this median taste by composing watery views of rural France with nostalgic charm, while **Adolphe Braun** (1811-1870)—who is best known for his flower pieces (see pp. 38-9)—helped establish the stereotype of Switzerland's pristine beauty with his prolific photography from 1859 of its mountain lakes. The long expo-

DR. JOSEPH F. ROCK PIONEERED IN
PHOTOGRAPHING CHINESE LANDSCAPES
AND RITUALS, HERE IN 1924.

sures used by both men turned rippling water into satiny reflecting surfaces, stilling nature and adding to the appeal of their picturesque scenery. The picturesque, defined for painting by Uvedale Price, William Gilpin, and other 19th-century British theorists, offered engaging irregularities and multiple visual incidents suggesting nature's benign cycle of decay and regeneration. Picturesque landscapes—and photographs of them—looked like pictures, in a pleasantly romantic, sometimes melancholy vein.

THE AMERICAN ERA OF EXPLORATION, 1840-1879

To Europeans looking west since the 17th century, North America was El Dorado, the Promised Land, and also a howling wilderness surrounded by savages with a trackless void beyond. Whatever the contradictions, the New World represented Nature to an Old World of culture. U.S. settlers and their 19th-century descendants staked their sense of national identity in large part on the uniqueness of the land. In the early 1840s, the first daguerreotype firms made plates and panoramas of America's natural wonders, as well as its architectural achievements (see p. 34). At Niagara Falls, for instance, Southworth and Hawes depicted John Roebling's suspension bridge being built in 1845; and in 1848 **George Platt Babbitt** (1855-1878) pictured tourists on the American side of the falls, just as artists sketched them for keepsakes. When Frederick E. Church, a leading painter of the Hudson River School, created his mural-size "Niagara" in 1857, he probably drew on stereo cards of the falls photographed by Frederick and William Langenheim of Philadelphia in 1845. The accuracy of the photograph ensured a painting's authenticity, while the conventions of painting ensured a photograph's artistry.

Regardless of medium, however, landscapists responded to public interest in areas newly accessible by railroads and to popular, nondenominational associations of scenic beauty with transcendental truths. "Every natural fact," wrote Ralph Waldo Emerson in Nature, 1836, "is a symbol of some spiritual fact." In 1851 a minister titled his toast to the American Art Union, "Art, the Interpreter of Nature; Nature, the Interpreter of God."

The camera was also a trusted tool for geologists, botanists, naturalists, and ethnographers. By contrast, the expeditionary sketch artist was too slow for the generals, and too vague for the scientists. In Kosmos (1845-62), the naturalist Alexander von Humboldt recommended photography to explorers, and Lt. Col. John C. Frémont had anticipated him. He was the first to take a camera along with him, on his 1842 expedition to the Rockies. His daguerreotypes were failures, but technology soon matched his ambitions, when the wet collodion process was invented in 1851. The wet collodion and glass plate photographer would accompany all the key explorations of the United States through the 1870s.

By the mid-19th century, the modern shape of the country, apart from Alaska and Hawaii, had been set. In the Mexican-American War, 1848-49, the United States took possession of lands west of Texas to California and north from today's Mexican border to what became Washington State. But what actually lay west of the Mississippi River was hardly known. Beginning in the early 1860s, the federal government and private enterprises, especially the railroads, launched expeditions to find out more, with photographers among the experts hired. Their mandate was to document the West's natural resources in geology and geography for potential development, its topography in aid of mapping and further exploration, and its native peoples in the interests of ethnographic study and pacification. What was photographed would also answer the world's curiosity.

There was also the matter of a transcontinental railroad. In 1848 Senator Thomas Hart Benton (great uncle of the mid-20th-century Regionalist painter) declaimed: "To reach the golden California—to put the populations of the Atlantic and the Pacific into direct communication—to connect Europe and Asia through America … such is the grandeur of the enterprise!" The following year, the discovery of gold in California electrified the world and triggered the migration of a quarter-million optimists. They got to the goldfields by two routes: by wagon train overland from St. Louis ("gateway to the West") across the great plains and north across the enormous barrier of the Rockies, or by sailing ship down the East Coast and across the Gulf of Mexico, then by portage across Panama, and then by sail north to California. Both routes were slow and dangerous, one with hostile native peoples, the other with malaria and other tropical diseases. Even during the Civil War,

the U.S. Government encouraged railroad building west, and guaranteed the privately owned railroads laying track that they could exploit the finds made in the process, and have the right to transport settlers and service them thereafter.

The Union Pacific and Central Pacific railroad companies entered the competition to see which could lay the most miles of track (and secure the richer franchise). The Central Pacific started construction eastward from Sacramento in 1863. The Union Pacific built west from Omaha, Nebraska. On May 10, 1869, the two tracks met at Promontory Point, Utah; and the last tie was symbolically secured with a golden spike. The tens of thousands of builders (many of them Chinese, imported from their homeland for the work) had dynamited through the Sierra Nevada range, spanned innumerable gorges, fought off tribesmen's attacks, and survived the country's worst extremes of heat and cold.

Knowing their achievement would make history, the Union Pacific hired **Andrew J. Russell** (1830-1902) to photograph its progress west; while the Central Pacific employed **Alfred A. Hart** (1816-1908) to document its way east. Both had established their technical skills with wet collodion and their hardiness as field photographers in the Civil War. Their albumen prints stress the drastic perspectives of track slicing into mountainsides, rimming riverbanks, or plunging into the desert, alongside mesas and rock spires silhouetted against the sky. The contrast of the wilderness void and the busy order of trestles, iron tracks, masonry, and hordes of laborers makes clear that human industry would subdue the astonishing, still inhospitable land—that the railroads would conquer space.

The photographs of Hart, Russell, Alexander Gardner, and others were tipped into albums by the companies and given to their investors and the government. The photographers made additional prints to sell on their own, and they also marketed stereo cards, which reached a broad public at a low price. The cards created a startling effect of three-dimension-

DRAWN TO THE WEST DURING THE GOLD RUSH, CARLETON WATKINS MEMORIALIZED THE LANDSCAPE IN HIS PHOTOGRAPHS.

al space when seen in a stereo viewer—an effect that may have spurred the photographers' frequent choice of diving perspectives.

Compared to the railroads, the four government survey expeditions of the 1870s had a broader mission—to map the terrain, picture its topography, study its geology, botany, and native inhabitants—and the results reflected the expertise of their leaders: Clarence King, George Wheeler, Ferdinand V. Hayden, and John Wesley Powell. Each expedition took along geologists, surveyors, botanists, and sketch artists, as well as photographers. As with the railroaders' photographs, expeditionary works were made into albums for government use, provided to publishers for reproduction, and sold by the photographers in stereo and larger formats. Thus they served specialized knowledge and simultaneously fed popular imaginings of the West. Art and documentation were intertwined.

CARLETON E. WATKINS (B. ONEONTA, NEW YORK, 1829– D. IMOLA, NAPA, CALIFORNIA, 1916)

Though not the first American landscape photographer, Watkins was the first to describe the West systematically, and with a signature style that viewers identified with High Art. He was not the first to photograph in the Yosemite Valley, but his name is synonymous with this natural wonder, for his work led to its being protected in 1864 by an act of Congress from future development. This was the first step toward the federal government's establishment of a national parks system, a U.S. invention, and Watkins can be credited with effectively encouraging it. Yet despite the nation's debt to him, he had the rags-to-riches-to-rags life story of many prospectors in the American West.

The son of a carpenter and innkeeper, he arrived in California in 1851, to make his fortune in the Gold Rush. In 1854 he learned daguerreotypy; in 1858 he opened his own studio; and by then he knew enough landscape photography to make a panorama of a quicksilver mine for a court case. In 1859 he photographed the estate of explorer-landholder John C. Frémont, who wanted to attract potential investors: this suggests Watkins could already glamorize as well as record California terrain.

In 1861 Watkins had a cabinetmaker construct a camera to handle 18 x 22-in. glass-plate negatives—an unprecedented size in U.S. practice—and he took it to Yosemite, then an overnight stagecoach ride from San Francisco. Charles Leander Weed had preceded him there, but Watkins outdid that photographer in the size and glorious vision of his albumen prints: they were exhibited in 1862 at Goupil's in New York City, a fashionable gallery for paintings, and praised by both the chief of the California State Geological Survey (which employed him in the mid-1860s) and Ralph Waldo Emerson. "The Best General View, Mariposa Trail" typifies Watkins's calm, godlike conception of the valley. The prize-winning image locates viewers beside a heroic lone pine and penetrates the deep space via alternating planes of dark and light, past landmarks such as Bridalveil Falls and Half Dome on the horizon, into infinity. In other prints, Watkins dwelled on the grandeur of giant sequoias, which scientists dated to biblical times. No wonder that in 1864, in the heat of the Civil War, President Lincoln signed the bill to preserve Yosemite "for public use, resort and recreation … inalienable for all time." In Watkins's photographs, it resembled a new Eden, a place of healing and reconciliation.

Watkins returned to Yosemite seven more times, but he also took commissions for straightforward documentation (trees, lumberyards, mines), while he made new, exalted descriptions for tourists (views on the majestic Columbia River in 1867). And he also satisfied San Francisco's civic boosters with panoramas of the city. He and his admirers had no doubt that industry and natural beauty could coexist. In 1871, now a charter member of the San Francisco Art Association, he opened a new, luxurious studio, the Yosemite Art Gallery, with hanging space for 125 of his largest prints; from 1873 his boyhood friend Collis P. Huntington, who had become a principal of the Central Pacific Railroad, lent him two railroad cars to transport his equipment and pack horses to distant sites.

But a financial panic hit in 1874, and overproduction of stereo cards slashed publishers' profits. In 1875 Watkins lost his gallery and his negatives to creditors, and though he began rephotographing his best-loved sites, some think he

WILLIAM HENRY JACKSON PHOTOGRAPHED THE
NATURAL BEAUTY OF UNDEVELOPED LANDSCAPES
SO WELL THAT HIS IMAGES HELPED TO ESTABLISH
YELLOWSTONE AS A NATIONAL PARK.

never fully recovered his spirit. In 1890 he photographed copper mines in Montana using electric light, flash powder, and dry-plate negatives, yet his embrace of new technology could not offset his failing eyesight. In 1895-96 he had nowhere to live but an abandoned boxcar; he lost his entire studio in the San Francisco earthquake and fire of 1906. In 1910 he was committed to a hospital for the insane; he died six years later.

WILLIAM HENRY JACKSON (B. KEESEVILLE, NEW YORK, 1843–D. NEW YORK, NEW YORK, 1942)

Sheer industry and longevity made Jackson one of the best-known photographers of the U.S. West. At nearly one hundred years old, he lived to see his mammoth, 20 x 24-in. albumen prints of Yellowstone and the Grand Canyon exhibited at the Museum of Modern Art in 1942. His career had begun eight decades earlier.

Jackson learned to paint as a teenager, and following high school he became a retoucher and colorist in a commercial photography studio. After serving in the Civil War, he went west and eventually settled in Omaha, Nebraska, the head-quarters of the Union Pacific, then building the transcontinen-

tal railroad west. His experience photographing landscapes and Native Americans along the route in 1869 led to an invitation in 1870 to join the fourth of the great expeditions to the West. This was the "United States Government Geographic and Geologic Survey of the Territories" (mainly Wyoming and Utah), led by geologist Ferdinand V. Hayden through 1878.

Jackson went on seven Hayden trips, and in 1871 he made the first surviving photographs in Yellowstone. Hayden brought along artists, including Thomas Moran, and the photographer and painter became collaborators: Moran scouted vantage points (he carried no heavy equipment) and Jackson gave him prints as bases for the sketches he contributed to *Scribner's* magazine. The artist helped Jackson "solve many problems of composition," the latter recalled. With both art and documentation in mind, the two described the natural marvels of Yellowstone—the geyser "Old Faithful," Mammoth Hot Springs, spire-like rock pinnacles, and more. The album Hayden produced for the U.S. Congress was praised by the *New York Times*: "While only a select few can appreciate the discoveries of the geologists or the exact measurements of the topographers, everyone can understand a picture." In 1872 Congress declared Yellowstone a national park, forever protected against development; it was the first park in what would become a vast federal system.

Jackson went on to make over 800 negatives for Hayden, and the 20 x 24-in. ones were the largest ever taken in the field. His technical achievement must have been spurred by the magnitude of the landscape itself and the vision of the explorers. Indeed, his *Grand Canyon of the Colorado* shows two of them, puny in the wilderness but centered in the composition, one reclining nonchalantly, the other surveying the scene through a telescope—that other tool, besides the camera, of visual possession. More obviously symbolic (and popular) was Jackson's "Mountain of the Holy Cross," which showed the giant cross formed by snow in the mountain's crevasses: it demonstrated the popular belief that the West was "God's country." For this prize-winning print, Jackson had to ascend 14,000 feet and carry a hundred pounds of gear by hand, since the end of the trail was too narrow for mules.

In 1879, after the Hayden project effectively ended, Jackson

moved to Denver, Colorado, and opened a studio. In 1881 he began photographing for railroad companies, making grandiose views and panoramas of their track-laying across virgin terrain. In 1883-84 he incorporated as a publishing firm, and at the 1893 World's Columbian Exposition in Chicago, he sold albums of his scenic photographs at a lavish $1,000 a copy. His last expedition was a global trek in 1894 from England to Japan (via Russia by sleigh); *Harper's Weekly* paid him a princely $100 a page for his photographs. In 1897 he became director of the Detroit Publishing Company, which published his images as postcards and sold hand-colored landscape photographs. Exhibiting them in a railroad car fitted as a gallery, he toured the Southwest, selling to the growing tourist market that the railroads—and his photography—had always encouraged. In his late years, he resumed painting, wrote two autobiographies, and lectured about his adventures as a youth in the 1870s.

TIMOTHY O'SULLIVAN (B. IRELAND, 1840– D. STATEN ISLAND, NEW YORK, 1882)

Among the post–Civil War photographers of the American West, O'Sullivan was unusual in working solely for U.S. Government surveys. While Carleton Watkins, William Henry Jackson, and others took such commissions but also reached a broad public with gorgeous landscape images, O'Sullivan photographed only for geologist Clarence King (1867-70 and 1872), Lt. Thomas O. Selfridge (1870), and Lt. George Montague Wheeler (1871, 1873, 1874), and his approach was drastically different. O'Sullivan's field experience documenting "The War for the Union" prepared him physically for the July rigors of the Nevada desert and Death Valley, California; the boating trip 200 miles up the Colorado River against the current; and for penetrating the canyons of the Southwest. If his battlefield photographs illustrate General Sherman's assertion "War is Hell," his expeditionary views suggest that nature is not much better. Was that his intent? The evidence is inconclusive, for he died of tuberculosis at age 42, having written nothing about his work.

As a teenager O'Sullivan apprenticed in Mathew Brady's New York studio, and relocated to his Washington, D.C., branch in 1856-57. When Alexander Gardner quit the Brady gallery, O'Sullivan joined him in 1862, and both photographed the most contested

THE REPHOTOGRAPHIC SURVEY OF CASTLE ROCK,
GREEN RIVER, WYO. INCLUDED PHOTOGRAPHS BY
(TOP): TIMOTHY O'SULLIVAN, 1872;. MIDDLE: MARK
KLETT AND GORDON BUSHAW, 1979; BOTTOM: MARK
KLETT AND BYRON WOLFE FOR THIRD VIEW, 1997.

battlefields of the Civil War—Antietam, Fredericksburg, and, most famously, Gettysburg, where O'Sullivan homed in on the bootless, bloated corpses for "The Harvest of Death." This appeared in *Gardner's Photographic Sketch Book of the War*, almost half of which was illustrated with his albumen prints.

In 1867 O'Sullivan was hired by Clarence King for the first of the four epic government surveys that would map North American lands from the Missouri River west to California. King's insistence on including a photographer set the precedent for the surveys that followed. The mission of "The 40th Parallel" project was to examine the geology and topography along the proposed northern railroad route between the Rockies and the Sierra Nevada Mountains. With Army protection, the King party trekked east from Sacramento over the infamous Donner Pass (where snowbound travelers had turned cannibal in 1846-47); and it wintered in Virginia City, Nevada, in 1867-68, where O'Sullivan became the first to photograph inside the mines of the Comstock Lode. Using magnesium flares, he showed miners ready to descend into the shafts, a cave-in, and other aspects of the hard-rock industry. Above ground, he photographed Shoshone Falls in a series of views, and documented fissure vents, geysers, tufa mounds, and sand dunes: the latter of which, in one striking picture, was empty except for his darkroom van and his wheel tracks and footprints marking the desolation. As scholar Alan Trachtenberg points out, O'Sullivan underlined the relativity of knowledge and the process by which the intrepid recorder can turn inhuman places into informative photographs.

In 1870 O'Sullivan was official photographer for a military expedition seeking a canal route through the Isthmus of Darien (Panama), but the jungle damp and darkness limited his camera work. In 1871, he was luckier, however, with the Wheeler survey of the 100th Meridian; and though his collodion boiled in the desert heat, he took memorable images of the Black Canyon of the Colorado. In the Arizona–New Mexico territories for Wheeler in 1873 and 1874, he made the photographs for which he is best known: of the dramatic rock faces and ruined pueblos of the Canyon de Chelly. These photographs show signs of both transient habitation and cata-

clysmic geologic change: again O'Sullivan apparently sought to both awe and inform.

In 1880 he was appointed official photographer for the U.S. Treasury, but he died before he could complete any assignment. In 1942 his Southwest photographs were shown at the Museum of Modern Art with the benignly sublime landscapes of Watkins and Jackson; in 1981 his work was viewed through the lens of 1970s Conceptual art by scholar Joel Snyder and heralded for its proto-modern style.

In 1879 Congress merged the surveys led by Hayden, Powell, and Wheeler into the U.S. Geological Survey (with King as its director) and the Bureau of American Ethnology (under Powell). The albums they commissioned had proved the worth of photographs as evidence and persuasion. Coupled with explorers' texts and oral reports, they aired the question whether the arid Southwest could be settled, and they assured the protection of Yosemite and Yellowstone as national parks. The heroic era of Western expeditions was over. From the 1880s, American landscape photographs described a domesticated wilderness.

The odd rock formations of the Wisconsin Dells were portrayed by **H. H. Bennett** (1843-1908) as tourist destinations. In New York State's Adirondack mountains, **Seneca Ray Stoddard** (1844-1917) depicted glassy lakes and dense forests as invitations to wealthy sportsmen. With sensational advertising, Buffalo Bill Cody parlayed his exploits as an Army scout and buffalo hunter into a Wild West show and took it East in 1883 and then to Paris and London, where he dazzled Queen Victoria. Native Americans played themselves in the troupe's staged battles. Of course, they were defeated.

NATIVE AMERICANS

The Hopi, Zuni, Navaho, and Pueblo were settled agricultural tribes in the Southwest. By 1885 railroads from both coasts made their communities accessible, and such photographers

EDWARD CURTIS TRAVELED THROUGHOUT THE
WEST FOR 30 YEARS TO PHOTOGRAPH THE
NORTH AMERICAN INDIANS.

as **Adam Clark Vroman** (1856-1916) and **Karl Moon** (1879-1948) served the tourist industry that the railroads promoted. As scholar May Castleberry remarks, their photographs reflected rising nostalgia for America's pre-industrial past, in which communities were thought to live in harmony with nature and to espouse timeless traditions. Images of peaceful aboriginal peoples gratified anyone unnerved by modern life. Visitors bought their handwork and photographs of them, and, with the hand cameras cheaply available in the 1890s, they took pictures themselves. Frederick Monsen's *With a Kodak in the Land of the Navaho*, 1908, was one of the books showing the way.

Photographs for documentary and scientific purposes by Vroman, Moon, Frank A. Rinehart, and others acknowledged their subjects' contemporary lives, while those for popular consumption edited out the presence of Anglos, readymade clothes, and so on. To observe and preserve the folkways of the "vanishing American" in pre-contact state was a fond ambition at the turn of the century. It became an obsession for one remarkable photographer.

EDWARD SHERIFF CURTIS (B. NEAR WHITEWATER, WISCONSIN, 1868–D. LOS ANGELES, CALIFORNIA, 1952)

Ethnography and the Aesthetic movement met in 1901 when Curtis undertook the most ambitious encyclopedic project in photo-history, to portray all the Native American tribes in the United States west of the Mississippi. He worked for 30 years, produced over 40,000 images, and covered over 80 tribal groups, from the Inuit people of Alaska and the Sioux and Cheyenne of the Rockies to the Hopi and Zuni of the Southwest. Twenty volumes (leather-bound) contained his portraits of well-known chiefs—such as Geronimo, Red Cloud, Chief Joseph, and Medicine Crow—and his photographs of religious rituals; traditional ways of hunting, planting, and cooking; artifacts and their making; clothing, dwellings, games, and reenacted battles. The first volume appeared in 1907, with his detailed text, the photographs printed as photogravures, and accompanied by a portfolio of 36 larger, loose images. This sumptuous format and exhaustive documentation were the same in the following numbers. President Theodore Roosevelt wrote the foreword to

Volume 1, and the *New York Herald* called the opus "the most gigantic undertaking in the making of books since the King James edition of the Bible." When Curtis conceived *The North American Indian*, he thought it would take five years to do and cost $25,000. It cost almost $1.5 million.

Curtis marketed the publication not just to scientists but to the broad public; the complete set of volumes was $3,000 for subscribers, but individual photographs could be had for $15. Some were promoted as wedding gifts: they were elaborately framed and printed as orotones (positives on glass backed with an emulsion of gold dust in banana oil). But after 1930, when Curtis completed the 20th volume, his audience was shrinking. The Depression, the reduced vogue for his subject, and his own exhaustion forced him to stop printing. He could not find subscribers for an intended 500 sets; he only produced 272.

It had been a different story at the turn of the century, however. Native Americans were identified with North America's heroic frontier past, and the widely accepted idea that they were a "vanishing race" gave urgency as well as poignant appeal to Curtis's project. He had learned photography as a youth and was apprenticed to a portrait photographer in St. Paul, Minnesota, at age 17. In Seattle, Washington, he bought a half-interest in a photography studio, and in 1898 while mountain-climbing he encountered George Bird Grinnell, the ethnographer of Native Americans. Grinnell invited Curtis with him to photograph the Blackfeet in Montana two years later; and in 1899 he was the photographer on the E. H. Harriman expedition to Alaska, where he documented Inuit as well as glaciers and plants. On these trips Curtis conceived *The North American Indian* and also learned the survey methodology he would use for it.

Traveling with assistants and a studio tent, he photographed tribal people on site, and where possible in their dwellings. Ethnographic study standards had not been formalized then, so the reenactments he paid for, his provision of traditional dress and accoutrements to those who had none, and his retouching of his negatives to remove modern intrusions,

"EAST COAST FISHERMEN," CIRCA 1886: "PHOTOGRAPH PEOPLE AS THEY REALLY ARE—DO NOT DRESS THEM UP," SAID PETER HENRY EMERSON.

such as alarm clocks and automobiles, were not frowned on. With Pictorialist devices, he ennobled his sitters and made their activities look natural and timeless. Poetic lighting generalized them, and they seemed at one with their striking landscapes.

When descendents of Curtis's subjects were interviewed for a TV documentary in 2000, half were angry that the "Shadow Catcher," as he was sometimes called, had "appropriated their heritage," while the other half were grateful that he had preserved it. Some objected that he had ignored the poverty and misery of the Native Americans' present-day lives. A few noted that certain subjects had not fully cooperated: for example, they performed rituals backwards and with omissions. The debate catalyzed by Curtis's work goes on. Meanwhile his photographs continue to be collected for their romantic beauty as well as consulted for their data.

ENGLISH GENRE PHOTOGRAPHS OF THE 1880S AND '90S

Closer to home than Curtis's noble "Indians" were the urchins photographed by **Frank M. Sutcliffe** (1853-1941) and the sturdy fisherfolk portrayed by Peter Henry Emerson in late Victorian photography. As nostalgic as Curtis about disappearing ways of life, they shared the theme of the interdependence of people and place in what could be called "genre" camerawork. Like their predecessors, 17th-century Dutch and 19th-century French genre painters of peasants, these photographers showed figures as types defined by their labor and pastimes and landscapes as their attractive backdrops. They appealed like early ethnographers to curiosity about those outside mainstream society—the poor and those living by traditional occupations—but without scientific classification. Sutcliffe brought the quick, amused eye of the snapshooter to Whitby, a Yorkshire fishing village that was a magnet for painters and photographers of the picturesque. Emerson portrayed the laborers in the wetlands of East Anglia's Norfolk Broads.

PETER HENRY EMERSON (B. CUBA, 1856– D. FALMOUTH, ENGLAND, 1936)

Emerson's subjects tapped an ancient longing, of urban sophisticates for a simpler rural existence, lived in harmony with nature. His scenes of tidewater life in England's remote East Anglia were late additions to a genre spread in the mid-19th-century by the painters Jean-François Millet and Jules Breton, and illustrators inspired by them. Londoners leafing through Emerson's books and limited-edition portfolios such as *Life and Landscape on the Norfolk Broads*, 1886, and *Pictures from Life in Field and Fen*, 1887, were invited to admire his sturdy peasants gathering reeds, harvesting hay, and fishing, and to imagine fishing with them, in ways unchanged since the wetlands were settled. Emerson's photographs, beautifully printed in platinum or gravure, extolled the foggy marshlands identified with historic England and the picturesque hunter-gatherers whose supposed agrarian idyll was fast disappearing from the industrializing West.

While Emerson generalized and heroicized his figures with high horizons and backlighting, he focused on them and let the background blur, using a long focal-length soft lens. His "differential focus" imitated how the eye sees, he insisted (wrongly: the eye scans a scene and sends multiple crisp images to the brain). And he loudly publicized his opinions in lectures and print, notably in *Naturalistic Photography for Students of the Art*, 1889. He was combating both the staged scenes and composite prints popularized by Henry Peach Robinson as well as the all-over soft focus and pigment processes identified with Pictorialism. Indeed, Robinson's book, *Pictorial Effect in Photography, Being Hints on Composition and Chiaroscuro for Photographers*, 1869, which helped name the fin-de-siècle art photographers' movement, was his chief target.

"Photograph people as they really are—do not dress them up," Emerson said. "Nothing in nature has a hard outline, but everything is seen against something else, and its outlines fade gently … often so subtly that you cannot quite distinguish where one ends and the other begins. In this mingled decision and indecision, this lost and found, lies all the charm and mystery of nature." To this Robinson snapped: "Healthy human eyes never saw any part of a scene out of focus." Emerson was also scornful about Pictorialist manipulations, and he even condemned retouching as "the process by which a good, bad, or indifferent photograph is converted into a bad drawing or painting."

A graduate of Cambridge University with a degree in medi-

cine, Emerson bought his first camera in 1881 as a hobbyist bird-watcher and meteorologist. Such naturalist interests led him to East Anglia and gave his scenes verisimilitude. He devoted himself to photography from 1885. In 1890 he published *The Death of Naturalistic Photography*, however, and after 1895 he stopped exhibiting and publishing his prints: he had concluded from scientific findings about exposure that photographers, unable fully to control tone, could never be artists. But his earlier support for art photography was more influential. Around 1890 his words and example encouraged the preferences of The Linked Ring members J. Craig Annan and Frank Sutcliffe, and in a larger sense the history of "straight" aesthetic photography of directly encountered life—the history from Alfred Stieglitz to the "street" photography of the 1960s.

"REDDING, CONNECTICUT," 1968, EXEMPLIFIES PAUL CAPONIGRO'S ABILITY TO EVOKE LANDSCAPE'S SPIRITUAL BEAUTY.

THE SYMBOLIST LANDSCAPE

Emerson, Sutcliffe, and, in the United States, Robert Redfield and William Rau were among those who implicitly criticized the pace, materialism, and alienation of modern life in their sharp-focus photographs of the 1880s-1900s. That theme was even stronger among the soft-focus Pictorialists, those art photographers who veiled and beautified nature through lens and darkroom manipulations at the turn of the century. They supported the aesthetics of poet Stéphane Mallarmé and composer Maurice Maeterlinck, among others. The landscape expressed the mysteries of existence and offered mystical correspondences for the artist's and the viewer's emotional states. The details of topography were subordinated to "breadth of effect," which generalized facts into symbols. Misty or moonlit scenes offered healing escape. "We spend our days in the sordid streets and hideous suburbs of our vile cities," Oscar Wilde snapped, "when we should be out on the hillside with Apollo."

Among the American Pictorialists, **Anne W. Brigman** (1869-1950) staged nudes like dryads among the cypresses of California, while Edward Steichen restricted his nature to a weave of trees or a single cloud looming over a twilit lake. Even in New York City, he and Alfred Stieglitz poeticized the latest skyscraper, the Flatiron Building, by associating it with nature: they photographed it from Madison Square Park framed by branches and softened by nightfall or snow. Stieglitz's cloud studies also embodied the Symbolist definition of nature and its aggrandizement of the artist. From 1922 he subsumed them, his "Songs of the Skies," and " Songs of Trees" series under the title *Equivalents*: they were "equivalents" of his feelings.

After World War II, the work of **Paul Caponigro** (b. 1932) and **Minor White** (1908-1976) extended this tradition. Exquisitely conceived and meticulously printed from large-format negatives, their photographs of ancient trees and battered rocks invited metaphoric readings and underlined the primacy of the artist's emotions. As seen in *Aperture*, the refined photography magazine that White edited in 1952-75, such images of aestheticized nature helped advance the acceptance of camerawork as art.

AMERICAN PEOPLES AND HOPEFUL LANDSCAPES, 1920S-1960S

Ethnographic interests in the United States took new, more personal turns in the 1920s in the work of **Laura Gilpin** (1891-1979) among the Navaho and Pueblo and **Doris Ulmann** (1882-1934) among the poor whites and blacks of the Appalachian hills. Both beautified their subjects while adding a

FROM ANSEL ADAMS'S "PERSONAL CREDO"

In the war year 1944, Adams concluded his statement for the *American Annual of Photography* with this paragraph: "My approach to photography is based on my belief in the vigor and values of the world of Nature—in the aspects of grandeur and of the minutiae all around us. I believe in growing things, and in the things which have grown and died magnificently. I believe in people and in the simple aspects of human life, and in the relation of man to nature. I believe man must be free, both in spirit and society, that he must build strength into himself, affirming the 'enormous beauty of the world' and acquiring the confidence to see and to express his vision. And I believe in photography as one means of expressing this affirmation, and of achieving an ultimate happiness and faith."

sense of intimacy and individuality to those who were often stereotyped as childlike and backward. (For more on Gilpin, see Biographies.)

The 1930s spawned at least three kinds of landscape photographs: the "tractored-out" fields of the Dust Bowl, published by Dorothea Lange in *An American Exodus: A Record of Human Erosion in the Thirties*, 1939; the radiant abstracted deserts of Edward Weston, made in 1936 on a Guggenheim fellowship; and the grandiose views of the Sierras by Ansel Adams, who like his friend Weston relied on the 8 x 10-in. camera for its capture of detail. The subtext of their work in the early 1940s was World War II and the widespread desire to reassert American values. Weston and Adams identified them optimistically with the American landscape—Weston in a 1941 project to illustrate Walt Whitman's *Leaves of Grass* with scenes of the South and East, Adams with the spiritualized West of mountains and Pacific Coast.

ANSEL ADAMS (B. SAN FRANCISCO, CALIFORNIA, 1902– D. CARMEL, CALIFORNIA, 1984)

In crystalline black-and-white prints made over five decades, Adams expressed and enlarged one of North America's oldest and most popular convictions—that its Western landscapes are sources of national identity and restorative beauty, a church without walls to unite and inspire all sects and faiths. The interlocking goals of his work, teaching, publishing, and charismatic proselytizing were to champion "straight," unmanipulated photography and the U.S. conservation movement. And while his epic views of mountains and coast were (and still are) sold in calendars and postcards, his enlarged, editioned prints of them set auction records from the late 1970s, confirming the art status of photography.

Adams was introduced to photography and to Yosemite National Park in 1916. In 1919 he joined the Sierra Club, the association founded by naturalist John Muir in 1890 to preserve the 400-mile-long mountain range from development and to foster the U.S. National Parks system; in 1928 he became the club's official photographer. Adams had just published *Parmelian Prints of the High Sierras*, the first of eight portfolios (through 1976). But his stylistic identity was not confirmed until he met Paul Strand in 1930; in 1932 he cofounded Group f64 with Weston and others, so-called for its use of the smallest marked camera aperture on most 8 x 10-in. format lenses to ensure maximum detail and depth of field. Adams's achievement in applying Group f64's modernist aesthetic to landscape was recognized by Alfred Stieglitz with an exhibition in 1936; the two men shared the romantic idea that their photographs of nature were equivalents of their deepest feelings, and like music could inspire such emotions in viewers.

"WHITE SANDS NATIONAL MONUMENT," 1942: ANSEL ADAMS WAS A TECHNICAL GENIUS AS WELL AS AN ARTIST AND ENVIRONMENTALIST.

In 1940 Adams taught his first summer workshop in Yosemite and began developing his Zone System, a method to control and exploit the fullest possible range of tonal values in exposure, development, and printing: values from pure black to white that he numbered I to X. Epitomizing Group f64 's concern for flawless, previsualized prints was his comparison of the negative to a musical score and the print to a symphony's performance. In 1935 Adams had published the first of ten photography manuals; in 1946 he established one of the first photography departments in a college of fine arts, the San Francisco Art Institute. The same year he received the first of three Guggenheim grants to photograph national parks and monuments. His travels and publications with this purpose filled the 1950s.

In 1960 the Sierra Club published Adams's *This is the American Earth*, an eloquent call for conservation. In 1980 his advocacy and his artistic stature were recognized by a Presidential Medal of Freedom. The citation that he was "visionary in his effort to preserve this country's wild and scenic areas, both on film and on Earth," caught the transcendental quality of his unpopulated Nature. There, changing weather and the seasonal cycle provided an elemental drama of light. The small-scale prints of the 1930s had given way to sublime, large-format vistas by mid-century, culminating the Victorian tradition of the photographers Adams had rediscovered—Carleton Watkins, William Henry Jackson, and Timothy O'Sullivan—and of America's Hudson River School painters. Adams's artistic goals were continued for some years at the Friends of Photography center in San Francisco until its demise in 1961.

Given to President Franklin Roosevelt, Adams's *Sierra Nevada: The John Muir Trail* led to the establishment of the half-million-

acre Kings Canyon region as a national park in 1939. Adams's dedication to wilderness protection was shared by **Eliot Porter** (1901-1990), whose black-and-white prints composed the last exhibition at Stieglitz's An American Place gallery in 1938-39 and whose landscapes were the first solo display of color photography at the Metropolitan Museum of Art, in 1979. Porter contributed to both the histories of color and the Sierra Club as a force for conservation. In 1939 he began to use Kodak's recently introduced Kodachrome transparency to photograph birds, and then Kodak's durable dye-transfer printing process after its debut in 1946. With *In Wildness Is the Preservation of the World*, 1962, the Sierra Club paired his forest scenes and lapidary flower studies with quotations from Henry David Thoreau (the title is Thoreau's): the book sold more than a quarter-million paperback copies. Porter's *The Place No One Knew: Glen Canyon on the Colorado*, 1963, was an elegy for the canyon before it was flooded in the construction of a major dam. These were some of the Sierra Club's "battle books," designed to promote preservation by showing the virgin beauty that development threatened to despoil. Porter's restrained palette and sensitivity to form also made the publications into worthy art books, which helped legitimize the use of color in serious photography.

NEW TOPOGRAPHICS AND SPOILED EDENS

Other visions in the 1960s and '70s were far from transcendental. For example, the Los Angeles-based artist **Ed Ruscha** (b. 1937) scoffed at the myth of the uplifting Western landscape and open road in *Twentysix [sic] Gasoline Stations*, 1967. A cross between Minimalist serial art and Pop commentary, his straight-faced photographs defined a 1,500-mile road trip on Route 66 by the punctuation that these vernacular buildings afforded. One could consider the prints architectural studies (they also mocked postcard depictions of mundane structures), but their bite came from their dialogue between the man-made and the debased land.

CAROL BECKWITH AND ANGELA FISHER HAVE BEEN DOCUMENTING THE DIFFERENT CULTURES OF AFRICA, SUCH AS THE MASAI WARRIORS, FOR MORE THAN 30 YEARS.

Such asymmetrical and astringent dialogues were typical of the photographs in the influential "New Topographics" exhibition of 1975 (see p. 51). The title alluded to the 19th-century mapping expeditions of O'Sullivan and others, as well as the quasi-scientific detachment of some current art. The subject was the inhabited landscape, largely in the West. Of the ten photographers shown, **Robert Adams** (b. 1937), **Lewis Baltz** (b. 1945), **Joe Deal** (b. 1946), and **Frank Gohlke** (b. 1942) shared a particularly distanced and downbeat affect.

As a youth, Adams had been given a copy of *This Is the American Earth* by Ansell Adams (no relation), and he bought a print of Adams's famous "Moonrise over Hernandez," but he found that such grandiloquent imagery did not square with the air pollution over Denver, tract houses invading the desert, and joy riders' tire tracks gouging foothills. Ansel's style also seemed operatic. The New Topographers eschewed his dramatic clouds and long dawn shadows and the "earth gestures" of mountain skylines. They photographed in even light, like Bernd and Hilla Becher (also in the show), and head on or looking down at mobile homes and blank modular façades.

In his series "New Industrial Parks near Irvine, California," 1975, Baltz found alien vernacular buildings and sites that resembled "Primary Structures" in Minimal art, while Adams ironically contrasted such landmarks as Pike's Peak with the cheap constructions built to serve tourists there. Around Albuquerque, New Mexico, Deal showed the seepage of suburbia into open land, using the repetitive textures that **Frederick Sommer** (1905-1999) had photographed in the Arizona desert. The faults lay in overpopulation and unregulated development, these photographers seemed to say, and they presented their cumulative evidence in black and white and a neutral style. It was elitist to fuss about preserving pristine nature, they implied. "Where we live is far more important than where we visit," said Gohlke.

How far were current realities from those of the 19th-century, now mythic West? For comparative data, the Rephotographic Survey Project was conceived and directed in 1977-79 by **Mark Klett** (b. 1952), **JoAnn Verburg**, **Rick Dingus** (b. 1951), and others, to document some 85 sites on the Western surveys of the 1860s and '70s. Matching the van-

tage points, seasons, and times of the original images as closely as possible, the new photographs presented some surprises. Certain landforms were now framed by trailers and phone wires, and rocks had been vandalized, but some scenes remained the same, while new forests enriched others. The paired photographs allowed no simple conclusions about human impact and nature's regeneration.

Klett went on to photograph Western attractions, but with evidence of his own and other presences. The panorama—which Muybridge and his contemporaries had attempted to make seamless—was an obvious composite of separate photographs in Klett's versions, and he wrote information on the print margins to stress the contingency and personal nature of his images. In his "Cancellations" series, 1974-76, **Thomas Barrow** (b. 1938) printed Western landscapes with the X's he marked across the negatives, as if in rejection of the New Topographics style but also of the flotsam scattered across his subjects.

By the late 1970s, color was a powerful chord in landscape photography, and its uses ranged from Pop humor about the built environment (first shown by Robert Venturi, Denise Scott Brown, and Stephen Izenour in *Learning from Las Vegas*, 1972) to evocations of Impressionism, as described early on in Sally Eauclaire's *The New Color Photography*, 1981. **Stephen Shore** (b. 1947) photographed the all-over pastels of Monet's Giverny and also the measured structure of color on American streets. In *Cape Light*, 1978, **Joel Meyerowitz** (b. 1938), at first a New York "street" photographer, achieved his greatest popularity with a nuanced exploration of Cape Cod's spectrum of natural and artificial illumination playing across vacation vistas.

Irony arose from the contrast between the beauty of the scene photographed and its literal content. In the "Power Places" series, 1981-83, by **John Pfahl** (b. 1939), nuclear cooling towers and the like were the focus of effulgent scenery; the threat was invisible. Pfahl's sardonic presentation of the nuclear facilities in Old Master compositions suggested how successfully they have been naturalized as an unquestioned energy source. Other color photographs of the environment were more ambiguous.

AN IMAGE OF SUBURBAN DEVELOPMENT
FROM JOEL STERNFELD'S GROUNDBREAKING
PROJECT "AMERICAN PROSPECTS"

JOEL STERNFELD (B. NEW YORK, NEW YORK, 1944)

Sternfeld's best-known works, the lovely, subtly hued, expansive landscapes published in *American Prospects*, 1987, reveal the sensibility of a wounded Romantic. His wide vistas with the rich details made possible by his 8 x 10-in. view camera, his alluring palette of muted secondary colors, and his mythic locales on the Pacific Coast and in the Southwest, promise the thrill of the sublime delivered by his late 19th-century predecessors in the same states. But then you look more closely. On an untouched beach in Oregon, the distant human figures have gathered to attend beached and dying whales. In the vast desert of Arizona, a storm points to a derelict structure that is not of the Old but the New West: this was a uranium plant and its wastes have poisoned the soil. Sternfeld has said that he "looked at the landscape for what it revealed about humanity," believing that it "contains clues about the society." Yet the beauty of his rendering, his distant and high vantage points, elegiac colors, and classical compositions are the conventions of art, not sleeve-tugging photojournalism. He gives the viewer space to make inferences about the "humanity" he shows.

Sternfeld graduated from Dartmouth College in 1965 and began photographing in color in 1970. In the '70s he focused

both 35mm and 4 x 5-in. cameras on the streets of his native New York, capturing office workers as they rushed past him unaware. His use of flash in daylight singled out certain figures from their comrades in this series, which led to his Guggenheim fellowship in 1978. That year he began to travel the United States, inspired by the writings of Edwin Way Teale, Leo Marx, Charles Reich, and other commentators on the American relation to nature and culture. He found an old 8 x 10-in. Wista field camera and sacrificed snapshot surreptitiousness for the wide-angle views and greater information it could yield. The people he encountered were necessarily conscious of his equipment: it imposed a portrait-like formality on his images of wandering Americans in this time of double-digit inflation and Rust Belt decline. He admitted the pictures' similarity to FSA photographs of the '30s: "Fifty years [later] people are still looking for work, still in dire straits."

From the early 1980s, Sternfeld's photographs alternated between encompassing views and portrayals of individuals and small groups representing occupations and types—updating the 19th-century genre. The incongruities in single photographs of the late 1970s now appeared in separate images in the same series, inviting comparisons. At stake in almost all the series and their books is humanity's clouded relation to nature: age-old and recent in *Campagna Romana*, 1992, photographs made outside the Eternal City on a Prix de Rome grant; ambiguous in *On This Site: Landscape in Memoriam*, 1996, locations of American violence, such as the street where Rodney King was beaten; and cautiously optimistic in *Walking the High Line*, 2002, pictures of an abandoned, grass-covered section of the West Side Highway that nature is reclaiming from Manhattan.

As for figures, Sternfeld shows compassionate and tactful interest in a range of mostly everyday Americans. In *Stranger Passing: Collected Portraits*, 2001, his subjects are both individuals and representatives of class and paycheck. For *Treading on Kings*, 2002, he showed the protestors at the economic summit meeting in Genoa the year before, demonstrating his sympathy for those championing the world's dispossessed. But these series, like his landscapes, are far from exposés. "Experience has taught me again and again that you can never know what lies beneath a surface or behind a façade," he wrote in 1996. Though referring to his landscapes, he suggested the mystery shown in all his work, as well as the limits to understanding in photography per se.

A NEW SUBLIME

North Americans' ability to scar the environment has not been the only theme of recent landscape photographs. The overawing power of nature drew **Frank Gohlke and Emmet Gowin** (b. 1941) to photograph the devastation wreaked by the eruption of Mount St. Helens in Washington State in 1981, and Gowin described the patterns of felled trees and bare hillsides with sobering beauty. In giant icebergs, **Lynn Davis** (b. 1945) found natural grandeur but also metaphors for mortality on this planet: the floes are all destined to melt into the sea. (Photographing this subject and the Pyramids with grave formality, she alluded to the expeditionary photographs of Dunmore and Critcherson in the Arctic and Frith in Egypt. Her photo-historical referencing is typical of many current camera artists.)

Most disturbing are the full-color apocalyptic visions of the Californian **Richard Misrach** (b. 1949) and the Canadian **Edward Burtynsky** (b. 1955). Since 1979, Misrach has devoted himself to "Desert Cantos," a series of reflections on the savaged landscapes of the Southwest and West. Nuclear testing grounds with toxic ponds and mass graves of livestock, copies of *Playboy* used for target practice on a Nevada site, salt flats with racing cars, sagebrush in flames—all compose eerily handsome prints that point to institutions and the values they have fostered as sources of destruction.

Since 1981 technological forces exerted on the landscape have concerned Burtynsky, whose mural-sized color photographs depict what has been called an "industrial sublime." The megalomaniac scale and history of human claims on the Earth are visible in his images of centuries-old quarries in Italy and New England, scarlet rivers of tailings from Ontario mines, and cities being leveled in Central China to make way for the largest hydroelectric dam in the world, which environmentalists estimate will destroy the region's ecosystem and displace 1.2 million people by 2009. In the godlike views given by Burtynsky's huge panoramas, everything is in focus

yet distanced, and figures and trucks are toylike. The viewer is seduced by the lofty vantage point and the aestheticized spectacle, but also implicated in its human content. The cycle of production, consumption, and waste, and the voracious appetite for energy, touch anyone who wants to put gas in the tank, as he points out. Like Sebastião Salgado, he photographed ship-breaking on the poisoned beaches of Bangladesh (2001-02), but while the Brazilian focused on the

"SWAMP AND PIPELINE, GEISMAN, LOUISIANA," 1998, IS A MORE RECENT EXAMPLE OF RICHARD MISRACH'S MOVING ENVIRONMENTAL LANDSCAPE PHOTOGRAPHY.

unprotected workers, Burtynsky pulled back to show the ruined coast and the hulks of the tankers they were torching apart. One could choose to see the latter's foreboding prints as accusations: such deadly labor takes place in Third World countries with First World complicity. Or as ironic celebrations: workers with hand-held tools were making counterparts of Richard Serra's giant sculptures.

WILDLIFE PHOTOGRAPHY

In the history of camera work, hummingbirds, nursing whales, cheetahs versus gazelles, and the gorillas of Rwanda are fairly recent subjects. Wildlife itself has fascinated artists—and great ones at that—since the Renaissance, when Dürer attempted to

draw a rhinoceros, and since the 17th century, when zoos began to spread as the living counterparts of aristocratic *wunderkammern*, or cabinets of curiosities. But photographers attracted to wonderful animals and to showing them in their habitats had to wait for fast lenses and film and reliable flash (see pp. 230-1) illumination before they could fulfill the demand for authenticity. The profession of wildlife photographer was (and is) a specialty within photojournalism, and like that field it first flourished in the 1920s when camera and publishing technologies, and adventurous photographers and editors, came together with inquisitive readers to create a genre. Just as photojournalists specialize in breaking news, social issues, human interest, living beauty, humor, and so on, wildlife photographers can be profiled by their dominant interests—whether filmic firsts in natural sciences; photographs supporting conservation; popular, often anthropomorphic portrayals; or ravishing images of the world's creatures in their multiplicity of forms and colors.

Furthering its mission to spread general knowledge of the earth sciences, *National Geographic* magazine published the earliest night photographs of wildlife in 1906, by **George Shiras** (1859-1942). Wildlife photography as such barely existed, and images of undomesticated animals acting naturally in nature were rare. Shiras's graceful deer with glowing eyes at the edge of Lake Superior so enchanted readers that through 1932 he contributed nine articles to the magazine. In 1935 he published *Hunting Wild Game with Camera and Flashlight*. Though instructive, Shiras's world was closer to Eden than Darwin, however. Photographs of nature "red in tooth and claw," of carnivores and herbivores fighting to survive, would not appear until later. Animals in mass-market media were often viewed selectively, much like ethnographic types, to soften differences that might seem threatening.

Describing avians, mammals, and marine life for the popular press in the mid-20th century, some nature photographers

CHRIS JOHNS CAPTURES THE WILDNESS OF
A CHEETAH FOR THE COVER OF HIS
BOOK *WILD AT HEART.*

JAMES BALOG CHOSE TO TAKE WILD ANIMALS LIKE THIS JAGUAR OUT OF THEIR HABITATS
FOR HIS 1990 PROJECT, "SURVIVOR: A NEW VISION OF ENDANGERED WILDLIFE."

aimed for the most vivid close-ups, generally with saturated color, while others used telephoto lenses or aerial photography to capture the patterns of migrating zebras or the pink explosion of flamingos in flight. Wild animal behavior was of increasing interest, and taboos were challenged from the 1950s on, notably when Walt Disney films—beloved for their cartoon talking animals—included the birth of a bison in the documentary-style *The Vanishing Prairie, 1954*. In the 1960s and '70s, as wildlife conservation became a heated issue (alongside land protection), shocking photographs of big game

slaughter were made—notably by **Peter Beard** (b. 1938) of Kenya's elephants—while pictures of predators hunting and killing and of wildlife mating began to be published.

Enriching popular understanding of social behavior among African primates, **Hugo van Lawick** (1937-2002) photographed his then-wife, the English primatologist Jane Goodall, in her fieldwork among the chimpanzees and great apes of Tanzania. Though her fame—and that of her subjects—was made by the CBS television special of 1965 sponsored by the National Geographic Society, Lawick's still and motion-picture images

helped to engrave upon First World imaginations the reality and range of ape and human kinships, as Goodall showed them, and the dependence of one species on the other.

With a similar theme but drastically different means in *Survivor: A New Vision of Endangered Wildlife*, 1990, **James Balog** (b. 1952) borrowed examples of endangered and threatened animals from zoos and photographed them in the studio against white seamless paper like Hiro's high-fashion models. The hyperreality and strangeness of the striking "portraits" discomfited some viewers, who may have preferred to ignore that zoos, wildlife safari tourists, and art-book buyers commodified animals but in so doing gave important support to species survival.

Nick Nichols (b. 1952) tackled the subject of zoos directly in *Keepers of the Kingdom: The New American Zoo*, 1995. In the late 1990s he photographed forest elephants and tigers for *National Geographic* magazine, winning the Overseas Press Club's prize for reporting "above and beyond the call of duty." The honor, customarily awarded to combat photographers, acknowledged the physical danger courted by Nichols and many wildlife photographers. Because their photographs rarely indicate the difficulties of their creation, magazines often describe the assignments and how the pictures were made. Like 19th-century expeditionary and ethnographic photographers, these practitioners are professionals and often courageous and resourceful "extreme" travelers: they make good copy. Meanwhile, readers can imagine being there among the animals, but without insects, downpours, extremes of heat or cold, boredom waiting in blinds, equipment failure, or encounters with insurgents looking for payoffs or blood.

Among the most honored nature photographers, **Frans Lanting** (b. 1951) is a fellow of the Royal Photographic Society (RPS), the winner of the Netherlands' highest conservation honor, and a photographer-in-residence at the National Geographic Society. In Madagascar some of the wildlife and tribal traditions he documented had never been photographed before. His coverage of rain forest ecology in Borneo, Botswana's Okavango Delta, the last free white rhinoceroses in Central Africa, and Antarctic emperor penguins aroused wide attention to the conservation of these species and their environments.

Lanting came to wildlife photography after advanced study in economics and environmental planning. His colleagues **Chris Johns** (b. 1951) and **Joel Sartore** (b. 1962) began as photojournalists. Johns has published on Africa's Rift Valley and on at-risk nature in the Everglades and Hawaii. Sartore's territory includes the American and Canadian Pacific, desert life, and grizzly bears. For the underwater photography of **Bill Curtsinger** (b. 1946) and **David Doubilet** (b. 1946), see Chapter 9.

NATIONAL GEOGRAPHIC SOCIETY

The first issue of *National Geographic*, of 1888, reached 165 charter members of the National Geographic Society. The most recent reached 12.5 million. Who could guess so many would join the Society in its mission to promote "the increase and diffusion of geographic knowledge." "Geography" was also defined broadly—as everything on Earth, and eventually in outer space. The commitment to exploration, science, and education has remained constant. The Society's lasting impact came from its early commitment to photography. The magazine's color photography was early among world publications, and from the early 1960s it has appeared entirely in color. Hard-hitting photography—with in-depth investigation of newsworthy places and peoples as well as human achievements—has characterized *National Geographic* since the '70s. Readers can always learn something, which accounts for the folklore about millions of attics stuffed with back issues.

STEREO PHOTOGRAPHY
A VISION OF DEPTH

No sooner had photography established itself as a commercial success in the 1840s than photographers began experimenting with ways to depict an aspect of human vision that painters had been capable of rendering for centuries—the perception of depth. What artists achieved through the technique of linear, or "diminishing," perspective, photographers would accomplish mechanically with special equipment for creating and viewing stereoscopic images.

The principle of depth perception was known as far back as A.D. 280, when Euclid observed that humans perceive slightly different views of an object with each eye. This phenomenon—known as stereo, or binocular, vision—stems from the fact that a person's eyes are about two and half inches apart. The slightly different views that our two eyes take in are fused into one image by the brain, creating a sense of depth.

Artists learned how to represent depth following the discovery of the laws of perspective by Italian architect Filippo Brunelleschi in the 15th century. Knowing that objects appear to get smaller and parallel lines converge the farther they are from the observer, artists could simulate depth with versimilitude—a classic example being Leonardo da Vinci's painting *The Last Supper*, in which all lines of perspective converge on the figure of Christ.

ALFRED A. HART, CIRCA 1865
"BLOOMER CUT," PART OF A
SERIES COMMISSIONED BY THE
CENTRAL PACIFIC RAILROAD

With the introduction of the daguerreotype in 1839, photography became accessible to a mass audience. The first photographs, being two-dimensional, conveyed only the sense of depth afforded by the natural linear perspective within the images themselves, such as the receding lines of buildings or streets. It wasn't long, though, before a new method of photography sparked the creation of images that drew viewers into the very depths of the scene, as if they were beholding nature itself. This new type of photography took advantage of the phenomenon of binocular vision by capturing slightly different perspectives on a scene in two separate photographs, which were mounted side by side on a card for viewing. The equipment used to create this pair of images consisted of a camera with two lenses spaced the same distance apart as a human's eyes. The card bearing the two photos, known as a stereograph, was viewed through a device called a stereoscope, which permitted the left eye to see one version of the image and the right eye to see the other. Just as

when interpreting a scene in nature, the brain fused the two photographs into a single image that conveyed a realistic-looking sense of depth.

The technology of stereo photography grew out of the research of Sir Charles Wheatstone, who developed the "reflecting mirror stereoscope" for viewing three-dimensional drawings in the 1830s. Adapting Wheatstone's findings to photography, Sir David Brewster invented the "lenticular stereoscope," the first practical device for viewing stereo photos, in 1849. Two years later, Brewster demonstrated his invention to Queen Victoria at the Great Exhibition in London's Crystal Palace. The queen's enthusiasm for the ultra-realistic stereographs she saw helped popularize the technique. Even daguerreotypes were produced as stereographs, although the metal plates were soon superseded by paper, with most stereographs being produced as albumen prints. One of the most frequent subjects of stereographs was landscapes, where natural perspective enhanced the 3D effect.

The social impact of stereo photography was remarkable. At the height of its popularity, from 1860 to 1920, the stereograph represented the main type of home entertainment, with friends and family gathering in the parlor to view the latest images from

H. C. WHITE CO., CIRCA 1909, CITY HALL TRIMMED IN LIGHTS, NEW YORK CITY

around the world. Companies in Europe and in America churned out millions of stereographs, depicting everything from the Pyramids to the streets of Paris to haunting scenes from the American Civil War and World War I. Boston area physician and writer Oliver Wendell Holmes, who invented an inexpensive hand-held stereoscope himself, declared that the stereograph was "the card of introduction to make all mankind acquaintances."

While the popularity of stereographs began to wane in the early 1900s with the introduction of cheap, simple cameras such as the Kodak Brownie, along with the rise of motion pictures, stereo photography has never died out. Since the 1930s, the View-Master, with its disks of

stereo images filled with travel scenes or cartoon characters, has long been a family staple. Kodak and other companies manufactured stereo cameras in the 1950s and '60s, and the 1970s saw the introduction of the NIMSLO camera, which takes four photos simultaneously that can be viewed as a stereoscopic image without special equipment. For a short time in the 1920s and again in the 1950s, 3D movies were the rage. Their new incarnation is the IMAX movie, introduced in the 1990s. Stereo photography is still utilized in star mapping and aerial reconnaissance, and its principles have been adapted to computer graphics. Perhaps the most imaginative ongoing use of this technique is the hologram, which is used as a security device on credit cards—meaning that a sizable portion of the world's population carries an example of stereo photography with them wherever they go.

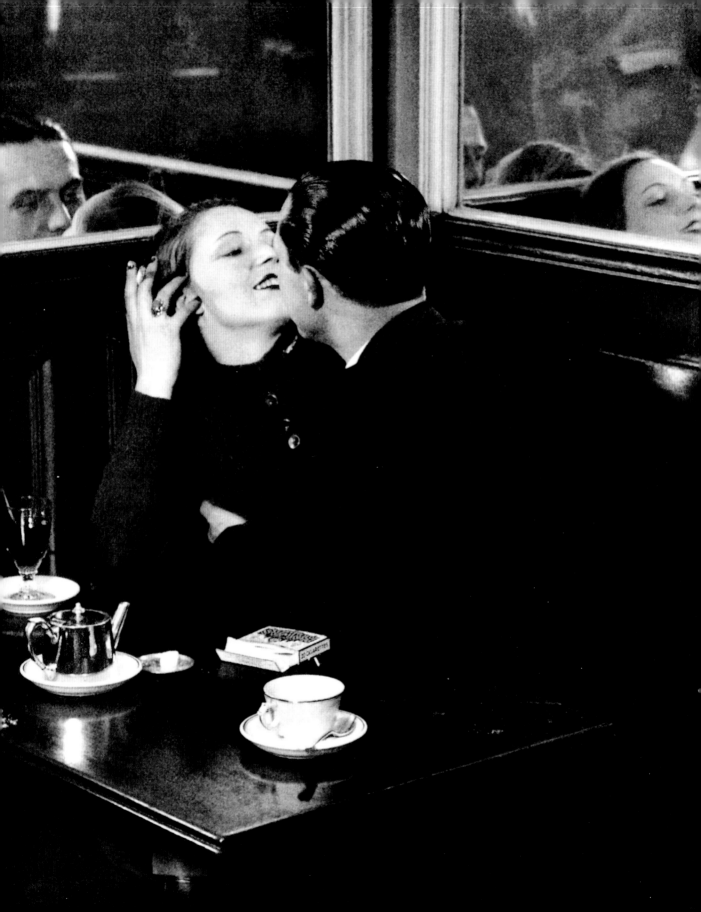

PHOTOJOURNALISM

Photographs can change our lives. Certainly some of them have—which is a topic of this chapter—and photojournalists always hope to make such shots while they report on events and people of public interest. Even though moving pictures stream across televisions, theater screens, and computers everywhere and at all times, the mind seizes on still images. The South Vietnamese general shooting a Vietcong suspect in the head on a Saigon street was televised soon after this happened in 1968. But the indelible image is Eddie Adams's photograph showing the moment just as the pistol goes off. The general's casual delivery of summary justice shocked America, and heightened a growing repugnance for the undeclared war in Vietnam. Such pictures not only document events but help shape public opinion on the broader issues of which they are emblems. They can, in sum, make history.

Photojournalists probably have the hardest job of anyone with a camera, and they are traditionally honored for risking their lives to cover war and other calamities, man-made or natural. Social documentarians are similarly respected for entering hostile or alien worlds to describe social ills and then present them to those who can effect change. These photographers face physical and psychic hardships, plus the often conflicting demands of their publishers, subjects, and audiences. In war, they balance the government and the military's need to control information against the public's right to know. For all matters of public concern, they and their editors risk offending some readers while titillating others. Do they contribute to "compassion fatigue" in a media-saturated world and coarsen communication with their increasingly gruesome and shocking images? Do they beautify suffering and thus neutralize the desire to intervene? Do they give "aid and comfort to the enemy"? Or does their freedom to report constitute a safeguard of other freedoms in a democratic society?

These are some of the questions asked of photojournalism since the 1970s, and they were implicit earlier; they inform the

"LOVERS IN A CAFÉ ON THE PLACE D'ITALIE," 1932: AFTER STUDYING PAINTING, BRASSAÏ TOOK HIS CAMERA INTO THE STREETS OF PARIS WHERE HE CREATED HIS BOOK *PARIS DE NUIT*.

brief history of the profession that follows. The urgency of the debate reflects the still-vital relation between the camera and facts. Though camera work has been falsified virtually from the medium's inception, and now digital technology makes detection impossible to the naked eye, the photograph is still accepted as evidence and its truth value remains high.

Many current conventions of photojournalism are also continuous with the earliest depictions of disasters and suffering. Photographs of fires and floods, dead soldiers and starving children, tenements and street people exist from the 1850s and '60s and seem to differ only by degree from recent images. Similarly, depictions of war and social inequities seem to tap the same vein of horror and pity. For these reasons, this chapter is chronological and interweaves analysis of the two kinds of photojournalism.

19TH-CENTURY DISASTERS AND WARS

The picture press existed well before photojournalism, and the public's appetite for images of breaking news and public personalities in action was evident by the mid-18th century. The demand for realism in all the arts was a significant force leading to photography's invention, as described in Chapter 1, and likewise it impelled the development of reportage. True, photographs through the 19th century were less thrilling than paintings of the same events, and some events could not be photographed at all, owing to technical limitations. But the photograph's indexical relation to the world gives it unique authenticity: as a bullet hole marks the trace of a bullet, a photograph records light bouncing off objects in real space and time. And by the 1860s the photograph's detailed yet deadpan descriptions began to influence paintings. Francisco de Goya's "Executions of May 3, 1808," a canvas of 1814-15 showing French troops massacring Spanish insurgents, is extraordinarily gripping and cinematic. When in 1867 the Goya admirer Edouard Manet began painting a similar execution, however, he based his work about the Emperor Maximilian in Mexico on noncommital photographs of the firing squad and the hapless Austrian.

Photographs were limited vis-à-vis artwork for other reasons. To be printed alongside the text in early newspapers

and magazines, photographs had to be turned into a relief form that could retain ink like the metal type itself. The first solution was to copy them by hand on hardwood blocks and carve out the images. Again, the camera's truth was so valued that the wood-engraved illustrations were published with captions stating their sources in photographs. At last, in the late 1870s the halftone contact screen was invented. When exposed onto a sensitized metal plate, a negative was turned into a field of tiny dots that could be etched onto the plate to form a printing surface. Though images printed with such plates lost the true continuous tones of photographs— from black through grays to white—they resembled photographs enough to satisfy journal readers. The *New York Daily Graphic* was first to use the process, in 1880, with a photograph of a squatter's shanty in Central Park. After a faster method of making halftone screens was patented (1893), this photomechanical process came to dominate print media. Its nature reassured viewers: a photoengraved image lost none of the "mechanical" quality of photography (a guarantee of its authenticity) to the intervention of the human hand.

In the 1840s, photo-reporters were undaunted by these technicalities. In 1842—just three years following the announcements of photography—the portraitist **Hermann Biow** (1810-1850) recorded the devastation of Hamburg, Germany, after four days of fire, while in 1844, **William Langenheim** (1807-1874) and his brother **Frederick** (1809-1879) showed the militia occupying the majestic Girard Bank in Philadelphia. These men used the unwieldy and toxic daguerreotype process, and their images are claimed as the first photojournalism—documenting conditions and events of wide curiosity. Their pictures were not preconceived for press illustration, however: that "first" may belong to the photographs commissioned by the French journal *L'Illustration* during the 1848 revolution, depicting a Paris street before and after its barricades were attacked by government soldiers. Yet these two distant views, by **Eugène Thibault** (active 1840-1870), were relatively humdrum. Not until George N. Barnard photographed the mills burning in Oswego, New York, on July 5, 1853, was a catastrophe given its deserved drama. His daguerreotypes were small and

unique metal plates, like all daguerreotypes, but the best-known one shows flames from the skeletal buildings, hand painted in orange, licking the dark sky, while ghostly figures watch helplessly from the blue-tinted lake. The fire leveled a ward of the city and left 2,000 people homeless. With his vantage point and choice of moment during the long fire, Barnard suggested an all-devouring cataclysm. No wonder he went on to become a star photographer of the Civil War.

The Mexican-American War, 1846-48, was the first war to be photographed, but no memorable images have surfaced from it. Though the Texas-Mexico skirmishes followed by two years of bloodshed led to U.S. dominion over five future Southwestern states, the surviving photographs are static and anonymous, recording troops and encampments, officers on horseback, and a few town views—an inevitable result of photography's cumbersome equipment and then-long exposure times. One daguerreotypist photographed what may have been a reenactment of an amputation in Mexico. Unlike Southworth and Hawes's 1848 staged scene of an early use of anesthesia, however, the wartime image is dim and damaged. Scholar Olivier Debroise has identified the doctor as the inspector general of Mexico's medical corps, and the figures are posed as if for a history painting. Like later battleground medical photographs, the daguerreotype was probably made to record a drastic surgical procedure and to assure "our" soldiers and their relatives of their progressive treatment.

The 1840s and '50s also witnessed the birth and growth of illustrated media using photographic images as well as drawings. The *Illustrated London News*, founded in 1842, was early and influential in its mixed coverage of balloon ascensions, train wrecks, vacation spots, and celebrities (including Queen Victoria's masked ball of 1842 in the first issue, and her reopening of the Crystal Palace Exhibition in 1853). The London paper was joined at mid-century by German periodicals such as Leipzig's *Illustrierte Zeitung* and U.S. counterparts including *Harper's Weekly*, *Frank Leslie's Illustrated Newspaper*, *and Gleason's Pictorial Drawing-Room Companion*. The inventions of the stereo camera and the lenticular stereopticon viewer in 1849, and the wet collodion

LESLIE'S WEEKLY PUBLISHED THE FIRST PHOTOGRAPH OF PRESIDENT WILLIAM MCKINLEY'S ASSASSIN, LEON F. CZOLGOSZ, IN 1901.

process of sensitizing glass-plate negatives boosted the world's output of informative photographs. And these journals boosted their circulations in using them, which in turn increased demand. Such camerawork was intended to document facts and widen knowledge, rather than express the photographer's feelings or aesthetics. An unintended consequence to knowledge was that phenomena that could not be photographed—such as economic forces and political and religious convictions—tended to be shortchanged in news coverage and analysis, while the "great man" theory of history

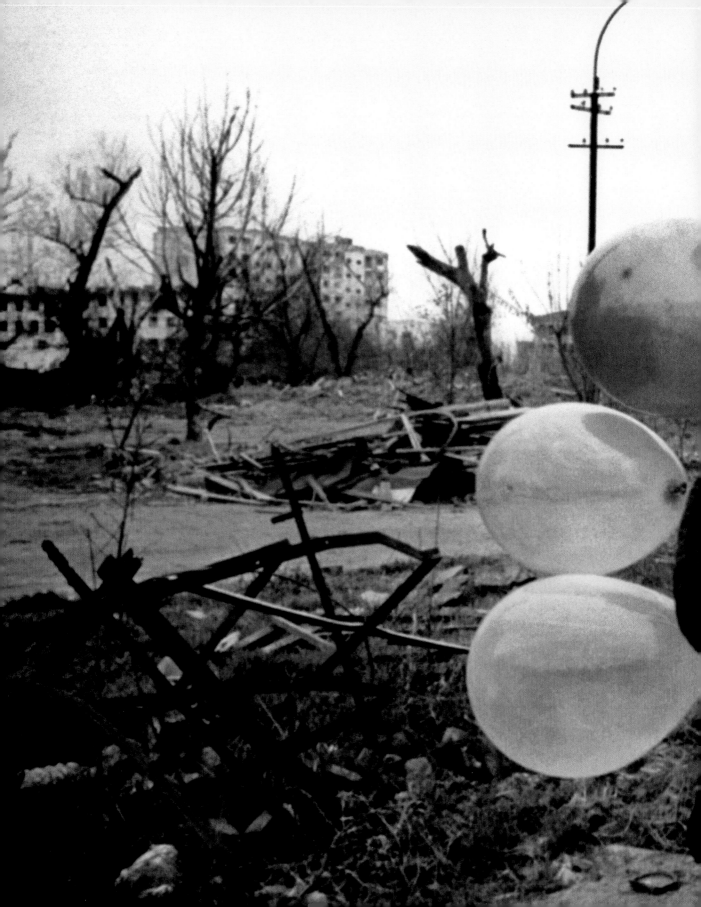

PRECEDING PAGES: THOMAS DWORZAK HAS WORKED TIRELESSLY TO TELL THE STORY OF CHECHNYA AND ITS PEOPLE. IN 2002 THIS GIRL STOOD AMONG THE RUINS OF GROZNY.

flourished; portraits, after all, were a primary purpose for camerawork (see Chapter 2).

Certainly the 19th-century photograph was increasingly accepted as evidence—in travelogues, ethnographic studies, criminal identifications, records of events, and the like. The role of war photographer was an inevitable creation. The first whose name is known was the British surgeon **John McCosh** (var. MacCosh; 1805-1885), who picked up photography as a hobby in the 1840s and photographed fellow officers in the Second Anglo-Sikh War, waged in 1848-49 against the British in India. In the Second Burma War, 1852-53, he depicted British artillery pieces and soldiers in contrast (and mute challenge) to the monuments of that ancient country (now Myanmar). How useful soldier-photographers could be to the military was soon recognized, and by 1861, as photo-historian Mary Warner Marien observes, an officer in every French brigade was ordered to learn how to handle a camera.

Another British cameraman has been claimed as the first war photographer. Unlike McCosh, he was a full-time photographer, yet he too was commissioned to cover the conflict. Was his objectivity compromised? Of course. And objectivity itself—including equal treatment of combatants of all ranks and both sides—was not demanded by the British public. They simply wanted the physical evidence of the photograph to establish if in fact "someone had blundered."

ROGER FENTON (B. NEAR ROCHDALE, LANCASHIRE, ENGLAND, 1819–D. LONDON, 1869)

One photograph has overshadowed Fenton's variegated career. He took "The Valley of the Shadow of Death" in the Crimean War, well after the disastrously conceived Charge of the Light Brigade, which was immortalized in Alfred, Lord Tennyson's poem. A line of the poem provided the title, and the image of cannonballs littering the barren landscape, brute

stand-ins for the slaughtered British, could be read broadly as anti-war. But was that Fenton's purpose? Most probably not.

The war (1853-56) was fought in the Crimea, on the north shore of the Black Sea, by a coalition of the British, French, and Ottoman Turks against the Russians, who were threatening the Mediterranean from their naval base at Sevastopol. The coalition wanted to maintain the balance of power in the Near East, and Great Britain needed to protect its trade routes to India and beyond. But it mismanaged the war, in which disease and extreme cold caused 80 percent of the casualties. To counter negative reports in the London *Times*, Fenton was hired by the publisher Thomas Agnew & Sons and given government permission to photograph in the Crimea. He was not the first photographer so commissioned, but the first whose photographs survive in bulk—some 360—forming the first extensive photo-documentation of war.

Fenton's pictures show British officers posing, neat rows of their tents and ships, and the harsh terrain, but no signs of bloodshed or cholera, which Fenton caught at the end of his four-month stay in 1855. The wet collodion process was too slow and awkward to allow photographing action, but his omissions were apparently purposeful: he photographed no wounded or sick soldiers and no casualties. Furthermore, he was not present for the fall of Sevastopol (whose destruction was photographed by **James Robertson** [1813-1888], who came out from Constantinople), and this conclusion to the war meant his photographs were out of date by the time Agnew could exhibit them in late 1855. With the armistice in sight, the British public wanted to forget the distant, costly war, and, unlike Americans in the Civil War, they could.

Breaking news had not been Fenton's subject before. Of a wealthy family, he trained as a painter in London circa 1840 and before 1844 in Paris under the painter Paul Delaroche, a Delacroix follower whose students Gustave Le Gray, Henri Le

IN 1853 ROGER FENTON FOUNDED THE PHOTOGRAPHIC SOCIETY OF LONDON. IN 1855, ASSISTED BY MARCUS SPARLING, HE MADE 350 LARGE-FORMAT NEGATIVES OF THE BATTLEFIELDS OF THE CRIMEAN WAR.

WET COLLODION IN WAR

The wet collodion process was the only nega-tive–positive means of making detailed pho-tographs before the 1880s. Photographers using it needed chemical knowledge, speed, manual dexterity, and clean working condi-tions, for they had to sensitize a glass plate and expose it before it dried, in 20 minutes or less depending on the weather. To get to different British encampments, Roger Fenton—the first war photographer publi-cized as such—converted a wine-seller's van into a mobile darkroom. The spring of 1855 in the Crimea was blistering. "Though [the van] was painted a light colour externally, it grew so hot towards noon as to burn the hand when touched. As soon as the door was closed to commence the preparation of a plate, perspiration started from every pore …. It was at this time that the plague of flies commenced. Before preparing a plate the first thing to be done was to battle with them for possession of the place. The necessary buffeting with handkerchiefs and towels hav-ing taken place, and the intruders having been expelled, … the door had to be rapidly closed for fear of a fresh invasion, and then some time allowed for the dust thus raised to settle before coating a plate." As summer arrived, Fenton found the developing fluid so hot he could barely put his hands into it. And he had to stop work earlier each day, taking many of his portraits before 7 a.m.

Secq, and Charles Nègre may have introduced him to photography. Perhaps realizing his limited painting talent, Fenton studied law in 1844 and gave up oils for the camera in 1851. He was doubtless impressed with the displays of photography at the Crystal Palace Exhibition in London that year. In 1852 he went to Russia to document a bridge under construction by a civil engineer friend, and he also photographed major Russian cities. In 1854 he began por-traying the British royal family and probably taught Queen Victoria and Prince Albert how to photograph: they became amateurs of the medium, photo-col-lectors, and eventually patrons of the first photographers' association in Great Britain, founded by Fenton in 1853, which became the Royal Photographic Society. In 1854 Fenton became official photographer for the British Museum, and through 1860 he used impressive technique on a vari-ety of subjects—landscapes of the British Isles and their medieval architec-ture, luscious still lifes, and studio tableaux of romantically imagined Muslim life. He abandoned photography in 1862, apparently disgusted by its increas-ing commercialism.

The Crimean war set the pattern for war correspondents to come, as curator-scholar Frances Fralin points out. Photographers, reporters, and sketch artists represented all the countries in the fray, and the public hoped for photographs with the drama of current illustrations. The British humor magazine *Punch* mocked their romanticism in a fake letter to the front: "I send you, dear Alfred, a complete photographic apparatus which will amuse you doubtlessly in your moments of leisure, and if you could send me home, dear, a good view of a nice battle, I should feel extremely obliged. P.S. If you could take the view, dear, just in the moment of victory, I would like it all the better." But of course photo-technology was too slow for such moments, and photographs showed no bodies either.

That "first" was left to the Italian-born **Félice Beato** (1830-1903). This nat-uralized Englishman covered many of the armed conflicts engaging Queen Victoria's finest, from the Crimea to the Second Opium War in China, 1856-60, and the wars in Africa's Sudan, 1885. During the Sepoy Rebellion (sometimes called the Indian Mutiny), 1857-58, he photographed the Secundra Bagh Palace in Lucknow a year after it was besieged and taken by the British. He scattered the courtyard with human bones, recreating the British slaughter of the 1,800 surviving Sepoy defenders. Perhaps the British press accepted the gruesome scene as recording a just revenge on the native rebels. In the first important challenge to British rule in India, these troops had killed their British officers, then spread revolt widely in India, and massacred several hundred British civilians. The taboo against showing one's *own* dead remained intact: these bones belonged to the enemy, who was

FÉLICE BEATO PHOTOGRAPHED THIS CAREFULLY
ARRANGED SCENE IN THE COURTYARD OF THE
SECUNDRA BAGH PALACE AFTER THE 1857
SEPOY REBELLION IN INDIA.

perceived as an inferior, heathen, ethnic type, one undeserving burial. In the Taku forts in China in 1860, Beato showed enemy corpses with as little compunction. He set the standard for such depictions in the U.S. War between the States.

THE AMERICAN CIVIL WAR
AND THE FRENCH COMMUNE

An estimated 1,500 photographers recorded the American Civil War, 1861-65. Mathew Brady was the most visible of them. They made tens of thousands of glass-plate negatives of battlefields, fortifications, arsenals, bivouacs, hospitals, ruins, generals, soldiers, prisoners, and the wounded and the dead, while working for the Federal government, the Union armies, newspapers, or independent businesses like Brady's. In the heat of events, they tried to answer the public's need to know, the news media's drive to satisfy that public interest, the participants' urge to memorialize themselves, and the armies' effort to give their officers trustworthy information (including copies of maps and battle plans). When it was all over, with slavery ended and over a half a million casualties, including Abraham Lincoln, they tried to help the country understand what had happened and what it meant. The results were partial.

The most common photographic process at the time, wet collodion, was too slow to record action, so no battle scenes were captured; and Confederate photographs were rare because the Union blockade limited photographic supplies from reaching the South. Though the Connecticut-born photographer **George S. Cook** (1819-1902) relocated to the South and took and collected thousands of war photographs, his holdings (now in the Valentine Museum, Richmond, Virginia) are an exception. Once again, history was told mainly by the winners.

But no subsequent war would go unphotographed. And though previous wars, in Mexico and the Crimea, had generated some photographs, the scale of coverage of the Civil War meant that future conflicts would be documented exhaustively, making the press photographer a major participant.

Many 19th-century photographic techniques were employed to produce pictures during the Civil War: daguerreotypes, ambrotypes, tintypes, *cartes-de-visite*, stereo cards, and albumen prints from wet collodion glass-plate negatives. Tintypes (or ferrotypes) were the cheapest portraits, most often made for enlisted men, and they were sturdy enough but light enough to be mailed home. Stereo cards made the war visually real with unprecedented conviction. Placed in a stereopticon viewer, Timothy O'Sullivan'S card of a just-slain cannoneer would have given the illusion of three dimensions. And there were atrocity photographs—not for the last time in war. Photographs taken at the South's notorious Andersonville Prison of captured Union soldiers became part of postwar criminal proceedings against its commander (who was executed). And the publication of the *carte-de-visite* of the severely whipped slave "Poor Peter" in 1863 was surely intended to inflame Abolitionists.

Mathew Brady (1823-1896) shaped both portrait photography (see Chapter 2) and photojournalism in mid-19th-century America, and his success with the first genre powered his success with the second. When war began in 1861 with the Southern shelling of Fort Sumter and the public began clamoring for images of officers and battlefields, Brady was ready with capital and connections: he outfitted and salaried some 20 "operatives" who generated over 30,000 negatives by 1865, helping to make this the most fully photographed war to that date. Journals such as *Harper's Weekly* and *Frank Leslie's Illustrated* regularly published wood engravings made from Brady team photography, while E. & H. T. Anthony and Co. mass-produced and sold Brady's *carte-de-visite* portraits and Brady's galleries displayed portraits in all sizes, along with album cards, stereographs, and mounted prints of his photographic "Incidents of the War." Having made portraits of key Union generals, Brady won ready access to battlefields before and after the bloodshed. But he rarely operated the camera

ALEXANDER GARDNER, A MEMBER OF THE MATHEW BRADY TEAM, PHOTOGRAPHED THE CIVIL WAR BATTLE SCENE IN ANTIETAM, MARYLAND, IN 1862.

himself, owing to diminishing eyesight, and instead relied on his corps of photographers. Some of them became famous in their own right during the war, and others took the skills they learned on the battlefield into the West in the late 1860s and '70s, where they accompanied mapping explorations and railroad expansion.

Brady was not so fortunate after Appomattox, however, and his fortunes faltered. The New York Historical Society refused his collection when he offered it in 1866; in 1868 he sold his Washington gallery, and in 1870 he filed for bankruptcy. Five years later, Congress bought his negatives and prints for $25,000; he estimated he had spent over $100,000 documenting the Civil War. Running a succession of Washington galleries, he continued photographing, even though he was nearly blind, until a year before his death.

Brady's protégés Alexander Gardner and George N. Barnard became celebrated during the Civil War, despite Brady's reluctance to give them credit for their wet collodion photographs. Salaries were not enough: by this time, the war photographer was enjoying public recognition and could hope to sell photoalbums with his own name.

ALEXANDER GARDNER (B. PAISLEY, SCOTLAND, 1821– D. WASHINGTON, D.C., 1882)

This Civil War photographer's best-known photograph was staged. The "V" between two boulders at Gettysburg, the war's bloodiest battlefield, may have been "The Last Home of the Rebel Sharpshooter" (his title), but the soldier died in a field, where Gardner first photographed him, as the scholar William Frassanito discovered in 1975. Then Gardner moved the body and supplied the weapon to make a more affecting image. He published that photograph in 1866, in *Gardner's Photographic Sketch Book of the War*, stating he had returned for the consecration of Gettysburg Cemetery (when Lincoln delivered his famous address), but found the skeleton still unburied: "Some mother may yet be patiently watching for the return of her boy, whose bones lie bleaching, unrecognized and alone …." A photojournalist's "improving" on reality would not be forbidden until later, after more consequential and frequent manipulations.

Gardner came to photography from the newspaper business. In Glasgow around 1850 he had purchased the weekly *Glasgow Sentinel* and made it the second best-selling newspaper in the city. At the Crystal Palace Exhibition of 1851 he saw Brady's prize-winning daguerreotypes, and, building on his curiosity about chemistry and science, he decided to try photography. He mastered the just-introduced wet collodion process, and when he emigrated to New York in 1856, it was for this skill and his understanding of the Woodward "solar camera" for enlarging negatives that Brady hired him. Soon Brady put him in charge of his Washington, D.C., studio. There, according to a Brady advertisement, the public could see "Incidents of the War" (battlefields, scenes of camp life, the dead in prints and stereo cards), and portraits of generals, congressmen, and other celebrities in prints of various sizes, some painted on canvas or ivory in full color from the photographs.

Gardner prospered, but in 1862 he quarreled with Brady over his refusal of credit and copyright. He quit and opened his own studio, taking Timothy O'Sullivan and other Brady employees with him. In his two-volume *Sketch Book*, they are named beside each of the 100 photographs. By 1865 Gardner had photographed many Union generals: George Armstrong Custer (later famous as the "Indian fighter"), Ambrose Burnside (who provided sideburns with their name), Joe Hooker, William Tecumseh Sherman, and George McClellan; and he had been official photographer for McClellan's Army of the Potomac until Lincoln removed the dilatory general from his post. Gardner photographed Lincoln's funeral and, in a remarkable step-by-step sequence, the hanging of his assassins. Once claimed as the first photo-essay, this

"REALITY OF WAR"

"Let him who wishes to know what war is, look at this series of illustrations," wrote Oliver Wendell Holmes when Mathew Brady exhibited his corps' photographs of the bloody battle of Antietam in 1862. "These wrecks of manhood thrown together in careless heaps or ranged in ghastly rows for burial were alive but yesterday …. Many people would not look through this series …. It was so nearly like visiting the battlefield to look at these views, that all the emotions excited by the actual sight of the stained and sordid scene, strewed with rags and wrecks, came back to us, and we buried them in the recesses of our cabinet as we would have buried the mutilated remains of the dead they too vividly represented." Timothy O'Sullivan's photograph of Gettysburg's bloated corpses, called "The Harvest of Death," had this text when it was published in 1866 in *Gardner's Photographic Sketch Book of the War.* "Such a picture conveys a useful moral: It shows the blank horror and reality of war, in opposition to its pageantry. Here are the dreadful details! Let them aid in preventing such another calamity falling upon the nation."

"BURNING MILLS AT OSWEGO, NEW YORK" 1853,
A DAGUERREOTYPE BY GEORGE N. BARNARD

sequence was probably conceived not by Gardner but by the Secret Service as a straightforward documentation.

In 1867 Gardner became official photographer for the Union Pacific Railroad, documenting its thrust west, laying track in Kansas, and the Native Americans in the area. His portfolio *Across the Continent on the Kansas Pacific Railroad* was published in 1868. Back in the capital, he took mug shots for the Police Department in 1873. He was an active photographer till his death, but, like Brady, he was little honored in his era for his historic work. Some 90,000 of Gardner's negatives were destroyed after his death—their emulsion scraped off for its silver content and the plates sold as scrap glass. The digital revolution, as well as increased historical consciousness, would be needed to make preservation of such archives easy.

GEORGE N. BARNARD (B. 1819, OSWEGO, NEW YORK– D. 1902, CEDAROAK, NEW YORK)

Like Brady, his famous employer, Barnard is celebrated for his Civil War photography, and his career also spanned the early history of the medium, from the daguerreotype to the dry plate and halftone printing process. Barnard began making

daguerreotype portraits in 1843; ten years later he took some of the earliest disaster photographs, daguerreotypes of burning mills and buildings in his native Oswego, New York, which he showed head-on and also in a distant panorama. This shrewd framing of the event and his sense of human drama may have commended him to Brady, for he joined Brady's Washington, D.C., gallery, where he helped photograph Abraham Lincoln's inauguration in 1861. Angered by Brady's refusal to give him credit for his photographs, he, like Alexander Gardner, left his employ in the middle of the war, and Barnard became official Union photographer for the Military Division of the Mississippi. Key to his blend of artistry and documentation is his *Photographic Views of Sherman's Campaigns*, 1866, which pictures sites in the Union general's devastating victory in Georgia and his March to the Sea. Though taken later, after the bodies and debris were removed, Barnard's albumen prints of the fortifications around Atlanta evoke the tumult of the epic siege through stormy clouds, an effect he created using a second negative for his skies. That area would otherwise have appeared blank in the print owing to the disproportionately high sensitivity of the wet collodion negative to blue light.

Following the modest success of his expensive album, Barnard opened studios in Chicago, then Charleston, South Carolina, and finally Rochester, New York, where his interest in the gelatin dry-plate process helped the inventor George Eastman on his road to multinational success. Barnard retired around 1888, the year before Eastman patented the Kodak camera, sold loaded with gelatin-coated film.

The horrific fascination of Confederate deaths made voyeurs out of their observers, who appreciated photographs for their distance from the facts yet their realism. Remote from the stench and din and chaos of battle, photographs of its aftermath were less viscerally shocking. Yet they were disturbing enough to be excused and even hailed as anti-war tracts, while they primarily portrayed the losers. They reflected blood-chilling statistics: the Civil War was the deadliest war to date, with some 600,000 casualties out of a population of 32 million. Subsequent photographs of wars, in which the enemy was not a relative or fellow American, would treat the fallen less tactfully.

In the Franco-Prussian War, 1870-71, the conflict was shorter but photography's uses were more creative and cruel, as Mary Warner Marien describes them. France declared war, but Germany's victory was swift and decisive at Sedan, where the emperor Napoleon III was captured, and this shame would rankle through the First World War. During the German siege of Paris in the winter of 1870, pigeons flew photographically reduced messages to the government outside the encircled capital. For three months in 1871 a revolutionary band of anti-royalists and workers governed Paris as the equalitarian "Commune" and happily photographed one another, most memorably in pulling down the Vendôme Column, a monarchic symbol topped by a statue of Napoleon I. When the government retook the city, such photographs became means of identifying and executing the Communards, who were then photographed in their coffins as the ultimate proof of their defeat (or of their martyrdom, depending on the viewer's politics). To further the government's propaganda control of France, the "Crimes of the Commune" photography series was published by **Eugène Appert** (active 1870s) in late 1871. This cameraman had actors reenact scenes smearing the Communards, and after photographing them, he pasted in the portrait heads of Commune leaders and then rephotographed the composites. It was known that action shots were impossible in photography and the collages' artifice looks obvious (at least today), yet photography was evidently considered powerful in the war for French hearts and minds.

SOCIAL DOCUMENTS OF THE 19TH AND EARLY 20TH CENTURIES

If the European approach to war and its vanquished seems harshly polarized in late 19th-century photographs, the approach to lower social classes and their problems appears scarcely gentler to modern eyes. Sociology, ethnology, and other social sciences were nascent fields of study, mobilized by the class conflicts and social ills of the Industrial Revolution. The soot-blackened, crime-ridden, overcrowded cities described by novelists Charles Dickens and Emile Zola alarmed politicians fearing urban unrest and appalled humanitarians with their costs in misery, disease, illiteracy, and other hard-

PERPIGNAN

In the digital age there are few reasons for people who work in photography to meet. However, there is one place most people try to get to and that is Perpignan, France. The first week in September the city is overrun with nearly 10,000 photographers, editors, and agents attending the photo festival called Visa Pour l'Image. "I wanted to create a gathering point," says festival founder, Jean-François Leroy. "The other photo festivals [Arles, Houston, etc.] were about the photography, generally speaking. Visa was the first one to be totally devoted to photojournalism."

Exhibitions selected and edited by Leroy can be found throughout the city. At night, everyone gathers on temporary stadium seating to watch a two-hour digital slide show that can include stories as diverse as women in Afghanistan, seal hunting in Greenland, and the war in Chechnya. On the final evening, selected photographers and editors receive awards of recognition and in some cases grant money for their work.

"When I launched the very first festival 17 years ago, I had no idea it would become so huge," admits Leroy. "As a father, I'm really proud. My baby grew up very well."

ships to society. The convictions powering Communism were born in Victorian London: in 1845 Frederick Engels published *The Condition of the Working Class in England in 1844*, while from 1849 Karl Marx lived in poverty in the capital where he wrote *Das Kapital*, the foundation of international socialism. In France in the early 1850s, Napoleon III took action to secure his power from the urban mob and directed the Baron Haussmann to a drastic redesign of Paris. The results glorified his reign and French culture with new railroad stations, vast apartment blocks, and wide boulevards radiating from grandiose monuments like the Arc de Triomphe. These avenues allowed glittering military parades while they replaced the little crooked streets of medieval Paris, so easily barricaded in past uprisings, and displaced the rebellious underclass that populated them. Urban renewal, though not yet named, and informal social engineering went hand in hand, and not for the first time.

In 1851-53 France's Commission des Monuments Historiques photographed old Paris and Paris in construction (see Chapter 1), and in 1859 Napoleon III commissioned Charles Nègre to document the Imperial Asylum at Vincennes, a government-supported hospital for workers injured on the job. Such social documents were propaganda for the government's benevolence toward various classes. Medieval Paris as photographed by the Commission and by Charles Marville can be compared to old Glasgow in photographs of 1866-68 by **Thomas Annan** (1829-1887). This Scottish city rivaled London in its explosive growth: between 1801 and 1861 its population increased five times over, creating new slums out of the old town. The Glasgow City Improvements Act of 1866 empowered the city fathers to level the worst tenements and build solid and sanitary housing. The Act has been termed the first massive intervention for urban renewal, and its reach was so great—changing 86 acres—that the municipality decided to document what it planned to knock down. It turned to Annan, Glasgow's leading commercial photographer and an expert in landscape photography and art reproductions. His ability to work outdoors and in adverse conditions was tested by the assignment, which may have been intended to combat future criticism while making a historic record. "The poorer classes of Glasgow excel even those in Liverpool," observed American novelist Nathaniel Hawthorne in 1856, "in the bad eminence of filth, uncombed and unwashed children, drunkenness, disorderly deportment, evil smell, and all that makes city poverty disgusting" (quoted by Anita Mozley in her monograph on Annan).

Annan delivered 31 albumen prints depicting the dead-end streets and dark passageways of Glasgow's slums. His exposures were long enough to blur laundry hanging from windows and the few people present: his goal

was to describe the blighted buildings rather than their occupants, and the narrowness of the streets and Scottish weather and coal-burning limited his light. He gave more space to drainage ditches than to sky. No data about the occupants appeared in his first album; or in his second version, 40 carbon prints published by the City Improvement Trust in an edition of 100 in 1878-79; or in the posthumous, 1900 edition *Old Closes and Streets, a Series of Photogravures 1868-1899*. Photo-historian Naomi Rosenblum states that Annan's project was nostalgic, not reformist, but many of his photographs forecast those of Jacob Riis, the first in the United States to use the camera as a tool for social change. Annan's images were far from exposés, but their commission did reflect growing public awareness of connections between habitats and human behavior, and that poor districts might deserve demolition as a seedbed of social ills.

FOR THE GLASGOW CITY COUNCIL, THOMAS ANNAN PHOTOGRAPHED THIS HIGH STREET SLUM IN 1868.

The next landmark in social photo-documentation put day laborers and street people in focus. But John Thomson, like Annan, saw his poor subjects as alien, and he treated them as semi-amusing specimens of resourcefulness in their improvised lifestyles and only rarely as pathetic in their want. The secular notion that the have-nots can lay claim to the haves' compassion was yet to be born. Indeed, Annan's photographs of fellow Britons resemble the ethnographic photographs he made in his early career in England's Asian outposts: whether of "navvies" or coolies, his images linked these workers in the exotic otherness of their poverty.

JOHN THOMSON (B. EDINBURGH, SCOTLAND, 1837– D. EDINBURGH, 1921)

Thomson's *Street Life in London*, 1877-78, is the first photographically illustrated study of an urban underclass. Thirty-seven of his photographs are paired with detailed descriptions by the author Adolphe Smith of those who earned a precarious living on London's streets: old furniture sellers and army recruiters, flower girls and day laborers at Covent Garden, photographers and donkey-ride sellers in Hyde Park, bootblacks and tinkers, sandwich-board men and for-hire coachmen, beggars and those too weak to do anything but beg from them. Thomson's model was Henry Mayhew's *London Labour and the London Poor*, 1851-62, but that early study of city "types" was illustrated only with wood engravings from daguerreotypes. And though Mayhew's book established the norm of firsthand interview and illustration used in today's sociology, it was not the success that Thomson's was. The latter was first issued in serial installments, then published in book form, and abridged as *Street Incidents* in 1881. In Thomson's lively photographs, his figures and groups were posed but nonetheless appear at ease with his camera. Some of them have the picturesque local color of descriptions by Dickens, and their dialects and accents are approximated in Smith's quotations. The tone overall is patronizing but sympathetic: these are the deserving poor, not individuals so much as Others for middle-class readers who wanted information, agreeably presented. Thomson aimed to record rather than to reform, but nevertheless the publication encouraged the building of the Thames

THE VOICE OF A VICTORIAN "NOMADE"

For *Street Life in London*, 1877-78, Adolphe Smith interviewed the street people then called "nomades" that John Thomson photographed. The man standing in front of his van in one plate is William Hampton, who "reminded me of the Nomades who wander over the Mongolian steppes, drifting about with their flocks and herds He honestly owned his restless love of a roving life, and his inability to settle in any fixed spot. He also held that the progress of education was one of the most dangerous symptoms of the times, and spoke in a tone of deep regret of the manner in which decent children were forced now-a-days to go to school. 'Edication, sir! Why what do I want with edication? Edication to them what has it makes them wusser. They knows tricks what don't b'long to the nat'ral gent No offence, sir. There's good gents and kind'arted scholards, no doubt. But when a man is bad, and God knows most of us aint wery good, it makes him wuss. Any chaps of my acquaintance what knows how to write and count proper aint much to be trusted at a bargain.' Happily this dread of education is not generally characteristic of the London poor While admitting that his conclusions were probably justified by his experience, I caused a diversion by presenting him with a photograph, which he gleefully accepted. 'Bless ye!' he exclaimed, 'that's old Mary Pradd, sitting on the steps of the wan, wot was murdered in the Borough, middle of last month.'"

Embankment to protect the homes of London's poor from the river's periodic flooding.

Thomson had honed his documentary skills in the Far East in 1862-72, where his subjects were different not only in economic class but in race, culture, language, and attitude toward him. He first went out to Singapore to join his brother, an optician and a photographer, and he set up a commercial studio. From there he traveled though mainland territories, and to Ceylon (Sri Lanka) and India, photographing people's daily lives in situ—an advance on the usual studio portrayal of figures representing occupations and professions. In 1865 he moved his studio to Siam (Thailand) and photographed in Laos and Cambodia, returning to England in 1866. That year his achievements led to his election to the Royal Geographical Society (though he had never advanced beyond primary school), and in 1867 he published his first book, *The Antiquities of Cambodia.*

In 1867 Thomson returned to the Far East, settled in Hong Kong, and embarked on photographing the peoples of China, whose ethnic and cultural diversity was then little known in the West. He traveled from Canton to the Great Wall and 3,000 miles up the Yangtze River, and persuaded Chinese from beggars to monks and princes to pose for him. Finding the chemicals for the wet collodion process was one inconvenience; another was overcoming superstitions that caused stoning attacks, for those who called him a "Foreign Devil" thought his camera would eventually kill its subjects.

In London from 1871 Thomson lectured and published, chiefly the four-volume *Illustrations of China and Its People*, 1873-74. He opened a portrait studio in 1881 and was appointed photographer to the Royal Family. He retired in 1910.

Victorians recognized that children were the innocent victims of poverty and its attendant hardships, and also that they made poignant visual aids in charity appeals. Around 1860 Oscar Rejlander posed a pretty little girl as Dickens's "Poor Jo," a door-to-door milk seller, for a photograph reproduced on handbills seeking contributions for a private social agency. More effective were the real urchins appearing in British photographs commissioned around 1875. These images were made by an unknown cameraman for **Dr. Thomas John Barnardo** (1845-1905), who wanted to show chil-

SCOTTISH PHOTOGRAPHER JOHN THOMSON'S IMAGES OF CHINA AND SOUTHEAST ASIA BROUGHT THE CULTURE OF THE FAR EAST INTO VICTORIAN BRITAIN IN THE 1860S. THESE BROTHERS ARE A MANDARIN'S SONS FROM CANTON, CHINA.

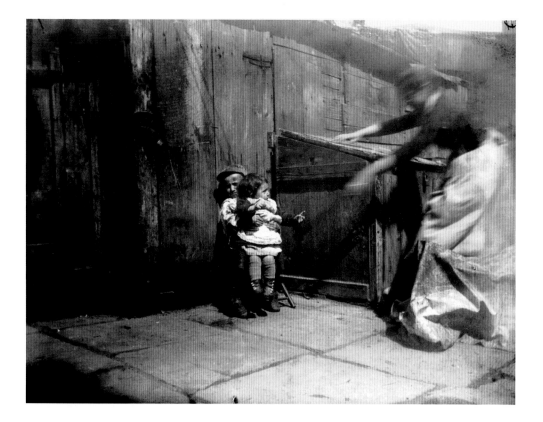

"MINDING THE BABY, GOTHAM COURT," 1890:
JACOB RIIS WAS HORRIFIED BY THE SQUALOR OF
THE NEW YORK CITY SLUMS AND ADOPTED THE
CAMERA AS A MEANS TO EXPOSE IT.

dren before and after they entered his homes and training programs for poor and homeless youths. "Once a Little Vagrant" and "Now a Little Workman" captioned one pair of albumen prints, whose sales helped raise funds for the missionary's work. The lad's rags were as exaggerated "before" as his cleanliness and industry were "after." But Victorian donors were encouraged to believe that their charity would not produce lifetime dependents. These authentic clients of Barnardo's illustrated the moral value of work.

Sufferers outside Europe were not seen so sympathetically. In 1878-79 the British army officer **Willoughby Wallace Hooper** (1837-1912) photographed the victims of famine in Madras, India, both in the field and by having the victims brought to him. Skeletal natives staring at the camera, too weak to stand, would become stereotypes of Third World privation, but Hooper did not make his photographs to raise money for relief. They were simply part of his general camera survey of India, and reflected a colonial ability to distance fellow feeling in proportion to the literal or cultural distance of a misfortune. Colonialism may have encouraged the tendency to believe that because famine, flood, plague, and other disasters can be frequent in developing countries they are somehow "normal" or beyond help and therefore deserve less attention than related ills at home.

How "home" and the growing numbers of poor within it were perceived in the late 19th century helped mobilize reform movements then taking shape, particularly in the United States. Progressives and certain journalists recognized the insufficiency of private charities and agitated for government intervention. Living conditions for New York's indigents at the end of the 19th century cried out especially for change.

From the 1840s, waves of immigrants had crowded into the wooden tenements of the Lower East Side—the Irish in flight from the potato famine, middle Europeans and Russians escaping wars and pogroms, southern Italians and U.S. blacks fleeing dying farms. The population density was as high as any in the world; and crime, communicable diseases, and gang violence flourished between fires. One reporter of these conditions picked up the camera to convince readers of his truthfulness.

JACOB RIIS (B. RIBE, DENMARK, 1849–
D. BARRIE, MASSACHUSETTS, 1914)

Riis was one of the growing number of progressive observers who believed that poverty was the cause of "vice," not the result, and that social ills were worsened by housing unfit for animals. An immigrant himself, he knew the problems firsthand.

Riis was the third of 15 children and worked as a carpenter before he came to New York in 1870. After three years of menial jobs, he was hired by a news bureau; in 1877 he became a police reporter for the *New York Tribune*; and in 1888, a year after he began employing photographs to document his writing, he moved to the *New York Evening Sun*. From photographer friends, he learned to use a camera and magnesium flash to reveal the lives led in sweatshops, cellars, police lodgings, and alleys at night. The closed eyes of some of his helpless subjects indicate that he had taken more than one photograph of them, with his assistant throwing a match into a tray of explosively flammable magnesium powder. The resulting pictures were sensational exposés of a squalid and inhumane environment, one attributable to profiteering slumlords and indifferent city government.

Riis converted the images into lantern-slides for his lectures to charitable groups, and in *How the Other Half Lives: Studies Among the Tenements of New York*, 1890, his first and most influential book, they appeared as halftone illustrations and line drawings. The book ran through 11 editions in five years, and brought Riis together with Theodore Roosevelt, the future U.S. president and then the chief of the New York Police Board of Commissioners. The public indignation that Riis aroused and Roosevelt's political clout led to significant changes in New York housing, education, and child labor laws at the beginning of the 20th century. It was then that sociologists were beginning systematic study of the urban underclass, while muckraking authors were attacking unregulated capitalism and demanding government action.

Riis never considered himself a photographer, and after 1898 he stopped taking pictures, remaining content to illustrate his lectures and books with his older work and photographs by those he had inspired, such as Lewis Hine and Jessie Tarbox Beals. After his death, his prints, slides, and negatives were forgotten until 1946, when his son donated them to the Museum of the City of New York at the instigation of photographer Alexander Allard. Large modern prints made from them by Allard introduced a new public to Riis's photography soon afterward. Appreciation of it has been enhanced with hindsight, as admirers related it over-broadly to the documentary work of the 1930s. Nevertheless, it stands as a valid first chapter in reformist photojournalism, showing the camera's potential in effecting social change.

The differences in the social documentation of Riis and Lewis Hine mirror not just their differences in character but the professionalization of U.S. social reform efforts and welfare programs from the 1890s to World War I. The Progressive party attacked the abuses of laissez-faire capitalism and lobbied on behalf of labor: mayors were elected on platforms to improve city services and introduce building codes; state politicians stumped for minimum wages, workers' compensation, and limits on working hours and child labor; and social workers built settlement houses in big city slums to serve the poor and teach skills and self-reliance. Muckraking journalists such as Ida Tarbell, Lincoln Steffens, and Upton Sinclair won support for the Progressives by exposing corruption in government and Big Business abuses. Their audience was national, thanks to the growth of mass-circulation magazines like *Collier's* and *McClure's*, whose growth had been exponential since second-class postal rates were instituted in 1879 and rotary presses made fast, high-volume printing possible. These and older journals increased the audience for photojournalism, especially when they dropped prices to boost circulation, and photographs became required evidence for proposed social change.

PRECEDING PAGES: "SARDINE BOY, EASTPORT, MAINE," 1911: LEWIS HINE DOCUMENTED THE WORKING CONDITIONS FOR CHILDREN IN MINES, MILLS, AND CANNERIES ACROSS THE U.S.

LEWIS WICKES HINE (B. OSHKOSH, WISCONSIN, 1874– D. NEW YORK, NEW YORK, 1940)

"I wanted to show the things that had to be corrected; I wanted to show the things that had to be appreciated," Hine said. In his pioneering social documentation, he identified those qualities in the same people: he saw his human subjects as heroes struggling against correctable conditions. They were individuals, not Victim-Others, caught up in the massive socio-economic changes of early 20th-century America.

The son of a small shopkeeper, Hine studied education at the University of Chicago in 1901, and came to New York to teach at the Ethical Culture School, founded as a working-man's school and dedicated to training social reformers. Around 1903 he adopted the camera as a classroom tool, and in 1904 he began photographing at Ellis Island, so his students might regard the new immigrants with the same respect as "the Pilgrims who landed at Plymouth Rock."

The scale of immigration to the United States had only increased since Jacob Riis sensationalized its impact on the Lower East Side in *How the Other Half Lives* ..., 1890. As historian Marvin Trachtenberg points out, Hine documented a major challenge to American culture: how to convert these agricultural workers, hand-craftsmen, and rural homemakers into urban industrial laborers. In sympathetic response to the newcomers, Hine photographed small numbers of them with a 5 x 7-in. camera on a tripod, returning his gaze as they waited in line or looked for lost luggage.

Recognizing the implicit power of photography as evidence and persuasion, social welfare activists of the Progressive movement found Hine. He next photographed in Pittsburgh, in 1907-08, and in this steel capital examined the nexus of worker and industry for a six-volume publication, the first full-scale sociological survey of an American city. For his greatest series, of 1908-18, he photographed for the National Child Labor Committee, compiling the evidence of systematic, countrywide use of children, from age six upward, in mines, mills, factories, and farms. The goal was to outlaw the practice. From Maine to Texas, he traveled some 50,000 miles, producing thousands of photographs, some at personal risk (for mill owners wanted no limit put on their cheap labor). Each print was labeled with the name, age, kind of work, and pitiful pay of the child. The children, often dwarfed by the machinery and adults around them, look into his camera and by extension at us. For a poster, he combined such photographs with his text, reading: "Making Human Junk: Good material at first [children with sign, 'Small Girls and Boys Wanted']; The Process [a factory]; The Product [close-ups of scrawny youths]; No Future and Low Wages—'Junk'—Shall Industry be allowed to put this cost on society?"

Framed by Hine's writings and lectures, and published with reports and essays by others in journals of social reform, his photographs produced a cumulative, convincing picture of the exploitation of hopeful and hard-working youth. In 1916 congressional legislation was passed against the employment of those under age 14. Hine had shown the power of photography, using it innovatively with texts and in series of pictures, and infusing it with new compassion.

At the end of World War I in Europe, he documented Red Cross relief efforts for refugees and displaced persons. In 1930-31 his career of documenting labor was climaxed by his series on the men who erected the Empire State Building. While others were enthralled by the world's tallest skyscraper as a symbol of modernity, he followed the construction workers up each floor, and as the last rivet was driven, he photographed the riveter from a crane swung out over New York City. He published *Men at Work*, 1932, with the goal of giving such workers positive images of themselves as masters of the Machine Age.

During the Depression he worked for the Red Cross again, and also for the WPA's National Research Project, studying industry. Hine was unable to support himself through his photography, however, and despite the interest of Berenice Abbott and others in exhibiting his work, he died in poverty.

The flourishing picture press of the 1890s and 1900s supported Hine's reforming photographs and also the new career of photojournalist, designed to feed the hunger for news and entertainment in photographs. Halftone reproduction encour-

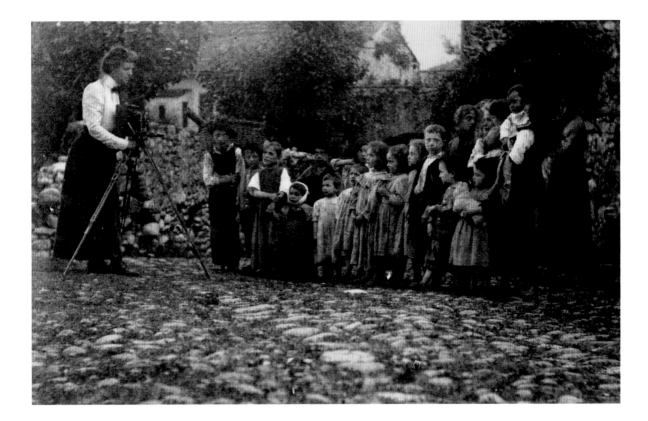

aged the multiplication of photographs in advertising and edito-
rial texts, and the design of newspapers and magazines gained
a new eye-catching beat. World-traveling correspondents
became news in their own right; politicians and stars arranged
photo-opportunities to advance their careers; and independent
photo-agencies emerged to represent photographers to the
media. As Keith Davis notes, these developments in the making
of a world press preceded the flowering of photojournalism
between the world wars and forecast many of its traits.

Among the public, the spread of amateur photography
sparked by George Eastman's Kodak and other small cameras
and the invention of faster lenses, shutters, and film led to a taste
for candid, often close-up images with a sense of immediacy and

spontaneity: the posed group portrait was obsolete in leading
media by circa 1900. U.S. President Theodore Roosevelt sported
various hats and grinned with countless dignitaries; German
Chancellor Bismarck was snapped on his deathbed by a pair of
early paparazzi—the intrusive chronicler of celebrities' intimate
moments. By the turn of the century, photographic human inter-
est stories, whether comic, sentimental, or grim, became a regu-
lar feature of periodicals. The current boom in communications
included the inventions of the telephone, phonograph, motion
picture, and wireless telegraph, and also an explosion in stereo
card production. At its height, Underwood and Underwood, the
largest manufacturer of this early form of infotainment, produced
25,000 cards a day and nearly 1,000 stereo viewers.

The versatility of the German émigré **Arnold Genthe**
(1868-1942) typified the new photographer. His scenes of San
Francisco's Chinatown before World War I, made with a con-
cealed hand camera, reveal an immigrant culture as it was
lived, while his Autochromes of Isadora Duncan's troupe, other

early dancers, and Broadway stars are lovely Pictorialist art-works. When San Francisco suffered its famous earthquake and four-day fire of 1906, which destroyed one third of the city, he borrowed a camera (his studio had burned) and pho-tographed vistas of the smoke-shrouded city with spectators and some of the 25,000 buildings that were leveled.

Certain emancipated women of the fin-de-siècle were moti-vated by improved camera technologies, including the simpli-fied processing of gelatin silver film, to adopt the profession of photographer. Female photojournalists had models in **Frances Benjamin Johnston** (see p. 83; 1864-1952) and **Jessie Tarbox Beals** (1870-1942). Entering the field in 1889, Johnston

JIMMY HARE WAS ONE OF THE FIRST PHOTOGRAPHERS TO GO TO WAR WITH A HANDHELD CAMERA.

was the first woman to document manual labor, and she pre-ceded Hine in her reports, which included coal mines, iron mines, and women's factory work. Her coverage of Washington, D.C., schools in 1899 led to commissions to pho-tograph the Carlisle Indian School in Pennsylvania and the Hampton and Tuskegee institutes for African-Americans. Stage-directing the students at work, she produced classical compositions that embodied the moral probity then attributed to education and the assimilation it was hoped these schools could foster. She was equally successful at portraiture, and photographed five presidents and their wives and cabinets.

Beals, for her part, was one of the first woman press pho-tographer in the United States, on staff at the Buffalo, New York, *Inquirer* and *Courier* in 1902-05, and then freelance in New York City for the rest of her life, except 1928-29, when she photographed lavish estates in California. In covering crime,

she scooped the nation when she photographed a sensational murder trial in a no-camera courtroom by climbing up to shoot through a transom. Her subjects also included social issues, politics, automobile racing, artists, and Greenwich Village bohemians—the heady brew of popular newspapers.

LATE 19TH- AND EARLY 20TH-CENTURY WARS

The new speed possible to end-of-the-century camerawork shortly redefined "the real" in photographs. Most photojournalists did not use the amateur's small camera, preferring the greater sharpness possible with larger negatives and the focus control of professional equipment, but they began to photograph action and to accept a degree of blur as a sign of it.

Press coverage and photography were central to the Spanish-American War, in Cuba, 1898, where the first combat photographs were made in stills and the first war movies were shot: indeed, the seven-week conflict has been called "Hearst's war" because his tabloid syndicate (and that of rival Joseph Pulitzer) inflamed interventionist feeling in the United States against Spain. Who or what sank the U.S. warship *Maine* in Havana harbor, with 260 crewmen lost, remains unknown to this day, but the Spanish colonial government was blamed and stereo card photographs of the wreck were bestsellers in America. "Yellow Journalism" also made this the first "living-room war," using banner headlines and atrocity stories in the daily papers to arouse sympathy for the Cuban rebels. As photohistorian Susan D. Moeller observes, Americans could feel idealistic and humanitarian in supporting armed invasion. No photographer caught Teddy Roosevelt's volunteer cavalry known as the Rough Riders charging up San Juan Hill, but the future president's action (the way down was blocked) became epic-heroic in press reports. Reporters operated very freely, and one led a charge himself and was wounded capturing a flag.

James H. (Jimmy) Hare (1856-1946), whose Cuban photographs had a you-are-there verism, made his name as a swashbuckling combat photographer. This British émigré had chased after train wrecks and regattas as a news photographer for the *Illustrated American*; in Cuba he represented *Collier's Weekly*. He went on to photograph the San Francisco fire, the Russo-Japanese War, the first of the Wright Brothers' flights, the Mexican Revolution, the first Balkan War, and World War I. He retired in 1931 and became a popular lecturer.

Gruesome Spanish deaths were rarely shown in the war reportage in Cuba (American soldiers were held to be noble), while stories replayed the notion that combat was a passport to manhood. That war sells newspapers was proved by the *New York Journal's* circulation: it doubled, to 1.5 million a day. The U.S. military saw the merit of records and began to train soldier-photographers. The Spanish-American War ended with Cuba in American hands and few U.S. casualties—a forecast of the Gulf War of 1990-91 in its speed, asymmetrical troop numbers, and limited American body count.

In the Boer War in South Africa, 1899-1902, journalism was different, perhaps because the war was unpopular in Great Britain. It ended with the original states of the Dutch and German settlers forcibly brought under British rule. Action shots of combat were made but rarely seen, owing to British press censors, who wanted to counter anti-war sentiment in England and insisted that photography should raise patriotic spirits. While sentimental views of British soldiers were staged, the German **Reinhold Thiele** (1856-1921) made immediate photographs behind the lines, while the Briton **Horace W. Nicholls** (1867-1941) tried to combine the "truthful" and "the artistic," as he put it, for the British press.

In Mexico, the Revolution of 1911-17 was heroized by **Agustín Víctor Casasola** (1874-1938), Mexico City's leading commercial photographer. Francisco Madero's troops galloping into the capital following the overthrow of leader Porfirio Diaz, revolutionary leader Emiliano Zapata alive and dead, train derailments, and women soldiers—all were captured in cinematic or formal style by Casasola or family members working for his agency. Selling to news media and the public, he advertised "I have or will have the photograph you need" and accumulated an archive for Mexicans seeking a pictorial record of the country's history in the making. With peace and stability, the Casasolas made individual and group portraits with late 19th-century studio conventions (reminiscent of those by James van der Zee), which reflect the professions and tastes of early modern Mexico; and they bolstered civic pride with pictures of construction, urban bustle, and religious and social ceremonies. Their

In July, 1931, Brüning and Curtius visited Paris. At a banquet in their honor held at the Quai d'Orsay Briand learned from his chief of protocol that press photographers had not been allowed in. Briand doubted this and wagered that at least one would be there. Slowly he peered around the room. When he finally discovered Salomon he called out, "Ah, le voilà! Le roi des indiscrets." Left, next to Briand, is Paul Reynaud, Minister of Colonial Affairs, to the right, Chautjentice de Rives, Minister of Pensions, Edouard Herriot, and Léon Bérard, Minister of Justice.

A PAGE FROM ERICH SALOMON'S GROUNDBREAKING PRE-WORLD WAR II BOOK, *PORTRAIT OF AN AGE*

total output was so vast—a half-million portraits alone—that a single distinctive style is not evident. Like the archives of contemporary photo agencies, their work mirrors the range of period approaches while illustrating past lifestyles with vivid detail.

During World War I, the initial idealism that led U.S. President Woodrow Wilson to declare it "the war to end all wars" rapidly dissipated before the reality of stalemate in the trenches stretched across France from Switzerland to the English Channel. Thirty-two countries took sides and shared in the 8.5 million combat deaths and the over 13 million civilian deaths caused by massacres, starvation, or what officials now call the "collateral damage" of war. Photographs were unequal to this enormity and to such weapons as invisible poison gas—written accounts were better—and the cameraman was rare who wished to risk his neck following sorties "over the top" through barbed wire across no-man's-land. In fact, no combat photographers died. The war itself was difficult to understand from

the ground: there were no massed charges, and making panoramic views was dangerous. As one general said, "when conditions are good for fighting, they are, of necessity, poor for photography, and vice versa."

Newspaper correspondents were eventually banned from the Western front anyway, and photographs were censored until the last year of the war (though soldiers took some informally). Army corps photographers made records, however, and aerial reconnaissance with camerawork was recognized as invaluable in scouting troop movements, locating targets, and the like. Pioneering in this area was Edward Steichen, who commanded a U.S. aerial photographers' corps in 1918.

Propaganda pictures were rife, however, and the *Berliner Illustrierte Zeitung* ran cover photographs of imposing cannons and a French town street scattered with anonymous bodies at the beginning of the war. In photographs the trenches looked clean, dry, and securely sand-bagged. Among the Allies, trumped-up pictures of German atrocities in Belgium were electrifying in recruitment drives, while no photographs of Allied dead were released. It is argued by scholar John Taylor

and others that such bans can lead to military indifference to loss of life: there were no British cameras at Gallipoli, for example, a notorious slaughter scene. To be sure, the press enthusiasm for war reporting, so high during the Spanish-American War, seeped away in "The Great War," though pictures that could be used against it—of piled bodies, the shell-shocked, the hideously maimed—were not circulated until peacetime. The most horrific were gathered and published in 1924 by the German pacifist Ernst Friedrich in *Krieg dem Krieg!* (War Against War!). The U.S. Army Signal Corps and the Keystone View Co. sold nationalistic views at popular prices.

THE PICTURE PRESS BETWEEN THE WARS

Thwarted by military censors from reporting the "what, where, and how" of World War I, journalists enlarged on the "who"—the human interest stories that were already a staple of early 20th-century media. These were cheaper and easier to file than hard news and analysis. They were also encouraged by the new lightweight cameras and faster lenses introduced in the mid-1920s. Oscar Barnack's inventions, the small plate-film Ermanox and then the even more compact, sturdy Leica, which took 35mm roll film, were both marketed from 1925, while the somewhat larger twin-lens Rolleiflex, which had a 2 1/4-in.-square negative, was sold from 1930. These easily handled cameras performed in low light and could be used surreptitiously. If they did not give birth to paparazzi as well as "street" photographers—those nimble observers of life's odd encounters and human comedies—they helped make spontaneous, sharp-eyed photojournalism a key language of modern vision. They changed the approach of photo reporters: no longer official observers beholden to those in power, photojournalists could be the eyes of the public—prying, amused, or watchdog eyes.

Such reporters suited the exuberant, creative, and competitive press of the interwar period. America's prosperity in the 1920s and Germany's political tumult both spurred newspaper growth. Berlin alone had 45 morning and 14 evening newspapers, while special topics—health, sports, fashion, cars, homemaking, etc.—had their own magazines. Photographs gave each one a profile and changing appeal. As "life became more hectic," wrote Kurt Korff of publications like his *Berliner*

Illustrirte Zeitung, "it became necessary to find a sharper, more efficient form of visual representation, one which did not lose its impact on the reader even if he glanced fleetingly at the magazine page by page." The term "photojournalism" was commonly used.

Other visually sophisticated, design-oriented editors contributed to the photo-driven magazine. The Hungarian Stefan Lorant became editor of the *Münchner* (Munich) *Illustrierte Presse* in 1929, the same year that Lucien Vogel founded the left-wing *Vu* (Seen) in Paris. When the Nazis came to power in 1933, Lorant went to London, where he edited the *Weekly Illustrated* and founded *Lilliput* in 1937 and *Picture Post* in 1938. *Regards* (Looks) was launched in Paris in 1931, while in Germany *Die Dame*, of the vast Ullstein publishing empire, was aimed at women and employed Hannah Höch, and *Arbeiter* (Workers) *Illustrierte Zeitung* served socialism and ran John Heartfield's savagely satirical photo-collages. These and other magazines offered the gamut of photography, and a photographer could make a living supplying them or the agencies that sprang up as middlemen. This medium set the tone of modern photojournalism.

ERICH SALOMON (B. BERLIN, GERMANY, 1886– D. AUSCHWITZ, POLAND, 1944)

The title of Salomon's book *Celebrated Contemporaries in Unguarded Moments*, 1931, sums up his life's focus: he was the first career paparazzo, a master of candid shots of public figures, a headhunter in the jungle of European politics between the wars. It is a truism that the camera cannot explain; it only describes. But Salomon's lively descriptive images contributed to early modern photojournalism: they are irreverent, spontaneous, and revealing about the personalities and relationships making news.

Salomon, who inherited family money, studied mechanical engineering and also earned a law degree at the University of Munich. He spent World War I as a prisoner in France, adding another language to the many he spoke. Runaway inflation in the early Weimar Republic destroyed his inheritance, however, and he went to work in the advertising department of the giant magazine publisher Ullstein, where he picked up a camera in 1927 as a recording device. He soon adopted one of

Germany's first "miniature" cameras, an Ermanox, with glass plates measuring 1 5/8 x 2 1/4 in. and an f2 lens, which was fast enough to allow photography indoors, without flash. Hiding this in his attaché case, he was able to photograph a sensational murder trial, and the scoop encouraged him to become a freelance photojournalist.

Diplomats were Salomon's chief quarry. At first they did not think his small camera actually took pictures, but soon he had to use subterfuges, hiding it in his bowler hat, in hollowed-out books, or a flowerpot, and tripping the shutter with a concealed cable release. His ingenuity in crashing state functions and the wit of his images made him a celebrity in his own right. At one conference the French prime minister Aristide Briand reportedly quipped: "Where is Dr. Salomon? We can't start. What's a meeting that isn't photographed by Salomon? People won't believe it's important at all!" The term "candid photographs" was coined for his shots, which made traditional posed celebrity portraits look old-fashioned. Using a Leica from 1932, he also covered society balls, musical premieres, and, on several trips to the United States, the White House, where he was the first European allowed to photograph. In a sequence with the young actress Marlene Dietrich, he photographed her in bed talking on the telephone and finally appearing to fall asleep. Salomon, whose example spurred on such photojournalists as Felix Man and Alfred Eisenstaedt, was early in creating unwritten contracts with stars: if they gave him access, he would make them look natural—and good.

When the Nazis came to power, Salomon and his family fled to Holland, but no farther. A contemporary recalled that everyone knew Hitler would invade, but the photographer "did not want to miss a single phase of the important coming events This time Erich Salomon came too close to the wheels of history." He died in the concentration camp at Auschwitz.

Salomon's politicians generally got front-page treatment, in keeping with their importance, but the same magazines also

"UNDERWATER SWIMMER," 1917: ANDRÉ KERTÉSZ
ONCE SAID, "THE THINGS I PHOTOGRAPH ARE
NOT AT ALL OUTSTANDING. BUT I MAKE
THEM STAND OUT."

bought idiosyncratic and artful photographs by Henri Cartier-Bresson and André Kertész in which the style was crucial to the content. Editors such as Vogel and Lorant had an eye for distinctive camera vision, and some of their readers might have seen photographs by Cartier-Bresson and Kertész on exhibition and therefore enjoyed seeing them reproduced. At the time there was no line between photojournalism and personal expression for these men and for most European photographers. Kertész made some of his most engaging photographs on assignment: indeed, his sensitive 1928 story on Trappist monks was an early photo-essay made on site. Conversely, magazines ran his most unusual images, and one housewares manufacturer turned his *Fork*, 1928, which he showed at the prestigious "Film und Foto" exhibition, 1929 (see p. 279), into an advertisement. The careers of these and many cameramen were shaped by both reportage and art. Though today they are most valued as art photographers, they are described here as part of the interwar picture press, which recognized camera aesthetics.

ANDRÉ KERTÉSZ (B. BUDAPEST, HUNGARY, 1894– D. NEW YORK, NEW YORK, 1985)

Even before the invention of the Leica, Kertész explored the aesthetic made possible by the hand-held camera. Faithful to spontaneous personal seeing through his 70-year career, he inspired a generation of Europeans who photographed encountered life. His countryman Brassaï praised him for having "two qualities that are essential for a great photographer: an insatiable curiosity about the world, about people and about life, and a precise sense of form." These qualities—so rarely found together—won Kertész both critical esteem and popular affection. Curious, playful, intuitive, tender, his photographs fix the moment when poetic vision transmutes everyday existence into art. "The little happenings," as he called them, when chance reveals both the underlying order and human mystery in humdrum life, recurred through his career, in Budapest, Paris, and New York.

Born into a bourgeois family, Kertész graduated from the Budapest Academy of Commerce in 1912, and went on to clerk at the capital's stock exchange under parental pressure. As a child he had loved the anecdotal photographs and drawings in magazines; at age 18 he bought his first camera—an ICA box model with 4.5 x 6-cm plates—and he taught himself how to develop and print his negatives. His early photographs set the lyrical tone of his oeuvre: the images of his family, peasant activities around their country home, and his scenes of army life behind the lines during his World War I service are charming in their unpretentious humanity. A few are also formally inventive: his brother swimming is amusingly distorted beneath the water, and his silhouette animates an early nocturnal photograph. The prizes and magazine publications Kertész won in 1916-25 resolved him to prove he could earn a living with his camera.

In 1925, he arrived in Paris, where he became part of Europe's cultural capital. He photographed the artists Mondrian, Chagall, and Calder, the novelist Colette, and the film director Sergei Eisenstein, among others; he befriended and encouraged Brassaï and Bill Brandt, notably in their night scenes; helped launch Robert Capa's career, and set an example to him and to Henri Cartier-Bresson with his agile photojournalism. His first solo exhibition took place in 1927, and he began selling prints to museums, an almost unheard-of coup. He published widely, in magazines such as *Vu, Variétés, Le Matin*, and the illustrated journals of Berlin, Frankfurt, Munich, Cologne, Florence, and London. Working with a Leica, which he bought in 1928, he made no distinction between his self-assigned and commissioned work. Sophisticated editors welcomed his linkage of modernist form and the "human interest" tradition. He used the aerial views, contrasts of near and far, and geometries readable in both two and three dimensions of the camera vanguard, but he made them serve his documentary curiosity and warm response to the world. At the "Film und Foto" show, a triumph for photography, he showed 30 prints; and in 1933-37 he published four thematic books of his work (on children, Paris, animals, and great vineyards).

In 1933 a commission from the risqué *Le Sourire* led Kertész to photograph two nudes in fun-house mirrors. His inventive imagery rivaled the biomorphic abstractions of the Surrealist Miró, just as his previous work suggested awareness of de Chirico and Mondrian. But 1933 was the year Hitler came to power: the *Distortions* would wait until 1976 for pub-

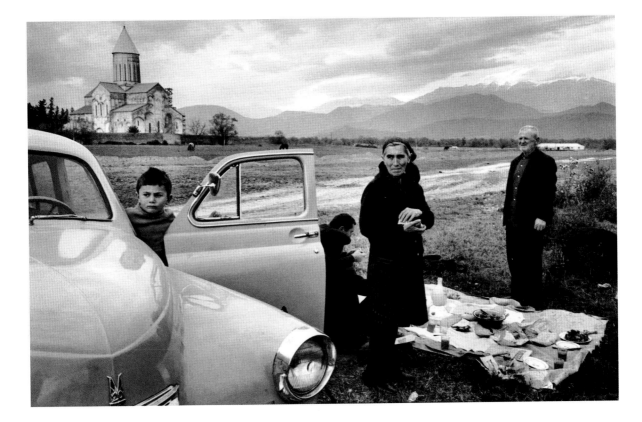

HENRI CARTIER-BRESSON CAPTURED THE
ESSENCE OF STORIES IN ONE "DECISIVE MOMENT,"
AS HE DID IN 1972 DURING THE FEAST OF SAINT
GEORGE IN WHAT IS NOW TELAVI, GEORGIA.

lication. In 1936, when the Keystone agency offered him a year's contract for reportage in New York, he left Paris.

Kertész quickly saw his mistake. At *Life* magazine, he recalled being told: "You are talking too much with your pictures. We only need documents. We have editors to write the text to go with it." When war broke out, he could not return to France, and as an enemy alien he was forbidden to photograph on the streets. Through art director Alexander Liberman, he was contracted to shoot interiors for *House & Garden*, which helped support him between 1946 and 1962. His personal work grew melancholy, his vantage points more distant. Nevertheless, he retained his youthful pleasure in the chance encounters and moments of unexpected beauty that city life offers. He found

these again in his late eighties when, much honored again, he returned to photograph in Paris and Hungary.

Kertész's New York work was inward and slightly melancholy; Cartier-Bresson's postwar photography was the reverse. While the Hungarian slipped into temporary obscurity in the 1940s, the Frenchman began to command a world stage. In their convivial Paris years, the two 35mm camera users can be related in their similar pleasure in the odd juxtapositions of Surrealism, which they found on the streets. The second half of Cartier-Bresson's career, however, connects with a more public, *Life*-style photojournalism and a younger generation of "street" photographers.

HENRI CARTIER-BRESSON (B. CHANTELOUP, FRANCE, 1908–D. PARIS, 2004)

For many observers, Cartier-Bresson was the world's greatest photographer, if measured by influence and sheer number of memorable images. With the simplest means—a Leica, black-and-white film, existing light, and then full-frame printing by

THE DECISIVE MOMENT

"Photography," wrote Cartier-Bresson in *The Decisive Moment*, "is the simultaneous recognition, in a fraction of a second, of the significance of an event as well as of a precise organization of forms which give that event its proper expression Through the act of living, the discovery of oneself is made concurrently with the discovery of the world around us, which can mold us, but which can also be affected by us." Photographers, he continued, "work in unison with movement as though it were a presentiment of the way in which life itself unfolds. But inside movement there is one moment at which the elements in motion are in balance. Photography must seize upon this moment and hold immobile the equilibrium of it." How to catch this moment? The Surrealist poet André Breton observed that the photographer—a game hunter and admirer of Surrealist art in his youth—adopted an "ultra-receptive posture" and "put himself in a state of grace with chance."

commercial labs—he composed formally complex photographs in a split second, full of humane observation, social awareness, and visual wit. Effortlessly, it seemed, he made photographic art and everyday life reinforce each other.

Born to a well-off family in the textile business, Cartier-Bresson pursued painting with the Cubist André Lhote in 1927-28 and then studied at Cambridge through 1929. On a year's hunting trip to the Ivory Coast in 1931, he began to photograph; in 1932 his first surviving work was published in *Vu* and exhibited in New York and Madrid. For the next three years he shot in Europe and Mexico, and in 1935, his primary interest shifted to film. In the United States that year, he studied cinema with Paul Strand; in 1936-39 he contributed photographs to the Communist magazines *Ce Soir* and *Regards*, and he worked on films by Jean Renoir.

Cartier-Bresson would mine the influences of the early 1930s in his photography thereafter: the Cubist sense of pictorial geometry and formal self-sufficiency; the Surrealists' use of unexplained omissions and juxtapositions to suggest the psychic forces underlying mundane life; and the "human interest" photojournalism of Kertész, Martin Munkacsi, and others, in which small unexpected moments and impulsive movements are transformed into broader insights. Throughout, he framed the spontaneous with high-art sophistication, transcending the amateur's snapshot. In the late 1930s his reportage grew larger and more legible in meaning, and his "candid" portraits of the famous caught the "animal in his habitat," as he put it.

The war ended his camera work and in 1940-43 he was held prisoner in Germany; he escaped after three attempts and joined the French Resistance. In 1945 he completed a documentary film on the homecoming of POWs. In 1946-47 he traveled in the U.S. and enjoyed a "posthumous" retrospective at New York's Museum of Modern Art (MoMA curators believed he had died in the war). With Robert Capa, David Seymour, George Rodger, and others, he cofounded Magnum in 1947. "I had been engaged in looking for the photograph for itself, a little like one does with a poem. With Magnum was born the necessity for telling a story. Capa said to me: 'Don't keep the label of a surrealist photographer. Be a photojournalist. If not you will fall into mannerism' This advice enlarged my field of vision."

From 1948 to 1950 Cartier-Bresson lived in the Orient, filing stories represented by Magnum on the finales of colonialism: the end of Kuomintang power in China, the independence of Indonesia, and the funeral of Mohandas Gandhi and other events following India's independence and partition from Pakistan. Gathering together a lifetime's photographs (sans chronological order), his highly influential book *The Decisive Moment* appeared in 1952.

Subsequent books summarized his views of nationalities and their mores: on China, 1954; on Europe, 1955; on the USSR, 1955, among others. In 1969-70 he made documentary films for American television. In 1973 he decided to limit his photography and concentrate instead on painting and drawing.

In Europe the interwar picture press nourished the careers of Tim N. Gidal (1909-1996), later a writer; Felix H. Man (1893-1985); Walter Bosshard (1892-1975), Martin Munkacsi, and **Alfred Eisenstaedt** (1898-1995), who went on to become a founding photographer at *Life* and the source of over 80 covers for the weekly and a thousand photo-essays for it. Unflappable in the presence of the powerful, ever-charming, he captured telling expressions and gestures and organized complex subjects into clearly resolved graphic patterns. In Great Britain, **Humphrey Spender** (1910-2005) worked for the *Daily Mirror* and also for *Mass-Observation*, a journal that published workers' photographs of their own lives. (Such photography originated in the 1920s in Russia and Europe as a social awareness tool promoted by leftist organizations.) Sympathetic to the laborer's lot, Spender photographed extensively in the depressed industrial North of England in the 1930s. "Human interest" for such photographers had a socialist slant.

Socialism squared off against Fascism in the Spanish Civil War, 1936-39, which drew world press attention. General Francisco Franco's military coup against Spain's socialist government had support from Hitler and Mussolini. They tested new war tactics and technologies in Spain—notably in the fire bombing of the town of Guernica, immortalized in Picasso's 1937 painting, and systematic aerial attacks on civilians and cities. Would Western democracies intervene to support the Loyalists and the legitimate government of Spain against the Nazi and Fascist countries and stop the atroci-

ROBERT CAPA MADE INTIMATE PORTRAITS
OF AMERICAN SOLDIERS IN BATTLE
DURING WORLD WAR II.

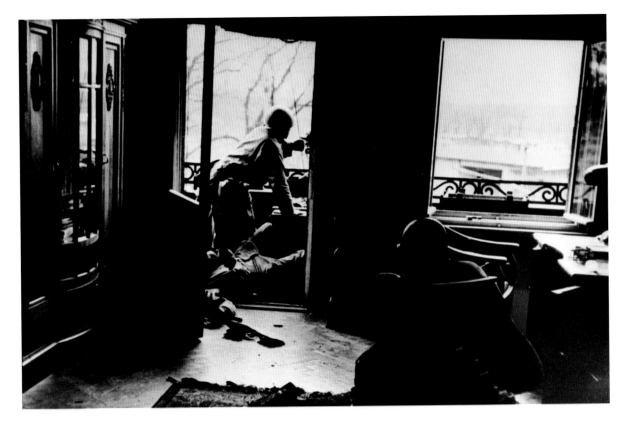

THE AUTHENTICITY OF CAPA'S "LOYALIST SOLDIER"

That Capa staged a mock death for his most celebrated photograph—of a Loyalist soldier falling in the Battle of Cerro Muriano on September 5, 1936, in the Spanish Civil War—is a canard refuted most definitively in 2005 by his biographer Richard Whelan. Doubts about the picture's authenticity were raised by a photojournalist who covered the war and 40 years later claimed he shared a hotel room in September 1936 with Capa, who supposedly spoke of photographing fake maneuvers with Franco's Republican soldiers. Retracing the travels of both men, Whelan established that they were hundreds of miles apart then and that there was no evidence they met before 1939. Capa, a known anti-Fascist, would have been shot by Franco's insurgents, and he never had contact with them.

The fallen man was identified as Federico Borell Garcia by his distinctive cartridge case, clearly visible in a photograph of him alive with his comrades before the battle; only one death from his militia was recorded for that battle; and he was recognized in Capa's photograph by a relative, who knew independently that he died on September 5. Capa's negatives have not survived: they were cut up for the publications that used his coverage and never returned. No one knew then that "the moment of death," first seen in *Vu* on September 23, 1936, would soon become a world-famous photograph.

Whelan concludes with an appeal to logic: why would any soldier stage his own death? The Battle of Cerro Muriano was real, and Capa needed no actors to get powerful combat photographs.

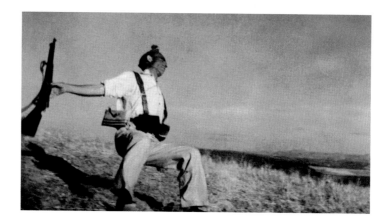

REPUBLICAN MILITIAMAN FEDERICO BORELL GARCIA AT HIS MOMENT OF DEATH DURING THE SPANISH CIVIL WAR IN 1936.

ties? Public opinion could be decisive. News agencies sent photographers to the front lines and refugee camps, and both the Loyalist and Nationalist sides ardently propagandized for their cause. Demonstrations took place, relief funds were raised, international volunteer fighting brigades went to Spain. Neutrality was difficult for any photographer or writer. Among those who photographed in Spain for the Loyalists were, most famously, Robert Capa, his friend **David Seymour**—**"Chim"** (1911-1956), and Capa's lover Gerda Taro (killed in the war). Though Capa's career reached into mid-century, it is discussed here because the interwar press and the small camera essentially shaped it.

ROBERT CAPA (B. BUDAPEST, HUNGARY, 1913– D. INDOCHINA [VIETNAM], 1954)

Capa's *Loyalist Soldier at the Moment of Death*, 1936, is his most famous image and arguably the best-known war photograph by anyone. But Capa repeatedly illustrated his credo, "If your photographs aren't good enough, you're not close enough," in the five wars he covered, and he raised the bar for photojournalists who aspire to convey firsthand experience of combat and also distill its historic meaning.

Capa mixed photography and left-leaning politics as a teenager: in 1931 he was expelled from Hungary for his protests against the government and went to Berlin, then the capital of the picture press, with some 60 newspapers published every day and hundreds of magazines a week. Working at the Dephot photo agency, he picked up photography to earn a living and "as the nearest thing to journalism for anyone who found himself without a lan-

guage." When the Nazis came to power in 1933, he migrated to Paris where fellow Hungarians such as André Kertész helped the charming and resourceful youth. From 1936 through 1939, Capa's reporting of the Spanish Civil War appeared regularly in the French journals *Vu*, *Regards*, and *Ce Soir*, and in *Life*, the new American weekly. The immediacy of his reporting, and the risks he took to get it, as well as his compassionate views of war's victims—widows, refugees, and children—led *Picture Post* (British) to call him "the greatest war-photographer in the world" in 1938. That year he published *Death in the Making*, of his Spanish photographs and those of Gerda Taro and David Seymour, and he was in China photographing the Japanese invasion; in 1940 he documented the bloody presidential elections in Mexico. In 1941-45 he was the best known of those covering the European theater of World War II for *Life*, from the bombing of London, to D-Day and the liberation of Paris, to the pursuit of Hitler across the Rhine.

In peacetime Capa portrayed such figures as Matisse and Picasso and the celebrities who became his intimates, including Ingrid Bergman and Ernest Hemingway. In 1947 he published *Slightly Out of Focus*, an autobiography he hoped to sell to Hollywood (he failed); and he was the first photojournalist allowed into the USSR since the war, on a project with his novelist friend John Steinbeck that generated *A Russian Journal*, 1948. That year he founded Magnum, one of the earliest and still the most celebrated photographers' collaborative agency, with Henri Cartier-Bresson, Chim, George Rodger, and others. In 1948-49 he captured the drama of Israel's beginnings as a nation and its floods of refugees, publishing *Report on Israel* with Irwin Shaw in 1950. In 1954 he was killed by a landmine in Indochina, the first photographer to die in what would become the American war in Vietnam. He was 40.

In the 1920s and '30s European and British journals published feature stories with tough and moody candid photographs by Brassaï, Bill Brandt, Lisette Model, and others, revealing urban underworlds at night and the folkways and vices of different classes by day. The American counterparts of their *noir* photographs were produced by Weegee, a character the New York police called "the official photographer of Murder, Inc.," the U.S. crime syndicate. He made lurid entertainment out of poor people's misfortunes. In the 1920s when he joined Acme Newspictures (later absorbed by United Press International [UPI]), the American picture press was as exuberant as Europe's, serving an increasingly urbanized readership seeking local and national news and entertainment in easy-access visual form. Newsreels, though wildly popular (along with feature films), were not competitive, since most people could not afford to go to the movies more

GETTING THE "GOOD MEATY STORY"

In his autobiography Weegee recalled his career supplying photographs to New York's tabloid press in the 1930s: "Being a freelance photographer was not the easiest way to make a living. There had to be a good meaty story to get the editors to buy the pictures. A truck crash with the driver trapped inside, his face a crisscross of blood … a tenement-house fire, with the screaming people being carried down the aerial ladder clutching their babies, dogs, cats, canaries, parrots, monkeys, even snakes … a just-shot gangster, lying in the gutter, well dressed in his dark suit and pearl hat, hot off the griddle, with the priest, who seemed to appear from nowhere, giving him the last rites … just-caught stick-up men, lady burglars, etc. These were the pictures that I took and sold. It was during the Depression, and people could forget their own troubles by reading about others."

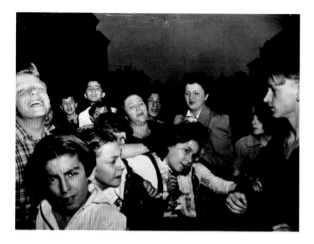

"THEIR FIRST MURDER," 1941, PORTRAYS THE REACTION OF PETER MANCUSO'S AUNT AS SHE FIRST SEES HIS CORPSE IN BROOKLYN.

than once or twice a week. Radios, found in almost every home, sharpened the appetite for images.

WEEGEE (USHER, LATER ARTHUR, FELLIG) (B. LEMBERG, OR LVOV, AUSTRIA, NOW UKRAINE, 1899– D. NEW YORK, NEW YORK, 1968)

Hollywood loved Weegee. Born Usher Fellig, he was not the first freelance photographer for the tabloids, the small-format newspapers aimed at popular tastes and attention spans. But in the 1930s and '40s, the hard-bitten, wisecracking photojournalist arrived at New York crime scenes with the police— and sometimes earlier—and got sensational pictures of mob rub-outs, slain two-timing spouses, cop-killers, and suicides, almost all in pools of blood. For relief he sold photographs with broad charm, sex, or slapstick: kids leaping through fire hydrant spray in August, hookers and transvestites grinning from paddy wagons, and in one example, thousands of bathers shoulder to shoulder at Coney Island, facing his camera, an impromptu group portrait of his readers. *Naked City,* 1945, the hit book of his photographs, was turned into a movie of the same name (he was a consultant), and his life and that of paparazzi like him are still dramatized.

Weegee's prime years were the Depression through World

War II, when crime, poverty, and social and racial tensions were at extremes in big U.S. cities. His work relates to the coeval candid photography of Brassaï and Bill Brandt, but he went beyond their observation of proletariat folkways and relatively restrained taste. His style was also extreme, and it defined tabloid photography. Working mostly at night but using flash all the time, he homed in on the few figures and gestures needed to tell his stories. In the darkroom, he cropped out unwanted material, and if the flash did not exaggerate tonal contrasts enough, he burned and dodged prints in the darkroom to produce graphic images that could survive cheesy reproduction and catch the eye from the newsstand. He chose a 4 x 5-in. Speed Graphic in part because the police did not take 35mm cameras seriously.

Though not an official police photographer (an evidence collector), Weegee was allowed to work out of the Manhattan Police Headquarters from the mid-1930s. And after a *Life* magazine story appeared on him in 1938, he was permitted to install a police radio in his car, where he soon kept "an extra camera, cases of flash bulbs, extra load [sheet film] holders, a typewriter, fireman's boots, boxes of cigars, salami, infra-red film for shooting in the dark, uniforms, disguises, a change of underwear, and extra shoes and socks …. I no longer had to wait for crime to come to me; I could go after it." In locating breaking news, the radio gave him the appearance of psychic powers, like those used in the Ouija board game of the day: from Ouija came "Weegee," he liked to say. (More prosaically, "Weegee" may have derived from his early nickname, "Squeegee boy," when he dried prints in the 1920s at the photo syndicate Acme Newspictures.)

After 1935, when Weegee decided to go freelance, he sold to the *Herald Tribune,* the *World-Telegram,* the *Journal,* the *Sun,* the *Daily News,* and the *Post,* the last two still in business in New York. (Until the early 1970s, New York had some 20 daily newspapers.) In 1940 he took a special position with Ralph Steiner's progressive evening newspaper *PM,* where he created his own photo-stories. In these years his crime photographs were so well-known that he called himself "Weegee the Famous." In 1947-52 he lived in Hollywood, making short, 16mm films and experimenting with

"Distortions," manipulated, caricatural photo-portraits. These were his attempts at artistry, even though the Museum of Modern Art had bought his tabloid pictures as early as 1943. The year 1958 may have been a high point in his career, for he was a consultant on Stanley Kubrick's film *Dr. Strangelove*, he photographed for the *Daily Mirror*, and he worked on photography, film, book, and lecturing projects—all at a time before TV had replaced print in popularity and had begun to rival cinema for mass viewers.

In the 1960s Weegee was discovered by the younger generation of New York "street" photographers—William Klein, Diane Arbus, and Garry Winogrand, among them—who

RUSSELL LEE CAPTURED THE JOY OF THE FOURTH OF JULY AMID TERRIBLE DROUGHT IN OREGON, 1941.

admired his confrontational, even voyeuristic approach and the emotionally raw dramas he pictured. The differences between their work and his *noir* photographs, which took from cinema and taught cinema in turn, have much to do with their audiences, for Weegee and his editors imagined a hardened underclass and served it jolts of tragedy and comedy.

1930S DOCUMENTS OF SOCIAL CONCERN

Weegee's gift to Depression sufferers was to show people even worse off—the dead. Hollywood photographers such as George Hurrell enshrined the immortal. Between these extremes in 1930s photographs of people lay the documentation of Depression victims, those one in four Americans thrown out of work by the stock market crash of 1929 and by a series of droughts that turned much of the Southwest into the Dust

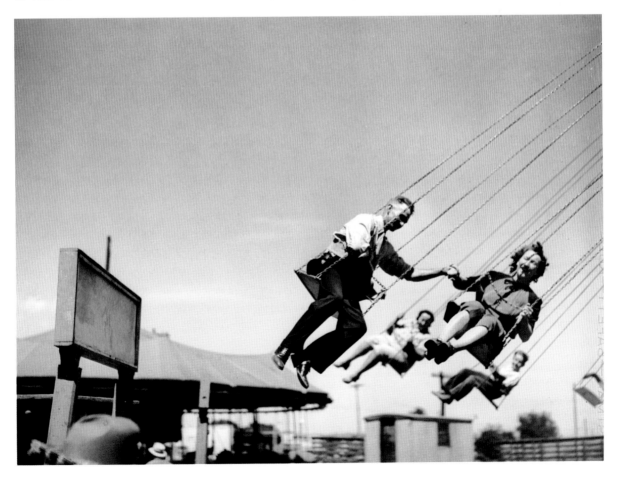

NEW YORK TIMES MAGAZINE

In 1987 Kathy Ryan became picture editor of the *New York Times Magazine* and quickly began commissioning unlikely photographs. Big names, newcomers, and photographers best known through exhibitions were invited to illustrate the weekly's range of essays. Some accepted atypical assignments—fashion photographer Taryn Simon portrayed exonerated death-row prisoners—while "art" photographers gave their topics a special twist— Andres Serrano pictured torture instruments. Ryan also devised new formats to showcase photography. In portfolios a photographer tackles a theme, such as Gregory Crewdson on his "Dream House," and in entire issues devoted to camerawork, groups of photographers are paired with writers on subjects such as "Turning Thirteen" and "Women on Women." Ryan's benchmark camera issue was on Times Square, 1997: it had popular appeal and a news hook, and it sparked diverse responses from Abelardo Morell, Nan Goldin, Thomas Demand, and others on the "documentary-art continuum." Certain exposés have brought change, like Eugene Richards's essay on mental wards in Mexico. But because the *Times*'s front page handles breaking news, Ryan can, she says, "take a step back and try for the equivalent of a literary essay."

Bowl. The rural population—penniless migrant workers and tenant farmers—and the urban poor became subjects for federally sponsored photographs and for independent mass media, works explicitly intended to inform and move city viewers about their fellow citizens in the country and vice versa. The villains were rarely sought—America had no John Heartfield—but the victims were photographed in their rags, often with their gaunt children. Poverty, which had afflicted immigrants and their offspring in the photographs of Jacob Riis and Lewis Hine, was now humbling white Americans and ethnic and racial minorities alike. Older stereotypes survived in the new photographs, such as "the Madonna of the slums," but photographers heightened their force with the modernist devices of close-ups, striking vantage points, and bold compositions. They could not make visible the causes of the Depression, but they dramatized the results.

The most heart-wrenching of these photographs showed migrants and tenant farmers. As described in Pare Lorentz's federally funded film, *The Plow that Broke the Plains*, 1936 (with camerawork by Paul Strand, Ralph Steiner, and others), the treeless Plains states, once the cattleman's grazing lands, were turned into farms and over-cultivated by World War I. Then plows were outmoded by tractors and the soil was exhausted. When the droughts came and crops failed, farmers who had mortgaged their lands to buy seed went bankrupt and their property was seized. Some remained as tenant farmers in debt to absentee landlords; others migrated West, looking for day labor where crops could still be grown. Meanwhile, in the cities, there were breadlines, former businessmen selling apples on street corners, and tent cities known ironically as "Hoovervilles" for the president who had promised that prosperity was just around the corner.

From 1934 President Franklin Delano Roosevelt's New Deal programs brought emergency relief to city and country and created long-term work-relief projects, such as dam and highway construction, that gave thousands of people employment. But the scale, complexity, and costs of the endeavor were unprecedented. In explaining and promoting his programs, FDR himself was an early "great communicator," using radio, newsreels, and the press as the government's propaganda tools. Roy E. Stryker, an economist he hired from Columbia University, would prove to be his greatest ally in using photography as persuasion.

Stryker came to Washington, D.C., in 1935 to head the Historical Section of the Resettlement Administration (later called the Farm Security Administration, or FSA). He hired Walker Evans, Dorothea Lange, Esther Bubley, Russell Lee, Carl Mydans, Gordon Parks, Marion Post Wolcott, Arthur Rothstein, Ben Shahn, and ten other photographers

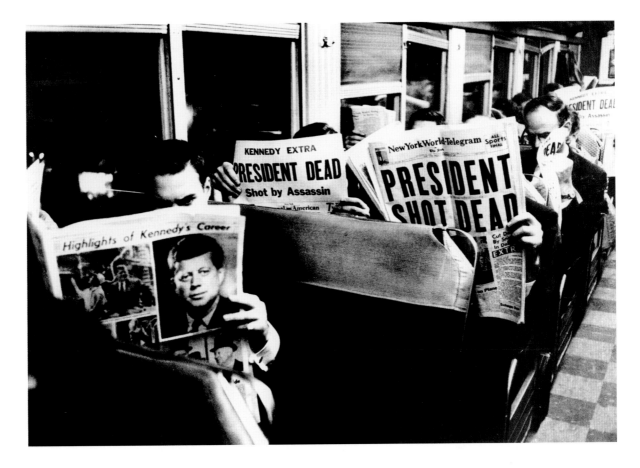

LIFE MAGAZINE PHOTOGRAPHER CARL MYDANS CAPTURED A NATION IN MOURNING IN 1963 ON A LOCAL COMMUTER TRAIN IN NEW YORK.

through 1943, to document the impact of the Depression across the nation, and then the fruits of New Deal programs. This was the largest government photography project ever mounted. The film sent back to Washington was processed and the prints were given away to virtually anyone, with the goal of educating the public through newspapers, magazines, books, and exhibitions. Eventually, 270,000 images filled the FSA file (now in the Library of Congress).

In the beginning, Stryker did not guess how attention-getting his program would be (picture magazines were relatively young), but he soon learned. "I especially remember one of Walker's early pictures," he later stated, "one of a cemetery and a stone cross, with some streets and buildings and steel mills in the background. Months after we'd released that picture [of Bethlehem, Pennsylvania] a woman came in and asked for a copy of it. We gave it to her and when I asked her what she wanted it for, she said, 'I want to give it to my brother who's a steel executive. I want to write on it, "*Your* cemeteries, *your* streets, *your* buildings, *your* steel mills. But *our* souls. God damn you.'"

DOROTHEA LANGE (B. HOBOKEN, NEW JERSEY, 1895– D. MARIN COUNTY, CALIFORNIA, 1965)

Lange's signature work, *Migrant Mother*, *Nipomo*, *California*, 1936, demonstrates the power of photography to produce social change. She documented Depression-era conditions with other memorable photographs of individuals, and her career in photography began well before 1936 and lasted till

1960. But her "Migrant Madonna" gave a topical bite to Nativity iconography while reporting on a pea-picking camp outside San Francisco caught in a sudden freeze. The photograph has overshadowed her oeuvre while largely typifying it.

Lange studied at the New York Training School for Teachers, but was drawn into photography in her late teens, and apprenticed herself to portraitist Arnold Genthe in Manhattan in 1914. She also took courses with Clarence White at Columbia University, learning the Pictorialists' careful printing techniques and eye for Japanesque composition. In 1918 she moved to California and the following year opened her own portrait studio. Her early documentary work included portrayals of Native Americans, made on travels with her painter-husband in the Southwest. In 1932 the impact of the Depression inspired her to begin photographing the breadlines, homeless men, and waterfront strikes of San Francisco. She posted her photograph "White Angel Breadline,' 1933, in her studio with a quotation from the English philosopher Francis Bacon: "The contemplation of things as they are without error or confusion, without substitution or imposture, is in itself a nobler thing than a whole harvest of invention."

When Lange's poignant photographs of emblematic sufferers were exhibited in 1934, she met Paul Taylor, a University of California labor economist. The two became activists for New Deal programs such as public housing and farm subsidies, and would marry and travel through California, the Southwest, and the Plains States to document conditions deserving federal aid. In 1935 Lange was hired by the California State Emergency Relief Administration, and then the Federal Resettlement Administration, to record the impact of the mass migration of day laborers into the state, a relocation forced by Dust Bowl conditions and farm evictions across the Southwest. In 1936 she happened on the Nipomo camp that had been hit by an overnight freeze, destroying the harvest and with it any hope of work. With a large-format camera, Lange made six exposures of 32-year-old Florence Thompson and her children, coming closer as she learned that Thompson had just sold the tires from their car in order to buy food. Lange later remarked that the limp she had had

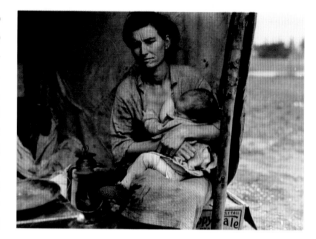

FSA PHOTOGRAPHER DOROTHEA LANGE CAPTURED SOMBER BEAUTY IN THE DAILY ROUTINES OF A MIGRANT FAMILY IN CALIFORNIA IN 1936.

since childhood polio made people sympathize with her. She also edited the final images judiciously: she omitted Thompson's other children, including an adolescent daughter, retouched the tent pole to hide a thumb, and possibly directed the children to hide their faces. The result is a highly emotive, compact composition, which dramatizes the strength yet desperation of this handsome woman, whose gesture is the ancient sign of melancholy thought. As scholar Vicki Goldberg points out, we are reassured when life imitates art and art ennobles life. This woman is a temporary victim, Lange seems to say; she deserves help, and there is no condescension in giving it. The photograph was quickly published and reproduced worldwide. Relief was brought to Nipomo's 2,500 migrants and to places like it; the state began constructing camps; and laws were enforced to guard against abuses in existing camps, like those described in John Steinbeck's The Grapes of Wrath, 1939. In her field notes, Lange wrote that Thompson "thought that my pictures might help her, and so she helped me." In 1939 Lange and Taylor's study of migratory workers, An American Exodus: A Record of Human Erosion in the Thirties, was published with the first-person statements of their subjects.

During World War II, Lange photographed the plight of

Asian-Americans removed from their homes and interned for fear they would become spies for Japan. She was hired by the federal government, but her sympathy for these American citizens led to censoring of her photographs. In 1941 she was the first woman photographer to win a Guggenheim Fellowship. In 1943-45 she worked for the federal Office of War Information. During the 1950s she was a *Life* staff photographer and a freelancer. The best of her later work retained the powerful graphic sense of her FSA photography, its command of telling gesture and body language, and its dramatization through vantage point and close-up.

Lange gave Stryker powerful tools to combat those who saw New Deal programs as un-American, socialist, meddling, and fiscally unsound. He commissioned no photographs of strikers, urban beggars, or celebrity spokespeople. Instead, images of the desolation in American fields and small towns—the traditional heartland—were meant to touch observers of all political stripes. **Arthur Rothstein** (1915-1985), the first photographer Stryker selected for his team, made the iconic image of the Dust Bowl, 1936, of a father and his two sons running to escape a dust storm in Cimarron County, Oklahoma, once-heroic cowboy territory. The leftist artist **Ben Shahn** (1898-1969) had already begun taking pictures for his paintings, in 1932, using a Leica, and he brought both social awareness and a modernist sense of flat pattern to his photographs of the urban and rural poor of both races.

Latecomers to the FSA were **Marion Post Wolcott** (1910-1990) and **Esther Bubley** (1921-1998). Wolcott, born into a liberal middle-class family, was a university student in Austria during Hitler's rise to power; and after she returned to the United States her political awareness and photographic skills were sharpened by working for the left-leaning Paul Strand. In 1938-42, she was a wage earner under Stryker at the FSA. In this later phase of the project, his goal was not just to document the toll of the Depression, but also the benefits of federal programs. In addition to handsome farm scenes, Post Wolcott showed black culture in the Deep South with a sympathy unusual for its time; and she also described the rich and

the middle-class snowbird to Florida with dry wit.

Bubley was hired in 1942, the year the FSA became part of the Office of War Information. Her first assignment, following Southern women on a Greyhound bus trip, documented the happy fact that they were heading to Washington, D.C., to fill new wartime jobs. But she caught the anxiety and loneliness of these dislocated rural folk and forecast the anomie of postwar experience for newly urbanized blacks.

The anomaly in Stryker's corps was Walker Evans, who strived for a style of transparent objectivity with an 8 x 10-in. camera. He recorded the rough buildings and farmers of the South as equivalent elements in a cultural fabric, even when living with some of them for two months. His 1930s photographs are still influential.

WALKER EVANS (B. ST. LOUIS, MISSOURI, 1903– D. NEW HAVEN, CONNECTICUT, 1975)

Photography "is not cute cats, nor touchdowns, nor nudes, motherhood, or arrangements of manufacturers' products," Evans sneered. "Under no circumstances is it anything ever anywhere near a beach." He was dismissing sentimental amateur snaps, Stieglitz's arty images, Steichen's commercial shots, even Edward Weston's dunes. What was left to American photography between the Wars was his own understated, head-on, cumulative documentation of American culture as seen in its anonymous artifacts and people, and his careful, serial presentation of it. *American Photographs*, the book and exhibition he organized of his work at the Museum of Modern Art in 1938, was the museum's first retrospective for a photographer. Today he is seen as both an heir to 19th-century chroniclers such as Mathew Brady and Eugène Atget and a touchstone for late 20th- and 21st-century photographers from Robert Frank and Lee Friedlander to the "New Topographers" and the "Düsseldorf School" of Bernd and Hilla Becher. Evans was modern in insisting on expressing a personal vision within documentary photography and special in conveying it with transparent, seemingly mechanical means. Though he worked for the federal Farm Security Administration, he was atypical of most of its photographers: he disdained pictorial rhetoric as he bridged art and sociological recording.

Born into wealth, Evans attended Eastern prep schools and for one year Williams College, before dropping out to go to Paris in 1926. He tried photographing there and returned to New York in 1927 intending to be a writer. He joined the progressive art circle around Lincoln Kirstein and poet Hart Crane, and in 1928 took up photography seriously. The impact of his cold-eyed literary heroes, Baudelaire and Flaubert, has been seen in his dispassionately descriptive photographs, but his first city scenes used skewed New Vision framing and vantage points; and for the publication of Crane's *The Bridge*, he shot the Brooklyn Bridge dramatically from below. But in 1930 Evans saw Berenice Abbott's Atgets and Kirstein commissioned him to record Victorian architecture in New England. He needed to adopt a view camera on tripod, a distanced viewpoint, full sunlight, and a small aperture for sharp focus, to document the buildings fully. This task and the possible influence of a cousin's architectural photography (as noted by curator Keith Davis) shaped his style in the 1930s. Subsequently, Evans faced his subject head-on like a duelist, and turned solids and sky into flat patterns. Yet he was not so close that his structures devolved into textures abstracted from reality. With a modernist eye, he framed specific American data, and he did so at the nadir of the Depression, a time of new urgency in the country's search for national identity in a "usable past" (the phrase of cultural critic Van Wyck Brooks).

In 1932 Evans made photographs for Carleton Beals's polemical *The Crime of Cuba*, observing the chasm between rich and poor on the island. In 1935-37 he was one of the photographers hired by the FSA to document conditions in rural America. In summer 1936, he took time off for a commission from *Fortune* magazine, and he and writer James Agee spent eight weeks documenting three sharecropper families in Hale County, Alabama, an area hard hit by the Depression. "This is pure record, not propaganda," both men insisted about their work. It had none of the heartbreak shown by Margaret Bourke-White or Dorothea Lange in the Dust Bowl; and it even lacked *Life*-style narrative captions. When the work was published in 1941 as the book ironically titled *Let Us Now Praise Famous Men*, the photographs were shown separately, as "coequal, mutually independent." Allie Mae Burroughs stares back at us in one photograph like a type in August Sander's collective portrait

WALKER EVANS ON THE PHOTOGRAPH AS FACT AND METAPHOR

Museum of Modern Art Curator John Szarkowski recalled Evans's credo for his camera work. The photographer, Evans told him, "must define his subject with an educated awareness of what it is and what it means; he must describe it with such simplicity and sureness that the result seems an unchallengeable fact, not merely the record of a photographer's opinion; yet the picture itself should possess a taut athletic grace, an inherent structure, that gives it a life in metaphor."

A WRITER AND A PHOTOGRAPHER, WALKER EVANS ABANDONED HIS PREVIOUSLY RIGOROUS, DIRECT STYLE IN 1938 TO MAKE WHIMSICAL PORTRAITS OF PEOPLE ON THE NEW YORK CITY SUBWAYS.

of Germany; for her kitchen and porch, Evans used modernist composition to frame her poor but clean household.

Folded into *American Photographs*, the sharecroppers joined Evans's collective study of 1930s U.S. culture. His sequences of photographs noted vernacular art and signage in small-town America (billboards, movie posters, graffiti), evidence of time and disillusionment (rundown antebellum buildings and auto graveyards), and the disparate nature of unknown citizens on the street (defying generalizations about "the people"). Evans's volume, greater than the sum of its parts, was an early example of a photographer's book as a work of art in itself.

In 1938-41 Evans photographed anonymous New Yorkers on the subway, extending Paul Strand's 1916 series on poor individuals. Using a 35mm camera concealed in his coat, Evans produced a new kind of portraiture that questioned when an individual's identity is most visible. In 1943-45 he was a staff writer for *Time*, and in 1945-65 he was *Fortune*'s sole photographer, often pursuing self-assigned essays. His photographs of unaware Chicago shoppers of 1946 forecast Garry Winogrand's "street" photographs. In Polaroid color work of 1973-74, sketch-like photographs made with a gift SX-70 camera, he returned to his old Americana—ordinary architecture, signs, and people—at the end of his life.

LIFE MAGAZINE WAS THE PREMIER PHOTO NEWS PUBLICATION FROM WORLD WAR II THROUGH THE VIETNAM WAR, 1936-1972..

At another pole from Lange's dramatic advocacy and Evans's lucid transcriptions was the photography most identified with *Life* magazine. The term "documentary" is vague, since every photograph documents something, and "documentary" and "photojournalism" have overlapping meanings and are sometimes used interchangeably. But in the case of Evans and *Life*, the differences between the terms are visible. This glossy weekly, launched in November 1936 with an upbeat cover story by Margaret Bourke-White, took the success of the 1900s-1920s picture press to a new level. At its height as a weekly (to 1972), it had some seven million subscribers and was passed along reportedly to reach three times that many. The photograph was key, and crucial was the photo-essay, in which editors directed the

selection and sequence of compelling photographs and their integration with copy in lively layouts. Publisher Henry Luce's sense of mass-market interests and his conservative politics were decisive; photographers supplied pictures to illustrate its grand mission, published in its first issue: "To see life; to see the world; to eye-witness great events; to watch the faces of the poor and the gestures of the proud; to see strange things—machines, armies, multitudes, shadows in the jungle and on the moon; to see man's work—his paintings, towers, and discoveries; to see thousands of miles away, things hidden behind walls and within rooms, things dangerous to come to; the women that men love and many children; to see and take pleasure

in seeing; to see and be amazed; to see and be instructed."

With Stefan Lorant's counsel, *Life* promised content as diverse as any in European journals: news, social issues, advances in technology and science, arts, and human interest; and it expanded to include celebrities (who won more covers than politicians over the years), sports, wildlife, travel, gag and amateur photographs, and the winners of *Life* photo competitions. The magazine shaped political discourse and cultural values for two generations of Americans through photo-essays, stories with a clear point and a beginning, middle, and end. The photographs of the laconic, aristocratic Evans represent a different aesthetic, if not a different country.

In addition to Bourke-White and Alfred Eisenstaedt, the first *Life* photographers included Carl Mydans, Peter Stackpole, William Vandivert, John Phillips, and Fritz Goro. Henry Luce could build on the earlier successes of his breezily written, big-circulation *Time*, the weekly news magazine he founded in 1922, and *Fortune*, a subscription-only, handsomely illustrated journal begun in early 1930 to report on business. Bourke-White's lead story for *Life*'s debut issue epitomized the new magazine's dedication to topical photostories with cheerful human interest. The gigantic buttresses of the Fort Peck Dam dwarfed two engineers on the cover, while the story inside was "10,000 Montana Relief Workers Make Whoopee on Saturday Night." Though still in the Depression, the aptly named town of New Deal was full of new jobholders, whose labor on the dam would bring electrification—and more jobs and prosperity—to three Western states. Of course they made whoopee. The story was arguably as propagandistic as anything in the contemporary Soviet magazine *USSR in Construction*, and Bourke-White's dam resembles Aleksandr Rodchenko's record of building the White Sea Canal, 1933. The difference of course lies in the context of their heroic modernism and their shared belief in the mission of technology. Bourke-White (and Luce) measured the massive work-relief project by its impact on real people: they were gleeful evidence of President Roosevelt's successful work-fare and welfare programs. (Stalin's dam was built with slave labor.)

MARGARET BOURKE-WHITE (B. NEW YORK CITY, 1904– D. STAMFORD, CONNECTICUT, 1971)

Bourke-White was a star in a colorful constellation that defined photojournalism in the 1930s and '40s. She captured the glamour of industry in the machine age in tandem with human interest, and her graphically powerful images reduced complex realities to a few immediately understandable forms and contrasts. As a reporter under daunting conditions—in steel mills, stinking meat-packing plants, under fire in World War II in Russia, in London during the Blitz, and on bombing raids over Italy—she used force of personality, feminine wiles, and her increasing celebrity, and she got her pictures. It helped that she had a sophisticated command of lighting and equipment and that her magazines, *Fortune* and then *Life*, were read by millions. Only a few female photojournalists preceded her in the profession, notably Frances Benjamin Johnston and Jessie Tarbox Beals at the beginning of the 20th century; and she was childless and without real home-life for most of her career. But she won fame and top pay, published six books (including her autobiography), and helped open her field to women.

Bourke-White attended six colleges before graduating from Cornell University in 1927; she had become interested in photography through a class at the Clarence H. White School, and she began her career by using campus shots to win assignments photographing society estates in Cleveland in 1927-28. On her own she persisted in photographing the city's Terminal Tower and Otis Steel Mill, inside and out; she finally succeeded in recording the explosion of molten steel out of darkness by borrowing a Hollywood photographer's stage lights. (Later she used multiple synchronized flashbulbs to open new subjects to photography.) Henry Luce was impressed enough to invite the 25-year-old to join the staff of *Fortune* in 1929; the following year when it was launched, she photographed Germany's rearmament and managed to get into Russia, the first Western photographer officially permitted to document its industrialization. Invited to return twice, she published her photographs in her first book, *Eyes on Russia*, 1931.

Bourke-White's photomurals of 1933 for the RCA Building

in New York's Rockefeller Center also lauded industrial might, and when Luce began *Life* in 1936 it is not surprising that she won the cover story. Bourke-White was not blindly optimistic during the Depression, however, and she showed her social concerns in supporting the PhotoLeague, formed in 1935 to pursue progressive issues, and in photographing the plight of sharecroppers in the South, caught by the Depression as well as agribusiness and disastrous weather. With co-author Erskine Caldwell, the best-selling novelist, she published *You Have Seen Their Faces* in 1937, one of the first books to illustrate this regional tragedy. In 1941 the two also co-authored *Say, Is This the U.S.A.?* on North American industrial growth. Caldwell, then her husband, recalled her shooting style: "She was in charge of everything, manipulating people and telling them where to sit and where to look and whatnot …. She was almost like a motion picture director …. That's how she achieved such a good effect, I think, with her settings and her people, not so much staging it, but helping people to be themselves." The results were "posed candids," in the phrase of her biographer Vicki Goldberg.

In 1941 Bourke-White was the only foreign photojournalist in Moscow when the German army invaded Russia. On the roof of the American Embassy she set her camera on time-exposure and slipped inside when the bombing came too close; a presidential envoy got her an interview with Stalin and then took her film to *Life* in his diplomatic pouch. During that summer she was able to give *Life* exclusive coverage of the Russian front. After the United States entered the war in December, she was attached to the U.S. Army Air Corps in England and North Africa, then the U.S. Army in Italy and Germany. She was the first woman accredited by the armed services as a war photographer and the first woman allowed to fly on a combat mission. In 1945 she was with General Patton's troops when they liberated the concentration camp at Buchenwald; her photographs of the

dead and half-dead were scorching evidence of the Holocaust.

In 1946-48 she photographed India's struggle for independence, its partition from Pakistan, and its leader Mohandas Gandhi hours before his assassination, publishing *Halfway to Freedom* in 1949; she later photographed in South Africa's goldmines during apartheid, and the Korean War. She discovered she had Parkinson's disease in 1956, and thereafter her output diminished, but she continued working and writing, finally retiring in 1968, only three years before her death.

PHOTOGRAPHERS IN WORLD WAR II

Life's salaried positions for its photojournalists were one of its unique features. When America entered World War II, the magazine continued to invest, by training, equipping, and sending out an army of photographers and illustrators. W. Eugene Smith commented that "*Life* was really the only outfit to work for if you covered a war. They had the greatest freedom, the greatest power, and the best expense accounts!" Luce knew General Dwight D. Eisenhower, who believed "public opinion wins wars," and so the U.S. armies in Europe and the Pacific shared jeeps, mess, quarters, and uniforms with 21 *Life* combat photographers, including Bourke-White, Capa, Smith, Eisenstaedt, Carl Mydans, Eliot Elisofon, George Rodger, George Strock, Ralph Morse, Leonard McCombe, and George Silk. Their work had to pass strict army censors, but what was released filled Allied news media.

The Army Signal Corps gave a 13-week training course for military still and movie photographers, and a photo unit was attached to every branch of the armed forces. At age 63 Steichen served again, with the Navy in the Pacific, commanding professional photographers who had enlisted. Insisting on technical excellence in their photographs, which were used for recruiting and publicity, he also advised his corps to "photograph everything that happens, and you may find that you have made some historic photographs. But above all, concentrate on the men. The ships and planes will become obsolete, but the men will always be there." Human interest material of course got past the censors and appealed to civilian readers. The soldier's story, however, also reflected the war's progress, for

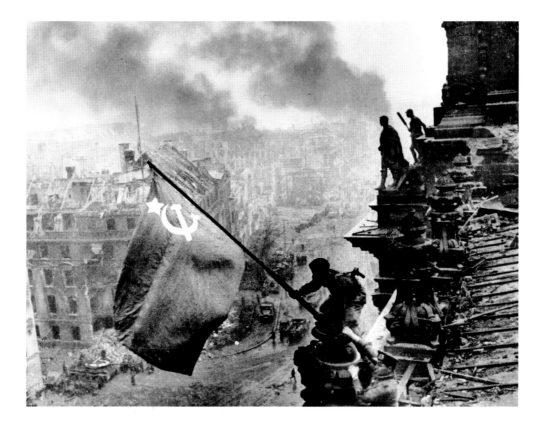

though its technology was remarkable, especially in the air, its successes had to be clinched by the infantry as ground was retaken and enemy troops were pushed back.

During the first two years of American participation, no photographs of U.S. bodies were shown, with the familiar explanation that they would shake morale. But in 1943, as hardships mounted at home, *Life* decided to run George Strock's picture of three dead Marines sprawled on a New Guinea beach. Their faces and therefore their identities were hidden. *Life* editors wrote: "If Bill [one of the men] had the guts to take it, then we ought to have the guts to look at it." On another occasion, they said: "Dead men have indeed died in vain if live men refuse to look at them." Reader response was patriotic and positive; morale was actually raised within the context of this morally righteous war. (This was a far cry from the response to photographs and videotapes of a U.S helicopter pilot's body being dragged through the streets of Mogadishu, Somalia, in 1993: President Bill Clinton quickly withdrew U.S. troops.)

The iconic photograph of World War II was also made in the Pacific, an image representing the military ideal of selfless collaboration and patriotism. In February 1945 Joe Rosenthal photographed the second raising of a flag on Iwo Jima, after the hardest-fought battle in the islands (as well as a posed picture of the soldiers afterward). It was their idea to replace the first flag with a bigger one, they said, "so it can be seen by all the Marines down on the island." When Rosenthal learned later that one of his photographs had been published in the States, he thought it was the portrait and commented on its posing. Thus the celebrated photograph of the flag-raising—perhaps the best known of any war—has been misunderstood as a set-up. Rosenthal later quipped that if he had posed it, he would have asked the soldiers to face him so AP

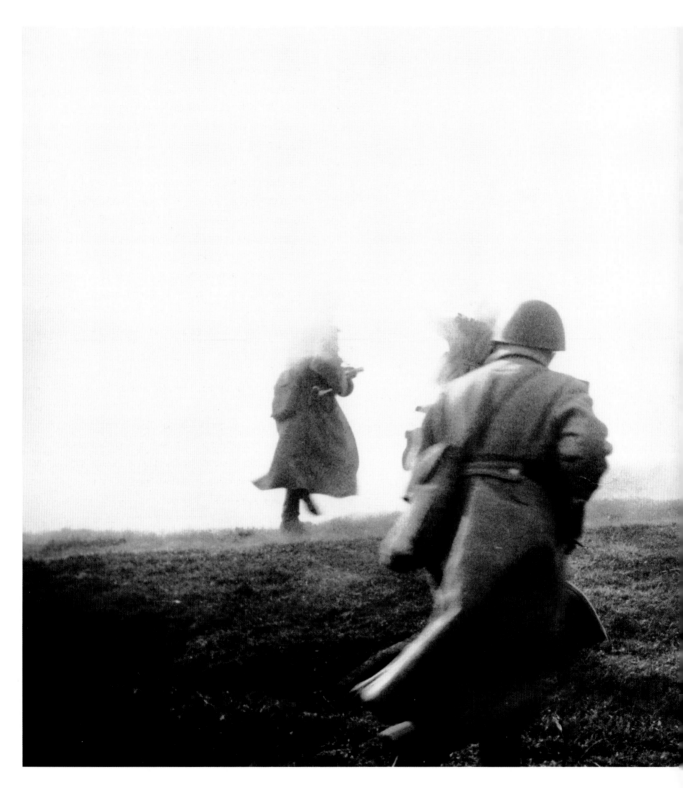

(Associated Press) could carry the identification of each one for his mother. The impact of his photograph was so wide that **Yevgeny Khaldei** (1917-1997) said it inspired him to direct and photograph the raising of the Russian flag over the Reichstag when Berlin fell to the Allies in spring 1945.

After the defeat of Germany, photographers followed the U.S. troops that opened the Nazi concentration camps. Bourke-White, George Rodger, Lee Miller (1907-1977), and others photographed the piles of eyeglasses discarded outside the ovens, the living dead, townsfolk forced to look at the evidence of the Holocaust they had denied, and skeletal corpses left stacked like cordwood because fleeing soldiers had no time to burn them. The pictures scalded world consciences and remain central today to the theme "lest we forget." (When picture editors faced the same decisions during recent conflicts, such as Bosnia and Rwanda, these photographs from the camps were presented by certain critics as arguments for freer publication—again, lest we forget.)

"The Last Good War" exacted the heaviest toll in history: including the six million Jews, Gypsies, and others who were exterminated, there were an estimated 45 million losses among soldiers and civilians. Of those, about 20 million died in the Soviet Union. War entered a new age: guided missiles were introduced by Germany; and the United States dropped two A-bombs on Japan. Mainland America saw no combat on its soil, but it shared the Allies' belief they were fighting for survival in a war against evil, and that a victorious end justified the means. Most photographers were impassioned. "I was going to save the world by my photographs," said George Silk. W Eugene Smith later wrote that he had hoped to produce "not the coverage of a news event, but an indictment of war." Most photojournalists saw themselves as participants, not observers: as a partial result, casualties among photographers and reporters reached an unprecedented height.

The horror photographs of World War II were more graph-

"FORWARD!" 1943: WORKING FOR *IZVESTIA*, DMITRI BALTERMANTS COVERED THE RUSSIAN OCCUPATION OF EASTERN POLAND AND THE LATER YEARS OF WORLD WAR II.

ic and plentiful than those of "the war to make the world safe for democracy." And American cruelties to Japanese soldiers were published, doubtless in response to well-publicized atrocities by the Japanese services. The fire-bombing of Tokyo and the atom bombs dropped on Hiroshima and Nagasaki, with as many as 330,000 civilian deaths, were generally seen as necessary in the United States. They remain living memories in Japan.

Shomei Tomatsu (b. 1930) is one of the Japanese photographers who attempted to visualize the meaning of the nuclear devastation soon after it happened. He returned regularly to Nagasaki to photograph the survivors and the city as they tried to cope. *Hiroshima-Nagasaki Document 1961*, which he co-authored with photographer **Ken Domon** (1909-1990), was published by an anti-nuclear league. Without signs of nationality, many of the figures and motifs in the photographs are general symbols of war's toll and warnings of Armageddon. In the seven photography books Tomatsu has published, the wrenching changes in Japanese culture since the war are a theme, and the decay of traditions is observed in the sometimes poignant contrasts on city streets.

Among the Allies, Soviet photographers—whose work began to come to light in the West during *perestroika*—were as courageous as any in history and endured the brutal conditions that their countrymen and fellow soldier did. One of them made several iconic images of war on the Russian front.

DMITRI BALTERMANTS (B. WARSAW, POLAND, 1912– D. MOSCOW, RUSSIA, 1990)

Thanks to the Iron Curtain, Baltermants's photographs of Russian soldiers in World War II only gradually appeared in the West, which perhaps made them the more searing. When his most famous image, "Identifying the Dead, Russian Front, Kerch," 1942, known as "Grief," was shown in the world-traveling photography exhibition, "What is Man?" 1965, it reminded Cold Warriors that Russia had been a crucial ally against Hitler, and a country whose people had suffered appallingly, with over 20 million Soviet deaths. "Grief" was also an indelible image of war. It can be seen in the line from Roger Fenton's "Valley of the Shadow of Death, Crimea," 1855, to Timothy O'Sullivan's

"Harvest of Death, Gettysburg," 1863. It too displays the price of conflict in scattered corpses, but it gives the mourners a voice—a howl, in fact, that one can almost hear from the woman at the right as she recognizes a body. Beyond, searchers stand against a lowering sky, as if awestruck by the enormous battleground, where over 176,000 men died. "War is, above all, grief," Baltermants said in 1977 when the group exhibition "The Russian War" was shown at New York's International Center of Photography. "I photographed it nonstop for years, and I know that in all that time, I produced only five or six real photographs. War is not for photography." Five or six, however, were enough to secure his reputation.

Baltermants, the son of an Imperial Army officer, moved with his family to Moscow during World War I, and was a youth in the years after the Revolution of 1918. At the University of Moscow in 1928-33, he studied to be a mathematician, but a series of manual jobs that Lenin forced on the upper classes to "proletarianize" them exposed him to the camera. His first photograph was published in *Izvestia* while he was a student, and he became a correspondent for this state news publication. In 1939, he recalled, "the telephone rang, and somebody said, 'Our troops are crossing the border tomorrow. Get ready to shoot the annexation of western Ukraine!'" Between 1941 and 1945 he served *Izvestia* and later the army newspaper *Na Razgrom vraga*, as well as the army: unlike their Western counterparts, Soviet photojournalists were also front-line troops, carrying both arms and cameras. At Stalingrad, where 750,000 died, Baltermants was gravely wounded. After his hospital discharge, he went to document the defense of Sevastopol, the Battle of Leningrad, and the liberation of the southern USSR. On his way to photograph another front there, he stopped at Kerch, in the Crimea, and made his best-known photographs.

After the war, Baltermants became a photo-reporter for the magazine *Ogonyok*, and eventually rose to its editorial board. His propaganda skills, used in his war photography, proved essential. He traveled the gigantic country looking for sunny personifications of Soviet values—the robust, cheerful workers of Soviet Realism in art—and he montaged official group portraits for political correctness (Stalin a few inches taller than his aides). Later he said, "I made some truly grandiose stagings." He

WAYNE MILLER SHOWED THE CROWDED OPENING
NIGHT OF "THE FAMILY OF MAN" AT THE MUSEUM
OF MODERN ART IN NEW YORK IN 1955.

was not ironic, for his successful darkroom manipulation and photojournalistic skills made him essential to the Politboro, and he documented all six general secretaries, from Stalin to Gorbachev. He was self-taught as a photographer, but an adherent of the Russian tradition of art's service to the state.

PHOTOJOURNALISM AT MID-CENTURY

After the War, *Life* and its contemporaries and imitators—*Look*, *Holiday*, *Picture Post*, *Heute*, *Paris Match*, and *Der Spiegel*, among other illustrated weeklies—found new subjects in the reconstruction of Europe, the building of the West's consumer economy, and by the late 1940s the Cold War. Heart-warming human interest stories flowered, along with entertainment and travel themes. Jet transport, available to middle-class vacationers by mid-century, made the globe smaller and revitalized the ethnographic tradition of depicting exotic Others. Readers, exhausted by the war, favored themes of reconciliation and reunification in a hoped-for new world. Revealingly, the photographic series of 1947-48, "People Are People the World Over" *The Family of Man*" exhibition), was the first group project proposed by Magnum, the photojournalists' collaborative formed by Robert Capa, Henri Cartier-Bresson, David Seymour, George Rodger, and three others in 1947.

Magnum was the first photo agency run by photographers, who initiated stories, retained control over their negatives, and, while still taking individual commissions, exerted more leverage as a collective over how publishers handled their work. Their war coverage had brought renown to the founding four photographers; and their prestige reflected on those they subsequently elected to membership. Early additions to Magnum included **Werner Bischof** (1916-1954), **Ernst Haas** (1921-1986), **Eve Arnold** (b. 1913), **Marc Riboud** (b. 1923), **René Burri** (b. 1933), **Elliott Erwitt** (b. 1928), and, after Capa's death, his younger brother **Cornell Capa** (b. 1918), who estab-

lished the Fund for Concerned Photography in 1967 and its foundation, The International Center of Photography in 1974. The Magnum model inspired later photographers' collaboratives, including Contact Press, co-founded by David Burnett (b. 1946) and Robert Pledge (b.1942), and VII, of whom James Nachtwey is the best known.

From the late 1940s the front pages reflected the regional conflicts that would remain unresolved a half-century later. Robert Capa covered the birth pangs of Israel as the new state was carved out of Palestine by the United Nations and withstood the first armed Arab opposition. Cartier-Bresson photographed in India during the partitioning of Pakistan and the aftermath of Gandhi's assassination, and then in China in 1949 as it went Communist. In South Africa the government policy of apartheid was formalized in 1948, and soon opposition was seen in photographs from the Progressive Photographic Society and *Drum* magazine. **Peter Magubane** (b. 1932), **David Goldblatt** (b. 1930), and **Ernest Cole** (1940-1990) were chief among those who, over the next decades, called Western attention to the crimes of this segregation by depicting its black victims. In the American South, **Charles Moore** (b. 1931), Bruce Davidson, and Danny Lyon were among those who documented the violence surrounding the Civil Rights Movement in the 1950s and '60s. The world revulsion at Moore's photographs of police dogs attacking peaceful protestors in Montgomery, Alabama, is credited with speeding the passage of the Civil Rights Act of 1964.

In Korea in 1950, the Cold War between Russia and the West turned hot when the Communist-backed North invaded the pro Western South. For the first time the United Nations played a military role, but U.S. troops were the main force sent in to restore the postwar status quo and contain Communist expansion. By the end of the war in 1953, 23,300 Americans were dead, but no peace treaty was ever signed. **David Douglas Duncan** (b. 1916), **Carl Mydans** (1907-2004), and **Horace Bristol** (1908-1997) were the best-known photojournalists at the front. They continued the focus on the individual soldier that was so successful in World War II, but now with emphasis not on his heroics in a just cause, but on his stoic endurance in fulfilling his duty and facing death in the subzero cold of Korean winter.

DAVID DOUGLAS DUNCAN TOLD THE STORY OF A BRUTALLY COLD DECEMBER IN 1950 IN KOREA WHEN HE PHOTOGRAPHED AMERICAN TROOPS MARCHING.

The grainy tight shots that typified the coverage reflected the reliance on 35mm cameras, especially the hardy Japanese-made Nikon. (In World War II, small cameras were less numerous than the Speed Graphic—the reporter's first choice in the 1930s—which took gelatin film plates.) Duncan, who earned his sympathy for the dog soldier as a Marine in World War II, used the unobtrusive 35mm equipment for intimate, informal images. The uncaptioned photographs in his 1951 book, *This is War! A Photo-Narrative in Three Parts*, were shot, he wrote, "as if through the eyes of the infantryman … the guy under fire …." They were intended "to show something of what a man endures when his country decides to go to war, with or without his personal agreement on the righteousness of the cause."

The ultimate threat of war—humankind's nuclear annihilation—was the subtext of "The Family of Man," 1955, an exhibition of 503 prints by 257 photographers of 68 countries. This was perhaps the most popular photography show in history. Organized by Edward Steichen, director of the photography department at the Museum of Modern Art (1947-62), with advice from Dorothea Lange and photographer Wayne Miller, his assistant, the show traveled in four editions to 38 nations through 1960 and was seen by over nine million people. Its

catalog is still in print. In every installation, a photograph of a hydrogen bomb explosion, followed by one of the UN in session, was near the end of the sequence of pictures grouped by theme—courtship, childbirth, family, learning, work, play. The unmistakable liberal message was that humanity's survival depended on avowal, beyond cultural differences and political divisions, of shared experiences and values. In this humanistic celebration, photography was seen as a universal language.

Among its most persuasive speakers were W. Eugene Smith and Gordon Parks. In 1958, when *Popular Photography* reported the "Ten Greatest Photographers" named in an international poll, all of them had contributed to *Life* and seven of them were photojournalists identified with the magazine: Smith was at the top, followed by Cartier-Bresson, Alfred Eisenstaedt, Ernst Haas, Gjon Mili, Philippe Halsmann, and Yousuf Karsh, in addition to the masters of fashion and advertising Richard Avedon and Irving Penn, and the landscapist Ansel Adams. Of all of them, Smith's byline could sell the most copies of *Life*. And reader response to his essays showed the fund-raising power of photography. In his 1951 story on Maude Callen, a heroic nurse-midwife in rural Alabama, a caption read: "She dreams of having a well-supplied clinic but has small hope of getting the $7,000 it might cost." Within two years, readers donated $18,500. As scholar Vicki Goldberg points out, *Life's* caption gave readers a place to put the emotions that Smith's photographs had aroused.

EUGENE SMITH'S STORY OF WATER POLLUTION IN

MINAMATA, JAPAN, SHOCKED A GENERATION.

W. EUGENE SMITH (B. WICHITA, KANSAS, 1918–D. TUCSON, ARIZONA, 1978)

This master of the photo-essay typified *Life* and transcended it. Humanitarian themes and "everyday heroes" were his subjects, and he combined Paul Strand's sense of the lonely dignity of the individual and his admiration for traditional communities with André Kertész's tender revelation of human relations. His "decisive moment" was a psychological one, when he caught the emotional climax of the narratives he followed. These climaxes seemed timeless to many readers: a baby's birth, a doctor's emergency aid, an old man's wake. Smith composed these moments with the grandeur of religious art and got them by living with his subjects for weeks, until they forgot his presence. His ardent identification with his people and his sense of photography's social mission and its stature as art made him a romantic, embattled figure at mid-century and a model to many younger photojournalists. He created some of photojournalism's iconic images.

Given a camera as a teenager, Smith began selling his pictures to local newspapers. In 1936, at the University of Notre Dame in Indiana, a scholarship was created to let him study photography; but he dropped out after a year, went to New York, and joined *Newsweek*, where he was fired in a matter of months for using a 2 1/4 -in. format camera. A 4 x 5-in. camera was the norm for press, but he wanted the mobility of 35mm, chosen by his hero, Martin Munkacsi. Throughout his career, Smith would favor the small camera, but use various additional equipment, and toil in the darkroom burning, dodging, and bleaching for the most dramatic light–dark effects. In 1939-41 he was a *Life* staff member for the first time, but he quit to return to freelancing. In 1942 he became a war correspondent for Ziff-Davis Publications, and then for *Life*. Across the Pacific theater, he followed the savage fighting with bravery equaling Robert Capa's, accompanying 26 combat missions and covering D-Day on Okinawa. There in 1945 he was photographing "A Day in the Life of a Front Line Soldier" when he was shelled: "I forgot to duck," he commented, "but I got a wonderful shot of those who did."

After two years of hospitalization, Smith returned to photography in 1947, and stayed with *Life* through 1954, undertak-

A PHOTOJOURNALIST WITH "PASSION" ABOUT PEOPLE

"Know your subject," Smith advised novice photojournalists. "Know people's surroundings, analyze their emotions, understand their motivations. Then, by emphasis, get the significances of their actions. These add up to interpretation." In 1958 he told *Popular Photography*: "My photographs at best hold only a small strength, but through them I would suggest and criticize and illuminate and try to give compassionate understanding. And through the passion given into my photographs (no matter how quiet) I would call out for a spiritualization that would create strength and healing and purpose, as teacher and surgeon and entertainer, and would give comment upon man's place and preservation with the new age—a terrible and exciting age. And with passion. Passion, yes, as passion is in all great searches and is necessary to all creative endeavors …"

ing over a hundred assignments. On many of them he battled with editors for aesthetic control over picture selection and presentation, but the best were shaped by *Life* staff. These essays are credited with moving the genre from narrative to compassionate interpretation of character. "I am constantly torn between the attitude of the conscientious journalist who reports facts," he admitted, "and the creative artist who knows that poetry and literal truth seldom go together."

GORDON PARKS (B. FORT SCOTT, KANSAS, 1912)

Superlatives cluster around Parks, who has recently added a creative old age to his list of achievements. His life—now perhaps as well known as any of his photographs—is an African-American success story, made in the face of grudgingly diminishing prejudice against his race in the United States.

The youngest of 15 children, Parks supported himself after high school as a busboy and piano player, but he did not consider photography a career until age 25. A magazine introduced him to photographs of rural poverty made for the FSA (Farm Security Administration) by Ben Shahn, Jack Delano, John Vachon, and others under the direction of Roy Stryker: he would meet and learn from all of them when he joined the FSA in 1941, on a fellowship awarded by the Julius Rosenwald Foundation, the first to be given to a photographer.

Working as a black in racially divided Washington, D.C., was tougher than any field assignment, Parks found. But he took the issue head-on in documenting the life of Ella Watson, a cleaning woman in the FSA building. She told him she was hired at the same time as a white woman there and with the same education; but the latter became a notary public. Parks posed Watson with her mop and broom in the woman's office, under an American flag, in a parody of Grant Wood's iconic painting "American Gothic." He also showed her in church and at home, raising her grandchildren. Dramatizing a painful social issue through an admirable individual was a strategy that connected FSA photographs to the photo-essays of *Life*, which Parks joined in 1948, as the magazine's first African-American photographer. It was a dramatic step, prepared for by his work in the government Office of War Information (into which the FSA merged), then his photography of industrial workers for Standard Oil of New Jersey, and the publication of his first two books, on flash photography and "documentary portraiture" (his title) in 1947 and 1948.

GORDON PARKS CHOSE TO PORTRAY CHARWOMAN ELLA WATSON WITH DIGNITY DURING HIS ASSIGNMENT WITH THE FARM SECURITY ADMINISTRATION IN 1942.

BRUCE DAVIDSON MADE EMBLEMATIC PICTURES OF THE U.S. CIVIL RIGHTS MOVEMENT, WHICH HE EDITED INTO A BOOK ENTITLED *TIME OF CHANGE: CIVIL RIGHTS PHOTOGRAPHS, 1961-1965.*

For *Life*, where he was a staff member until 1972, when it folded as a weekly, Parks first portrayed gang warfare in Harlem, personified by a teenaged leader with whom he established rapport. For a 1961 story on the extreme poverty in Rio de Janeiro, he focused similarly on a single family and the efforts of its desperately ill son to help it survive. The photo-essay touched so many readers that Flavio was flown to the United States for a cure and money was raised for his family. Among the over 300 stories he filed for *Life*, Parks also covered the Black Power Movement and Malcolm X's Nation of Islam, as well as celebrities and the Paris couture collections. Indeed, his success in fashion photography is visible from the 1930s to as recently as fall 2004.

In 1969 Park's first film, *The Learning Tree*, based on his fictionalized autobiography, was released: he was the first African-American to produce, direct, and score a film for a major Hollywood studio. His black detective stories, *Shaft* and *Shaft's Big Score*, defined the avid black market for black action films. Documentary and fiction filmmaking occupied him through the 1980s. He also wrote novels, three autobiographies, books combining his photographs and poems, and volumes illustrating his paintings, in addition to musical compositions. The *Life* managing editor Phil Kunhardt, Jr., recalled Parks's most memorable years: "At first he made his name with fashion, but when he covered the racial strife for us, there was no question that he was a black photographer with enormous connections and access to the black community and its leaders. He tried to show what was really going on there for a big, popular, fundamentally conservative white magazine…. Success among whites never made Parks lose touch with black reality."

Smith's and Parks's photographs typified "The Family of Man," which marked the apotheosis of *Life* in popular favor. In fact, many of the exhibition's photographs came from *Life*'s files and Magnum members. But the show was criticized as Steichen's "editorial achievement" rather than a survey of worthy individual photographers. Their photographs were taken out of context, blown up, and sometimes cropped. The show's lofty ambition and poetic affirmation were derided as sentimental schmaltz. And its unifying notion of people was attacked for ignoring the differences between cultures, races, ethnicities, and even family members. Such negativity signaled the fissures developing in American culture and in photojournalism, which would widen in the 1960s as illustrated magazines lost ground to television in advertising revenues and began to collapse. As photographers fought to wrest creative control from editors, it was becoming obvious that photo-reportage was unable to make clear sense of important conflicts. The notions that "all politics are local" and that experience is individual would become the strength and the weakness of much reportage. It was authentic but admittedly partial.

U.S. SOCIAL DOCUMENTS OF THE 1960S

Photojournalists emergent in 1960s' America were notable for pursuing social issues at length that were close at hand. W. Eugene Smith spent weeks with his ennobled subjects to ensure the naturalism of his photo-essays; the new generation lived months and even years with groups on the outskirts of society. **Bruce Davidson** (b. 1933) hung out with a gang of Brooklyn teenagers in 1959 and spent nearly two years in New York's Spanish Harlem on "what people called the worst block in the city," making socially alert and sympathetic portraits. They were published as *East 100th Street*, 1970. After covering the early Civil Rights Movement, **Danny Lyon** (b. 1942) followed a tribe of young motorcyclists for *The Bikeriders*, 1967, and then reported on life in a Texas prison for *Conversations with the Dead*, 1971. **Leonard Freed** (b. 1929) made his first mark with the book *Black in White America*, 1969; his *Police Work*, 1980, gathered the photographs he made following New York cops on their beats.

The most unsettling of these notes from the underground

were made by Larry Clark. The tendency to glamorize a subject in isolating it, which is built into a technically competent photograph, became troubling when the subjects were dropouts and addicted youths, Clark's friends, who generally behaved as if his unjudging camera were not there. The border is hazy between such personal documentary and the formally related "art" photography described in Chapter 7. Davidson and Lee Friedlander are contemporaries who, with Garry Winogrand, worked as photojournalists based in New York. Clark was one of Nan Goldin's touchstones. One may justify the separate treatment of these photographers by the differences in their intended audiences; the different weights of style and subject in their work; and also by how they were first seen. Friedlander, Winogrand, and Diane Arbus were presented in "New Documents" in 1967 at the Museum of Modern Art; Davidson remains identified with Magnum—though his *East 100th Street* was a 1970 MoMA exhibition—and he has had three solo shows at the International Center of Photography, where Clark received a retrospective in 2005.

LARRY CLARK (B. TULSA, OKLAHOMA, 1943)

Critical approaches to Clark's gripping half-documentary, half-personal photographs and films are often sociological. For his explicit images of drug use, violence, and underage sex are disturbing, and have been since the 1973 publication of *Tulsa*, a revelation of adolescent narcotics use from a user's vantage point. Seeing his teenagers' self-destructiveness and anomie as symptoms of the failures of U.S. culture is distancing and perhaps accurate, though condemnation was far from Clark's purpose. Indeed, part of the continuing disturbance of his work is his apparent approval of youthful rebellion despite its price, and his relish for its sexual freedoms despite his own advancing age.

Clark was first of all a cinematic storyteller with a 35mm camera and wide-angle lens. The repressions and hypocrisies of the 1950s fueled his desire to expose the abusive parent–child relations he had witnessed and their costs. For subsequent viewers, the behavior of his circle of rock musicians, dropouts, druggies, and hipsters, photographed from 1963 to 1971, reflected an extreme of American experience in the Vietnam era. His friends, the subjects of *Tulsa*, acted out small-town

group alienation as Diane Arbus's subjects personified its individual forms, and they resembled the outlaw gangs in contemporary photographs by Danny Lyon and Bruce Davidson—work also made in grainy spontaneous style in existing light. Their photography was one legacy of Robert Frank's downbeat view of the country in *The Americans* of 1959. Clark's narrower exploration, recognized with a 1973 National Endowment for the Arts grant, would lead the way to Nan Goldin's diaristic color photographs of her fringe society in the 1980s. Both photographers describe their outsider clans warmly, as self-selected families opposed to mainstream culture.

In 1983 Clark published a second book, *Teenage Lust*, which remains particularly controversial. His close-ups of youths having sex and prostituting themselves implied his acceptance by

LARRY CLARK'S GROUNDBREAKING BOOK *TULSA* DEPICTED THE INNOCENCE AND VIOLENCE OF THE LIVES OF HIS FRIENDS.

this tribe. "Since i [sic] became a photographer," he wrote in the introduction, "i always wanted to turn back the years, always wished i had a camera when i was a boy …. in 1972 and '73, the kid brothers in the neighborhood took me with them in their teen lust scene. it took me back." His film *Kids*, 1995, was based on the book. His other books are *1992* (of 1992), and *The Perfect Childhood*, 1993.

Around 1999 Clark's wife gave him a digital camera, and he has used it since then "to pursue an old dream of doing glamour/pinup photography"—the calendar art he saw in gas stations as a boy. Digital technology allows him to "remove all blemishes" in his full-length nudes. "This is fantasy and there is no place in it for reality," he says. "I have had plenty of reality in my life and generally it sucks."

WAR PHOTOGRAPHY, VIETNAM TO IRAQ

The undeclared war in Vietnam cast an enduring shadow over America's self-image, and also altered the tenor of war pho-

tography in the West. The split in U.S. society over the war in Vietnam and the controversy about it worldwide were reflected in media coverage, which in turn helped sharpen opposition to the war from around 1968. Photojournalism itself changed. The issues were too complex for neat photographic embodiments, and the war itself had few triumphs. Could America successfully combat the spread of Communism in this rural land (where the French had failed) and win the peasants' "hearts and minds" for democracy as North Vietnamese soldiers infiltrated and their South Vietnam allies, the Vietcong, gave them widespread guerrilla support?

When South Vietnamese forces proved unequal to defending themselves, American troops were flown in. As historian Phillip Knightley summarizes it, there was no front line, no easily identifiable foe, no direct threat to the United States, no need for sacrifice, no need for patriotism. And there were no visible victories. There were no flags raised on islands like Iwo Jima or U.S. generals wading ashore in triumphant return, as in Carl Mydans's view of Douglas MacArthur in the Philippines. In fact in Vietnam, the most famous photographs were shameful: in addition to Eddie Adams's photograph of a Vietcong suspect shot in the street, there was Malcolm Browne's picture of a Buddhist monk who set himself fatally on fire to protest the U.S.-supported Diem regime, 1963; Nick Ut's view of Vietnamese children, their clothes burned off by U.S. napalm strikes, running from their burning village toward the camera, 1972; Ron Haeberle's color photograph of a ditch filled with the bodies of Vietnamese women and children, the evidence of the My Lai massacre, 1968; and the final pictures of the conflict, of 1975, showing U.S. officials and their Vietnamese aides scrambling onto a helicopter evacuating the U.S. Embassy as the Vietcong overran Saigon.

These images stood out in a media blitz. The military gave the press remarkable access, and publishers successfully resisted government pressure to limit such coverage. Television gave body counts on the evening news, and though the figures for Americans, Vietnamese, and Vietcong could be fanciful, they brought the war home. The images did not change people's views, but hardened opposition, in tandem with the nightly statistics and war fatigue, for this was the

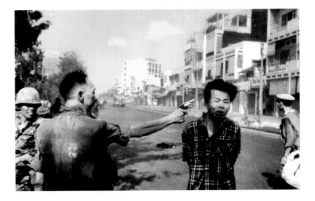

THE EXECUTION OF A VIETCONG OFFICER IN SAIGON IN 1968 WAS EDDIE ADAMS'S MOST WIDELY PUBLISHED IMAGE.

longest war in American history. Atrocities happened before Ron Haeberle witnessed My Lai; and Dickey Chapelle photographed a summary execution before Eddie Adams. But the images were published when the United States was ready to see them, especially after the Tet Offensive, 1968, which proved the U.S. was not winning.

The first book of photographs of the conflict, **Philip Jones Griffiths**'s *Vietnam, Inc.*, 1971, was also the only one for a long time. This Briton (b. 1936) was one of the few to show the war's impact on Vietnamese civilians, and he excoriated the U.S. intervention as a capitalist enterprise in his sarcastic text. The South Vietnam government banned his return to the country.

Of the nearly 700 Western correspondents in Vietnam, Larry Burrows and Don McCullin were outstanding photojournalists. Burrows, like Duncan, focused on the lives of the GIs in Vietnam, innovating in war photography by his use of color in *Life*. McCullin, his younger countryman, chose black and white and photographed for the *Sunday Times Magazine* (London) for the better part of his career, covering Vietnam but also the savage civil wars and plagues of the last third of the 20th century. The work of these photojournalists—while no less graphically compelling than that of Capa and Bourke-White—was new in conveying the complexity and ambiguity of the photographer's position and provoking the viewer's thought.

LARRY BURROWS (B. LONDON, ENGLAND, 1926–D. LAOS, 1971)

In 1962, when Burrows began covering the escalating U.S. military presence in Vietnam, he was a self-proclaimed hawk, but his photographs changed over the next nine years. In Vietnam, he made a ground-breaking, sustained series of combat photographs in color and some of the most memorable images of any war. While responsive to the complex and shifting politics in play, his work evolved from close-ups of individual moments of heroism and grief to stories of fruitless efforts and landscapes of devastation and "friendly fire." About his best-known series, from the 1963 cover story, "We Wade Deeper into Jungle War," and about Operation Prairie, 1966, the photographer Cecil Beaton wrote: "They are *tableaux vivants*, packed with incident and details of extraordinary horror and beauty, showing us the wounded, those about to die, and those recently dead. They are the nearest we have to a demonstration that the camera could say everything that the grandiose historical paintbrush has ever attempted." In fact, photographing artworks for *Life* after World War II helped teach Burrows color, as well as the "grand compositions" he said he sought for choreographing human drama.

The Cockney school-dropout came to the Keystone Photographic Agency in London's Fleet Street at age 16 as a lab assistant and then joined the London bureau of *Life* in 1944. There he was one of those processing the photographs by *Life*'s staffers Robert Capa, Margaret Bourke-White, Carl Mydans, and others that were riveting world readers. After the war Burrows became a photojournalist, picturing Winston Churchill, Ernest Hemingway at bullfights, and other personalities, but most significantly the conflicts ignited in the Middle East, India, China, and Congo at mid-century. He was assigned to Saigon as U.S. president John F. Kennedy was sending more military "advisors" to bolster the South Vietnamese army.

Burrows's 1963 cover essay for *Life* received an unprecedented 16 pages, with full-color images spread across double pages and an editor's note titled "He Went Off to War with Film in His Socks," profiling Burrows and his technical ingenuity. His 1965 story in black and white, "One Ride with *Yankee Papa 13*," extended W. Eugene Smith's traditions of following the troops (which Smith had done in 1944 in the Pacific) and describing large themes through individuals. Burrows pictured a day in the life of a 21-year-

PHILIP JONES GRIFFITHS FOUND THE HEART-WRENCHING HUMAN IMAGES OF WAR IN HIS COVERAGE OF VIETNAM, AND IN NORTHERN IRELAND, WHERE HE PORTRAYED THIS SOLDIER STANDING BEHIND HIS PLEXIGLASS SHIELD SCRATCHED BY NUMEROUS BLOWS IN 1973.

BURROWS ON THE PHOTOGRAPHER IN WAR

For a BBC film of 1969, Burrows reflected on the end of one of his great photo-essays for *Life*, after his hero was unable to save a buddy: "It was a very sad moment … when our crew chief broke down—cried …. So often I wonder whether it is my right to capitalize, as I feel, so often, on the grief of others. But then I justify, in my own particular thoughts, by feeling that [if] I can contribute a little to the understanding of what others are going through—then there is a reason for doing it." Burrows himself had tried to rescue the soldier, and he helped U.S. medics in later firefights in Vietnam. "Do I have a right to carry on working and leave a man suffering? To my mind, the answer is 'No, you've got to help him.' You cannot go through these elements without obviously feeling something yourself—you cannot be mercenary in this way because it will make you less a photographer."

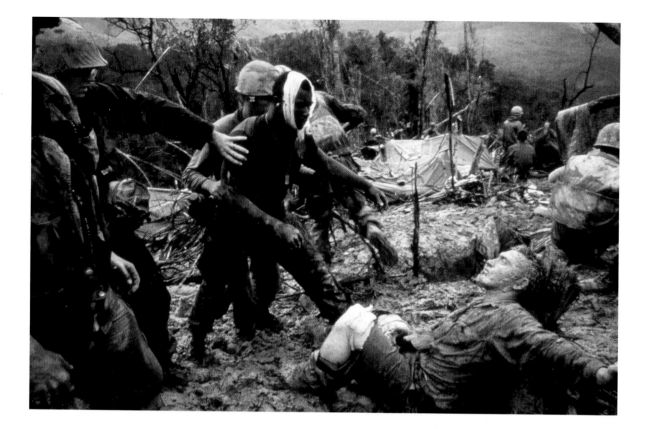

LARRY BURROWS CAPTURED EMOTIONAL BATTLE
SCENES LIKE A MOMENT ON HILL 484 NEAR THE
DMZ IN VIETNAM, 1968.

old helicopter machine gunner, who rescued two comrades while under fire, only to see one die in his care as they escaped to safety. The gunner's trajectory from innocent optimism as he set off, to battlefield heroics, to despair back in the barracks, personalized the toll of war on the young. Burrows's essays had no obvious heroes after this, and instead he focused on the comradeship and suffering of the soldiers. A smoky and oddly beautiful view of a helicopter dropping ammunition into the besieged Khe Sanh, 1968, describes the GIs' isolation. In an essay on a Vietnamese boy partly paralyzed by shelling and sent to America for rehabilitation, the outcome symbolized the futility of U.S. involvement in the war: the returning child was rejected by his rural family and friends.

Burrows had the time, skill, and experience to develop his stories, and the persistence of a film director in getting the potent images he wanted, sometimes sketching them in advance. Traveling with 26 cases of equipment, working with four 35mm cameras around his neck, he was seasoned in following battle and depicting its action. Three times he won the Overseas Press Club's Robert Capa Award for Still Photography Requiring Exceptional Courage and Enterprise.

Burrows was shot down and killed in 1971 with three other photojournalists covering a South Vietnamese army helicopter mission into Laos. He was one of 45 correspondents who died in Vietnam, a number that included **Dickey Chapelle** (1919-1965), the first casualty among woman photojournalists. However, summarizing a poll of 1972, a year away from the ceasefire, Newsweek concluded the public was developing a tolerance for horror. One respondent noted that "we turn off part of ourselves instead of the TV set."

DON MCCULLIN (B. LONDON, ENGLAND, 1935)

A dead Vietcong soldier, his pockets rifled, lies among spare bullets and snapshots of his girlfriend; a half-naked Biafran refugee, a child at her shriveled breast, glares at the camera; a skeletal child begs the viewer for food, shunned by other starving Biafrans for his albino skin. In concise close-to photographs such as these, McCullin condemned war and its punishment of civilians, in the tradition of Robert Capa and others, but he also shared the guilt. His documentation is different from his predecessors' in its acknowledgment of the camera's presence and its implication of the West in worldwide conflicts. McCullin's vision is bleak of the events he covered over 30 years—from the Six Day War in the Sinai Peninsula and the Tet Offensive in Vietnam to the massacre in Palestinian refugee camps in Lebanon. The despair he showed about the human capacity for evil is leavened only by glimpses of bravery and family bonds.

Reared in a working-class home in north London, McCullin won a trade art scholarship in 1949 to the Hammersmith School of Arts and Crafts and Building. But when his father died after a long illness, which McCullin blamed partly on their poverty, the youth had to work to support the family. Drafted in 1954, he joined the Royal Air Force and was sent to the Suez, where he became a photographer's assistant. Later posted to Kenya and Cyprus, he bought his first camera. In 1959, when one of his acquaintances in a London gang was tried and convicted for a policeman's murder, he brought his photographs of the gang to the *Observer,* and his career in photojournalism began.

In 1961 McCullin flew to Berlin on his own to photograph the building of the Wall. For this he won his first British press award. In 1964, on his first international assignment, he photographed the war in Cyprus, an essay that garnered the prestigious World Press Photo Award. The same year in Congo, he entered the capital disguised as a mercenary and covered the rebellion by supporters of the assassinated president, Patrice Lumumba. A year later he was sent to Vietnam for the first time. In 1966 he joined the *Sunday Times Magazine* (London), and for the next 18 years he reported on uprisings, genocides, victims of famine, flood, drought, and cholera, and religious and tribal warfare, including the Irish Republican Army versus British troops and the rise of the Khmer Rouge in Cambodia.

By the early 1980s McCullin was burned out. "When I was young I thought I'm gonna make people look at these pictures …. I do make people think twice, and they do look at them, but they're normally the converted." Like a traumatic stress victim, he re-experienced the horrors he had witnessed, at odd moments at home. Developments in the photography profession disturbed him: "Every man and woman and child in the world can take a pho-

WAR LOVERS

The exhilaration of surviving battle—especially ground combat against individual enemies—may be felt by most soldiers. Add to this the satisfaction of reporting war in image and text—of writing "the first draft of history," possibly of a "just cause"—and one might understand the attraction of being a war photographer. Don McCullin caught war fever and said in the early 1970s that he now needed "two wars a year" to be happy, but would "start to worry at three to four." (He renounced combat photography entirely in the 1980s.) Horst Faas had atrocity photographs tacked to his Saigon office wall and said he liked the war's "boom boom." The daredevil Tim Page (b. 1944), who became a stringer for *Life* at age 20, was injured four times in covering action, the last time so severely that he was not expected to live, though he survived disfigured. In *Dispatches*, the *Esquire* correspondent Michael Herr told of Page's response when approached with a proposed book that would "take the glamour out of war." Page couldn't believe it. "Take the glamour out of war! I mean, how the bloody hell can you do that? Go take the glamour out of a Huey [helicopter], go take the glamour out of a Sheridan [tank] …. It's like trying to take the glamour out of sex …. it just can't be done! The very idea! Ohh, what a laugh!" Larry Burrows, on the other hand, soberly described his focus on the viewer of his combat photographs: "I think if pictures are too terrible, people quickly turn over the page to avoid looking. So I try to shoot them so that people will look and feel, not revulsion, but an understanding of war."

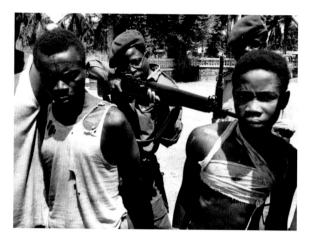

DON MCCULLIN SPENT 30 YEARS COVERING
CONFLICT IN PLACES SUCH AS VIETNAM,
LEBANON, AND LIBERIA, WHERE HE
UNFLINCHINGLY PORTRAYED WAR.

tograph now," he said, and photography is "actually looked upon as art." "I can't help admitting that when I take photographs … even in the moment of battle … I try to compose them, not so much in an artistic way, but to make them seem right, to make them come across structurally. So there is confusion and I try not to associate myself with art, really." In Beirut, at an apartment bombing covered by numerous journalists, he was attacked by a grief-stricken woman for photographing her, and she was killed soon afterward. This chapter in the Arab-Israeli conflict was the last war assignment he took.

McCullin turned to photographing still-lifes and the bucolic landscape of Somerset, where he lives. For income, he used his documentary style on advertising campaigns. In 1999 he received a Kaiser Foundation grant to photograph African HIV-AIDS sufferers, and especially their children, work then exhibited in London and at the United Nations. In the classic format of FSA photographs, his families pose themselves in their homes and face his camera. "I didn't want to be taking advantage of wretched people dying on the floor," he said. "I wanted to become their voice in a way."

McCullin continues to influence photojournalism, especially in Great Britain, through his books: *Is Anyone Taking Any Notice?* 1973; *Unreasonable Behaviour,* 1990; *Sleeping with Ghosts: A Life's Work in Photography,* 1994; and the retrospective *Don McCullin,* 2001. He has also made certain of his photographs available to Amnesty International, the war relief agency and human-rights watchdog.

Color photography, which Burrows had used expressively in Vietnam's green jungles, proved equally powerful in the 1980s in the brilliant light of Central America. There was an ironic beauty mixed with horror in the reportage of the insurrection in Nicaragua against the oppressive Somoza regime and the civil war that began in 1980 in El Salvador. In lush landscapes by **Susan Meiselas** (b. 1948) or James Nachtwey, for example, one would discover half a body or a corpse with its face ripped off. In the garishly painted towns, Meiselas's near-to views of the masked rebels battling the military junta made them hyperreal in striking compositions. Photographers were also witnesses to atrocities: the remains of four American women relief workers (three of them nuns), murdered by the military; the assassination of Archbishop Arnufo Romero, the government's most outspoken critic. **Harry Mattison** (b. 1948) photographed the corpses of some of those killed by government snipers when over 80,000 gathered for the archbishop's funeral. Assembling the work of 30 fellow photojournalists, Meiselas published *El Salvador,* 1983, which became a traveling exhibition. Since then she has photographed in Chile and in Nicaragua. Her *Kurdistan: In the Shadow of History,* 1997, is a monumental attempt to revitalize ways of presenting photojournalism. She resists reportage, she says, that perceives "the world as a story." Her concern with finding new ways to the public is shared by Nachtwey and Gilles Peress.

JAMES NACHTWEY (B. SYRACUSE, NEW YORK, 1948)

Nachtwey thinks his photographs can make a difference, and in some instances they have. Not because he holds more honors than any photojournalist: the Robert Capa medal for exceptional bravery (an unprecedented five times); the Magazine Photographer of the Year (six times); the International Center of

Photography photojournalism award (three times), the World Press Photo award and the Leica award (both twice), and others. These honors recognize the power of his journalism over 25 years to inform and arouse. For example: When his editors at *Time,* where he has been on contract since 1984, proved uninterested in stories on Romanian orphanages and famine in Somalia, he financed his own trips there, and his photo-essays led to wider media coverage and relief efforts, including the establishment of U.S.-Romanian adoption conduits. More often, he has covered wars and highly visible social issues on assignment, with the goal of creating awareness and channeling Western and particularly U.S. public opinion toward what he carefully calls "change."

Nachtwey studied political science and art history at

SUSAN MEISELAS PHOTOGRAPHED THE CONTRAS BATTLING THE SANDINISTAS IN NICARAGUA IN 1985.

Dartmouth College in 1966-70, when photographs from the Civil Rights Movement and the Vietnam War were making a crucial impact on government policy. They encouraged his decision to become a photographer, and he taught himself the craft while working in the Merchant Marine after college and then as an assistant news-film editor. In 1976 he began his career in photojournalism on a newspaper in New Mexico, and in 1980 he moved to New York and became a freelancer for national magazines. A year later his first foreign assignment took him to Northern Ireland to cover reactions to the suicidal hunger strike of Irish Republican Army prisoners. Represented by the Black Star agency from 1980 to 1985, he was elected to Magnum in 1986. During these years he covered the civil war in El Salvador and unrest in Nicaragua and Guatemala. Nachtwey's first book, *Deeds of War,* 1989, revealed his courage in photographing under fire, his insistence on showing the horrors inflicted by both sides in conflicts, and his eye for disturbingly beautiful hues and patterns

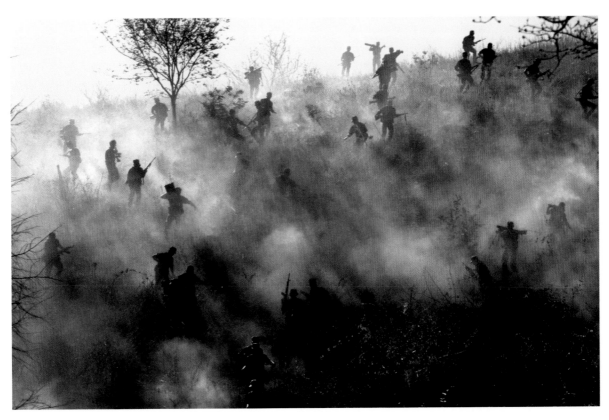

THE "WAR PHOTOGRAPHER" ON BEAUTY

Nachtwey was asked about "the function of beauty" in his "compositions" in an interview with John Paul Caponigro. He answered: "Beauty is inherent in life, and oftentimes, it's inherent in tragedy. It's nothing that I impose. It's something that I perceive. I don't think that in my pictures the beauty overcomes the tragedy. It sometimes envelops it and makes it more poignant. It makes it more accessible. The paradox of the coexistence of beauty and tragedy has been a theme in art and literature throughout the ages. Photography is no exception. The beauty of a Pietà is in the body language, it's in the connection between the mother and the son. The Pietà is not a figment of imagination, it's taken from life. A photograph that resembles a Pietà is not an imitation of art. It's a representation of the source of that art in real life. The beauty is still in the connection between the mother and the son."

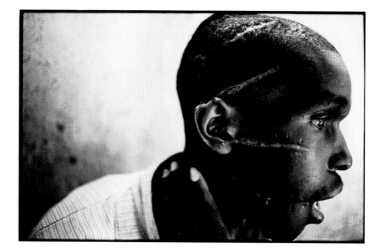

WIDELY CONSIDERED ONE OF HIS GENERATION'S BEST WAR PHOTOGRAPHERS, JAMES NACHTWEY PURSUES THE DETAILED PHOTOGRAPH THAT WILL TELL THE STORY OF A CONFLICT. HERE HE DEPICTS THE HORRORS OF THE RWANDAN MASSACRE BY THE SCARS LEFT BEHIND IN 1994.

of movement and form amid violence. In a typical image, a wounded fighter carried by his buddies resembles a Deposition of Christ.

From the mid-1980s, Nachtwey has photographed on contract for *Time*, and for *Life*, the *New York Times Magazine, National Geographic, Geo, Stern*, and *L'Express*, among other mass news magazines. He has covered breaking stories in the Philippines, Sri Lanka, South Korea, India, Brazil, Israel's West Bank and Gaza, Somalia, Sudan, South Africa, Chechnya, Bosnia, and the 9/11 attacks, one of the several events he documented that nearly cost him his life. The "ethnic cleansing" in Rwanda and Kosovo led to some of his most searing images. In *Inferno*, 1999, he selected and sequenced black-and-white photographs from these assignments to form a dossier of the late-20th-century's linked "crimes against humanity," in his words. Close-ups made with a wide-angle lens, figures cropped and framed for maximum physical immediacy, low vantage points to equalize the viewer and the victim: the total was cinematic and indicting, yet dirge-like. "The basis of the design, the size, the whole physical presentation," he said, "is to create an archive that will enter into our collective memory and our collective conscience." This was distinct from a museum exhibition of his essays, such as ICP's "Testimony," also 1999, or the assignments he took or initiated after 2001, when he left Magnum and formed the VII agency with six other pho-

tojournalists. His work's first purpose, he stated, is "to appear in mass circulation publications during the time that the situations are happening in order to … bring about an atmosphere in which change is possible." Its second purpose "is to enter into our memory so that these things are preserved and not forgotten …. Hopefully, we won't make the same mistakes we've made in the past." Presented with sophisticated awareness of different venues and audiences, Nachtwey's photographs are impelled by a sense of social justice and moral responsibility. They are potent additions to the history of engaged expression.

GILLES PERESS (B. NEUILLY, FRANCE, 1946)

Of today's highly respected photojournalists, Peress is among the most knowledgeable about media and among the most skeptical of its powers. He has documented the bloodshed and suffering of the late 20th century, from the struggle against British rule in Northern Ireland to the condition of Moslem "guest workers" in Germany. In all his books, he reminds the viewer of his presence, presents formally complex images to mirror complex political realities, questions any easy conclusions, and attempts to stimulate thought rather than play on emotions.

Peress's political engagement, adoption of photography, and, doubtless, his questioning stance date from his university days. In 1966-68 he studied at the prestigious, strongly Marxist

GILLES PERESS'S BOOK *TELEX. IRAN* WAS A HIGHLY CREATIVE AND PERSONAL WAY TO TELL THE STORY OF THE 1979 REVOLUTION IN IRAN.

Institut d'Études Politiques in Paris, and then at the Université de Vincennes, 1968-71. In these years student protests nearly toppled the government of premier Charles de Gaulle. Also in these years, deconstructivism and semiology in French philosophy spread through academe, refocusing attention from the authors of texts to their readers and the reading process, from *what* a text means to *how* messages are conveyed. In 1970 Peress adopted a camera: "Given the fact that …France in the late '60s [was] a fairly verbose period both intellectually and politically," he recalled, "I came to a distrust of words and the codes attached to any description of reality …. I had to find another tool … to stay sane and connected." His first subject was a French mining village in the aftermath of a bitter strike. His photographs led Magnum to invite him to join the collaborative agency, and he went on to be elected its president twice.

In the 1970s Peress launched what would be a 20-year project in Northern Ireland, where Catholics and Protestants battled one another and the British, and car bombings and assassinations were commonplace. His book *Power in the Blood*, 1997, gathered this work, and he considered it the first part of an ongoing project he called "Hate Thy Brother," on the toxic flowering of intolerance and nationalism in the postwar world.

In 1979 Peress went to Iran to document the impact of the flight of the American-supported Shah, the rise of Islamic fundamentalism, and "the hostage crisis," the media frenzy surrounding the 52 Americans held prisoner in the U.S. Embassy in Tehran. His book *Telex Iran: In the Name of Revolution*, 1983, wove together his "street" photographs—often of jagged, spatially dizzying images of crowds, black-shrouded women, political posters and slogans—and his telexed exchanges with Magnum, which mixed political observations with homely questions about money and other jobs. A group of these packed, cubistic images was published in the *New York Times Magazine* as "A Vision of Iran"—a title echoing Peress's own refusal of traditional photojournalism's Olympian authority.

For *Farewell to Bosnia*, 1994, on the systematic eradication of Kosovar Albanians, Peress organized his images not by chronology or pictorial narrative but by explosive themes, stating: "The book was very much conceived as a raw take, a sequence of work prints, which found its design accidentally on

the platen of a Xerox machine … a short burst of sequences on the same issues, the same moments." About his photograph of a weeping woman surrounded by photographers, he said: "Any work you do has an element of confession and autobiography, because you have to be honest to the reader that what they are about to see, hear, or read has gone through the distorting prism of one individual's subjectivity and has also been shaped by the limitations of any given media, be it photography, literature, cinema …." Peress also set up an extensive Web site with images made on a return trip to Bosnia in 1994.

The Silence, 1995, concerned the slaughter in Rwanda of nearly half a million Tutsi tribespeople by the majority ethnic group, the Hutus, in 1994. In 1997 Peress said he was taking more still lifes, showing the human impact on things. He was proceeding differently from "the classical photojournalist. The work is much more factual and much less about good photography …. I'm gathering evidence for history, so that we can remember." In exhibitions of his work, he is painstaking about presentation; alternatively, the Web sites he sets up, generally for each project, allow viewers to access changing images that pile up as documentation of what he calls "the abnormal behaviors that constitute crimes of war."

Like Peress, the Iranian photojournalists **Reza** (b. 1952) and **Abbas** (b. 1944) documented the 1978 insurrection that toppled the Shah of Iran, and Reza was the only photo reporter to witness the first moments of the takeover of the U.S. Embassy in Tehran, beginning the 444-day-long hostage crisis. For *Newsweek* from 1978 to 1983 Reza covered Iran and the fundamentalists' revolution, and then Iraq's invasion of his country. He may be best known for his work in Afghanistan, where in 1983-88 he represented the guerrillas' side in the war against Russia, and to which he has returned, significantly in 1990, when Soviet tanks killed hundreds of civilians in Azerbaijan; in 2000 when he and author Sebastian Junger described the Northern Alliance resistance for *National Geographic Adventure* magazine; and after the American invasion and removal of Taliban rule following the 9/11 attacks. Often focusing on children and women, Reza showed the victims of war and those overjoyed when Western freedoms came.

Reza began his career using a single name to protect his anonymity. Abbas had set the precedent; and in 1978-80 he covered the mullahs' revolution in Iran, which instated the Ayatollah Khomeini. Abbas relocated to France and then returned to his homeland on assignment in 1997; in 2002 he published *Iran Diary 1971-2002*, a critical view of the country's history with his photographs and text. He has also published books and photographic series on religions—Christianity, Islam, and animism—and on Mexico and Japan. Among his photographs of the Gulf War of 1990-91, the juxtaposition of an American tank and an Iraqi corpse typified his eye for the asymmetry of the conflict and his ability to evoke the conflicting cultures in succinct ironic images.

For the U.S. government and to a degree for Great Britain's since the 1980s, the photojournalism of war has become theater directed by military and political needs. Official censorship was complete, for example, in 1982 when the British invaded the Falkland islands, 300 miles off the coast of Argentina, to stop a right-wing Argentinian takeover of this longtime British colony. No non-British reporters were given access, and photojournalists suspected of being unfriendly, such as Don McCullin, were barred from the press corps. Those at home who objected to the action were labeled unpatriotic or treasonous, in the tradition of press intimidation.

In the Gulf War, 1990-91, the goal was clear and the stakes were higher, to drive occupying Iraqi forces from oil-rich, pro-American Kuwait following the dictator Saddam Hussein's successful invasion. U.S. government media handlers were more open, with daily briefings given the press, but those who chose to leave the press pool to work independently were given no further military information. The public was widely aware that the news was censored, and, according to one poll, 80 percent approved this. They were presumably happy with the spectacular bombings of Baghdad and the reporting from within the capital by CNN's Peter Arnett, who was himself censored by Saddam's officers. The weeks of initial air bombardment had a video-game quality (this was often called "the Nintendo War"), with American Patriot missiles supposedly killing Iraqi Scuds and other nighttime fireworks. Only a few targets destroyed by U.S. Stealth fighter

AVOIDING MILITARY CENSORSHIP, KENNETH JARECKE TOOK THE MOST LASTING IMAGE OF THE "HIGHWAY OF DEATH" DURING THE 1991 GULF WAR IN IRAQ.

bombings were shown, however, for "surgical precision"—a kind of bloodless victory—was claimed as the achievement of "smart bombs" and other high-tech weaponry. The coalition's public was spared the sight of civilian dead. When the lightning four-day ground war finally took place, the Iraqis' flight from Kuwait City was shown in aerial views as a total rout. It was only later that photographs began to appear, like Kenneth Jarecke's, of the incineration of the defeated soldiers along the "Highway of Death." Images of their massacre were few and primarily taken by French photographers and others outside the official press pool. More widely reproduced were photographs of Saddam's "eco-terrorism" in releasing Kuwait oil into the Gulf to thwart naval attack and the burning of multiple wells. If he was the Devil incarnate, here were the blackened skies of Hell.

As if in retaliation for the West's triumphant images of Desert Storm, terrorist organizations such as Al Qaeda have used camerawork and events for the press with increasing sophistication since 1991. The time between the first and second planes flying into the World Trade Center towers, for example, seemed to guarantee the maximum coverage of the attack, in a city that is a national press center. No disaster has been so fully documented. Since the U.S. invasion of Iraq in 2003, terrorists and their Iraqi supporters have executed coalition soldiers, civilians employed by the military, and relief workers in sometimes successful attempts to force the withdrawal of their countries' troops. The tools were videotapes of anguished pleas by the hostages, often followed by their beheadings. Western media

were caught between reporting the news with its heartrending drama and furthering the groups' goals of spreading terror. The view on the ground was more fully given by Arab television networks like Al Jazeera, yet the West was reluctant to use footage from this anti-American source.

Meanwhile the spread among amateurs of digital cameras, and cell phones with digital cameras built in, which allow easy Internet transmission of photographs, had unexpected consequences. In 2004 certain U.S. soldiers photographed their torture victims at Abu Ghraib prison in Iraq as souvenirs and also as means to humiliate the prisoners and thus extract information from them. The photographs came to light and proved that U.S. treatment of prisoners defied Geneva Convention protocols. The images were seized by terrorist organizations and Iraqi insurgents for posters inflaming anti-Western hatred and aiding terrorist recruitment. In America, they were evidence in the trial that led to prison sentences for the soldiers and effectively ended the career of the prison commander, and they have catalyzed divisions between pro- and anti-war factions in the American public.

The government of President George W. Bush has learned from previous wars (particularly Vietnam)—as can be expected of all governments—and it attempts to control the imagery from Iraq. In 2005, however, publication of another amateur photograph led to debate over a press blackout on showing the return of military dead in their coffins to a Delaware airbase. Some U.S. nightly newscasts continue to name and picture the latest casualties—a precedent set by Life for the Vietnam war. What remains unknown is the direction of public interest in Iraq, a distant war with many competing, battling parties—Sunnis, Shiites, Kurds, anti-Western insurgents, Western coalition troops dominated by Americans, and terrorist groups—a war that is reportedly becoming more hazardous to cover and to photograph independently.

One solution to both the information overload of daily cov-

erage of Iraq and government censorship was found by **Nina Berman** (b. 1960) in 2003-2004. Her book of 2004, *Purple Hearts: Back from Iraq*, combined her photographs of wounded American soldiers in their homes with their statements about experiences in the urban guerrilla war. The book was purposely apolitical: Berman avoided photographing implicitly pro-war homecoming parades and celebrity photo-ops with the soldier-"heroes," but also over-dramatizing the soldiers' often shocking injuries from car bombs and mines. "Together, the words and photographs create a complex, sometimes contradictory portrait of American youth," she wrote, "depicting their values and their dreams, the lack of opportunity many face after high school, the culture of violence or drugs that many tried to escape by enlisting, and the myths of warfare that influenced their decisions to join." Many of the soldiers said they supported the war or were just doing their job. Magazine publication of selections from the book led a soldier advocacy group to ask if she would permit their use on the group's Web site. The photographs proved to be powerful fundraising tools, and the group built a Web site for Berman in return. She also produced a video and, with a veteran amputee, she has spoken at high schools and other locales targeted by recruiters. The experience illustrated how to take a photo-essay beyond magazines and books, she said, calling it "a model for other photographers."

WORLD CONFLICTS AND SOCIAL ISSUES SINCE THE 1960S

In Europe much socially concerned photography since the 1960s has been grounded in a strong political sense of injustice, and its practitioners are widely traveled and international in their frame of reference. Their expression also shares the subjectivity that arose in all communication arts in the 1960s.

JOSEF KOUDELKA (B. BOSKOVICE, MORAVIA, CZECHOSLOVAKIA, 1938)

A sense of existential loneliness pervades the majority of Koudelka's photographs, and this bleak, inconsolable spirit has only darkened in the last 20 years. In retrospect, the pictures that launched his international career, of the Czechs' doomed

PHOTOGRAPHER UNKNOWN, 2003
EVIDENCE PHOTOS, SUCH AS THIS PHOTOGRAPH
FROM ABU GHRAIB PRISON IN IRAQ, CAN BE
DEFINING MOMENTS IN HISTORY.

PRECEDING PAGES: GERD LUDWIG SHOWS MEN
FISHING IN THE POLLUTED WATERS OF THE URAL
RIVER OUTSIDE THE LENIN STEEL WORKS IN
RUSSIA IN 1993.

uprising against Russia's invasion in 1968, strike a rare positive note, for these gripping documents show people sharing a cause and willing to die for freedom and country, as Koudelka was willing to do in making them. His powerful photojournalism is nothing if not personal, and it takes to an extreme that tendency evident in the genre from the 1960s.

As a teenager Koudelka photographed his family and small town, and while he worked as an aeronautical engineer in Prague and Bratislava in 1961-67 he was also a theater photographer. In 1961, the year of his first photography exhibition, he began documenting the Gypsies of Slovakia, who were under state pressure to assimilate. He extended the project to their nomadic communities in Romania in 1968. In that year, the USSR cracked down on its Communist satellite, and the "Prague Spring" of relative political and cultural tolerance ended with Soviet tanks in the Czech capital. Koudelka's photographs of a youth opening his shirt to a Soviet rifle and other acts of the population's futile defiance were smuggled out of the country with the help of Czech photography curator Anna Farova and published anonymously to protect Koudelka's family. He won the Robert Capa Gold Medal for them in 1970,

In 1970 Koudelka left Czechoslovakia and received asylum in England. He was introduced to Magnum, the photographers' collaborative, by Elliott Erwitt and became an associate in 1971 and a full member in 1974. His fifth book, *Gypsies*, 1975, showed the harsh lives and archaic rituals of clans across Europe, with the intimacy and occasional tough humor of an insider. His own rootless personal existence and refusal of most assignments seemed gypsy-like to more than one observer. In *Exiles*, 1988, his photographs of people at the socioeconomic margins in Ireland, Spain, Portugal, and Greece showed his expansion of the theme of alienation to include those impoverished and dislocated by unseen social forces. Taut and graphic black-and-white composi-

tions, these images freeze theatrical gestures and isolate revealing concatenations of figures out of the continuum of hard lives.

In 1986, for a project commissioned by the French government, Koudelka adopted a panoramic camera with a one-to-three proportion and began blowing up its 2 1/4 x 6 3/4-in. negatives to make mural-size photographs for exhibition. The commission was to photograph landscapes, and this and the format led him to scenes across Europe: characteristically he chose unpeopled places on the verge of extinction, despoiled by industrial exploitation and abandoned. "I have always been drawn to what is ending, what will soon no longer exist," he said in 2002. In pursuit of the cemeteries of the iron and steel ages, he went on to photograph in Greece, Poland, Romania, Ukraine, and Wales, publishing such books as *The Black Triangle* (on the Ore Mountains of Bohemia), 1994; *Reconnaissance Wales*, 1999; *Limestone*, 2001; and *En Chantier*, 2002. "Devastation is photogenic," he stated. "Tragic but beautiful …. In that wounded landscape I find an untamed beauty. Strength. The struggle for survival. After its destruction, land slowly begins to recover, to renew itself, and life begins again …. In that landscape you can see how strong Nature is. That it is stronger than Man."

In *Chaos*, 1999, the eminent photography publisher Robert Delpire, a longtime friend of Koudelka's, gathered selections

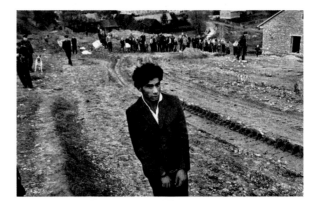

JOSEF KOUDELKA TOLD THE STORY OF
DISCRIMINATION AGAINST GYPSIES IN
CZECHOSLOVAKIA, 1963.

from his blasted landscapes, which now included war zones, and reproduced them in triptychs and sequences removed from their original projects and places. The presentation underlined formal qualities at the expense of the photographer's sociological concerns, recalling the abstracted and expressionist imagery of Minor White and Carl Chiarenza to some observers. But the overall message of the book and exhibition stressed Koudelka's lifelong, despairing quest for human meaning within the void.

SEBASTIÃO SALGADO (B. MINAS GERAIS, BRAZIL, 1944)

Salgado pursues compassionate photojournalism in the tradition of W. Eugene Smith, and with late-20th-century skills. This multilingual former economist has photographed in more than 60 countries, showing the impact of sociopolitical forces and technological revolution on the Earth's increasingly wretched. Through often epic images he asks Eurocentric viewers to grasp the struggles and dignity of the Mexican subsistence farmer, the African famine sufferer, the migrant Pakistani coalminer in India, and so on. "There is no third world," he says, "there is just one world." The beauty of his many prints of this world's heroic victims and the media attention paid to his well-orchestrated presentations of them have made him controversial.

Salgado grew up on a cattle ranch in Brazil, and studied economics at the University of Saõ Paulo, Vanderbilt University (U.S.), and the Sorbonne (Paris), where he completed coursework for a Ph.D in 1971. He then worked for the International Coffee Organization, but on a trip to Africa in 1973 he began photographing with his wife's Leica. Photography became his profession: he quickly joined the French agency Sygma, 1974-75, then Gamma, 1975-79, and then was elected to the Magnum collaborative. It represented him until 1994, when he founded his own agency, Amazonas, which is distributed by Contact Press Images. in the U.S. He identifies himself with what he calls "humanist, even humanitarian" photojournalism.

In supplying pictures of events to periodicals such as *Paris Match, Stern*, and the Sunday *New York Times Magazine*, Salgado covered the war in Angola, the Israeli hostages in Entebbe, and, most famously, the attempted assassination of President Ronald Reagan in 1981. But long-term projects resulting in books and exhibitions have been more typical. *Other Americas*, 1986, explored peasant life and rituals in villages across Brazil and Mexico through photographs made in 1977-84. *An Uncertain Grace*, 1990, concerned the poor *mestizos*' customs and faith. A related, more politically engaged project was *Terra: Struggle of the Landless*, 1997, on farmers in Brazil trying to acquire land. In *Sahel: Man in Distress*, 1986, he showed the peoples of that drought-blasted region of Africa. The profits from book sales

SALGADO: THE END OF MANUAL LABOR DIVIDES THE PLANET FURTHER

For an essay in *Workers: An Archaeology of the Industrial Age*, Salgado's wife and partner Lélia Wanick Salgado wrote in 1992: "This book is an homage to workers, a farewell to the world of manual labor that is slowly disappearing … a visual archaeology of a time that history knows as the Industrial Revolution, a time when men and women at work with their hands provided the central axis of the world." Because production is changing, she went on, work is changing, benefiting few. "The developed world produces only for those who can consume—about one fifth of all people. The remaining four-fifths have no way of becoming consumers because they have transferred so much to the developed world. So the planet remains divided, the first world in a crisis of excess, the third world in a crisis of need, and, at the end of the century—the second world—that built on socialism—in ruins." Yet she found hope and human heroism. History is "a testament to man's ability to survive. In history, there are no solitary dreams; one dreamer breathes life into the next."

benefited the emergency medical-aid group Doctors Without Borders. For *Workers: An Archaeology of the Industrial Age*, 1993, he photographed laborers in 26 countries, showing manual occupations about to be outmoded by mechanized agriculture, high-tech materials, and automation, throwing thousands out of work. An outgrowth of this survey, *Migrations: Humanity in Transition*, 2000, dealt with massive population movements across 43 countries—migrants seeking jobs and refugees from war and natural disasters. *The Children* was a corollary publication, a compilation of portraits made over six years in refugee camps. In 2001 Salgado portrayed the success of UNICEF in reducing polio in certain African countries and the need for wider vaccination.

Many of Salgado's black-and-white photographs in his handsomely printed books evoked religious art and so gave their subjects a Biblical timelessness. Did this suggest that suffering was inevitable and even redemptive, relieving the viewer of responsibility for help? Some critics thought so, and also damned the radiant illumination and careful design of Salgado's images as aestheticizing pain. He countered that "the most unbearable realities should be approached with the gentlest means, with the best composition, the most beautiful light, in order to involve people in the image so they understand that the beings they see who are suffering are people like themselves. These children could be theirs, this woman could be theirs, and they too could appear in the image. [By contrast] shocking [journalistic] images are so brutal that no one could ever imagine this could happen to them." He also told critic Patrick Roegiers, "to add ugliness to horror is fruitless." Furthermore, some of his subjects, even dying, saw beauty around them, and he sought to suggest this, rather than imitate television's "hyper-immediacy" and "instant death."

While pursuing his camerawork, Salgado also supports a foundation he created to help rebuild the rain forests

AN ECONOMIST BY TRAINING, SEBASTIÃO SALGADO STUNNED THE PHOTOGRAPHIC WORLD WITH HIS IMAGES OF THE RIGORS OF GOLD MINING IN BRAZIL.

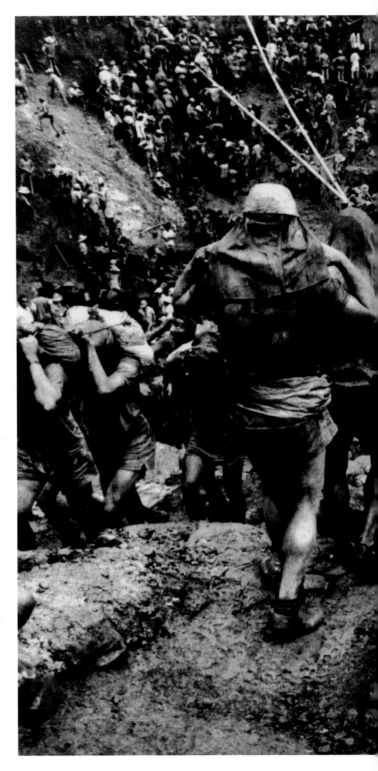

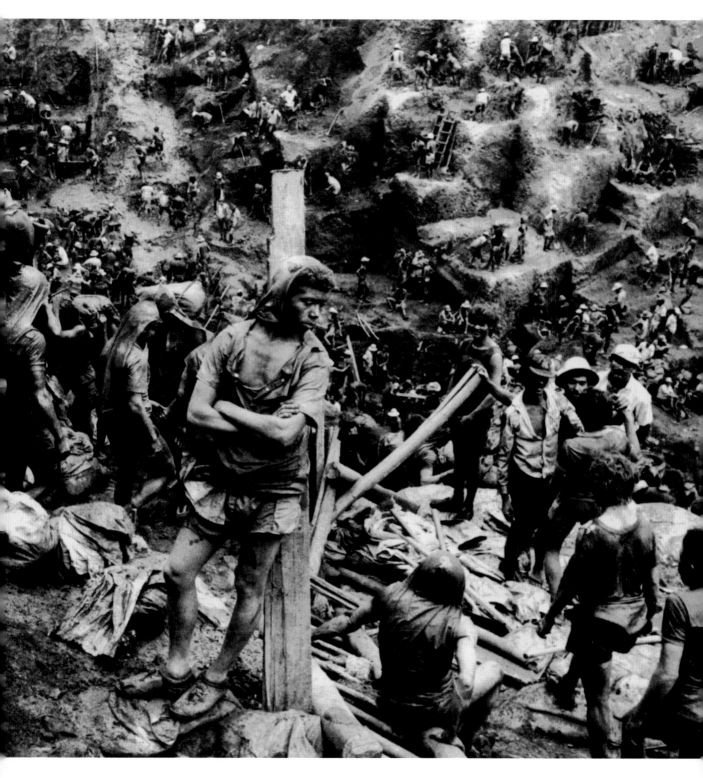

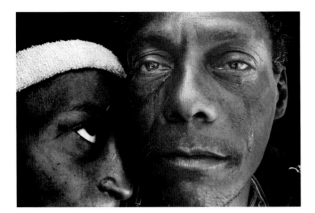

EUGENE RICHARDS ELOQUENTLY CAPTURED
THE HARDSHIP OF PRISON WHEN HE PORTRAYED
FRED, WHO HAS JUST SEEN HIS FORMER
GIRLFRIEND, ROSE, FOR THE FIRST TIME
AFTER HIS SENTENCE, IN 1986.

that his father and other ranchers cut down in Brazil before mid-century.

The tradition of compassionate concern is still alive in U.S. photojournalism today, but its expression is less often seen. Mass-circulation illustrated magazines have less impact, given the decline in their numbers, the glut of special-interest journals, and the rise of 24/7 news coverage on television and in cyberspace. The *New York Times Magazine*, *Stern*, *Paris Match*, and the Sunday *Times* of London are among those presenting high-quality photography to illustrate their contents, and they occasionally commission extended photo-essays. *National Geographic* remains an important venue for photojournalism, as do the German and French editions of *Geo*. But for a good look at the field, one must go to a bookstore, not so much a newsstand, and to museums and galleries, since books and exhibitions have largely replaced the picture press as outlets for important social expression. They are Eugene Richards's primary means to his public.

EUGENE RICHARDS (B. DORCHESTER, MASSACHUSETTS, 1944)

A photojournalist of compassion and unflinching honesty about society's afflicted ones, Richards extends the tradition of W.

Eugene Smith on America's domestic front. Gripping, graphically powerful stories in black and white, made over months and sometimes years with his subjects' cooperation, have won Richards numerous honors over the past 30 years. As Smith was, he is a member of Magnum, and likewise his projects have had high impact at the International Center of Photography and elsewhere. But the differences between the two men's work reveal not just their characters but U.S. society since the mid-1970s, when Smith published his last book and Richards his first.

Richards grew up in Dorchester, Massachusetts, a working-class town outside Boston, and was graduated from Northeastern University with a degree in literature and journalism. At the Massachusetts Institute of Technology, he studied with the art photographer Minor White, who gave Group f64 values a metaphysical cast. In 1968, a year of widespread student protests against the Vietnam War, Richards joined VISTA, a stateside social services counterpart of the U.S. Peace Corps, and was assigned as a health care advocate to eastern Arkansas. There he helped found a service organization and a community newspaper reporting on black political activity and the Ku Klux Klan. The experience generated his first book, *Few Comforts or Surprises: The Arkansas Delta*, 1973. Revisiting his birthplace produced *Dorchester Days*, 1978, while *Exploding into Life*, 1986, dealt with his companion's losing battle with cancer, contrasting individual anguish and healthcare bureaucracy—topics then rare in photojournalism. In these years, Richards also contributed photo-essays to U.S. periodicals, notably on the warehousing of the mentally ill, but his books gave him forums for extended, nuanced explorations of themes he knew firsthand.

In the boom years of Reaganomics, when federal policies widened the gap between the haves and have-nots, Richards depicted the impact of poverty on individuals in *Below the Line: Living Poor in America*, 1987, and on poverty's corollary, the violence of life for the urban underclass, in *The Knife and Gun Club: Scenes from an Emergency Room*, 1989. An outgrowth of the topic, *Cocaine True, Cocaine Blue*, 1994, showed the lives of crack addicts in Harlem, Philadelphia, and Red Hook, New Jersey. None of these books had heroes, and the "villains" were unseen social forces and human weakness. This

made Richards's close-ups of poor people all the more scorching, and in *Cocaine Blue* they were often also skewed and grainy, as if seen with a crack high. Some black activists were outraged, though Richards revealed an equal-opportunity scourge striking all ethnicities: he had presented a crisis, but no answers, unlike Smith at *Life*.

Subsequent books included *Americans We*, 1994, *Stepping through the Ashes*, 2002, and *The Fat Baby*, 2004, on survivors' efforts to mourn and make sense of the 9/11 attacks on the World Trade Center. A theme of recent concern is the fate of the aged in America, and he made two documentary films, in

MARY ELLEN MARK PUSHED DOCUMENTARY PHOTOJOURNALISM INTO THE ART WORLD WITH HER COMPLEX, ENDEARING PORTRAITS OF THE CHARACTERS SHE MET, LIKE TINY IN SEATTLE.

2000 and 2003, on the transition from home to nursing home and on life inside such a facility. Like the best of his photo-essays, these films personalize topical social problems that are overlooked or willfully ignored. They admit the complexity of the issues and refrain from judgment. Their immediate, even diaristic intimacy removes the photographer from any pedestal, and aims to arouse the viewer's authentic response.

Sympathetic treatment of difficult social subjects also typifies the work of **Mary Ellen Mark** (b. 1940), and like Richards she has pursued long-term projects on the edges of society. Homelessness, teen runaways, prostitution, and the warehoused mentally ill came to public attention in the late 1960s and '70s and were soon seen by many as insoluble problems, but she gave their complexity a human face. "Tiny," a Seattle runaway who turned tricks, the brothels of Bombay, a California family reduced to living in their car, the children working in India's circuses—all presented themselves with unsentimental frankness in her photographs. These graphically strong images crystallized a mixture of individual personality and social predicament in acutely observed body language and expression: these were "environmental portraits," in Mark's phrase. She published them in such periodicals as *Life* and in book form: e.g., *Ward 81*, 1979; *Falkland Road* (Bombay), 1981; *Streetwise*, 1988. The decline in magazine numbers has affected her, as it has all photojournalists, and has made her entrepreneurial. To finance her series on circus performers, for example, she invested her own funds (earned largely from portrait commissions) and secured a Kodak grant and a *Life* guarantee of publication.

The support of *National Geographic* magazine, in staff positions for photographers and commissions for extended work on individual stories, has helped make the careers of more than a dozen photographers since the 1970s. The best-known today may be **Steve McCurry** (b. 1950), thanks to his widely reproduced 1984 portrait of a young refugee whose parents were among the civilians killed in air strikes in the Russian-Afghani war. McCurry showed her as classically beautiful in her red shawl, with green eyes filled with fear: the image, a *National Geographic* cover, aroused widespread protective feelings, and

DIANA WALKER CAPTURED A MOMENT INSIDE THE
WHITE HOUSE THE NIGHT BEFORE THE EXPECTED
VOTE ON PRESIDENT CLINTON'S IMPEACHMENT.

when he returned to find her 17 years later, the follow-up story inspired gifts that allowed him to co-found an agency operating schools and medical centers in rural Afghanistan.

McCurry's photograph came out of his continued coverage of Afghanistan, which began when he documented the start of the Russian invasion in 1979—pictures awarded the Robert Capa Medal. He has photographed other wars and civil strife—Iran-Iraq, Beirut, Desert Storm—but he may be better known for his meditative books synthesizing the results of his long fascination with India and Tibet, notably *Monsoon*, 1995, *South Southeast*, 2000, and *The Path to Buddha: A Tibetan Pilgrimage*, 2003. These incorporate more topical images into essays revealing the cultures and landscapes of these countries.

The problem of depicting Third World peoples to First World readers without condescension is partly solved by the intimacy of the portrayals. **David Alan Harvey** (b. 1944), a Magnum member and *National Geographic* photographer like McCurry, often plunges into festivities where he goes unnoticed or befriends his subjects, and his resulting close views—sometimes blurred and tilted like Garry Winogrand's—witness his acceptance and full-bodied immersion in the lives he describes. The Spanish-speaking world has absorbed him for some 30 years, and since he first photographed Cuba in 1996, he has returned nine times for *National Geographic*. Like **Alex Webb** (b. 1952) in Haiti, he caught the brilliant contrasts made by hot light and tropical colors and the verve of animated figures tightly framed and shot with a wide-angle lens. The contradictions of a Caribbean culture under socialism intrigued him. "Enjoying a place and making a good story are two different things…. You have to have a little bit of tension there for a good story." His book *Cuba: Island at a Cross Road* was published in 1999; *Divided Soul*, on peoples of the Spanish and Portuguese diaspora in Mexico, Cuba, and Brazil, appeared in 2003.

The problem of human interest stories about Americans for

American readers is different. The task is not tactfully handling the foreign but making the familiar new. Some stereotypical cues may require inclusion—a Las Vegas story needs a showgirl, or at least her feathers. And the "tension" Harvey seeks in Latin lifestyles colliding with politics has to come from something else. **William Albert Allard** (b. 1937) found it for the subject of cowboys in the nature of their hard solitary lives and in the aging of one man. "Arizona, 1971," is Allard's signature image, of an old cowpoke, Henry Gray, lost in thought, with a steer's head and a 48-star American flag mounted on the wall behind him. It shows Allard's characteristic knack for getting close to people; his interest in assignments with "a significant spiritual stake," and his belief that "photographing the situation [isn't] nearly as interesting as photographing the edges." The "situation" for this shadowy color photograph was a *National Geographic* assignment to photograph on the nearly 2,000-mile border between the United States and Mexico. Allard has photographed for the magazine for 35 years, and is credited with contributing an essay in 1965 that helped redirect the monthly toward more socially engaged, interpretive photojournalism. This story, on the Amish of Pennsylvania, was commissioned by Director of Photography Robert Gilka, who brought some of the urgency and topicality of newspaper journalism to the organization from the 1960s on.

The balance of artistry and information in photojournalism

has always varied with the photographer and the outlet. As books and exhibitions have overtaken magazines as preferred avenues for serious reportage, aesthetic qualities have gained importance. **Sam Abell** (b. 1945) has worked for *National Geographic* since the 1970s and published nine books with the Society on subjects including gardens, the Galapagos, the Australian outback, and the westward voyage of Lewis and Clark. Whether in emblematic still lifes or action shots, he prefers balanced compositions in which successive planes lead the eye into depth. His previsualization of effective story-telling pictures, patience in waiting for the human and artistic moment, and ability to judge lighting without elaborate equipment make him a persuasive teacher.

W. Eugene Smith remarked: "I realized to be a good photojournalist I needed to be the finest artist that I could possibly be." But Alex Webb told curator Adam Weinberg: "I'm bored by pictures that don't on some level make you think about the world. I don't want to just be able to see my navel in fascinating ways." **Manuel Rio Branco** (b. 1946), who makes evocative color images of his fellow Brazilians and others, comments that he begins with an "anthropological approach," but "photojournalism is the … ground where I put my feet before taking off for a flight." The sensuous pleasures yet complex meanings purveyed by these photographers are of course altered by how and where their photographs are presented. An image by **Luc Delahaye** (b. 1962) of a dead Afghan rebel becomes, in a large print in a New York art gallery, somewhat disconcertingly, a study in browns. McCurry's Afghan refugee is now a cover girl. So images first grounded in history, like the battles of Alexander the Great, become museum art.

JODI COBB CAPTURED SCENES OF RURAL LIFE FROM MENTONE, TEXAS, IN 2000.

FLASH PHOTOGRAPHY
BEYOND NATURAL LIGHT

T he 1800s took place in the bright light of day, since sunlight was originally the only source of lighting sufficient to record an image on the low-sensitivity media used by early photographers. But even the first photographers sought ways to make images in dark or low-light settings. However, until the sensitivity of their materials was improved, they were unable to make exposures by common sources of artificial light, such as gaslight or tungsten lamps. Instead, they turned to the technique of flash—a brief, intense light that allowed them to capture images of poorly lit subjects.

The earliest type of flash was limelight, produced by heating lime with an oxygen-hydrogen gas flame. The burning lime gave off an intense light. L. L. B. Ibbertson demonstrated this type of illumination in 1840 at London's Royal Polytechnic Institution, and soon portrait photographers were using limelight in their studios. The quality that made limelight effective was its strong blue component, which worked well with the blue-sensitive media of the time.

But because its use resulted in harsh images, limelight soon fell out of favor.

William Henry Fox Talbot, the inventor of the first practical method of negative-to-positive imaging in the 1830s, experimented with illumination provided by a high-voltage spark from a Leyden jar. Using this technique, Talbot took a picture of a rapidly spinning newspaper during a lecture at the Royal Institution in 1851, thereby demonstrating the principle of stopping motion with a high-speed flash for the first time. The spark that Talbot used yielded an estimated exposure time of 10 millionths of a second.

In the early 1860s, portrait photographers experimented with a chemical light produced by burning a mixture of potassium nitrate, sulfur, and antimony. Called Bengal light, this material created an intense blue illumination that lasted several seconds. Unfortunately, the burning chemicals gave off poisonous fumes, and the system was quickly abandoned.

About that same time, French photographer Gaspard Félix

Tournachon, known professionally as Nadar, made use of Bunsen batteries and reflectors to take a series of some hundred photographs in the catacombs of Paris. In 1864, photographers in England used burning magnesium wire to light photographs taken in underground mines. Two years later, American Charles Waldack used the same material to illuminate the photographs he took inside Kentucky's Mammoth Cave. In the 1880s, a powder made of magnesium and potassium chlorate became the standard for flash photography, and it continued to be used until the creation of a prototype flashbulb in 1925 by Germany's Dr. Paul Vierkötter, who encased magnesium wire inside a glass bulb, creating a safer, smokeless flash.

Flashbulbs of various designs dominated flash photography prior to the introduction of electronic flash, which came about through experiments in the 1930s at the Massachusetts Institute of Technology. Researchers there developed a flash device using an electrical discharge inside a gas-

filled tube. Unlike the light produced by flashbulbs, which takes time to reach peak output, an electronic flash unit's peak is instantaneous, although there is a slight delay between susccessive flashes while the unit's electronic circuits recharge to sufficient voltage. The first electronic flash units were marketed for studio use around

NICK NICHOLS CHOSE A FLASH FOR THIS PORTRAIT OF AN ETHIOPIAN GELADA.

1940. Despite the fact that most modern cameras—even inexpensive recyclables—come equipped with built-in electronic flash, photographers still use flashbulbs for special requirements, including

cave photography and imaging related to research on explosives and the testing of aircraft engines.

Soon after William Henry Fox Talbot demonstrated the possibilities of stopping motion with flash, photographers became fascinated with making pictures of a variety of fast-moving objects. In 1858 photographers at the British War Department captured the fastest object that then existed—a bullet in flight. They managed the feat by using a variation of Talbot's spark technique. In the 1890s Lord Rayleigh used sparks to photograph a stream of water breaking into drops. Among the most familiar stop-action images are those made with high-speed stroboscop-

ic light, pioneered in the 1930s by MIT's Harold E. "Doc" Edgerton. Edgerton's strobe lights and underwater cameras produced many of the startling deep-sea images published by *National Geographic* over the years.

Besides illuminating an underlit scene or stopping high-speed action, flash photography has come to be used in other ways. Pictures taken in daylight can benefit from fill-in flash, which can counteract extreme backlighting and soften hard shadows. Flash can also highlight a subject or create a special effect. In the 1930s and '40s, New York crime photographer Arthur Fellig, known as "Weegee the Famous," used a harsh flash to render his subjects in the starkest possible light.

For the average photographer, coping with the technical requirements of flash can be daunting, which is why high-quality cameras now come with such features as auto-flash, fill-in flash, and red-eye reduction. But even these conveniences can still result in a harsh, flat-looking photo that bears little resemblance to the refined images achieved by a professional—illustrating just how complex the proper use of lighting can be, whether the light is natural or artificial.

PICTORIALISM & EARLIER ART

Can photography be art? Today the question is rarely asked. The medium is nearly 170 years old, and thousands of choice examples are treated as art and understood as unique personal expression. Photography has its own department in almost all the world's major museums; there are close to 30 institutions devoted to collecting and exhibiting it internationally; and over a hundred galleries in New York City sell photographic prints at all price levels. In 1999 one of them sold a photograph by Man Ray for $1.3 million. Auctions, magazines, books, and critical coverage in the art press have raised interest in art photography, arguably beyond the level of interest in comparable prints and drawings. But such enthusiasm was a long time coming. The text in this and the following two chapters traces photographers' pursuit of equal standing with other graphic artists and the kinships of their styles and concepts with those of contemporaneous painting movements. A theme is how such camera work caught up with vanguard painting in innovation.

THE MID-19TH-CENTURY PHOTOGRAPH AS SERVANT

Photography's contested status as an art form derived from the mid-19th century's profound ambivalence about the machine and its products and about realism in art. The camera and photograph were nothing if not mechanical and chemical. "By means of this contrivance," William Henry Fox Talbot wrote in 1839, "it is not the artist who makes the picture, but the picture which makes ITSELF." In supporting the verisimilitude of his "sun pictures," he implicitly denied the creative variables he himself exercised in making photographs (variables intrinsic to photography today: choice of camera, film, subject, vantage point, framing, focus, and exposure time); and treating the art and chemistry of developing and printmaking. The French aesthetician Charles Blanc, echoing poet and critic Charles Baudelaire, claimed that because "photography copies everything and explains nothing,

"CLEFT OF THE ROCK," 1912: ANNE BRIGMAN, THE ONLY WESTERN MEMBER OF THE PHOTO SECESSION GROUP, CHOSE TO PHOTOGRAPH THE FEMALE NUDE IN DRAMATIC LANDSCAPES.

it is blind to the realm of the spirit." The camera as a machine has no imagination; and if photographers are mere technicians, they have none either.

A grudging admission of the merits of some photographs was voiced in 1872 by John Ruskin, Great Britain's leading art theorist: "For geographical and geological pursuits they are worth anything." But he added: "for art purposes' worth—a good deal less than zero." When accurate detail and consistent light were wanted, the camera could be accepted as a useful tool. But since Ruskin and others defined art by its aesthetic refinement and its inventive genius, its ability to raise the spirit to contemplation of the "Supreme Creator of all beauty and goodness," they found the "unreasoning machine" lacking. Realism in art itself was controversial at mid-century, and the growing popularity of verisimilitude in all media alarmed elitist opinion makers. The pinnacle of art, as defined by the French Académie des Beaux-Arts in the 17th century and exhibited annually at its Salons, was still the history painting—a moralizing theme from history or great literature composed with figures of ideal beauty. Gustave Courbet's contemporary rural scene, *A Burial at Ornans*, 1849-50, was called "the burial of painting"; and Baudelaire's poems and the writing of Gustave Flaubert were prosecuted for indecent frankness in the 1850s. It was plain that official taste was threatened by sharp-eyed observation—which included the camera's "truth."

Meanwhile art photographers denied they were products of an ardently curious and materialistic age. To establish their distance from cut-rate portraitists, ambitious professionals promoted their artistry. With the goal of raising the taste level of their field, they published journals on the principles of art as well as the practice of their craft and formed photographers' associations in the early 1850s. *La Lumière* (The Light) began biweekly publication in France in 1851, including criticism as well as technical advice. In 1853 the Photographic Society of London was founded. The following year the Société Française de la Photographie began, and like the RPS it initiated regular exhibitions of its members' photographs (it, too, functions today). In 1862 the Photographic Society of Philadelphia was formed, and by the end of the decade such associations could be found in most major cities internationally.

These societies passionately agitated for the display of photography in the art sections of the era's world's fairs and national expositions. The 1851 Great Exposition at the Crystal Palace in London relegated photography to the "Philosophical Instruments" division of the Machines section; and at the 1855 Exposition Universelle in Paris, photography was ghettoized in the Industry Pavilion. At the 1859 Salon in Paris, nine calotypes by Gustave Le Gray were hung among the lithographs, but then recognized as photographs and moved to the Science section. That year a defender of camerawork asserted: "Photography is a process like engraving and drawing, for what makes an artist is not the process but the feeling." Because some photographs were indeed made to serve science, and others to rival art, the issue continued to be debated, but in the 1880s photographs were finally included in Salon exhibitions.

There was never a question that photography could aid art. Portrait painters might work from photographs, which conveniently translated three dimensions into two as they recorded features and proportions, while "académies," or nude studies, served as substitutes for live models and preliminary drawings. French photographers excelled in producing the latter, perhaps understandably, for study from the nude was the cornerstone of artistic training. The great Romantic painter Eugène Delacroix attempted to learn daguerreotypy and collaborated around 1853 with **Eugène Durieu** (1800-1874) to photograph nudes as odalisques, while Gustave Courbet worked in the same years from prints made from wet collodion negatives of meaty models possibly by **Julien Vallou de Villeneuve** (1795-1866). The same prints might please erotic tastes, and also serve the personal expression of the photographer. Vallou, a former painter, posed his quiet figures as milkmaids and other genre types, with ample forms and ingenuous feeling. The small prints, with few studio baubles, were charming additions to connoisseurs' albums. **B. Braquehais** (active 1850-1874), on the other hand, surrounded his nudes with ballooning draperies and plaster statues, which themselves allowed study of tonal subtleties.

ALFRED STIEGLITZ (SECOND FROM LEFT) AND
EDWARD STEICHEN (FAR RIGHT) TRAVELED WITH
FRANK EUGENE TO LEARN ABOUT THE
AUTOCHROME PROCESS IN 1907.

In England, the former painters **Oscar Rejlander** (1813-1875) and **Henry Peach Robinson** (1830-1901) photographed female nudes, not only for incorporation into larger compositions but as independent displays of their aesthetics and art-historical knowledge. In meeting current classicising tastes, Robinson produced the antique "wet drapery" effect literally, by dressing his models in moist white fabrics tinted with coffee to lessen tonal differences from their chilled skin.

The dialogue between photographers and painters continued from the 1850s on, and while photographers adopted aspects of official art, adventurous painters appropriated less calculated components of the new technology. In England such Pre-Raphaelite painters as John Everett Millais and Dante Gabriel Rossetti used prints as figure sources, while in France vanguard leaders from Edouard Manet to Camille Pissarro and Edgar Degas exploited photographic effects such as abrupt tonal contrasts, blurred figures in crowd scenes, elements cropped by the frame, and data from motion studies. Degas and the American realist painter Thomas Eakins became accomplished photographers in their own right.

IMITATIONS OF VICTORIAN PAINTING

That photography could rival accepted art, with its instructive, idealizing, and narrative goals, was a conviction shared by the British practitioners Fenton, Rejlander, Robinson, Lewis Carroll (the Reverend Charles Dodgson), **William Lake Price** (1810-1896), **David Wilkie Wynfield** (1837-1887), and others in the RPS. Price exploited the popularity of illustrated literature in *Don Quixote in His Study*, early 1850s, for example, while Julia

Margaret Cameron, famed for her portraits, volunteered to depict scenes from her friend Alfred, Lord Tennyson's *Idylls of the King*, 1859-85. Wynfield portrayed artists in the guise of those they admired—Millais as Dante, 1860-65, for instance—and thus encouraged Cameron in her pursuit of poetic typologies of great men.

Fenton, who encouraged Queen Victoria and Prince Albert to learn camera technique, photographed their children in a tableau of the Four Seasons, with Prince Alfred as Autumn on a wine cask like Bacchus (to the Queen's dismay). With period sentiment, he also staged the Four Stages of Courtship for *A Romance*. In 1860 he dressed and photographed figures as

Nubians and Turks in rivalry with coeval Orientalist paintings; and he won acclaim for his picturesque landscapes and luxurious, over-life-size still lifes, which flaunted Great Britain's superiority in manufacturing decorative arts by including ostentatious examples. As official photographer at the British Museum from 1854, he fulfilled the government's ambition to raise public taste through spreading knowledge of artworks. In this goal, photography was the perfect servant. Indeed, it fostered popular appreciation as it helped create modern art history, which began with concerns for authentication and comparative dating of widely scattered objects.

As for overtly artful, constructed photographs, the storytelling tradition in British art encouraged elaborate studio and darkroom manipulation. As in contemporary tableaux vivants, a popular entertainment form with frozen enactments of acknowledged masterpieces, models were costumed and posed alone or in small groups, against suitable backdrops. Then they were pho-

OSCAR REJLANDER USED "COMBINATION PRINTING" IN 1860 TO CREATE THIS "SPIRITISTICAL PHOTOGRAPH," AS MARKED ON THE PRINT, AND TITLED IT "HARD TIMES."

tographed, and the resulting negatives were masked, combined, and printed as storytelling compositions on a single sheet. This "combination printing" solved the directorial problem of coordinating multiple actors and the photographic problem of dealing with limited depth of field and consequent unequal focus. The manipulation itself was worthwhile, in the view of these photographers: "a method that will not admit of the modification of the artist cannot be art," Henry Peach Robinson insisted. "All arts have their limits, and I admit that the limits of photography are rather narrow, but in good hands it can be made to lie like a Trojan." While Robinson used combination printing for a wide range of sentimental and decorative compositions in the 1850s-70s, Oscar Rejlander gave the device its first fame.

The artistry of Rejlander's best-known photograph (then and now) is unmistakable. *The Two Ways of Life*, 1857, is a catalog of poses and of Victorian definitions of virtue and vice. The photographer made over 30 negatives to illustrate Industry and Dissipation, using 28 models from a troupe specializing in tableaux vivants. Scantily and classically draped, the models present vignettes of gambling, sloth, and debauchery on the left, of piety, charity to the sick, and manual labor on the right. The architecture, centralized layout, and theme of choice would have recalled Raphael's *School of Athens* to educated observers: Rejlander had been one of that fresco's many copyists when he was a painting student in Rome in the 1830s. The intended instruction and moral uplift of the photograph commended it to Victorians, who expected art to aid self-improvement. And though the models' nudity and shady reputations were scandalous to some, Prince Albert bought a print, and it won a gold medal at the Manchester Art Treasures exhibition of 1857.

Rejlander, stung by the uproar over his nude actresses, never attempted such a complex tableau again, but he portrayed characters from literature, such as Poor Jo from Charles Dickens's *Bleak House* (forecasting later documentation of the poor), sold nude and drapery studies to artists, and made portraits of society figures and notables such as Lewis Carroll, whom he inspired to adopt photography. In London he replaced the studio he had opened in 1862 with a more opulent one in fashionable Belgravia in 1869. And in 1872 he provided seven illustrative photographs for Charles Darwin's *The Expression of the Emotions in Man and Animals*, including himself as "Wrath" and "Helplessness."

When Rejlander died, his theatrical style and didactic content were long outmoded. But he had established the importance of imagination in photography, the role of artistic principles in its genesis, and the right of the photographer to alter reality. Nonetheless, Robinson, his colleague and junior, had been quicker to grasp that the verism of photography was better suited to scenes of contemporary life than to moralizing inventions. For his best-known combination print, "Fading Away," 1858, Robinson used five negatives to picture a fatally ill girl and her grieving family—a topical theme in a period when tuberculosis and other wasting diseases were widespread. Some critics were offended by the theme; others, who found beauty in melancholy subjects, were touched.

Along similar lines, Robinson's "Lady of Shalott," 1861, portrayed Tennyson's doomed medieval heroine, and emulated Millais's painting of Shakespeare's Ophelia. That the photographer was scored for attempting to illustrate literature reflects the rising tide of realism in the arts and the resistance to photography as artful. Robinson's response was the nearly four-foot-wide "Bringing Home the May," 1862. Using nine negatives, this depiction of contemporary rural girls celebrating May Day offended no one. Such unimpeachable themes as the poignant cycle from youth to age made Robinson's prints popular through the 1880s. At the same time, his 11 books on photography and voluminous essays promoted artistic camerawork. His 1869 *Pictorial Effect in Photography: Being Hints on Composition and Chiaroscuro for Photographers* was the fullest expression of his ideas and gave the word "Pictorial" to the camera artists who banded together—Robinson included—in the 1890s.

PICTORIALISM

The international rage for the new Kodak push-button camera helped propel art-loving photographers to band together in the 1890s and early 1900s. "Pictorialism" is the most familiar term for their moody "Aesthetic" or "Salon" photography: they sought to distinguish themselves from the mobs of hobbyists and vulgar commercial photographers who had multiplied since the 1880s, when industry began to take over film pro-

cessing and eliminated the practitioner's need for special technical knowledge. Earlier photographers had sworn that the camera could serve art as well as science, but the Pictorialist crusade was new in its international scale, effective organization, self-promotion, and success. The camera, most critics admitted by 1910, could be a tool of individual expression, on a par with other print media. Photographs could embody "art for art's sake," not to speak of the artist's genius.

Pictorialists fought for fine-art status on every ground: style, technique, content, and print presentation. Given their widespread preference for soft-focus effects—produced with gauze over the lens, specially made lenses, or pinhole cameras (no lens at all)—their work was dubbed "Fuzzygraphics." Some in fact liked sharp-focus details, with a differential focus for a soft perimeter; others embraced new pigment processes, like gum bichromate and bromoil, that allowed handwork on negatives and prints, thus ensuring a work's uniqueness. Almost all evoked aspects of 1890s painting—whether the twilit poetry of American tonalism, the atmospherics of late Impressionism and Symbolism, or the flattened and simplified, often asymmetrical compositions of Japanese prints and screens and the homages to them by the painter James McNeill Whistler. Against the realism widely felt to be intrinsic to film, these camera artists adopted for photography Mallarmé's credo for poetry: "To name an object is to do away with three-quarters of the enjoyment to be found in the poem. To *suggest*—that is the dream."

Pictorialist subjects echoed those in advanced art of the 1880s on, and their graceful maidens, reticent nudes, loving mothers, noble peasants, and misty landscapes were openly escapist. Even New York and London—real-life sites of drastic social and physical change—became remote picturesque skylines. Pictorialism, like Aesthetic painting, sprang from fin-de-siècle culture, which had lost faith in positivism and material progress and preferred imagined or recollected realms to mechanical imitations of the everyday world. "Life," sniffed the hero of J.-K. Huysmann's influential novel *A Rebours* (Against

the Grain), "our servants see to that for us." The Pictorialists aimed to appeal to such heroes, who were connoisseurs of fine prints, and to the increasingly literate public, and so they formed clubs, circulated exhibitions across Europe and the United States, published handsomely printed magazines, and fostered critical debate and advocacy. At the same time, they tapped the moralizing side of Aestheticism in the arts, which found the industrialized environment ugly and considered beautification a social duty. Beauty in photographs—or in any other artworks—could be spiritually uplifting, according to thinkers in the Arts and Crafts movement and Art Nouveau groups, groups that supported Pictorialism.

Most camera associations founded in the mid-19th century served photography's many purposes: commerce, science, pastime, art. To pursue art exclusively, however, the Pictorialists "seceded" from parent organizations, forming the Vienna Camera Club, 1891; The Linked Ring, London, 1892; the Photo-Club de Paris, 1894; and the Photo-Secession, New York, 1902; in addition to societies in Germany, Italy, Russia, several South American countries, and Japan.

The Vienna Camera Club was first to reach the public, with an international juried exhibition of art photographs in 1891. Alfred Stieglitz helped organize the American submission, and out of 4,000 entries, 600 prints were hung (including Stieglitz's). The German **Heinrich Kühn** and the Austrians **Hugo Henneberg** and **Hans Watzek** became the club's outstanding members, known for their experiment with new printing techniques and, by the first decades of the 20th century, the Autochrome full-color process. From 1897 to 1903 the trio traveled and exhibited together as Das Kleebatt (or Trifolium, for cloverleaf). Other camera groups and advanced painters' societies welcomed them, typifying the internationalism of the Pictorialists and their success in bridging media. The three were elected members of both The Linked Ring and the Photo-Club de Paris by 1896. The Munich Secession showed Watzek's gum bichromate photographs in 1898, and the

AN AUTOCHROME ENTITLED "MISS MARY
AND LOTTE (?) AT THE HILL CREST,"
CIRCA 1910, BY HEINRICH KÜHN

Vienna Secession exhibited Henneberg's gum prints in 1902.

Kühn's reputation was spread by Stieglitz's reproduction of his prints in *Camera Work* in 1906 and 1911: the tranquil, idealized images, particularly of genteel women and children, recalled the idyllic spirit and Japanist form of works by Clarence White and the painter John Singer Sargent. Kühn met the Americans and corresponded with Stieglitz from 1899 through 1933. He operated a portrait studio from 1906 to 1919, and after 1920 devoted himself to writing about photography and inventing camera equipment to further its artistic potential.

IN 1890 GEORGE DAVISON SHOWED "THE ONION FIELD" AT THE PHOTOGRAPHIC SOCIETY OF GREAT BRITAIN EXHIBITION, TO GREAT ACCLAIM. DAVISON BECAME A FOUNDING MEMBER OF THE LINKED RING IN 1892.

In London in 1892 both negative and positive energy spurred 15 British photographers to found The Linked Ring (an idealistic title recalling that of the Pre-Raphaelite Brotherhood of Victorian painters). The "Links" rebelled against the conservative Royal Photographic Society and commercial photographers with their mechanically detailed gelatin silver photographs on glossy paper. They admired subjects softened by special lenses, all the hand processes, the dense blacks of photogravures, the silvery softness of platinum papers, and prints made on coarse stock, which could resemble charcoal sketches. Landscape and portraiture were their favorite genres, as they were of British painters historically. But aesthetics ranged from the Impressionism that George Davison created with a pinhole camera and the sonorous darkness of J. Craig Annan's photogravures to the pale refinement of Frederick H. Evans's platinum prints. From its first exhibition in 1893

"SPEED" BY ROBERT DEMACHY WAS FIRST
SHOWN IN *CAMERA WORK* IN JULY 1904.

through the dissolution of the group in 1910, The Linked Ring salon was the most important annual event in photography. It was usually the biggest, for the Links grew to 114 members, including 15 American photographers, 15 Austro-Germans, and 10 from France and Belgium. The leading Englishmen were Horsley Hinton, Frederick Hollyer, Alfred Maskell, and Henry Peach Robinson.

When the Bostonian F. Holland Day and his young cousin Alvin Langdon Coburn exhibited 375 prints as "The New School of American Photography" in London in 1900, the *British Journal of Photography* slammed it as representing the "Cult of the Spoilt Print." But French critics were almost unanimously favorable to the American Pictorialists when Day brought the exhibition to Paris in 1901. How to explain the different receptions? British jealousy of the assured Americans, who would be a third of those represented in the 1908 Links Salon? Or damnation of the Pictorialists through their association with Aestheticism, personified by such iconoclastic, even scandalous artists as Whistler and Aubrey Beardsley and writer Oscar Wilde? Or confusion about the Links' merits, given the arguments between Henry Peach Robinson and Peter Henry Emerson over Pictorialism and "Naturalism" as most desirable in photography? Certainly, the French were prepared for the dissident art photographers by their half-century of vanguard painting movements, and Day's show encouraged French Pictorialism.

Photogravure was in wide use in art circles by circa 1900, and it remained the most aesthetically pleasing and permanent means to reproduce black-and-white photographs in bulk for a century. The process was developed by the Austrian printer Karel Kliĉ in 1879, and spread in Great Britain from 1883 by the Linked Ring member J. Craig Annan, son of Thomas Annan. The younger Scot's impact was great on Alvin Langdon Coburn and Alfred Stieglitz, among others, who recognized that photogravure's coal blacks and chalk whites can be more intense than those in gelatin silver prints, and that its inks have none of the photograph's vulnerability to light. Some photogravures, in fact, are more beautiful than the photographs used to generate them. American and English art photographers, building on the long traditions of fine book publishing in their countries, embraced the process before World War I, and it dominates among the reproductions in such finely produced periodicals as *Camera Work*.

Gravure, a modification of etching, exploits the fact that bichromated gelatin hardens according to its exposure to light. First, the negative of the image in question is contact-printed to make a transparent positive; this positive is laid on a tissue coated with sensitized gelatin and exposed to light. The tissue is pressed onto a copper plate dusted with resinous powder, and after the two are soaked in warm water, the tissue is pealed off and the gelatin areas not exposed to light are washed away. The copper with its surviving uneven coat of gelatin then goes into an acid bath. This bites the copper to different depths, which thus will hold different amounts of ink, reflecting the tonal gradations of the original photograph. The inked plate is then put into a printing press with any choice of paper.

The Photo-Club de Paris held its first salon the year it was formed, 1894; its cofounders—**Robert Demachy** and **F. J. Constant Puyo**—are still its best-known photographers, along with members Pierre Dubreuil and Leonard Missone. Demachy was the son of a wealthy banker; Puyo was a former army commandant; and both had the leisure for artistic experiment in the darkroom. They developed and propagandized for the gum bichromate process, and in 1897 Demachy

copublished a "practical treatise" on it with The Linked Ring's Alfred Maskell. In 1906 Demachy and Puyo collaborated on the manual *Artistic Processes ...*, spelling out all the means, including the use of special lenses, to defeat photography's "automatism"—the mechanical uniformity of industrially processed prints. Demachy would flood the press with over 1,000 articles on camera art and its methods.

In his variously manipulated prints, Demachy alluded to French art esteemed in the 1890s: Degas's pastels of ballerinas, Toulouse-Lautrec's sketches and posters of bohemian characters, Rodin's voluptuous despairing nudes. His work was reproduced in six issues of *Camera Work*, today the photography periodical most valued by collectors. In 1906 he turned to making oil prints and around 1910 to oil transfers (both processes allowing painterly alteration of the print). Puyo alternated between impressionistic landscapes and more linear portraits, indebted to Art Nouveau's decoration. The flat patterning and contrasts of scale in Art Nouveau inspired Dubreuil, whose simplified rural and city scenes have a proto-modernist sense of abstracted form.

The beauty of **pigment processes**, including gum bichromate, carbon, and carbro, is their versatility and permanence: their emulsions are far less vulnerable to light than the metal compounds—silver, iron, platinum, and palladium—used in photographic prints. And because pigment processes allow handwork, they reveal the touch of the artist-printer as individually as handwriting or painting. They perfectly suited the aims of Pictorialists.

Gum bichromate, a signature process of Pictorialism, was discovered in the early 19th century, but it was only popularized from 1894 on by the French photographer Robert Demachy and his circle. A negative of any kind can be used; the artistry begins with the photographer's choice and hand-sensitizing of the paper, usually watercolor quality, for the print. Pigment and colloids, such as gum arabic or gelatin, are mixed together and sensitized with potassium bichromate or the like. This solution is brushed onto the paper and allowed to dry. The negative and paper are placed together and exposed to light, the colloids hardening

according to the degree of exposure. The print is then bathed in water, which dissolves the softer areas and creates highlights. The surfaces can be scratched or brushed in the bath, dramatizing the art photographer's hand. For additional color, the process is repeated, with the paper resensitized with another pigment and colloid solution and exposed to the same negative or part of it, in careful registration. Edward Steichen's "Flatiron" illustrates this multiple printing, with its warm browns, blue-greens, and touches of orange (for the lamplights around what was then the tallest building in the world).

Founded in New York in 1902, the Photo-Secession was the last and most visible of the important Pictorialist movements, thanks to Alfred Stieglitz. This charismatic and contentious photographer was an ardent promoter of vanguard expression. As the leader of the Photo-Secession, editor of its primary journal, *Camera Work* (1903-17), and director of its gallery, "291," in operation at 291 Fifth Avenue in 1905-17, he advanced the cause of art photography and American art at the same time as his own photographs.

In the 1890s Stieglitz emerged as a spokesman for photography as a "distinctive medium of personal expression." He consolidated New York groups into the Camera Club of New York in 1896 and began publishing *Camera Notes* in 1897. When the Bostonian F. Holland Day organized the exhibition of American Pictorialism that electrified London and Paris in 1900-01, Stieglitz moved to assert his own leadership and formed the Photo-Secession in 1902, inviting Gertrude Käsebier, Clarence White, Edward Steichen, and Frank Eugene to join him. He exhibited their work, his own, and that of 26 others, and in *Camera Work*, the exquisitely produced successor to *Camera Notes*, he featured Käsebier in the first issue, White in the second, and Steichen in the third. Steichen, Stieglitz's lieutenant, designed the cover and type, and in 1905 he expanded and redecorated his rooms at 291 Fifth

"THE STEERAGE," 1907, TAKEN ABOARD THE *KAISER WILHELM II* SAILING FROM THE UNITED STATES TO EUROPE, WAS ONE OF ALFRED STIEGLITZ'S FAVORITE IMAGES.

Avenue as "The Little Galleries of the Photo-Secession."

In the gallery and magazine, Stieglitz showed Photo-Secessionists, choice members of international Pictorialist groups, and figures he claimed as progenitors such as Hill and Adamson and Julia Margaret Cameron; and he published criticism supporting aesthetic photography and vanguard painting, such as excerpts from Kandinsky's *Concerning the Spiritual in Art*. With Steichen making introductions, he exhibited progressive French artists before World War I—Cézanne, Toulouse-Lautrec, Picasso, Matisse, Braque, Rodin's drawings, sculpture by Brancusi and tribal Africans, even children's art—and younger American painters he considered equal to this competition. They included John Marin, John Weber, Marsden Hartley, Arthur Dove, and eventually Georgia O'Keeffe. Stieglitz's treatment of American and European painting and photography demonstrated his view of them as equivalent modern arts: this was one of his many startling messages to American collectors, who were generally conservative and insular relative to Europeans. For such proselytizing and the financial support he gave his artists, Marin called "291" "the biggest little room in the world."

In 1910 Stieglitz's exhibition of over 600 Pictorialist prints at the Albright Gallery in Buffalo (now the Albright-Knox Gallery) marked the movement's critical acceptance and his hand in it. He had moved art photography into U.S. museum exhibitions and collections. Before the Armory Show of 1913 introduced North America to vanguard European art from Post-Impressionism to Cubo-Futurism, his exhibitions at "291" were the most significant conduit for modernism. While his own photography after 1900 was almost wholly free of darkroom handwork, in the early days he supported specialists in pigment processes, such as Karl Struss, a student of Clarence White who invented a soft-focus lens (and became a cinematographer for more than 135 Hollywood films), and the Californian Anne W. Brigman, whose ecstatic nudes in nature were published with her poems as *Songs of a Pagan*, 1950. He also included the poetic George Seeley in Photo-Secession membership and Baron Adolf de Meyer, who became the century's first fashion photographer.

In 1917 the "291" lease expired and Stieglitz was low on money; he closed the gallery and folded *Camera Work*, with Paul Strand as its last subject. Now he left broad promotion of American photography to the younger generation and concentrated on doing his own work and promoting Strand's photography and the painting of O'Keeffe, Marin, Dove, and Hartley, for whom he ran the Intimate Gallery in 1925-29 and An American Place from 1929 to his death. In the last gallery he introduced Ansel Adams and Eliot Porter. His career as art advocate, his donation of his collection of Photo-Secession prints to the Metropolitan Museum of Art, and, on his death, O'Keeffe's gift of his "key" prints to the National Gallery of Art in Washington, D.C., established the dominance of his definition of art photography in the United States. Its aesthetics were free of any social purpose; its history was of changing styles; its goals were the formalist ones of beauty and stylistic and technical innovation.

F. HOLLAND DAY (B. NORWOOD, NEAR BOSTON, MASSACHUSETTS, 1864–D. NORWOOD, 1933)

Day "epitomizes the elegant uninhibited artist of the decadent '90s," writes his biographer, the scholar Estelle Jussim. This dinner companion of the poet William Butler Yeats, the art connoisseur Bernard Berenson, and the playwright Oscar Wilde entered the arts through books, as did his friend Frederick H. Evans. With his inherited wealth, the improper Bostonian funded the publishing house Copeland and Day, which produced the American editions of *The Yellow Book* and Wilde's *Salomé*, both illustrated by Aubrey Beardsley, and 96 other titles between 1893 and 1899, all to the high design ideals of William Morris's Kelmscott Press. Meanwhile, Day was taking photographs, first with a small hand camera in 1886, then with such mastery that he was elected to The Linked Ring in 1895. In darkly handsome portraits and figure studies, he excelled with many of the Pictorialists' processes—carbon and platinum prints, and platinum combined with glycerine or gum bichromate. He dressed and photographed his chauffeur as an Ethiopian chief (a print Alfred Stieglitz bought); and he devoured Old Master paintings and their reproductions: "Become a student

GERTRUDE KÄSEBIER OPENED HER OWN
PORTRAIT STUDIO ON FIFTH AVENUE IN NEW
YORK IN 1897. SHE PHOTOGRAPHED SHOWGIRL
EVELYN NESBIT IN 1902.

and lover of art," he said, "if you wish to produce it." By 1890 he and his friends Gertrude Käsebier and Clarence White had international standing as Pictorialists.

Day's most notorious and best work is "The Seven Last Words of Christ," a seven-print sequence in which he posed. For this and other religious subjects of 1898-1900 he let his hair grow long, half-starved himself, and imported custom-made robes and a cross from the Middle East. Fortunately, these documentary details are blurred in his powerful close-ups (if not in his other Passion scenes). He was inspired by seeing the Passion Play at Oberammergau in Bavaria, and Yeats's idea that suffering is a redemptive experience bringing contact

with the spiritual world, and also moved by Wilde's imprisonment after a shocking court case and Beardsley's death at age 25. Most of his viewers, however, were offended by his playing Christ. And some disapproved of his Romantic implication that the artist is a Christ-like leader sacrificing himself for aesthetic and spiritual expression, and his claim that photography can equal the great paintings of Western art. But as a sign of changing tastes, today's viewers may find his faces more beautiful than the Saviors painted by Guido Reni that inspired them and more genuine in their restrained anguish.

Day's prominence as a Pictorialist spokesman was overshadowed by Stieglitz when he established the Photo-Secession in New York in 1902. And Day's activities on behalf of art photographers ended in 1904 when his studio burned, destroying most of his negatives and all of his collection of Pictorialist prints. "Losing everything" may have encouraged his greater frankness in depicting homoerotic subjects between 1905 and 1917, when he gave up photography. His reticent yet intensely sensual half-lengths and classical figures in landscapes are part of the history of the nude. After 1917, when platinum papers were no longer available, the ailing and hypochondriac Day took to his bed, like the novelist Marcel Proust, and died there 15 years later.

GERTRUDE KÄSEBIER (B. FORT DES MOINES, NOW DES MOINES, IOWA, 1852–D. NEW YORK CITY, 1934)

Käsebier's friends in the Photo-Secession group called her "Granny." She was one, by the time she gained recognition, and she could photograph children and mother-and-child compositions with seasoned observation. The late Victorian belief that women are innately gifted portrait photographers worked to her benefit, but she also innovated in the field, and in her lifetime commanded some of the highest prices in the United States.

After raising three children, Käsebier started her career in her late thirties, and first tried portrait painting. With her husband's support, she studied painting at the Pratt Institute in Brooklyn, New York, in 1889-93, and on a trip to Europe in 1894-95 she chose photography as a career. Back in New York she got a commercial photographer to teach her the business, and

in 1897 she opened her own portrait studio on lower Fifth Avenue. Among other celebrities, she photographed the Sioux in Buffalo Bill's Wild West show, and she showed her Pictorialist prints in the First Philadelphia Photographic Salon in 1898, going on to serve as a judge for the Salons of the next two years. In 1900 she and Anne W. Brigman were the first two women elected to The Linked Ring. Two years later Alfred Stieglitz invited her to become a founder-member of the Photo-Secession.

While he praised her as "beyond dispute, the leading portrait photographer in the country," her "maternities" such as *The Manger* sold for a record $100 and proved her artistic credentials: the ethereally pale print is a tour-de-force of back lighting and platinum printing—never mind that the Madonna-like figure was holding a doll. Most famous of this type was her "Blessed Art Thou Among Women," a title from the Rosary that sanctifies this mother sending her child off to school, perhaps for the first time. The girl's stiff pose contrasts with that of the tenderly bending woman, whose robes echo those in the print by the Pre-Raphaelite painter Edward Burne-Jones on the wall behind. "One of the most difficult things to learn in painting is what to leave out," Käsebier wrote. "How to keep things simple enough. The same applies to photography. The value of composition cannot be overestimated: upon it depends the harmony and the sentiment."

These two photographs were reproduced in the first issue of *Camera Work*, 1903, in addition to "Miss N." The latter represented Käsebier's portraiture—and showed her appreciation of a notorious beauty. "N," or Evelyn Nesbit, had been a show-girl when she attracted society architect Stanford White; and later her husband would kill him in a fit of jealousy. Käsebier's close-up crops the top of Nesbit's head and accents her direct gaze and decolletage: the photographer's simplification became a new fashion, succeeding the fussily appointed studio scenes of Victorian portraiture. Käsebier was also early in photographing her subject's hands alone, as a token of personality—an idea she may have got from Auguste Rodin, to whom Edward Steichen introduced her in Paris.

Stieglitz's declining interest in Pictorialism after 1910 led Käsebier to break with him; she resigned from the Photo-Secession in 1912; and in 1916 she and White founded the

Pictorial Photographers of America as an exhibition society. In 1929, her sight failing, she closed her studio.

CLARENCE H. WHITE (B. WEST CARLYLE, OHIO, 1871– D. MEXICO CITY, 1925)

The idealized woman, an embodiment of Beauty and benign Nature, reigns in White's photography. His wife, Jane, who often posed for him, is all innocence and grace among flowering trees, and her flowing, virginally white garments (in an era when certain real women were rebelling against corsets) suggest eternal youth, life without social hierarchies. At the World's Columbian Exposition in Chicago in 1894, where White was enchanted with paintings by the Impressionists and James McNeill Whistler, a Woman's Pavilion displayed female achievements in arts and sciences. But White, like many other Pictorialists, was extending the vision of womanhood presented by Julia Margaret Cameron and Pre-Raphaelite painters in the mid-19th century, and offering a vision of domestic sanctuary in a time of social change. His young women and children were charming shapes in harmonious compositions; he concentrated his innovations on pictorial form. His efforts to associate his photography with high art included shooting into the sun, which how-to books decried, so that back-lit motifs became flat dark silhouettes; and he cut and framed the print of "Spring" as a three-part arrangement, like a decorative screen. To convey the mystery of twilight and shadowed interiors, he learned to excel in platinum printing, which allows for a longer tonal range than gelatin silver.

In Newark, Ohio, where he grew up, White worked as a bookkeeper by day, learned about art through magazines, and taught himself photography, beginning seriously in 1894 and winning a medal two years later. In 1898 his participation in the First Philadelphia Photographic Salon brought him international recognition (as it did Gertrude Käsebier), and the following year Alfred Stieglitz published his work in *Camera*

"RAINDROPS," CIRCA 1905, EXEMPLIFIES CLARENCE WHITE'S ABILITY TO TRANSFORM A SIMPLE PHENOMENON INTO LIGHT-STRUCK MAGIC.

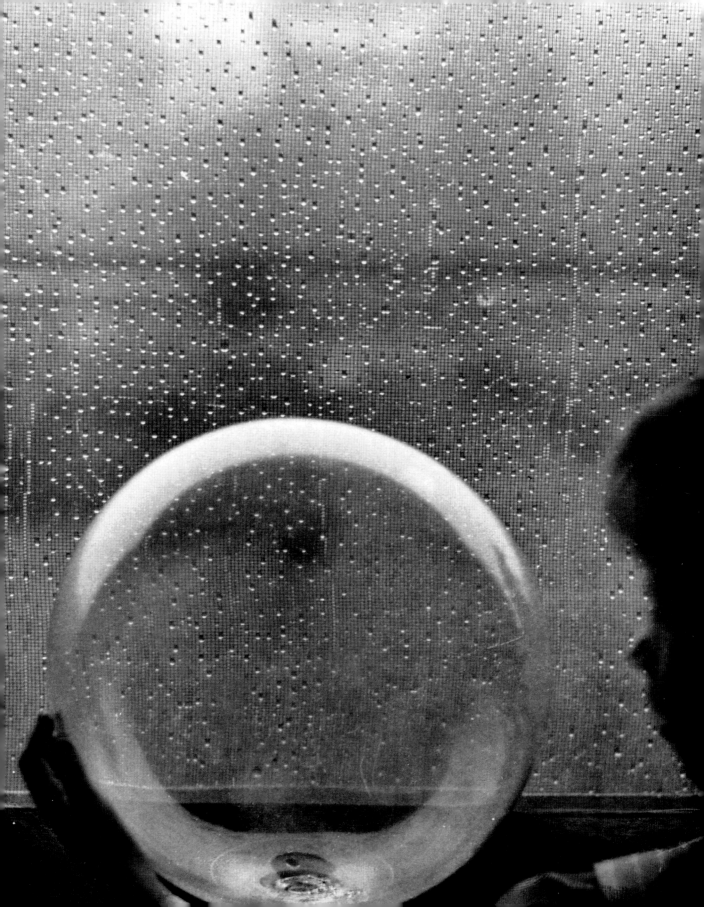

Notes. By 1902, when Stieglitz invited him to be a founder-member of the Photo-Secession, White had exhibited in London and Paris in the Pictorialist show organized by his new friend F. Holland Day, and in Boston and New York. Stieglitz devoted the third number of *Camera Work* to him, as well as four more issues. In 1906 White was confident enough to move to New York and set up a commercial studio. To supplement his income he began teaching photography in 1907 at Columbia University Teachers' College at the request of Arthur Wesley Dow, whose Japanist conception of composition would influence a generation of photographers and painters, including Georgia O'Keeffe. In 1910 White began a summer school of photography in Maine.

Gifted in platinum and palladium printing and the gum bichromate pigment process, White broke with Stieglitz in 1912 over the latter's growing insistence on straight photography, and in 1916 he established the Pictorial Photographers of America with Käsebier. Meanwhile his teaching assured his continued influence. In 1914 he had opened the Clarence H. White School of Photography in New York City, which would be attended by a who's who of photographers, including Margaret Bourke-White, Dorothea Lange, Paul Outerbridge, Ralph Steiner, and Doris Ullman. As scholar Naomi Rosenblum points out, large numbers of his women students went on to professional careers in photography; he was unusual in hiring a woman to teach advertising photography, a field then defined as male. The school survived his death on a trip to Mexico with students, and continued until 1942.

EDWARD STEICHEN (B. LUXEMBOURG, 1879–
D. WEST REDDING, CONNECTICUT, 1973)

At age 23, in his "Self-Portrait with Palette and Brushes," Steichen modeled himself on a nobleman painted by Titian, showing the panache he would use to become the best-known celebrity and fashion photographer of the 1920s and '30s. Though he had been photographing since age 16 and was Alfred Stieglitz's first protégé, he portrayed himself as a painter. The gum bichromate process let him improve his dashing silhouette and turn his brush into an extension of his fingers: here he insisted on the equal artfulness of the painter and photographer and claimed to be a Renaissance man.

Reared in Milwaukee, Steichen studied painting while apprenticed in a lithography firm and made portrait photographs for extra income. In 1900 the photographs he exhibited at the first Chicago Photographic Salon impressed Clarence White, who

AFTER BEING RECOGNIZED FOR ARTISTIC TALENT AT THE
CHICAGO PHOTOGRAPHIC SALON IN THE 1890'S, EDWARD
STEICHEN MOVED TO FRANCE WITH HIS FAMILY WHERE HE SHOT
"GRAND PRIX AT LONGCHAMPS: AFTER THE RACES, PARIS," 1907.

THE JURY OF THE PHILADELPHIA
PHOTOGRAPHIC SALON IN 1899 INCLUDED, FROM
LEFT, CLARENCE H. WHITE, GERTRUDE KÄSEBIER,
HENRY TROTH, F. HOLLAND DAY, AND
FRANCES BENJAMIN JOHNSTON.

recommended him to Stieglitz. Steichen met the latter on his way to Paris in 1900, and later that year contributed to the American Pictorialist show that F. Holland Day mounted in London and Paris. In 1901 Steichen joined the social and artistic circle around Auguste Rodin, and photographed the celebrated sculptor and his work. The following year he was a founder-member of the Photo-Secession, and also opened a commercial studio in New York. In 1904-5 he experimented with color photography and exhibited his paintings. Through the end of the decade his long stays near Paris and resulting French connections served Stieglitz in bringing European vanguard art to the Little Galleries of the Photo-Secession.

Steichen's Pictorialist photographs have the dark allure of late 19th-century Northern Romantic paintings by Edvard Munch and Ferdinand Hodler. Moonlit landscapes, nudes, even portraits and opening day at the races are simplified and darkened to accent a single formal effect: the contrast between cloud and branch, a woman's graceful silhouette, the gleam in the eye of financier J. P. Morgan and on the dagger-like arm of his chair. Though Steichen enjoyed painterly experiment with photographic processes and Stieglitz did not, both were encouraged by modernist art to abstract their subjects just before World War I. But in this period the two separated over what Stieglitz saw as his friend's commercialism, which originated with financial need. (Stieglitz, on the other hand, had the inherited means to run "291" as a labor of love, and sold its art only to "worthy" collectors.)

During the war Steichen joined the Army Signal Corps, and afterward his photography grew less impressionistic and more monumental. His career as art director and chief photographer for Condé Nast publications in 1922-38 belongs to the story of editorial photography; in those years he also took freelance advertising commissions. During World War II, he supervised naval photography in the Pacific. On his curatorial role at the Museum of Modern Art in 1947-62, (see p. 198-9).

AFTER A ROCKY FIRST MARRIAGE, ALFRED STIEGLITZ IMMORTALIZED HIS LOVE FOR ARTIST GEORGIA O'KEEFFE IN SUBLIMELY BEAUTIFUL PORTRAITS, INCLUDING CLOSE-UPS OF HER HANDS.

ALFRED STIEGLITZ (B. HOBOKEN, NEW JERSEY, 1864– D. NEW YORK, NEW YORK, 1946)

Does "The Steerage" epitomize Stieglitz's career? He later saw it as a turning point, and proudly showed it to Picasso. "A round straw hat, the funnel leaning left … white suspenders crossing on the back of the man in the steerage below, round shapes of iron machinery …," he recalled, "I saw a picture of shapes and underlying that the feeling I had about life." He was not bemoaning the class division on shipboard (though his composition made it obvious) or the fate of immigrants who were returning to Europe. For him, "The Steerage" marked his achievement in reconciling the documentary and formal capabilities of the camera; he found his sense of "life" in what the art critic Roger Fry would call "significant form." In his photography and proselytizing for that of others, Stieglitz bridged fin-de-siècle camera art and the modernism of the 1920s and '30s. In the United States, his work has set the standard for museum acceptance of the medium.

From the beginning, Stieglitz put up obstacles to overcome. In 1881, he was sent to Berlin to study mechanical engineering, but he adopted the camera in 1883 and determined to learn photo-chemistry. His European photographs counter the cardboard sentiment of late Victorian anecdotal art with spontaneous figures he caught with a hand camera. Back in New York in 1890, he flaunted his ability to work in difficult interior light, at night, and in adverse weather. In the blizzard of 1893, he heroized drivers of horse-drawn transport; in rain and snow he subsequently turned Manhattan skyscrapers into evocative outlines in Japanist compositions. Cropped in various ways, these prints were unmanipulated—weather instead softened their subjects—and so they stood out among the Pictorialists' pigment-process photographs. Stieglitz's admirers would later tout the superiority of "straight" prints as truer to photography, but his own position did not harden until after 1910 when he had secured critical acceptance for the Photo-Secessionists, the group he founded in 1902.

In 1913 the Armory Show of European painting and sculpture, organized by others, proved he was no longer the solitary standard-bearer for vanguard art in the United States; and the onset

ofWorld War I ended this phase of his career, as well as most of the Pictorialists' associations. His life and work were revitalized, however, by Paul Strand and Georgia O'Keeffe, who received exhibitions at "291" in 1916-17. Stieglitz's portraits of O'Keeffe form a chapter in the history of portraiture; his exhibition of them in 1921 was so discussed that he decided to photograph clouds to prove his artistic excellence was unrelated to the supposed "power of hypnotism I had over my sitters." He called the series *Equivalents*, for they were meant as mood-inducing parallels to music, like that of Debussy, as "equivalents of my most profound life experience, my basic philosophy of life." Here he fully adopted the Romantics' passionate identification of art and artist, and pioneered the photographic series as a genre.

In 1925, Stieglitz and O'Keeffe moved to the 30th floor of a midtown hotel and both depicted Manhattan from their windows. Stieglitz's style became fully modernist: its bold dark–light contrasts, hard edges, and geometric shapes celebrated the structure of skyscraper New York. But he still loved challenging light, and seized the transition from sundown to night's artificial illumination. These photographs and his Pictorialist ones are equally artistic, in alluding to advanced painting (though to Mondrian now, not to Whistler), in presenting superb print quality, and in seeking elite collectors. In 1937 ill-health ended Stieglitz's photography, but these prints were featured when the Museum of Modern Art opened its department of photography in 1939. O'Keeffe, whom he had promoted as a young woman, advanced his reputation after his death and until her own, in 1986.

ALVIN LANGDON COBURN (B. BOSTON, MASSACHUSETTS, 1881–D. DENBIGHSHIRE, WALES, 1966)

Coburn was one of the most gifted photographers in the Pictorialist movement, and an articulate go-between for American and British camera artists. The development of vanguard photography—with Pictorialism's smoky fin-de-siècle style giving way to the crisp abstraction of modernism—is illustrated in his career of 1898-1917.

Coburn was given a Kodak at age eight, and when he was 15, his cousin, the eccentric F. Holland Day, convinced him to pursue photography full-time. In 1899 Day asked the teenager to help take his collection of 375 Pictorialist prints to London for exhibition, and Coburn became part of that exhibition of 1900-01 and one at The Linked Ring. His success assured, Coburn traveled for the next two years across Europe, meeting photographers such as Robert Demachy who agreed with the Americans' conviction that the camera could create poetry—not just the prose of documentation or the slang of snapshots.

Coburn returned to the United States in 1902, worked in the studio of Gertrude Käsebier, who became a second mentor, and opened his own studio. The following year Alfred Stieglitz founded the Photo-Secessionist group and invited the two to join, along with Steichen and Clarence White. In 1902-3, Coburn studied with Arthur Wesley Dow, who promoted the sense of space and subtle atmosphere in Japanese art: "Japanism" and the painter James McNeill Whistler's "Nocturnes" were an aesthetic source for Coburn's early cityscapes and for Pictorialism in general.

In 1904 the photographer decided to expatriate to England, but he traveled frequently between London and New York and so maintained relations between the Photo-Secession and The Linked Ring. His portrait photography flourished with such notable sitters as George Bernard Shaw, who in 1907 called him the greatest photographer in the world. Coburn's portraits would be collected in his books, *Men of Mark*, 1913, and *More Men of Mark*, 1922, while Stieglitz published Coburn's velvety gravures in seven issues of *Camera Work*.

In 1910 and 1911 Coburn traveled through the American West and photographed the Grand Canyon. The vantage points it necessitated may have encouraged his last photographs in America, "New York from Its Pinnacles, 1912." The diving perspectives of these photographs, which eliminated the horizon line and flattened the space, created radical proto-abstractions, which were rare in any photography to that date. In his next step, in London in 1915, Coburn joined an artists' group called the Vorticists,

THE MAJORITY OF ALVIN LANGDON COBURN'S WORK WAS
PICTORIALIST, BUT IN LONDON, HE LATER BEGAN TO MOVE
TOWARD ABSTRACT COMPOSITIONS, AND IN 1917 HE MADE
THIS VORTOGRAPH OF POET EZRA POUND.

AN EARLY CHAMPION OF MODERNISM

In 1916 Alvin Langdon Coburn urged modernist experiment in photography with arguments forecasting those of László Moholy-Nagy in the 1920s: "What would our grandfathers have said of the work of Matisse, Stravinsky, and Gertrude Stein? … If we are alive to the spirit of our time, it is these moderns who interest us …. [W]hy should not the camera also throw off the shackles of conventional representation and attempt something fresh and untried? Why should not its subtle rapidity be utilized to study movement? Why not repeated successive exposures of an object in motion on the same plate? Why should not perspective be studied from angles hitherto neglected or unobserved? … Think of the joys of doing something which it would be impossible to classify, or to tell which was the top and which the bottom?" For his cubistic portrait of American poet Ezra Pound (a Vorticist group member), Coburn rotated the negative and surprinted it in four directions.

"I do not think that we have begun to even realize the possibilities of the camera," he went on. "The beauty of design displayed by the microscope [could be] explored from the purely pictorial point of view, the use of prisms for the splitting of images into segments has been very slightly experimented with …. I suggest that an exhibition be organized of 'Abstract Photography' [and] that no work will be admitted in which the interest of the subject-matter is greater than the appreciation of the extraordinary …"

whose dynamic art was inspired by Futurism, and by 1917 he showed his first "Vortographs"—photographs of crystals he made by pointing his lens down a kaleidoscope-like device of his invention. His images of faceted repeating planes are considered the first fully abstract camera work.

Between 1917 and 1930 Coburn ignored photography for studies of the occult. His later photographs of nature resemble the coeval work of Minor White.

AUTOCHROMES
PAINTING WITH LIGHT

Of the many innovators in the history of photography, none had a more auspicious surname than the inventors of the Autochrome, the first widely used color process. French brothers Louis and Auguste Lumière—whose last name means "light"—patented their new color system in 1904. Brought up near Lyon, the brothers worked for their father's photographic firm, Louis as a physicist and Auguste as a manager. Even before they'd begun work on their color technology, the Lumières had contributed to the advancement of photography with the invention of a fast black-and-white dry-plate process they called Étiquette Bleue. In 1895, they became pioneers in the field of moving pictures when they patented the *cinématographe*, a combination camera, projector, and printer. Despite making a number of short black-and-white films, which they showed in Paris, London, and New York, the brothers soon abandoned moving pictures, proclaiming "the cinema is an invention without any future."

Instead, the Lumières turned their attention to the challenge of color photography. While three quarters of a century had passed since Joseph-Nicéphore Niépce made the world's first photograph, there had been little progress in coming up with a practical color process. Color illustrations were still

"FOUR TROUT," CIRCA 1909,
AN AUTOCHROME BY
ADOLPHE DE MEYER

largely the province of the painter. Photographer L. Pellerano expressed the hopes of all photographers of the era when he said, "How many times when focusing on a splendid panorama, on any scene filled with nature's dazzling colours, did I withdraw from under my cloth with the ardent desire … to be able to fix all the infinite tints that met my eye! …"

Alexandre Becquerel and Niépce de Saint-Victor did develop a color photographic technology by 1860, but their silver chloride–based images were impossible to stabilize. In that same period, James Clerk Maxwell and Louis Ducos du Hauron independently developed rudimentary systems of photographing subjects through color filters. In 1891, Gabriel Lippmann managed to produce permanent color images based on the process invented by Becquerel and Saint-Victor, but Lippmann's procedure was too complicated to be feasible.

Building on the existing additive principle of color reproduction—in which all colors are replicated through the combination of red, green, and blue—the Lumières set about perfecting a process that would be easy to use and commercially viable. To make an Autochrome, the Lumières ground up potato starch into microscopic granules, which were then dyed in separate batches of red, green, and blue. The three colors of powder were evenly mixed, and a

fine coating of this material was spread on a glass plate treated with pitch. Since the color granules were not perfectly flat, the spaces between the grains were filled with lampblack. The powder was then sealed with a layer of varnish before a final layer of black-and-white photographic emulsion was applied.

To expose an Autochrome, the glass plate was placed in a view camera with the emulsion side away from the lens. As light traveled through the glass plate, it was filtered by the color granules before reaching the emulsion. The plate was then reverse-processed in acid dichromate to produce a positive transparency. To view the image, light was passed through the glass plate, and the tiny grains of potato starch filtered the light into the proper colors. The thousands of glowing color granules gave the image the stippled look of a Pointillist painting, with a wide gradation of soft, pastel tones.

The Lumières introduced the Autochrome in 1907, and the new color process was immediately embraced by professional and amateur photographers alike. At first, the Lumières had trouble keeping up with production demands, as critics everywhere heaped praise on the new process. "Soon the world will be colour mad," proclaimed noted photographer Alfred Stieglitz, "and Lumière will be responsible."

With the addition of color, photographers had a new tool to help them produce striking images. Color could render the most quotidian scene interesting, which was demonstrated by the countless informal family portraits captured on

"DOUG, 1910,"
A NIECE OF THE LUMIÈRE
BROTHERS

Autochromes, images that have a luminous, painterly quality.

Autochromes also brought scenes of the world to the readers of periodicals. The National Geographic Society embraced these new color images, publishing many in the pages of its journal between 1914 and 1937 and amassing a collection of some 14,000 glass plates.

The Autochrome, however, did have limitations. Relatively expensive and not viable for making prints, the technology left many of its early enthusiasts frustrated. The Autochrome had a narrow exposure latitude, and its colors were difficult to manipulate. The long exposure time that was required seemed most suited to still lifes and portraits taken outdoors in bright sunlight. Artistic photographers such as Stieglitz, Edward Steichen, and Alvin Langdon Coburn eventually abandoned the process.

Nevertheless, Louis Lumière, the scientific brains of the Lumière brothers' partnership, would call the autochrome the greatest invention of his life, saying it demanded the most intellectual effort and imagination of any of his creations. As the invention of the *cinématographe* had captured movement on film, the Autochrome had captured color. Until it was surpassed by the color film of the 1930s, the Autochrome would be the most popular method of depicting life photographically in its full spectrum of colors—and it would go down as a step in the evolution of photography that has come to be appreciated by many as an art form itself.

EARLY 20TH-CENTURY ART

The explosion of invention in vanguard art in the years around World War I sharpened the ambitions of camera artists. The Cubism of Picasso and Braque, Futurism in Italy, Suprematism in Russia, and de Stijl in the Netherlands were sequential movements in painting, named between 1908 and 1917, that sought to analyze the geometric structures believed to underlie visible reality. At the same time, Fauvism in France and Expressionism in Germany identified art with the artist's emotional responses to the world and the self. And while both the cerebral and subjective currents in art led to the creation of non-objective canvases by 1913, yet a third movement, called Dada, attacked high-art conventions and dominant political powers with popular ingredients—that is, mass-produced objects, mass-media images, and assorted rubbish. The much-debated term "modernism" has been applied to these contradictory and kaleidoscopic tendencies, and most often to the analytical and reductive exploration of artistic form and materials. What can be agreed on is that the artists of every early 20th-century movement considered themselves modern—dedicated to reflecting the conditions of the modern world. Innovation was hailed as progressive in art, as in technology. The past was scorned, along with received definitions of art and their supporters, who were often the majority of viewers. Though modern artists varied in political consciousness, all of them believed their activity was promoting a better world.

By the second decade of the 20th century, Pictorialist camerawork was seen as old-fashioned by its former champions. Art photographers rapidly adopted the ideals and styles of leading European art movements, including Surrealism, born in France in the 1920s. Simultaneously painters hailed the camera as the most modern image-making device available and adapted journalistic photographs and aspects of photographic technology to their approaches. The photographer, once an imitator of academicians and vanguards past their prime, was now seen as an equal and even a model for advanced painters. This chapter of the

"THE OLLY AND DOLLY SISTERS," 1925, EXEMPLIFIES LÁSZLÓ MOHOLY-NAGY'S VISUAL WIT AND ABILITY TO COMBINE GRAPHICS AND PHOTOMONTAGE. THE SISTERS WERE A POPULAR DANCE TEAM IN EUROPE.

STRAND ON STRAIGHT PHOTOGRAPHY

Strand's 1915-16 photographs and his defense of his "straight," unmanipulated printing of them confirmed the end of Pictorialism among advanced camera artists. In *Camera Work*, 1917, and in an address to students at the Clarence White School of Photography, 1923, he asserted that in printing, "oil and gum introduce a paint feeling, a thing even more alien to photography than color is in an etching …. By introducing pigment texture you kill the extraordinary differentiation of textures possible only to photography. And you destroy the subtleties of tonalities. With your soft-focus lens you destroy the solidity of your forms … and the line diffused is no longer a line." "Honest" models of photography could be found: " …in scientific and other recordmaking, there has been at least, perhaps of necessity, a modicum of that understanding and control of purely photographic qualities [that I value] …. These other phases were nearer to a truth than all the so-called Pictorialism … a simple record in the *National Geographic Magazine*, a Druot reproduction of a painting, or an aerial photographic record is an unmixed relief. They are honest, direct, and sometimes informed with beauty, however unintentional."

book charts these developments in the interwar period in the order in which they emerged, in the United States, Germany, the Soviet Union, and France..

FROM PICTORIALISM TO MODERNISM IN THE UNITED STATES

The charismatic Alfred Stieglitz dominated U.S. camera art as a photographer, editor, and gallery director from the first years of the 20th century, and he engineered the critical acceptance of his Photo-Secession group by 1910. Though less active as a propagandist for photography after World War I, he maintained his influence through the example of his own work and such protégés as Paul Strand, Edward Weston, Ansel Adams, and Eliot Porter, whom he represented in his New York City galleries, "291" (1903-17), the Intimate Gallery (1925-29), and An American Place (1929-46). Steiglitz's photography had always been "straight"—unmanipulated in the darkroom except for cropping, burning, dodging, and spotting—and he began describing it as such in 1913. So was the work of Strand, which Stieglitz began encouraging in 1915, and that of Charles Sheeler and Morton Schamberg, who became admired friends in 1916. Stieglitz's advocacy of their sharp-focus abstractions from still-life and architectural motifs was so persuasive that a contemporary critic wrote that the impresario had turned these three men into "the Trinity." They were making photographs on a par with Cubist paintings. Their prints were not isolated experiments, like the 1916 Vorticist compositions of Alvin Langdon Coburn, but platforms for further modernist exploration. They launched modernist camera art in America.

The Trinity replaced Pictorialist "fuzzygraphs" of idyllic landscapes with sharp-focus photographs of building elements and machine parts, especially identified with the metropolis, a source of American pride and an emblem of modernity. Their motifs, while recognizable, were transformed by framing, camera angle, and extreme vantage points. They disdained painterly print manipulations and embraced straightforward darkroom technique—the camera equivalent of progressive sculptors' "truth to materials." Yet they shared the Pictorialist dedication to making "perfect" prints, their belief in photography as an expression of individual genius and a heightened vision of life, and their dream of achieving museum status for their work

PAUL STRAND (B. NEW YORK, NEW YORK, 1890– D. ORGEVAL, FRANCE, 1976)

In addition to Stieglitz, Strand had a very different lodestar for his 60 years of photography: Lewis Hine. The values of the pioneering social documentarian and the champion of vanguard art and art photography influenced the

younger man in different proportions throughout his career of formal innovation and humanistic commitment. Strand is best known for his modernist experiments of circa 1915-24, while his post-1944 photographs heroicize representatives of pre-modern cultures with modernist devices. For both veins of work, he was a master printer in the "straight" tradition.

Strand was born into a progressive middle-class Jewish family and received a camera at age 12. While a student at Manhattan's Ethical Culture School, he joined the student camera club run by Hine, and they first visited Stieglitz's "291" in 1907. Strand would have known of Hine's sympathetic photographs of new Americans at Ellis Island, but it was the world of new art that snared him. At "291" he saw Stieglitz's painters—Americans such as Marsden Hartley, Max Weber, and John Marin, and their European inspirations, including Picasso, Braque, and Brancusi; and in the pages of Stieglitz's *Camera Work* he read critic Sadakichi Hartmann's defense of the purely photographic values of sharp detail and long tonal range and painter Wassily Kandinsky's justification for abstraction in "Concerning the Spiritual in Art." In 1911, two years after graduation, Strand visited Europe, and in New York in 1913 he saw the Armory Show, which charted advanced painting from Cézanne to Duchamp's "Nude Descending a Staircase." In 1915 Stieglitz critiqued the soft-focus photographs that Strand was showing at the New York Camera Club, and recommended a smaller aperture. All this made 1915 a turning point for Strand from Pictorialism to modernism. In 1915-16 he produced three groups of images that established his lifelong themes; they were also the most condensed and abstracted photographs made anywhere to that date. Stieglitz exhibited them at "291" in 1916, Strand's first solo show, and devoted the last two issues of *Camera Work* to them, 1916-17.

At first glance, the photographs Strand made in summer 1916 in Connecticut appear the most radical in their geometric reductivism. A few simple objects—a porch rail, a chair, a table—appear so close up and tilted they are only recognizable with effort. But in New York Strand also trained his camera down over brownstone backyards and created taut, linear compositions with the contradictory spatial cues of Cubism. These marry the sense of place he showed in a series on

PAUL STRAND WAS WORKING CLOSELY WITH ALFRED STIEGLITZ WHEN HE CREATED "CHAIR ABSTRACT, TWIN LAKES, CONNECTICUT" IN 1916.

movement in the city with a modernist awareness of two- and three-dimensional formal ingredients. His third theme was Lower East Side street people unaware of his camera, candids made "before there were any candid cameras," in his words. These close-ups evoke, oddly, both Hine's immigrants and Marcel Duchamp's found objects: their human and pictorial strengths are balanced.

In the 1920s Strand earned a living as a commercial filmmaker, and in the scant time he had for photography, he explored close-ups further, revealing the patterns in both plants and precision machinery. An intimate portrait series on his first wife was inspired by Stieglitz's extended portrayal of Georgia O'Keeffe (the two couples were then close friends). Simultaneously, Strand pondered how to convey American

identity: his "sharply particularized" photographs of objects, such as his Akeley movie camera, were intended to make us "experience something which is our own, as nothing which has grown in Europe can be our own," he said. In *Manhatta*, 1920, an experimental film he made with Sheeler, he evoked the jazzy rhythms and angularities of New York City in quick cuts and diving perspectives.

During the Depression, Strand became politically active, and he collaborated on social documentary films, notably *The Wave*, 1934 (made during a two-year stay in Mexico), *The Plow that Broke the Plains*, 1936, and *The River*, 1937, the latter two with director Pare Lorentz of Frontier Films. In 1944 he returned to still photography and subsequently published a series of books, including *Time in New England*, 1950, which was innovative in juxtaposing his photographs with quotations chosen by Nancy Newhall from Emerson, Thoreau, and other Yankee authors. Similarly, the books of photographs he later made in rural France, Italy, Egypt, the Outer Hebrides, and Ghana celebrated the community tradition, in which he believed individual and collective life was satisfied materially and spiritually. These books were his implicit critique of mid-century America, where Cold War fears were embodied in Senator Joseph McCarthy's "Red hunting." The attacks on civil liberties had led to Strand's self-exile to France, where he lived from 1950 until his death.

Strand and Charles Sheeler were fellow protégés of Stieglitz, friends from the late 'teens, and artistic collaborators: it is not surprising that their photographs of 1916 were remarkably similar in their geometric reductivism and use of novel vantage points to abstract and flatten their subjects. Sheeler, the more cerebral of the two men, always subordinated his photography to his painting, however, and pursued personal and commercial camerawork without stylistic distinctions. Using a vertiginous perspective from *Manhatta*, the experimental film he and Strand made together in 1920, Sheeler produced a dramatic canvas that year that differed from its source only in color. Though his paintings grew more literal over the 1920s, they would be called "Precisionist"—along with the work of Charles Demuth, Ralston Crawford,

Preston Dickinson, and others—for the clean-cut geometries they underlined in the man-made landscape. This graphic idiom proved ideal for advertising, and Sheeler and the photographers Ralph Steiner (1899-1986) and **Paul Outerbridge** (1896-1958) supplied striking images for the printed page from the 1920s on. The Machine Age was thus epitomized in art and commerce by the modernist photographs of these and other practitioners—dazzling machine-made representations often of dazzling machines.

In the United States and in Europe, photography was acknowledged as the exemplary art of this era. It also entered American museums in the 1920s, in the form of gifts that Stieglitz made of his own fastidiously printed work to the Museum of Fine Arts, Boston, and to New York's Metropolitan Museum of Art.

CHARLES SHEELER (B. PHILADELPHIA, PENNSYLVANIA, 1883–D. DOBBS FERRY, NEW YORK, 1965)

Commercial industrial photography and modernist art shaped Sheeler's astringent photographic style. "My interest in photography, paralleling that in painting," he remarked, "has been based on an admiration for its possibility of accounting for the visual world with an exactitude not equaled by any other medium." The pragmatism and Puritanism found by some cultural historians in the American character stand out in his ground-breaking 1915-27 photographs of purely functional buildings—whether Ford factories and Manhattan skyscrapers or colonial barns. In these artifacts of America's past and present, he identified what was modernist.

Sheeler was first and last a painter. In 1903-6 he studied at the School of Industrial Art and the Pennsylvania Academy of Fine Art in his native Philadelphia. By 1913, when the epochal Armory Show introduced Americans to vanguard European art in one blow, he had visited Europe three times—1902,

"CRISS-CROSSED CONVEYORS—FORD PLANT": FORD MOTOR CO. HIRED CHARLES SHEELER TO CONVEY THE MACHINE-AGE GRANDEUR OF ITS HUGE RIVER ROUGE PLANT IN 1927.

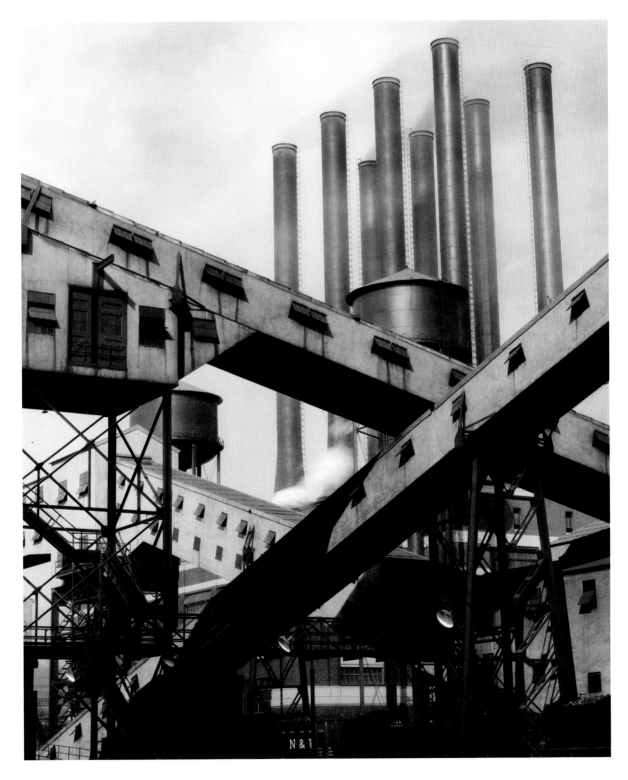

1903, and 1908—and absorbed the lessons of the Old Masters and Picasso, Braque, and Matisse. Self-taught as a photographer, he had "the usual $5 box Brownie" as a teenager, he said. But by circa 1911 he and fellow Academy painter Morton Schamberg (1881-1918) were earning money from photographing buildings, and they soon used the camera for personal exploration. Untouched by Pictorialism, Sheeler applied Cubism's geometric simplifications in the photographs (and paintings) he made in the Doylestown, Pennsylvania, farmhouse that he and Schamberg shared on weekends until the latter's death (of influenza) in 1918. Photographs by both men were as radical in their modernism as camera work by Strand made in the same years. Though never abstract, Sheeler's austere, closely cropped photographs of his farmhouse staircase and barn are equivalents of Malevich's and Mondrian's minimalist paintings of the 1910s and later. "We began to understand that a picture could be assembled arbitrarily with a concern for design," he observed, "and that the result could be outside time, place, or momentary considerations."

In 1919 Sheeler moved to New York City, and in 1920 he made *Manhatta* with Strand, in which they used drastic vantage points up and down to convey the breathtaking scale of the city's skyscrapers and the hectic speed of its traffic. As advertising kept pace with America's booming consumer economy, Sheeler continued his commercial photography, and promoted products from typewriters to tires. In 1927 he won the commission from the N. W. Ayer agency to photograph Henry Ford's River Rouge assembly plant in Dearborn, Michigan, then the most advanced factory complex in the world. Ford introduced the Model A that year, a challenge to General Motors competition, but he wanted a paean to industry from Sheeler, not photographs of his car. Sheeler made 32 8 x 10-in. prints from his six weeks work at the plant, and though some 75,000 workers turned coal into steel into cars there, he showed only a few human beings. Instead, he

EDWARD WESTON CHOSE TO FOCUS ON
THE SUBLIME BEAUTY OF ORDINARY OBJECTS,
AS IN "WHITE RADISH," 1933.

aggrandized the already gigantic stamping presses, smokestacks, and some of the 27 miles of conveyors; and through sharp focus and low, distant standpoints, he turned them into a man-made landscape of what has been called "the technological sublime." European architects such as Le Corbusier and Erich Mendelsohn had already identified America's industrial structures as the country's Parthenon and cathedrals. Sheeler confirmed the analogy in naming one of his River Rouge paintings "Classic Landscape," commenting, "Our factories are our substitute for religious expression." An inversion of this idea may be seen in his 1929 photographs of Chartres Cathedral, where he looked down on the massive, repeated lines of the Gothic buttresses, stressing its engineering over its religious symbolism. As in Pennsylvania and Michigan, he dramatized the clean-lined geometric forms and purified beauty shared by the purpose-built structures.

In 1931 Sheeler began exhibiting his paintings at Edith Halpert's Downtown Gallery, an influential home to American modernist art. Thereafter his independent camera work diminished, and he photographed mainly for his canvases, notably those commissioned and published by *Fortune* magazine in 1939 as the series "Sources of Power." His canvas surfaces remained as smooth as photographic prints, even though he continued painting through the heyday of Abstract Expressionism. "An efficient army buries its dead," he said. "I don't want to see the … struggle that was passed through in order to arrive at what we are presently witnessing in the picture."

While the influence of Stieglitz on Strand and Sheeler extended over several years, he met with Edward Weston for just a matter of hours in 1922. But the meeting was decisive. Stieglitz confirmed the younger man's stylistic direction and, more important, his convictions about his art. Later, in 1931, Weston wrote: "[C]louds, torsos, skulls, peppers, trees, rocks, smokestacks, are but interdependent, interrelated parts of a whole, which is Life. Life rhythms felt in no matter what, become symbols of the whole …. To see the *Thing Itself* is essential: the quintessence revealed direct without the fog of impressionism." Weston here cited most of his subjects to that date, and what he felt united them: his sense of the pantheis-

WESTON'S "STRAIGHT" AND SUBLIME TOILET

Throughout his career, Weston demonstrated the power of photography to transform mundane reality, and in 1925 he set himself this extreme test, as quoted by Ben Meddow from Weston's *Daybooks*: "'Form follows function'—who said this I don't know—but the writer spoke well!

"For long I have considered photographing [our toilet,] this useful and elegant accessory to modern hygienic life, but not until I actually contemplated its image on my ground glass did I realize the possibilities before me. I was thrilled!—here was every sensuous curve of the 'human form divine' but minus imperfections.

"Never did the Greeks reach a more significant consummation to their culture—and it somehow reminded me, in the glory of its chaste convolutions and its swelling, sweeping, forward movement of finely progressing contours—of the 'Victory of Samothrace.'

…"Trying variations of the W.C.—different viewpoints—another lens. From certain angles it appeared quite obscene: so does presentation change emotional response …. [Yet] by placing my camera on the floor without tripod I found exactly what I wanted …. But I have one sorrow … the wooden cover shows at the top …. [What to do? Or should he do nothing? Nothing.] To take off the toilet's cover—either by unscrewing or retouching—would make it less a toilet—and I should want it more a toilet rather than less. Photography is realism!"

PRECEDING PAGES: "THE UNMADE BED," 1957: INSPIRED BY GERTRUDE KASEBIER, IMOGEN CUNNINGHAM WORKED WITH EDWARD CURTIS BEFORE SHE ESTABLISHED HERSELF AS A SUCCESSFUL PORTRAITIST.

tic "life force"—the philosopher Henri Bergson's *élan vital*. And he stated his goals, to reveal the Platonic essence of each "part," so that together his photographs would convey Life. Through his interwar oeuvre, Weston extended the art tradition in American photography originated by Stieglitz and Strand to photographers including Imogen Cunningham, Ansel Adams, and the next generation, of Minor White and Brett Weston. At the same time, he used the devices of modernist "straight" camera art to celebrate a 19th-century Transcendentalist idea—that the real world, intensely observed, can reveal a higher order. Weston's hyperreal close-ups on glossy paper, "previsualized" in his large-format camera and "perfectly" printed, manage to be Puritan, mystical, and sensuous at the same time.

EDWARD WESTON (B. HIGHLAND PARK, ILLINOIS, 1886– D. CARMEL, CALIFORNIA, 1958)

Weston began photographing at age 16, when his father gave him a Bull's-Eye No. 2, and he quickly bought a 5 x 7-in. camera. At the Illinois College of Photography in 1908 he learned darkroom procedures; and in 1909 he relocated to Southern California, where—after marriage and the birth of the first two of four sons—he opened a portrait studio in 1911. Through that decade he thrived as a Pictorialist among West Coast photographers, including the more aesthetically adventurous Cunningham, Margrethe Mather, and Johan Hagemeyer. Their influence, and that of photographs in Stieglitz's *Camera Work*, helped streamline his style by 1922. That year in Ohio, he photographed the Armco Steel factory with a new, stark simplification. These photographs were among the few that impressed Stieglitz when Weston showed them to the impresario later that year. He recommended "the maximum of detail with the maximum of simplification," Weston remembered, and the advice was reinforced by Strand and Sheeler, whom he also met in New York. Back in Glendale, California, Weston resumed the affair he was having with the actress Tina Modotti; in 1923 they moved to Mexico City, where new lives began for both of them.

HANNAH HÖCH TITLED THIS PHOTOMONTAGE "CUT WITH THE KITCHEN KNIFE DADA THROUGH THE LAST WEIMAR BEER BELLY CULTURAL EPOCH OF GERMANY."

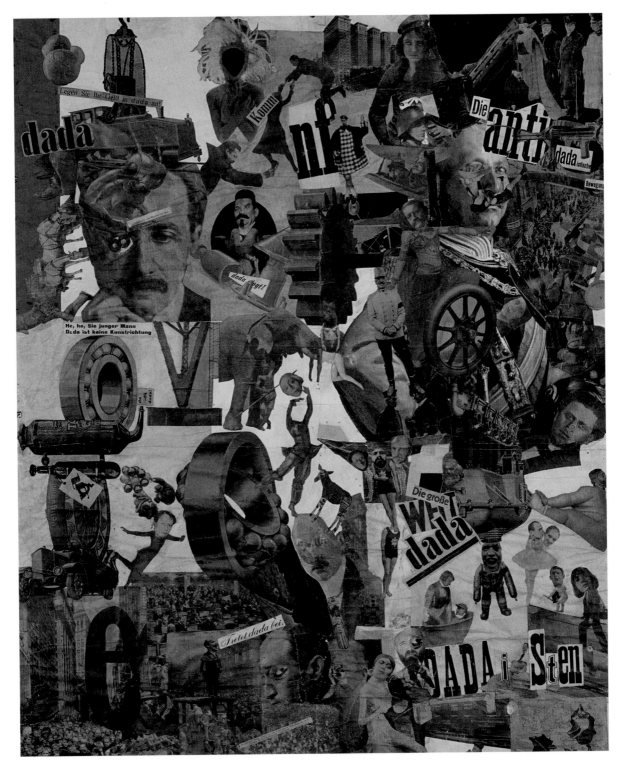

Weston applied the modernist language of sharp-focus close-ups and dramatic perspectives to portrait heads and landscapes in the blazing Mexican sun. He also transformed simple sculptural objects through tight cropping and novel vantage points, using a large-format camera for its superior rendition of tonal range and resolution. He taught Modotti how to photograph, and they both exhibited their camera art to acclaim. Back in California in 1926, he soon concentrated on single objects, which he decontextualized and turned into metaphors for nature's unities: he revealed the Gothic arches of an artichoke's leaves, for example, and lovers embracing in a pepper's sculptural forms. In 1929 he and Edward Steichen were chosen to select the U.S. photographers in the "Film und Foto" exhibition. This ratified his stature, as did the founding of Group f64 in 1932, with Cunningham, Adams, Willard Van Dyke, Sonya Noskowiak, and others. These friends named themselves for what was usually the smallest aperture on their 8 x 10-in. view camera lenses, which produced the maximum depth of field and thus maximum detail; and they upheld printing on glossy paper because its sheen suited their industrial aesthetic. Their credo was the photographic equivalent of the modern sculptor's insistence on "truth to materials." Only burning, dodging, and spotting were allowed in the making of their "honest" prints.

In 1937-38, as the first photographer to win a Guggenheim Fellowship, Weston photographed across the West. Now his landscapes were expansive, though no less voluptuous; and he showed full-length nudes, though no less chastely. In 1940 he published *California and the West;* in 1941 *Leaves of Grass*, his photographs with Walt Whitman's epic poems; and in 1950 *My Camera at Point Lobos* (his home on the rugged Pacific Coast). In 1946 he was diagnosed with Parkinson's disease. Two years later, having taught his sons how to print his negatives to his exacting standards, he stopped photographing.

DIVERSE EXPRESSIONS IN GERMANY

In the violent years in Germany between 1918 and 1933—between its defeat in World War I and the accession to power of Hitler's National Socialist Party—German photography was

as adventurous and multifaceted as any in the world. Dada artists appropriated mass-media photographs for their own mocking, anarchic ends; and by the 1920s photomontage became a tool of scathing leftist commentary. Painters of the *Neue Sachlichkeit* (the New Objectivity) embraced like-minded photographers of coolly documentary stripe. And the radical experiments of "New Vision" camera work were widely pursued and published, notably by the famed school of architecture and design, the Bauhaus.

In the 1920s as well, the thriving German picture press fostered epochal developments in photojournalism (see Chapter 4), which in turn invigorated art photography. In fact, the borders between photographic genres were porous, as were borders between nationalities in the early years of the Weimar Republic, so-called for Germany's new capital in that grand-ducal city.

GEORGE GROSZ DEPICTED HIS FRIEND JOHN HEARTFIELD WITH A MECHANICAL, PHOTOGRAPHIC HEART TO SIGNAL HIS POLITICAL DEFIANCE.

Germany was a way station for artistic influences from the Soviet Union, Central European countries, and the Netherlands; and as the totalitarian regimes first of Stalin and then of the Nazis drove artists and intellectuals West, German developments spread to France, Great Britain, and by the late 1930s to the United States. The goals of these photographers were inclusive and revolutionary. While the American photographers Stieglitz, Strand, Weston, and Ansel Adams attempted to purify and ennoble photography in order to secure its art status, the Europeans embraced photography's heterogeneity, as seen in everything from films and advertisements to x-rays, and believed in its potential to remake not just the arts but the whole of visual culture.

PHOTOMONTAGE IN BERLIN

Dada was born in New York, Zurich, Hannover, Berlin, and Paris almost simultaneously, created by artists who shared outrage and horror at the toll of "the war to end all wars" and at the hypocrisy of the power elites supporting it. Whether "Dada" came from a nonsense syllable, the German for "yes, yes," the French for "hobbyhorse," picked at random from a dictionary, or a soap promoted as an all-purpose cleanser, its adherents defied art conventions and the political and cultural establishments identified with them. Photomontage was the weapon of choice of the Berlin Dadaists, most of whom supported the Russian Revolution, and they wielded scissors and paste for both nonsense art and political attacks. In 1916-20 in particular they coopted the design strategies and photographs of Germany's vigorous picture press and turned them against their sources, as well as high-art institutions, Weimar politicians, and capitalist excesses. Photographs torn from periodicals gained new ironic meanings based on inversions of their original ones. They gave Dada artworks the topicality and popular energy of newspaper stands. And as collage elements were added to pictures or composed them from edge to edge, they challenged the time-honored ideal of the artwork's refined handcraftsmanship and its integrity of means. The Hannover Dadaist Kurt Schwitters called his pasted-paper compositions *Merzbild*, or refuse pictures (an equivalent of *merde* in French). In Berlin, artists such as **Raoul Hausmann** (1886-1971), **Hannah Höch** (1889-1978), **George Grosz**

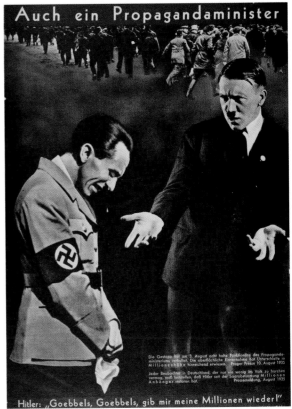

A JOHN HEARTFIELD DESIGN FOR THE AUGUST 22, 1935, COVER OF *AIZ* SAYS, "GOEBBELS, GOEBBELS, GIVE ME BACK MY MILLIONS!"

(1893-1959), and **John Heartfield** (1891-1968) used photomontage to fling *merz* in the faces of authority.

Collage (from the French *coller*, to paste) had entered art in 1912 when Picasso and Braque introduced newspaper clippings, wallpaper scraps, and the like into their canvases. But these painters were playing with the forms and patterns of their low-life materials more than their content. Nonetheless, collage and assemblage (involving additional media and three-dimensional elements) became essential techniques in picture-making and sculpture—perhaps the essential compositional means in 20th-century art. Among the defiant young Germans, however, the identities of mass-produced images were crucial, and their photomontage had older sources.

The first photomontages, Höch reflected in 1934, were popular late-19th-century fabrications "found sometimes in the boxes of our grandmothers," where the photographic heads of family members were pasted into preprinted pictures of military groups or vacationers at landmarks. Furthermore, joke postcards of cut-up and rephotographed snapshots were sold worldwide from the 1880s through the early 20th century. Then, at the end of the 1910s, the Dada artists and commercial picture editors discovered photomontage at the same time. Höch observed from her experience working at Ullstein Verlag, the giant publisher: "When a potentate was welcomed in Tröchtelborn and the journalistic photo taken on the spot was not impressive enough," extra figures were glued in and the total was reshot, thus creating a mob "when in reality the welcoming crowd was only a male choir." Feature-story layouts freely silhouetted and surprinted photographs of startlingly different sizes. Such devices, as well as banner headlines and blaring typography, appealed to Dadaists as attention-getters. And their satiric uses of them in turn emboldened commercial layout artists to further invention, as vanguard and popular image-makers inspired each other. Though Höch and Hausmann have been credited with inventing photomontage, all the Berlin Dadaists deserve to be identified with its first significant artistic use.

In 1921 Hausmann asked, "Why don't we paint works today like those of Botticelli, Michelangelo, Leonardo, or Titian? Because our spirits have utterly changed. And not simply because we have the telephone, the airplane, the electric piano, and the escalator. Rather, because above all these experiences have transformed our entire psycho-physiology." Photomontage—which aped the quick cuts and startling juxtapositions of images in cinematic montage—seemed to mirror modern experience in its multiplicity of rapid-fire sensations and fragmented perceptions, its disorientations and illogic yet its thrills. The mass-media sources that Hausmann and fellow Dadaists used were intended to relocate art within popular culture and to ensure its social and political pertinence, and with much the spirit of contemporary Soviet art. The German group chose to call their collages Potomonages,

he said, because of "our aversion at playing the artist" and preference for "thinking of ourselves as engineers … [intending] to construct, to assemble [montieren] our works." Thus George Grosz pictured his friend as The Engineer Heartfield with a photograph of a telephone where his heart and larynx would be and a convict's shaved head (evoking his jail term for Communist activities). And at the 1920 Dada Fair in Berlin, in which they all exhibited, a banner read, "Art is dead! Long live the new machine art of Tatlin," referring to the Russian's utilitarian designs.

Despite their Communist sympathies, the Germans' subjects and styles were multifaceted. Hausmann saw photomontage as equivalent to his and other Dadaists' poems of pure sounds—aggressive and dynamic—and between 1920 and 1924 he moved from placing his clippings in de Chirico-style stage spaces to letting images and type overlap and explode, like the Dadaists' phonetic recitations in their provocative performances, the forerunners of the Happenings of the late 1950s. Höch in her chef-d'oeuvre, Cut with the Kitchen Knife Dada through the Last Weimar Beer Belly Cultural Epoch of Germany, 1919-20, assembled portraits of the Dadaists, their heroes (such as Karl Marx), and their enemies (Weimar politicians and generals), and enlivened the mix with images of the liberated New Woman and the wheels of progress. In her series "From an Ethnographic Museum," 1924-34, she created composite multi-ethnic figures from her clippings, which were early in underlining the relativity of concepts of race, gender, and beauty.

Heartfield, who had Anglicized his name (Herzfeld) out of loathing for Germany, sharpened photomontage into a tool to scourge Hitler and his supporters, and while such collage entered advertising and poster design (by László Moholy-Nagy and Herbert Bayer, for example), he applied it most famously in covers for AIZ (Arbeiter Illustrierte Zeitung, The Worker's Illustrated News), a Communist magazine. With airbrushing, the dove of peace appeared to be bayoneted in front of the Geneva League of Nations building in one example; while "The Meaning of the Hitler Salute" was given by a businessman slipping currency into the Führer's raised hand. The latter cover's punning subtitle was "Millions Stand

ALBERT RENGER-PATZSCH COOLLY RECORDED NATURE'S PATTERNS, AS IN "SNAKEHEAD," PHOTOGRAPHED BETWEEN THE WORLD WARS.

Behind Me!" Graphically immediate photographs, clipped or commissioned by Heartfield, and his savagely ironic headlines in bold modern type, set a standard for political photomontage that arguably has yet to be matched. In the exhibitions of photomontages that took place through the early 1930s, Heartfield always showed the printed magazine and book cover illustrations alongside his mockups. He thus insisted that his works were left-wing criticism for the masses, not unique and elitist works of art. Driven out of Germany in 1933, he continued to work for *AIZ* from Prague until 1938 when Hitler's threat to invade Czechoslovakia became real.

GERMANY: THE NEW OBJECTIVITY

Like photomontage, "the New Objectivity," named in 1923 for a literalist tendency in photography and painting, defied the ivory-tower hermeticism of abstract art, but with very different means. Emerging out of the chaos of the war and its turbulent aftermath in the Weimar Republic, German painters such as Christian Schad, Otto Dix, and Anton Raderscheidt, and photographers August Sander, **Albert Renger-Patzsch** (1897-1966), and **Karl Blossfeldt** (1865-1932) were applauded by progressive critics for their dispassionate descriptions of material facts. Likewise, photography's potential for emotionally distanced, detailed documentation was heralded, as was its versatility in serving science, advertising, journalism, art, and personal record-making. The camera's practical applications and seemingly intrinsic "objective" style distinguished it from both academic art, identified with bourgeois support-

ers of the Great War, and Expressionist painting. As a machine, the camera was considered as ideally suited to describing and classifying the phenomena—both machine-made and natural—of a new, technologically oriented world.

Sander, Renger-Patzsch, and Blossfeldt all reached their broad publics with books. They benefited in particular from recent improvements in printing technology and public interest in photography publications: their richly toned prints, reproduced on slick paper, appeared in volumes of 1928 and 1929 and demonstrated the camera's equally rigorous approach to the spectrum of subjects. Renger-Patzsch's *Die Welt Ist Schön* (The World is Beautiful), 1928, discovered graphic beauty in elements of architecture, technology, and nature—what he called "the magic of material things." Blossfeldt's *Urformen der Kunst* (Art Forms in Nature), 1928, profiled and compared plant specimens in close-ups of elegant severity. And Sander's *Antlitz der Zeit* (Face of the Times), 1929, presented 60 portraits of a cross-section of German citizenry. Sander's book was "a treasure-trove for lovers of physiognomy," wrote novelist Thomas Mann, "an outstanding opportunity for the study of human types as stamped by profession and social class." For these photographers, the camera was a tool of quasi-scientific neutrality; their photographs, which they made in the same way and then sequenced for the reader, presented interesting information and revealed typologies for the edification and delight of a broad, data-hungry public.

Blossfeldt did not set out to display the camera's transformative insights. From 1898 he was a professor of decorative arts at the Berlin Kunsthochschule (High School of Arts and Crafts), where he taught the study of organisms as the basis of an Art Nouveau-style ornament. Trained as a model builder and metal caster, he bought a large-format camera around 1900. On weekend bike trips to the countryside and vacations to Italy, North Africa, and

KARL BLOSSFELDT WAS A BOTANIST AND
A PHOTOGRAPHER IN BERLIN WHO
CREATED A SENSATION WITH HIS BOOK,
ART FORMS IN NATURE. THIS IS #72.

Greece, he gathered over 6,000 plant samples, which he set on plain backgrounds and magnified to 18 times or more in his photographs. Some he arranged in diptychs and triptychs to stress mirrored or repeated forms. The Berlin art dealer Karl Nierendorf discovered his archive in the mid-1920s and helped him publish selections from it. Though Blossfeldt's sensibility was more Gothic than modernist and his goals were scientific and academic, his sharp-focus, portrait-like depictions of seedpods and spiky ferns appealed to vanguard artists among both Surrealists and New Objectivity members.

Renger-Patzsch learned photography from his father, an amateur; then studied chemistry in Dresden, and became head of the photo archive at a Hagen publishing house, where he documented anthropological artifacts. Living in the Ruhr district in 1929-44, he photographed its industrial architecture in crisp detail, and eventually published his work in nearly 40 volumes. In the 1920s and later, he and Blossfeldt championed the "straight," literal-minded photography of the New Objectivity in the press against the experiments of László Moholy-Nagy and others at the Bauhaus school. The former's sober classifications would influence later Conceptual photographers such as Bernd and Hilla Becher and their followers; the contemporaries of Renger-Patzsch and Blossfeldt were delighted by their photo archives, which could be viewed as art or information or both. They were studiously apolitical. In the combative, faction-ridden Weimar Republic, this annoyed the Marxist critic Walter Benjamin, who called the photographs that decontextualized their subjects "a sort of art journalism." But the elegantly described "things" in these photographs were reassuring. While they did not hint at Platonic essences or life forces, like the similarly reductive shells and vegetables of Edward Weston, they offered the same pleasures of intensified seeing.

GERMANY: "THE NEW VISION"

In 1924, after the disastrous inflation of the previous two years, the Dawes Plan brought American investment to Germany, and some financial stability. It also broadened appreciation of American popular culture and the country's

MOHOLY-NAGY'S EIGHT KINDS OF CAMERA SEEING

In his 1925 book, *Painting, Photography, Film*, Moholy-Nagy listed all the ways he thought the camera had revolutionized seeing to that date (he left out only the cliché-verre): 1. Abstract seeing—the photogram, "capturing the most delicate gradations of light values"; 2. Exact seeing—reportage; 3. Rapid seeing—snapshots; 4. Slow seeing—prolonged time exposures, "by means of the fixation of movements spread over a period of time; for example, the luminous tracks made by the headlights of motor cars passing along a road at night"; 5. Intensified seeing—microphotography, infrared photography; 6. Penetrative seeing—x-rays; 7. "Simultaneous seeing by means of transparent superimposition"—photomontage; 8. Distorted seeing, optical jokes—"exposure through a lens fitted with prisms (the device of reflecting mirrors)" [Moholy probably knew of Alvin Langdon Coburn's Vortographs] or mechanical and chemical manipulation of the negative after exposure." Assignments to explore all these kinds of camera seeing were part of teaching at Moholy's New Bauhaus, and many were continued by his protégés when they taught, notably at the Illinois Institute of Technology and Rhode Island School of Design through the 1960s.

LÁSZLÓ MOHOLY-NAGY PORTRAYED ELLEN FRANK IN 1929, IN EXTREME CLOSE-UP.

Machine Age modernity, and led Germans to see kinships between its New Objectivity artists and the Americans who would be called Precisionists, between the architectural photography of Charles Sheeler and Werner Mantz, for example, and the advertising still lifes of Ralph Steiner and Hans Finsler. The early 1920s also saw liberating interchanges between Soviet artists and those in Germany, such as El Lissitzky and Moholy-Nagy; exhibitions exchanged between the countries; and cultural gatherings such as the Dada-Constructivist Congress in Weimar in 1922. United by revolutionary political idealism, disdain for capitalist institutions, and dedication to new art, the Congress gathered the Dadaists of Berlin, Paris, and Zurich with Lissitzky, representing the Constructivists, Theo van Doesburg, leader with

Mondrian of Holland's de Stijl movement, and Moholy-Nagy, who was then identified with abstract painting and the experiment of the MA group in his native Hungary. Were the languages of mass-media photomontage and pure nonobjective painting to be reconciled, and to what ends? If easel painting was dead, what was photography's role? As scholar-curator Christopher Phillips points out, Moholy-Nagy and the Russian Aleksandr Rodchenko followed similar paths in becoming proponents for their countries' "New Vision" photography—from painting to collage to photomontage and graphic design and finally to camera work. Moholy's all-embracing but politically neutral interpretation of modernist photography would prove the most influential.

Moholy-Nagy valued photographic materials for their extraordinary light sensitivity and their potential as a new image-making system, uniquely suited for expressing the new, modern experience of space and time. For much the same reasons, he explored abstract painting, kinetic and constructed sculpture, graphic design, and design for film and stage: they all offered new ways of conveying his sense of mobile modern life. Light as common to all visual expression underlay his choice of illustrations for his seminal 1925 Bauhaus book, *Malerei, Fotografie, Film* (Painting, Photography, Film), and his statement of 1932 that "the essential tool of photographic procedure is not the camera but the light-sensitive layer." At the same time, Moholy insisted on photography's centrality to modern communications, claiming in 1936 that "the illiterate of the future will be ignorant of the camera and pen alike." By eloquent words and examples, he urged his eager students in Germany and the United States to experiment with diverse ways of camera seeing. His photographs may be the most inventive aspect of his multifaceted art production.

LÁSZLÓ MOHOLY-NAGY (B. BÁCSBORSÒD, HUNGARY, 1895– D. CHICAGO, ILLINOIS, 1946)

Moholy-Nagy studied law at the University of Budapest and explored painting before World War I, and was wounded during his service then. Recuperating, he began to photograph while maintaining his interest in painting and graphic design. By 1920 he was dedicated to art and living in Berlin, and by 1922 he was friendly with both the Berlin Dadaists and Lissitzky, who familiarized him with Constructivism. That year he and his first wife, Lucia, a professional photographer and journalist, experimented with photograms, the Cubist-derived camera-less photographs that Christian Schad (better known as a New Objectivity painter) had pioneered in 1919. Moholy-Nagy, a great appropriator of creative ideas, may have known of Schad's work or the Rayograms of Man Ray, made in late

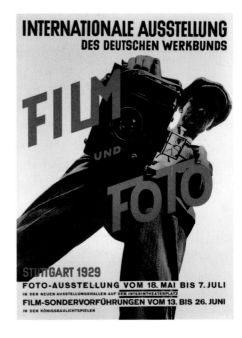

FILM UND FOTO, 1929

Organized by the Werkbund, a trade association of German architects and designers, the 1929 exhibition "Film und Foto," demonstrated the camera's emerging central role. The work ranged from camera art, photojournalism, and advertising to microphotographs and astronomical images. The photographers represented were international: Weston and Steichen chose the Americans, El Lissitzky the Russians, Karel Teige the Czechs, Piet Zwart the Dutch, and Moholy-Nagy the Germans. Moholy-Nagy's camera work filled a room. Werner Gräeff's *Here Comes the New Photographer!* and *Photo-Eye (Foto-Auge)* by Franz Roh and Jan Tschichold were catalogues presenting the show in three languages. Designed by Tschichold, the poster reproduced Willi Ruge's photographs of a cameraman, taken from a vantage point that turns him into a colossus apparently bestriding the world. Modernism in photography had arrived.

1922; but his own were pure light abstractions, without evidence of the objects that had produced them. The same year he phoned instructions for a painting to a factory technician: the gesture, like that of exploring photochemistry in photograms, showed his belief in the superiority of industry over handicrafts.

In 1923 Moholy-Nagy was invited to the Bauhaus, the new, state-sponsored school of architecture and design, to head the metal workshop and teach the foundation course, which introduced all Bauhaus students to materials and their properties. He never taught photography—in fact, it only entered the curriculum in 1928 (with Walter Peterhans), after Moholy-Nagy had left. But his witty experiments with photo-collage ("Fotoplastiks") from 1924, using his own or others' prints, and his later exploration of aerial vantage points as he photographed on his vacations, of negative images, differences in focus, distorting shadows, and other aspects of photographic practice, opened lively possibilities for his admirers. In his Bauhaus book *Painting, Photography, Film*, he illustrated the gamut of photographic types: advertising images, photo-collages, x-rays, architectural studies, etc. This potpourri demonstrated the range of "The New Vision," as Moholy-Nagy defined it: he convincingly argued that the camera was creating new, uniquely modern ways of seeing the modern world.

In 1928 Moholy-Nagy left the Bauhaus to pursue graphic art and advertising and theater design in Berlin. The following year he chose the photographers representing Germany in the massive "Film und Foto" exhibition, an indication of his high standing among photographers. In 1934 he left Hitler's regime for Amsterdam and then London, where he designed sets for Alexander Korda's futuristic film, *Things to Come*. In 1937 he relocated to the United States, and in Chicago, with the financial backing of Walter Paepcke, head of the Container Corporation of America, he opened the New Bauhaus with Gyorgy Kepes and other former Bauhaus colleagues, intending to recreate the union of art and technology of the original school (closed by the Nazis in 1933). After a year the New Bauhaus became the School of Design, and in 1944 the Institute of Design, which finally merged with the Illinois Institute of Technology.

Moholy's still photographs and his film of his kinetic abstract sculpture, the *Light Space Modulator*, summarize his fascination with modern means of capturing light and motion. Nothing in the three media is sensuous in material or emotionally expressive in content: rather, they all represent Moholy-Nagy's admiration for the novel optical experience in its own right and his quest to liberate seeing. His books, *The New Vision: From Material to Architecture*, 1932, and *Vision in Motion*,1947 (on his foundation course at the Bauhaus), also expressed his utopian view of the interrelatedness of art and life, and invigorated art teaching in the mid-20th century.

THE USSR: "THE GREAT EXPERIMENT"

The early 1920s were years of vital interchange between German and Russian vanguard artists, as they forged a modern form language of simplified geometries, dynamic diagonals, and exhilarating perspectives in all media, and especially in photography. Collaboration among practitioners and interchange among media were watchwords. While the Germans sought ways of coping with modern life, amid postwar political and socio-economic disruption, the Russians sought a new art for their wholly new society, one that would express their utopian faith in the potential of "the new man" created, they thought, by the Revolution of 1917.

After the Revolution, the remaking of Russia from a feudal empire to a modern Bolshevik state was the task facing Communist leaders. Lenin saw progressive art as vital to the effort, and between 1917 and 1922 he supported the most thorough alliance in history between government and the avant-garde. The nonobjective geometries of Malevich's Suprematism, which he named in 1915, and the Constructivism of Tatlin, Rodchenko, and Lissitzky, identified by 1921, were thought to provide universally understandable symbols in "a new art for a new society." Regardless of differences over the practical applications of their form language, all the Russian vanguard attempted to use space dynamically in

ALEKSANDR RODCHENKO CHOSE UNUSUAL ANGLES TO TELL STORIES OF POLITICS AND ORDINARY LIFE.

THE RUSSIAN CAMERA IN FLIGHT

Cinematographer Dziga Vertov trumpeted the uniqueness and freedom of camera seeing in 1923, to the delight of his artist-friends Rodchenko and Lissitzky: "I the machine show you the world as only I can see it. I emancipate myself henceforth and forever from human immobility. *I am in constant motion.* I approach objects and move away from them, I creep up on them, I clamber over them, I move alongside the muzzle of a running horse, I tear into a crowd at full tilt, I flee before fleeing soldiers, I turn over on my back, I rise up with aeroplanes, I fall and rise with falling and rising bodies *I juxtapose any points in the universe regardless of where I fixed them.* My path leads toward the creation of a fresh perception of the world. I can thus decipher a world that you do not know." Even more invigorating to Russian still photographers than director Sergei Eisenstein's montage in films like *The Battleship Potemkin*, Vertov's films *Cine-Eye*, 1924, and *Man with a Movie Camera*, 1929, celebrated the camera's freedom from gravity and its unprecedented ability to convey the speed of modern life.

their different media; all achieved the look of machine execution, and all advocated the use of new materials, media, and constructive techniques. Photography was a key new medium, and one ideally suited to agit-prop—"agitation propaganda"—designed to unify the nation and promulgate revolutionary ideals to a largely illiterate population. Photography's use in photomontage and in its own right became more important as Lenin's cultural policies were dismantled from 1924 on and an ascendant Stalin demanded the illustrative painting called Socialist Realism.

ALEKSANDR RODCHENKO (B. ST. PETERSBURG, RUSSIA, 1891–D. MOSCOW, RUSSIA, 1956)

In politics and aesthetics, Rodchenko was revolutionary, and the two realms were intertwined in his career. This Russian is perhaps best known as a leading Constructivist and co-author of the 1921 *Constructivist Manifesto*, calling all artists to dedicate themselves to serving the new society created by the Russian Revolution of 1917. Photography was but one of his media, which included graphics, furniture, theater-set and clothing design, constructed sculpture, painting, illustration, photomontage, and filmmaking. He expanded the boundaries of almost all these forms, as he explored the most radical aspects of modernism between the wars.

Rodchenko first mastered turn-of-the-century styles in art school in provincial Kazan in 1910-14. But after moving to Moscow in late 1915, he quickly showed his awareness of the abstract paintings of Wassily Kandinsky and Kasimir Malevich: he contributed abstract compass-and-ruler drawings to "The Store" exhibition organized by Vladimir Tatlin in 1916. After army service through December 1917, he returned to Moscow as Lenin and the Bolsheviks came to power. Now artists were commanded to serve the masses in the most practical ways possible. Henceforth his paintings and constructions would be reductivist challenges to the spiritual aspirations of prewar painters; his 1918 black-on-black canvases asserted the materiality of the art object; his 1921 hanging constructions defied the traditions of floor-bound carvings. By 1921 Rodchenko, his lifetime companion, the artist Varvara Stepanova, Tatlin, El Lissitzky, and others decided that the "laboratory period" of abstract art was over and that they should henceforth design and produce nothing but useful objects. Representation was dead; "we should only make, process, and construct," they stated. Rodchenko's teaching since 1920 at the state-run VkhuTEMAS (the Higher State Artistic-Technical Workshops) and his leadership at INKhUK (Institute of Artistic Culture) spread his ideas. "[We seek the] making of the new man,

"THE CONSTRUCTOR," 1924, IS A SELF-PORTRAIT
BY EL LISSITZKY.

using art as one of the means of this creation," announced the first issue of *Lef*, 1923 (the magazine *Left Front of the Arts,* for which Rodchenko was the chief designer).

Rodchenko first adopted photography in 1923 not with a camera but with scissors. The defiant formal freedom and political bite of Dada photomontages by Heartfield, Höch, Grosz, and Hausmann were familiar to him (Lissitzky and the poet Mayakovsky brought him suitcases of German and French magazines from their trips to Europe), and he imitated the Germans' appropriations from the picture press. Notable among Rodchenko's early photocollages were those illustrating Mayakovsky's poem *Pro Eto* (About This), 1923. The lack of evidence of the artist's hand and the photographs' sources in mass media ensured that the photocollages were seen as both modern and popular.

In 1923-24 Rodchenko bought his first cameras, to photograph Mayakovsky, and he produced mug shots—portraits of

"NUDE, CAMPDEN HILL, LONDON," 1949, IS ONE OF BILL BRANDT'S MOST FAMOUS IMAGES.

unprecedented directness. On his one trip abroad, to Paris in 1925 to build the workers' club in the USSR Pavilion at the world's fair, he bought more cameras. That fall, possibly inspired by the novel vantage points in Moholy-Nagy's *Painting, Photography, Film*, he tried bird's-eye and worm's-eye views at his Moscow apartment. The vertigo he induced became more extreme in his 1927 series on pine trees at Pushkino Park. Drastically cropped, seen as series, these experiments with recognizable things "made strange," dynamic, and two-dimensional through vantage point, were his most innovative photographs.

Ironically, they were also used to engineer Rodchenko's fall from power in Stalin's Russia. In 1928 examples were juxtaposed with photographs by Moholy-Nagy and Renger-Patzsch

in an article accusing the Russian of "bourgeois formalism." Rodchenko's motivation and pictorial energy were powered by his Communist utopianism, but the photographs were undeniably similar. The issue demonstrated that modernist devices could serve many political masters, and it forecast Stalin's move toward Socialist Realism in the arts. In 1930 the VkhuTEMAS school was closed, and Rodchenko and Stepanova lived hand-to-mouth afterward, with occasional assignments to him for propaganda photojournalism. These included Moscow sports competitions, official parades, and theater events, as well as travel commissions from *USSR in Construction*, a periodical primarily intended to tout Soviet achievements to the West. In one of his best reportages, of 1933, on the building of the White Sea Canal (which cost close to 200,000 political prisoners their lives), Rodchenko seemed to believe the Party line that work on this disguised gulag would be redemptive. After decades of being "an invisible man," in his words, he died the year that premier Nikita Khrushchev denounced Stalin's murderous policies toward his own people.

EL LISSITZKY [LAZAR MARKOVICH LISITSKII], B. POCHINOK, SMOLENSK PROVINCE, RUSSIA, 1890– D. SCHODIA, NEAR MOSCOW, USSR 1941)

Lissitzky's self-portrait as "The Constructor," 1924, is famous for good reason: it sums up his self-image and talent in the 1920s and the ideals of Russian revolutionary art. Though he was a painter, an architect, and a book, typography, and exhibition designer, Lissitzky shows himself as an engineer, his eye centered in the superimposed photograph of his hand with a compass. Though the compositional divisions allude to the time-honored Golden Section, and the circle is the primary artwork in myths, they are made by ruler and compass, the tools of builders, not painters. No wonder this image was the cover of Franz Roh and Jan Tschichold's *Foto-Auge* (Photo-Eye), one of two publications on photography for the 1929 exhibition, "Film und Foto." Lissitzky's work is a handsome photomontage, which haloes the Constructivist artist as the creator of modern sign languages, from A (*auge*) to stenciled Z.

With its echoes of Cubism and Suprematism, *The Constructor* also marks the years of decisive change in Lissitzky's career—the early 1920s—from abstract geometric painting to practical designs. In 1926 he wrote: "The invention of easel-pictures produced great works of art, but their effectiveness has been lost. The camera and the illustrated weekly magazine have triumphed. We rejoice at the new media which technology has placed at our disposal." Photomontage was the medium of choice among many young Dada artists when Lissitzky reached Berlin in 1921, sent to establish cultural contacts between the USSR and Germany. (He had studied architecture in 1909-14 at the Technische Hochschule in Darmstadt, and he knew the German language and many progressive German artists before the war.) In the 1920s the picture press was thriving across Europe, especially in Germany where technical advances made cheap but good-quality illustrated media possible. Lissitzky, like Rodchenko, saw that found photographs, as well as their own camera work, were modern tools—without elitist artistic associations—to support their utopian artistic and social goals.

In 1922 Lissitzky contributed photomontages to Ilya Ehrenburg's *Six Stories with Easy Endings*, published in Berlin. The same year he was part of the Dada-Constructivist Congress in Weimar, with Moholy-Nagy, the de Stijl artist Theo van Doesburg, Dadaists Hausmann and Tristan Tzara, among others; and he designed "The First Russian Art Exhibition" in Berlin and exhibited his work in it.

Lissitzky's career exemplifies the changes in Russian art practices before and after the Revolution of 1917 and following Stalin's rise to power. Reared in Vitebsk, he was asked in 1919 by the painter Marc Chagall to return there to teach architecture and graphics at the art school, alongside Kasimir Malevich. All three men were familiar with Cubism and Futurism through their Western visits and education, and Malevich had pioneered the most reductivist art in history, a move epitomized by his 1918 "White on White," a white square tilted on a square white canvas. The paintings Lissitzky began in 1919 also had tilted geometries, but he called them *Proun* works (an acronym in Russian for "Project for the Affirmation of the New") and explained that they were a "switching station" between painting and architecture. In 1921, when he, Tatlin, Rodchenko, and other artists signed the *Constructivist Manifesto*, they declared their alle-

giance to art of purely practical application, at the service of Russia's new collective society.

In the early '20s Lissitzky organized Russian art exhibitions in Germany, gave book and exhibition designs the simplicity and dynamism of his clean-lined Proun paintings (which he expanded into a room decor in 1923), and collaborated on the new German journals *Merz* and the trilingual *Vesch/Gegenstand/Objet*. In 1925, to pay for hospital care, he made photograms and photo-collages to advertise Pelikan ink. Around 1925, when he returned to Russia permanently, he gave up painting to concentrate on graphic design, and through 1930 he taught at the VkhuTEMAS. His huge murals of photo-collage distinguished the Soviet pavilion at the 1928 "Pressa" exhibition, which showcased modern publishing. The following year he helped select the Soviet photographers included in the "Film und Foto" show in Stuttgart. His own photographs were effervescent experiments, involving multiple exposures, sandwiched negatives, prints cut up and rephotographed, etc. After Stalin's ascent, he co-edited the propaganda magazine *USSR in Construction*; in 1941 he wrote his biography. His last work was an agitprop poster, "Give More Tanks!"

FRANCE : PHOTOGRAPHY AND SURREALISM

In France the hard-edged glamour of the Machine Age was less compelling than in Germany. Instead, the art world's attention was dominated from the mid-1920s through the '30s by Surrealism—the movement in all the arts largely inspired by the tools and ideas of Sigmund Freud's psychoanalysis. André Breton, the poet "Pope" of the movement, gave it a half-serious dictionary-style definition in his 1924 *Surrealist Manifesto*: "Surrealism. Noun, masculine. Pure psychic automatism, by which one intends to express verbally, in writing or by any other method, the real functioning of the mind. Dictation by thought, in the absence of any control exercised by reason, and beyond any esthetic or moral preoccupation." The stream

"FLY AND LANDSCAPE," 1935-36, SHOWS MAN RAY'S LOVE OF THE UNCANNY.

of consciousness talking and dream analysis of Freudian thera-py were touchstones for the Surrealists' play with "automa-tism," or creative techniques incorporating chance effects, and their delight in illogical juxtapositions of dissimilar objects. They resurrected the late-19th-century author Comte de Lautréamont and applauded his faintly sexual simile, "beautiful as the chance encounter of an umbrella and a sewing machine on a dissecting table." Poets, painters, photographers, and film-makers shared the conviction that a rich and more authentic, surreal world underlies the world of reason and waking per-ception, to be unlocked by hallucinatory seeing, extreme psy-chic states, dreams, and the artworks created in such states and with such bizarre imagery. While Freud attempted to restore his patients to reason, the Surrealists reveled in the world of the Id, where new sources of beauty and mystery were felt to lie. While the Dadaists, who first used chance effects, tried to revolutionize society by attacking its social and political structures, the Surrealists felt they were renewing it by reani-mating the individual's imagination.

The indexical nature or "truth" value of photography made it, paradoxically, a key medium for the Surrealists. Accepted as a document of reality, the photograph could more thoroughly upset conventional ways of looking at the world than a painting, as it captured oddities in life or allowed fantastic alterations of it through such technical experiments as photograms and pho-tomontages. Breton and artists such as Dalí (who called his can-vases "hand-painted dream photographs") selected documen-tary photographs and gave them new visionary readings, to insist on the interpenetration of oneiric and waking experience. Breton reproduced works by Eugène Atget in the Surrealist mag-azine *La Révolution Surréaliste*; while Dalí collaged scientific photographs of hysterical women together with details of the Spaniard Antonio Gaudí's fantastic architecture. Brassaï pho-tographed nude torsoes from the rear to resemble bones, like Arp's biomorphic sculpture, and he recorded graffiti as the art of the child and the aberrant mind—as the pure expression of the subconscious "without control exercised by reason."

Other photographers explored various darkroom effects to undercut photographic realism. None was more inventive than the American-born Man Ray.

MAN RAY (B. PHILADELPHIA, PENNSYLVANIA, 1890– D. PARIS, 1976)

Ever alert to status, Man Ray—born Emmanuel Radnitzky and raised in Brooklyn—always presented himself as a painter, though he earned a living as a photographer from around 1921 through the 1940s, and his photographs are arguably superior to his other work. His portrait photographs, nudes, and pho-tograms made a key contribution to Dada and Surrealism, and his studio was a seedbed for his assistants, the photographers Berenice Abbott, Lee Miller, J. A. Boiffard, and Bill Brandt. Yet Man Ray was right to position himself within the world of art and within highly visible modern movements: the stellar prices his photographs continue to command are partly attributable to their identification with an artist—not a photographer. In Paris in the effervescent interwar years, this child of a poor Jewish immigrant family bridged the realms of vanguard art, fashion, and high society, and he lived to receive the gold medal for photography from the Venice Biennale in 1961. He made it all look easy.

Man Ray's artistic career began in New York in the 1900s, as American artists were beginning to find themselves vis-à-vis European modernism. He took night classes at the National Academy of Design, 1908, and the radical Ferrer School, 1911-13, while he produced commercial art and frequented Stieglitz's "291" gallery. In 1915 he learned to photograph in order to doc-ument the paintings in his first solo exhibition, and he began a lifelong friendship that year with the Dada artist Marcel Duchamp. In 1917 he and painter Francis Picabia published one issue of a Dada magazine, and in 1918 he established a com-mercial portrait photography studio. "If I'd had the nerve, I'd have become a thief or a gangster [to support my painting]," he recalled, "but since I didn't, I became a photographer." When Duchamp returned to Paris, Man Ray followed him in 1921.

In Paris, Man Ray had his first painting exhibition and resumed commercial photography, portraying his friends and their artworks as well as fashion for such couturiers as Paul Poiret. In winter 1921-22 he discovered cameraless photogra-phy, or the photogram, reportedly by accident, when an unex-posed sheet slipped into his developing tray. Rather than waste it, he exposed it to objects placed on or above it, and then fin-

THE GAMES OF THE DOLL WAS A BOOK OF
PHOTOGRAPHS BY HANS BELLMER WITH POEMS
BY PAUL ÉLUARD PUBLISHED IN 1949.

ished the development. The unforeseeable results combined identifiable silhouettes (as in William Henry Fox Talbot's 1835 "photogenics" of flowers) with abstract passages of light. In further works, objects such as a key, a pistol, wire mesh, and numbered paper scraps took on mysterious narrative associations. Man Ray here defied the flat-footed verism of photography as well as the handwork of painting; and he used chance as a creative principle. The 1922 exhibition of what he called "Rayographs" confirmed his artistic reputation and position as a Surrealist, a member of the group that sought to bypass reason and find new sources of creativity in the unconscious.

During the 1920s and '30s Man Ray photographed Paris's international bohemia of artists, aristocrats, and wealthy tourists—the likes of Hemingway, Joyce, Picasso, Dalí, Peggy Guggenheim, and the Aga Khan. In 1929 he and Lee Miller produced another "accident" in the darkroom—solarization. While they were developing

a negative, a light suddenly switched on produced a reversal of tones in the contours and shadows of forms. Though this "Sabattier effect" was known before, Man Ray was first to use it systematically, giving the silhouettes in his portraits, nudes, and still lifes a haunting silvery aura. Again, he exploited chance, which gave his flattering portraits additional cachet.

Man Ray also subverted reality by using huge blowups of details, printing through screens, superimposing negatives, and so on, and he made straightforward documents of subjects that attracted the Surrealists for their uncanny vitality, such as mathematical models at the Institute Poincaré and the deadly mating dance of the praying mantis. Reproduction in journals as diverse as *Harper's Bazaar*, *Vanity Fair*, *Vu*, and *La Révolution Surréaliste* spread his reputation. He also made experimental films such as *La Retour à la Raison*, 1923; *Emak Bakia*, 1926; *Étoile de Mer*, 1928; and *Les Mystères du Château de Dix*, 1929. They were often as playful, elegantly erotic, and seemingly spontaneous in style as his photographs.

In 1940, as France was occupied by the Nazis, Man Ray relocated to Hollywood. In 1942-50 he taught photography in Los Angeles, and in 1951 returned to Paris. In his autobiography, 1963, he commented: "I photograph what I do not wish to paint, and I paint what I cannot photograph." Surrealist leader André Breton defined his friend like a dictionary entry: "Man Ray, n., masc., synon. de joie, jouer, jouir"—"noun, masculine, synonymous with joy, jest, exhilarate."

A collaborator from time to time with Man Ray, **Raoul Ubac** (1910-1985) applied his solarization techniques to figure compositions and architecture, making them silvery, evanescent, and difficult to read, like dream shadows. He also invented *brulage*, in which he heated the film emulsion and used its liquefaction to distort his forms.

Of all the Surrealists, **Hans Bellmer** (1902-1975) was the most disturbing in his combination of taboo iconography and exquisite craft. In 1933 this former engineer created a lifesize doll modeled on the prepubescent body of his niece and photographed the demounted nude parts in suggestive arrange-

ments on mattresses or tied to trees, with real hanks of hair, undershirts, and patent-leather pumps. He then lovingly tinted his prints like Victorian valentines, giving the doll flesh tones in some versions and lurid hues in others. Born in a German-dominated area of Silesia, Bellmer was supported in his hatred of authority by the Berlin Dadaists and the Surrealists, and he constructed the doll, he said, to defy the Nazis' demand for art serving the state. Little could be further from the saccharine moppets and purified maidens in Nazi-approved painting than Bellmer's Lolita, whose seductiveness embodies Freud's recognition of the latent sexuality of children and whose disconnected, anatomically correct limbs suggest sex crimes.

Other European photographers who incorporated disquieting Surrealist effects in their technically brilliant work of the 1930s include the Germans **Herbert List** (1903-1975) and **Erwin Blumenfeld** (1897-1969): they went on to show how effective disturbances can be in the already fanciful world of fashion photography (see p. 367). In Great Britain, **Paul Nash** (1889-1946), better known as a painter, found disturbing animistic vitality in the landscape and its multivalent forms of growth. In the United States through the 1940s, **Frederick Sommer** (1905-1999) made poetic photomontages recalling those of the Dada and Surrealist artist Max Ernst, whom he met in 1941. While many Surrealists explored the power of Eros, Sommer seemed to explore Thanatos, the death wish, visible in nature from an amputated human foot and artfully arranged chicken parts to the Arizona desert, as alien as a rocky landscape painted by Yves Tanguy. Sommer also experimented with *cliché verre*—painting and scratching the negative—and he made negatives of oil paint pressed between sheets of cellophane. His work thus represented the two major sides of Surrealist imagemaking: the exploration of chance effects and the literal description of the fantastic found in the external world.

That chance human encounters and odd conjunctions of objects in waking life can reveal another world of unexpected poetry was a Surrealist idea that appealed to some hand-camera photographers, for example, André Kertész and Henri Cartier-Bresson. Though described in this book within photo-

journalism, where their work is best known (see Chapter 4), they were both liberated by Surrealist ideas to show the world "made strange" in certain of their photographs of 1928-34. In Mexico and Spain—emotionally and literally foreign countries for the Frenchman—Cartier-Bresson hinted at primordial forces underlying ordinary lives (a baby is carried in a shroud-like shawl, as if between womb and tomb; a cobbler suffers seemingly about a heart shape formed by two ladies' shoes). Photographs made in Paris by Kertész, for his part, smoothly incorporated his knowledge of de Chirico's eerie arcaded streets, Arp's and Miró's amoebic forms, and the Surrealists' fondness for manikins as equivocating between life and art.

SLY WIT SET ELLIOTT ERWITT AND HIS PHOTOGRAPHY APART, EVEN WHEN HE JUST SIMPLY WALKED DOWN THE STREET OF WILMINGTON, N.C., IN 1950.

Clearly Surrealism did not champion one line of formal investigation (like Cubism or de Stijl) in photography or any other media. Instead, it genuinely liberated artistic imaginations worldwide, and it still operates to give permission and examples to emotionally adventurous photography. Moholy-Nagy's technical experiments, on the other hand, brought new forms, including commanding abstractions, to American art photography at the end of the 1930s, while the typographies of the New Objectivity live on in the giant photographs of the so-called Düsseldorf School, active from the 1980s to the present. As photo-historian Mary Warner Marien notes, the photography of Surrealism and abstraction demonstrated between the wars that important camerawork need not record the visible world or improve society. These currents thus countered the powerful claims of contemporary photojournalism and photography of humanitarian concern and strengthened the history of camera work as unrepentant personal expression.

KODACHROME
VIBRANT, LASTING COLOR

Before American George Eastman introduced the world's first multilayer color slide film—Kodachrome—in 1936, the leading system of color photography was the Autochrome, invented by the Lumière brothers and first marketed in France in 1907. A glass transparency with a positive image, the autochrome was produced by the additive synthesis of the three primary colors—red, green, and blue. To create a color image, granules of red, green, and blue-dyed starch were coated on a glass slide before the application of a black-and-white photographic emulsion. Upon exposure, the colored granules filtered the light into its constituent parts before it reached the emulsion. After processing, the autochrome was viewed by passing light through the glass slide, with the starch granules once more filtering the light into the proper colors.

Kodachrome, however, relied on a different principle to create color, the technology known as subtractive synthesis. This process uses filters of yellow, magenta, and cyan—colors complementary to the primary colors—to remove the varying proportions of primary colors not found in the subject being photographed. Working with Eastman's lab, researchers Léopold Mannes and Léopold Godowsky achieved the subtractive process in Kodachrome by laying down three separate layers of black-and-white emulsion on a clear film base—one layer of red-sensitive silver halide crystals, one layer sensitive to green light, and one layer sensitive to blue. After exposure, the film was developed a layer at a time, with cyan, magenta, and yellow dyes added to the correct layers. The exposed silver was bleached out and replaced by the dyes, resulting in a full-color positive image.

Following the introduction of Kodachrome, the subtractive process became the standard for all color film. What set Kodachrome apart from its competitors is the fact that those films incorporated the dye-forming chemicals into the film itself, which made for simpler processing. Kodachrome's unique method of developing—a demanding, multistep process that originally could only be performed at the Eastman Kodak labs—also produced colors of greater saturation than those of rival films.

One of the driving forces behind the advancement of color-film technology was the motion-picture industry, which counted on the novelty of color movies to bring people to the theater in the depths of the Great Depression. In 1923 Eastman Kodak produced Kodacolor 16mm motion-picture film, and a year before the company introduced Kodachrome as a 35mm slide film, it marketed a 16mm version for home movies.

For consumers, the high cost of color slide films kept them from being widely used until the 1960s, although professionals embraced Kodachrome immediately, making it the most popular color transparency film on the market. Leica cameras and lenses seemed especially suited to the film's accurate colors and sharp detail. For many years, the German-made camera and the American-manufactured film were standard equipment for professional news photographers.

Another quality of Kodachrome that contributed to its popularity

was its stability, again thanks to the unique process in which the color dyes were added during development. Kodachrome came to be regarded as the best film for archival purposes. If stored properly, Kodachromes retain their vivid colors for decades.

One of the drawbacks to the original Kodachrome was its low sensitivity, which meant that the film could not be used for every application. Over the years, the sensitivity was greatly improved. With the introduction of Kodachrome II in 1961, the film was doubled in sensitivity, and today's higher-speed Kodachrome is many times faster than the original, making it suitable for fast action and low-light situations.

Despite the superior qualities of Kodachrome, the complicated processing it requires opened the door for other color films to overtake it in the marketplace. Simpler technologies, such as the E-6 process, meant that photographers could get their color transparency film processed faster and more conveniently at local labs. Kodak itself introduced an E-6 process film, Ektachrome, in 1946. The many types of E-6 films now on the market offer a variety of emulsions with different color palettes to choose from. In addition to more

convenient processing, the newer E-6 processing slide films made by Fuji, Agfa, and Kodak itself now match Kodachrome's legendary color saturation.

As Kodachrome has dropped in popularity, the labs available to develop the film have also dwindled. Consumers now face waits of a week or more to receive their slides back from processing. In recent years, Kodak has reduced the varieties of Kodachrome it offers to ISO 64 and 200. The company has also decreased the total amount of

NICKOLAS MURAY CHOSE KODACHROME WHEN HE WAS ASKED TO MAKE CAMEL CIGARETTES APPEALING TO WOMEN AFTER WORLD WAR II.

Kodachrome it produces. But even if the film someday disappears from the market altogether, millions of sharp, color-rich Kodachrome slides will remain in the archives of stock agencies and publications, and in the home collections of amateurs—perpetuating the legacy of this milestone color film.

ART PHOTOGRAPHY SINCE WORLD WAR II

At mid-century the strongest photography of personal expression was not made by the usual suspects. True, interwar exploration continued—there were New Vision experiments with light phenomena and with the camera's capabilities, as well as Surrealizing fantasy and introspection. But in the United States the most influential photographers worked on the streets, not in studios, and drew inspiration from popular sources—photojournalism, humanitarian documents, tabloid exposés, amateur snapshots—rather than high art.

"STREET" PHOTOGRAPHERS OF THE 1950S AND '60S

"Street" photographers were identified by their subject matter, which they caught apparently on the fly with candid camerawork. What they found among city crowds said more about their psyches than postwar urban life. But their photographs mediated between the two and took energy from both. These athletic photographers seemed to agree with critic and novelist James Agee, who wrote in 1945: "The artist's task is not to alter the world as the eye sees it into a world of aesthetic reality, but to perceive the aesthetic reality within the actual world, and to make an undisturbed and faithful record of the instant in which this movement of creativeness achieves its most expressive crystallization."

In a monumental study, curator Jane Livingston called the heterogeneous group of U.S. photographers "The New York School," referring to their chief locale and associating them with the contemporaneous painters better known as Abstract Expressionists. Neither the photographers nor the painters were collegial enough to form schools, yet they had kinships in their intense response to American experience and willingness to defy technical conventions of picture making. Both groups helped shift the balance of important artistry from Europe to the United States, which emerged from the war as the dominant world power. Each

"KABUKI STAGEHAND," 1964: SINCE HE PHOTOGRAPHED THE VICTIMS OF THE NAGASAKI BOMBING, SHOMEI TOMATSU HAS STRIVED TO PORTRAY AN IDIOSYNCRATIC AND BOLDLY BEAUTIFUL JAPAN.

grappled with the mixed blessings of American prosperity and scale—the photographers more obviously—and each attracted controversy and new, broader audiences for their media.

For many observers, "street" photography is summed up by the subjects and style of Robert Frank's *The Americans* (French edition, 1958; in English, 1959). The judgment is partly right—and in fact Frank opened the door for younger photographers including Garry Winogrand, Lee Friedlander, Diane ARBUS, and others. All of them earned livings in photojournalism early on, and the evolution of their work was symptomatic of the gradual transformation of reportage from affirming collective ideals to expressing private feelings. "When people look at my pictures," Frank wrote, "I want them to feel the way they do when they want to read the line of a poem twice." *The Americans* challenged the faith of *Life*'s photoessayists such as W. Eugene Smith and social reformers like Lewis Hine, who found community heroes in the common man and believed photographic narratives could effect social change. Frank's photographs also defied the pictorial order imposed on life by masters of 35mm camerawork such as Henri Cartier-Bresson. While the Frenchman had also used a Leica to photograph across America, he brought a piquant, Cubist-derived unity to slapdash reality. Frank's techniques, to the contrary, ranged from the "classical" frontal stance of Walker Evans to what appeared accidental and amateur—the tipped horizons, blur, grain, and spontaneous cropping of snapshots. Champions of reformist documentary and the Group f64 aesthetic were equally appalled by *The Americans*. But viewers who shared Frank's sense of a spiritual malaise in America hailed his work, as did those seeking a new vitality and intuition in personal photography.

Frank's version of "street" photography was arguably the most influential vein in American expression of the 1950s. It was not immediately obvious that it amalgamated various earlier traditions, even while defying major aspects of them: the observation of class in England and France by Bill Brandt, Brassaï, and Lisette Model; the hard-bitten tabloid photography of Weegee in New York streets and alleys; the swiftly composed 35mm photographs of Cartier-Bresson, André Kertész,

Helen Levitt, and others in the city; and the documents of social concern by members of the Photo-League. But these sources help account for "street" photography's broad strengths. At the same time, Frank's editorial control over the American edition of *The Americans* and his poetic sequencing of its images announced that the photographer's book would henceforth frame serious camera work. This reinforced the example of Walker Evans's *American Photographs*, 1938, and laid groundwork for such photographer's books as Ralph Gibson's trilogy, *The Somnambulist, Deja-Vu*, and *Days at Sea*, 1973-74.

The practice of "street" photography was wide enough to be recognized in a 1976 issue of the fine-art photography magazine *Aperture* devoted to "The Snapshot," which included work by Todd Papageorge as well as the photographers recognized in the 1960s. In color photography, Frank's example helped liberate such individuals as William Eggleston and Joel Meyerowitz. William Klein, who had expatriated to Paris in 1948, evolved his street style independently, and was only recognized later and linked to the group. His rebellion against technical norms was more extreme than Frank's, and the parallels between his work and contemporary U.S. and European painting underline the interchanges across media at mid-century.

Since the 1980s, aspects of "street" style have continued to inform personal work as well as photojournalism. Indeed, in staged "documentary" photographs, Jeff Wall, Philip-Lorca DiCorcia, and others adopt its trademarks, to underline the ambiguities of photographic truth, while photo-essayists with strong aesthetic signatures, such as Gilles Perres and Alex Webb, personalize their reportage with snapshot traits such as tilted framing, compressed space, and drastic cropping. The roots of "street" photography in both vernacular photographs and documentary work from Walker Evans to Weegee seem to ensure the continued vitality of the genre.

Frank is discussed first here, as the generative figure in "street" photography at mid-century. The biographies that follow—of Winogrand and Friedlander—reflect different responses to his example, as well as distinctive personalities; while Klein represents remarkable invention parallel to Frank's.

ROBERT FRANK'S BOOK *THE AMERICANS* INSPIRED A GENERATION OF PHOTOGRAPHERS.

ROBERT FRANK (B. ZURICH, SWITZERLAND, 1924)

"Robert Frank, Swiss, unobtrusive, nice, with that little camera that he raises and snaps with one hand, he sucked a sad poem right out of America onto film, taking rank among the tragic poets of the world." So wrote Beat author Jack Kerouac in his introduction to the American edition of Frank's *The Americans*, 1959. The volume summed up "street" photography at mid-century and was the most influential photographer's book of the post–World War II generation. It was outrageous (at the time) and seminal for the same reasons: in grainy, elliptical, sometimes skewed and blurred images made with a 35mm camera, Frank exploded national myths and punctured the bland optimism of Eisenhower's America. Here were pictures of anonymous multicultural Americans with their jukeboxes, TV sets, gas stations, pool tables, cemeteries, and U.S. flags, caught spontaneously in "indecisive" moments taken from life's continuum. In a sequence unlike any seen before in publishing, they formed an iconography of racial repression, mind-numbing routine work, vapid politics, boring travel in a car culture, lonely city crowds, class tensions, and unsatisfied yearnings for meaning in a world of plenty. *The Americans* remains the touchstone of Frank's career, though he continues to photograph.

Frank first rebelled against social strictures while growing up in a cultured, bourgeois Jewish family in Zurich, Switzerland. There, and later in Geneva and Basel, he apprenticed to commercial photographers, rather than join his

ROBERT FRANK OUTSIDE HIS APARTMENT BUILDING
ON BLEECKER STREET IN NEW YORK CITY, 2000

father's business. He spent 1946 in Paris, and in 1947 emigrated to New York, pursuing a magazine photographer's career. At *Harper's Bazaar*, he showed art director Alexey Brodovitch a book he had made by hand, titled "40 Fotos," and was hired immediately. In 1948 Frank took six months off and photographed in Bolivia and Peru, and though he worked regularly for national magazines until 1951, he began pursuing independent projects on his travels. Acknowledging the work of Bill Brandt and André Kertész, he photographed in Wales, England, France, and Spain, and he began exhibiting and winning prizes. In 1954 his reputation was such that Brodovitch, Walker Evans, Edward Steichen, Alexander Liberman, and art historian Meyer

Schapiro supported his successful application for a Guggenheim fellowship. He was the first non-American photographer to win one.

Frank's proposal was to cross America and make "a visual study of a civilization ... an authentic contemporary document." In 1955-56 he drove West and South, and with existing light he exposed 750 rolls of 35mm film. His choice of 83 photographs became *The Americans*. This was a dysfunctional "Family of Man" (although his work was shown in that 1955 exhibition). It was anti-narrative—he said he hated "those goddam stories with a beginning and an end"—and organized instead with recurrent motifs, such as the American flag, and uncaptioned groupings that functioned metaphorically, offering multiple, layered meanings. The work was technically inconsistent, some photographs resembling Evans's classical-

ly composed images (which Frank admired), others looking accidental. Indeed, Frank rarely previsualized an image, and he mutilated figures with his framing and allowed flare and graininess, accepting accidents and the technical traits of his 35mm camera. Most damning for some critics, Frank's title promised to show America to Americans, but his photographs were partial, subjective, and by turns mournful, satiric, or disturbing— never upbeat. It was in France in 1958 that his book was first published, by Robert Delpire.

In 1959 Frank produced his first film: based on an autobiographical story by Kerouac. *Pull My Daisy* was co-directed by painter Alfred Leslie and it featured Beat poet Allen Ginsberg. Half-documentary, half-fiction, the film was trailblazing in independent cinema. Frank devoted himself to filmmaking in the 1960s, also making *Me and My Brother*, 1965-68, and *Cocksucker Blues*, on the Rolling Stones' 1972 U.S. tour. In 1971 he and his second wife moved to remote Mabou, Nova Scotia, making literal the alienation his photographs embodied. His work since then has overtly shifted from cultural to private issues. In the early '70s he resumed making photographs, in part to come to terms with personal tragedies, including his daughter's death in a plane crash. He combined these images with words painted over and scratched into the negatives: "I destroy the descriptive elements in the photographs so I can show how I am, myself." Though the constructions suggested the work of a mad, tragic Robert Rauschenberg, they expanded Frank's themes of loneliness and the quest, despite broken illusions, for existential meaning.

After Frank's publication of *The Americans*, photographers as different as Garry Winogrand, Diane Arbus, Lee Friedlander, Danny Lyon, and Bruce Davidson were associated with its projection of the photographer's personality upon the encountered world, even though they had matured partially independent of Frank, and each innovated remarkably, in their subjects and techniques. Curator Nathan Lyons at the George Eastman House first recognized the phenomenon in "Toward a Social Landscape," 1966, which included Winogrand, Lyon, and Davidson, and Duane Michals. The following year, curator John Szarkowski's "New Documents" grouped Winogrand and Friedlander with Arbus (whose work is covered here in Chapter 2).

GARRY WINOGRAND (B. NEW YORK, NEW YORK, 1928–D. TIJUANA, MEXICO, 1984)

With Rabelaisian appetite and manic energy, Winogrand devoured public life with his camera in decades of explosive change in the United States. He caught the 1960s in particular—its hardhats and hippies battling over

FRANK'S "STREET" WORK— "WHERE MATTER ENDS AND MIND BEGINS"

"Black and white are the colors of photography," Frank wrote. "To me, they symbolize the alternatives of hope and despair to which mankind is forever subjected. Most of my photographs are of people; they are seen simply, as through the eyes of the man in the street. There is one thing the photograph must contain, the humanity of the moment. This kind of photography is realism. But realism is not enough—there has to be vision, and the two together can make a good photograph. It is difficult to describe this thin line where matter ends and mind begins." Evaluating his own roots in mid-century magazine photography, Frank also sought "less taste and more spirit … less art and more truth." With time, he became aware he was attempting to understand the world and, in so doing, himself. But he also recognized the provisional nature of perceived reality. "I'm always looking outside, trying to look inside. Trying to say something that's true. But maybe nothing is really true. Except what's out there. And what's out there is always changing …. Life dances on, even if you're on crutches."

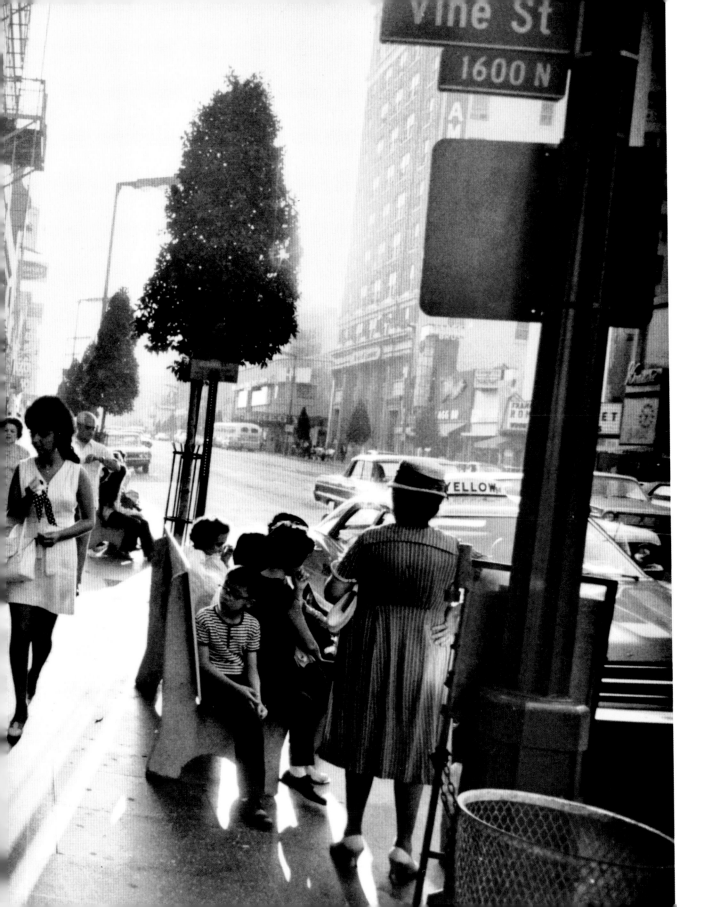

COLLECTING PHOTOGRAPHY

You have $10,000 to spend on pictures for your new apartment or house: do you buy photographs or prints? The question alone suggests the rise in status for photography as a collectible since the 1970s. Contributing factors have been multiplying art school programs, galleries, periodicals, auctions, festivals and conferences, and institutions devoted to camera work, especially in the United States. In 1979 dealer Lee Witkin and Barbara London published *The Photography Collector's Guide* and AIPAD (Association of International Photography Art Dealers) was founded. AIPAD's first annual fair showcased 30 dealers; that of 2005 had 175. Photography auctions targeting the rare book market began at mid-century, and regular photography sales started at Sotheby's London in 1971. In 1975 Sotheby's New York founded an independent photography department, and Christie's began regular sales in New York in 1978. The still-exuberant annual festival at Arles, France, was launched by photographer Lucien Clergue in 1970, and Jean-Luc Monterosso established the biennial "Mois de la Photo" in Paris in 1980. With a similar multi-site format, Fotofest in Houston, Texas, began in 1986, and there are now festivals in Perpignan, France (photojournalism), Montreal, Madrid, Moscow, Buenos Aires, and Bamako (Mali). Though photography and modern print sales are equally sensitive to the economy, photography's rate of increased profit has been steeper overall since 1970, according to Denise Bethel, director of photography at Sotheby's. For example, a print of Diane Arbus's "Boy with a Hand Grenade" sold for $6,900 in 1993; a nearly identical print fetched $144,000 in 2005, a dozen years later.

Vietnam, its miniskirted flirts and interracial couples, its generations confronting new cultural freedoms—much as Robert Frank seemed to have summarized the 1950s and Walker Evans the 1930s. Further, Winogrand captured the human comedy and found a photographic equivalent for its colliding energies: his trademarks were tilted framing, spontaneous cropping, the inclusiveness of the wide-angle lens, the blur of action—his own and his subjects'—and the drastic dark–light contrasts produced by flashbulb lighting. If Frank had opened the door to improvisational techniques used in personal documentary, Winogrand exploded through it. His credo, "I photograph to find out what the world looks like photographed," reveals not just delight in the camera's transformation but guileless curiosity and lack of premeditation.

Born to working-class parents in the Bronx, Winogrand began photographing during his Air Force service in 1946-47. Back in New York and enrolled on the GI Bill at City College and Columbia University, he studied painting and then discovered the darkroom. On a 1951 scholarship he studied with Alexey Brodovitch, who introduced him to magazine photography and advised, "if you recognize the picture in your viewfinder, don't press the shutter." For Winogrand, Brodovitch's insistence on new ways of picture making must have reinforced the Abstract Expressionists' contemporary sense of the picture as "an arena in which to act." The youth had already begun roaming the city making 35mm photographs; by the mid-'50s he was shooting for agencies such as Pix at Coney Island, El Morocco, and elsewhere, and crossing the tabloids' social satire with *Life*'s visual jokes, as seen in its last page, "Speaking of Pictures." As a freelancer, he contributed to *Bazaar, Look, Life, Argosy, Sports Illustrated*, and the like through 1969.

In 1955 Winogrand took the first of several cross-country trips with his Leica, and he saw Evans's book, *American Photographs*. Frank's *The Americans* also strengthened his urge to explore the tumultuous national scene and the photographic means to convey it. Winogrand had his first solo exhibition in 1960, and this and the 1962 Cuban missile crisis determined him to pursue independent expression. In 1966 and 1967 his work was recognized in key shows. Books and exhibitions, rather than magazine assignments, and projects funded by three Guggenheim Foundation grants would be Winogrand's subsequent routes to his audience.

Winogrand's first book, *The Animals*, 1969, showed beasts, hilariously, on

both sides of zoo fences. His second, *Women Are Beautiful*, 1975, managed to offend both feminists and male voyeurs. *Public Relations*, 1977, identified the new collusion between celebrity and consumer that produced the "media event" and "photo op" and thereby altered the nature of news and photography's perceived truth quotient. In his last book, *Stock Photographs: The Fort Worth Fat Stock Show and Rodeo*, 1980, Winogrand's style was most radical. Skewed horizons, proportions expressively distorted by his wide-angle lens, figures blazing out of black backgrounds through his flash: he turned the all-American livestock show into a rollicking carnival of clowns and animals worthy of Bruegel, the 16th-century Dutch painter.

Winogrand's teaching supported him from the 1970s, and his stints at the Illinois Institute of Technology, the University of Texas at Austin, and the University of California motivated his relocations. In 1982 he acquired both a motor drive and an 8 x 10-in. camera, perhaps indicating his desire to break yet newer ground. He died suddenly of cancer at age 56, with some 2,500 rolls of film undeveloped.

Of the three photographers heralded by the Museum of Modern Art's "New Documents" show, 1967, Lee Friedlander is the survivor. His curiosity about the world as seen through cameras continues to generate books that could be covered

"NEW ORLEANS," 1968: LEE FRIEDLANDER
BEGAN PHOTOGRAPHING THE SOCIAL LANDSCAPE
AT AGE 14.

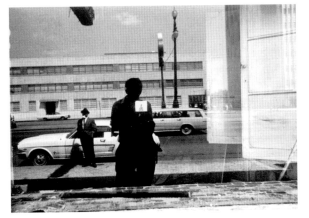

in several sections of this one—on the natural and man-made landscape, portraiture, and the nude. His work remains part of the "street" tradition in incorporating chance concatenations of figures and settings and in retaining an effervescent sense of spontaneously encountered experience.

LEE FRIEDLANDER (B. ABERDEEN, WASHINGTON, 1934)

Seventeen books to date, five National Endowment for the Arts grants, three Guggenheim Foundation fellowships, a "genius" grant from the MacArthur Foundation, a "core collection" of 450 of his photographs at Washington, D.C.'s National Gallery of Art, and over a thousand at New York's Museum of Modern Art: the statistics for Friedlander span a prolific career that began in his teens and shows no sign of flagging. He has been identified with the "social landscape" since his inclusion in the 1966 George Eastman House show of that name. Yet his variegated work includes self-portraits and portraits of jazz musicians, his wife, children, and grandchildren; nude studies; close-ups of trees, flowers, and bushes; and landscapes including the parks of Frederick Law Olmsted and the Sonoran desert, as well as what could be called "social"—depictions of industrial and computer technology workers, of statuary in American cities and parks, and letters and words in American signage. In the late 1960s he collaborated with Pop artist Jim Dine on projects juxtaposing images and photographs; and in 1968 he made and published new prints from the glass-plate negatives he discovered by E. J. Bellocq, an early 20th-century photographer of the New Orleans red-light district. All this is grounded in Friedlander's interest in exploring culture and the self through photography, while playing with its formal possibilities. His expansions of the traditions and the work in series of Eugène Atget, Walker Evans, and Robert Frank prove the fertility of their different documentary approaches to places, people, and their interdependence.

Friedlander began photographing at age 14, and in 1953-55 he studied under Edward Kaminski at the Los Angeles Art Center. In the late 1950s he photographed jazz musicians in performance for record covers, then moved to New York when his main client, Atlantic, relocated there. Frank's *The*

DIFFERENCES AMONG "STREET" PHOTOGRAPHERS

For *Bystander: A History of Street Photography,* critic Colin Westerbeck and photographer Joel Meyerowitz discussed their colleagues who pioneered that ballet-like, quick-witted style of documenting encountered life. Westerbeck: "When [Robert] Frank holds his camera out at arm's length, it's aimed at the world; doing so is a way of losing himself in an otherness that's out there somewhere. When Friedlander does it, he aims the camera back at himself." Meyerowitz: "Yeah, [his] work [is more] coolly intellectual in a way. He's more cerebral than Diane [Arbus] or Garry [Winogrand]. They were capable of being dispassionate, even detached. But the hard truths of their needs and urgencies and personalities are what made their photographs so astonishing. Lee's … complexity hits me first." Westerbeck: "Oh, I don't know. I would say that it's Winogrand and Arbus who are truly self-involved. The 'urgencies' of their own 'personalities' … make them that way. It's only as a photographer that Friedlander is self-conscious, not as a personality …. He's always aware of the medium when he's using it … which may be why his career has had such longevity and such a diversity of projects. More than any other street photographer, he's been able to generalize what he learned on the street … and apply it to other genres. When you look at the portraits, or even the nudes, you see that it is often the errant detail or the odd, improvised, off-balance feel of the composition that gives the picture its originality. Friedlander has taken the lessons that the street teaches and applied them … to all sorts of other subjects …. Some of the best … are little essays on the aesthetics of photography in general."

Americans, which he saw in its 1959 edition, freed his vision and sense of irony—a liberation other young photographers also felt. In 1960 he won his first Guggenheim grant. A series on televisions, a motif Frank had isolated, and on his own and other reflections in shop windows established Friedlander as a wry observer of mediated, alienated America: his book of the latter images, titled *Self-Portrait,* was published in 1970. He and his friend Winogrand were both "street" photographers with 35mm cameras and wide-angle lenses, who sold their work to magazines such as *Esquire* and *Sports Illustrated* and exploited chance overlaps of objects and accordionized space in snapshot-style photographs, but their differences grew more evident with time. Though nodding to Atget's photographs of manikins in Paris windows and to the Frenchman's accidental inclusion of his shadow in some pictures, Friedlander's sense of spatial complexity showed a Cubist's tastes, while his self-consciousness was modernist and drolly self-deprecating. In their later series, he and Winogrand seemed to court chaos, but while Winogrand remained enthralled by the human comedy, Friedlander stayed aloof, exploring how fully life can be transformed in photographs.

In his "American Monument" series of the early 1970s (published in the bicentennial year, 1976), Friedlander saw statues of often forgotten American heroes muted by the urban cacophony: some of these photographs posed "Where's Waldo"–like puzzles of discovery, so aggressive were the popular scenes surrounding the symbols of high art and historic time. A series he undertook on factory workers, in which machine and operator were virtually one, led to a commission in 1985 from the Massachusetts Institute of Technology to photograph the then-new tribe of computer specialists at work: his collective portrait revealed their unique, alert "looks" without showing their PC screens.

Since 1991, when his series of nudes were exhibited (with some criticism from feminists), Friedlander's work has grown more intimate in focus and richer in information, in part due to his adoption of the square, medium-format Hasselblad camera. His wide-angle close-ups of some nudes showed frank quantities of pubic hair and distorted proportions; his spontaneous portrayals of his grandchildren revealed both his fondness and his keen eye for surprising juxtapositions and details. At the same time, the photographs in his "Letters from the People," 1993, moved from letters and numbers to graffiti and words, found throughout the visual landscape of America. Aptly titled to convey its cultural resonance, the collection took off from Walker Evans's photographs of such anonymous vernacular art and his collection of road signs, and acknowledged Helen Levitt's documents of children's chalk drawings at mid-century.

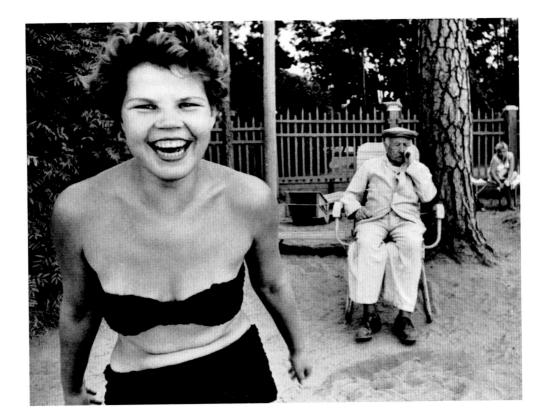

Though William Klein came to critical attention later than Friedlander, Arbus, and Winogrand, he is of Robert Frank's generation, and his filmmaking and hybrid works of painting and photography provoke comparisons with Frank's. Both embody the personas of mid-century bohemian expatriates—Frank the doleful introspective version, Klein the muscular expressionist one.

WILLIAM KLEIN (B. NEW YORK, NEW YORK, 1928)

Klein's title for his first book, of 1956, telegraphed his style: *Life is Good and Good for You in New York William Klein Trance Witness Revels*. The mocking slogan, name, and nouns could be neon signs flashing from Times Square; the explosive images of New York street life inside the book looked like a speed freak's wild shooting, with sudden croppings, jam-packed frames, aggressive close-ups, and blur, grain, and distortion that defied "good" technique more drastically than anything seen before. "I wanted to be visible in the biggest way possible," Klein said later. "My aesthetics was the New York *Daily News*. I saw the book I wanted to do as a tabloid gone berserk, gross, grainy, over-inked, with a brutal layout, bull-horn headlines. This is what New York deserved and would get."

Klein, born into a poor family in New York, had seen his father lose everything in the Depression, and had just returned from self-exile in Europe, from 1948 to 1954, where he was an abstract painter and kinetic sculptor. Alexander Liberman, art director of *Vogue*, had met him in Paris and offered him a contract to work in New York. With Liberman's blessing, Klein pursued this diaristic book, photographing daily for eight months, "gathering evidence" and inventing freely, with the exuberance of the self-taught. A 28mm, wide-angle lens he found was "love at first sight. I rushed out in the street and shot away, aiming, not aiming, it didn't matter. I could never get enough into the

CHAPTER SEVEN

KLEIN, THE GI IN PARIS

A Paris resident from 1948, Klein studied at the Sorbonne on the GI Bill and was an aspiring painter hungry for culture and advanced art. The brilliant college dropout had frequented New York's Museum of Modern Art from age 12; now he apprenticed himself to painter Fernand Léger, admiring the man "who did sets, costumes, murals and films as well." In correspondence with curator Jane Livingston, Klein recalled of his early years in France that he saw Dziga Vertov's film *Man with a Movie Camera* "every time around" and read László Moholy-Nagy's *Vision in Motion* and Gyorgy Kepes's *The New Landscape.* "Pity, no Bauhaus in Paris—architecture plus typography plus design-for-life plus cinema plus photography were right up my alley. But where did photography fit into this triumphant march to the modern? Everywhere. First, it was defined as the organization of meaningful visual signs, so what's wrong with that? Then, it was a new frontier. Something to be explored, with experiments in light, light creations and so on. Then art would have two faces: biological and social, with the artist as seismograph."

camera. I wanted it all in a gluttonous rage." For the book itself, Klein obsessed over every aspect of the layout, typography, and cover. But just as Frank's *Americans* offended Americans and was first published in Paris (1958), Klein's *New York* found no New York publisher and appeared first in France (followed by Italy and England). The book caught the energy and eruptive violence of the city through its style; its graphics evoked the Abstract Expressionism of Franz Kline, France's gestural *art informel*, and the torn posters of the Italian Mimmo Rotella. It won France's Prix Nadar and led Italian film director Federico Fellini to offer Klein a job. Klein returned to Paris, and his French wife, and has never lived anywhere else since.

While Fellini's film was delayed, Klein photographed for the book that ultimately became *Rome* (1958), and he also produced similar high-octane views for *Moscow* (1961) and *Tokyo* (1961). These were purposely anti–Cartier-Bresson volumes—full of profligate croppings, overexposures, and darkroom handiwork. Their images captured Klein's intrusion into everyday lives and his quarry's dramatic reactions. They were the opposite of elegant. In 1955-65 he also photographed fashion for *Vogue*, and invigorated the hothouse genre there with his on-location set-ups, shot with wide-angle and telephoto lenses, sometimes with flash and multiple exposures. This work supported his films, which now total over 20, and his books: his debut was *Broadway by Light*, 1958, a kaleidoscopic Pop paean to the Great White Way that materialized his early projection of lights onto photosensitized papers for mural-sized blowups. *Qui êtes-vous* [Who Are You], *Polly Magoo?* 1966, mocked the fashion world; *Mr. Freedom*, 1968, satirized America; *Muhammad Ali, the Greatest*, 1974, documented the world's heavyweight champion; and *Loin de* [Far from] *Vietnam*, 1967, a collaboration with directors Jean-Luc Godard, Alain Resnais, and others, voiced anti-war views. For filmmaking, Klein gave up photography in 1962, and he returned to still camera work only in the mid-1980s, encouraged by renewed public interest in his early photographs.

Klein's recent photography and films still ebulliently defy aesthetic and technical norms and send up American culture. Between 1996 and 2000 he blew up parts of old contact sheets and painted over them, as if in a graphic shouting match with his past. For his film titled *Messiah*, 2000, he marked the millennium with images of U.S. kitsch and decay scored to Handel's oratorio.

In Japan in the postwar years, "street" photography grew out of an urban environment like America's, but with searing memories of the bombing of Hiroshima and Nagasaki and the American occupation and continued military presence. Daido Moriyama was the most visceral photographer of this social landscape.

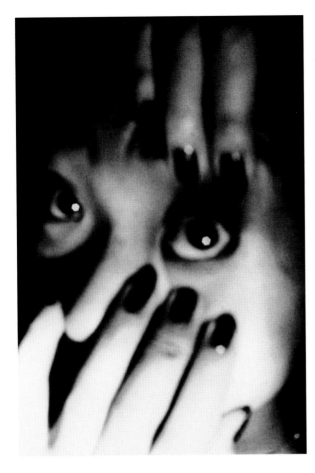

"MIDNIGHT," 1986: DAIDO MORIYAMA CAPTURED THE EFFECTS OF INDUSTRIALIZATION ON JAPANESE SOCIETY IN THE 1970s.

DAIDO MORIYAMA (B. OSAKA, JAPAN, 1938)

If Moriyama's medium were words, he might be a rapper or a Lenny Bruce. His brilliant, profane, excoriating photographs have the immediate, abrasive impact of such social comment, delivered in purposely provocative form. The work that made his reputation in the late 1960s—grainy, high-contrast, sometimes blurred and tilted images taken on Tokyo streets—were the more shocking by contrast with recognized postwar Japanese photography, the fastidiously printed nudes of Eiko Hosoe, for instance, and the wrenching documents of Japanese atomic bomb survivors by Ken Domon. These two

photographers had mastered the idioms of such U.S. models as Edward Weston and W. Eugene Smith, an achievement valued in Japan's highly literate and rapidly Westernizing culture after World War II. Moriyama, however, appropriated the snapshot styles and interest in popular culture of William Klein and Andy Warhol and used their means to reveal the *noir* side of Japan's urbanization and Americanization.

A rebellious teenager, Moriyama flunked his high-school exams—then unthinkable in Japanese culture—and was admitted to an arts and crafts school only through his parent's greatest efforts. Later he worked for the large-format photographer Takeji Iwamija, and learned the older man's traditional aesthetics and discipline. In 1961 he moved to Tokyo from Osaka where he became an assistant to Hosoe. While the latter was photographing in the studio or in the rural landscape, Moriyama shot on his own time in the city's seediest clubs and strip joints and joined the underground of the poet and theater impresario Shuji Terayama. In 1968 he showed with the group called Provoke in Tokyo, and his disturbing images of what industrialization was leaving behind in society won critical attention. His 1971 photograph of a snarling stray dog became an emblem of the country's disenfranchised people and of growing disenchantment with the pace of social change. The images in *A Hunter*, 1972, a book he dedicated to the U.S. Beat writer Jack Kerouac, implicated the viewer in the photographer's quest for meaning among dwellers in Japan's city slums.

In the 1970s Moriyama had two solo shows at the Nikon Salon in Tokyo (funded by the giant camera manufacturer), and he was part of "New Japanese Photography" exhibitions in New York and Graz, Austria, which established his leadership among his country's younger generation. From 1976 to 1981 he headed a photography gallery in Tokyo called Camp. In 1980 while in Europe for a large retrospective of his work, he visited Klein in Paris. His "Light and Shadow" series was exhibited in Tokyo and published in 1982, followed in 1984 and 1985 by publication of collections of his writings. His place in the exhibition "Black Sun: The Eyes of Four" consolidated his reputation overseas when it traveled in Britain and the United States in 1986. In 1989 he hung his photographs of Morocco and Paris in his new gallery, Foto Daido (which he ran from 1987 to 1992).

In the 1990s Moriyama's activities reached a peak, with multiple exhibitions, including surveys of his 20 years of color work and a show of his Polaroids, and publications of books and limited editions. In 2000, when a retrospective of his photographs traveled from the San Francisco Museum of Modern Art to New York, where it appeared at both the Metropolitan Museum of Art and the Japan Society, he exhibited silkscreen works and inkjet prints in separate galleries in Tokyo. The multiple displays typified his energy and polymorphous creativity; he continues to use different cameras and films to express his passionate, even physical response to life in contemporary city streets.

In the United States the vitality of the "street" tradition is visible in the range of photographers involved in it at mid-century, from Helen Levitt and Roy DeCarava, whose reticent personal expression anticipated that of better-known figures in the 1960s, to Danny Lyon and Bruce Davidson, who were first recognized for their engaged photojournalism. For the latter two men, see Chapter 4. For Levitt and DeCarava, see Biographies.

PHOTOGRAPHY AND POP ART

The jukeboxes, TVs, and equally gaudy cars that stood for American alienation and soul-killing materialism for Robert Frank and William Klein's Beat Generation gained different, mixed meanings for artists in the late 1950s. **Richard Hamilton**'s 1956 photo-collage was paradigmatic, having both the subject and the primary materials of Pop art—American consumer culture and the photographs used to sell it. "What is it about today's homes that makes them so different, so appealing?"—a British take on exuberant U.S. affluence—is confected entirely of clippings from mass magazines, advertisements for movies, tape decks, and vacuum cleaners centered on a body builder holding a giant Tootsie Pop. Critic Lawrence Alloway gave "Pop" wide currency as a name for the international art movement, but here was its earliest showing.

Hamilton (b. 1922), Eduardo Paolozzi (b. 1924), and other members of the Independent Group were responding out of British postwar privations to what media guru Marshall McLuhan called "the Global Village," the new world united by advertising and the conspicuous consumption that ads inflamed. Between 1947 and 1957 the number of televisions in U.S. households leaped from ten thousand to forty million. And by 1962 the average American, according to *Time* magazine, saw some 1,600 advertisements daily. American mass culture and the must-have products it touted set the standard for popular aspirations worldwide. The artists who reached their twenties during this boom appropriated consumerism's tools and acquired its appetite for ever-changing images. The existentialist angst of 1950s expressionists ceded to the ironic detachment of Pop artists, who shifted attention from their private feelings (which seemed ambivalent) to the values and style of the broader culture. Mass-media photography was seen as central to that culture, and no one understood it better than **Andy Warhol**.

Warhol's forecast that the media would make everyone "famous for fifteen minutes" continues to be prescient, and artists since the 1980s still mine the veins of mass culture this über-Pop artist opened to serious expression. He was not the first to recognize the power of commercial image vendors—Nathaniel West's *Day of the Locust*, for example, chillingly portrayed silver-screen fans in 1939—and he was not alone in co-opting the vernaculars of Hollywood and Madison Avenue: in the United States; his work and that of Roy Lichtenstein and James Rosenquist were recognized together in 1962, and, before them, Robert Rauschenberg had collaged media images into an ambitious art. But Warhol—born Warhola in a working-class, steel-town family of Czech immigrants—embodied Pop in its self made, bleached-blond glamour and lack of affect, which gave viewers a screen where they could project their own desires.

Warhol's most familiar work may be his silk-screened paintings of Marilyn Monroe, 1962, serial compositions in which he repeated the iconic face of the sex goddess up to 50 times, in black and white and in four lurid colors. The face

HENRI DAUMAN COVERED A MULTI-ARTIST SHOW AT THE BRANCHINI GALLERY IN 1964 CALLED "THE AMERICAN SUPERMARKET," WHICH HELPED CLINCH ANDY WARHOL'S CELEBRITY.

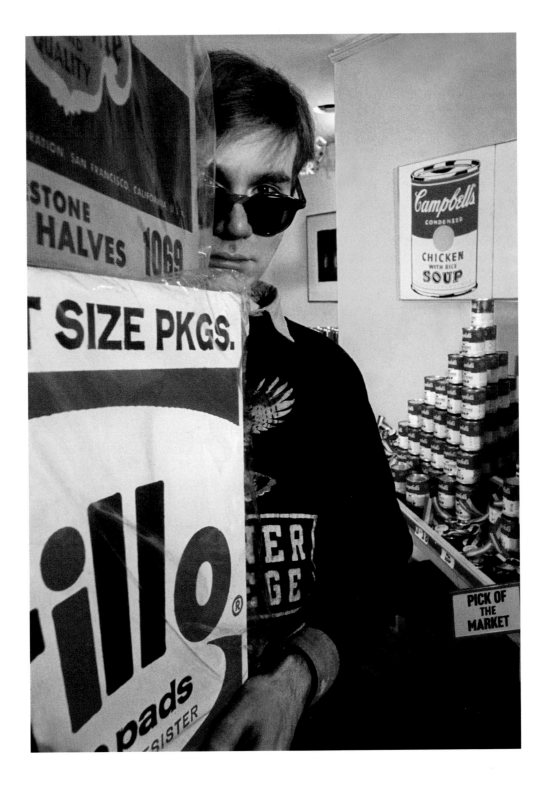

came from a still shown on television, which Warhol photographed. His intentionally rough printing of the third-generation reproduction evoked the literally and figuratively degraded photographs in daily newspapers: Norma Jean Baker had died with the star's drug overdose in 1962, but Monroe's image of course lived on, a commodification of an individual as a simplified yet near-universally recognized emblem of allure. Repetition reinforced the power of such signs and represented the hunger for them of their fans, Warhol seemed to say. Reproduceability—built into camera technology—made a single icon ubiquitous.

The art world quickly anointed Warhol a celebrity in his own right, and the publicity glare illuminated his retinue of patrons, assistants, and assorted hangers-on, who performed without inhibitions for the experimental films he began making in 1963. For portrait commissions (see Chapter 2), he sent his subjects to four-for-a-dollar photo-booth machines, and then silkscreened the head shots with the stereotyping he used for his renderings of Marilyn, Liz Taylor, Jackie Kennedy, and other media darlings. The resulting candy-colored, flattened, and simplified faces had the blank appeal of movie posters: as art historian Robert Rosenblum noted, Warhol became the court painter to 1960s parvenu society and made it look hip through his transformation of popular photography. His women resembled his Marilyns, icons of themselves; they were Warhols and therefore superstars.

Warhol's fluency in commercial art was polished by his study of graphic design at Carnegie Tech and his early success in fashion illustration and window-display design in New York in the late 1950s. At parties through the 1960s and '70s he casually photographed personalities large and small who seemed media-savvy; the superstars were an extension of his fascination with fame and mediated identity.

The darker side of Warhol's absorption with anonymous photography was his "Disaster" series, begun in 1963. His repetitions of tabloid pictures of grisly car crashes, the electric chair, the atomic bomb, and so on, echoed period critiques that claimed violent imagery anesthetized viewers to violence in real life. "The more you look at the same exact thing, the more the meaning goes away, and the better and emptier you feel,"

"DUSTED," 1982 IS ONE OF THE LAST PICTURES WILLIAM WEGMAN TOOK OF HIS WEIMARANER, MAN RAY, BEFORE HIS PET'S DEATH.

he said. Seemingly performing a duet of obsession and rejection, he collected the charged photographs and then inured himself to them by repeating and aestheticizing them. In his studio, he and his assistants generated artworks as if on an assembly line. "The reasons I'm painting this way is because I want to be a machine," was his shocking, Dada-like remark. The impersonality yet power of reportage and promotional photographs as public languages absorbed Warhol, and he underlined their syntax in the way he translated such images onto canvas. Few critics of photography as it functions in culture have been as disturbing, eloquent, or influential.

PHOTOGRAPHY IN CONCEPTUAL AND OTHER ARTS, 1960S AND '70S

Warhol's friend Robert Rauschenberg had famously said of his Combines, magpie assemblages of found objects, mass-media and personal photographs: "There is art and there is life. I try to act in the gap between the two." His shift of aesthetic focus from personal out into public "life" was typical of

artists in the 1960s and '70s, who employed photographs in a spectrum of ways.

Photo-Realists like Chuck Close, Richard Estes, and Audrey Flack began their paintings with photographs, sometimes projecting transparencies onto canvas and meticulously rendering the images of faces, humdrum streets, and garish flotsam, while concealing their brushwork. In Performances and Body art, the theatrical events and gestures staged by artists were recorded in photographs, which remained the only tangible products of these unscripted descendents of the Happenings of the late 1950s. And in Conceptual art, in which ideas—often interdependent with words—dominated the art object, photographs served as documents and were valued for their neutrality vis-à-vis other image-making systems.

All these developments were part of the 1970s' "dematerialization of the art object," in critic Lucy Lippard's phrase. The unique, unrepeatable, mural-scale, self-revealing abstraction that ensured "the triumph of American painting" by the mid-1950s was repudiated a decade later. While art schools built darkrooms, museums added photography to their departments of prints and drawings, and *Aperture* magazine displayed the legacy of American interwar photography as fine art, adventurous artists adopted photographs for their unpretentious reporting, their apparent transparency. Though their photographs were not then valued as such, they bore witness to the liberating dissolution of boundaries between high art and vernacular expression that had begun with Pop art.

Typical of the range of camera uses were works by the Britons **Gilbert and George** (Gilbert Proesch, b. 1943, and George Passmore, b. 1942), the American **Robert Smithson** (1938-1973), and the Dutch artist **Jan Dibbets** (b. 1941). Gilbert and George made their debut in gold face paint singing in an art gallery as a "living sculpture" (with photographs as the surviving evidence). They went on to monumentalize aspects of their lives as gays and their political views in huge altarpiece-like prints combining photographs and painting. Smithson, an artist of Earthworks—architectonic alterations of the landscape recorded in photographs—dematerialized his minimalist expression further in his "Mirror Displacements" series of 1969. After placing a half-dozen mir-

rors in the jungle, he photographed the unsettling combination of man-made geometries and chaotic nature, and then removed the mirrors, letting his photographs serve as the only records of a brief human intervention, an ephemeral artwork. With dry humor about the differences between sights and concepts, Dibbets toyed with photography's conventions of treating time in split seconds and perspective as a single plunging space. "Dutch Mountain/Sea," 1971, for example, is a wide composite of multiple photographs he made of a distant horizon as he rotated the camera: what looks like the Earth's curvature illustrates the work's title in that flat country.

Coolest of the cool in the 1960s was **Ed Ruscha** (b. 1937), who is best known as a West Coast Pop artist. Trained in commercial art like his East Coast counterparts, Ruscha is unique in the fidelity of his transfer of his photographs' documentary style to his paintings and in the inventiveness of his 15 books of his photographs of 1963-72. Mischievous and anti-heroic, Ruscha pointed his camera at 26 gas stations on Route 66 between Oklahoma City and Los Angeles for his first book, which he called "a collection of 'readymades,'" in reference to Dada artist Marcel Duchamp's elevation to art status of banal found objects. (Because *Twentysix [sic] Gas Stations* could be considered an anti-travelogue, it is cited in Chapter 3 of this volume.) Then Ruscha shot "every building on Sunset Strip," the title of his 1966 volume, which reproduced exactly that, the south side of the street at the top, the north side upside down at the bottom of an accordion-folded sheet measuring close to 25 feet wide. For *Thirtyfour Parking Lots*, 1967, he hired a commercial photographer and a helicopter, and with tongue-in-cheek sociology let the resulting aerial views reveal which lots had greater use by their incidence of oil spots. Ruscha was playing with photography without being a photographer, he said, and with the book format, which lets the viewer enter anywhere and edit the photographs "in your own mind as you move through the pages." These books were also spoofs of Southern California's car culture and Hollywood dreams, as well as commercial real estate photography and popular travel books.

Ruscha's serial documentation of his industrial environment can be associated with the typologies of such New

PRECEDING PAGES: "TWO BOWLERS WITH QUES-
TIONING PERSON", 1994, BY JOHN BALDESSARI

Objectivity photographers as Karl Blossfeldt, August Sander, and their heirs, Bernd and Hilla Becher, and it has been admired by younger art photographers including Andreas Gursky, Thomas Struth, Thomas Demand, and Jeff Wall. In organizing his 1975 *New Topographics* exhibition, William Jenkins acknowledged the influence of Ruscha's deadpan approach on the landscapists, whose concerns seemed "anthropological rather than critical, scientific rather than artistic." Meanwhile, curator Sylvia Wolfe recently observed that Ruscha's "art is too rooted in the real for pop art, too lush for minimalism, and too pictorial for conceptualism," all of which it overlapped in dates. Indeed, Ruscha's art remains aloof and distinctive in its bone-dry wit and refusal of categories: his painting, photography, printmaking, and artist's books mark the broader cross-fertilization of media in American image-making from the 1970s on.

With a similar nonchalance, **William Wegman** (b. 1943) mocked the camera's supposed truth and imaging conventions in his whimsical, conceptually inspired photographs and videotapes of the 1970s. A parrot (stuffed?) on its perch casts the shadow of a songbird in one set-up photograph, and in a straight-faced video Wegman attempted to teach his dog Man Ray and other canines how to play baseball. Wegman's discovery that Man Ray would pose patiently in ludicrous costumes opened another, immensely popular line of work for the photographer, who with punster's humor titled his first book on the subject *Man's Best Friend*, 1982.

Perhaps most influential of the Southern California artists is **John Baldessari** (b. 1931), whose early readings of film stills and whose teaching at Cal Arts (California Institute of the Arts, Valencia) affected the generation of painter-photographers emergent in the late 1970s and known as Postmodernists. In 1970 Baldessari burned all his Abstract Expressionist canvases, and in a subsequent work (which ribbed New York Language-as-Art experiments) he repeatedly painted the line "I will make no more boring art" like a wayward student punished at a blackboard. Discovering a mass of

cut-up, discarded publicity photographs showed him a way out of solipsistic painting. Since that discovery, he has blown up, masked, and combined segments of such highly charged but anonymous B-movie photographs in his paintings, dramatizing their theatrical codes of expression and gesture like a linguistic analyst of Cinemascope's tropes. In some works of the 1960s he had satirized the pretensions of art-historical writing by combining quotations with banal photographs, and he also mocked the pronouncements of how-to photography books with "dumb" invented illustrations. Since then, however, words have dropped away from his conceptually based work, and its fluid play with image codes has led the viewer down increasingly sophisticated yet visually attractive paths through media's "forest of signs."

THE "NEW COLOR" PHOTOGRAPHY

Walker Evans scorned color photography till late in his life. Until the 1970s he was not alone among art photographers. "Color photographers confuse color with noise …. They blow you down with screeching hues … a bebop of electric blues, furious reds and poison greens," said this aesthetic aristocrat, who was complaining about the over-saturated palette of advertising and some fashion photography, of amateur snapshots and travel pictures—what *National Geographic* magazine editors themselves admitted was "the red-shirt school" of photojournalism for the use of figures in red to set off emerald landscapes. Black and white connoted "serious" art photography: it was inherently more abstract than color and it lent itself to symbol-making; it had Stieglitz's and Group f64's traditions behind it in the United States; and its gelatin silver prints lasted longer than color prints or transparencies without fading—a concern for collectors and museums. In "The Family of Man" exhibition, which traveled the world from 1955 through 1959 and confirmed photojournalism's potential for artistry, only one photograph was in color—of a hydrogen bomb explosion. All this challenged Eastman Kodak, the Polaroid Corporation, and German and then Japanese competitors in film manufacture, who sought the prestige of the art photographers' endorsement of their color products. With this in mind, Kodak, for example, commissioned color photo-

COLOR PHOTOGRAPHS BY MARIE COSINDAS,
SUCH AS "TRIPLE PORTRAIT," 1967, HAVE
A TIMELESS QUALITY.

graphs from Edward Weston and Ansel Adams in the late 1940s.

The technical advances represented by Kodak's more permanent color films, Ektachrome and Kodachrome, and by Polaroid's succession of "instant" cameras are described on pp. 292-3 and pp. 350-1. Fade-resistant printing processes, such as dye transfers, are also noted there. Following are comments on some of the photographers who adopted these commercial and amateur tools and made them serve influential personal work.

Among photojournalists, **Ernst Haas** (1921-1986) and **Eliot Elisofon** (1911-1973) charmed *Life* magazine readers with obviously aestheticized color photography, which was reproduced to indicate color's possibilities in the 1950s. This was the heyday of the big Technicolor movie musical (as well as the launching of color TV), and Elisofon's consultancy to *Moulin*

Rouge and other films was reflected in the stills published in *Life*. On New York sidewalks in the early 1960s, **Helen Levitt** adopted vivid color for her Hispanic subjects, while retaining the colliding energies of the street life she had previously shot in black and white. In the same decade, **Eliot Porter**'s exquisite landscapes (see pp. 133-4), starring in Sierra Club books, proved that nature could yield subtle chromatic harmonies. And the Polacolor portraits of **Marie Cosindas** showed that the careful controls of Dr. Edwin H. Land's invention and a painterly sensibility could produce glowing Old Master hues. Harry Callahan, who had made color photographs as early as 1942, turned almost exclusively to color in 1977, notably making architectural studies on Cape Cod with primary compositions and hues to match. A critical mass of art photography in color was accumulating in the 1960s, and museum acceptance canonized the development. The Museum of Modern Art gave solo shows to Haas and Cosindas in 1962 and 1966 respectively and in 1976 to William Eggleston, and the phenomenon was

first surveyed by Sally Eauclaire in *The New Color Photography*, 1981, which concentrated on those Americans with a tough "street" aesthetic.

WILLIAM EGGLESTON (B. MEMPHIS, TENNESSEE, 1939)

The outrage greeting *William Eggleston's Guide*, the exhibition and catalog presented by curator John Szarkowski at the Museum of Modern Art in 1976, is hard to imagine 30 years later, given the photographer's huge influence. Eggleston's unposed color photographs showed aspects of the Deep South, but there were none of the beautifully decayed mansions of Clarence John Laughlin, for example, the stalwart sharecroppers of Walker Evans, or the racial conflicts dramati-

"UNTITLED (TALLAHATCHIE COUNTY, MISSISSIPPI),"
CIRCA 1972, BY WILLIAM EGGLESTON,
WAS DEBATED WHEN IT WAS
FIRST PUBLISHED IN 1976.

cally recorded in the 1960s by Charles Moore. Eggleston's content and style resisted conclusive definition. His settings ranged from upper-middle-class interiors to subdivisions and motel rooms, his characters from an old coot with a pistol on his bed to an executive and his black servant in the same stance. Disconcertingly, his compositions were sometimes oblique and snapshot-casual, sometimes formal (a combination like Robert Frank's); and he often put a mundane item—an old Buick, a rusted water tank—in the center of the picture, for no obvious reason. His subjects included trash, a dog lapping from a puddle, and the inside of a stove. To Szarkowski's claim that these photographs, mostly taken by 1971, were "perfect," critic Hilton Kramer huffed, "Perfect? Perfectly banal, perhaps. Perfectly boring, certainly."

Eggleston's work was innovative not just because of its elliptical, diaristic nature and its subordination of individual pictures to the cumulative effect of the series. His color was equally new in serious photography. Most color then, Szarkowski pointed

out, was either formally extraneous, as if black-and-white photographs were made with color film, or imitative of abstract painting. "In the first case the meanings of color have been ignored; in the second they have been conceived at the expense of allusive meanings. While editing directly from life, photographers have found it too difficult to see simultaneously both the blue and the sky." Eggleston could do both for this curator, and his subject was life, or more particularly his sense of identity as tied to place. His color was one with his understated interpretation of his emblematic figures, expressing his awe, humor, or irony. A decaying garden surrounds an aging belle in a bright flower-printed dress, for instance; and in an image of circa 1965 a teenager is literally gilded youth, though he collects shopping carts at sundown. Szarkowski's claim that "Bill Eggleston may have invented color photography" was half-humorous hyperbole, but his exhibition ratified the unglamorous, expressive use of it for a whole generation.

Eggleston made photographs as a boy growing up comfortably on a cotton plantation, but he did not begin to take the medium seriously until college, when he variously attended Vanderbilt University, Delta State College, and the University of Mississippi. Around 1959 a book on Henri Cartier-Bresson determined him to become a photographer. Eggleston's photographs of the 1960s show his absorption of the examples of Frank, Garry Winogrand, Lee Friedlander, and Diane Arbus. In the late '60s he met the painter and photographer William Christenberry (b. 1936) in Memphis, and the color photography by this Evans admirer and that of Joel Meyerowitz on New York streets turned him to color. In 1974 Eggleston had his first exhibition, in Washington, D.C., won a Guggenheim fellowship, and lectured at Harvard University. His subsequent photo-series, which number thousands of images, include "The Los Alamos Project," 1972-75, on life in the South and West seen at an almost molecular level (whence the title); *Graceland,* published in 1983, on Elvis Presley's Memphis mansion (which originated in a commission from the Presley estate); *The Democratic Forest*, 1989, drawn from his work of the 1980s; and *Faulkner's Mississippi*, 1991, with a text by novelist Willie Morris; as well as portfolios such as *Cadillac*, 1999, and *Los Alamos*, 2003. All this work has benefited from the distillation required by pub-

lishing. As the scholar-photographer Jonathan Green observed: "What Eggleston is attempting is no less than the perennial photographic search: the construction of an expressionism out of the most realist, vernacular idiom. This search, of necessity, always treads dangerously near the narrow line that separates triviality from mystery and beauty."

By comparison to Eggleston's intimate, snapshot-style photographs, the handsome prints of such "New Color" photographers as **Jan Groover** (b. 1943) and **Stephen Shore** (b. 1947) look almost classically composed, and they suggest the artistic backgrounds of these East Coast camera artists. Groover, who holds a BFA and an MFA and taught art at high school and university levels, adopted color film in 1973 and began photographing studio still lifes with a 4 x 5-in. view camera in 1977. Her refined pleasure in nuances of hue and tone led her to palladium and platinum printing, which she continues to explore while living quietly in France. "Formalism is everything," she is known for saying; and her nearly monochrome photographs have been compared to the serene still life paintings of Giorgio Morandi.

Shore, on the other hand, is a virtually self-taught camera artist, who was an assistant to Andy Warhol at age 15, and who made his debut in photography at age 24, with a solo show at the Metropolitan Museum of Art. His first color exhibition took place at the Museum of Modern Art in 1976. While his photographs of Monet's gardens at Giverny (a Met commission) are the most seductive of his early prints, his eye for the unobtrusive rhythms of elements on brightly lit city streets has proved enduring. For its formal balance and detached air, Shore's crystalline work is favorably compared to Walker Evans's. His cityscapes can resemble depopulated movie sets, so deliberate are their fugal compositions.

Far more active intervention in urban life typified the early career in Manhattan of **Joel Meyerowitz** (b. 1938), who was so inspired by watching Robert Frank work that he left his art director's job in 1962 to focus on "street" photography. In 1966 this New Yorker began favoring color, and by the mid-1970s he was proud of what he called his "field photographs," in which the urban scene vibrates with color-charged incident from

edge to edge of the picture. In 1976, trying out an 8 x 10-in. view camera on Cape Cod, he found another chord. The small camera, he wrote, is "about keeping your experience alive as you move," while "the big camera is more about making a single picture carefully." In his Cape Cod photographs Meyerowitz risked the prettiness associated with amateur holiday snaps and on-location advertising photography. But while he let nature dominate humanity and spread voluptuous hues across beach scenes, he spiced them with the neon chromatics of roadside stands. Color could be gorgeous but

JOEL MEYEROWITZ'S COLOR COULD BE BOTH LUSCIOUS AND POP, AS SEEN IN HIS BOOK *CAPE LIGHT.*

also Pop, and in the same photograph, as he revealed in his popular book *Cape Light*, 1978.

A rival in appeal were Meyerowitz's studies of St. Louis and Eero Saarinen's Arch, 1980, and New York and the Empire State Building, where each landmark was a motif recurring musically in the symphonic variations in city scenes. While his early work often had Winogrand-style human comedy, the photographs of the mature artist—alternating between city and seaside—offer plangent combinations of beauty, sadness, and endearing signs of human triviality. It's not surprising that he photographed at length at the World Trade Center.

Other "New Color" photographers included **Len Jenshel** (b. 1949), a Meyerowitz student, and **Mitch Epstein** (b. 1952), who both tackled touristic landscapes—Epstein in India—and

managed to leaven their exotic appeal with unexpected harmonies and spots of color and observations of local detail. **John Pfahl** (b. 1939) and **John Divola** (b. 1949) dealt with the pitfalls of natural and chromatic beauty and the power of the landscape tradition by altering their settings. For his "Moonrise over Pie Pan," a send-up of Ansel Adams's beloved "Moonrise over Hernandez," Pfahl shot a full moon rhyming with a tin he placed in the desert. Pfahl's subsequent use of color has become ironic in industrial landscapes of sinister import (see pp. 133-9 for broad ecological concern in camera work). The charm of billowing pink clouds in Pfahl's skies, for example, is undercut by his captions indicating their toxic makeup.

POSTMODERNISM IN CAMERA ART

By the early 1980s color was so widely used in serious photography that it no longer attracted attention as such. Color film, which had dominated black-and-white sales from 1965, now saturated the amateur, commercial, and art markets. By 1988 only 3 percent of all photographers used black-and-white film, according to a survey published in *Popular Photography* magazine. The synergy between commercial and fine art photography this represented extended far beyond materials. "Hybrids" and "pluralism" were watchwords of the 1970s, in which movements in all the arts borrowed from one another and from popular and non-art sources, while no single group or style won preeminence. "Postmodernism" became the soft umbrella term for all the activity, most effectively to distinguish it from modernism (which was simplified in retrospective reading).

Postwar photography had no Clement Greenberg, the formalist critic who identified modernism in postwar painting with reductivist abstraction, a development he praised as showing what was unique and intrinsic to the medium. But photography's "gatekeepers," notably at New York's Museum of Modern Art, had used similar arguments to elevate both "straight" and "street" photographers, from Strand and Sander to Weston, and from Cartier-Bresson to Winogrand and Friedlander. Now, however, a generation of university-educated camera users challenged this progressivist model as authoritarian and stultifying. Like the literary critics and architects who were first to be dubbed Postmodernists, in the late 1960s, they applauded

expression with multiple stylistic allusions and a critical stance toward orthodoxies, artistic and political.

Take the differences between Minor White's art and that of Warhol, Ruscha, and Baldessari, who were touchstones for the Postmodernists. While the former explored his subjective self in carefully crafted prints, the latter looked outward, to the media, for images and styles that exposed contemporary culture. While White and his forebears sought unique formal languages to express ideas and identities they conceived to be unique, the Pop and Conceptual users of photographs appropriated existing images for their critiques and seemed to care little that their work lacked originality in the traditional sense. Subsequent Postmodernist appropriators, such as **Richard Prince** (b. 1949), **Sherrie Levine** (b. 1947), **Sarah Charlesworth** (b. 1947), and **Barbara Kruger** (b. 1945), operated not as connoisseurs of older high art (like Ansel Adams, say, apropos Carleton Watkins), but like art directors let loose in the world's image bank. Those who staged their camerawork in the studio, including Cindy Sherman, **Laurie Simmons** (b. 1949), **Ellen Brooks** (b. 1946), and **David Levinthal** (b. 1949), resembled Hollywood directors and advertising photographers more than conventional camera artists perfecting technique, or "street" photographers capturing momentary but revealing coincidences in reality. The Postmodernists' defiance of canons for fine art photogarphy seemed Dada-like, but it had backing from several French philosophers, who were widely read in Anglophone colleges in the 1970s—if not by Postmodernists themselves, then by their critic champions.

In *The Society of the Spectacle*, 1967, Guy Debord posited that since the late 19th century, capitalist institutions had succeeded in replacing the sense of reality with images of it, as they persuasively advertised consumer goods and controlled society through its appetites. Jean Baudrillard went further in this vein and claimed that such images or *signs* had lost direct relation with their sources, creating a world of *simulacra*, of images in a hall of mirrors reflecting only themselves. His thought was based in semiotics, Ferdinand de Saussure's analysis of signs in language and the relationship between the signified (the image or concept) and the signifier (the written or spo-

ken word). Theories evolving from Saussure's held that such relationships were not stable and inherent but fluid and conventionalized and that meanings in all texts shifted with the reader and the culture. Nevertheless, individual consciousness was seen as composed of these shifting significations. Such concepts led, in one example, to "The Death of the Author," a 1968 essay by Roland Barthes that denied the existence of the unique creator of any work or of an individual's fixed identity, apart from socially negotiated forms. Culture at large and its power relations were instead conceived as the source of meaning and the setting for its display.

This dark, politicized view of communications—of images as "mediating" or even supplanting the sense of reality—supported the radical activism of civil rights and feminist movements in the 1970s. American Postmodern critics, led by Craig Owens, Douglas Crimp, Hal Foster, and Rosalind Krauss, saw their task as "deconstructing" or exposing the contradictions and coercive devices in current art, and especially in photography as a ubiquitous and particularly persuasive means of culturally coded representation. Their mission was to explode the canon of traditional art history and to "interrogate" the "master narratives" of white male European imperialism. A girl's dressing up for the camera would never be the same.

CINDY SHERMAN (B. GLEN RIDGE, NEW JERSEY, 1954)

Sherman's photographic exploration of the mediated self, generally female, spans 1975 to the present and shows no sign of flagging invention. Nevertheless, her best-known work remains what launched her career, her "Untitled Film Stills," 69 photographs of 1977-80, in which she conceived each image and served as set designer, costumer, make-up artist, star, and photographer. Not one of the 8 x 10-in. prints concerned her own identity. Rather, Sherman synthesized the stereotypes of femininity in B-films, American and European, of the 1940s-'60s, which she absorbed growing up. She chose photography "to get away from the preciousness of the art object," she said, and these were not art photographs in any conventional sense. They were featured in "Pictures," an influential essay of 1979 by Douglas Crimp; in Sherman's first museum retrospective, of 1982; and in a cover story in *Artnews*, 1983, headlined, "Cindy Sherman—Who Does She Think She Is?" The punning title signaled Sherman's personal reticence and refusal to theorize and her continued creation of multiplying personas. Her sexpots, girlish victims, sullen housewives, office temps, and so on were critical and popular hits.

"THE COCKTAIL PARTY," 1992" BY SANDY SKOGLUND, IS CONSIDERED AN INSTALLATION AS WELL AS A PHOTOGRAPH.

APERTURE AND MINOR WHITE

With hindsight, "street" photography appears to be the most vital current in 1950s camera art. But an exquisitely produced American magazine and its first editor wielded more influence at the time.

The notion that photographs, especially of nature and evanescent lighting effects, could be "equivalents" of the artist's feelings was pursued by Minor White (1908-1976) in his camerawork, teaching, and editorial direction of *Aperture*, which he co-founded in 1952 with Ansel Adams, Barbara Morgan, Dorothea Lange, and the curator-scholars Beaumont and Nancy Newhall. The magazine and White's charismatic example strengthened the metaphoric tendency in American fine art photography from Stieglitz through Group f64 and gave it a forum of carefully printed reproductions and critical essays at a time when photography publishing was in its infancy. White, who had studied botany and a mixture of Eastern and Western mysticisms, saw his series of black-and-white nature studies, nudes, and still-life elements as enlightening, like Zen Buddhist koans; the high calling he gave photography encouraged its growing respectability in museum acquisitions and university curricula in the 1960s. Some skeptics found his visual and verbal poetry mumbo-jumbo, but the *Aperture* platform was larger, and its supporters eventually established the Aperture Foundation, with a book publishing division, a program of print editions from founders' best-known images, and a public gallery in a New York town house.

Sherman was early in being known solely as an artist, despite her production exclusively of photographs (then and now). The *Film Stills* built on the uses of the camera in Conceptual art and Performances with gendered role-playing. And they recalled older personifications—F. Holland Day as Christ, for instance, or Julia Margaret Cameron's Alice Liddell as Pomona—yet they directed viewers not to the portrait subject or to the artist but to the source of their theatrical conventions, in the popular medium of film. Pursued even there, however, Sherman's characters proved to be *Untitled*—composites of feminine conventions, not specific filmic roles. They were simulacra, copies without originals, in Baudrillard's phrase. They were also viewed as illustrating feminist contentions that gender is not intrinsic but "performed," a set of behaviors enacting society's expectations, which are mostly male. In critic John Berger's formulation in the widely read *Ways of Seeing*, 1972: "Men *act* and women *appear*. Men look at women, women watch themselves being looked at." In a man-dominated realm, the woman necessarily becomes a victim of voyeurism or an accomplice to it. Sherman's *Film Stills* invited such readings, though she denied she was "consciously aware of this thing the 'male gaze.'" A given image, particularly of Sherman as a toothsome blonde, let viewers play voyeurs. The series, on the other hand, foregrounded the artifice of such stereotypes and turned viewers into cultural critics.

For her next series, "Rear Screen Projections," 1980-81, Sherman projected images for her backgrounds and exaggerated the contrivance of her

"EL PASO STREET, EL PASO, TEXAS, 1975" BY STEPHEN SHORE

setups. In "Centerfolds," 1981, commissioned by *Artforum* magazine, she moved in closer and shot herself lifesize in full color and more elaborate lighting as blends of soft-core pin-ups and helpless heroines. For a 1983 series spoofing fashion photography, the first of several commissions from adventurous figures in that industry, she acted out contemporary personas implied by the clothes—dominatrix, songstress, All-American girl. Did these attractive large-scale C-prints subvert male codes of representation or perpetuate them? Feminist politics were so embattled at the time that *Artforum* did not run the "Centerfolds" series. Meanwhile Sherman veered toward subjects of the grotesque and apocalyptic.

Fairy-tale witches and mythic sirens and ogres were revealed as further female stereotypes in Sherman's increasingly larger and more luridly lighted photographs from the mid-1980s. "In horror stories or in fairy tales, the fascination with the morbid is also, at least for me, a way to prepare for the unthinkable The real horrors of the world are unwatchable It's much easier to absorb—to be entertained by it, and also to let it affect you psychologically—if it's done in a fake, humorous, artificial way," she said later, in 1996. This was just before *Office Killer*, 1997, the horror film she directed, was released (to mixed reviews).

"Disasters," 1986-89, of contemporary and futuristic victimizations such as women reduced to vomit by anorexia and to dust by nuclear attack, was countered in period and mood by "History Portraits", 1989-90, send-ups of Old Master portrayals of power. Here Sherman played both male and female roles, and though she parodied few specific paintings, her antique dramatis personae were recognizable if goofy—pious prelates, sage counselors, nursing Madonnas.

From museum art, evoked with prosthetic devices, Sherman next tackled hard-core pornography. For "Sex Pictures," 1992, she constructed bodies from medical demonstration kits and anatomical models, then posed and lighted them like porn stars. The series was topical. She wanted to respond, she said, to the artist Jeff Koons's photographs of himself with his then-wife in sexual poses, and to the national controversy over public funding for supposedly "obscene" art (see below, pp. 328-35). The debate over explicit imagery then

"UNTITLED, MARILYN," 1982: CINDY SHERMAN CONTINUES TO ADDRESS STEREOTYPES OF FEMININITY IN HER WORK.

made unlikely bedfellows of certain feminists and radical conservatives who both fought to prevent exploitation of women, while female "sex workers" fought for freedom to sell their bodies in an open economy and psychologists battled over whether sexual violence in pictures led to violence in life. In Sherman's photographs, the objectification of women's bodies was literal and inescapable: the series remains shocking in its literal, confrontational detail at mural size.

SHERMAN'S EARLY STAGED SELVES

"I was always glued to the television when I was a kid, and I loved movies," Cindy Sherman reminisced when the complete series of her "Untitled Film Stills," 1977-80, was published by the Museum of Modern Art in 2003, after its purchase. "I loved all those vignettes" the hero watches in Alfred Hitchcock's *Rear Window.* "You don't know much about any of those characters so you try to fill in the pieces of their lives." TV's *Million Dollar Movie* played the same film for a week "so you could really know it by heart." At the State College of Buffalo, Sherman took introductory film courses, worked for an independent filmmaker, and made films, including "a three-minute animation of myself as a paper doll that comes to life." Living at Hallwalls, an alternative gallery space with studios, she began dressing in wigs, makeup, and thrift shop clothes to create personalities like Lucille Ball, which she documented in a fellow student's photo booth. Then in New York City in 1977, after graduating, she visited painter David Salle and came upon photographs that were part of his freelance work. "They were quasi-soft porn, cheesecakey things and it was hard to figure out what was going on in any of them, they were totally ambiguous and I just loved that. This kind of imagery would solve my problem of trying to imply a story without involving other people, just suggesting them outside the frame: something clicked."

Sherman's assemblages were compared to the Dolls of Hans Bellmer and to Pierre Moliner's self-portrayals as a transsexual in erotic poses. In fact, Sherman researched Dada and Surrealist photography in 1994 (and found it over-aestheticized). More cogently, critics have related Sherman's work of the 1990s to the wider appearance of the "abject body" in art. In this view, which built on Julia Kristeva's feminist theories, depictions of the dismembered, infantile, or humiliated body materialized the era's fears of a disintegrating society, one under physical attack from pandemics and terrorism. As indelibly as Robert Gober's installations and Kiki Smith's wax sculptures of the '90s, Sherman identified the agents of human mutilation as social and gendered.

Sherman's recent work includes series of clowns (2000) and what she calls the California "types you'd spot in a supermarket" (2000). The "Clowns" depict both sexes and various characters beneath the costumed personas; the California types address the mismatch of age and role-playing as poorly made-up, middle-aged females pose for their close-ups. Their pathos seems new in Sherman's work, while they extend her investigation of the power of photography over self-image and self-presentation.

Like Sherman, Postmodern camera artists such as **Laurie Simmons** and **Ellen Brooks** studied painting in college before picking up photography. Similarly, they addressed gender definitions in their work of the 1970s, but they innovated in creating tabletop tableaux of figurines. Both avoided photographing themselves or live models because, said Brooks, they would suggest autobiography or "introduce their own narratives and personas." The quarry of these artists was more generic—the housewife in her dollhouse of culturally defined domesticity, the middle-class contestant on TV's *Queen for a Day*, unable to escape "the Feminine Mystique" except as a game-show Cinderella. Their manufactured toys as such reflected and reinforced popular stereotypes of female roles, and the artists' use of them also suggested that women were miniaturized in Western society and made to conform to directives not their own.

Subsequent work by Brooks and Simmons was also glossily attractive and sometimes in brilliant color, and it gained scale competitive with contemporary painting (typical of camera art from the 1980s on), while expanding on the theme of coded representations of women. In a black-and-white series alluding to Chesterfield cigarette commercials of the 1950s, Simmons topped a doll's pair of sexy legs with various female emblems, such as a toy cottage or a purse. Like Barbara Kruger's photomontage of a hand holding a credit card–size sign reading, "I Shop Therefore I Am," these photographs identified women as commodity seekers as well as commodities themselves.

BARBARA KRUGER'S MARRIAGE OF WORDS AND IMAGES CREATES VISUAL JABS OF RECOGNITION.

Dolls also composed **David Levinthal**'s expressive repertory as early as 1973, but he drew on snapshot effects rather than declamatory graphics. Defining gender and racial stereotypes was the quest of his color photographs, in which blur, soft focus, and other seemingly spontaneous elements delay recognition of his mass-produced ingredients. At first glance, the toy soldiers in *Hitler Moves East: A Graphic Chronicle, 1941-43*, 1973, resemble real Germans in combat photographs; in his "Modern Romance" series, 1985, Polaroid SX-70 prints look like clips from a poor surveillance tape of illicit lovers. Viewers were implicated as they tried to decode the loaded

imagery. Where Levinthal used sharp focus, on a series of Aunt Jemima–type dolls and ornaments, the casual racism of these once-comic *tschotkes* and his straightforward photographs of them proved controversial. Again the viewer was drawn into interpreting charged concepts and recognizing the popular conventions employed to convey them.

Other photographers of tabletop arrangements in the late 1970s-'80s, such as **James Casebere**, **James Welling**, and **Zeke Berman**, have been cited in Chapter 1. It might be recalled here that the practices of these artists typified Postmodern manipulations, which combined the skills of traditional still-life painting and commercial product photography. Their technically polished work epitomized the phrases first coined for art photography of the late '70s: it was "directorial" in critic A. D. Coleman's sobriquet of 1976 and "fabricated to be photographed" as curator Van Deren Coke put it in 1979. More specifically, such still lifes dramatized the codes in Hollywood sets (Casebere), high art photography (Welling), and art school pedagogy (Berman). And if viewers failed to identify the butt of the mockery, they could still enjoy masterly black-and-white compositions.

The art of all these still-life manipulators—from Simmons to Berman—represented the Postmodernists' shift of focus from the *auteur* out to the audience as the locus where meaning was defined. Such appropriators as **Sarah Charlesworth** and **Barbara Kruger** took the process further and made no photographs themselves, instead scissoring them out of media sources for their seamless "rephotographs." Charlesworth asked viewers to read her brilliantly hued prints of juxtaposed images like religious paintings of commodity culture. A siren's gown was equated with a bondage shroud in one diptych; a large single panel depicted the gold trinkets of multiple cultures. In the tradition of John Heartfield's anti-Nazi photomontages, Kruger, a former art director at Condé Nast publishing, attacked contemporary power relations by combining boldly graphic stock photographs with her accusatory statements in supermarket-sign capitals. "Your Glance Strikes the Side of My Face" and "We Won't Play Nature to Your Culture," for example, broadcast feminist resistance to male dominance. The line "When I Hear the Word Culture, I Reach for My Checkbook" placed over a photograph of the dummy Howdy Doody mocked the boom-

THE MUSEUM OF MODERN ART, NEW YORK

The photography department at the Museum of Modern Art was the first in a major art institution. Its first director, Beaumont Newhall, established its scholarly excellence in 1937 with a vast survey of historical and contemporary work, from Abbott to x-rays. This became the core of his *History of Photography*. Next, from 1947-62, was Edward Steichen, who supported current art photographers, but remains best known for his popular narrative, "The Family of Man," 1955. From 1962 to 1991 John Szarkowski was director, as U.S. reportage became personally expressive and photography entered art curricula and Ph.D. programs. Seeking to define photography's syntax, notably in *The Photographer's Eye*, 1966, and *Looking at Photographs*, 1973, he found a special use of vantage point, motion, framing, and detail in anonymous photographs as well as prints by the masters. When Peter Galassi took over, Szarkowski's and Newhall's commitment to straight photography and documentary was reinforced in imposing exhibitions of Walker Evans and Friedlander, while modern conceptual work by Andreas Gursky and Thomas Demand was also introduced.

ing art world. Both the victims and the perpetrators were included in the "We," "You," and "I" of her address.

Kruger extended the activism of her work by placing it on billboards, in bus shelters, and even on shopping bags. Thus she used marketplaces and marketing styles to critique market values. Yet her presentations were eye-catching. "I want to make statements that are negative about the culture we're in," she said, "and I also think it's important to project them through pleasurable representation. Or else people will not look at them." Her success proved how resilient was the capitalist value system she attacked. In a somewhat ironic development in the late 1980s, she was commissioned to design mass-magazine covers in her signature style when feature stories covered cultural controversies, such as that of the outspoken radio commentator Howard Stern. Her fluid career moves from art director to vanguard artist to art director suggested how readily Postmodernist ideas were adopted by media. Many had originated there, after all.

A "cultural ventriloquist" was one art historian's bemused term for **Richard Prince**, who began photographing advertising images systematically in 1977, apparently the first artist to do so. Studiously avoiding comment on the values implicit in the Marlboro Man or the haughty fashion model, Prince left viewers to interpret his lab's blowups of such images, shorn of copy and rendered fuzzily as mythic forms and gestures. Advertising represents the culture's "wishful thinking," he said, couched in the most "psychologically hopped-up" terms. "I like the presumptuousness and the shame usually associated with these images," the gall of product hucksters, the shame of ever-needy consumers.

The "official fictions" of Madison Avenue intrigued Prince, whereas **Sherrie Levine** was drawn to museum art, especially the paintings and photographs whose canonical status was reinforced by their circulation in art book reproduction. Her attack on originality—on the artist as originator and the artwork as unique—was similar to Prince's but the most radical of the Postmodernists'. From 1979 Levine tore reproductions of photographs out of books on Edward Weston, Walker Evans, and Eliot Porter, as well as volumes on painters; photographed them; and signed the prints "Sherrie Levine, After Walker Evans" or "Sherrie Levine, After Ernst Ludwig Kirchner," and so on. Her "rephotographs" differed from their primary sources in size, color, surface, and resolution, but they were admitted imitations. They were read as gibes at the male-dominated art canon and the rocketing prices of vintage photographs in a medium of near-infinite reproducibility. More generally, they were interpreted as comments on the loss of authenticity in image-making and the growing inability of modern art to move the sophis-

ticated observer. Levine (like Warhol) was original, ironically, in the thoroughness of her denial of originality. In pursuing the implications of Duchamp's selection of mass-produced objects for his Readymades, she underscored how the art world confers value and required her audience to forego new visual pleasures while examining its assumptions. The lesson was bracing and subversive.

POSTMODERN PRECURSORS

The roots of Postmodern staging and appropriation can be found in Performance art and studio experiments of the early 1970s, a time when camerawork was entering art practices in adventurous university departments. An acknowledged influence on Cindy Sherman was **Eleanor Antin** (b. 1935), who began photographing for her Conceptual art in 1971 and turned the camera on herself for her "autobiographical fictions" the following year. Like a film director, she staged herself in various personifications, each sending-up female stereotypes as well as photographic genres. She was Eleanor Nightingale in the Crimea, as if photographed by Roger Fenton, in a series of 1977; and the black ballerina Eleanora Antinova starring in Diaghilev's troupe in what resembled fin-de-siècle studio cards, made in 1982. Antin's photographs, along with her drawings, videotapes, and publications, were outgrowths of elaborate Performances, involving her theatrical enactments in installations at her gallery. The humorous narratives of her personas extended Antin's own traits across media, which distinguishes her use of herself from that of Postmodernists'. She anticipated the absorption in Harlequin romances, thrillers, and comic strips of Sherman, Simmons, and **Eileen Cowin** (b. 1947), but Antin wanted, she told critic Dinah Portner, "to bring these forms back into art, not like Pop artists did by framing them, but in ways that try to find the human meanings behind their psychological, representational, even structural properties." While Cowin used herself, her twin sister, and other family members for her "Family Docu-Drama Series" of 1980-83, the histrionic scenes she directed were purposely soap-operatic, underlining the conventions of daytime TV serials. Antin's dramatizations, on the other hand, led audiences back to this New York-born artist, who took ballet lessons as a girl and fantasized about being a nurse.

As for appropriations, they can be found throughout the work of **Robert Heinecken** (b. 1931), but with open political content fueled originally by his share in the U.S. counterculture's opposition to the Vietnam war. In 1971, for instance, he silkscreened a news photograph of a Vietnamese woman soldier holding severed heads onto same-sized models in cosmetics ads in weekly magazines, and then returned the magazines to their news stands. (The buyers' reactions are unknown.) During Ronald Reagan's 1981 inaugural address, he pressed Cibachrome materials upon the TV screen and then exhibited a grid of the cameraless "videograms" like images of Big Brother, captioned with stock phrases from the address. His photo-hybrids ranged from delicate renderings based on soft-core photographs to rooms papered with videograms of newscasters. His subject was popular culture as shaped by mass media, and his outrage at how it infantilized public discourse appeared in forms from Swiftian satire to locker room humor. Like later appropriators, he was uninterested in creating new photographs but concerned instead with analyzing existing ones. The key difference is his attitude. Heinecken saw himself as a "guerrilla" artist and despised the media's manipulation of mass fantasies.

JOHN SZARKOWSKI WAS INFLUENTIAL AS DIRECTOR OF PHOTOGRAPHY AT THE MUSEUM OF MODERN ART FROM 1962-91.

POSTMODERN VS. LATE MODERN

The cultural vigor of the 1980s was visible in more than Postmodern camerawork. Photography's arrival on the art scene was announced in prints depicting elaborate stagings of painstaking craftsmanship and in photo-collages, which also defied the mechanical nature of the conventional solitary print. Many of these works gave conservators nightmares, but all of them ensured collectors (and investors) of the uniqueness of the artwork. In this traditional identification, such "camera-based art" could be called Late Modern: it exalted its creators, who enriched their expression with multiple cultural allusions.

In the novelty and in some cases genuine disturbance of its content, this work also required audiences to examine their expectations and taboos. Postmodernists were all "manipulators of signs more than makers of art objects," wrote critic Hal Foster in 1982. This meant "a shift in practice that renders the viewer an active reader of messages more than a contemplator of the esthetic." But the explorations of camera users as diverse as the Starn Twins, Joel-Peter Witkin, and David Hockney also purposely challenged norms for art photographs.

THE "CULTURE WARS" OF THE LATE 1980S

Fortunate in his friends, his timing, and his talent, **Robert MAPPLETHORPE** (1946-1989) was both successful and controversial in his lifetime, and to this day remains a symbol of America's "culture wars" of the late 1980s, which pitted First Amendment/freedom of expression supporters against an increasingly vocal right wing. Just as Oscar Wilde and Aubrey Beardsley polarized Aesthetes and proper Victorians at the fin-de-siècle, Mapplethorpe, along with performance artist Karen Finley, and photographers Andres Serrano, Jock Sturges, and later Sally Mann, embodied a nation's anxieties about cultural decadence and health at the end of a period of social change.

Did it all start in the permissive 1970s, dubbed "the Me Decade" by writer Tom Wolfe for its many human potential movements? The sexual revolution, in which free love was claimed for both sexes, had flowered with the first marketing of birth control pills in the mid-1960s. And the gay liberation movement built on that revolution, with its freedom of personal, physical expression, while it claimed the legal rights won by

the women's and black liberation movements. But AIDS, recognized as a sexually transmitted disease in the early 1980s, cast a pall over these developments; and when Republican President Ronald Reagan entered a second term in 1985, fundamentalist Christians, Southern conservatives, white supremacists, and the like found a convenient target for their fears in the arts. The unapologetically gay Mapplethorpe, some of whose photographs showed sado-masochistic practices, was the most visible whipping boy. And because his 1989-90 exhibition "The Perfect Moment" was partly underwritten with a grant from the National Endowment for the Arts, it gave North Carolina Republican senator Jesse Helms an excuse to decry "indecency" in publicly funded arts from a public platform. The exhibition had been seen without incident at the Whitney Museum in New York, but in Washington, D.C., the Corcoran Gallery of Art feared the NEA would refuse it future funding. The Corcoran cancelled the show. It was then seen at a small space and finally in Cincinnati, where the director of the Center for Contemporary Arts was arrested for showing "obscene" work (even though the half-dozen sexually explicit photographs were curtained off and labeled as possibly unsuitable for children).

Also in 1989 New York Senator Alphonse d'Amato accused Andres Serrano of desecration and tore up a reproduction of his photograph showing a crucifix floating in a golden-orange bubbly fluid. Without its title, *Piss Christ*, 1987, would have looked dreamlike, even transcendental. An exhibition including Serrano's work had received NEA funding, making it a butt of conservative outrage.

Should public money be spent on art that a sector of the public finds objectionable? One side argued that tax money often goes to programs that displease certain taxpayers (subsidies for tobacco farmers, for instance), and that the NEA's total funding was a fraction of that spent on culture by governments of smaller countries, e.g., France and Holland. The other side asserted that federal funds should only support art of mainstream "American" values. The response was that corporate and private support was easily found for such art, whereas the nation needed to underwrite riskier creativity to ensure its cultural strength and diversity.

"THE HUMAN CONDITION," 1970: DUANE MICHALS STAGED NARRATIVES IN HIS WORK AND SO BROKE ART PHOTOGRAPHY RULES AT THE TIME.

In Cincinnati, the Mapplethorpe defense called witnesses of national art-world authority. They judged that his work, taken as a whole, was of artistic value; it was not obscene, intended solely for prurient interest. The victory was pyrrhic, however:

federal and state funding for the arts was cut, and grants for artists were largely eliminated.

ROBERT MAPPLETHORPE (B. FLORAL PARK, QUEENS, NEW YORK, 1946–D. BOSTON, MASSACHUSETTS, 1989)

Mapplethorpe was more than a lightning rod for controversy. He can be seen as a romantic, late modernist camera artist: he helped secure wide art status for photographs through his

work's formal refinement, technical mastery, and deluxe presentations; he expanded acceptable subject matter to include overtly homosexual themes and beautiful black males, while displaying his own fringe lifestyle; and he died relatively young—a Rimbaud-like cursed poet—of AIDS-related illness.

Mapplethorpe was reared in a middle-class Catholic family in an outer borough of New York, and he earned a B.F.A. from Pratt Institute in Brooklyn in 1970. In his early work—including composites of appropriated and over-painted photographs—he sorted the influences of Andy Warhol, Man Ray, and Marcel Duchamp as artists and art-world personalities, as well as Minimalism's serial constructions. He adopted a Polaroid camera and black-and-white film to produce instant portraits—of himself and notably the singer-poet Patti Smith. These composed his first solo exhibition, in 1973. His photographs of Smith were reproduced on her record covers, and his portraits of their Lower East Side circle of artists, porn film stars, and members of sado-masochistic clubs gave him a reputation for daring, much as underworld subjects identified Weegee and Brassaï. By the mid-1970s Mapplethorpe was concentrating on photography, having acquired a large-format press camera and a Hasselblad. Encouraged by a Metropolitan Museum of Art curator, he began collecting vintage photographs, especially by such homoerotic photographers as F. Holland Day and George Platt Lynes.

In 1972, Mapplethorpe met the well-respected curator-collector Sam Wagstaff, who encouraged his expanded subjects of classically posed nudes and still lifes of exotic flowers; his growing skill with color, platinum, and palladium printing; and his painting-style mounting of his large photographs, sometimes with fabric panels in diptych and triptych formats. His portraiture of celebrities widened to socialites and Hollywood stars; and he produced a series on body-builder Lisa Lyons, on well-endowed black men, published as *The Black Book*, 1986, and on homosexual practices and other explicit subjects, presented as the *X, Y,* and *Z* portfolios, 1978 and 1981. The photo-

"SELF-PORTRAIT," 1988: AS CONTROVERSIAL AS HE WANTED SOME OF HIS WORK TO BE, ROBERT MAPPLETHORPE FACED HIS DEATH FROM AIDS WITH SOLEMN GRACE.

graphs in these portfolios became the crux of the 1990 Cincinnati trial for obscenity, which finally exonerated Mapplethorpe's body of work.

Today the testimony of Mapplethorpe's supporters continues to frame his transgressive photographs, and they are often seen as the dark obverse of his obsession with exquisite beauty, visible in voluptuous flowers, famous faces, and perfect bodies in studio settings, lovingly lighted for their close-ups. Mapplethorpe's "Perfect Moment" is, for poet Richard Howard, that ideal physical peak before inevitable decay, that balance between light and dark, *eros* and *thanatos*, life affirmation and dread of death. Mapplethorpe's portrayals of black men remain debated, however. Black critics and artists have accused him of objectifying blacks, particularly homosexuals, and of supporting stereotypes of black sexuality and "primitivism" as a "racial fetishist." His defenders respond that he mocked stereotypes in portraying them, and that his models, named in his photographs, were proud to be pictured. (At stake may be the objectification involved in portraying *any* nude, or in "taking" a photograph of *anything*.) Nonetheless, Mapplethorpe is still a touchstone for gay pride and an emblem of Manichean poles in American photography, romanticizing subcultures or high culture, seeking out deviance and idealizing perfected form.

THE "CULTURE WARS" CONTINUE

In the early 1990s, as HIV-AIDS mortality came under control through costly drug combinations, gay issues in America were sidelined by a new fear. The World Wide Web and increasing use of personal computers allowed unregulated access to sexual imagery and trafficking, most objectionably, in child pornography. While interstate trade laws were invoked to prosecute some flagrant offenders, the practice was obviously wider than any government agency could control. In some states, photo labs and drugstore processors were alerted to turn in any films of naked children—smearing parents who innocently photographed bath-times and skinny-dipping. In this context, portrayals of pubescent nudes by Jock Sturges (made with their parents' cooperation) and Sally Mann's depictions of her beautiful children, sometimes aping adult sexual-

MANN ON MEMORY AND COLLABORATION IN FAMILY PHOTOGRAPHS

Answering a questionnaire from the Chrysler Museum of Art, Mann gave this statement: "I photograph my children growing up in the same town I did. Many of the pictures are intimate, some are fictions and some are fantastic but most are of ordinary things every mother has seen …. [My children] have been involved in the creative process since infancy. At times, it is difficult to say exactly who makes the pictures. Some are gifts to me from my children: gifts that come in a moment so fleeting as to resemble the touch of an angel's wing …. We put ourselves into a state of grace we hope is deserving of reward and it is a state of grace with the Angel of Chance …. We are spinning a story of what it is to grow up. It is a complicated story and sometimes we try to take on the grand themes: anger, love, death, sensuality and beauty. But we tell it all without fear and without shame. Memory is the primary instrument, the inexhaustible nutrient source; the photographs open doors into the past but they also allow a look into the future …. There's the paradox; we see the beauty and we see the dark side of things; the cornfields, the full sails but the ashes, as well …. How is it that we must hold what we love tight to us, against our very bones, knowing we must also, when the time comes, let go?"

ized behavior, became public issues. Some bookstores displaying Mann's and Sturges's books were picketed and a few were vandalized. As workplace gains made by the women's movement were being challenged, the issue of "kiddie porn" that included Mann and Sturges encouraged attacks on women as careless mothers.

Some critics saw Mann's photographs of her kids' dress-ups, and related childish parodies of sexy adult poses, as evidence of the media's corruption of American culture and Mann's failure to protect her children from it. Others accused her of exploiting her offspring for shock value or prurient interest. Meanwhile, her defenders invoked First Amendment rights to freedom of expression and the truth of her depictions of pre-adolescent, "latent" sexuality, in Freud's term. The consensus seemed to permit eroticism in art if the nudes were adult and idealized, but condemned children's expressions of sexuality and any kind of portrayal of it, whatever the realities of infantile and youthful behavior.

Today sexual material is increasingly repressed in advertising and television programming, but inconsistently, and often by networks' self-censorship as they fear punishment from the FCC (Federal Communications Commission). For the time being, art world activists seem more intent on protesting the war in Iraq than the less visible destruction of First Amendment rights.

SALLY MANN (B. LEXINGTON, VIRGINIA, 1951)

While rearing her three children in rural Virginia, Mann found time to photograph the adolescents she knew and encountered. One of her early books was *At Twelve: Portraits of Young Women*, 1988, in which she portrayed that turning point from girlhood to womanhood. Not all her subjects welcomed their bodies' sexual changes, while some were half-grown smirking sirens. When Mann began photographing her own offspring—her most famous images—she found a similar mixture of innocence and precocious sexuality. In her book *Immediate Family*, 1992, she revealed childhood as poignantly transient, frankly physical (with wet beds, dripping Popsicles, bite marks), and fraught with emotional conflicts and dangers; and she showed it evolving in settings of seasonal change (nature's time), anchored with homely details (inner-tube swings, rusted pickup trucks). In *What Remains*, 2003, she focused on the evidence of decay and death. That book suggests that the inevitable changes of the bodies of loved ones—and the beauty and sorrow attending both—have been her subjects all along.

Mann has lived on her family's 423-acre farm for all but a few years, notably when she went to private school and then Bennington College in Vermont. She began photographing as a teenager, in 1969; and continued

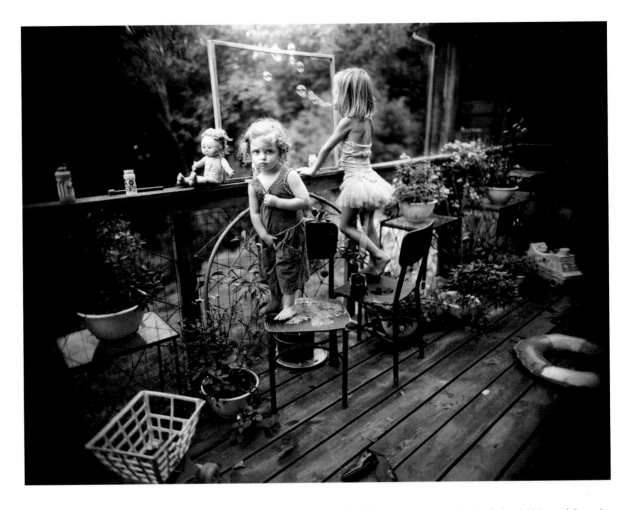

SALLY MANN'S LIFE IN LEXINGTON, VIRGINIA, WAS THE SUBJECT OF HER BEAUTIFUL, CONTROVERSIAL BOOK *IMMEDIATE FAMILY.*

as she finished her BA and then her MA in writing in 1975 at Hollins College, not far from her birthplace. Her earliest photographs, the series Dream Sequence, 1971, established the brooding, diaristic nature of her camerawork, and her meditation on how girls and women relate and evolve. In completing lush landscapes of 1972-74, she was given a century-old, 8 x 10-in. camera, which vignetted scenes because its lens did not fully cover her large sheet of film. She adopted the large format, and would exploit the antique camera's traits in her series published as *Still Time*, 1994, and *Mother*

Land, 1996, of landscapes she made in Virginia and Georgia.

Second Sight was Mann's first book, 1984; *At Twelve*, her second, sparked some discussion because of its focus on pubescent girls; but *Immediate Family* plunged Mann into the seething national "culture wars" with its unsentimental, complex depiction of children who seemed by turns angelic, knowing, and carnal. Her images were dark, exquisitely observed and printed black-and-white scenes of Emmet, Jessie, and Virginia— of naptimes, play-acting, squabbles, summer swims, and the like, some 20 percent of which showed the siblings nude or half-dressed. But this percent, and perhaps the beauty of the children themselves as seen in Mann's tender portrayals, enraged the radical right. They argued that children's innocence was a universal fact, and must be protected. Mann countered by

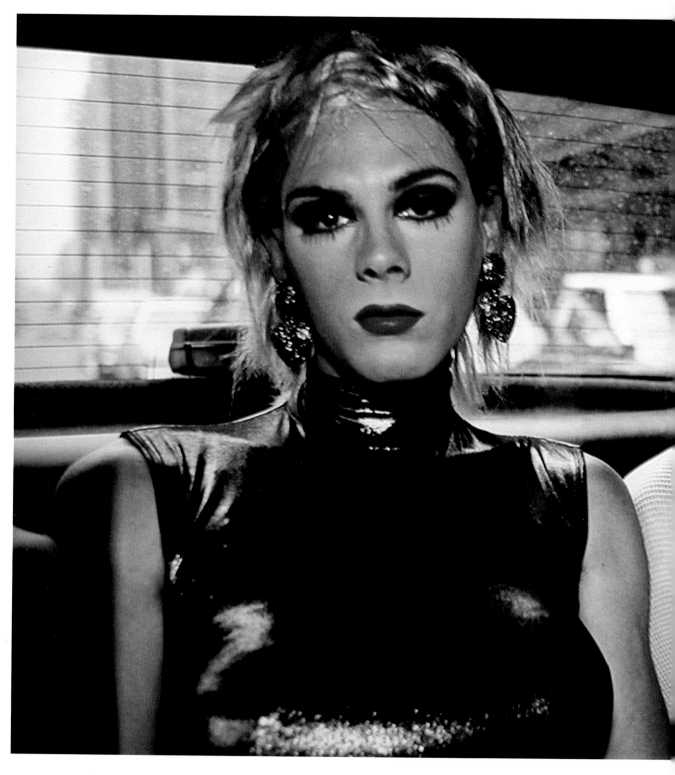

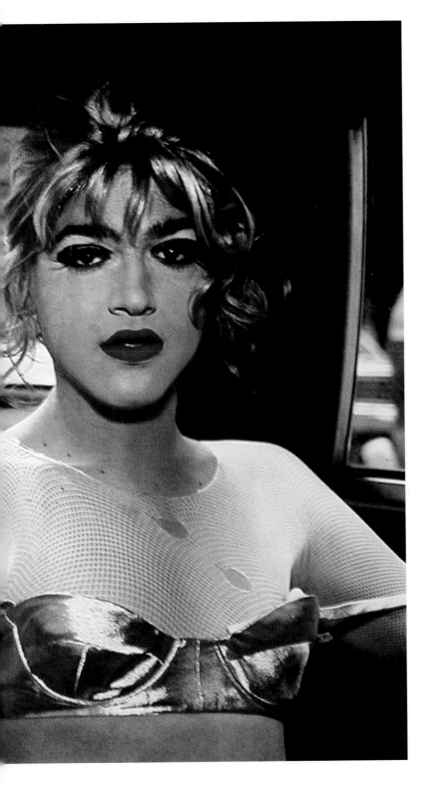

showing the complexities and ambiguities of her children growing up. She was exploring dangerous social ground *because* it was dangerous, because conflicting cultural norms were shaping the maturation of her children (and others). Ultimately, however, her artistry shielded her from the repression experienced by certain advertising and amateur photographers of preteens. And her children and she finally agreed to end their collaboration as they reached adolescence.

Mann next explored her Southern heritage, with its historic memory, in melancholy, evocative views of Civil War battlefields, inspired by her discovery of a trove of glass-plate negatives by a Confederate soldier. Then an escaped convict pursued by police committed suicide on her farm while she watched. The extraordinary event led her to ruminate on death, and to her series "What Remains." Now the taboos surrounded mortality and bodily decay: she photographed corpses at a forensics study site, as well as the family's beloved pet greyhound, before and after a year's burial. Using wet collodion, she exaggerated its accidents and her camera's quirks—spots, smears, distortions, and light leaks—as correlatives for the mysterious, chance nature of death. With the cool of the generation after Diane Arbus, Mann seemingly accepted her doctor-father's claim that the only subjects for art are "Sex, Death, and Whimsy." Though certain photographs evoke Edward Weston and Robert Frank, Joel-Peter Witkin and William Eggleston, her series form a unique oeuvre of Southern Gothic lyricism, of philosophic inquiry in poetic form.

NAN GOLDIN (B. WASHINGTON, D.C., 1953)

The Ballad of Sexual Dependency, Goldin wrote in 1986, is "the diary I let people read." This book of her snapshot-style color photographs was culled from a slide show with music track she first screened at

"JIMMY PAULETTE & MISTY IN A TAXI, NYC;" 1991, BY NAN GOLDIN

punk rock clubs in 1979. By turns sexually explicit, violent, or tender, the images reflected and memorialized her "recreated family" from 1972 on, the young lovers and friends who were prostitutes, transvestites, drug users, and bi-, homo-, or transsexual, in the period before and during the identification of AIDS. The book and ever-changing show, one of several that Goldin continues to update, had tremendous impact on photographic fields from fashion to personal work in Japan. For Goldin expanded on the explorations of gender identity and taboo behaviors by Diane Arbus and Larry Clark and validated the use of the camera in serious expression as a tool of autobiographic narrative. If the 1970s saw the inversion of modernist ideals in postmodern ironies, it saw, in Goldin's work, the inversion of "Family of Man" universalism and optimism. Replacing those values was her affection for her "tribe" of disparate individuals, marginalized by biology, choice, or society (despite then-expanding tolerance for different lifestyles).

Goldin's early biography is easily seen as motivating her choice of subjects. The youngest of four children, she was 11 when her sister committed suicide; Nan dropped out and went to a free alternative school. While living in various foster homes, she took night classes at the New England School of Photography with Henry Horenstein in 1972 and attended the School of the Museum of Fine Arts, Boston, in 1974-78. She also tried Super 8 filmmaking on the model of Andy Warhol's 1960s films of his circle. Photography seemed a way of preserving memories; at the same time, fashion photography and the drag culture of her friends spurred them all to cross-dress and pose for her 35mm camera. Horenstein showed her Clark's autobiographical *Tulsa* and "encouraged me enormously to feel that my so-called snapshots were as valid an art form as … the rocks and trees that were being printed in the early '70s." Goldin adopted color and flash; and she had her slides printed on Cibachrome, a glossy plastic material that heightened the already pumped-up hues she found in nightlife and the dark–light contrast exaggerated by her flash.

In 1978 Goldin moved to the Bowery in New York City, where her photographs caught everyday extremes—the defiant world of heavy metal music, heroin highs, an abusive lover who nearly blinded her, and the first AIDS toll among her friends. In 1988, she shook off her own substance dependence in a five-month detoxification program, where she made somber self-portraits. The 1990s brought her success. She spent a year photographing in Berlin on a German grant; the book, *The Other Side*, 1993, presented her drag queens; *A Double Life*, 1994, paired her photographs with those of her friend David Armstrong of the same people. For *Tokyo Love*, 1994, she and Japanese photographer Nobuyoshi Araki contributed similarly intimate work that alternated through the book. Her retrospective "I'll Be Your Mirror," at the Whitney Museum of American Art, took place in 1996.

Two commissions of the 1990s gave Goldin wide notoriety in fashion photography's phase of "heroin chic." In photographing her friends in couture, who were of different body types and ages, she wanted to fight Seventh Avenue's "ageism and anorexia," she told Scott Rothkopf in an interview. But the fashion identification ultimately threatened her credibility, she felt: "when has a fashion photograph ever made you cry?" Her recent series, of her friends' relationships and children as well as landscapes and religious emblems, are more introspective and "spiritual," with gentler light and color. Aware of "aging and maturity," she photographs "those who've survived. I'm interested most of all in tracing histories of lives."

STAGED "DOCUMENTS" IN RECENT PHOTOGRAPHY

The legacies in today's photography of Conceptual art and Postmodernism can be seen in the permutations of typologies and tableaux. The so-called Düsseldorf School—of those who studied with Bernd and Hilla Becher—includes Andreas Gursky and Candida Höfer (covered in Chapter 1 for their imposing depictions of architecture) and Thomas Ruff (cited in Chapter 2 for his deadpan large-scale portraits). Thomas Struth is one of their colleagues, and his subjects, like theirs, reflect the global vantage points and travels of European artists since the 1990s. Struth overtly engages contemporary constructions of culture and society in cities across the world—what they share, how they differ. In series that also depict unpopulated nature, he favors the muralesque scale, saturated color, and fastidious detail typical of

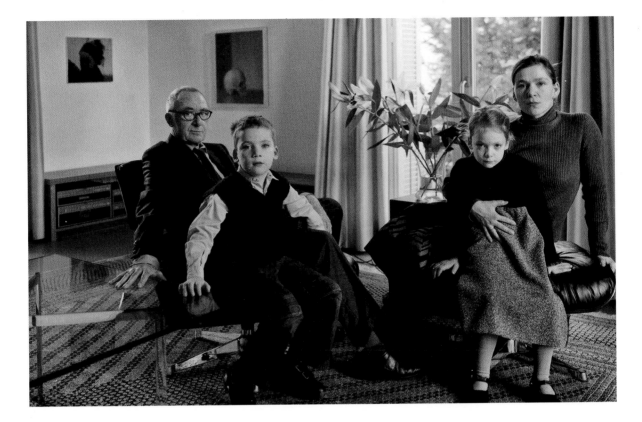

THOMAS STRUTH PORTRAYED HIS MENTOR IN
"THE RICHTER FAMILY, I, COLOGNE," 2002.

the School, and indeed of almost all current camera art.

Those who construct tableaux are closer to architects and big-budget film directors than older camera artists, even though they draw on Postmodern fabrications of the 1980s. While their predecessors resembled freelance product photographers, they command multiple skills in lighting and *mise-en-scène* and can direct teams of assistants when need be. The photographers drawn to typologies and the tableaux directors both exploit the indexical or "truth" value of photography, its recording of figures who are "real" even if they are posed friends or hired actors and settings that are "real" even if the artist built them. All exploit visual ambiguities and challenge the viewer to distinguish actuality from the ersatz. They ultimately ask whether staged scenes are any less illuminating than those snared from life's continuum. Each reflects the artist's insight.

The photography described here varies in how much it is fabricated and how obvious that is. Struth directs friends to act as *staffage* in recognizable museums and cities, and his intervention is barely visible, perhaps only in the unlikely harmony of figures and spaces and the thorough lighting, which would not be so informative without his technology. DiCorcia concentrates on people in seemingly spontaneous moments and those he isolates in crowds: he leaves unclear how well he knows the "Others" in his sophisticated extension of "street" photography. The first world of Tina Barney was her own, and she saw it intimately in its privileged lifestyle and family relations. Recently she has used her formidable gifts with color on the wealthy of European countries, but in all cases her directorial role remains ambiguous. Jeff Wall, on the other hand, conjures up the ambitions and work habits of a Romantic painter like Géricault: he presents Big Subjects and is not afraid to spend time constructing them. His artistry is obvious within his documentary framework.

DICORCIA ON THE INWARD PEOPLE IN CROWDS

In 1977 diCorcia commented on his series "Streetwork," where his quick eye for telling gesture, dress, and composition separates individuals from the crowd in cities as diverse as those of Japan, Mexico, Germany, India, and the United States: "In the sense that the part represents the whole, I am interested in society at large The most consistent conclusion I have drawn in my travels is that no one really knows what's going on—it is apathy and self-preservation that define the socio-political aspect of the cities and their societies. Subjectivity becomes a comforting trap. It obsessively focuses on the self as a standard for an exterior reality, which exists only in the mind. Psychology is reality for many people. I try to show this. It may not, in fact, be the actual psychology of the subject that I portray, but it is played out in the image and the projection of that psychology into the surrounding space. The street does not induce people to shed their self-awareness. They seem to withdraw into themselves. They become less aware of their surroundings Their image is the outward-facing front belied by the inwardly gazing eyes."

PRECEDING PAGES: FOR 13 YEARS, 1985-98, NICK WAPLINGTON PURSUED A SERIES OF PICTURES TITLED "LIVING ROOM" FROM THE DAILY LIFE OF A COUNCIL ESTATE IN ENGLAND.

THOMAS STRUTH (B. GELDERN, GERMANY, 1954)

One of the now-famous students of Bernd and Hilla Becher, Struth overtly engages contemporary constructions of culture and society in cities across the world—what they share, how they differ. In series that also depict unpopulated nature, he favors the muralesque scale, saturated color, and fastidious detail typical of his cohort, which includes Andreas Gursky, Thomas Ruff, and Candida Höfer. But Struth allows himself moments of lyricism and tenderness within his otherwise dispassionate renderings of such traditional subjects as the cityscape, portrait, landscape, and still life. "Between Beauty and Objectivity," the name of an exhibition including him, suggests the blend in his work of August Sander and Old Master aesthetics.

Struth was raised in an upper-middle-class family and first intended to be a painter. He enrolled with Gerhard Richter at the prestigious Kunstakademie Düsseldorf in 1973. Like Richter he transformed popular photographs in his paintings, and then began taking his own. His first series were central-perspective 35mm views down city streets, shown in grid formation. When the Bechers arrived at the academy, he transferred to their classes: since the late 1960s they had been documenting industrial relics—water towers, silos, etc.—and arranging their prints in grids. They introduced him to the photographs of Atget, the American "New Color" photographer Stephen Shore, and the large-format camera. Struth pursued his city series in Europe and then in New York City, where he spent 1978 on a scholarship. Working at early hours and on cloudless days, he treated the cities like archeological evidence, as cumulative products of urban decay and growth. In their eerie emptiness, they suggested urban futures in which human contact was no longer needed.

After graduation in 1980, Struth spent two years doing civil service at a community center; he calls himself "a humanist, leftist, liberal, curious guy." At mid-decade he started making portraits of close friends and he turned to color. His best-known work began in 1989—people gazing at masterpieces in Europe's greatest museums. The jet-age phenomena of international tourism and cultural consumerism is one theme; another is the relation—or lack of it—between the museum-goers and the painted figures. In his long exposures, the former blur while the latter become hyper-real. His selective focus underlines how time has intervened to separate the values of those who look from those who are looked at. Yet the "interaction" between them differs in each wall-size photograph: a woman looks ready to enter a

"MARIO," 1978, BY PHILIP LORCA DICORCIA

Caillebotte street scene in Chicago's Art Institute, while Venetian tour groups ignore Bellini's saints. "Pergamon, Berlin, 2001," shows some of the scaffolding Struth climbed for his embracing vantage point. He likes the detail "because it indicates the scene is constructed, history is constructed."

In 1991 Struth made flower studies and landscapes for the patients' rooms in a Swiss hospital. He also continued photographing at city crossroads, but now in color, with multiple figures. The visual chaos in an Asian metropolis led to a series of jungles and forests he began in 1998. He dubbed the unpeopled scenes "Paradise." A series launched with the new millennium comprises head-on exterior views of European cathedrals with their visitors.

The city, the crowd, the monument, nature: over his career Struth has tackled these culturally laden subjects of history and modern times, of people and their absence, and like Atget in Paris and Sander among the German people, he presents somewhat melancholy, beautifully rendered typologies, which remain for the viewer to interpret. His 2002 retrospective seen in Dallas and New York City confirmed his international reputation.

PHILIP-LORCA DICORCIA (B. HARTFORD, CONNECTICUT, 1953)

Among the contemporary photographers who stage their images with documentary verism, diCorcia is the most reserved in his relation to Hollywood and still media. He shares with Cindy Sherman, Jeff Wall, Gregory Crewdson, and others an impressive mastery of camera technique— staging, lighting, direction of his figures—and he subverts notions of photographic truth with similar intellectual provocation. But in this group's mix of fact and fiction, his photographs engage daily reality most transparently and with subtlest mystery. His interventions in the scenes he shows are imperceptible to the casual viewer: his prints thus reinvigo-

ICP

Photography wasn't popularly considered art when Cornell Capa founded the International Center of Photography in 1974, and it was rarely seen on museum walls. Capa believed photography deserved a place in museums for both artistic and social reasons. His mission was to show documentary work by his brother Robert Capa and others who devoted their lives to humanitarian causes, because their "concerned photography" could mobilize consequential social change. Technology and politics have transformed the world since 1974; tastes and values have evolved and photographs now hang in the most exalted museums. A new generation of curators has expanded the compass of the International Center of Photography to include the work of contemporary artists grappling with issues of race, terrorism, health care, science, and globalization. The institution has also highlighted the work of some of the medium's under-appreciated practitioners such as daguerreotypists Southworth and Hawes, Soviet avant-garde artists Gustav Klutsis and Valentina Kulagina, and American photographer Ralph Eugene Meatyard. Fully committed to its founders' original ideals, ICP continues to explore the definition of the photographic medium.

rate "street" photography and portraiture and require thoughtful reading.

DiCorcia's interest in photography dates to his years at the University of Hartford in the early 1970s. He went on to earn an undergraduate degree and postgraduate certificate in photography from the School of the Museum of Fine Arts, Boston, in 1975 and 1976; and he received his MFA in photography in 1979 from Yale University. At Yale he began staging narratives for the camera, recalling the conventions of melodramas and B-movies, with their portentous camera angles and emotionally charged gestures.

Such theater techniques enriched his earliest mature works, of siblings and friends posed to enact cryptic moments in domestic life. His brother Mario stares disconsolately into an open refrigerator, for example, in what is lighted to suggest the dark night of the soul—or at least the unsatisfiable hungers of 2 a.m. For this seemingly impromptu vignette, diCorcia rehearsed Mario repeatedly, made numerous test shots, and wired electronic flash in the fridge.

After graduation, DiCorcia tried and failed to find a job in the film industry and returned East, taking a position as a commercial photographer's assistant in New York. By 1984, his craft assured, he was earning a living as a freelance photographer for *Fortune*, *Esquire*, and travel magazines. In 1989 he won an artist's fellowship from the National Endowment for the Arts. It was the year when Robert Mapplethorpe's exhibition "The Perfect Moment" was attacked in Congress for its photographs of homosexual and sado-masochistic acts. DiCorcia spent the NEA grant on Santa Monica Boulevard in Los Angeles, inviting male hustlers and addicts to be photographed for pay and then taking them to locations he had selected earlier. There he often photographed the men through windows, or other distancing devices, and in the evocative light of neon or fading sunshine. The final Ektacolor prints, almost 20 x 40 in., were titled with the man's name, age, town of origin, and his price. Apart from their subversive humor about the NEA's definition of obscene photographs, these "Hollywood Pictures" of 1989-90 raised questions about how camerawork commodifies reality and how hustlers "really" look, as well as what this quasi-documentation said about a Los Angeles underclass. In other words, diCorcia toyed with *what* and *how* photography means, using a loaded subject.

DiCorcia has also photographed anonymous people on other big city streets. For the photographs in "Streetwork" 1996, he used hidden lighting to single out individuals who seemed to typify the place: an upscale New Yorker isolated under his Four Seasons Hotel umbrella, three Belgian businessmen too preoccupied to notice a sexy woman in front of them. For the "Heads" series, 2001, he rigged a hidden strobe light over a spot on a Times Square sidewalk, and

TINA BARNEY CREATED "NEW YORK STORIES,"
WHICH INCLUDED "THE RED LIPSTICK"
FOR *W* MAGAZINE IN 1999.

when a passerby stepped on the spot, it activated the strobe and he photographed the person from 20 feet away with a telephoto lens. Isolated from the crowd, each individual was struck by the cinematic light yet remained withdrawn in thought. They suggest theatrical versions of the "portraits" covertly taken on Chicago streets and in New York subways by Walker Evans (who taught at Yale). DiCorcia's giant head shots (5 x 4 ft.) also challenged definitions of portraiture and candid photography, and they invited speculation about the conundrums of identity and how we recognize it. "The more specific the interpretation suggested by a picture," diCorcia comments, "the less happy I am with it." These photographs invert the strategy of the "Hollywood Pictures": they are spontaneous images that appear posed.

TINA BARNEY (B. NEW YORK, NEW YORK, 1945)

The conviction that "the rich are different," as novelist F. Scott Fitzgerald put it, has always lent interest to Tina Barney's large color photographs, first of East Coast blue bloods (her own tribe), which she began in the early 1980s, and since the mid-'90s of English and European aristocrats. Exactly *how* different can be seen in her astutely observed, richly textured tableaux of her subjects in their habitats—plush rooms whose artworks and décor rhyme or contrast with the relation-revealing gestures and characteristic expressions of their owners. (Barney's mother was a successful fashion model and interior designer.)

In her own WASP milieu, Barney's characters pursue their amusements and rites of passage seemingly unaware of her 4 x 5-in. camera. The "Europeans" series, on the other hand, is portrait-like, and Barney shows her nobility at ease but gathering themselves for the camera's occasion. These are neither keyhole exposés nor flattering society news pix: their mixture of candid and posed self-presentation shows the photographer's effort to convey these people as family members with emotional and social bonds with one another and with her. Chance gives her telling details and pleasing forms, but she also asks her subjects to reenact gestures or positions for her carefully illuminated scenes. "Theatre of Manners" was the apt title of her 1999-2000 traveling exhibition; she was included in the

PRECEDING PAGES: JEFF WALL, "AFTER *INVISIBLE MAN* BY RALPH ELLISON, THE PREFACE," 1999-2001

Museum of Modern Art's "Pleasures and Terrors of Domestic Comfort," 1991, a survey of photography of the family that also showed work by diCorcia, Sally Mann, and Larry Sultan (b. 1946).

JEFF WALL (B. VANCOUVER, CANADA, 1946)

Western culture's love affair with movies, storytelling pictures, and the art-world status of certain big photographs are all reflected in Wall's successful career of photographing the elaborate tableaux he constructs. He brings a professor's expertise in art history and aesthetics to bear on his fake documentaries: they are both engaging to look at and intellectually engaged.

Wall received his M.A. in art history from the University of British Columbia in 1970, and then went on to doctoral research at the august Courtauld Institute of Art in London, where his thesis concerned Berlin Dada, that field of appropriated mass-media photographs, and Marcel Duchamp, the artist-provocateur who mocked received definitions of art. In 1976 Wall began teaching at Vancouver's Simon Fraser University, and two years later at his first solo exhibition he presented "The Destroyed Room," which set some guideposts to his subsequent camera work. In vivid color, nearly eight feet wide, the photograph showed a bedroom he had constructed, furnished (apparently for a woman), and then carefully vandalized. A single figurine remained intact, to witness the artifice of his document of an apparently violent scene—or was it a clue to the supposed vandal's motives? Confusing the veracity of his photograph further, he showed it pressed to the street window of his gallery's nondescript commercial space: what was "art" doing there, or an ersatz reportorial photograph, for that matter? Later he mounted it in a backlit box, like a subway-wall or bus-shelter advertisement; the total was packaged as a sales pitch, but what was being sold? The composition of slashed mattress and twisted clothing was inspired, he said, by Delacroix's 1827 canvas, "The Death of Sardanapalis," a Romantic ode to sexual violence and megalomania. Wall was scrambling codes, and thus challenging the "truth" of photographs, the nature of narrative in camerawork (and painting),

the identity of art photography as commodity, and so on. Meanwhile, the viewer was teased into imagining and explaining an invented crime, while enjoying a Baroque composition.

Wall's next works were attempts, he explained, to infuse photography with "the heroism of modern life," in the 19th-century critic Charles Baudelaire's phrase. Without quoting directly from paintings by Courbet, Manet, or Seurat, his tableaux nonetheless described urban vignettes and encounters with the pungency of 19th-century realist art and its physical scale. A streetwalker is turned down by a potential client; a biracial couple with their child quarrel while strolling a dirt road in exurbia—both in mural-sized transparencies. Wall's native Vancouver substituted for Paris, and the realities he photographed (though acted by models) provoked thought about current social issues. Literature became an inspiration for "After *Invisible Man*," which materialized the "warm hole" of Ralph Ellison's novel of black experience. Wall lit a room with 394 bulbs and powered it with stolen electricity. And satire of Canadian socialism (and bureaucracy in general) infused "The Stumbling Block," 1991, in which pedestrians fall over a prone worker with a badge reading "Office of the Stumbling Block—Works Department."

For the latter photograph Wall began digitizing his ingredients in the studio: the process became his way of exerting more complete directorial control over his mise-en-scène and cast and in creating more seamless illusions. Like the Old Master painters he admired, it let him work in the studio, and piecemeal, on separate figures, which he then combined in his grand compositions. Most epic of these works was "Dead Troops Talk (A Vision after an Ambush of a Red Army Patrol, near Mogor, Afghanistan, 1986)," 1991-92. As critic Thomas Crow points out, this assembly of gory "corpses" evokes battle scenes by artists from Bosch and Goya to the Romantics Ilya Repin and Baron Gros, all in a comic-grotesque allegory of Russia's military debacle at the end of the Cold War. For Crow, Wall has bridged today's key "two pursuits," of "new forms of historical awareness and new moves in art," and testified "to the potential of social-historical inquiry to motivate persuasive work in the studio." Given Wall's interest in defining pressure points in today's culture, and his command of art history, one can expect to see further provocative inventions.

FROM THE SERIES "MY GHOST," 2000,
BY ADAM FUSS

THE ANTIQUARIAN AVANT-GARDE

Dubbed "The Antiquarian Avant-Garde" by critic Lyle Rexer in 2002, a group of camera artists has been shaping their intense idiosyncratic visions through outmoded 19th-century processes since the mid-1990s. Older art photographers set a precedent for literally showing their hand, and an art school-educated generation emergent in the late 1960s encouraged all sorts of manipulations with photographic materials to defy photography's usual flatness and mechanical repetitions. Artists such as Betty Hahn (b. 1940), Bea Nettles (b. 1946), Thomas Barrow (b. 1938), William Larson (b. 1942), and Robert Fichter (b. 1939) were among those who set examples through their work and teaching. The "antiquarians," however, look not to Pop assemblages for cues but wax nostalgic about the aura of age and sense of history built into old processes. Through daguerreotypes, tintypes, cyanotypes, albumen prints, pinhole cameras, and other near-lost devices, they create unique art objects in the face of digital photography's growing popularity.

The cameraless photograph, or photogram, that was William Henry Fox Talbot's first "sun picture" absorbs artists as diverse as **Adam Fuss** (b. 1961), **Susan Derges** (b. 1955), and **Joan Fontcuberta** (b. 1955). They expose their light-sensitized paper to three-dimensional objects and prints, positioned at different distances from the surface to produce different degrees of res-

olution and luminosity. While Fuss and Derges hint at primal states and obscure rituals, Fontcuberta delights in creating visual conundrums that engage definitions of his media and mock the solemnities of painting and photo-history. The taxing and toxic daguerreotype process inspired some of Chuck Close's most mesmerizing portraits (see Chapter 2), while its chemical vagaries, which can produce vaporous hues, and its mirror replication of detail interest **Mark Kessell** (b. 1956). **Jerry Spagnoli** (b. 1944), who has advised Close and Fuss on their processing, employs daguerreotype plates to portray New York's architectural vistas: his depopulated landmarks are both exquisite and ominously dreamlike.

Jayne Hinds Bidaut (b. 1965) makes tintypes of insect specimens, birds, and animals as if in a Victorian natural history museum, as well as draped nudes in the tradition of mid-19th-century artists' studies. Revealing the hand painting needed to sensitize her metal plates and using period frames, she pays homage to long-dead practitioners while reveling in the vitality of her subjects.

The dialogue with time, life, and death implied in antique processes also informs **John Dugdale**'s (b. 1960) use of cyanotype, the blueprint photography published by Anna Atkins in the 1840s. His adoption of the method has poignant personal reasons: he is losing his sight to AIDS-related illness, and cyanotype is one of the least toxic processes. His plate size monumentalizes the often nude males and homely objects he portrays, while the blue speaks of melancholy and remembrance.

Humblest of all apparatus is the pinhole camera, which requires no lens and is often made by school children. Its intrinsic soft focus attracts **Barbara Ess** (b. 1948), who, like her predecessor with the device, **Ruth Thorne-Thomsen** (b. 1943), uses it to suggest the vagaries of memory and their blend of personal and collective recall of places and history.

All these artists defy the mechanical uniformity of popular photography and enjoy their unique mastery of handwork. Risking preciousness, they embrace the chance effects and even the dangers of some old methods, and together address the question of time in photography. "A standard photograph is an instant captured," Spagnoli said, "but a daguerreotype is an eternal return."

"ATTRACTED TO LIGHT I," 2000-2003, BY DOUG AND MIKE STARN, 10 X 23.5-FT., IS TEA-STAINED AND TONED, AND PRINTED ON THAI MULBERRY PAPER.

THE POLAROID SYSTEM
IMAGES WHILE YOU WAIT

E ven those who have never owned a Polaroid instant camera have very likely been touched by the genius of its creator, Edwin H. Land. Anyone who has ever attached a polarizing filter to a camera lens or worn a pair of polarizing sunglasses can thank the American physicist and inventor. That's because before Land marketed his innovative camera, he patented a new type of polarizing material that could be used to reduce glare and reflection in a variety of products.

When Land entered Harvard University in 1926, he became intrigued with the study of polarized light rays that vibrate in a single plane, typical of many nonmetallic surfaces. Land dropped out of school to pursue the research, and within two years he had invented a polarizing filter consisting of a grid of lines created from tiny crystals of iodoquinine sulphate embedded in a sheet of clear plastic. Forming his own company, Land was soon manufacturing a variety of articles utilizing this technology. In 1937, his company became known as the Polaroid Corporation. Following World War II—during which time the company made night-

vision goggles, infrared filters, and other equipment for the military— Land came up with his most successful invention, the Polaroid Land Camera, an instant photography system that went on the market in November 1948.

The key to the Polaroid system was the diffusion-transfer process, a one-step method of converting negative images to positive, invented in Europe in 1939. The Polaroid camera contained a roll of dual-layer photo paper—one layer of a light-sensitive silver halide negative film and a second layer of unsensitized positive material. A sealed compartment at one end of this "sandwich" contained developing chemicals. After exposure, the dual-layer print passed through a pair of pressure rollers as it was pulled from the camera. The rollers evenly spread the chemicals between the two layers of paper, immediately developing the silver halide negative. After about a minute of contact between the developed negative and the positive paper, the silver halide from the unexposed areas of the negative diffused into the unsensitized sheet, resulting in a positive image. The negative and positive layers were

then peeled apart, the negative discarded, and a supplied clear sealant applied to the surface of the positive to help preserve it.

The first Polaroid prints were sepia-colored, and they were relatively small, at 3 1⁄4 x 4 1⁄4 in. Black-and-white film followed in 1950. In 1958, the size of the prints was increased to 4 x 5 in. Two advances in the Polaroid system were announced in 1963, film pack cameras and color film. By that year, five million Polaroid cameras had already been sold. Even renowned photographers such as Ansel Adams were exploring applications for Polaroid technology.

In 1972, the original wet, peel-apart developing process was replaced with a self-contained process called SX-70, which could be developed in broad daylight. This technical achievement cost the Polaroid Corporation three-quarters of a billion dollars, but it proved to be a good investment. With none of the timing, peeling, or waste materials associated with the old-style prints, Polaroid cameras soared in popularity. Within two years of the introduction of SX-70 cameras, the company estimated that a billion

prints a year were being made. Building on the success of the SX-70 system, Polaroid continued to market an array of new camera models, such as the inexpensive plastic One-Step. Improvements in film, including the 600 and Spectra series, resulted in even more new cameras being introduced.

Over the years, Polaroid cameras became a fixture at birthday parties, weddings, and other social events. Professional photographers used the peel-apart version as test shots to help gauge composition and lighting. Fine art photographers created striking images by transferring Polaroid dyes to paper or fabric. Many artists have explored the possibilities of Polaroid photography, including Joyce Neimanas, who created collages made of dozens of Polaroid prints, and Lucas Samaras, who produced fantastical images by manipulating prints with a stylus while they were still developing. By the early 1990s, the demand for instant cameras was being steadily eroded by the increasing popularity of digital technology. Like Polaroids, digital cameras afford instant images, but without the need for film. Digital pictures had another advantage over Polaroid photos in that multiple prints could be made from a digital image. From the beginning, each Polaroid instant print has been one of a kind, similar in that regard to a daguerreotype.

ANSEL ADAMS SERVED AS A CONSULTANT TO THE POLAROID CORPORATION FOR MANY YEARS.

FASHION & ADVERTISING

The goal of fashion and advertising photography—to sell as many products to as many people as possible—is simple. The means aren't. Appropriating aspects of high art, photojournalism, film, and sometimes literature, images of couture and commodities have dangled guilty pleasures before daydreaming viewers throughout their history—glimpses of privileged or exotic worlds whose entrance fees pretend to be the purchase of a style of suit, lip gloss, or car. As they openly or covertly play on sex appeal, snobbery, and related insecurities and curiosities, are such images taken seriously? Absolutely.

For over half a century, popular media critics of "the hidden persuaders" have thrived alongside fashion and advertising photographers (not to speak of directors of TV commercials). And since the 1970s the shock tactics increasingly used in clothing ads and fringe lifestyle magazines to penetrate the information overload have raised public outcries when they have escaped regulation by government communications agencies. The industries largely reliant on such photographs for their sales—from jeans manufacturers to glossy periodicals—represent high-profit, international, late-capitalist consumerism, and their images reflect and shape viewers' deepest desires and fears, as well as their spending.

Perhaps because the clothing and cosmetics industries generally target elite consumers and traffic in such absorbing but undefinable, ever-changing concepts as "beauty" and "high style," they seem to have commissioned more inventive photographs than have other product manufacturers over the history of photography. Furthermore, a product or service can be sold as easily with a slogan as a picture—Pepsi "the Uncola," "Avis Tries Harder"—while fashion and beauty copy is secondary to the photograph. An advertising photograph need not be an innovative *photograph* to be effective; an effective fashion photograph most often is innovative. Nevertheless, the two kinds of commercial expression are covered chronologically here,

AN IMAGE FROM JEAN FRANÇOIS CARLY'S SERIES, "LES ENFANTS TÉRRIBLES," SHOT FOR *EXIT* MAGAZINE, EXEMPLIFIES THE "REALISM PERIOD" IN FASHION PHOTOGRAPHY.

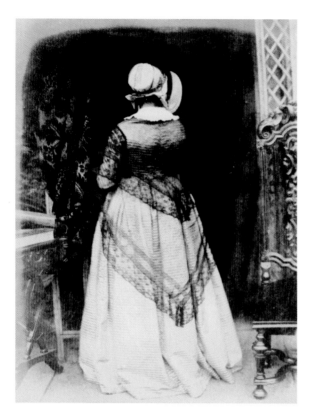

CURRENT FASHIONS APPEAR IN SOCIETY
PORTRAITS LIKE THIS OF LADY MARY RUTHVEN
BY HILL & ADAMSON IN 1845, WHICH
FLATTERS HER DRESS.

Nature, 1844-46. In an era when hats were one way to distinguish the baroness from the banker's wife, his typology was useful, and it touted the milliner's invention as well as photography's advantages over earlier fashion illustration. For their part, the portraitists Hill and Adamson pictured Lady Mary Ruthven full-length and from behind in circa 1845, complimenting her choice of translucent lace shawl. Their tribute to the lady, otherwise unrecognizable except for her dress, suggests they saw the parallels between period fashions and photography in their capture of light and lapidary patterns. When Disdéri's *cartes-de-visite,* or calling-card portraits (see p. 72), became popular in the early 1850s, their sitters used the whole-figure format to show off their clothes and jewelry. Some *cartes* were apparently made as pocket-sized advertisements for tailors and couturiers.

Most remarkable of all these demonstrations of the symbiosis of fashion and representation is an album of 288 photographs of the Countess de Castiglione, which she commissioned around 1860 from the portrait firm of Mayer Brothers and Pierson. Every albumen print, some of them hand-tinted, shows her swanning in her sumptuous wardrobe, proving why Paris was the world's capital of dressmaking arts. The album also suggests the recognition by the mistress of Napoleon III that fashion could be self-expression and "an integral part of her renowned beauty"—in the words of the pioneering fashion-photography scholar Nancy Hall-Duncan.

Certainly the power of depicted display was known in the 16th and 17th centuries, if portraits of Medici princes by Agnolo Bronzino, Louis XIV by Hyacinthe Rigaud, and Charles I of England by Anthony van Dyck are any indication. In the ostentatious culture of 19th-century France, portrait painters from Jean-Auguste-Dominique Ingres to Franz Xavier Winterhalter lavished new attention on the garb of their noble and upwardly mobile sitters and so added to what philosopher Guy Debord called that period's "society of the spectacle."

Fashion illustrators—and then the photographers imitating them—could do no less than ape important painting. In the late 19th century, the Maison Reutlinger of Paris was the most active among photography studios in producing fashion photographs. Of socialites and models generally set against paint-

sometimes together, more often in adjacent sections. For they draw on the same cultural sources, require similar collaborations (among product designers, photographers, models, art directors, copywriters, editors, and publishers), and satisfy similar material and psychic needs.

EARLY FASHION PHOTOGRAPHS

"A fashion photograph is a news photograph about the way we look and the way we live," wrote fashion editor Polly Devlin. Her comment sums up how informative such images can be, even the earliest ones. Delight in dress and its almost infinite variety radiates from William Henry Fox Talbot's calotype of rows of bonnets, which he published in *The Pencil of*

ed backdrops, these heavily retouched images were as stiff as the corseted fashions of the 1880s and '90s. They were copied as engravings to let couturiers keep track of their inventory and reproduced in fashion magazines, such as *Godey's Ladies' Book*, *Penrose's Pictorial Annual*, and *Les Modes*. These periodicals built upon writings advising courtiers on proper manners and dress in the High Renaissance and in the first fashion journals, born in the ornate French court of the late 1690s. In highly fluid modern society, such magazines flourished for an aspiring upper middle class as guides to etiquette and changing fashions, which themselves were ever more important markers of social status.

When the halftone plate, patented in Germany in 1882, allowed reproduced photographs to appear side-by-side with printed text in journals and books, it marked a revolution—for coverage of couture, as well as news, feature stories, sports,

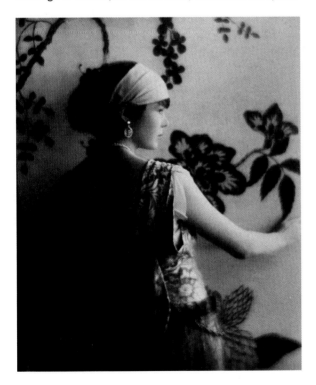

CONSIDERED THE FIRST FASHION PHOTOGRAPHER, ADOLPHE DE MEYER WAS HIRED BY CONDÉ NAST TO TAKE PICTURES FOR *VOGUE* IN 1913.

and the like. Photographs, always trusted as objective, mechanical evidence, proliferated in print media; but their documentary value in describing fashion was soon eclipsed by their poetic power to evoke its alluring effect. In 1892, *La Mode Pratique* became one of the earliest journals to use halftones regularly. A year later the first photograph on a *Vogue* cover showed a cameo-like profile of the pretty young Countess Divonne. Beauty, rank, youth, and chic would be the standards for fashion photographs for the next half-century.

Vogue was a society journal aimed at New York's "four hundred," the elite who could fit into Mrs. William Astor's ballroom in the gilded 1890s. When Thomas Condé Nast bought the magazine in 1909, he built on its exclusivity and refocused it on fashion. In partnership with editor Edna Woolman (later Chase), he made *Vogue* an international couture and celebrity magazine, with knowing up-to-the minute cultural commentary and high design and production values, including ravishing photographs. "He didn't want a big circulation; he wanted a good one," Chase recalled. "He wanted a paper that would be authoritative in matters of taste, or dress, or whatever it dealt with" Condé Nast's formula was so successful that he launched a British *Vogue* in 1916, a French edition in 1920, and an Italian one in 1950. The publisher shared his success with his photographers and profited from their fame: the first one was **Baron Adolphe de Meyer** (1868-1946).

De Meyer epitomizes the photographer-as-aristocrat, no matter how illusory were his claims to blue blood. Indeed, de Meyer's birthplace and upbringing (in Paris or Germany) and his family name (Meyer or Meyer Watson) were kept obscure with his connivance, while the descent of his aristocratic wife, Donna Olga Alberta Carraciola, made for favorable gossip: the godchild of King Edward VII, she was rumored to be his illegitimate daughter. All this, and de Meyer had talent, too. After studying painting in Paris and exhibiting his art photographs there and in New York, Brussels, and London, he had moved to the British capital in 1895, and then married Olga. Soon he was elected to both the august Royal Photographic Society and the Pictorialist group called The Linked Ring (see p. 242-3). He began calling himself Baron at the time; and in 1901 he was knighted so that he and Olga could attend Edward VII's

coronation. His soft-focus style of photography and poetic, Whistlerian still lifes and figure studies charmed his aristocratic circle; and by 1903 he was corresponding with Alfred Stieglitz, leader of the American Pictorialists, and vacationing with Gertrude Käsebier at the society spa of Newport, Rhode Island. That year he bought a specialty lens, which produced images with a relatively sharp-focus center and softer periphery: the device enriched his repertory of impressionistic effects, which ranged from jiggling the camera during exposure, to misting the lens with water or shooting through silk gauze—all to defy photography's "vulgar" documentary verism. In 1907 he exhibited at Stieglitz's "291" gallery, and in 1908 an entire issue of *Camera Work* was devoted to him.

In 1910 de Meyer was included in the apotheosis of Pictorialism, the survey exhibition of the group that Stieglitz organized in Buffalo. But then Edward VII died, ending the artist's royal patronage. De Meyer's 1912 platinum prints of the dancer Nijinsky in costume for his sensational performance in *L'Après midi d'un faune* for Diaghilev's Ballets Russes were his last important art photographs. His German blood and Saxon title had become liabilities in England as the Great War threatened, and in 1913 the de Meyers emigrated to New York. Condé Nast promptly hired him as chief photographer of *Vogue*, where he reigned extravagantly until 1923, when publisher William Randolph Hearst hired him away for the rival fashion magazine *Harper's Bazaar*.

For both American publishers, de Meyer's social connections, flawless taste, and flattering style proved invaluable: in an era when professional models were still slightly *declassé* and aristocratic patronage could make or break a couturier, he persuaded society's arbiters to pose for him and turned them into ethereal beauties. His backlighting haloed their hair and graceful poses, as well as the lavish sets he decorated with huge bouquets, Chinese screens, and filmy draperies. Though his style was old-fashioned in art photography after World War I and had faded out of painting with the *fin-de-siècle*, it was ideal for fashion. De Meyer successfully traded facts for fantasies, sacrificing the data of cut and handicraft for the aura of fairy-tale charm that a fashion photograph—if not fashion itself—can create. He and Condé

Nast may have been the first to see fashion photography as a theater of dreams.

EARLY ADVERTISING PHOTOGRAPHS

Victorian bonnets and glassware: if William Henry Fox Talbot could be called the first fashion photographer for the hats, he may also be called the first advertising photographer for the glassware, since he pasted his photograph of rows of glistening glasses into *The Pencil of Nature*, demonstrating the power of photography to describe products. Subsequent kinds of photographs were explicitly used for sales purposes, especially stereo cards with their illusion of the third dimension. An 1858 writer advised traveling salesmen to carry stereos rather than heavy samples: "'as nature never told a lie,' and never can, a *photograph* of any article *carries conviction with it*."

Certainly, the photograph's truth to appearances brought it into what may be the first American photo-advertisement, the War Office's 1865 "Wanted" poster picturing Abraham Lincoln's assassins. The poster, issued a scant two weeks after the shooting, had images based on *cartes-de-visite* of John Wilkes Booth and his co-conspirators.

Advertising photographs were usually more humdrum, however. In the late 19th century, they looked as frozen and fussily detailed as the fashion photographs of the Maison Reutlinger, and they too did not thrive until the halftone process made them economical additions to news and magazine printing. At first they appeared in pattern books and trade albums, as well as posters: their chief goal was to inform, and later to promote.

In Isaiah W. Taber's *View Album and Business Guide of San Francisco, Photographically Illustrated*, circa 1884, for example, city firms from ironworks to printers got a page each, with a photograph, a business card, and additional illustrations in lithographs. Taber served as cameraman, art director, and copywriter, concludes photography curator Robert A. Sobieszek. He may have been paid by the businesses to

SOCIETY MATRON MRS. CONDÉ NAST POSED FOR DE MEYER IN 1925 IN ONE OF THE FIRST ADVERTORIALS.

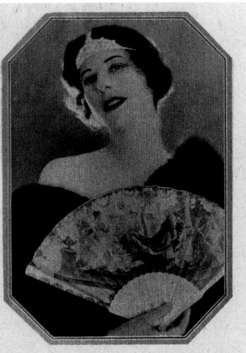

Photo—Baron de Meyer

MRS. CONDÉ NAST

wife of the distinguished publisher of Vogue, Vanity Fair, and House and Garden, is a social leader of exceptional charm. The exquisite taste and smartness of her clothes are matched by the intellectual brilliancy and the fascinating personality of their wearer.

"Women are realizing more and more the necessity of a clear, smooth youthful skin. The very clothes they wear — so chic and simple of line — call for youth in their faces.

"Pond's Two Creams are the foundation of a sure and simple means of caring for the skin, of keeping the complexion in exquisite condition."

Mrs Condé Nast

MRS. CONDÉ NAST
on the importance of being beautiful

IN Mrs. Condé Nast's apartment that morning I sensed the bustle of arrival. Trunks bulked excitingly in the background and Mrs. Nast herself, from the cut of her shoes to her black bengaline frock with its white organdie collar and cuffs—was the chic, the youthfulness of Paris itself. While her line-free, exquisitely cared for skin bespoke youthfulness as eloquently as did her clothes.

"Paris was never so fascinating," Mrs. Nast was saying. "The clothes? Marvelous! So chic and simple of line, so unadorned! But they call for youth in the face as well as in the figure. So the smart woman *must* keep her skin youthful—radiant."

"What did you do for your own skin while you were abroad?" I asked her. "It looks perfect."

"I took plenty of good cold cream along," replied Mrs. Nast. "I positively depended upon it for cleansing Pond's of course."

Then we talked of both the famous creams Society women are using to keep that youthfulness of skin Mrs. Nast finds essential for harmony with the mode.

This is How to Use Them

Once a day at least, and especially after exposure, smooth Pond's Cold Cream liberally over your face and neck. Let its pure oils bring to the surface the powder and dust with which the pores are clogged.

Repeat this process, and finish with a dash of cold water. Let a little cream stay on all night if your skin is inclined to be dry.

For the delicate finish you want by day, smooth in a light film of Pond's Vanishing Cream. It is instantly absorbed, giving your skin such a soft, lustrous finish that now your powder goes on smoother than ever before and clings longer. And you are perfectly protected against winter cold and wind. So before you go out be sure to use Pond's Vanishing Cream. The Pond's Extract Company, 131 Hudson Street, New York City.

Every skin needs these Two Creams

Mrs. REGINALD VANDERBILT
Mrs. GLORIA GOULD BISHOP
Mrs. O. H. P. BELMONT
Mrs. MARSHALL FIELD, Sr.

are among the women of distinguished taste who have expressed approval of Pond's Two Creams.

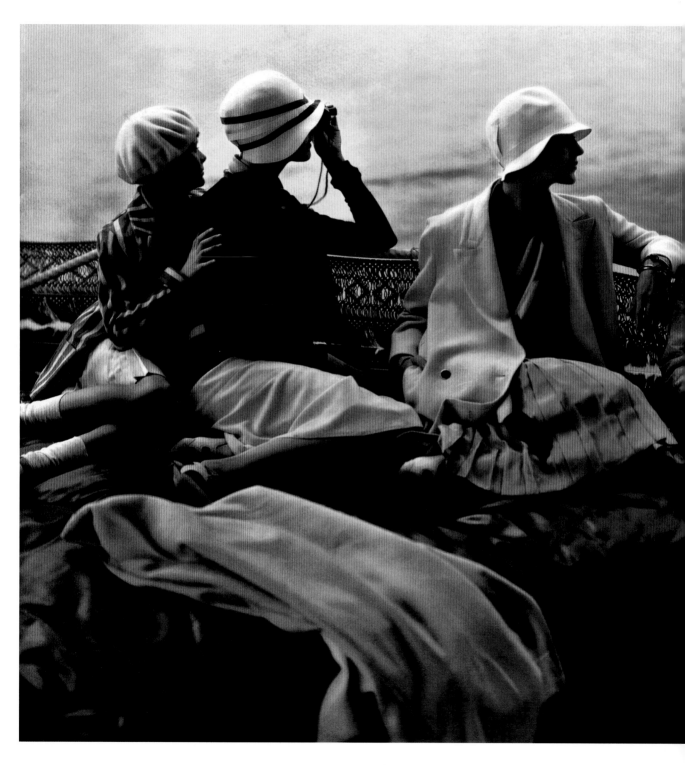

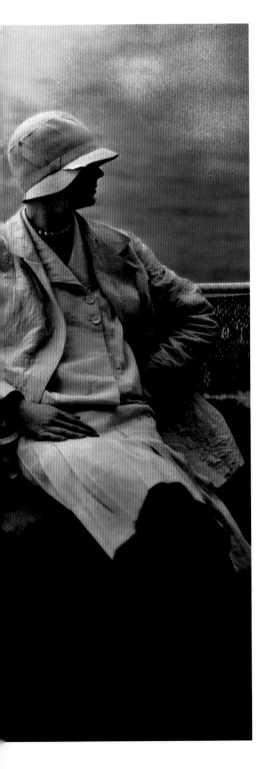

assure his album's wide distribution. "The main object of this work," Taber wrote, "is to so combine art and advertising that some of the many thousands of business men before whom these albums will come in the hotels and mail steamers of America, England, and Australia, will be able to relieve the tedium of travel, inform themselves on the industries and products of California, and gain some idea of, or renew their acquaintance with, its beautiful scenery." The graphic design integrating text and images was central to the album's impact—as it would be in many later advertisements.

By the end of the century, photographs of pretty girls became selling devices, alongside the more common pen-and-wash illustrations of their sisters, and pictures of actresses and anonymous beauties were distributed as premiums in cigarette packs and the like. The celebrity endorsement was photographed, even by the mighty Baron de Meyer. For Pond's cold creams, Mrs. Condé Nast's portrait, her testimonial, and interview—an early advertorial—filled a page in the Sunday *New York Times*. The text described her as the wife of "the distinguished publisher of *Vogue*, *Vanity Fair*, and *House & Garden* [and] a social leader of exceptional charm … exquisite taste … [and] intellectual brilliancy." Her appearance in the *Times* helped promote Condé Nast publications, while Pond's gained upscale distinction. One hand beautifully "cleansed" the other.

De Meyer's Pictorialist blur flattered Mrs. Condé Nast in 1925, but the style was less effective in product advertisements. There the models and setting might be hazy, but the goods were generally in sharper focus. It was not until modernism simplified photography and aggrandized the medium itself that advertising photographs truly became aesthetically satisfying in their own right.

MODERNISM IN FASHION PHOTOGRAPHY

De Meyer survived the death of his lovely wife and muse in 1929 but not that of Pictorialism. In 1932 *Harper's Bazaar* let him go. Fashion and celebrity photographers such as Edward Steichen, George Hoyningen-Huene (1906-1968), Horst (1906-1999), and Cecil Beaton (1904-1980) sometimes used his signature pose—an insouciant hand on hip with the torso leaning back—but they replaced his style with modernism (and aspects of Surrealism). Beginning in the 1920s, Steichen, Huene, and Horst adopted the sharp focus, hard-edged geometries, simplified forms and compositions, and preference for close-ups of Machine Age art photography. They used side lighting (not back lighting) to dramatize the continuous, svelte lines of a new couture of draped cocktail dresses and the sharp silhouettes of big-shouldered suits. In austere sets, on

BETWEEN THE TWO WORLD WARS, EDWARD STEICHEN

WORKED FOR *VOGUE* AND *VANITY FAIR*.

the roof at French *Vogue*, or in Condé Nast's glittering duplex penthouse on Park Avenue, they staged tableaux of icy elegance, mixing chic professional models, "stars of stage and screen," and the assertive wives and daughters of the meritocracy, which powered the rich café society of the interwar period. Male models sometimes appeared as bewitched extras, adding sexual tension to their set pieces. And projected shadows, sometimes of male figures, animated their chic dumb shows while locking the fashion into angular compositions. Accessories were few but luxurious (of course) and occasionally avant-garde, signaling that the fashionable woman could have vanguard tastes. For *Black*, a 1935 story on evening wear, for example, Steichen included a grand piano and an African carving, recalling his early, curator's role with Stieglitz and "291."

Edward Steichen dominated fashion, celebrity, and advertising photography from 1923, when he was made chief photographer for all Condé Nast publications and began taking advertising assignments for the J. Walter Thompson advertising agency, until 1938, when he closed his Manhattan studio. The eye for feminine allure he showed in his 1906 photograph of opening day at the Paris races; the command of personality he mobilized for his prewar portraits of J. P. Morgan, Rodin, Matisse, and others; and the mastery of lighting and technique he achieved with exhaustive still-life studies around 1920—all informed his commercial photographs, which formed a second career for him after the Photo-Secession dissolved and he broke with Stieglitz. For his stylish portraits, in which his self-assured sitters manage to dominate their stark black-and-white sets and dramatic illumination.

Modernism seemed tailor-made for the innovative fashions of the 1920s and '30s, which replaced the abundant detailing and diaphanous frills of prewar styles with clean lines and relaxed fit, suiting the New Woman. These elements crossed over from men's uniforms and sportswear, which appealed to newly health-conscious consumers. For instance, **George Hoyningen-Huene**'s trademark photograph, 1930, shows Izod bathing suits worn by a couple with only light gender differences: she has fashionably bobbed hair; he is Horst P. Horst, the photographer's assistant, who would begin his own career

in fashion photography in 1932. Gazing out to "sea" (*Vogue*'s roof parapet), the two resemble high divers, admired athletes in a period fascinated by such Olympic sports.

Huene, a genuine baron who fled the Russian Revolution, had studied painting, sketched fashion, and acted as a movie extra, before he joined French *Vogue* in 1925. There he first designed photographers' backdrops and learned camera technique, becoming chief photographer for the magazine by the end of the decade. In addition to his careful, often off-center compositions and ingenious lighting, he was known for revering Greek antiquity: he posed models in flowing drapery in imitation of Hellenic reliefs and combined them with plasters of classical statues and busts. Steichen may have originated the lofty device in fashion photography, but manikins and antique heads appeared in both Surrealist and classicizing art of the time. Huene was mythologizing couture while playing with illogical relations of scale and with "reality" versus artifice in an artificial world—*and* showing he was culturally au courant. His studio photography was "a cross between stagecraft, interior decoration, ballet and society portrait painting done by camera," said Dr. Mehemed F. Agha, art director for Condé Nast.

In 1935 Huene left French *Vogue* for *Harper's Bazaar* and relocated to New York; after World War II he moved to Hollywood where he taught photography and was color consultant to films by director George Cukor. Fashion photography now bored him (and indeed the war irrevocably altered fashion itself and its narrow social world). Honoring the sources of beauty as he saw them, Huene published books of his travel photographs from Greece, Egypt, and Mexico in the late 1940s.

Horst took over from Huene at French *Vogue*, where he became known by just one name, and he continued using his mentor's lighting to sculpt forms and his Greek props. The German-born youth had studied design and architecture under Walter Gropius and Le Corbusier; and in the late 1930s he openly appropriated Surrealist devices and fetishized the figure and hands when he was not teasing the eye with the

AS HEAD PHOTOGRAPHER FOR *VOGUE*'S PARIS
STUDIO, HORST P. HORST ARTFULLY POSED AND
LIT A MAINBOCHER CORSET IN 1939.

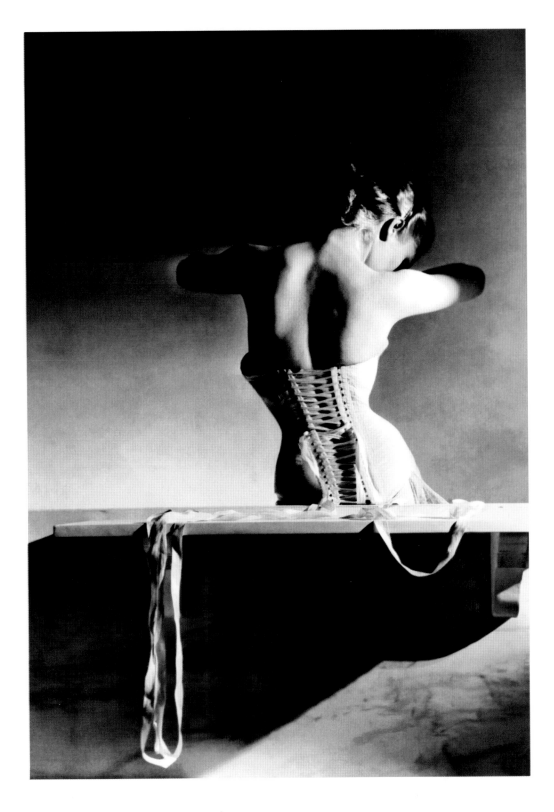

trompe-l'oeil of photographs within his photographs. In his best-known image, *Mainbocher Corset*, 1939, he posed his model like a dying-swan ballerina, shot her from the rear, and contrasted the tight lacing of her isolated torso with the corset ribbon dangling in the viewer's space. The model seems to be on a pedestal—summing up fashion photography's relation to high art as well as the classic view of women.

(As fashion scholar Paul Jobling points out, Horst's photograph apparently helped inspire the singer Madonna's video called *Vogue*, directed David Fincher, and a fashion story by photographer Mario Sorrenti for *The Face* magazine in 1990— although Sorrenti may refer only to *Vogue*'s appropriation. Such are the layered allusions of current fashion and celebrity photography.)

Horst escaped to the United States in 1939 on the *Normandie*'s last voyage. He had already been dividing his time between Paris and New York, and he easily transferred his now more elaborate lighting skills to fashion and personality photographs in the United States. A hallmark was his addition of backlighting to silhouette his models and produce novel shapes of background space. Such artifice went out of fashion in magazines of the 1950s and '60s, however, but in 1978, when the retrospective interests of postmodernism were materializing, Horst's career was revived in French *Vogue*.

MODERNISM IN ADVERTISING

The modernist style pioneered in art photography around World War I by Paul Strand, Charles Sheeler, Morton Schamberg, Ralph Steiner, and others, and found in the New Objectivity of the 1920s, translated easily into advertising. The modernists' sharply defined yet simple geometric forms were turned into brand-name goods. Their close-ups, bright lighting, eye for patterns, and graphic arrangements made product photographs eye-catching and easy to remember, especially in the visually overcrowded context of news and magazine pages. Combined with modernized type, which stripped serifs from letterforms, modernist advertising photographs gave advertising a clean and bold look in the 1920s. The photograph's reputation for truth and advances in halftone printing, which better reproduced its details and tonal range, led to its

victory over illustration in many commercial areas. Alongside camera art and medical and scientific photography, advertising photographs were featured at the great 1929 exposition "Film und Foto" in Stuttgart. *Fifo* recognized that advertising photography was a full-fledged genre of camerawork, equal to other kinds of photography in its utility and fully contemporary international expression. For the show's mass audience, advertising was already the most familiar form of photography—a stature it has never lost.

Manufacturers and the young advertising firms of the interwar period commissioned commercial photographs from camera modernists or bought existing photographs and incorporated them into ads. Karl Renger-Patzsch, for example, arranged a bag of coffee and a coffee cup in a diagonal composition for a crisp overhead photograph of 1925, while "The Fork" by André Kertész was used to illustrate an ad for table-

GEORGE HOYNINGEN-HUENE CHOSE THE CHICAGO WORLD'S FAIR AS A BACKDROP FOR HIS PHOTO OF MRS. WILLIAM H. MITCHELL IN 1934.

ware in 1929 (both ads were shown at "Film und Foto"). In 1931 the French photographer **Florence Henri** (1893-1982) used her dazzling skill with mirrors for a Lanvin perfume ad: She substituted the handsomely designed perfume bottle for her typical balls or fruit and simplified her composition to focus on it, but her photograph retains her signature cubistic perceptual play. Whether or not such adventurous photographers were credited in the reproductions, the products gained cachet by their association with vanguard styles.

Among the photographers who shifted easily from personal to commissioned work, **Paul Outerbridge** (1896-1958) was one of the most respected in his day. A sketch artist would probably have shown the detachable Ide collar being put on or worn. In Outerbridge's iconic photograph of 1922 for *Vanity Fair*, however, it rests alone on a checkerboard, and its white curl animates the geometry of the board, which is set on a diagonal with the picture edge, dynamically.

In 1921-22 Outerbridge had studied with Margaret Watkins, advertising professor at the Clarence White School; and he began freelance photography in 1922, soon contributing to *Vogue* and *Bazaar* as well as *Vanity Fair*. After two years in Paris, he returned to work in the New York area in 1929-1943. For advertisers and magazines he photographed products and foodstuffs in increasingly luscious, complex compositions, as well as Hollywood stars and, for his own pleasure, nudes and surrealizing still lifes. His mastery of color served both areas of his work, though magazine reproduction was no match at this time for his rich, fully saturated palette. Photography collectors prize both his advertising and personal work in part because of its lustrous, full-bodied hues, which are relatively permanent thanks to his use of the carbro process, a painstaking dye transfer method.

In advertising photography of the 1920s, radical camera experiments in Russia and at the Bauhaus also proved influential. The startling vantage points from above or below, negative images, photograms, double exposures, and photo-collages of László Moholy-Nagy, El Lissitzky, and Aleksandr Rodchenko were readily adaptable to commercial and propaganda purposes. Here was a new vision of modernity, and its variety of possible applications to advertising was stimulating. In Russia,

revolutionary photographers and designers intended to radicalize graphic communication as part of remaking the world for the worker. For them, photographs and simplified type served "agitation propaganda" or agitprop for the Communist International. "In every military victory, in every economic success, nine-tenths is the result of the skill and power of our agitation," said the poet Vladimir Mayakovsky in 1923. "Advertising is industrial, commercial agitation." The photomontage techniques of John Heartfield, Hannah Höch, and Raoul Hausmann in Germany and of Lissitzky, Rodchenko, Gustav Klucsis, and the Stenberg brothers in Russia were inspiring, apart from their political messages (which not all Westerners could read anyway). Photomontage could deliver more information faster, in the newest form. "We eat fast, we work fast, and our whole lives are spent trying to keep up with the pace makers," an American observer wrote in 1931. "So with photomontage, the flying civilization of today can take one look as it passes—and understand."

In Europe, unlike the United States, little or no stigma attached to designing for commerce. Out of different photographs, August Sander created a tourist advertisement for Cologne city, in the same way that Rodchenko promoted Lenin. Moholy-Nagy produced photo-illustrated ads for an airline, an optical company, fashion magazines, and other publications. Germaine Krull's clients included Citroen and Peugeot automobiles, while Maurice Tabard photographed Dunhill lighters like divine gifts. At the same time, advertising photographers like Foto ringel + pit (former Bauhaus students Ellen Auerbach and Grete Stern) created camerawork of distinction, transcending its commercial origin. Though Communist and capitalist ends clearly diverged, the means these photographers shared were often the same.

Advertising photographs were also integrated into graphic design in fresh ways. **Piet Zwart** (1885-1977), a Dutch architect, graphic and industrial designer from 1919, taught himself to photograph, and from 1924 combined his photographs and photograms in his compositions for print. In his catalogues for industrial manufacturers, such as the NKF cableworks, 1928, he set his pictures of the plant and its products as diagonal graphic elements with ample white space and brief copy. The page layouts

and photographs alone conveyed strength and modernity.

A few photographic elements set in drastic diagonals were also the trademark of **Herbert Matter** (1907-1984), a Swiss designer and photographer of great impact on U.S. graphic arts. In the 1920s he studied painting with Léger and in the early '30s he assisted the great poster artist Cassandre in Paris, while learning type design and camera work. Back in Switzerland in 1932, Matter put his mark on poster design with his work for the Swiss National Tourist Office. For graphic design historian Philip Meggs, he was a pioneer in combining black-and-white photographs with logos, type, and areas of color. In these posters, the huge heads of bronzed athletes contrast with little figures of skiers surprinted on alpine landscapes and bold type bands. Even without figures, his seamless combination of three photographs for the soaring perspective in "All Roads Lead to Switzerland," 1935, is mesmerizing.

Matter emigrated to New York in 1936, where he contributed freelance photography to *Vogue*, *Bazaar*, and *Fortune*. He was on staff at Editions Condé Nast in 1946-57 and taught at Yale University in 1952-76. In his 20-year association with Knoll, beginning in 1946, he designed spirited ads from his photographs of its modernist furniture.

SURREALISM IN INTERWAR FASHION

Modernism was not the only high-art development annexed by interwar fashion photographers. Surrealism, officially announced in 1924 by the movement's leader, the poet André Breton, united an attention-getting throng of artists and literati, all dedicated to exploring Freudian psychoanalysis as a source of new subjects and creative approaches. The illusionistic paintings and the assemblages of Surrealism were a sensation, and fashion photographers gleefully took notes.

Of the prewar fashion photographers at French *Vogue*,

Cecil Beaton quoted the widest range of styles and was the most outré in his invention. He could stage imitations of Winterhalter paintings, mimic the modernist elegance of Steichen and Huene, and rival the surprise of Surrealist artworks, with their juxtapositions of unlikely objects and figures in suspended animation. Beaton's backgrounds of crumpled cellophane, paper, or metal foil caught the light; his sets crammed with white-painted branches, cupids, stuffed birds, and fantastic bric-a-brac evoked prewar society's delight in elaborate masked balls; and his pretty models—actresses or socialites—struck patently artificial poses. His differences from modernist photographers were his strength, he thought. "Whereas Steichen's pictures were taken with an uncompromising frankness of viewpoint, against a plain background, perhaps half-black, half-white," he wrote later, "my sitters were more likely to be somewhat hazily discovered in a bower or grotto of silvery blossom or in some Hades of polka dots." Not surprisingly, Beaton went on to win Oscars for his art direction and costuming for the 1950s Hollywood musicals *My Fair Lady* and *Gigi*, both set in his favorite period, the Edwardian. The films' style of frothy extravagance, extending that of his fashion photographs, explains the quip about the witty Beaton circulated in *Vogue* offices: "his Baroque is worse than his bite."

Born into a wealthy London family and educated at Harrow and Cambridge, Beaton loved photography from childhood, made his lovely sisters dress up for him, and claimed that he got his nanny to develop film in the bathtub. At university, as he wrote later, he realized he was "a terrible, terrible homosexualist"—but this proved a smaller disadvantage in the worlds of art and fashion than elsewhere. In 1928 *Vogue* hired him as a cartoonist and illustrator, and he began freelance fashion photography for *Vogue* and *Harper's Bazaar*. Beaton's Surrealism was intertwined with his Victorian *horror vacui* and his puckish delight in extremes. He set the costliest gowns against backgrounds of bedsprings and eggbeaters, and in 1937 he chose to photograph his daywear models in an unfinished building amid ladders and rubble, like a premonition of the more realistic fashion photographs that he and others, such as Lee Miller, made during World War II. During the war, the British Ministry of Information appointed him an official photographer, to record the fronts in Africa and the Near and Far East.

Around 1950 Beaton became portraitist to the British royal family. In 1972 he was knighted for his cultural accomplishments, which included several entertaining autobiographical books with his illustrations, and designs for the American, English, and French opera, ballet, and stage. Like Horst, he was rediscovered as a photographer in his later years. But Beaton's renaissance occurred in London's 1960s, when designers revived Art Nouveau

CARBRO PRINTS

This nonsilver processs, introduced around 1919, is an extension of carbon printing in its permanence and a move toward dye transfers, the most light-resistant color prints. The first step in carbro printing is to press a gelatin silver-bromide positive against a bichromated gelatin tissue that has been bathed in bleaching agents. The gelatin of the tissue hardens chemically, as the silver of the bromide print is selectively bleached out. After the tissue is separated from the print, it is placed on transfer paper, which picks up the gelatin layer. The soft gelatin is washed away, and the print with its remaining hardened areas is dried.

For three-color carbro prints—in which Outerbridge excelled—the subject is photographed three times, using a red, a green, and a blue filter to produce "separation negatives." Each separation is then laid on a bichromated gelatin tissue, pigmented with the matching red, green, or blue. After the same process of hardening and washing used for monochrome carbro prints, the three transfer tissues are stacked in exact registration to produce one full-color image. Making a single print can take some 80 steps and up to 10 hours.

(This tedious process would evolve in the 1970s and be applied to a range of color photographs, allowing them to enter museum collections, where permanence is of course prized.)

patterns and foppish Edwardian dress and created amusing "mod" pastiches. Beaton's exuberant eclecticism was new all over again.

In 1930s fashion photography, however, there were more serious students of Surrealism than Beaton. Then and later, the Surrealism of photographers such as **Erwin Blumenfeld** (1897-1969) and George Platt Lynes (1907-1955) depended more explicitly than Beaton's on the paintings of Dalí and the photographs of Man Ray, whose forays into fashion from 1922 underwrote his personal work. Blumenfeld, a Berliner who had photographed as a hobby, turned the skill into a profession when his leather-goods business went bankrupt in the 1920s. Darkroom invention especially challenged him and color was his forte. Solarization, which Man Ray had pioneered, combinations of positive and negative images of the same model, sandwiched color transparencies, and bleached negatives, which removed intermediate tones and reduced faces to sketch-like graphics, were a few of his technical manipulations to create startling images. Yet he also took his models outdoors, and for one of his better-known images, of 1939, he had model Lisa Fonssagrives (later Irving Penn's muse and wife) teeter on a ledge of the Eiffel Tower on its 50th anniversary, waving her skirts, flag-like, in the wind. He was rewarded with covers of *Harper's Bazaar*, and he also worked for French *Vogue* and *Votre Beauté*. In 1941 he emigrated to New York and three years later won a lucrative contract from *Vogue*. There he introduced such graphic design surprises as two-page spreads to be read vertically. Advertising campaigns absorbed his later years.

The precise control of lighting, printing, and retouching that **George Platt Lynes** taught himself in his pursuit of portraiture in the 1920s served his fashion photography, which he turned to for a living after his father's death in 1932. This American was a Yale University dropout who settled in Left Bank Paris during its period as "a movable feast," in novelist Ernest Hemingway's phrase. Lynes knew and photographed Gertrude Stein, Jean Cocteau, and neo-romantic painters, and in 1932 he exhibited at New York's Julien Levy Gallery, a cradle of Surrealist art in the United States. With airbrushing and remarkable imagination, he made seamless photographs of mythological figures and fantastic dream images, such as a male nude curled fetus-like on a table supported by male legs. His fashion photography was rarely so disquieting, but it displayed his art-historical knowledge and benefited by his command of striking effects, theatrical illumination, and darkroom techniques. His nude studies and ballet photographs were sensitive homages, especially to the male body. The American magazine *Town & Country*, which relied on society stories more than fashion, first published his photographs, and he also contributed to *Harper's Bazaar* and ran *Vogue*'s Hollywood studio in 1946-48. That he destroyed many of his fashion photographs before his death indicates his low opinion of the genre—an opinion more widespread then than now.

Perhaps the greatest of Surrealist fashion and celebrity photographers was Man Ray, who was the greatest Surrealist camera artist. To support his personal work, he brought fashion photographs and Rayograms, his cameraless experiments, to the couturier Paul Poiret soon after arriving in Paris in 1922. Known for his patronage of advanced arts, Poiret purchased both—which was unusual, since fashion photographers were often paid by the magazines using their work. Man Ray's commercial career thrived from then on. And his indifference to the specifics of couture was no handicap: in this golden age for all kinds of magazines, the cachet of vanguard art and the charm of its novelty were more important than commercial data.

Man Ray's technical experiments invigorated the genre of fashion photography, as well as Surrealism proper, and *Harper's Bazaar* benefited by the dual association in the 1930s. Under editor Carmel Snow and art director Alexey Brodovitch, *Bazaar* then began a sponsorship of inventive photography and graphic design that lasted for over two decades, through their long employment there, 1934-58. In fashion spreads, Man Ray included his own and his friends' work to save money on set designs while promoting their art.

HERBERT MATTER'S AWARD-WINNING POSTER FOR THE SWISS TOURIST OFFICE IN 1932 WAS TRANSLATED INTO MANY LANGUAGES, INCLUDING SERBO-CROATIAN.

So his painting *Observatory Time—The Lovers* (of huge floating lips) entered mass circulation as a fashion background in 1936, as did Oscar Dominguez's velvet-lined wheelbarrow in 1937, carrying a model wearing silver lamé. Most amusingly, Man Ray used his Rayogram technique in 1936 to dramatize the process of sending photographs by radio airwaves. His model is reduced to a white negative shape on a blurred screen suggesting static, while Brodovitch set such copy as "everyone is cutting whoopsy bangs / do not believe that derrieres are flat" in wavy lines. As Freudian observers have pointed out, Man Ray's photographs made his models into "priapic women" through their "empowered silhouettes," and his torsos were fetishized fragments. Both types could be seen as projections of male anxieties, at a time when Englishwomen were exercising their new vote and French noblewomen were significant patrons of both vanguard art and fashion.

SURREALISM AND OTHER CURRENTS IN INTERWAR ADVERTISING

Beautiful as "the chance encounter between an umbrella and a sewing machine on a dissecting table" was Comte de Lautréamont's saying and the Surrealists' favorite simile. Imagine that the three items have brand names in a photograph, and you can see how well Surrealism suited advertising. Such unlikely juxtapositions and dislocations of common, manufactured objects were pioneered in paintings by the *Scuola Metaphysica* artist Giorgio de Chirico around World War I and then popularized by illusionistic Surrealist painters such as Dalí and René Magritte in the 1930s. Their goal was to trigger unexpected associations in the viewer's unconscious and thus undermine the tyranny of the rational waking world and the hold of conventional realism on art. The goal of advertisers was simpler: to catch the consumer's attention. From the late 1920s advertising photographers and illustrators placed their products in unlikely settings, staged them as dreamlike objects of desire, gave them illogical scale, wreathed them in clouds, etc.—often with a sense of humor, for this was the period in which dream analysis had become a parlor game, thanks in part to the Surrealists, and a cigar was more than a cigar.

HERBERT BAYER (B. HAAG, NEAR SALZBURG, AUSTRIA, 1900–D. MONTECITO, CALIFORNIA, 1985)

Bayer's photomontages of 1928-38 demonstrate memorable applications of Surrealist ideas, as well as Bauhaus design, and he made them as personal expression and for clients without significantly distinguishing between them. At the same time, as one of the most influential graduates of the famed Bauhaus school in Germany, he embod-

CECIL BEATON WAS THE COURT PHOTOGRAPHER FOR THE BRITISH ROYAL FAMILY AS WELL AS A STAFF PHOTOGRAPHER FOR *VOGUE*, FOR WHICH HE SHOT THIS IMAGE IN 1948.

ied its media-transcending philosophy: he excelled as a graphic designer, art director, photographer, painter, and arts teacher from the 1930s through the 1970s. True to the school's principles, his work bridged the worlds of commercial and fine arts.

Bayer was first trained in both painting and graphic arts: While apprenticed at age 19 to an artist in Linz, he designed

ERWIN BLUMENFELD'S CONCEPTUAL WORK SHOWS THE INFLUENCE OF DADAISM FROM THE EARLY DAYS OF HIS CAREER IN BERLIN.

letterheads and posters, and the following year he trained in the workshop of an architect at the Darmstadt Artists Colony in Germany. Architect Walter Gropius's vision of the unity of the artist and technology, to be taught at the Bauhaus, attracted Bayer, and he studied at the school's first incarnation, in Weimar, in 1921-23, significantly with the abstract painter Wassily Kandinsky. When the Bauhaus moved to Dessau in 1925, Bayer was appointed director of the typography and graphic design workshop. In this pivotal year, he designed all-lowercase sans-serif signage for the school's new modernist buildings and publications, invented Universal—a simplified

sans-serif type font without capital letters—and began experimenting with a camera. László Moholy-Nagy was a dominating presence in the Dessau arts curriculum, and though photography was not taught then at the Bauhaus, his experiments and interests in diverse photographic uses and in expressions by others inspired the younger man. In camerawork and typography, both men favored strong horizontal and vertical structures rotated diagonally for dynamism. Bayer also excelled in integrating letterforms with his images, playing with spatial illusions.

In 1928 Bayer left the Bauhaus and became art director of *Vogue* magazine in Berlin, and soon thereafter for *Die Neue Linie*, a woman's periodical. In covers for the latter and for other clients, he drew on Moholy-Nagy's's witty use of photomontage but also on Surrealist painting's double vision and dream worlds of irrationally juxtaposed objects: his concealment of the cut edges of his photographs added to his hallucinatory effects.

In 1938 Bayer emigrated to the United States in flight from Hitler, like many of the intellectuals of Europe who were helped to get visas by influential Americans. In the war years he worked in a Manhattan advertising agency and designed exhibitions for the Museum of Modern Art, including the photographic display, "Road to Victory," curated by Edward Steichen, and, with Gropius, a history of the Bauhaus in 1919-1928. In 1946, Bayer relocated to Aspen, Colorado, where the director of the Container Corporation of America, Walter Paepcke, was turning the resort into a summer think-tank. Bayer was a consultant for Aspen and for Paepcke's company, where he supervised its idealistic advertising campaign, "Great Ideas of Western Man," illustrating its quotations from philosophers and statesmen with vanguard art. From 1956 to 1965 Bayer chaired the company's department of design; and from 1966 until his death, he was a design consultant for the Atlantic Richfield Company.

Though Bayer's art was first exhibited in 1929, and he was given retrospectives in 1947, 1956, and 1962, his photo-collages and photographs were not singled out for display until 1973, in Germany. A retrospective of his photographic work circulated to 12 U.S. cities in 1977-78, marking his recognition in this area.

HERBERT BAYER SKETCHED A COVER IDEA FOR *HARPER'S BAZAAR* IN 1943.

ACTION ENTERS FASHION

In fashion photography, the demand for novelty has always been fiercer than in advertising: the seasonal changes of fashions for an elite clientele compared to the high costs of retooling mass-produced products made it so. In the 1930s fashion's pressure for change was heightened by the longstanding rivalry between Condé Nast's *Vogue* and Hearst's *Harper's Bazaar*. It heated up in 1932 when Carmel Snow was hired away from *Vogue* and in 1934 made editor-in-chief of *Bazaar*. She and her new art director, Alexey Brodovitch, saw the impossibility of beating the arty modernists at *Vogue* at their own game: Steichen's photographic formula of fastidious set design, Hollywood lighting, and haughty models was followed by Horst, Huene, and Beaton (though with personal variants). Further invention on the theme of mannered elegance

seemed impossible. So the *Bazaar* team adopted the startling Surrealist fashion photography of Man Ray and Blumenfeld, among others. But this was not their most radical innovation. Small-camera photojournalism, they recognized, had revolutionized the look of the weekly picture press. Fashion, after all, was news. In 1933, when Snow hired Martin Munkacsi, a sports photojournalist who had never shot couture, they boldly redefined fashion photography.

Snow remembered the moment. For the "Palm Beach" issue of 1933, they were shooting swimwear in February on Long Island Sound. "The day was cold, unpleasant, and dull—not at all auspicious for a 'glamorous resort' picture. Munkacsi hadn't a word of English, and … [he] began making wild gestures. '*What does Munkacsi want us to do?*' [The model Lucille Brokow] was blue with cold. It seemed that what Munkacsi wanted was for the model to *run toward him*. Such a 'pose' had never been attempted before for fashion (even 'sailing' features were posed in a studio on a fake boat), but Lucille was game, and so was I. The resulting picture, of a typical American girl *in action*, with her cape billowing out behind her, made photographic history." Cropped and blurred like his 1920s snapshots of athletes, Munkacsi's image broke ground for a new kind of lifestyle fashion photograph. Its message was that fashion was fun. The joie-de-vivre of young women in spirited movement was novel then and remains appealing even now. Snow put Munkacsi under contract in 1934, and his spontaneous, democratic vision of youth and beauty would remain a counterbalance to obviously posed, studio fashion photography to the present. Both Henri Cartier-Bresson and Richard Avedon acknowledged his example.

MARTIN MUNKACSI (B. KOLOZSVAR [CLUJ], ROMANIA, 1896–D. NEW YORK, NEW YORK, 1963)

As a youth Munkacsi attended several schools, was apprenticed to a house painter, and began work at a daily sports paper in Budapest, Hungary, at age 18. After his snapshot of men fighting was used as court evidence in 1923, he decided to become a news photographer. His quick eye and skill with the new 35mm cameras made him a high-paid photojournal-

ist, and in 1927 he signed a three-year contract with Ullstein Press, the magazine publishing giant based in Berlin. *Die Dame, Berliner Illustrierte Zeitung (BIZ), Photographie,* and *Studio* (London) were among his clients. When Hitler's National Socialist Party came to power in 1933, he prudently sailed for the United States.

The 1930s was Munkacsi's decade. In addition to filling regular assignments for *Bazaar*, he worked for *Town & Country, Good Housekeeping,* and *Pictorial Review,* and he photographed the series "How America Lives" for the *Ladies' Home Journal.* For fashion shoots, he used dynamic Constructivist compositions and Surrealist effects, in addition to photojournalistic action. In the studio, he photographed celebrities against seamless backdrops in split-second action, connecting the modern dance photography of 1920s Berlin with Avedon's high-energy work of the 1960s. In 1940 Munkacsi boasted that he was the world's highest paid photographer, earning $100,000 a year.

But Munkacsi's semi-autobiographical book *Fool's Apprentice,* 1945, was well named, for he soon lost his lofty standing, and he died in relative obscurity. Photography experts interested in fashion—Colin Osman, William Ewing, John Esten—discovered him in the late 1970s, and his legacy was kept alive by Avedon. Both photographers innovated by cross-breeding fashion, art experiment, and photojournalism.

Munkacsi was not the first fashion photographer to work outdoors: at the turn into the 20th century, the French firms of Seeberger and Cordonier had portrayed socialites wearing their own elaborate couture at open-air events. And as the fashion historian Martin Harrison points out, the French photographer Jean Moral preceded Munkacsi in location work, showing a model on the Champs-Elysées in 1932. But Munkacsi had high impact through his verve and his context: his stories ran regularly in *Bazaar* through the 1930s and reflected a breezy new

ON ASSIGNMENT FOR *HARPER'S BAZAAR* IN 1933, MARTIN MUNKACSI USED HIS EXPERIENCE AS A SPORTS PHOTOGRAPHER TO CHANGE THE DIRECTION OF FASHION PHOTOGRAPHY.

culture identified with America, in which attractive women dressed fashionably as part of their active lives. This image proved fertile, and understandably it inspired American women photographers before and after World War II. They included **Louise Dahl-Wolfe** (1895-1989); **Toni Frissell** (1907-1988); and **Frances McLaughlin** (later McLaughlin-Gill; b. 1919).

A *Bazaar* photographer from 1936 through 1958, Louise Dahl-Wolfe contributed 86 of their covers, where she showed her control of color and story-telling suggestion. The March 1943 issue started Lauren Bacall's acting career. In this war year, Dahl-Wolfe showed the then-model outside the door of a Red Cross blood donor station, the red of her lipstick, purse, and Red Cross insignia matching in this patriotic plea. Already the photographer was known for her use of natural light and location shoots. After the war, when jet travel made the world smaller, she favored such exotic spots as Morocco and Tunisia where her models relaxed like worldly vacationers.

Dahl-Wolfe had studied color and painting at the California School of Design in 1914; and she was drawn into *Camera Work* by the Pictorialist Anne W. Brigman in 1921. Her experience with location work effectively began in 1927-28 when she traveled in Italy and Morocco with the photographer Consuela Kanaga. Dahl-Wolfe's studies of Smoky Mountain people during the Depression, published in *Vanity Fair* in 1933, opened her New York career.

In the 1940s Toni Frissell also took her models outdoors, and she employed low camera angles, a short lens, and diagonal compositions to elongate and dramatize the body—including a beauty in what may be the first bikini in fashion photographs. For *Vogue* and *Bazaar*, she chose an 8 x 10-in. view camera, as Dahl-Wolfe did, though during the war Condé Nast started allowing the Rolleiflex because it used less film. These women preferred the greater resolution of their large-format sheet film to lighter equipment, however, indicating that gender did not affect their technical decisions. In the 1950s Frissell's interest in photographing action led her to abandon fashion for photojournalism, and she filed assignments for *Life*, *Look*, and *Sports Illustrated* on subjects like foxhunts (which she shot from a helicopter) and life at the King Ranch in Texas.

LOUISE DAHL-WOLFE PIONEERED THE USE OF NATURAL LIGHT, AS SEEN IN HER CAREFULLY CONSTRUCTED IMAGE, "JAPANESE BATH," 1954.

Educated as a painter, Frances McLaughlin-Gill graduated in 1944 with a BFA in art and design from Pratt Institute in Brooklyn, New York. Then she won a *Vogue* Prix de Paris for her photography and joined Condé Nast after that year in its Paris offices. Condé Nast's art director Alexander Liberman urged her to try 35mm photography outdoors, which she did. The results, he said warmly, "bordered on improvisational theater." The photographer also applied her talents to still lifes, which husband Eric Gill also pursued (in exquisite color), and portraits of actors.

Munkacsi's example in catching fashion in action also encouraged three male photographers, who infused their fash-

ion work with the spontaneity and realism of on-location work. They were the Briton **Norman Parkinson** (1913-1990); the American **John Rawlings** (1912-1970); and the German **Herman Landshoff** (1905-1986). "My women went shopping, drove cars, had children, kicked the dog," said Norman Parkinson, speaking of his prewar photographs. Evidently readers wanted more down-to-earth images to identify with, even before the war made ostentation seem tasteless. Parkinson joined the British edition of *Bazaar* in 1935 as a stand-in for Munkacsi; and he too broke out of the studio and learned how to exploit natural light and natural settings. His career continued at *Vogue*, which he joined in 1941, and in 1960-64 at *Queen*, where he was a contributing editor of this society-oriented magazine, founded in 1957. Like Dahl-Wolfe after the war, he mastered color and combined fashion and travel in his interests.

John Rawlings chose a small camera for his earliest work, which led to a job at Condé Nast in 1936 and a subsequent assignment to direct the studio at British *Vogue*. Though he restricted himself to sets for his prewar fashion photography, his models acted with casual allure. Back in New York in 1945, he opened his own studio and adopted the natural light, locations, and sunny models especially favored by the American magazines. Through the 1960s he contributed to American *Vogue* and took advertising commissions.

Connecting the work of Munkacsi and Avedon, Herman Landshoff drew directly on photojournalism, as the older Hungarian had. Landshoff studied design; and at the news magazine *Münchner Illustrierte Presse* (*MIP*), where he was a layout artist circa 1919, he learned camera technique. The Bauhaus discipline of his design experience and the humor of feature photo-reportage translated into his fashion photographs (including one of a model with a zoo elephant), made for French *Vogue* and *Femina* in 1935-38 in Paris. As an immigrant to New York in 1941, he first worked for Brodovitch at *Bazaar*, then at *Junior Bazaar*, 1945-46, and later at *Mademoiselle*. (The latter, newer magazines, stressing ready-to-wear for younger readers, then allowed experiment more easily than *Bazaar* or *Vogue*, since the demands of tradition and advertisers were lighter.) With Landshoff's help in the darkroom, Brodovitch designed and published *Ballet* in 1945, a book of his photographs that the German called a declaration of independence from photography's "sterile needle-sharpness." The experience led Landshoff to add motion to his own work, and he made what may be the earliest blurred-background shots in fashion, by panning as his sportswear models flew by on bicycles and roller skates. They were in focus while their landscape turned into expressive streaks of light.

FASHION PHOTOGRAPHY AT MID-CENTURY

The aesthetics of the photographers just discussed—from Dahl-Wolfe to Landshoff—were shaped by the postwar demand for more realism and psychology in fashion and the expansion of photojournalism, which partly motivated that demand. During the war, lavish sets were unaffordable, and Paris couturiers and their *beau monde* clients assumed low profiles in occupied France. Important photographers—and cultural leaders of all sorts—escaped to England and the United States. In America, Landshoff, Horst, and Blumenfeld joined the earlier émigrés Huene, Anton Bruehl (a fine photographer in color and advertising), and Lisette Model, among others, as well as the art directors Brodovitch and Liberman. This shift of creative capital to the United States coincided with the rise of Seventh Avenue, with its Paris knockoffs and informal ready-to-wear. Though Christian Dior's luxurious "New Look" of 1947 reasserted the power and inventiveness of French fashion, the most inventive photographers and magazines using them were now New York–based.

Much of the influence of the glossy fashion magazines came from their powerful art directors. In encouraging the cross-fertilization of photojournalism, art, and fashion photography and having *Bazaar* and *Vogue* report the latest cultural developments, Brodovitch and Liberman gave fashion journalism new vitality and importance at mid-century. The *Vogue* reader, Liberman said, should have up-to-date closets but, more important, an up-to-date mind.

Alexey Brodovitch (1898-1971) called himself a "creative can opener" and exerted influence through both his own bold

graphics and blurred and tilted photographs and his "Design Laboratory," a course he began at the New School for Social Research in 1941 (formally titled "Art Applied to Graphic Journalism, Advertising, Design and Fashion."). For over 20 years, he inspired art directors and photographers with his dynamic, documentary-style concepts for layouts and photo-illustrations, in which drastic contrasts of focus and vantage point, long shots and close-ups, and white space and grainy, full-bleed photographs, made magazines resemble film clips by the Russian director Sergei Eisenstein. Brodovitch was a White Russian who had come to Paris in 1920 and won medals for his designs at the 1925 Paris World's Fair. In 1930 he emigrated to the United States when he was invited to found a department of advertising design in Philadelphia, at the Pennsylvania Museum School of Industrial Art. Irving Penn studied under him there in 1935. At *Bazaar* Brodovitch hired Ted Croner, Louis Faurer, and Robert Frank, among others, for fashion assignments, and he helped create a taste for their personal work by illustrating photographs by the older generation of small-camera artists, such as Henri Cartier-Bresson, Brassaï, Bill Brandt and Lisette Model. Brodovitch's example and teaching were crucial to both the fashion and "street" photographers who appeared in the 1950s. He retired from *Bazaar* in 1958, succeeded by Henry Wolf (1958-61), and then Marvin Israel (1961-63).

Alexander Liberman (1912-1999) was also a White Russian whose design skills were recognized by French magazines between the wars. Whereas Brodovitch did layouts for the art journal *Cahiers d'Art* in the 1920s, Liberman was art director of the vital news and cultural magazine *Vu* and then its managing editor in 1933-36. From this predecessor of *Life* magazine, Liberman went to French *Vogue* where he succeeded the art director Dr. Agha. His New York career began at American *Vogue* in 1943, and in 1962 he became editorial director for all Condé Nast publications. He had originally studied painting with the Cubist André Lhote (as had Cartier-Bresson) and architecture with Auguste Perret, and he pursued monumental abstract painting and sheet-steel sculpture, which were well received in the 1960s, alongside his long career in fashion. That his best-known photographers were

Irving Penn and William Klein—aesthetic opposites—attests to his wide yet discerning tastes.

But it was not so much Penn as Brodovitch's protégé Richard Avedon who dominated fashion photography in the 1950s and '60s. Avedon's statement that "fashion photography must be about something" reflected his zesty story-telling and rapport with models, from his first representation in *Bazaar* in 1945 to his late books commissioned by fashion houses like Versace, in 1998. Yet Penn, Klein, and the best photographers at mid-century could have said the same, for the "something" fashion photography was about could be distinctive, even idiosyncratic camera style, or sociological reflection, or both. The clothes were not enough—though for the best photographers they never had been.

In 1957 **Richard Avedon**'s effervescent years at *Harper's Bazaar* inspired *Funny Face*, in which the fashion photographer "Dick Avery" was played by Fred Astaire and his favorite model by Audrey Hepburn. Avedon's career, amazingly, only went uphill from there. From the late 1970s he was sometimes better known than his renowned portrait subjects. (For Avedon's portraits, see p. 91.)

Born in New York City, Avedon began photography as a teenager with his sister as a model, and learned the craft in the U.S. merchant marine; in 1944, the year of his discharge, he enrolled in Brodovitch's "Design Laboratory" at the New School. The brilliant art director of *Bazaar* often repeated to his students Diaghilev's command to Cocteau, "astonish me!" and Avedon responded with the "spontaneous and casual approach" Brodovitch admired, presenting things that "could happen, not things which are obviously posed, obviously artificial," in the designer's words. Avedon became a staff photographer for him and photographed the Paris collections on models at the circus, the roulette wheel, and in action outdoors. Extending Martin Munkacsi's 35mm action photography for *Bazaar*, he showed beautiful women wearing high fashion in exciting, glamorous situations, inviting the viewer to imagine their outcomes. A peak of directorial drama was his spoof of paparazzi photography in a 1962 story in which he had model Suzy Parker and actor-director Mike Nichols play celebrity lovers pursued by the tabloid press. Similarly Avedon

satirized Pop, Op, and psychedelic art as guest editor of a 1965 issue of *Bazaar*.

In the mid-1950s Avedon relocated his models to the studio and shot their exuberant movement against white seamless backgrounds, freezing them in mid-gesture, their hair blown by an unseen fan, or allowing expressive blur. The kinship of this work to some modern dance photography of the 1920s lay in their joint revelation of personality and feeling through action, as well as their vivid silhouetting of flying figures. The seamless "isolates people from their environment," he said; "they become in a sense symbolic of themselves."

When Avedon joined *Vogue* in 1966, his openly sexy models helped magazine sales. For *Bazaar* he photographed the first bare-breasted woman for a woman's magazine. She was Countess Christina Paolozzi, whose title made her nudity both more acceptable and more shocking. Sexuality, latent in almost all fashion photographs, became an overt subject in Avedon's work from the mid-'60s on. In a bathing-suit spread of 1965, he

INSPIRED BY ART AND LITERATURE, MELVIN SOKOLSKY COMBINED MUNDANE ITEMS LIKE A CORSET AND AN AIRPLANE CABLE TO ACHIEVE THE PRESUMABLY IMPOSSIBLE IN PHOTOGRAPHY.

used sultry models and a Latin male to hint at a *ménage-à-trois*; and in 1975 he had two male bathers and a topless female sell Lanvin perfume—a bottle was tucked into her bikini bottom. These stories, reflecting the sexual revolution of the period, laid the ground for the more confrontational work of Helmut Newton and others in the 1970s.

Avedon's wit remained amusing to most sophisticated viewers, however, and one of his most talked-about advertising campaigns, "The Diors," 1982-83, for Dior luxury product lines, he created a year's sequence of single photographs involving a toothsome model and two New York personalities. The captions, by Doon Arbus, began by introducing "The Wizard, The Mouth, and Oliver. When they were good, they were very, very good, and when they were bad they were gorgeous." The story of their hi-jinks ended with a pregnant bride and two grooms at a wedding attended by a Jacqueline Kennedy Onassis look-alike. Mrs. Onassis sued Dior. This of course led to more talk about the campaign. Dior products had been noticed—even if they were secondary in interest to Avedon's scenes.

Compared to Avedon's handsomely produced work, the fashion photography of **William Klein** was startling for a different reason. His unconventional techniques were radical in fashion—or any photography—preceding by several years Robert Frank's better-known use of graininess, blur, and tilted framing for expression in *The Americans,* 1958. (For Klein's full career, which belongs to "street" photography, pp. 305-6.) Klein, like Frank, used a 35mm camera, but his budget from *Vogue* in his career there of 1955-65 let him add telephoto and wide-angle lenses, flash, and elaborate setups to his equipment. His models took deadpan, tough expressions, exhaling cigarette smoke at the viewer, for example, or striding through city streets among actual pedestrians. What Klein called "the sarcasm in my fashion photographs" was aimed at all the conventions, from seductive smiles to opulent interiors and diamond-bright prints. Klein's example contributed to the cinema verité of David Bailey and Helmut Newton in the 1960s and '70s.

In Irving Penn, Liberman recognized another kind of artist—not an expressionist but a classicist and a painstaking crafts-

man. Penn rivaled Avedon in reputation for his fashion and advertising photography in the 1950s and afterward, and their examples remain touchstones in this field today. But these personifications of the contemplative and active ways of life and art could not be more different.

IRVING PENN (B. PLAINFIELD, NEW JERSEY, 1917)

Art and commerce were twin aspects of Penn's career from age 18, when he enrolled in a four-year program at the Philadelphia Museum of Art and studied graphic design under Brodovitch. On graduation he became an art director for Saks Fifth Avenue department store, but at age 25 he quit to paint in Mexico. A year later, the failed painter became an assistant to Liberman, then art director of *Vogue*. Liberman, who always considered fashion second to his own masterly abstract painting and sculpture, encouraged Penn's ideas for covers, and when the youth had to photograph one of them and Liberman published it in 1943, Penn's career in photography began.

Penn's first significant work was portraiture in black and white. In 1948, when he placed artists and socialites in a sharp corner formed by two stage flats and observed their body language, it was not the last time he would create a telling series from restrictive circumstances. In later portraits, extreme close-ups and strong side lighting dramatized the shapes of his sitters' heads and hands within the frame and the hyper-real textures of skin, hair, and cloth. Also in 1948, while on assignment in Peru, he took time off to photograph ethno-graphic types in a borrowed, old-fashioned studio. Through 1971 he pursued seven such series, from San Francisco hippies to mud-covered New Guinea tribal warriors. Photographed against the same fabric backgrounds, the costume, gestures, and accoutrements of all his subjects could be read as anthropological evidence. At the same time, his beautiful use of existing light and choice of large format linked the series to studio portraits by such masters as Nadar and August Sander. Penn's photographs were anti-fashion on the obvious level of their fringe subject matter, and they also implied, by contrast, that French couture was just another kind of weird, culture-specific adornment.

Penn's fashion photographs of the 1950s were memorable for their graphic rigor and sacrifice of studio accessories. Here glamour came from elegance, which came from formal control, as expressed in the model's hauteur and attenuation and his homage to her exquisitely dressed and groomed silhouette. The model increasingly was Lisa Fonssagrives, and the two of them married. However, as if seeking an antidote to the world she reigned over, Penn photographed the massive forms of a Rubensian nude in 1949-50. His technique was also the polar opposite of that for his fashion photographs: he overprinted, bleached, and redeveloped given prints to stress high contrast and thus accentuate the female's sculptural volumes. These photographs were a private series, not publicly seen for another thirty years.

Distinguishing between his magazine and exhibition photographs, Penn remarked, "A beautiful print is a thing in itself, not just a halfway house on the way to the page." In the 1970s he made lavishly large platinum and palladium prints of urban rubbish such as cast-off clothes and cigarette butts. As paradoxically beautiful reminders of decay and death, like Old Master still lifes, they countered Penn's product photography, where the Olympian perfection of cosmetic jars and tubes promises eternal youth and beauty.

Penn's advertising campaigns for Clinique's cosmetics are as typical of him as Avedon's were for Revlon. For "The Most Unforgettable Women in the World Wear Revlon" series, begun in 1985, Avedon filled his frame with supermodels and young stars, who gaze steamily at the viewer from their voluptuous, richly colorful world of glossy skin and big hair. For Clinique, however, a more expensive, hypo-allergenic line, Penn has made various still lifes of the simply contoured, pastel product packages since the 1970s. In judicious alignments, bathed in a cool light in an undefined space, sometimes splashed with crystalline water, these products evoke visions of perfected health and beauty.

Penn has photographed over 160 covers for *Vogue*; his

"SUZY PARKER AND ROBIN TATERSALL, EVENING DRESS BY GRIFFE, FOLIES BERGÈRE, PARIS, AUGUST, 1957" BY RICHARD AVEDON

"GIRL DRINKING (MARY JANE RUSSELL),
NEW YORK," 1949, BY IRVING PENN

books include *Moments Preserved*, 1960; *Worlds in a Small Room*, 1974; *Passage*, 1991; and *A Notebook at Random*, 2004.

A SKETCH OF U.S. ADVERTISING PHOTOGRAPHS, 1930S-1960S

While applied photography flourished in interwar Europe, freely drawing on artistic sources from Constructivism to Surrealism, U.S. advertising photographers remained tied to

"the reality photograph" and pretty girls to sell almost anything. In New York in 1931, the *Foreign Advertising Photography* exhibition displayed 50 photographers from eight nations, and jurors including *Bazaar*'s art director Dr. Agha and film director D. W. Griffiths gave prizes to Herbert Bayer and Hoyningen-Huene, with honorable mention to Man Ray, Moholy-Nagy, Florence Henri, and Baron de Meyer. The trade journal *Printers' Ink Monthly* also recommended photojournalism as a stylistic source for advertising images. But the Depression quashed adventure among companies, which instead sponsored more realism in advertising.

For Cadillac in 1929, **Anton Bruehl** (1900-1982) had emulated Paul Strand's close-ups of precision machines, and with refined lighting **Grancel Fitz** (1894-1963) had portrayed Chevrolet admirers as socialites at a premiere in 1933. In new advertising in the 1930s, however, the historical recreations of "Surgery through the Ages" by **Lejaren à Hiller** (1880-1969) and the anxious moments in middle-class life photographed like *noir* film stills by **Victor Keppler** (1904-1987) offered sensations to a broader audience—either slightly prurient escape (doctors apparently favored semi-nude patients) or identification with mothers with sick children or flooded basements. Housewives were increasingly pictured in ads and targeted by advertisers, since a survey of 1936 identified women as making close to 70 percent of all consumer purchases.

Advances in color film were a bright spot in the decade, and color with its obvious sales appeal quickly appeared in advertising and fashion photographs. Carbro color prints (see p. 365) were reproduced in magazines from the early 1930s. And in a 1931 address Steichen lent his prestige to the idea of four-color photographs in advertising and editorial reproduction. Color use mushroomed after mid-decade, however, when Eastman Kodak introduced 35mm Kodachrome film (1937) and Agfacolor film was presented by the German firm Agfa Gevaert. These were "fully integrated" films, in which the layers sensitive to red, green, and blue light were sandwiched into one roll or sheet. While the carbro process required photographing a subject three times, through red, green, and blue filters, and then assembling the "separation negatives,"

Kodachrome (and later Ektachrome) and Agfacolor needed only one click of the shutter. Now a color print could be produced not in ten hours but in one.

By 1936 color photography was adopted by the Ford Motor Company for its ads, and color film was used by Margaret Bourke-White and Lejaren à Hiller, a journalistic endorsement. In advertising, like Keppler's "Witnessed Statements" series for Lucky Strike, color added to the realism of "real people in real situations," who were quoted lauding the tobacco. (The prevalence of color in monthly magazines from the 1940s made a black-and-white cover for *Vogue* by Irving Penn a remarkable change. Meanwhile, color's popularity in advertising and amateur use distanced most art photographers until the 1970s: color smelled of commerce.)

During World War II, ads and government posters urging support for the war effort were remarkably similar among the Allies and the Axis: the juxtapositions typical of modernist photo-collages often involved heroic soldiers' heads looming over crowd scenes or views of ruins, surprinted with a simple slogan. Four-color illustrated posters for the U.S. Office of War Information were even simpler. American consumer product advertisers continued to stage middle-class scenes, acknowledging the war with models in Armed Services uniforms and the Minute Man logo with "Buy War Bonds."

After the war, the boom in consumer spending unleashed new creativity in advertising. In the United States, the world's dominant economy, national print advertising expenditures zoomed 515 percent between 1935 and 1960. New agencies sprang up and put a premium on individual expression and novelty. All kinds of visual sources and types were mined, and the prize-winning campaigns united images and copy to convey a single concept of the product. "Think Small" for Volkswagen, 1960, and the series "You Don't Have to be Jewish to Love Levy's (real Jewish rye)" presented factual photographs of the car or an ethnic individual on blank grounds to accent the copy. The concept was all-important, not the photographer's or the designer's particular aesthetics. "If you have a remarkable idea for a photograph, it does not require a genius to click the shutter," wrote agency director David Ogilvy in 1963. "If you haven't got a remarkable idea, not even Irving Penn can save you."

Some art directors' ideas led to gag photographs (George Lois was notorious), but the best advertisements of the time integrated camerawork, copy, and design to convey their subject's selling points concisely and with winning humor.

One of the era's few advertising photographs to reach iconic status apart from its product sold Smirnoff vodka in 1955. **Bert Stern** (b. 1921) shot a full martini glass at eye level in the Egyptian desert and caught in it the inverted triangle of the Great Pyramid at Giza. This mirage-like image had the geometry, symmetry, and minimalism of abstract art, but it clearly evoked "the driest of the dry" cocktails. In its color and exotic setting it resembled Dahl-Wolfe's fashion photographs. The last thing it recalled was the vodka's Russian source in this Cold War period. Stern had successfully shifted attention from the product's origin to its quality.

The self-taught Stern, an art director's assistant at *Look* in 1946-48, opened what would be the first of four studios in 1954. The next year he convinced Smirnoff's American agency that he should travel to another continent for the campaign. "People will remember the ad if they hear I went all the way to Egypt for it," he explained. "On top of that, I think they have an instinct that tells them when something is fake."

In 1959 Stern began photographing fashion for *Vogue*, and before he dropped out of the business in 1971-75, he had *Glamour*, *Life*, Revlon, IBM, and U.S. Steel as clients. His most famous celebrity assignment may be his series on Marilyn Monroe for *Eros* magazine, 1962, designed by Herb Lubalin. Later called "The Last Sitting," Stern's cinematic head shots include images the actress crossed out as unacceptable, the big Xs now looking prophetic of her death.

PART OF THE "SWINGING LONDON" ERA, TERENCE DONOVAN USED THE CITY'S STREETS AS BACKGROUNDS IN HIS ESSAYS, SUCH AS "SECRETS OF AN AGENT," 1961.

FASHION OF THE SWINGING '60S AND SENSATIONAL '70S

In the social and sexual revolution of the 1960s, vanguard and popular cultures invigorated each other; class and behavioral boundaries crumbled; and the new tastemaker was Youth. The fashion magazines rushed to reflect this and to satisfy new young consumers by hiring new young photographers: the social hierarchies enshrined in interwar couture and its glamour photography were no more. This section covers the impor-

tant reportage-style fashion photographers of the '60s—David Bailey, Frank Horvat, Bob Richardson, and the associated Jeanloup Sieff—and the shocking cameramen identified by their sexual themes in the 1970s—Helmut Newton, Guy Bourdin, and Chris von Wangenheim—and the haunted storytellers Deborah Turbeville and Sarah Moon.

"We did a lot of naughty things and had a lot of fun," Helmut Newton put it mildly. In the 1960s, London's so-called "Terrible Three"—**David Bailey** (b. 1938), **Brian Duffy** (b. 1934), and

Terence Donovan (1936-1996)—were working-class kids who first succeeded in fashion photography by drawing in reportage style on their own raffishly exuberant lives. They altered forever the persona of the English fashion photographer: "Before 1960 [he] was somebody tall, thin, and camp," Duffy claimed. "But we three are different: short, fat, and heterosexual." Bailey's 1961-65 liaison with his model, Jean Shrimpton, could be read in his early, documentary-like photographs of her, which forecast the diaristic fashion prints of Corinne Day, Nan Goldin, and others in the 1980s and '90s. Bailey, who loved New Wave French films, gave the gamine model the spontaneous appeal of Jean Seberg in Jean-Luc Godard's *Breathless*, and he showed The Shrimp disheveled in the streets, as far from the studio as possible. The circle of allusions closed when Michelangelo Antonioni directed *Blow-Up*, 1966, a film sensation loosely based on Bailey's persona and career. (More prophetically, the story concerned the ambiguous relation between reality in photographs and reality as such.)

Bailey and Donovan had been hired at *Man About Town* in 1960, along with Don McCullin for feature stories. This men's journal and *Queen* gave new space to cultural coverage as the youthquake shook British society and fashion; and both magazines supported the photographers' gritty, natural-light, journalistic style with their high-contrast printing of "soot and whitewash." But after Bailey made his first trips to New York in 1962, met the artist Andy Warhol, and began contributing to American *Vogue* and *Glamour* (which competed with *Mademoiselle*), he began shooting in the studio against white seamless and simplifying his subjects like Pop icons. Borrowing stylistic elements from Avedon and Penn, he published *David Bailey's Box of Pin-ups* in 1965—square-format, closely cropped portraits of Pop personalities from the Rolling Stones to the British gangster brothers, the Crays.

The photographers who shared Bailey's early snapshot idiom and his affection for lively, unmade-up models included **Frank Horvat** (b.1928) and Bob Richardson (b. 1928). Born in Italy and trained in reportage, Horvat settled in Paris and joined the Black Star agency, known for its photojournalists, in 1956. His fashion career began the following year when William Klein introduced him to *Jardin des Modes*, one of the most adven-

turous fashion magazines in Europe. In 1959 Horvat joined Magnum and in 1961 he began working for *Bazaar*. The tastes of the culture and of the succession of art directors there, from Brodovitch to Henry Wolf to Marvin Israel, had killed off the goddess-model. Now Bailey, Horvat, et al., replaced her with a girlish "bird" or "dolly" who could rock with the camera crew all night and display her romantic despair to the lens the next day.

Like Horvat, **Bob Richardson** admired Neo-Realist and New Wave films, and even subtitled a 1964 series for *Bazaar* "with apologies to Signore Antonioni." When he pictured evening gowns, he humanized his models, as in "Giggling, 1965; and his best-known story, shot in the Greek islands in 1967, had drug scenes that had to be edited, though the published piece kept the riotous atmosphere of models and locals partying. Here fashion photography evoked news coverage of the period's rock concerts, with the air of authenticity that half-light and blurred, uninhibited figures conveyed.

In 1961 Horvat shared his New York studio with the Frenchman **Jeanloup Sieff** (b. 1933), who had also begun as a news photographer. In 1955 Sieff worked for *Elle*, a new magazine for younger readers; in 1961-65 for *Esquire*, *Ladies' Home Journal*, and others; and from 1963 for *Bazaar*, where his brooding dramatizations of fashion were featured by Israel's former assistants, now co-editors-in-chief, Ruth Ansel and Bea Feitler. Like his generation of photographers, Sieff identified himself with a particular young model and photographed her on location, but he adopted the dark printing and spatial distortions of Bill Brandt to stress his subject's soulful beauty.

By the mid-1970s the tenor of glossy magazine photography changed again. Scenes of sex and violence supplanted the effervescent happenings in the earlier hybrids of fashion photography and reportage. The hybridizing of genres continued, but now Helmut Newton (1920-2004) recalled the sinister side of German interwar culture, as in Ludovico Visconti's film *The Damned*; and his fellow German Chris van Wangenheim (1942-1981) and the Frenchman Guy Bourdin (1928-1991) evoked Weegee's screaming tabloid photographs in their uncensored subjects and flash-bombed style. In contemporary culture, bra-burnings and antiwar marches had replaced "love-ins" and folk

IN 1955, BERT STERN BECAME WELL KNOWN WHEN *LIFE* MAGAZINE PRINTED THIS SMIRNOFF AD, IN WHICH HE CAPTURED THE INVERTED REFLECTION OF THE PYRAMID OF CHEOPS IN GIZA IN A MARTINI GLASS.

ballads: these photographers, like their predecessors, were social mirrors.

The cool, statuesque, and sexually practiced women in **Helmut Newton**'s fashion and personal photographs were his most controversial creation. Starring in the vignettes he staged, often of fraught moments heavy with overtones of voyeurism, fetishism, lesbianism, and sado-masochism, his women outraged some feminist viewers and satisfied others. Were these Amazons the objectified victims of male domination or self-reliant, unromantic, "phallic" females in charge of

their own sexuality? Newton's dramas stopped short of pornography, and most took place in European jet-set retreats. The buyers of *Queen*, all the editions of *Vogue*, the German newsweekly *Stern*, and the racy men's magazine *Playboy*, and Newton's books (notably *White Women*, 1975, and the retrospective of his work to 1984, *World without Men*), could enjoy the controversy while playing voyeurs themselves of all this Old World decadence.

Born in Berlin, Newton bought his first camera at age 12, and was 13 when the Nazis came to power, a period memorialized by the play and film *Cabaret*. He apprenticed in the studio of Yvo, known for her elegant fashion photographs, nudes, and portraits of dancers. An émigré to Australia, he was hired by Australian *Vogue* in the 1950s; he worked for British *Vogue* in 1957-58, and settled in Paris in 1962. In 1971 a near-fatal heart attack determined him to deal directly with his obsessions. He had already begun using his commercial assignments to pay for his personal work: for example, the model in a St.-Laurent evening pants suit, for *Vogue*, 1975, gained a nude accomplice in high heels in the print Newton made for himself. Now the themes of sex and power in his 1960s and '70s work became more overt.

Since then, Newton's daring topics have overshadowed appreciation of his artistic skills, which include command of color as well as black and white. In his swimming pool scenes, for instance, his patterns of saturated colors electrify the entire picture space. His black-and-white photographs combine the feel of 1930s *noir* photojournalism with aspects of New Wave films, reflecting his directorial mastery.

Guy Bourdin's storytelling was even more lurid than Newton's: his most notorious photographs imitated police documents of crime scenes, with the *frisson* of garish color and sometimes night light. They composed a brilliant advertising campaign for Charles Jourdan shoes over 22 years, with the shoe of the season usually (but not always) appearing somewhere in the two-page spread, as a clue to some unspecified violence against its woman wearer. This was a campaign for brand-name recognition rather than sales of a particular shoe. Its "secondary selling" through narrative was ground-breaking in advertising.

The misogyny and sense of the grotesque in Bourdin's work

HELMUT NEWTON CREATED FANCIFUL WORLDS IN REAL PLACES TO DISPLAY CLOTHING AND JEWELRY AS IN "FRENCH *VOGUE*, PARIS," 1980.

were probably encouraged by his friend Man Ray, to whom he dedicated the catalogue of his paintings shown in Paris in 1952. Bourdin's fashion photographs first appeared in French *Vogue* in 1955. There he introduced the idea of a chase to animate his scenes. In the 1960s, he added comic-book boxes and black humor to his surrealizing ingredients, darkening the sense of threat. And voyeurism was the theme of his 1976 "Sighs and Whispers" lingerie catalogue for Bloomingdale's department store, in which his young models lolled expectantly in hotel rooms, apparently unaware of the camera and shown, as in films, with the rooms' fourth wall cut away. Such voyeurism in Bourdin's work, and in the suspense films that inspired him,

would reappear in fashion photography in the 1990s, by Philip-Lorca diCorcia and Glen Lutchford, for example.

Chris von Wangenheim's career in fashion photography began in 1967 after he had moved from Germany to New

GUY BOURDIN'S QUIRKY CRIME SCENES AND BOLD COLORS IN HIS WORK FOR CHARLES JOURDAN ADVERTISEMENTS REJUVENATED THE COMPANY IN THE 1970S.

York. First contributing to *Bazaar* and from 1971 to Italian *Vogue*, he chose more explicitly sexual and violent subjects in the 1970s, and exploited flash for its brilliant contrasts and exaggeration of reflections. A model's arm caught in a Doberman's teeth showed Dior jewelry in a 1976 photograph: the eyes of both creatures were light-struck, and she looked capable of strangling the dog. The power of such close views, and possibly of the model-as-dominatrix, led to commissions from male-oriented magazines such as *Playboy*, *Oui*, and

Esquire, and from advertisers including Helena Rubinstein, Clairol, and Revlon. Such risk-taking among competitive beauty products companies in the 1970s, relative to the increasingly conservative American fashion magazines, reflected the manufacturers' greater economic power, as well as their longstanding dependence on advertising with memorable photographs.

Also in the '70s, two women photographers appeared who seemed to respond to the male photographers' blatant style and subtexts. **Deborah Turbeville** (b. 1938) and **Sarah Moon** (b. 1941) revived the Pictorialists' delicacy of mood and technique while they adopted the men's narrative interests in their work from the late 1960s. Their goal was to engage the female viewer in their models' ambiguous romantic situations, in twilit settings rich with allusions. In fantasies without resolution, the clothes—it was hoped—would be noticed as clues and markers of character.

Both women came to fashion photography from inside the business: both began as models, and Turbeville became a fashion editor in 1963 at *Bazaar*, where she was responsible for the "Fashion Independents" section and showed non-models wearing fashion. She began taking photographs as notes on location shoots in Europe, working in color because she could send her film to the drugstore for processing and printing. The oddities of her out-of-focus images of slender, slouching women became purposeful by 1966, when she began selling her photographs to *Essence* (for black women) and *Bazaar*. The languorous cinematography in films by Antonioni and Bernardo Bertolucci impressed her, and flavored her best-known photograph, in *Vogue* in 1975, of five disaffected models in a bathhouse. Were they Auschwitz victims or druggies? In subsequent shoots, some resulting in books, she explored the allusions of decayed historical settings such as Versailles and Venice.

If Turbeville challenged the American ideal of cheerful femininity with her sad reveries, the French-born **Sarah Moon** overturned it in her reworking of fairy tales. Her relation with her models, she said, was "one of complicity," and from 1968 she introduced soft-focus wraiths as personifications of new drooping fashions with a turn-of-the-century silhouette. The title of Moon's retrospective, *Improbable Memories*, 1981 captured the perfume of fancy and nostalgia pervading her work.

This air was heightened by the distressed surfaces of her prints, which looked as aged as the settings they depicted. In 1985, she gave a personal interpretation to girl heroines like Little Red Riding Hood by directing adult models in sequences (not long after Cindy Sherman tackled women in fables), and her most recent gallery exhibition, of 2004, displayed her re-imagining of another children's story, *The Little Match Girl*.

"LIFESTYLE" AND SOCIAL CONCERN IN ADVERTISING FROM THE 1980S

In the gilded 1980s, America's nouveaux riches gave haute couture new visibility. In New York in 1972, Diana Vreeland, the imperious former editor of *Vogue*, had become special consultant to the Metropolitan Museum of Art's Costume Institute, and she made attending the annual benefit party in the latest designs a requirement for society wannabes. America's "Best Dressed" honor roll gained new power, while John Fairchild's "In and Out" lists in *W*, an irreverent spin-off of his industry-news *Women's Wear Daily*, caused fear and trembling among *fashionistas*. The wardrobes of investment bankers' wives made news, whether Paris was dressing them as cancan girls or dominatrix types in vast shoulder pads. At the same time, the gay community became widely vocal at the beginning of activism for AIDS research, and positive depictions of gays and lesbians became more visible, notably in the photographs of Robert Mapplethorpe. Postmodernism was flourishing in all the arts, with stylistic hybrids and ironic quotations and "deconstructions" of older styles and media sources—including fashion; and art and commerce began making new alliances. Cindy Sherman, for example, dressed up in Dorothée Bis styles on that company's commission and parodied fashion photography in a 1984 series, while other art photographers such as Barbara Kruger took commercial assignments intended to display their signature styles. There was plenty to report. But the dependence on advertising of American *Vogue* and magazines with similar circulations meant reportage was timid. Instead, the most creative fashion photography appeared in the ads themselves, in some European fashion magazines, and in the independent lifestyle periodicals that sprang up in the 1980s.

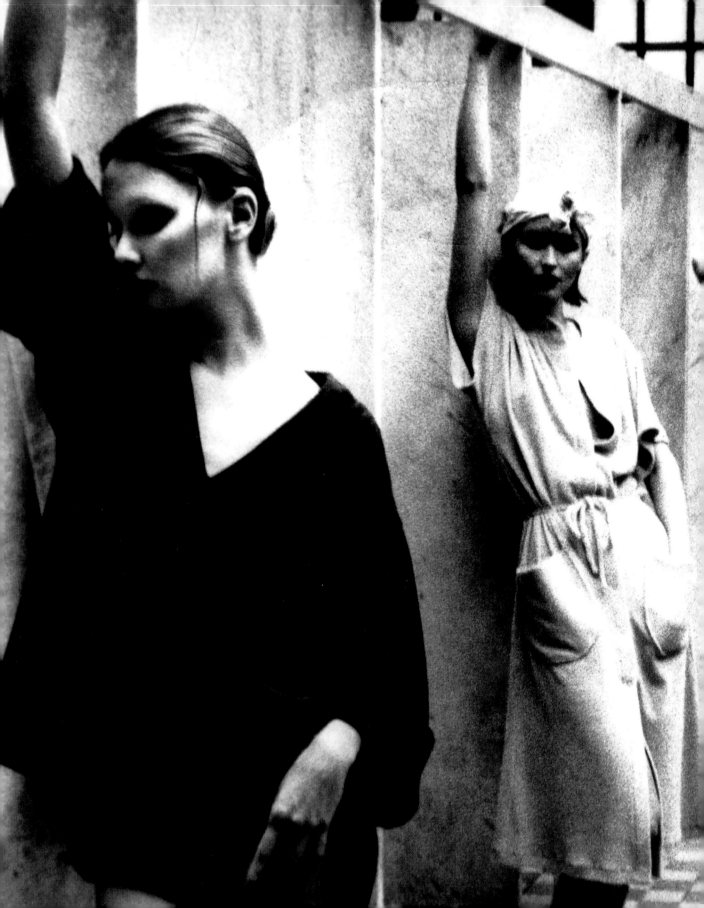

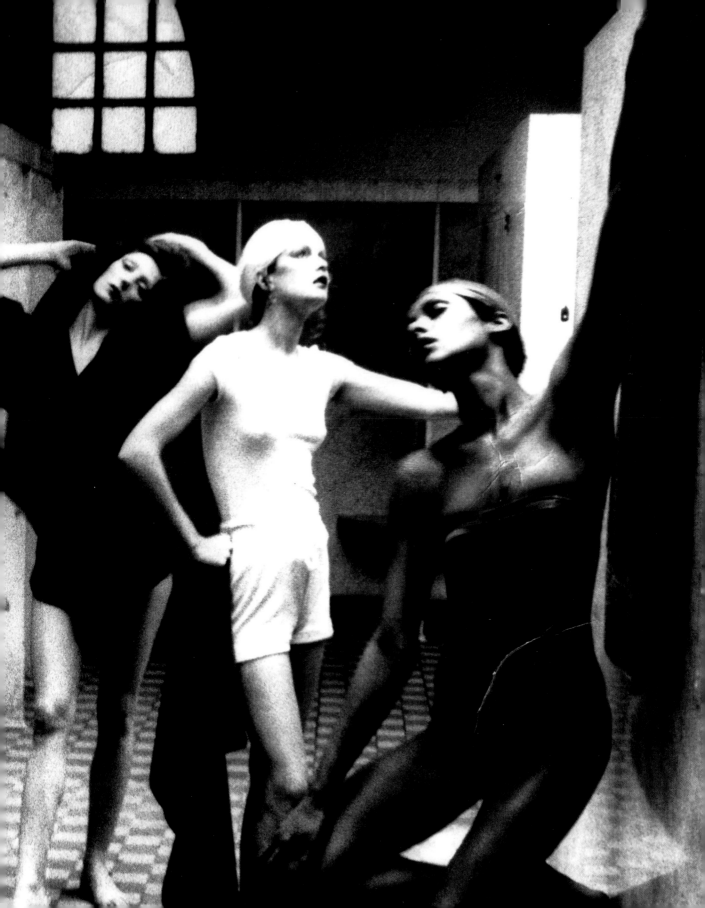

PRECEDING PAGES: DEBORAH TURBEVILLE'S SOFT-
LY FOCUSED ATMOSPHERE WAS EVIDENT IN THE
"BATH HOUSE SERIES" SHOT FOR *VOGUE* IN 1975.

In advertising, Calvin Klein and Ralph Lauren were two appar-el designer-manufacturers who sponsored and introduced important photographers and much-discussed campaigns. From the early 1980s to the present, Klein's ads for his jeans, under-wear, and perfume consistently challenged taboos on represent-ing sexuality. Lauren, on the other hand, exploited American snobbery and nostalgia in his carefully produced lifestyle cam-paigns for his Polo line of women's clothing and menswear. These master marketers found the ideal photographer in **Bruce Weber** (b. 1946), and Klein has also commissioned **Steven Meisel** (b. 1954).

Both Weber and Meisel freely quoted from older sources in photography and film; and they saw little difference between their fashion and personal work, where they showed clothing as part of an attractive way of life. "I just look at the newspaper and sometimes I see amazing fashion photographs," Weber said. "Or I look at a book by August Sander and I see a lot of fashion [there]. I think *National Geographic* has some of the best fashion I've ever seen. It's always people, if they're expressing a lifestyle or wearing something that is very per-sonal. For me, photographs like that bring something to life." Alexander Liberman recognized Weber's originality in 1986: "As clothes grow simpler and less important, the human factor becomes dominant, and there Bruce is unique. In 1978 Weber showed the 12-year-old Brooke Shields wearing men's clothes for *Soho Weekly News*, an offbeat cultural journal for downtown New Yorkers. The same year his photographs for the men's mag-azine *GQ* were new in mainstream publishing for their obvious homage to well-endowed body-building models. The editors then "were really frightened of seeing men's skin," Weber recalled, "pushing up the sleeves was an amazing adventure." A story he shot in Australia for British *Vogue* in 1980 led to Lauren's hiring him: Weber first photographed rugged outdoor styles in ways conjuring up fantasies of the American West. This campaign, tagged "We believe in style, not fashion," identified his WASPy models with the outdoors—a theme that continued even when

Weber shifted his locale to private estates on the Atlantic. Though Lauren's styles changed to rework Ivy League traditions such as the blazer, he was progressive in having Weber include a black male model and older Caucasians in the privileged "social occa-sions" he staged.

For Calvin Klein, controversy was preferable to safe taste, and his campaigns have sexualized successively younger models. In an ad of 1980, the caption has a jeans-clad Brooke Shields claim, "nothing comes between me and my Calvins." In 1995 Steven Meisel's photographs of young teenagers in Klein underwear in cheesy motel rooms so resembled ama-teur child pornography that the campaign had to be pulled. More beautiful but also more profoundly challenging were Weber's series of bronzed nude models of both sexes for Obsession perfume: they recalled Leni Riefenstahl's *Olympiad* photographs of 1936 lauding Hitler's perfect Aryans. Typical of much advertising since the 1980s was Weber's free quotation of a style without concern for its orig-inal meaning. His beautiful males were also somewhat con-troversial: did he "objectify" them, just as women have been turned into objects of the male gaze, and exploit the penis envy of males? Certainly the success of his images of narcis-sistic sunbathers was complimented by parody when a fake ad of 1995 was run in *Adbusters*, a Canadian magazine that critiques media culture. A model wearing "Kline"-labeled jockey shorts pulls them open and looks down with distress, because only his biceps bulge. As the slogan makes plain, this is the real "Obsession for Men."

At the opposite pole from Weber's and Meisel's fantasies of beauty, fitness, and social prestige was the controversial advertising for Benetton clothing conceived by **Olivier Toscani** in the late 1980s and art-directed by **Tibor Kalman**. Like Lauren and Klein fashions, Benetton goods were undistin-guished in design, but had to be distinguished from the com-petition. Toscani's first solution was to stress the bright colors

BRUCE WEBER BROUGHT THE MALE BODY INTO
THE FOREFRONT OF FASHION AND ADVERTISING
PHOTOGRAPHY WITH SUCCESSFUL CAMPAIGNS
FOR VERSACE AND CALVIN KLEIN.

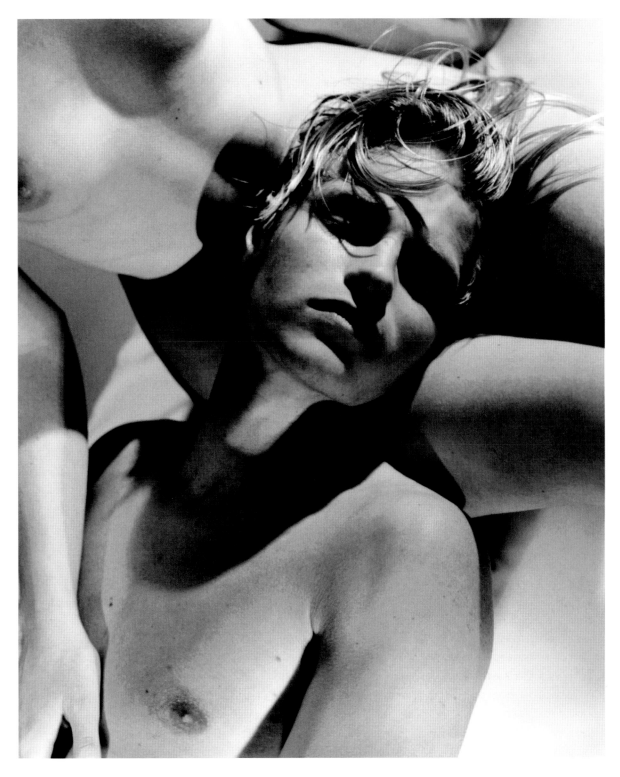

and appeal to youth of the comfortable sportswear. "United Colors of Benetton" showed ethnic models against backgrounds of saturated hues, like Avedon's portraits crossed with those of the art world photographer Neil Winokur. The political correctness of multiculturalism and the charm of the young people gave Benetton an edge in advertising wars with The Gap, Banana Republic, and other mass manufacturers. But when Toscani shifted focus from Benetton products and attempted to identify the international company with social concern in the early 1990s, he sparked debate. Print campaigns and the company magazine, *Colors*, ran photojournalistic images of Haitian refugees, an AIDS victim on his deathbed, and so on, with only the company's logo as identification. You assumed the company was contributing to relief and medical research funds, but critics objected that Benetton was exploiting the sufferers it pictured. When U.S. death-row inmates were given two-page spreads, a portrait facing an interview, the relatives of their victims insisted that they deserved equal space. In one issue of *Colors*, white public figures, like Queen Elizabeth, were made to look black, while people of color were turned white. Some Benetton dealers sued the company on the grounds the ads had decreased their sales.

Toscani replied that "if it's okay to do very powerful, socially concerned songs and sell a lot of records, and it's okay to do movies the same way, then I don't know why only advertising has to stay stupid." He credited his campaigns with enriching the company and gaining it world recognition. "There are a lot of people who, even if they don't agree with what you're saying, will appreciate that you have the courage to say it." His advertising was restricted to print and almost entirely to images, which he considered its strength. "We live in a world of images, we don't live in a world of words … you can use the same picture everywhere, and you don't have to deal with the problem of translation." Toscani left Benetton in 2000, became creative director of *Talk* magazine, and now runs a center for the study of communication arts. During his tenure, Benetton sales had rocketed, then fallen. As advertising critic Warren Berger put it, he raised the question "whether for-profit advertising can ever be an appropriate forum for examining serious issues; do advertisers like Toscani have enough objectivity and moral authority to take on the role of journalist or social commentator?"

INDEPENDENT MAGAZINES FROM THE '80S

Less electric issues than capital punishment and AIDS research inspired the growth of independent, fringe magazines in the 1980s. Their editors felt that the glossy weekly and monthly magazines no longer represented youth. Like the advertising of Calvin Klein and Ralph Lauren, they too purveyed "style, not fashion." Multiplying in London and the United States, some of these periodicals had the life spans of mayflies; others were so successful that they were purchased by publishing giants and eventually sanitized for mass circulation. Such magazines were encouraged by the spread of personal computers and desktop publishing; the boom in the art world, where clothes were seen as cultural codes to decipher and as valid personal expression; and the club scene, with its diverse young musical performers and fans eager for pictures of them. They recognized the men's market, for which Armani, Jean-Paul Gaultier, Lauren, and others were designing; while new magazines were started explicitly for men, to cover clothes as well as punk culture—in new music, art, photography—and to reach straight consumers in their teens and twenties, with cross-over appeal to gays. The editors were young art and design school graduates like some of their readers, not publishing veterans. Their eclectic interests mirrored a polymorphous fashion scene, in which no single designer dominated, whether in couture or ready-to-wear; and young people collaged their clothing out of new-bought, homemade, thrift-shop, and Army-Navy store pieces. "Retro" tastes for genuine antique clothing (encouraged by design revivals since the late 1960s) merged with this bargain-basement creativity, but without romanticism or nostalgia. And no single style or price level typified the mix: the fashion shown was united only by its freedom from haute couture and identification with defiant youth, from skinheads to rockers.

In London in 1980 *The Face* and *i-D* were both founded for readers who identified with the street-type models and musicians hanging out in their photographs. For their lively mix of

HERB RITTS SHOWED THE HUMAN BODY AS
AN ART FORM IN MANY OF HIS PORTRAITS OF
CELEBRITIES AND MODELS, AS IN
"NAOMI CAMPBELL, HOLLYWOOD," 1990.

contents—fashion, photojournalism, cultural comment—the periodicals could draw on English precedents such as *Nova*, founded 1964, and the *Sunday Times Magazine* (London). *The Face*'s art director Phil Bicker and *i-D*'s photographer-editor Nick Knight ran casual-looking, diaristic work from young photographers, who by the 1990s included **Corinne Day** (b. 1965) and such Germans as **Juergen Teller** (b. 1964) and **Wolfgang Tillmans** (b. 1968). Their fashion photography appeared virtually indistinguishable from their personal expression, and both seemed liberated by the color prints of Nan Goldin in her *Ballad of Sexual Dependency* (1986) and the edgy black-and-white portraits by the Boston-born Mark Morrisroe (1959-1989). At *Arena*, founded in 1986 for the "New Man" (the forerunner of

today's "Metrosexual"), the brash graphics of different type-faces by art director Neville Brody, who had also worked at *The Face*, included quotations from John Heartfield's photo-collages of the Weimar years, while some layouts resembled walls of layered and torn posters. Postmodern allusions abounded—in the graphic design and photography in these magazines and in the fashion and cultural news they surveyed.

In all of them, fashion was shown originating on the street, not promulgated by Paris or New York designers. In the first issue of *i-D*, for example, were photographs of youths interviewed on the street about their music tastes and dress, the latter ranging from costly to chain store to secondhand. "Style isn't what but how you wear your clothes. Fashion is the way you walk, talk, dance and prance," the back cover stated. Young Americans quickly adopted punk music and bricolages of dress, as seen in Andy Warhol's *Interview, Punk*, and inserts in New York's radical newspaper, *The Village Voice*.

In the 1990s punk culture merged with "grunge" style, so-called for the less aggressive but more apparently careless dress of fringe youths, including teen runaways, from Seattle to London. In the arts, the "abject body" appeared, while revulsion at it seemed evident in the buzzwords "transparency" and "spirituality" used in fields from business to architecture. As for grunge in fashion, the most notorious expression was Corinne Day's "Underexposed" story of 1993 for British *Vogue*, showing the reed-thin Kate Moss at home in her underwear. She not only looked anorexic but under 16, thus testing the British "Protection of Children Act," which regulates photography of minors. Press controversy raged over the normalization of children as sexual objects and of the eating disorder, and over the apparent exploitation of Moss, who was actually 19 at the time. Ten years later, though, a Tate Modern exhibition hailed the story as initiating "realism" in fashion photography.

In reaction to "heroin chic" (a term later associated with the death by overdose of photographer Davide Sorrenti), *Dazed and Confused* was founded in 1994 by a man named Rankin, a young photographer-art director. He directly revived '60s publishing styles, as seen in *Nova*, and blended careful aesthetics and parody. "We're not just a magazine, but a whole culture," he promised.

Photographers contributing to such magazines included

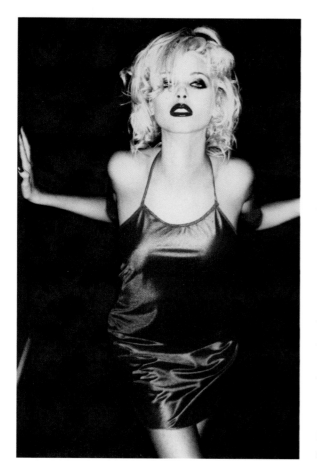

A FORMER MODEL, ELLEN VON UNWERTH
EMPHASIZED PLAYFULNESS AND SEXUAL
INNUENDO IN HER FASHION STORIES.

those with a taste for polished glamour, such as **Nick Knight** (b. 1958), **Mario Testino** (b. 1954), **Ellen von Unwerth** (b. 1954; an admirer of Helmut Newton), and **Inez von Lamsweerde** (b. 1963); those favoring a romanticized, nostalgic view of women, like **Paolo Roversi** (b. 1947); and their grunge colleagues, from the self-taught Day to **Terry Richardson** (b. 1943), son of Bob Richardson (see above), and Juergen Teller.

In the United States, *Visionaire* magazine represented a major alternative to grunge in its limited-edition, deluxe form and cutting-edge art and fashion contents. Founded in 1991 by

Stephen Gan, this "album" has a different theme and format in every issue—"Spring" (its debut, inspired by Irving Penn's *Flowers*), "Black," "Desire," "Movement," etc.—and contains the responses to that theme by fashion personalities, art directors, and photographers, working with the editors. Designer Karl Lagerfeld's photographs of nude celebrities for "The Emperor's New Clothes" came in an artist's box with handle; "Light" was a functioning light box conceived by Tom Ford at Gucci—"the first battery-operated publication"—with transparencies by photographers including Andreas Gursky, Sam Taylor-Wood, and Christopher Bucklow. "Fashion Special," prints by 44 artists, photographers, and "image-makers" interpreting work by 44 fashion designers, had a Louis Vuitton case. *Visionaire*'s hybrid of artist's book and costly corporate promotion was a summary of hip design trends and photography of the 1990s. And it reflected collectors' growing interest in fashion photographs, and in high-concept design in graphics and lifestyle products as well. Copies have become collector's items, and annual subscriptions are priced accordingly: in 2005 four issues cost $675.

FASHION AND ADVERTISING PHOTOGRAPHY TODAY

Some of the gifts of Postmodernism have kept on giving today. That movement in all the visual arts blurred boundaries between media in the 1980s, removing much of the onus from fashion photography as creatively limited work-for-hire.

In America the number of artist photographers taking fashion commissions has grown since that time, as surveyed by photography curators Susan Kismaric and Eva Respini. Nan Goldin's "Russian Baths" lingerie story, 1985, for a *Village Voice* fashion insert liberated others to try fashion (though she later swore off it; see p. 336). In photographing her friends, who included different ages and physical types as well as a very pregnant woman, she was combating, she said, the glossy magazines' ageism and monolithic definition of beauty. Younger art photographers whose full-color tableaux have attracted fashion and advertising work include Tina Barney, Philip-Lorca DiCorcia, Larry Sultan, Gregory Crewdson, and his former student Anna Gaskell.

What makes the marriage between art and commerce? Since Condé Nast hired the Pictorialist de Meyer, commerce has won the cachet of art by employing artists, while the artist has won a good fee and production budget without, ideally, compromising his or her vision or reputation. Crewdson's haunting cinematic scenes of the uncanny, for example, have grown increasingly elaborate, requiring Hollywood-level production teams. Staging a tableau of the cast of HBO's hit TV series "The Sopranos" would have helped pay the bills without falsifying his sense of the sinister lurking in mundane life. In Europe Wolfgang Tillmans supported his personal work through fashion, but distinguished between the two and cut down on assignments when they became repetitive. "I could have made hundreds of thousands of marks if I had accepted all the ad agencies' requests for photographs of 'street-savvy, grungy, over-the-top' characters," he said in 1997.

Meanwhile, there are distinctive poles in important current photography in fashion. They are marked by Tillmans (b. 1968) and **David LaChapelle** (b. 1963), who both gained attention in the 1990s. Born in Hartford, Connecticut, LaChapelle escaped his quiet birthplace to work as a busboy in Studio 54, a riotous dance club in the 1980s, and then in the office of *Interview*. *Details* magazine gave him his first photography assignment, where he was free to fantasize; subsequent magazines have let him "go completely crazy," he says. In pumped-up Pop color, his photographs flaunt his exuberant taste for popular culture and oddball Americans, from comic books and TV's *Star Trek* to Hollywood fans, teen marching bands, and body-builders. Like a cross between Federico Fellini and Martin Parr, he invents energetically for fashion, lifestyle, and advertising commissions, using character actors, models, and eccentric types he has discovered, directing them in scenes but allowing for accidents. In his advertising, the relation between his photograph and the product may be slender, but the ads are memorable and often cheerfully outrageous. For Candie's boots, 1998, for example, he had the bodacious black singer L'il Kim wear the heavy footgear while held aloft by nuns. This sort of photograph has been called "Oddvertising," for it

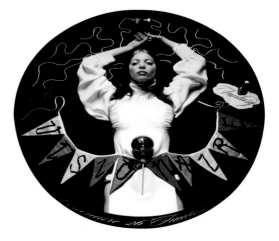

THE THEME OF *VISIONAIRE #26* WAS FANTASY. EACH ARTIST'S WORK WAS LEFT UNBOUND INSIDE A ROUND BOX TOPPED WITH A PHOTOGRAPH BY INEZ VAN LAMSWEERDE AND VINOODH MATADIN.

mischievously denies linear storytelling or description of the product and instead grabs for the media-wise viewer's attention with the twisted quotation and the bizarre or comically shocking scene.

Photographs like LaChapelle's often rely on digital imaging, with its ability to patch together images of diverse origin without showing the seams, to distort or repeat forms easily, to alter color, and to create outlandish spaces. Removing blemishes or pounds from a model in a straight photograph was once done laboriously by a retoucher, wielding an airbrush: for a decade or so, such plastic surgery has been done with computer software. Skills in using programs modeled on Adobe Photoshop, introduced in the early 1990s, are de rigueur in art and design schools. Still in question, though, is whether photographers in real numbers will create original imagery exploiting digital tech-

FOLLOWING PAGES: RAYMOND MEIER EMBRACES DIGITAL TECHNOLOGY TO HELP HIM ACHIEVE HIS IDEAS AS HE CONTINUES TO SHOOT FOR CLIENTS AS DIVERSE AS THE *NEW YORK TIMES MAGAZINE*, PARIS *VOGUE*, AND JIMMY CHOO.

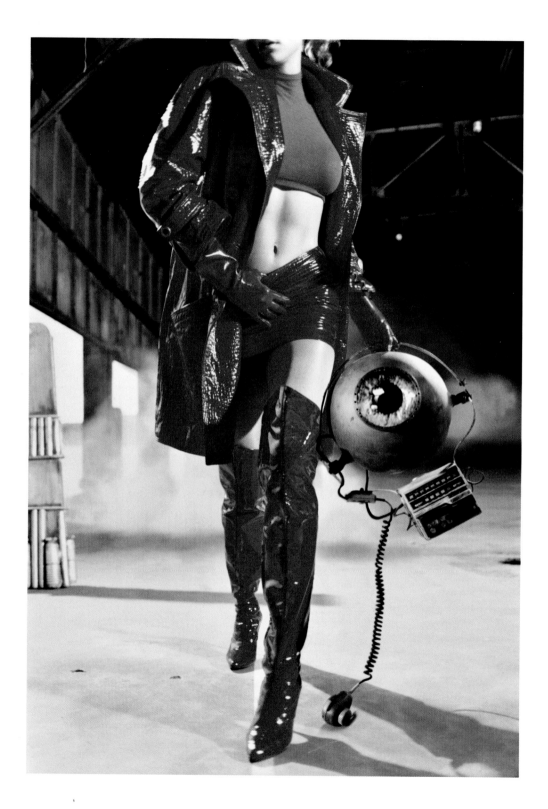

nology's unique capabilities, or whether they will continue using it merely as a shortcut to Surrealist or sci-fi effects. Exuberant photographs by Nick Knight, for example, suggest positive directions.

Yet the look of the snapshot retains its air of authenticity and remains in effective use. It is notable in **Wolfgang Tillmans**'s accretive, elliptical, sometimes lyrical work. His photography is best seen in installations where the different kinds and sizes of prints he makes—views from hotel windows, snaps of people he encounters, portraits of friends in relaxed moments, landscapes from his travels, and fashion commissions—cohere as a display of his peripatetic life. Compared to conventional fashion and portrait photography, his work denies the authority of the single authoritative beauty image or the journalistic "decisive moment." His openness to experience and unassuming style are suggested by the title of his 1996 retrospective "for when I'm weak I'm strong."

Photographers' refusal of distinctions between personal and commissioned work and the migration of fashion photography into galleries helped convince scholars Martin Harrison in 1991 and Val Williams in 1998 that, as she wrote, "fashion photography doesn't really exist." Yet the needs that distinguish fashion from personal photographs still remain. The advertiser needs to sell product; the consumer wants to know how to be "in fashion"; the publisher brings the two together via memorable images and words. American *Vogue*'s editor Anna Wintour admitted the difficulties of channeling individual expression into successful assignments: "We want a photographer to take a dress, make the girl look pretty, give us lots of images to choose from, and not give us any attitude. Photographers—if they are any good—want to create art. An editor's knee-jerk reaction to [an 'artistic' photographer is to fear that the shoot] … will cost a lot; there will be a three-week wait while the photographer edits; and then a single image will be delivered in

LEFT: WITH A MIXTURE OF VIVID HUES, REPORTAGE, AND SURREALISM, DAVID LACHAPELLE CREATES FRESH FASHION ESSAYS.

WOLFGANG TILLMANS'S RAFFISH WORLD EXEMPLIFIED HERE BY "SUZANNE AND LUTZ, WHITE DRESS, ARMY SKIRT," 1993, SEEN AT FIRST ON GALLERY WALLS, WAS APPEALING TO FASHION EDITORS.

which you can't see the clothes …. Yet … it is the combination of clothes and art that makes the memorable photograph we all yearn for. We don't want our magazines to look like catalogues …. The tension between editor and photographer will never disappear."

The high reputation today of LaChapelle in both art and magazine circles suggests that confrontational snapshot-like photographs of fringe lifestyles may have waned in interest. The cycle of taste, which varies between verism and obvious artifice in fashion photography, moves on.

DIGITAL PHOTOGRAPHY
A REVOLUTION IN IMAGERY

If ever a photographic innovation played to the human desire for instant gratification, it would have to be the digital camera. Even for film photographers who use modern one-hour photo processing, there's still a wait before they can see their images. Polaroid prints, the previous standard for instant photo results, require a wait of about three minutes to see the outcome of a shot. But with today's digital cameras, photographers can see the result of their efforts virtually instantaneously.

Admittedly, digital photography took years to catch on, and diehard film advocates remain, but in 2003, for the first time ever, more digital cameras were sold in the United States than film cameras. The reasons for the massive switch to digital are simple: convenience and control. Digital camera users don't have to purchase or carry bulky rolls of film—one reusable memory card can hold hundreds of images. LCD panels on digital cameras enable users to preview and delete bad shots. Once the images are downloaded into a computer, they can be enhanced, cropped, and transmitted electronically over the Internet,

and high-quality prints can be made at home on a digital printer. For the average photographer, digital has become easier to use—and in many ways, more fun to shoot—than film.

Developed by NASA in the

DIGITAL PHOTOGRAPHY IS
FASCINATING AND CONFUSING
SOMETIMES, EVEN TO THE
TOUGHEST CHARACTERS.

1960s, digital cameras were initially used for satellite photography. The technology was soon adapted to military surveillance, medical sci-

ence, archaeology, and many other applications. With the growth in the use of personal computers in the early 1980s, digital photography came within the reach of consumers. Sony announced the first

digital still camera in 1981, and improvements in the quality and ease of use of these cameras followed steadily. Today's higher-end digital cameras can produce picture quality commensurate with that of film cameras. Even professional photographers appreciate the advantages of the digital format,

although the technology raises certain issues. With digital, a professional in the field is newly empowered to edit on the spot, thereby influencing the selection of photographs available to the editor back in the office. In addition, the ability to self-select images means the photographer may hastily delete something that might otherwise grow in value over time.

The basic technology of digital photography is the same as that of a computer: Visual information gathered through the camera lens is converted by light-sensitive microprocessors into binary numerical code and stored electronically. The term for these stored bits of visual information is "pixel," short for "picture elements." The camera's light sensors interpret tone and color and assign each pixel a number. The more pixels a camera can record, the higher the resolution and greater the detail of the image. Another factor in image quality is the power of the camera's processing circuits; more processing power means improved color rendition and less graininess. Like any computer file, the millions of pixels that make up a photographic image can be displayed on a computer screen or printed out on paper.

For periodicals, digital photography has made the technical side of photo storage, transmission, and reproduction considerably more convenient. Thanks to the Internet, photographs taken in Asia or Africa can be printed in a publication in Europe or the United States within hours. "We are jumping into digital imaging with enthusiasm," says Chris Johns, editor of *National Geographic* magazine. But Johns cautions that the standards of photojournalism still need to be honored: "We can't forget this simple truth, 'It is the message, not the medium.' "

For sheer visual creativity, digital systems have ushered in a new era of technical sophistication. Fashion and advertising photography make heavy use of digitally "doctored" images, from the flawless skin of models we see in magazines to the talking animals of television ads or the lifelike scenes we're used to seeing in movies—everything from Luke Skywalker's fighter hurtling through space to the endless armies clashing in Middle Earth.

From a broader perspective, digital photography, with its limitless possibilities for manipulation, has blurred the lines between photographic "reality" and artistic invention. Since the early days of photography, images have been constructed through the creative use of composition, camera angle, lighting, and shutter speed. But when the image is made, that particular moment of reality, however creatively produced, has by and large been captured. With digital photos, on the other hand, tripping the shutter is just the beginning. Even for the amateur photographer, computer manipulation can do anything from removing red-eye or unwanted telephone lines from a scene to plopping a penguin on the shoulder of Aunt Millie.

And therein lies the contradiction of the digital revolution: Digital cameras can be used as a straightforward system of photography or they can be used to create something quite different from the photographic traditions of the past century and a half—artificially generated images that bear little relationship to "reality" and share more characteristics with painting than with conventional photography. This dichotomy has added new pressures on publications. Readers deserve to be able to distinguish between truly documentary photos and those that have been altered. When a photo is color-corrected to make the sky more blue, is that manipulation? Is it misleading when a distracting shadow is removed from an image? Such are the questions that need to be addressed in the digital age.

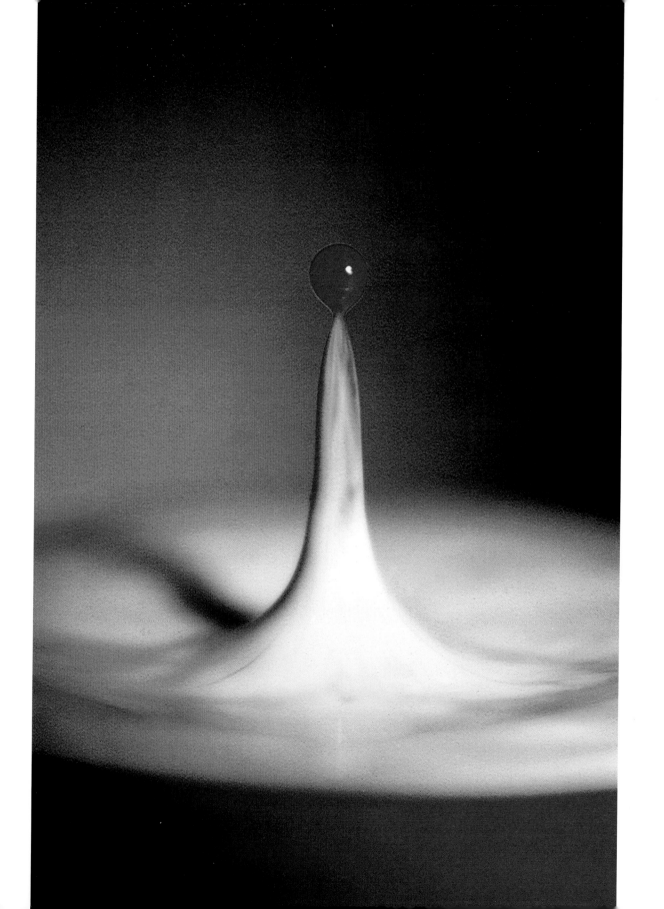

PHOTOGRAPHY & SCIENCE

A galloping horse with legs bunched under it, all hooves off the ground, a live, thumb-sucking fetus in the uterus 15 weeks after conception, a drop of milk making a crown-shaped splash seen at one-millionth of a second, the Earth resembling a child's marble as viewed from the moon: these photographs electrified mass viewers and also advanced scientific knowledge in their time. Even now, after their information is taken for granted, and technical advances have superseded their then-astonishing achievements in image-making, they retain significant power as iconic photographs. And with distance, one can see reflections of their cultures. For science answers questions posed by each era, and with progressively refined, purpose-built tools. Photographers such as Eadweard Muybridge, Lennart Nilsson, Dr. Harold Edgerton, and the team at NASA are among the subjects here, found in their respective places—during late 19th-century industrialization with its need to understand and regulate physical movement, in the baby boom following World War II, and during the space race between the USSR and the United States, which put a man on the moon.

From the beginnings of camerawork, art and photographic inventions have also contributed to the making of indelible scientific photographs. The most compelling of such images have in turn influenced art photographers, especially since the 1920s. And these photographers have adapted science's imaging systems to personal expression or interpreted scientific phenomena and discoveries for lay audiences.

PLANTS AND PLANETS

Picturing the visible world as a means to understand and master it drove much of both science and art in the West from the Renaissance onward. Of course, the need of each to observe had different goals: science sought to extrapolate from particu-

FOR THIS 1978 VARIANT OF HIS FAMOUS FLASH-FROZEN MILK CORONET, HAROLD EDGERTON
ADDED A DROP OF CRANBERRY JUICE.

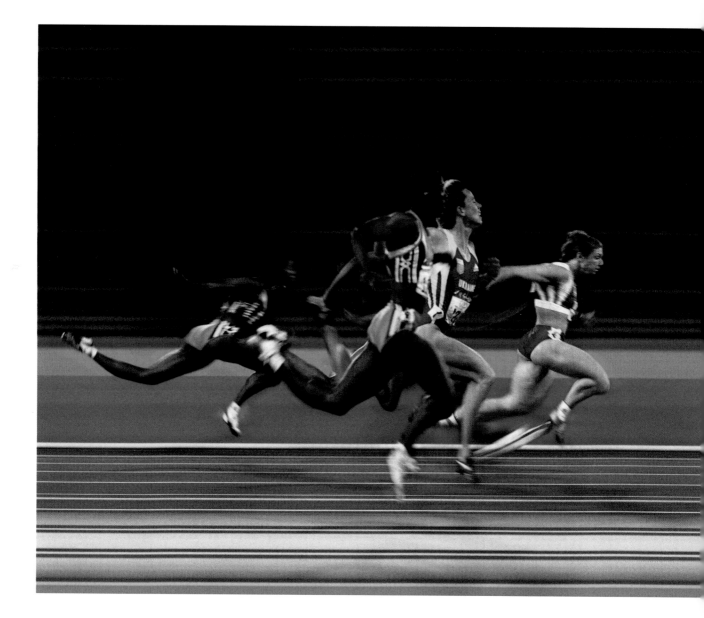

ORIGINALLY USED IN HOLLYWOOD AND IN THE MILI-
TARY, A STRIP CAMERA CAPTURED THIS COLORFUL
PHOTO FINISH BY 100-METER GOLD MEDALIST MARI-
ON JONES DURING THE SYDNEY OLYMPICS IN 2000.

lars the underlying patterns and principles of nature, and art sought beauty, human insight, and imaginative transcendence. But both valued photography for its new realism. Photography offered science a more reliable and sharp-eyed copyist than the human draftsman. And it was born of science, midwifed by inventors in chemistry and optics, many of whom used it interchangeably for documentation and aestheticized evocation. François Arago, French politician and director of the Paris Observatory, heralded the versatility of Daguerre's and Niépce's direct-positive process in convincing the French government to underwrite its publication in 1839. Arago suggested

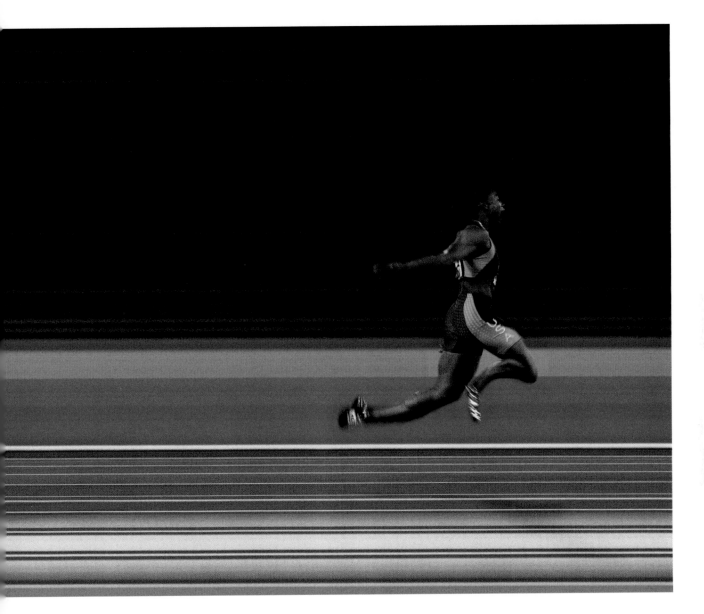

the new invention would eventually depict galaxies millions of light years away and also the origins of life in infinitesimally small life forms. His claim was a logical extension of camera-lens craft, for the lenses of the camera obscura, the microscope, and the telescope were invented in the same milieu, in the 17th century. Photography, in teamwork with these devices, promised to expand vision beyond human limits, map the macrocosm and the microcosm, and unlock the secrets of creation.

Talbot, the gentleman scientist and polymath, described his negative–positive process more modestly. The minute he heard the first announcement of the daguerreotype in Paris, he arranged to have Britain's Royal Institution exhibit some of his 1835 photographs—of flowers, leaves, and lace, and what he called "images formed by the Solar Microscope, viz. a slice of wood highly magnified, exhibiting the pores of two kinds." Later that year he told Sir John Herschel, "I expect to be able to com-

YOUNG EADWEARD MUYBRIDGE

"Muybridge" was one of his five different names, which suggests his several personas: he is famed for his studies of movement, but he was also a gifted landscapist. He first made a living as a book dealer, and he retired in 1900, after motion pictures—which he is credited with inventing—had advanced beyond his primitive mechanism. He dazzled contemporaries: one said the full-bearded British eccentric, who performed nude for some of his motion photographs, looked like "Walt Whitman trying to play King Lear." As a landscape camera artist, he challenged Carleton Watkins as preeminent in Yosemite from 1867 on. More theatrical than Watkins's albumen prints, Muybridge's photographs were larger, at 20 x 24 inches, and they exaggerated the valley's depth and height. To improve a composition, he didn't hesitate to cut down trees. While Watkins described a welcoming Eden, Muybridge's Yosemite was often primal and sublime.

pete with M. Daguerre in drawing with the Solar Microscope, when a few obvious improvements have been adopted." He was wrong: the interference of the fibers in his paper negatives blurred details, whereas daguerreotypes preserved razor-sharp data on their polished silver surfaces. For sheer information and truth to the experience of peering through a microscope, Talbot's 1840 microphotograph of a slice of a horse chestnut trunk was no match for an 1840 daguerreotype of a section of a clematis stem by the Daguerre student **Andreas Ritter von Ettingshausen** (1796-1878)—even though the clematis cells were distorted. The important difference, however, was that Talbot's photograph could be reproduced exactly and cheaply and tipped into books. The Austrian's exquisite picture, like all daguerreotypes, remained one of a kind.

In botanical photography, the laurels go to **Anna Atkins** (1799-1871) for producing one of the first photo-illustrated reference books, *British Algae, Cyanotype Impressions*. A practiced draftsman and a member of the Botanical Society of London (one of the first scientific groups to admit women), Atkins adopted photography because of its accuracy in recording, for she set out to depict some 400 different samples of native seaweeds, creating a full taxonomy of the plant form. Her methods were elemental and labor-intensive: she gathered her specimens, flattened, dried, and contact-printed them on paper she had hand-coated with a chemical mixture discovered by her friend Herschel in 1843, which silhouetted her artfully placed specimens against a deep Prussian blue. She wrote out her text by hand and scrolled strands of seaweed into titles. These pages were, in effect, all negatives, like Talbot's photograms, and over ten years, 1843-53, she made at least 15 prints of each of them for the edition of her specialized book.

At the opposite pole from plant specimens are the moons and eclipses also photographed in the 1850s. Here the camera captured an unearthly realm, literally and figuratively, where spatial reference points were lacking in the black sky, yet light-years and thousands of miles were represented on pieces of metal or paper little more than six by eight inches in size.

Daguerre is credited with making the first photograph of the moon, in 1839, now lost, but a prize-winning version was not produced until circa 1851. This daguerreotype by the Bostonians **John Adams Whipple** (1822-1891) and **George Phillips Bond** (1825-1865) was celebrated in Paris and London and shown at the Great International Exhibition at the Crystal Palace in 1851. Whipple, a daguerrean portraitist, and Bond, an astronomer, used Harvard University's telescope, believed to be the largest in the world then, and they were able to match its movement to the moon's in order to retain the orb's Swiss cheese detail.

William Langenheim (1807-1874) and his brother **Frederick** (1809-1879)

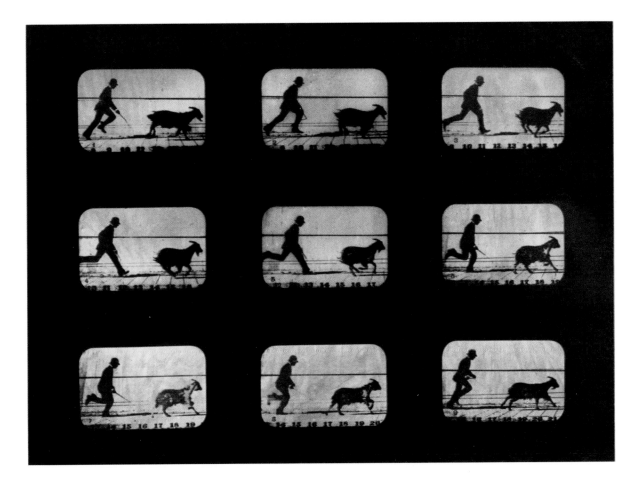

created a daguerreotype sequence of seven views of the solar eclipse of May 26, 1854, using four one-sixth plates and three one-sixteenth plates. The contrast between the physicality of the little jewel-like daguerreotypes, which can be arranged at will, and the ethereality of their subject has the enchantment of white magic.

Even more Surrealist to modern eyes are the lunar photographs by the Scottish engineer **James Nasmyth** (1808-1890) and **James Carpenter** (active 1860s-'70s), an astronomer at England's Royal Observatory in Greenwich. Reproduced as Woodburytypes (the richly detailed, continuous tone process used by John Thomson), the photographs composed their book, *The Moon, Considered as a Planet, a World, and Satellite*, 1874. There they compared images of a wrinkled male hand, a wizened apple, and the moon, proposing that its craters resulted from the same shrinkage with age. They also made plaster models from Nasmyth's astronomical drawings and photographed them under lighting conditions replicating what they saw with the telescope.

LATE 19TH-CENTURY MEDICAL DOCUMENTS

Examples of Victorian camera documents of some medical conditions now mercifully eradicated or controlled include certain birth defects, Siamese twins, large pendulous tumors, and the extremely disfiguring results of diseases such as syphilis, small-

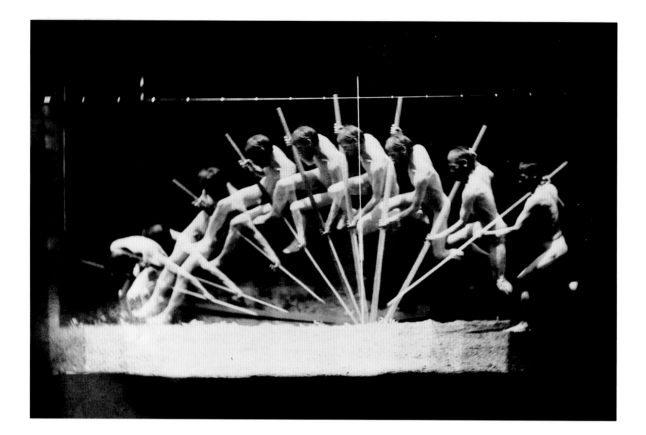

THE GREAT REALIST PAINTER THOMAS EAKINS BUILT ON MAREY'S PHOTOGRAPHIC RESEARCH IN 1885 TO STUDY THE HUMAN ANATOMY IN MOTION.

pox, and leprosy. Whether in a carnival freak show or a Greek myth, a hermaphrodite or a two-headed mammal is an instance of nature gone wrong that shocks the average eye, and the "redeeming social merit" of looking at such examples has been debated since the 19th century, as notions faded of a connection between suffering and sin. Modern taboos regard photographs of gross deformities rather like those of pornography and especially violent crimes. Yet medical history is full of such illustrations, which reveal 19th-century diseases as well as the period's greater tolerance of their outward symptoms. Dr. Stanley B. Burns, the veteran historian of medical photography, observes that as late 19th-century medicine began to distinguish diseases and doctors' specialization resulted, clinical photogra-

phers increasingly concealed patient identities and focused on their diseased parts instead. But such was not the case in the 1850s-1880s. Looking into the lens, subjects displayed their afflictions and wounds in photographs before and after treatment. Were they exploited or benefited by their exposure in headshots and full-length photographs? Or does the photograph of an isolated lesion equate the patient with his or her disease, diminishing the individual?

Such questions concerned mid-19th-century physicians less than improving treatment through photographic documentation—and of course in aggrandizing their profession (as seen, for example, in Southworth and Hawes's daguerreotypes of the early use of ether in operations at Massachusetts General Hospital). By 1849 medical journals were reproducing illustrations based on photographs, and by the late 1850s doctors were sending photographs to out-of-town colleagues for consultation. Medical camerawork served diagnosis, teaching, docu-

mentation of unusual cases, and recording of the disease process and treatment results. During the Civil War all photography flourished, and medical camerawork was commissioned by both sides. There was ample subject matter. (In the burning of Richmond, Virginia, most such Confederate records were lost.) The Army Medical Department could not have known that this would be America's bloodiest war, with over 625,000 dead (one in four combatants) and some 475,000 wounded. But the count would be made after the Union established the Army Medical Museum in 1862 as a registry of specimens of war wounds and diseases, with the goal of improving care. By January 1863 photography was the official means of documenting disease and treatment, and albumen prints were sent to battlefields to aid doctors. In 1865-72 seven volumes of the *Photographic Catalogue of the Army Medical Museum* appeared, each with 50 albumen prints, most of them by the Army photographer **William Bell** (active 1861-1872). From 1870 to 1888 appeared six elephant quarto volumes, with photographs by **Edward J. Ward** of *The Medical and Surgical History of the War of the Rebellion*. This cited every Union casualty with treatment and cause of death, and also wounded survivors. Ward made many of these photographs after the war at pension disability hearings, which could account for the dignity yet pathos of his studio portrayals of the scarred and mutilated men. Certainly they were tributes to the surgical skills learned in field hospitals.

MOTION STUDIES

One of the first steps to understanding movement through photography was taken by a horse named Occident. Artists have always wondered whether running horses ever had all four hooves off the ground at one time, with legs outstretched in a "flying gallop" like carousel mounts or the steeds in ancient Assyrian reliefs. Painters and scientists since Leonardo da Vinci have pondered how birds fly. The camera can be faster than the eye, however, in registering separate images of a moving body, and so it provided the first accurate analyses of birds' flight and human and animal locomotion. The findings by **Eadweard Muybridge** (1830-1904) in 1878-86 and by **Étienne-Jules Marey** (1830-1904) in 1870-80s served science as well as art, and had consequences as varied as improved training for athletes and soldiers, better prosthetic devices for amputees, time-motion studies for more efficient workplaces, the development of airplane design, the foundation of the study of ballistics, and the invention of motion pictures. Partly through artistic adoptions, their images produced a revolution in perceiving time and space.

In 1872 Muybridge was known as a spectacular photographer of Yosemite, but the rich racehorse breeder Leland Stanford hired him to define through photography how horses actually trot and gallop. The challenge, to film and shutter speed, was freezing the horse's legs while in action. Shutters were becoming mechanized, but most exposures were made manually, the photographer popping the lens cap off and on and judging exposure time through practice. Split-second photographs were needed to analyze the horse's movement. Muybridge first rigged 12 cameras along a chute with strings across it at 21-inch intervals. Each camera lens was covered by a board with a hole drilled just above the lens, a board supported by a pin attached to the string. As Occident rushed past, he broke the strings, let the boards fall, and each lens was momentarily opened as the hole passed across it. The horse took its own pictures. Nothing was published, however, and Muybridge's sensational trial for murder in 1874 interrupted his experiments with Stanford.

Work resumed in 1876, after Stanford had heard of Marey's independent graphing of men and horses moving. To get all the phases of the horse's trot and gallop, Muybridge now laid wires across the track, and ran an electric current through them. As the sulky's metal wheels spun over them, they fired the shutters of his battery of cameras, at an astonishing 1/1000th of a second. Later, to analyze the gallop, he had the horse break wires set chest high across the track. In 1878 he published *The Horse in Motion*, proving in 12 sequential silhouettes that, yes, the horse has all its hooves off the ground at once in both gaits, but bunched under it—not in the flying gallop favored in artistic representation. The results were indisputable, but disappointing to some artists. Though Edgar Degas and Thomas Eakins were among those adapting the information for their paintings, the sculptor Auguste Rodin upheld the artist's "higher" expressive truth: "it is the artist who is truthful and it is photography that lies," he trumpeted, "for in reality time does not stop."

By late 1879 Muybridge devised a means of projecting the trotting sequence, probably on the inspiration of Marey's treatise, *Animal Mechanism*, 1874. Adapting the child's spinning toy called a zoetrope, which Marey had already used, Muybridge had his photographs transferred to the circumference of a large glass disc, which rotated as a light beamed through it. Exploiting the fact that the eye cannot distinguish images separately if they rapidly succeed each other), his photographic horse appeared to trot. Because his "Zoöpraxiscope" involved photographs, his brief, soundless performance is considered the first "movie," and he premiered it for Stanford in 1879.

These horse photographs put Muybridge on the lecture circuit, and in 1881 he spoke in Paris (where he met Marey), in 1882 at the Royal Academy in London, and in 1883 across the United States. With the support of the painter **Thomas Eakins** (1844-1916), he spent the next three years at the University of Pennsylvania extending his study of the horse to male and female models and to animals at the zoo, photographing each in movement from three vantage points—in profile, and at 60- and 90-degree angles—and against the same backdrop, often gridded to permit measurement. The results were sequenced to indicate continuous movement (though nearly half the sequences were incomplete), and the results were highly detailed, thanks to the new invention of gelatin dry plates. A man saws wood or hits a baseball, a woman carries water up and down stairs, a spastic and an amputee walk, and so on, in an average of 24 images per plate. The mundane activities performed by the nude models, including Muybridge himself, indicate—somewhat disconcertingly—his practical and sometimes erotic interests and the rise of realism in art, which he and Eakins intended to serve. In 1887 *Animal Locomotion* appeared in 11 volumes of 781 plates, with nearly 20,000 of Muybridge's photographs of 1872-85, priced at $5,000 for the set. The price was high, but Muybridge sold some plates for as little as $1,

ensuring their wide circulation. In 1901 Muybridge published *The Human Figure in Motion*.

The French physiologist Marey preceded Muybridge in studying motion: he tried sketching in 1867, but did not think of photography until 1878 when he saw Muybridge's horses reproduced in the French science magazine *La Nature*. While Muybridge sliced motion into its component parts and sequenced the separate images on his plates, Marey graphed the continuity of movement in diagrammatic form on a *single* plate.

In each synthesizing composite image, Marey measured and conveyed the precise relations in time and space of a given movement—a pigeon flying, a man walking, running, or jumping. As scholar Marta Braun puts it, he produced "a visible expression for the passage of time simultaneously with a picture of a moving object in space."

Marey's first device for this imaging was a "photographic revolver" like the one invented by the astronomer **Pierre-César Jules Janssen** (1824-1907) to photograph the transit of the planet Venus over the sun's face in 1874. In Marey's gun were a lens, two slotted discs serving as shutters (one fixed, one rotating), and a gelatin dry plate (Marey's much faster substitute for Janssen's circular daguerreotype plate). The revolver mechanism ensured that Marey's exposures of 1/720th of a second

took place at regular intervals—something impossible for Muybridge's batteries of cameras fired by his running horse. The model chosen appeared in a sequence of overlapping positions, but the photographs showed too much extraneous detail for Marey. Next, he photographed his model with a conventional camera with the lens left open. In front of it he placed a slotted metal disc that rotated as the model moved, thus exposing the plate to the successive phases of his locomotion. This time he totally sheathed the model in black and marked his joints in white. The result looked like a stick-figure cartoon: it was both an unprecedented photograph and a linear chart of the pure dynamics of movement.

These "chronophotographs," in Marey's term, were his most influential pictures, and they represented a different image system from Muybridge's. The core of the men's differences lay in Marey's view of the body as a thermodynamic, energy-powered machine, whose activities could be quantified and measured like other machines. Muybridge remained a narrative artist, despite the apparent science in his systems, as he told little stories about human figures in action.

Active around the same time as Marey, **Ottomar Anschütz** (1846-1907), a professional photographer in Vienna, moved from the instantaneous photography made possible by the new gelatin dry plates to chronophotography in 1884, achieving 1/1000th of a second exposures. When published, his series of storks flying, landing, and then feeding their offspring enchanted viewers, foretelling the popularity of animal behavior sequences in mass magazines, and also inspired the flier Otto Lilienthal in his early glider designs—whose trial flights Anschütz photographed in turn. The news of Lilienthal's death in a glider mishap prompted the Wright Brothers to review Marey's *Animal Mechanism* for its descriptions of flight and later research by others, and they resumed their own aeronautical experiments. Thus the world's first manned, heavier-than-air, self-propelled flying machine, which Wilbur Wright first flew in December 1903, was connected to the Frenchman and a stork.

In art, Muybridge's and Marey's findings both made their mark. It was the great realist painter Thomas Eakins, then teaching at the University of Pennsylvania, who facilitated Muybridge's research there and advised him to use a gridded backdrop to locate relative body positions. In summer 1884, Eakins, who had already mastered photography to benefit his canvases, worked alongside Muybridge and made chronophotographs with Marey's "photographic revolver," whose design he improved. Eakins's painting "The Fairman Rogers Four-in-Hand," 1879-80, of his patron's fancy carriage and matched horses in a trot, revealed his interest in Muybridge's first findings; his "Swimming Hole," 1884-85, with young men diving and swimming, demon-

READING FACES

To diagnose and compare diseases and increase and systematize knowledge of the human species, photography was seized by mid-19th-century scientists. For *The Expression of Emotion in Man and Animals*, 1872, Charles Darwin (1809-1882) borrowed and commissioned photographs to document the similar appearance of such feelings as anger and pain in adults, babies, and animals. He concluded that some human expressions arise from spontaneous reactions of the nervous system, others are habitual and conscious, and many states of mind are "expressed throughout the world with remarkable uniformity," despite cultural differences. Such studies support the modern idea that no sure reading can be made of a given face, in life or in photographs. The codes of communication are slippery and require supplementary knowledge—a conclusion that undercuts the authority of the single portrait as revelatory and stresses the contingency of facial studies.

strated his eagerness to ground his depictions of movement in photographically verified observations. His camerawork of motion tapered off after 1886, but not before he portrayed the phases of pole vaulting and other athletics, each on a single plate showing the overlapping positions of a nude male athlete in action (p. 408). These gelatin silver photographs of sports excellence are also connected to Marey, who worked with his assistant **Georges Demeny** (1850-1918) from 1880 on improving physical education and teaching gymnastics through chronophotography. The single-plate time-lapse photographs of gymnasts that Demeny published in 1890 are ancestors of the crowd-pleasing, mid-20th-century photographs and films of champion golf swings, tennis strokes, and so forth.

For Marey, the unseen world of physics was as intriguing as animal locomotion, for he believed that the same laws ruled the animate and inanimate. In the late 1880s he made visible the motion of water and air by magnesium-flash photography of a miniature wind tunnel into which he blew multiple streams of smoke. The streams were interrupted by various thin shapes he introduced, and his flash revealed the different eddies the smoke produced. Teardrop shapes produced the fewest. In these modest experiments, streamlined design was born as a means of minimizing the resistance to air or water of vehicles such as planes and ships.

The action at higher velocities interested Austrian physicists including **Ernst Mach** (1838-1916), who with colleagues was able to photograph a flying bullet and its shock waves by 1886. Mach gave his name to the measurement of a projectile's speed as a ratio to the speed of sound in its atmosphere. (Supersonic speeds are higher than "Mach 1.") The photographs by his son Ludwig demonstrated the interlock of mechanical and thermal energies and revolutionized the study of ballistics.

Flash photography, which substituted the speed of light for the mechanical speed of a shutter, was essential to freezing such movement. Using electric sparks, English scientists photographed bullets shattering glass and liquids falling into splashes in the 1890s-1900s. But these explorations of particle physics did not really enter popular consciousness until after 1931 when **Dr. Harold Edgerton** (1903-1990) perfected the electronic flash mechanism he called a stroboscope. The instantly rechargeable

device, filled with mercury vapor and later with xenon gas, stopped action at astonishing speeds —such as a millionth of a second. Edgerton's strobe realized what the Victorian scientist Charles Wheatstone had noted about electricity in 1834, that its spark in a charged Leyden glass jar made a stream of water appear as separate drops and "insects on the wing [as] … fixed in the air." And his flash extended what may be the first flash photograph, Talbot's 1851 image of a printed page spinning on a wheel yet appearing still and legible. Talbot had forecast that "it is in our power to obtain the pictures of all moving objects"—no matter how rapidly moving—as long as sufficient light "with a sudden electric flash" was available. Edgerton's strobe, a contributor to both science and art, is now a standard component of many cameras and camera systems.

An electrical engineer teaching at the Massachusetts Institute of Technology (MIT), Edgerton devoted himself to strobe camerawork from 1934, and he made stop-action photographs as well as sequences in a single print—taking Marey's and Eakins's work to the hundredth power. "Doc" Edgerton photographed bullets piercing candle flames, balloons, bananas, and light bulbs; footballs and tennis balls deformed with the impact of toe or racquet; insects and birds frozen in midair; and sequential movements by champion sports figures—many in brilliant color and jewel-like detail.

Edgerton's 1957 dye transfer print of a milk splash forming a coronet, for example, did not advance science beyond his own black-and-white studies of the 1930s or *Instantaneous Photographs of Splashes*, 1908, by **Arthur M. Worthington** (1852-1916), but Edgerton's image was handsome and wondrous and his most beloved. Staged inside a red cookie tin, the first drop into a pool of milk has produced an almost perfectly symmetrical crown, while a second drop hangs suspended, a perfect globe, above it. Regardless of their knowledge of particle hydrodynamics, thousands of readers of *Life*, *National Geographic*, and other magazines in the 1940s-'60s welcomed his intensified seeing and the gratifying order he revealed underlying everyday experience. And in line with the compact between science and art renewed by such exhibitions as "Film und Foto" in 1929 and Beaumont Newhall's survey of photographic history and its multiple applications at the Museum of Modern Art in

DAVID SCHARF WAITED ABOUT A MINUTE
FOR THIS BODY LOUSE TO STRIKE A POSE INSIDE
THE VACUUM CHAMBER OF HIS SCANNING
ELECTRON MICROSCOPE.

1939, Edgerton's camerawork fed the appetite for knowledge of physical principles as seen in photographs—and for the marvel of seeing the unseen.

Edgerton's strobe had many practical uses. When machine parts failed or a propeller needed strengthening against water or air pressure, the strobe could demonstrate how. When sites were being determined for the 1944 D-Day landings during World War II, giant strobes on high, night-flying planes illuminated the ground and enemy troop movements. Edgerton's reconnaissance method, tried out on Stonehenge, proved safer and more accurate than dropping flares. Animal behaviorists learned how bats and hummingbirds feed, while sports photography was revolutionized in the late 1930s with images of knock-out punches,

perfect-score dives, and the like. Edgerton's *Flash! Seeing the Unseen by Ultra High-Speed Photography*, 1939, was one of his four books. His fellow student at MIT, **Gjon Mili** (1904-1984), converted to photography and forged a long career at *Life* using Edgerton's strobe to photograph dancers, athletes, and other performers in motion.

But the strobe was not Edgerton's only claim to fame. Though he is credited with inventing the first deep-sea water-tight camera and with developing a flash camera for Captain Jacques-Yves Cousteau's aquatic probes in the early 1950s, he also invented sonar devices to guide the undersea camera, to penetrate sediment and make archaeological cross-sections of the ocean floor, and to locate rocks believed to be the first samples taken from the deepest layer of the earth's crust. These projects had National Geographic Society funding, and in 1973, again with Society support, he helped find the remains of the Civil War ironclad *Monitor*, sunk in 1862. His inventions also served in discovering and photographing *Titanic* in 1985. With his commercial partners, he crafted a camera to record early nuclear-bomb tests: here the problem was not sufficient light but sufficient distance, and it was solved with a camera controlled from seven miles away and a magneto-optic shutter fast enough to freeze the image. The explosion in the first photographs looked ominous and skull-like to some observers, but Edgerton left such interpretations to others. "I don't mind my pictures being called artistic," he said. "The object is to find out what's going on, and if you happen to get a good picture, why, it doesn't hurt anything."

THE MODERN WORLD INSIDE

Microscopic investigation of life, begun in photographs in 1840, produced quantities of information from the tiniest samples. But for understanding the living body, medicine wanted both more and less—more interrelated data and less invasive ways of get-

AN UNDERWATER PHOTOGRAPHER SINCE AGE 11,
DAVID DOUBILET USES DOME OPTICS TO CAPTURE
LIFE UNDER THE WATER'S SURFACE, LIKE THIS
STINGRAY IN THE CAYMAN ISLANDS IN 1990.

ting it. The x-ray—discovered in 1895 by **Wilhelm Conrad Roentgen** (1845-1923) and still in significant use—was the answer, and it revolutionized physical science while captivating the popular imagination. Roentgen's experiments led the scientist Max von Laue to investigate the wave patterns of x rays and to picture the lattice structure of crystals. And this research, which won the 1914 Nobel Prize, led in turn to the first photographic tracing of DNA (the chemical deoxyribonucleic acid). The fuzzy, bilaterally symmetrical photographs of 1952 by **Rosalind Franklin** (1920-1958) and **R. G. Gosling** would be read only later as the double helix of fundamental genetic information.

The photographs of a live fetus in the uterus from 1957 on by **Lennart Nilsson** (b. 1922) could not be more different. These breakthroughs in showing the unseen lay not in their conception of photographic vision but in their camera technology. The explorations of this Swedish photographer, which

became a *Life* cover story in 1965, showed a 15-week-old fetus sucking a thumb, complete to sex organs and umbilicus, and in natural colors. Nilsson's tools were an endoscope, an ultra-thin instrument one millimeter in diameter, designed to visualize a body cavity or hollow organ from within; a tiny lens with a short, 1.5 millimeter focal length and a 170-degree field of view; and a strobe flash, all safely introduced (as in laparoscopy) through the stomach wall and connected to a camera. His photographs became the much-reprinted book *A Child is Born* (first edition 1965); and his counterparts of them in videotape, using new camera technologies and fiber optics, became award-winning documentaries on the first months of human life, from embryo to newborn, in 1982 and 1996. With increasing miniaturization of lenses and endoscopes, Nilsson has photographed the implantation of fertilized eggs in the uterus. And in response to a new era's medical concern, he made some of the first photographs of the virus known as HIV (human immunodeficiency virus) with a high-resolution scanning electron microscope (SEM) at the Pasteur Institute in Paris, and in 2003 the first image of the SARS virus.

SEM imagery, which can show data ten thousand times

smaller than the eye can see, is also a specialty of **David Scharf**, who has published his uses of it since 1977. Though a flea was portrayed in a microphotograph in 1840, Scharf's depictions of the parasite and other insects, as well as bacteria, yeast, and fungi, are colored in his prints for legibility and dramatic impact, and their three-dimensionality gives them an additional creepy thrill (p. 415). All SEM photographs are originally monochrome, since electrons, unlike the photons of natural light, carry no color. Scharf may have been the first to color SEM pictures, in 1980; and in 1991 he introduced another color system using multiple electron detectors. With footage from the SEM, he was early in creating HDTV sequences and motion pictures, winning the first Emmy award for telecasting electron microscopy in 2000.

The expressiveness of Scharf's vivid hues and his choice of menacing "poses" for his minute insects signal how much art he adds to his science. Art is even more significant in the work of **Gary Schneider** (b. 1954), although his most famous series, his "Genetic Self-Portrait," 1997-98, comprises photographs made in collaboration with doctors and biologists using the gamut of scientific imaging equipment—SEM and fluorescent-light microscopes, x-rays, auto radiograms, and the fundus camera (designed to photograph the eye's interior). Schneider's gathering ranges from images of his hands, ears, retinas, teeth, and a sperm, to specimens of the DNA that determined his looks and his tumor suppressor gene. That gene started it all: in 1996 he was invited to respond artistically to the mapping of the Human Genome (the identification of every gene in human DNA and its sequence across all 46 human chromosomes) just at the time his mother lost her battle with cancer. "I decided to marry my obsession with biology and portraiture," he said, and he undertook a new kind of scientific autobiography, risking he would receive bad news about his genetic makeup. He didn't. The images harvested from his body specimens became his raw materials. What he began and ended with defied conventional ideas of photography and portraiture.

Though respecting the data of scientific photography, Schneider chose the visually eloquent image over the informative one supplied by his scientists. Then he drastically enlarged the negatives, without concern for literal scale relations: a cell from inside his cheek, for example, became a nine-panel, nine-foot-tall display that was inspired, he said, by an ancient Chinese landscape at the Metropolitan Museum of Art. His five-micron-long sperm became eight inches long for its exhibition. He also printed in some cases with the platinum-palladium process, which gives full, rich tones to black-and-white photography.

Schneider's project concluded with his printing of his palms—pho-

PAINTING & CHRONOPHOTOGRAPHY

Artists learned from photography from its beginnings, and never more so than with chronophotographs—records of motion too fast for the eye to register. Edgar Degas's paintings of racehorses reflect Muybridge's studies, while his ballerinas acknowledge the photographer's nudes in their sometimes homely gestures. Indebted to Marey's graphs and figure sequences, Marcel Duchamp's *Nude Descending a Staircase*, 1912, is a sexy robot, with cartoon-like dotted lines signaling her swiveling hips. In his *Dynamism of a Leash*, 1912, the Futurist Giacomo Balla multiplied not the whole body but just the legs of his endearing dachshund: the pet was a comic version of Eakins's carriage horses. As an artists' group, the Futurists embraced the data provided by Muybridge, Marey, and motion pictures: their cinematic and kaleidoscopic approaches to physical reality marked the triumph (for them) of the notion of a space-time continuum over the stable worldview implied in Renaissance one-point perspective.

tograms that sparkle with body moisture and evoke both the power of the artist and the primordial markers of human identity found in Stone Age caves, as well as the fingerprinting used for forensic identification. These and his photograms of his ears are the only photographs in his project that connect with his outward appearance. Indeed, his compilation suggests that physiognomy is just one of many markers of identity, and not the primary one. In all, Schneider's "Genetic Self-Portrait" recaps much of biological science since 1840—from its attempts to record how the body is made, to explain how it works, and now to depict the genetic triggers that control how it appears and behaves. The collaboration of art and science that the best scientific photographs represent is also literal here. Asked about the time she had spent working with Schneider and his diagnostic samples, the genetic researcher Dr. Dorothy Warburton replied: "When artists treat these images as almost sublime, they are able to convey the significance, beauty, and meaning of this project to ordinary people."

AERIAL VIEWS

Like much scientific camerawork, aerial photographs belong to science, photojournalism, and art: they convey architectural and geographic information, allow analysis and measurement of human-directed and geological change, and flatten forms into potentially pleasing near-abstract patterns. They're also delightful. Seeing the 1860 view of Boston that **James Wallace Black** (1825-1896) made from a balloon tethered 1,200 feet above the Common, Oliver Wendell Holmes commended his capturing the city "as the eagle and wild goose saw it." This was America's first aerial photograph. Nadar had already photographed Paris from his balloon in 1858, and ten years later he would brag about his airborne views of the Arc de Triomphe, recorded with a multi-lens camera. Black foresaw the utility of camerawork from balloons in military reconnaissance; and though aerial photography was not used in the Civil War, cameras sent aloft on balloons and kites became means of surveillance in 20th-century conflicts.

Subsequent aerial views ranged from those Steichen ordered during World War I as a U.S. Army Signal Corps officer to examples appropriated or made by modernist photographers such as Moholy-Nagy for their affinities with abstract art

and their illustration of how photography intensified seeing.

There were also new firsts. In 1924 Captain Albert W. Stevens set several records at one time when he photographed Washington, D.C., from an airplane at night. For illumination, he used a strong flash from the plane, and he developed his film while in flight. In a lighted parachute, the film was dropped to the ground, then rushed to a laboratory and printed. The prints were brought to the capital's AT&T office where the wire service converted them into scan lines and transmitted them to New York City newspapers for publication. The whole procedure, as Keith Davis describes it, took two hours and 16 minutes. In 1935 Stevens ascended almost 14 miles above sea level in a balloon, breaking records for high-altitude photography. Co-sponsored by the National Geographic Society and the U.S. Army Air Corps, his photographic project revealed the action of cosmic rays, the curvature of the Earth, and the division between the troposphere and the stratosphere.

The extremes of aerial camerawork are those photographs of Earth beamed down from satellites and taken by astronauts since the beginning of the U.S.-Soviet space race. In 1972, for example, the NASA Landsat satellite pictured Earth from 570 miles above it, and the Goddard Space Flight Center processed the images and added color for geological interpretation—and perhaps for aesthetic appeal. Most memorable of U.S space program photographs was the one made of Earth by **Harrison Schmitt** (b. 1935) of *Apollo 17*, the last U.S. lunar mission, as it headed to the moon in December 1972. His color photograph was a simple snapshot taken with a 35mm camera and a 250mm lens at f/11. And it was preceded by photographs of the entire globe made in 1967 from *Lunar Orbiter 5*. But Schmitt's photograph was spectacular. Showing Africa's rainforests scattered with clouds and banded above by the ochre Sahara and below by the shining white of Antarctica, the globe hovering in blackness was seen by many as fragile and precious. It was two years after the first Earth Day in the United States, an event demonstrating that ecology had become a national concern. Schmitt's "Planet Earth" became ecology's emblem.

Photographs almost as popular were those taken on the

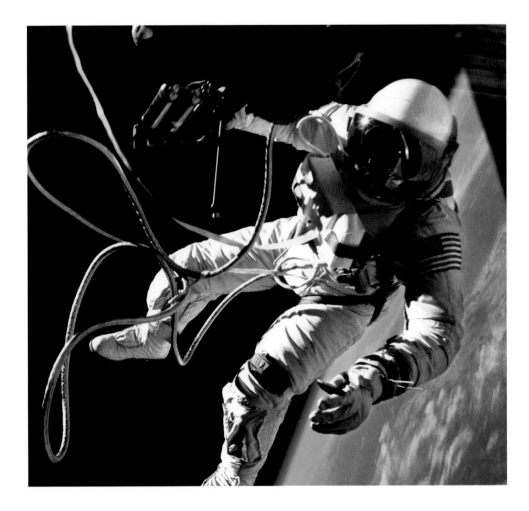

ONE OF THE FIRST DIGITAL IMAGES WAS THIS
1965 NASA IMAGE OF ED WHITE, THE FIRST MAN
TO WALK IN SPACE.

moon in 1969, honoring Neil Armstrong's first step and also showing him and the spacecraft reflected in Edwin Aldrin's helmet. Pictures by Alan Shepard of *Apollo 14* and by robot landing craft also caught the popular imagination in the 1970s. Shepard's photographs of the lunar desert in 1971, assembled as panoramas with his Atget-like shadow in the middle, looked marvelous yet familiar. The astronaut, Ed White, in a chunky spacesuit floating weightlessly with his lifelines was thrilling but endearing, too—America's high-tech man-child.

UNDERWATER PHOTOGRAPHY

"The last unexplored frontier" for Dr. Robert Ballard, the oceanographer who co-discovered the wreck of *Titanic*, is underwater. Photographers have brought back camera evidence of this frontier since 1893 and have shown it in color since 1927. Their magical images of a weightless blue-green world alive with relics of human history and nature's most fantastic creatures—from microscopic luminescent krill to giant spotted whale sharks—suggests such camera work is easy. It isn't. At more than 70 feet below the ocean surface, oxygen tanks are required equipment, and human life is timed by their liter-flow per second. At 200 feet, the weight of atmospheres is unsafe for divers, and if they ascend too rapidly—even from as little as 30 feet down—they risk the bends, a potentially lethal

condition in which nitrogen is released in the body and cuts off the oxygen supply.

Merely to photograph is challenging. Though 70 percent of the globe is covered by water, even the clearest of it (a diminishing commodity) is still full of particles and often turbid with the forces of currents, while its aquamarine hue filters out the appearance of red, orange, and yellow as the diver descends. Objects seen through water and a diver's mask are enlarged and distorted. The deeper the dive, the darker the world. Brilliant artificial light is needed to capture accurate hue and detail. Then there are the usual camera questions: what timing, exposure, and angle for the meaningful shot. **Emory Kristof** (b. 1942), who was the first to photograph *Titanic*'s remains in 1985, remembered this headline-making saga, sponsored by the National Geographic Society, in which Ballard worked with the French scientist Jean-Louis Michel and the Soviet Union lent a research vessel with two of the deepest-diving manned submersibles in existence. Their high-capacity battery systems lighted the great luxury liner from its prow, dripping icicles of rust, to its still-intact staterooms. From the submersible *Mir 1*, Kristof operated the lights and the still camera, in a remote-controlled sled of his conception. "What it all comes down to is f/4 at 1/100th of a second," he said. "And you have to figure out quickly where to put your 1/100th of a second because time is very expensive." *Titanic* is two and a half miles beneath the

A DIGITAL PANORAMIC CAMERA MOUNTED ON THE MECHANICAL ROVER *SPIRIT*, TOOK 108 INDIVIDUAL PICTURES TO CREATE A 360-DEGREE SCENIC VIEW OF MARS IN 2005.

North Atlantic's surface and 350 miles off Newfoundland, and Kristof was in *Mir 1* when it was snagged on a railing. It took 20 minutes to break free—a cost that he must have calculated in more than dollars.

Near-death experiences, or at least white-knuckle stories, have been part of underwater photography from the beginning. To get the first natural-color photographs of fish in their habitat almost killed scientist W.H. Longley and **Charles Martin**, who, with Society sponsorship, were working off the Dry Tortugas in the Caribbean in 1926. The Autochrome process (see pp.258-9) was the only full-color photography then available, and flash illumination depended on igniting loose, highly flammable magnesium powder. An ounce was enough for one photograph, but the team loaded almost 20 times that much onto a raft, which accidentally exploded all at once. Fifteen feet down, unaware of their photographers' close call, a school of hogfish was immortalized in Autochrome pastels.

Marine biology and photography of it advanced exponentially when the Aqua-Lung, co-invented by **Captain Jacques-Yves Cousteau** (1910-1997) during World War II, entered scientific (and recreational) use in the early 1950s. "The best way to observe fish is to become a fish," said the charismatic Frenchman, and his portable oxygen gear made this seem possible, at least for a few hours per dive. His National Geographic Society–funded aquatic projects—beginning in 1953 and photographed in stills and video—thrilled a generation of viewers as they expanded knowledge of marine behaviors, deep sea and coastal topographies, and the ecologies of humankind and oceans around the world. Cousteau's support for underwater photography helped make his research ship, *Calypso*, an unoffi-

cial school for diver-photographers, and a field laboratory for try-outs of new equipment designed to take cameras deeper and improve illumination. Edgerton was building the first remote-control undersea camera when in 1956 he met photographer **Bates Littlehales** on Cousteau's ship. Littlehales went on to co-invent the OceanEye underwater camera housing, which corrects the distortion of light waves under water.

Underwater color photography also began in earnest on *Calypso* in 1955, when **Luis Marden** (1913-2003) shot in the Red Sea and Indian Ocean for an extended story in *National Geographic* magazine. Marden then had only two cameras and about 600 flashbulbs: that was the era's advanced technology. He became another mentor for Littlehales, and the two photographed together in the Yucatan Peninsula's cenotes in 1958, raising some 6,000 ancient Mayan artifacts and bones from these natural sinkholes employed for rituals of human sacrifice. Marden, a pioneer in underwater use of Kodacolor and Ektachrome film, may be best known for discovering the wreck of Captain Bligh's H.M.S. *Bounty*, which mutineers on his crew sank off Pitcairn Island in the South Pacific in 1790 so that no one could return to England.

Littlehales in turn helped teach **David Doubilet** (b. 1946), who has been called the Audubon of marine photography for his dazzling marriage of science and artistry. The younger man had been scuba diving and photographing underwater since age 11, but at first his technical proficiency ran ahead of his vision. Littlehales advised him to be more intimate: "You have to shoot fish just the way you shoot children, on their level." Currently Doubilet is a photographer-in-residence at the National Geographic Society and a member of Britain's Royal Photographic Society. He has made ground-breaking photographs of great white sharks and the wrecks of Pearl Harbor, among other subjects in the Pacific, the Caribbean, and the Red Sea. His signature is the "over and under image," a photograph showing the diver's two worlds, above and below the sea surface, at one time. To put both worlds in focus, he, Littlehales, and others worked together to devise split-field 85mm and 20mm wide-angle lenses, which have two parts—diopters that adjust for the different refractive qualities of air and water and graded filters that compensate for the variation in light above and below the water surface. For some photographs, he masked the lower half of the lens while shooting above the surface, then rewound the film, masked the upper half of the lens, and shot the water below. All this work is invisible in the resultant photographs. Lyrical metaphors abound in his pairings—a gliding stingray beneath an equally graceful solo sailboat (see p. 421), a billow of Caribbean clouds as free of gravity as a torrent of fish below. Information seekers may learn about warm water biology and weather from Doubilet, but his ravishing photographs really convey the poetry of diving.

Among more recently recognized marine photographers are **Bill Curtsinger** (b. 1946) and **Charles "Flip" Nicklin** (b. 1948), a former assistant to Doubilet, who both began swimming with whales in polar regions in the 1970s. How in the murky frigid depths to describe these moving mountains? Submerged for only a half an hour, the photographers have found their hands too cold to work. Nonetheless, Nicklin sometimes follows the mammals in free dives to 70 feet down, dispensing with an oxygen tank because, he says, the whales dislike the bubbles.

X-RAY IMAGING
SEEING BENEATH THE SURFACE

The fact that x-rays can reveal internal structures of the human body was one of the first observations made by Wilhelm Roentgen, the man who discovered the existence of this form of electromagnetic radiation in 1895. The German physicist also noted that x-rays could be recorded on photographic emulsion, setting the stage for one of the major breakthroughs in medical diagnosis. Like so many scientific milestones, Roentgen's discovery of x-rays came quite by accident.

While conducting experiments with cathode rays—electrons emitted from the negative electrode of a gas discharge tube—Roentgen noticed that a screen in his lab that was coated with barium platinocyanide would fluoresce whenever he turned on the electron beam. While fluorescent material usually glows when struck by electromagnetic radiation, the screen in Roentgen's lab was shielded from direct rays by a thick cardboard housing surrounding the cathode ray tube. The German scientist reasoned that some type of invisible radiation from the tube had penetrated the cardboard, causing the screen to glow. Because he had no

idea what these rays were, Roentgen called them x-rays.

Continuing his experiments, Roentgen began placing different materials that would block visible light between the cathode ray tube

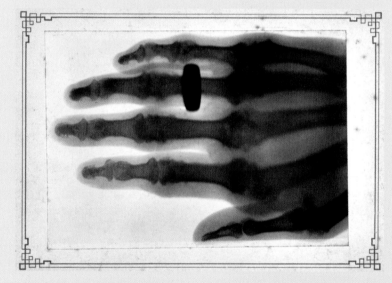

ONE OF THE FIRST KNOWN X-RAYS WAS OF A WOMAN'S HAND, HER WEDDING RING LOOMING ABOVE THE BONES.

and the screen. In each case, the screen still fluoresced when he turned on the electron beam. The most riveting moment occurred when Roentgen held his own hand in front of the tube

and saw the outlines of his bones cast upon the screen. At that instant, medical x-ray imaging had been born. Shortly afterward, Roentgen took an x-ray photograph of his wife's hand, which showed not only her bones but

also her wedding ring.

Immediately after Roentgen announced his discovery, other scientists began their own investigations of x-rays. In a year's time, over a thousand articles had been published. It was revealed that x-rays differ only in wavelength from other forms of electromagnetic radiation—gamma rays, ultraviolet light, visible light,

infrared, and radio waves. Because x-rays have extremely short wavelengths they possess tremendous energy. Their tiny photon particles can separate electrons from the atoms of a targeted material—the basic phenomenon producing x-ray fluorescence. However, an x-ray image reveals nothing about the energy of the photons that created it other than their spatial density. Another characteristic of x-ray images is that they are two-dimensional, with no depth information.

Most medical x-ray images are negatives, with denser materials such as bones or teeth—which stop the transmission of the rays—showing up as lighter areas. Softer material such as the lungs and other organs are recorded in shades of gray to black, since the x-rays pass through these structures at varying rates depending on their density.

Radiologists can interpret images of soft tissue to diagnose lung diseases such as cancer or pneumonia as well as abdominal conditions and circulatory problems. Real-time x-ray imaging procedures—which are displayed on a television screen rather than as still photographs—include radioactive barium swallowed to diagnose intestinal problems and injections of x-ray–sensitive material to aid in angioplasty and other arterial proce-

dures. However, for imaging the brain or muscles, other techniques are more effective than conventional x-rays, including computed axial tomography (CT scans), magnetic resonance imaging (MRIs), and ultrasound.

Beyond their medical use, x-ray photographs have recorded amazing images of outer space. The origins of x-ray astronomy date to 1949, when

A TULIP FROM ALBERT KOETSIER'S SERIES, "BEYOND LIGHT"

rocket-mounted radiation counters were used to measure x-rays emitted by the sun. The first imaging x-ray telescope, launched in 1963, captured photographs of hot spots in the sun's upper atmosphere. In 1990 the Chandra X-Ray Observatory was sent into orbit, allowing scientists to gath-

er x-ray images from energy sources billions of light years away—black holes, binary star systems, remnants of supernovas, neutron stars, comets, and other phenomena. A satellite-mounted telescope was necessary because x-rays from outer space are absorbed by the atmosphere before they reach the Earth's surface.

Less dramatic uses of x-ray imaging include industrial x-rays taken to detect flaws in castings and construction materials, images made with scanning electron microscopes, and the real-time images made by airport security machines (for photographers, the latter use presents a dilemma, since uncalibrated x-ray machines in some airports can damage unprocessed film, and newer high-dose CT scanning systems used on checked luggage will definitely cause damage). In the field of fine art photography, striking interior views of natural or man-made objects have been captured with x-ray photographs; Albert C. Koetsier is known for his radiographs that reveal the hidden beauty inside flowers or the perfect symmetry of a shell's spiraling interior patterns. In these and other ways, the accidental discovery made by Wilhelm Roentgen little more than a hundred years ago has opened up new vistas previously unseen by the naked eye— the amazing world within.

CAMERAS, FILM, AND THE DIGITAL AGE

1827
Nicéphore Niepce takes first "true" photograph of rooftops outside his window in Le Gras, fixing the image with bitumen of Judea on a metal plate.

1835
Louis-Jacques-Mandé Daguerre makes the first permanent, positive image. The earliest surviving image of daguerreotype is a still life of plaster casts taken in 1837.

William Henry Fox Talbot creates a paper negative of a window in his house, Lacock Abbey.

1839
Daguerre makes public the first widely used photographic process, the daguerreotype.

1840
Alexander S. Wolcott and John Johnson invent a camera that makes daguerreotypes in seconds rather than minutes. They become the first Americans to take out a photography patent. They open the world's first known photography portrait studio, called Daguerrean Parlor, in New York City.

1841
William Henry Fox Talbot patents the first successful negative-positive process, the Calotype, which he names the "Talbotype."

1842
Sir John Hershel invents the Cyanotype, which uses light-sensitive iron salts rather than silver, giving the image a blue tint.

Daguerreotypes are hand colored with finely powdered pigments.

1844-46
William Henry Fox Talbot publishes *The Pencil of Nature*, the first book with photographic illustrations; his glued-in Calotypes, together with text, indicate the range and possibilities of photography.

THE FIRST CAMERAS WERE MADE OUT OF WOOD.

1848
Abel Niepce de Saint Victor makes the first successful glass negative using albumen, or egg white, to bind silver salts.

1849
David Brewster, a Scottish physicist, invents the dual-lensed double camera and companion stereoscopic viewer, the first true system for creating photographic images.

1850
Louis Desire Blanquart-Evrard invents the albumen paper print process, dramatically giving prints a greater depth and contrast. This remains the primary printing medium until gelatin papers supercede it in 1895.

1851
Blanquart-Evrard opens a printing company, the Imprimerie Photographique, in Lille, France, to mass-produce photographic prints.

Frederick Scott Archer, a British sculptor, invents the wet collodion process. Using guncotton, or nitrocellulose, as the emulsion's binder, the glass plate is exposed and developed immedi-

ately. With an exposure time of 2-3 seconds, the inexpensive process yields photographs as detailed as daguerreotypes. The negative can be retouched and duplicated endlessly.

The Sociétè Héliographique, the first photographer's association, is founded in Paris and begins publishing its own periodical, *La Lumière*, (the Light).The bi-weekly features criticism and advice.

William Henry Fox Talbot makes the first photograph in the dark. He uses an electric spark for illumination, creating what many consider to be the first flash photograph. Exposure time is 1/100,000 of a second.

Frenchman Gustave Le Gray invents the dry waxed-paper process, producing negatives from paper permeated with wax, then sensitized. This process improves the negative's ability to transmit light. The negatives are easier to handle, can be prepared in advance, and make sharper, larger, more detailed prints.

1853
Roger Fenton founds the Photographic Society of London to promote the art and science of photography. It becomes the Royal Photographic Society in 1894.

Adolphe Alexandre Martin invents the tintype, or ferrotype. Popular in the United States, the direct-positive process involves coating a sheet of iron—not tin—with collodion and sensitizing it just before use. Inexpensive and durable, tintypes are often fitted into lockets and other keepsakes.

1854
James Ambrose Cutting invents the Ambrotype, or collodion direct positive image, in which a very underexposed collodion glass negative is bleached and then placed on a black background, causing the silvery image to appear as a positive.

André Adolphe Eugéne Disdéri, a French photographer, patents the small-format *carte-de-*

visite, or photographic calling card. By using a sliding plate holder and a camera with four lenses, he is able to produce eight exposures on a single 8 x 10 negative plate. Printed on albumen paper, the standard, 2 1/2 x 4-in. photographs are pasted onto calling-card stock.

1856

Alphonse Poitevin, a french chemist, develops the carbon process, the first practical method of printing an image with a permanent pigment, potassium dichromate.

1858

The first aerial photograph is taken from a Paris balloon by Nadar.

1859

C. C. Harrison invents the globe lens, the first wide-angle lens.

Thomas Sutton invents the "Sutton," the first patented panoramic camera.

1861

In Scotland, James Clerk Maxwell produces the first color photograph by using an additive process, forming colors by successively passing the subject's image through red, green, and blue translucent filters. Each of those black-and-white photographs is turned into three lantern slides and each is projected in registration through a separate color filter—red, green, and blue—onto a screen. The three projections combine to produce a color image.

1864

Englishmen Alfred Brothers uses magnesium to shoot underground mines.

1865

John Trail Taylor uses magnesium flash powder to create the first widely used flash. Contained in a protective holder and ignited by hand, this volatile powder produces a brilliant white flash of light, then a characteristic large puff of white smoke.

1866

Walter E. Woodbury invents the Woodburytype, a photomechanical process for making photographs. The Woodburytype, known for its quality and permanence, is very difficult to produce.

1868

In France, Louis Ducos du Hauren and Charles Cro introduce the tricolor carbon process.

1871

Dr. Richard Leach Maddox, an English doctor, suggests the use of a gelatin emulsion, instead of guncotton, to bind silver bromide to a glass plate. This would eventually lead to the dry-plate process.

1872

English photographer Eadweard Muybridge determines how to "freeze" fast-moving subjects photographically.

1873

Peter Mawdsley invents the first photographic paper with a gelatin emulsion. Commercially produced gelatin silver printing papers are available by 1885, and by 1895 have completely replaced albumen printing paper.

Hermann Wilhelm Vogel, a German chemist, discovers that dyes can be added to black-and-white photographic emulsion to make it more sensitive to the full spectrum of light. He develops a process called optical sensitizing.

William Willis develops a platinum printing process, the Platinotype. Platinum gives the photograph sharp details, yet soft gray tones.

1878

Eadweard Muybridge sets up a battery of cameras with mechanically tripped shutters to determine whether a horse lifts all four legs off the ground during a gallop, demonstrating a horse airborne during the gallop. The shutters allow Muybridge to photograph at less than half a second.

The dry-plate process, based on the use of gelatin emulsion, is perfected and manufactured commercially, removing the need to coat the film, expose it while wet, and process it immediately. Packaged and stored easily for long periods, it becomes the first mass-produced emulsion.

By converting the tones of a photograph into dots of varying sizes, Charles-Guillaume Petit perfects the halftone engraving process.

1879

Karel Klič invents the photogravure, a photo-mechanical process in which the photographic image is transferred to a copper plate, and finished prints are made in ink on a printing press.

1880

The first halftone photograph appears in a daily newspaper, the *New York Graphic*: Stephen Horgan's "A Scene in Shantytown."

Th twin-lens reflex camera is invented in England.

PHOTOGRAPHERS ETCHED THEIR CAPTIONS DIRECTLY ONTO GLASS FILM PLATES.

Twenty-four-year-old George Eastman founds the Eastman Dry Plate Company in Rochester, New York. The company mass-produces glass-film plates on an emulsion-coating machine invented by Eastman.

LeBlanc theorizes transmission of photos in segments.

1882

A photograph is transmitted electronically (wirephoto) for the first time.

Physiologist Etiènne-Jules Marey invents a chronophotographic fixed-plate camera equipped with a timed shutter. He succeeds in combining on one plate several successive images of a single movement.

1883

Ottomar Anschutz invents the focal-plane shutter, an opaque curtain in front of the film plane that is capable of exposure times up to 1/1,000 of a second.

1884

Eastman invents a flexible, paper-based film, the first practical roll film.

1886

Frederick E. Ives develops the halftone engraving process, making possible the reproduction of photographs in the same operation as the printing of text.

1887

Rev. Hannibal Goodwin, an American clergyman, files a patent for flexible clear celluloid roll film.

Edward Bausch introduces the leaf shutter, a circle of overlapping metal blades that can be incorporated into the lens itself.

1888

Searching for a lighter and less fragile support for the light-sensitive emulsion, John Carbutt, a pioneer in dry-plate photography, persuades a celluloid manufacturer to produce very thin, transparent sheets which he then coats with a gelatin emulsion.

The first Kodak camera, the Kodak No.1, is mass-marketed for $25. It contains a 20-foot roll of preloaded paper film. The entire camera is returned for processing to Kodak where the film is developed and printed and the camera reloaded with new film, making Kodak the first mass-market and processing service.

1889

The Eastman Co. produces and sells the first transparent roll film, a highly light-sensitive gelatin emulsion coated on flexible celluloid film.

1890

Charles Driffield and Ferdinand Hurter pioneer

the science of sensitometry—a method of measuring image brightness, exposure, and emulsion sensitivity. They create the first film-speed ratings, and make the actinograph, the first exposure calculator.

THE FIRST BROWNIE CAMERAS SOLD FOR $I IN 1900.

1896

Wilhelm Conrad Roentgen discovers the x-ray.

1901

In the United States, B. A. Slocum patents the first shutter-releasing device, or camera self-timer.

1902

The first zoom lens is patented by C. C. Allen, but the first commercial appearance isn't until 1959's Voigtlander Zoomar, 36-82mm.

In Germany, Arthur Korn devises phototelegraphy technology, for sending photographs over wire.

1903

In France, Louis and Auguste Lumière invent the Autochrome process. The process yields positive color images on glass plates. In 1907, the brothers start manufacturing Autochrome plates for commercial sale.

1906

The first panchromatic film is marketed. Its emulsion is sensitive to all colors in the spectrum .

1911

The cylinder rotary-press rotogravure (rotary photogravure) is invented. It makes possible magazine production of photographs.

1912

German chemists Karl Schinzel and Rudolf Fischer invent color couplers, chemical agents that can be incorporated into a film emulsion to create color dyes during processing.

1922

Kodak creates high-speed, heat-sensitive infrared film for military and scientific use.

1924

The first auto-wind camera, the Ansco camera, is invented. It is powered by a spring-wound motor to automatically advance the film.

1925

Paul Vierkotter invents the first modern photoflash bulb, or flashbulb.

German Johannes Ostermeier patents the first commercially available flashbulb and names it the *Vacublitz*.

The Leica, first developed in 1914, becomes the first practical 35mm camera to be put on the market.

1930

Leica introduces the first interchangeable lens system.

Kalart speed flash, the first flash synchronizer, is developed for the professional photographer to help minimize the problem of incorrectly timed flash exposures.

1935

The Associated Press forms the AP Wirephoto division, making it possible for newspapers to receive photographs the day they were taken. AP's first wirephoto, of a small plane crash in the Adirondacks, went to 24 different news groups.

Kodak introduces Kodachrome film, the first practical, commercial 35mm color slide film. The ASA was 10.

The synchronized flash makes flash photography possible up to 1/1000th of a second. It relies on a built-in flash socket built into the camera that allows it to be activated by the shutter,

1936

Canon releases the Hansa Canon, the first 35mm focal-plane shutter camera.

Agfa introduces Agfacolor-Neu, a color-transparency film with dye-forming color couplers incorporated into the emulsion.

1939

Harold "Doc" Edgerton, an American scientist, perfects the electronic flash, which he calls the stroboscope. More commonly known as the strobe, this light source with durations of one- millionth of a second, is used for both ultra-high-speed and stop-motion photography.

1939-1940

Ansel Adams and Fred Archer formulate the Zone System, a set of techniques designed to give the photographer great control over tonal range when using black-and-white film.

1940

Kodak begins using the ASA (American Standards Association) as a practical measurement of film speeds.

1941

First high-volume commercial color photofinishing service produces minicolor prints from 35mm and roll film formats of Kodachrome.

1942

Kodacolor, the first practical color negative film, is introduced by Eastman Kodak.

1946

The United States uses a captured German V-2 rocket, equips it with a camera, and snaps the first images of the Earth from space.

Kodak introduces Ektachrome, it's first color film that can be processed by the photographer.

Large factory-size laboratories take over film processing from individual chemists.

PHOTOJOURNALIST CARL MYDANS USED THE POPULAR SPEED GRAPHIC IN 1940.

1947

The Graflex Speed Graphic camera becomes the mainstay of press photography and remains so until the end of the 1950s. It is typified by its large, side-mounted flash.

1948

Instant photography becomes a reality when Dr. Edwin Land, an American scientist, introduces the Polaroid Land Camera 95. It produces a sepia-toned, 3 1/4 x 4 1/4-in. black-and-white print in just one minute.

Dennis Gabor invents the hologram.

1950

Eye-level viewing comes to the 35mm SLR through the roof-type pentaprism, giving SLR photography the directness of the rangefinder.

1954

Kodak introduces Tri-X Pan high-speed black-and-white film (ASA 200).

1955

Asahiflex SLR incorporates an instant-return

mirror, spring-loaded so that it returns to its down position, which keeps the viewfinder from blacking out after every shot.

1958

The German Iloca Electric is introduced. It has the first built-in, electric motor-driven film advance, allowing sequential photos to be taken at one-second intervals.

1959

Agfa introduces the Optima,the first fully automatic camera for amateur use.

1960

Calypso, later called the Nikonos, is the first camera built specifically for underwater use.

1960s

The Swiss International Organization for Standardization (ISO) sets the international ASA/BS/DIN standard for film speed.

1961

Kodak introduces the carousel slide projector with a rotary tray carrying 80 slides.

1962

Telstar, the first international communications satellite, transmits a photographic image across the Atlantic.

Co-inventors Emmett Leith and Jris Upatnieks in the United States and Yuri Denisyuh in the USSR devise a technique for recording a hologram on photographic plates.

1963

Kodak first markets the hugely popular Instamatic, a cartridge-loading snapshot camera.

Polaroid markets the first instant color film; developing time is 60 seconds.

1965

Honeywell's Auto Strobonar is the first flash unit to use a sensor to measure light reflected back from the subject, and thereby control flash exposure.

Topcon Super D is the first SLR with through-the-lens (TTL) metering.

1968

Apollo 8 astronauts transmit live photographs from lunar orbit.

1969

Bell Labs develops the CCD, a charge-coupled device, the basic image sensor that will be used in camcorders and digital cameras.

1972

Polaroid SX-70 is the first instant integral film that is developed before your eyes.

1975

Kodak creates an operational still camera with a CCD.

Raymond Kurzweil, an American technology pioneer, invents the first CCD (Charged Coupled Device) flatbed scanner.

1976

Canon introduces the Canon AE-1 (Auto Exposure #1), the first 35mm SLR camera with a built-in microprocessor.

1977

Apple I computer is invented.

1978

Konica introduces the Konica C35AF, the first point-and-shoot autofocus camera with automatic focusing.

1980

The first commercial video camera is marketed by Sony (CCD).

1981

Sony demonstrates the first consumer electronic still camera, the Mavica (Magnetic Video Camera): a video camera that records and stores still photographs on a small rotating magnetic disk. The recorded images can be viewed on a monitor or printed.

1983

Microsoft develops the bitmap (BMP) file, which produces a picture for computer viewing from a series of small dots, or pixels.

1984

Canon develops the electronic still camera.

THE SALE OF DIGITAL CAMERAS EXCEEDED THE SALE OF FILM CAMERAS IN 2003.

1985

Minolta introduces the Maxxum 7000, the first 35mm SLR camera with automatic focus.

1986

Aldus Corporation develops the TIFF (Tagged Image File Format) format, the leading commercial and professional image standard for exchanging images between various digital programs.

Fuji introduces QuickSnap, a camera that is used once, then discarded.

1987

Kodak scientists create the world's first megapixel CCD sensor, capable of recording 1.4 million pixels, or picture elements. It is capable of producing an acceptable 5 x 7-in. print.

1988

JPEG (Joint Photographic Experts Group) creates a way to compress a digital photograph into a much smaller file for storing on digital cameras and transmitting over the Internet. The acronym is also used for the standard itself.

1990

Adobe launches Photoshop 1.0, a professional image-manipulation program for Mac computers.

Logitech Fotoman, the first all-digital con-sumer camera, produces a 90k black-and-white image.

Eastman Kodak announces the PhotoCD, a process for digitizing photographic images to be transferred onto CD and viewed on a TV or computer. The digital data can be transferred to a computer for printing and storage.

1991

The Kodak DCS-100 uses a Nikon F3 camera body, tethering it to a huge digital sidepack. It is the first professional digital camera system (DCS) designed for photojournalists.

1994

The Apple QuickTake 100 becomes the first consumer-friendly color digital camera to work with a personal computer via a serial cable. It has VGA resolution—640 x 480 pixels—adequate for onscreen viewing but not high-quality printing.

1995

Casio QV-10 is the first digital camera with a built-in LCD monitor.

The Epson Stylus color inkjet printer with 720 dpi resolution allows the desktop printing of photo-quality digital images.

1997

Photo finishers digitize film-based images and send them directly to personal computers.

1998

The first consumer mega-pixel cameras come on the market.

2000

Sharp and J-Phone introduce the camera cell phone in Japan.

2003

Canon EOS digital Rebel, the first high-resolution (6.3 megapixels) D-SLR under $1,000, is very successful.

2004

Digital SLR cameras conquer shutter lag time, the annoying delay between pressing the shutter button and exposure.

A DICTIONARY OF SELECTED PHOTOGRAPHERS

Some of the following photographers appear in this chapter because their careers span various genres of camera work. Others receive briefer descriptions owing to limited space. Almost all are also cited in the preceding texts (see Index).

Dieter Appelt (German, b. 1935) has photographed himself since the 1970s in primal states and obscure rituals, often in nature. While drawing on Expressionism, Body art, Performance, and ideas of the artist as shaman, he has been professor of Photography, Film and Video at the Academy of Fine Arts, Berlin, since 1982.

Eve Arnold (American, b. 1913) One of the first female members of Magnum, she portrayed stars such as Marilyn Monroe with candid charm, as well as various cultures: the Soviet Union on five trips, 1965 on; Afghanistan and Egypt, 1967-71, where she made the film *Behind the Veil,* 1973; China for her 1980 book *In China*; the United States for *In America*, 1983; and Britain for the 1991 exhibition *Eve Arnold in Britain*.

Alice Austen (American, 1866–1952) chronicled her comfortable, rural, Staten Island milieu, her travels abroad, and the Lower East Side immigrant life in the years of Riis and Hine before the 1929 Crash, in which she lost her inheritance. In the late 1940s the Staten Island Historical Society saved 3,500 of her glass-plate negatives, and historian Oliver Jensen interested magazines in publishing her socially revealing period pieces, allowing her to afford a nursing home at the end of her life.

Uta Barth (American, b. Germany, 1958) Radically out-of-focus and off-center motifs ignore the camera's usual capacity for precise description in "in between places," as the title of her 2000 exhibition has it. Her shift of emphasis from narrative reading to sensations of looking may sound cerebral, but her color photographs aren't.

E. J. Bellocq (American, 1873–1949) New Orleans brothel belles posed for his sympathetic large-format camera in the first decades of the 20th century, and the plates, found in 1958, were printed by Lee Friedlander and shown in 1970. The portraits are the only known work by Bellocq, a commercial photographer for industry; and only a few of his prints survive.

Ilse Bing (American, b. Germany, 1899–1998): A photojournalist and modernist active in 1929-59 and known for her original use of vantage point, blur, and lighting, she was recognized in Paris, where she moved in 1930, and New York, from her emigration in 1941. She gave up photography in 1959, but was rediscovered in exhibitions of 1976, partly due to feminist interest.

Werner Bischof (Swiss, 1916–1954): A mid-century photojournalist for *Du, Life*, and other magazines, this early Magnum member covered then-distant peoples and places, especially in India and the Far East, and paid special attention to children. Soon after Robert Capa's death in Indochina, he died on assignment in Peru. These two tragedies led Cornell Capa to start the Fund for Concerned Photography in their honor.

Christian Boltanski (French, b. 1944) This painter and maker of installations and films adopted photography in 1968. Childhood became his subject circa 1970: he had himself photographed as a child, then made displays of youths' memorabilia, including toys and vacation snaps. His dimly lit installations of the early 1990s, with found photographs of children, are his signature: read as Holocaust memorials by many, they broadly evoke the loss of youth, the fragility of memory, and the role of photographs in attempts to preserve both.

Bill Brandt (British, b. Germany, 1904–1983) His best-known bodies of work are surrealizing nudes and trenchant observations of British class structure and rituals. He took up studio photography around 1927, then photographed for Paris magazines and the British picture press, including *Picture Post, Harper's Bazaar, Weekly Illustrated News*, and *Lilliput*. *The English at Home*, 1936, his best-known book, showed a nation during a period when seven in ten laborers in some British industries were out of work. In *A Night in London*, 1938, his contemporary photo-essay on a day in the life of a chambermaid, he observed a hierarchic society. For his postwar nude series, he evoked the biomorphic art of Henry Moore, using extreme wide-angle views.

Brassaï (French, b. Hungary, 1899–1984) Born Gyula Halász, Brassaï was one of the Middle Europeans, including Kertész and Capa, who created a personal photojournalism between the wars using a candid style, split-second reflexes, and an eye for unexpected subjects on European streets. His book *Paris de Nuit* (Paris by Night), 1933, defined *noir* style and imagery for still photographs. His studies of graffiti and other found art were reproduced in Surrealist magazines.

During the Nazi occupation, when unrestricted photography was impossible, he turned to drawing, with results published after the war. In the 1950s he photographed in France and Spain for magazines, and made paintings and sculpture. He published his reminiscences of his Left Bank circle in *Picasso and Company*, 1964, and a book on Henry Miller's life and writings, 1975.

Manuel Alvarez Bravo (Mexican, 1902–2002) The most acclaimed photographer of modern Central America, Bravo was born in Mexico City. The German Pictorialist photographer Hugo Brehme was Bravo's first mentor, from 1923; Modotti was his second, from 1927. In 1931 a first prize in a national photography contest let him become a full-time photographer, and while exhibiting and teaching photography in the 1930s, he was a cameraman on Sergei Eisenstein's film *Que Viva Mexico*, 1931, and he made *Tehuantepec*, 1934, a film based on a labor strike. At the same time, his acquaintance in Mexico City with Strand in 1933 and Cartier-Bresson in 1934, and Andre Breton in 1938 reinforced his eye for form and street life. His best-known work is *Good Reputation Sleeping*, 1938-39; his series of common folk are more typical.

René Burri (Swiss, b. 1933) Depicting world figures from Ché Guevara to Picasso and conflicts since Korea occupied this photojournalist from the 1950s. No shock effects: instead, restraint, human sympathy, and technical command typify his photo-essays, which are well regarded in mid-century reportage.

Harry Callahan (American, 1912–1999) In 1938, Callahan began taking pictures while working as an accountant. A 1941 visit by Ansel Adams to his camera club clinched his direction. He bought an 8 x 10-in. view camera, and by 1944 was supporting himself by working in the General Motors photography laboratory. His Detroit years (1938-46) established his career's coolly elegant aesthetic, in which themes from his life would all be intensely seen, purified, and composed with formal precision.

In 1946 Moholy-Nagy invited him to teach at the Institute of Design, Chicago, where he met Gropius, Mies van der Rohe, Bayer, and other modernists, as well as Siskind, who became a lifelong friend. Channeling the emigrés' experimental approach, Callahan urged students to explore the camera's technical potential as he did: multiple exposures, blur, silhouettes, abstracted motifs, various formats. In 1961 he moved to Providence, Rhode Island, to chair the photography department at the Rhode Island School of Design. His teaching, and Siskind's, helped establish photography as an academic discipline in the United States.

Sophie Calle (French, b. 1953) Her work since 1979 concerns how we know others in a media-saturated society, in which borders between privacy and publicity, anonymity and celebrity, voyeurism and surveillance are increasingly porous. At some risk, she followed and photographed an unknown man on the street over time for *Suite Venitienne*, 1980; for *The Hotel*, 1983, she became a chambermaid and photographed the contents of guests' rooms. For *The Shadow*, 1981, and its reprise *20 Years Later*, she hired a detective to observe her and presented the resulting documentation.

Cornell Capa (American, b. Hungary, 1918) Founder of the Fund for Concerned Photography in 1967 and the International Center of Photography, New York, in 1974, this charismatic photojournalist preserved the tradition of humanistic camera work. His own photography and publishing savvy are typified by his engaging coverage of JFK's campaign and first hundred days as U.S. president.

Lewis Carroll (Reverend Charles Dodgson, British, 1832–1898) Most famous as the author of *Alice's Adventures in Wonderland* (1865), this Oxford mathematician was an ardent wet-collodion photographer from 1856 to 1880. His virtually exclusive subject was costumed and sometimes nude young girls, whom he posed—with their parents' approval—as adorable little figures, often illustrating moments in Romantic literature and poetry. A single, full-length figure in sharp focus, his Alice Liddell "as the Little Beggar Maid," the child for whom he wrote his fanciful and satiric tale, is the antipode of Julia Margaret Cameron's monumental personification of Alice grown up, as Pomona, goddess of fruits and trees.

Martin Chambi (Peruvian, 1891–1973) Like Casasola in Mexico City, this commercial photographer, a portraitist in Cuzco from 1920, documented a complex Latin American culture from within. Social hierarchies and crosscurrents of modernization and Indian tradition are readable in his group portraits; and he was early in recording Inca sites and the ancient capital.

Lucien Clergue (French, b. 1934) Handsome black-and-white prints of voluptuous Mediterranean nudes, sometimes in water, and patterns in nature are signatures of his Continental postwar camera art. Like Cornell Capa, Clergue may be better known, however, as a champion of photographers and an institution builder—of the annual Rencontres Internationales, a festival of photography in his native Arles.

Lois Conner (American, b. 1951) is best known for her exquisite landscapes of China, made with tonal nuance and careful compositions associated with time-honored Asian aesthetics. Her fascination with the country was seen in her portfolio *The River Flows into the Heavens: Photographs of China*, 1988. Her publications also include *Panoramas of the Far East* (1993), *Out West: 30 Panoramic Views of the American West* (1996), and *China*, 2000. Generally she works with an antique "banquet" camera, designed to produce extended horizontal images, and she makes contact platinum prints of refined detail.

Gregory Crewdson (American, b. 1962) art-directs the most elaborate of the big, cinematic, full-color tableaux current since the 1990s. His "single-image films" show crises in Middle American life, Hollywood-style, and ask us to imagine the narratives and the B movies they reference. Mysteries and horror films are favorite genres, and complex lighting and detailed mise-en-scène may need forty technicians to produce. Not surprisingly, Crewdson has designed advertising for creepy but popular cable-TV series.

Imogen Cunningham (American, 1883–1976) Cunningham apprenticed for two years in Curtis's portrait studio. She opened her own studio in Seattle in 1910. With the graceful naturalism of Kasëbeir, she posed her clients in their homes. By 1921, now a friend of Weston, Cunningham began to use sharper focus to explore texture and pattern. Although she also tried multiple exposures and photographed reflections, her direct still lifes became a hallmark. She exhibited her work at "Film und Foto" in 1929.

In 1932 Cunningham, Weston, Ansel Adams, Willard Van Dyke, Sonya Noskowiak, and others exhibited together in San Francisco as Group f64. They preferred this smallest aperture on a large-format camera, which rendered maximum depth of field and crystalline detail, two super-realist effects they enhanced by contact-printing their big negatives on glossy paper. In 1932-35 she used double exposure as well as informal recording when she photographed Hollywood stars for *Vanity Fair*. In the 1940s she turned to more documentary photography with a small camera, and late in life made a portrait series of Americans over age 90. She died at 93.

Judy Dater (American, b. 1941) Known for her probing portraits of women and staged self-portraits, Dater has contributed to both feminist photography and the hybrids of media pioneered on the West Coast from the 1970s. She studied painting at UCLA in 1959, received an M.A. in photography from San Francisco State in 1966, and made her New York debut at the Witkin Gallery in 1972. Since 1992, she has taught widely.

Roy DeCarava (American, b. 1919) portrays subjects identified with black culture—his native Harlem, jazz musicians, and Freedom Marchers—but has achieved his goal of producing "a creative expression" rather than a "documentary or social statement." His meditative, sometimes mournful work sets urban and family experiences on the common ground of humanity, using a style of mid-century modernist and photojournalistic elements.

In 1952 he was the first black photographer to win a Guggenheim fellowship, which he spent in Harlem. Some of these bittersweet images became *The Sweet Flypaper of Life*, 1955, in which he pictured a spunky woman raising her grandchildren in the ghetto, while poet Langston Hughes imagined her interior monologue. In 1955, DeCarava opened A Photographer's Gallery to showcase creative photography by contemporaries and in the '50s he photographed such jazz stars as Billie Holiday and Duke Ellington in performance published as *The Sound I Saw* (2003). In 1958 he became a free-lance photojournalist, and in 1963 helped found the Kamoinge Workshop in Harlem. Around 1985 his prints grew darker, and he expanded his use of blur for evocation. Yet he is no formalist gamesman: his subjects still convey the questioning reflections of the sometimes lonely but unsentimental city dweller.

Raymond Depardon (French, b. 1942) Since the 1960s, reportage and making films have engaged him. Co-founder of the Gamma agency in 1966, a Pulitzer prize winner for his coverage of Chad, he is much published in Europe, with books on war, politics, sports, travel—especially in the desert—and his advertising campaigns.

Robert Doisneau (French, b. 1912) Gallic lovers kissing amid the crowd, the roving eye of the middle-aged bourgeois, animals behaving better than their keepers—these and other amusing glimpses appeared from the 1950s in his sometimes poetic "street" photography, first shown with that of Brassaï, Willy Ronis, and Izis. Doisneau's technique was honed by industrial and advertising photography from 1934 and fashion in 1949-52.

Frantisek Drtikol (Czech, 1883–1961) The angular stylizations of Art Deco, modern dance, and expressionist silent films cohabit with Pictorialist technical mastery in his nude studies of the 1920s, a decade

when his Prague studio was a vanguard mecca. He gave up camera art in the 1930s for painting and mysticism, making his constructed photographs the more alluring in their rarity.

Pierre Dubreuil (French, 1872—1944) Pictorialist traits—soft focus and skill with oil pigment printing—combine with proto-modernist experiments with close-ups, fragments, bird's-eye views stressing flat patterns, and near abstractions, in some of his remarkable pre–World War I photographs. More typical of his era were his Barbizon-style landscapes and staged sacred scenes.

José Ortiz Echagüe (Spanish, 1886–1980), a wealthy industrialist, documented what he thought industry was wiping out—the picturesque folkways and religious rituals of rural Spain. Over his amateur career, 1906-40, his Pictorialist printing romanticized his subjects further.

Elliott Erwitt (American, b. France, 1928) Gusto, charm, and laugh-out-loud comedy characterize the observant "street" photography, often of dogs, by this long-time Magnum member.

Bernard Faucon (French, b. 1951) Child models and manikins are mixed in the tableaux he has staged since the 1970s, dreamlike and fraught scenes evoking a youngster's fantasy life. Poeticizing the dramas are the pastels and pointillism of the Fresson process he uses.

Donna Ferrato (American, b. 1949) Her hallmark book, *Living with the Enemy*, 1982, probes spousal abuse in the U.S. in unsparing case studies. The graphic photographs and first-person testimonies of the cycle from violence to prison or counseling admit that photojournalists now combat "compassion fatigue," so Ferrato tried "to show as many aspects of the problem as I could." In 1991 she started a nonprofit organization to raise money for women's shelters.

Jaromir Funke (Czech, b. Hungary, 1896–1945), with Drtikol and Jaroslav Rössler, was a vanguardist of 1920s Prague. He experimented with photograms, store window reflections, and camera equivalents of abstract painting—studio set-ups of cones, cubes, and overlapping planes, which he ingeniously lighted and photographed to tease perception. He began teaching in 1931 and was an influential writer and curator to his death. Collectors covet his interwar prints.

Adam Fuss (British, b. 1961) Photography as transmutation engages this New York–based camera artist, who gives uncanny life to statuary through pinhole camera views and uses photograms to capture unlikely light effects—like the translucence of rabbit entrails or the circles made by falling water drops. Initially a commercial photographer, he knows how elemental these technologies are.

Mario Giacomelli (Italian, b. 1925) His grainy, graphic, distanced images of playful young seminary priests of 1962 are his signature work, but from the 1950s he also photographed farmed landscapes with a similar sense of pattern and of their symbolic importance as constants in Italian culture. Less known are his series on the mentally ill, cripples at Lourdes, and the 1974 famine in Ethiopia.

Ralph Gibson (American, b. 1939) In his best-known books, including *Days at Sea*, 1974, enigmatic sequences of high-contrast photographs, themselves containing irrational juxtapositions, reflect Surrealism as well as inspiration from Brandt, Frank, and Klein. Gibson published his volumes at Lustrum Press, which he founded in 1969, an instance of the importance of fine book publishing to camera work from the 1970s on. He was an assistant to Lange, 1961, and to Frank in his film making in 1967-69.

Laura Gilpin (American, 1891—1979) *The Enduring Navaho*, her work of 1950-54, represents Gilpin's best-known photography. She attended the Clarence White School from 1916-18. Her photographs were shown in Copenhagen and London in 1920 and 1921 and in a solo exhibit in New York In 1924. That year she photographed tribal ruins in the Southwest, and she created and financed photo-illustrated booklets on the Pikes Peak region, 1925, and Mesa Verde National Park, 1927. In 1942-45 she was a photographer for the Boeing aircraft company; and for a 1949 book on the Rio Grande she photographed the extent of the river, partly from an airplane. Rediscovered by feminists in the 1970s, she received a Guggenheim fellowship at age 84.

David Hockney (American, b. Great Britain, 1937), a sunny-spirited Matissean artist, was first identified with Pop painting, but has innovated in media from printmaking and set design to Polaroid photography and photo-collage. That last experiment, concentrated in 1982-86, helped trigger his recent, controversial writings on perspective in Western art and led to his photographic masterpiece, the nearly 7 x 10-ft. "Pearblossom Hwy," 1986. This exploded perspective of a California landscape conveys the sensations of driving through it, embodying Picasso's conception that visual experience is a composite of shifting views (or individual snapshots for Hockney) focused by interest and inflected by concept and memory. His cheerful photo-collage demolishes the one-point perspective inherent in a single photograph and in most Western art through the 19th century and intensifies the sensations of seeing across time and space.

Eikoh Hosoe (Japanese, b. 1933) has been one of the acknowledged leaders in Japanese art photography since 1960, especially in its dialogue with U.S. modernist traditions of depicting the nude. In his first book, *Man and Woman*, 1960, beautifully printed black-and-white images of male and female torsos, arms, and breasts were abstracted in their close-ups in undefined space, but sexually charged in their taut, dance-like juxtapositions. The book inspired the famed novelist Yukio Mishima to invite Hosoe to photograph him. The result of their collaboration was *Barakei* (Ordeal by Roses), 1963, which made Hosoe's international reputation. The theme of Japan and the West came forward in *Kamaitachi*, 1969, where Hosoe turned a Japanese folktale of villagers spellbound and injured by an evil wind into an allegory of the World War II atomic bombing of Hiroshima and Nagasaki and the subsequent U.S. military occupation. In *Embrace*, 1971, Hosoe resumed the theme of the nudes, now with a dark muscular model and ivory-skinned ones. In *Luna Rosa*, 2000, the nude studies originated in photographic workshops he taught in the U.S. in 1990-96, and most were set outdoors and then solarized in processing. In architectural photography, Hosoe depicted Hiroshima and its memorials, as well as the fantastic buildings by of the Spanish fin-de-siècle architect Antoni Gaudí.

Graciela Iturbide (Mexican, b. 1942) A peasant matriarch crowned with five iguanas is the cover of her *Juchitán, Town of Women*, 1989, and her best-known image. Iturbide, like her teacher Bravo, intended to counter stereotypes of Mexicans and to convey the vitality of folklore and pre-Conquest traditions among her people. Her unsentimental work on Mexicans in East Los Angeles likewise heralds their resilience and rich interior lives.

Seydou Keita (Mali, 1923–2001) Bold personalities and patterns of dress and backdrops vie for attention in his commercial portraits, made from 1945 through Mali's independence from France in 1960 and beyond. Old Western studio conventions obtain, but his sitters are collaborators, not exotics, and assert their identity and status —businessmen, boxers, sisters—through their Westernized or traditional dress and their composure, which Keita renders in full detail.

Gyorgy Kepes (American, b. in Hungary, 1906-2001) Collaboration and cross-fertilization among media and between art and technology were watchwords for this artist, graphic designer, educator, and author (*The Language of Vision*, 1944, is best known). He worked with Moholy-Nagy in Berlin from 1930 and at the New Bauhaus, Chicago, where he headed the light and color workshop; his own photography and his lessons stressed New Vision experiment and photograms. In 1946 he joined MIT and in 1967 founded the Center for Advanced Visual Studies, to foster interaction between artists and scientists that would result in new public art forms. He continued exploring photography's potential, using the Polaroid 20 x 24-in. camera in the early '80s.

Gustav Klucsis (Russian, 1895–1944) In revolutionary and Communist Russia in 1918-39, his photomontage and photography animated everything from postcards, book covers, and posters to combination news kiosks/speaker tribunes and temporary displays of building-size portraits of Stalin. Collaborating with his wife, Valentina Kulagina, he produced agitprop alive with dynamic abstract shapes as well as media images. Inspired by El Lissitzky, the couple aimed to communicate with the illiterate, though their Constructivist aesthetic had high art sources.

Germaine Krull (Polish, 1897–1985) An acme of Machine Age camera work is her *Métal*, 1928, a portfolio of her uncaptioned photographs of French and Dutch engineering feats. Devices from Soviet cinema and the New Vision, such as extreme vantage points and superimposed images, made many of the sites unrecognizable: her so-called "dance of the metal nudes" celebrated the marriage of industry and humanity.

Helen Levitt (American, b. 1913), a New York "street" photographer before the term was coined, met the 35mm master Cartier-Bresson in 1935, and began photographing with a Leica the following year in New York's East Harlem and other poor communities. Her first solo show took place in 1943, and she was recognized for her quick, unsentimental eye for spontaneous ballets of social interaction, especially among children. In 1948-59 she devoted herself to filmmaking, collaborating on *In the Street* (1945-46) and *The Quiet One* (1946-47). She returned to photography in 1959 on receiving the first of three Guggenheim fellowships; her best-known book, assembled with novelist-critic James Agee, is *A Way of Seeing*. Her book *In the Street* gathers her World War II–era photographs of children's chalk drawings on city sidewalks—made before spray paint turned this droll form of preteen expression into a gang activity.

Loretta Lux (German, b. 1969) Her big-headed, pretty Aryan children stare at us dolefully from digitally altered "portraits" in mid-20th-century pastels. Skirting the extremes of kitschy nostalgic charm and "Bad Seed" menace, these unsettling photographs suggest that the blankness of both childhood and much portrait photography is a screen inviting our projections.

Ralph Meatyard (American, 1952—1972) Childhood as strange territory concerned this Southern Gothicizing poet-photographer, an optician who on weekends staged his offspring in abandoned houses or graveyards with masks, mirrors, doll parts, etc. He studied with curator-photographer Van Deren Coke in 1954 and Minor White in 1956 and had his first solo show in 1959: all this marked him as an early master of the grotesque and of directorial photography, in critic A.D. Coleman's terms.

Ray Metzker (American, b. 1931) studied at the Illinois Institute of Technology with Callahan and was a longtime teacher of New Bauhaus ideas at the Rhode Island School of Design and in Philadelphia. He has consistently expanded the image-making potential of camera technology and photographic seeing since the 1960s, when he made "mosaics," serial compositions of film strips of abstracted nudes or street scenes, which defied the single fixed-frame image. Strips and negatives of different sizes, but related subjects, when printed together became spatially intriguing compositions; variable focus in the *Pictus Interruptus* series made some picture elements mysteriously unidentifiable; landscapes that were overexposed resembled silvery all-over paintings.

Pedro Meyer (Mexican, b. Spain, 1935) This socially concerned photographer of the 1970s began digitally altering his expressive prints in the 1990s, the better to interpret Mexican peasant life in its cultural and political complexity. Part of the First Colloquium of Latin American Photographers in Mexico City, 1978, he has also supported the field in seeking Latino identity.

Duane Michals (American, b. 1932) His cinematic series of five or more photographs in narrative form began in the 1960s and concerned elemental poetic themes—life, death, love, chance, humanity in nature. Self-taught and inspired by the Surrealists Magritte, Balthus, and de Chirico and poet Walt Whitman, he broke period art rules with his spare but obviously staged scenes. "You're either defined by the medium or you redefine the medium in terms of your needs." From the '70s Michals wrote on his black-and-white prints, and in the '80s his work reflected art world mourning for AIDS deaths and protests against right-wing repressions. His current work is whimsical or more openly personal than before, risking sentimentality and still defying norms in camera art.

Boris Mikhailov (Ukrainian, b. 1938) With the scathing satire of Rabelais, he has scored the individual–state relation in Russia since the 1970s, and especially as his former country fractured and moved from Communism to laissez-faire capitalism in the 1990s. He chose photography when his nude studies of his wife were found, termed pornography, and used to oust him from his engineering job. Since then he produced the Red Series, 1968-75, in which Soviet symbols contrast with daily life around them; the Private Series, where officialdom penetrates clubs and even apartments; Crimean Snobbery; and Case History, 1991, on the homeless produced by today's Russia. For the last, his most striking and perhaps his most important series, he paid derelicts of all ages to disrobe and show him their scars, needle tracks, and so on, stating that the coercion of money is the basis of the new social contract.

Lee Miller (British, b. U.S.A., 1907–1977) Man Ray's assistant, collaborator, lover, and subject, this beautiful ex–fashion model made Surrealist studies and incisive portraits in the 1930s and unsparing documents in World War II. She covered the Blitz as a member of the London war correspondents corps and for British *Vogue*; and as accredited to the U.S. Forces, she photographed the liberation of Paris and the camps at Buchenwald and Dachau.

Andrea Modica (American, b. 1960) Sensitive portrayals of blue-collar family life in rural upstate New York composed *Treadwell*, 1996, by this Yale graduate, an adept in platinum printing from 8 x 10-in. negatives. *Barbara*, 2004, followed an obese diabetes sufferer in Treadwell from adolescence to her death at age 22.

Tina Modotti (Italian, 1896—1942) That a flower photograph by Modotti broke auction records is no surprise: her prints are rare and few because her career in art photography was short, 1922-30; she was taught by the renowned Edward Weston, one of her lovers; her life intersecting revolution and wars and her premature death under mysterious circumstances have the stuff of romance; and, not least, her photographs combine boldly modernist form, liberal-leftist political symbolism, and beautiful printing.

Modotti emigrated from Italy to the U.S. in 1913, and married in 1917. As a bit-part actress and model, she met Weston in Hollywood. When her husband died in Mexico City in 1922, she and Weston moved there and became a part of the art world inspired by the Mexican revolution. The subjects of her photographs became the Mexican people, portraits, and emblematic still lifes. In 1926 she and Weston photographed Mexican art for the book *Idols Behind Altars* and she started contributing to the magazine *Mexican Folkways*. She advocated for the peasant in her photographs, shown in Mexico and California and published in the radical journal *El Machete*. In 1930 her activism led to her deportation to Europe. In Berlin Modotti became a photojournalist and soon went to Moscow, where she photographed for the Communist cause. Despite growing acclaim for her Mexican photographs, she gave up the medium to serve the Party. In 1936 she was a nurse in the Spanish Civil War. After Franco's victory, she fled to Mexico and gained asylum there in 1941. On January 5, 1942, she was found dead in a taxicab. The official cause given was heart failure: she was 45.

Abelardo Morell (American, b. Cuba, 1948) His teaching of photography since 1983 (at Massachusetts College of Art) and his first child's birth in 1986 inspired his best-known images—demonstrations of basic tools like the camera obscura (published as A Camera in a Room, 1995) and kid's–eye views of the world. Face to Face, 1998, engaged Old Master portraits in Boston's Gardner Museum, while A Book of Books, 2002, explored novel ways of regarding the printed page there and at the Boston Atheneum Library. "I think a lot about language—the idea of how things are communicated," said this émigré. "I am really rebelling against ... the standard way in which things are supposed to be looked at."

Barbara Morgan (American, 1900–1992) grew up in Southern California, and studied painting and printmaking at UCLA. After marriage to a photographer, she took up the camera and worked in portraiture, still lifes, photomontage "light drawings" (photograms made with a beam of light), and dance photography. Best known for depicting modern dance, she photographed Merce Cunningham, Erick Hawkins, José Limón, Doris Humphrey, and other famous American leaders in the field performing their most celebrated compositions. Morgan's best-known prints depict Martha Graham and her dancers performing in the photographer's studio, a 1936 commission from the company.

Yasumasa Morimura (Japanese, b. 1951) Presenting himself as Marilyn Monroe in her *Playboy* pinup, Cindy Sherman in one of her Centerfolds, and so on, this gender-bending manipulator of digital effects lets us recognize both his famous camera sources and his full-color artifice, as he sends up stereotypes of sex and race and theatrical conventions in photography. His masquerades are oddly touching.

Vik Muniz (Brazilian, b. 1961), an antic wit and gifted draftsman, deflates art world solemnity by rendering known photographs in unlikely materials—poured chocolate syrup, for example, for Hans Namuth's shots of Pollock painting. In general, he points out that all representation, no matter how "real," is a matter of conventions.: he hired a skywriter to draw a cartoon cloud in the sky and then photographed it.

Catherine Opie (American, b. 1961) Since she received her M.F.A. from CalArts (California Institute of Arts, Valencia) in 1988, she has been recognized since the late '80s for a variety of work, from sympathetic full-color portraits of members of fringe social groups to black-and-white scenes of unpopulated city streets in the Conceptual tradition of Bernd and Hilla Becher. Best known are her photographic efforts to confront stereotyping of lesbians and homosexuals, as well as ethnic minorities.

Bill Owens (American, b. 1938) For the deadpan *Suburbia*, 1972, this Bay Area photojournalist pictured and interviewed uprooted baby boomers raising families in new subdivisions—a consumer culture with stay-at-home moms and Vietnam on TV. While extending FSA sociology to the middle class, Owens set a tone between sympathy and comedy.

Martin Parr (British, b. 1952) Mesmerized by the comic vulgarity and carnal sins of Britain's working classes, Parr began as a Hogarth of the camera in the early 1980s and is rapidly becoming a Goya with color film. His transformation—and that of his subjects—from the government of Margaret Thatcher to that of Tony Blair can be charted in his prolific publishing, which includes 14 books from 1982 to 2002. He pioneered in uniting photojournalism in vivid color with British traditions of social comment, from Brandt's *The English at Home* to television's Monty Python.

Parr studied at Manchester Polytechnic Institute in 1970-73. His first widely recognized book, and his favorite project, was *The Last Resort*, 1986, showing daytrippers at the dilapidated, overcrowded seaside spa of New Brighton. In *The Cost of Living*, 1989, his mood was darker: the leisure he showed of British suburbanites was sour with social striving.

For his 1989 book *One Day Trip*, Parr followed Brits to France for free-for-all shopping sprees. Since then, his perspective has broadened to cover mass consumption across the obese First World, and his topics include mindless group tourism, heart-stopping fast food, and pets in hats and sunglasses. The high definition of his images and his close-up views implicate the viewer in his catalog of modern bad habits in a global capitalist economy.

Arnulf Rainer (Austrian, b. 1929) Austrian Expressionism is revived in his savagely overpainted photographs, most powerfully of himself, from the mid-1950s on. Playing the madman, fool, or child, this painter-printmaker-photographer was "not embarrassed to use psychotic talent," he said, while his defacements generalized his portraits as Everyman. Found photographs of corpses, wooden crucifixes, and Hiroshima were other raw materials in work that connects Surrealism and *art informel* with the psychodramas and Body art initiated in the 1970s.

Marc Riboud (French, b. 1923) Both Cartier-Bresson and Capa welcomed him in 1953 as one of the first members of Magnum. Cartier-Bresson recognized his sense of design, Capa his sense of adventure, and they were proved right by Riboud's extended photo-explorations of China, and his reportage in North Vietnam while the United States was at war in South Vietnam. Riboud's two signature photographs suggest the strengths in photojournalism at mid-century: the ability to summarize a complex issue in a memorable visual form (a young woman confronts army bayonets with a flower during U.S. protests against the Vietnam war) and the play with cultural stereotypes in an era eager for international knowledge (the six windows of an antique shop frame and beautify the street life of Old Beijing). The Overseas Press Club gave awards for his books *The Three Banners of China*, 1966, and *The Face of North Vietnam*, 1970; while the Metropolitan Museum of Art, New York, exhibited his photographs of China as *Behind the Great Wall*, 1972.

Though identified with "decisive moment" black-and-white photography, Riboud also used color, notably in photographing the Huang Shan mountains of China. These tributes to the ancient Chinese scroll painting tradition were published in *Capital of Heaven*, 1990. A recent book is *In China*, 1996. He expresses no politics beyond empathy for the everyday people he encounters. "Photography must not try to be persuasive. It "cannot change the world, but it can show the world, especially when it is changing."

Jan Saudek (Czech, b. 1935) The hearty humor and sexuality of Middle European folk tales enlivens his studio tableaux, whose 19th-century flavor is heightened by their skillful hand-tinting.

Lorna Simpson (American, b. 1960) is recognized for large impressive multi-panel works combining enigmatic phrases with repeated photographs of African-American motifs such as cornrows or a young black woman in a shift seen from behind. In handsome, Conceptually based form, they implicate the viewer in U.S. histories of racism and sexism.

Aaron Siskind (American, 1903–1992) His best-known images mirror the transition from social concern in the 1930s to introspection after World War II. His works of the 1940s are counterparts of some canvases by New York School painters—his friends—who turned to abstraction to convey deep human meanings. In 1933 Siskind joined the Film and Photo League, a cultural offshoot of the Workers International Relief organization, which documented the social ills of the decade. "The Harlem Document," conceived by the black writer Michael Carter, included photographs by Siskind of 1932-36 that showed the alienation of ghetto dwellers.

In sharp-focus studies Siskind made of found objects on Martha's Vineyard and Gloucester, Massachusetts, in 1943-44, he produced photographic parallels to the early Abstract Expressionism of Barnett Newman and Willem de Kooning. His extreme close-ups of torn posters, peeling paint, and graffiti abstracted transformed detritus them into metaphors for the human condition, for lonely self-awareness within a transient universe. In the 1953 series "Pleasures and Terrors of Levitation," Siskind photographed teenagers diving and then reduced them to silhouettes against whiteness through his cropping and printing. The series seemed to summarize the idea that to assert human existence was to leap into the void.

As a teacher, Siskind influenced a generation—Callahan invited him to the Institute of Design at the Illinois Institute of of Technology in 1951-71, and he taught again with Callahan at the Rhode Island School of Design in 1971-76. He was a founding member of the Society for Photographic Education in 1963-64, and of the Visual Studies Workshop in Rochester, New York, in 1969.

Sandy Skoglund (American, b. 1946) came to photography through studio art and exposure to Pop and Conceptualism, like many American camera artists in the late 1970s. Her 1978 series of boldly colorful still lifes of food expanded in scale and elaboration, until she was creating room-sized installations of nightmarish tableaux—a child's bedroom is invaded by dozens of huge goldfish, purple "radioactive" cats swarm over a household—which she then photographed. The installation, the objects she sculpted in epoxy resin, and the photograph became the total work of art, as she demonstrated at the Whitney Biennial in 1981.

Josef Sudek (Czech, 1896–1976) A master printmaker in his half-century-long career, Sudek gave Pictorialist aesthetics an extended life in Prague, the medieval and Baroque capital where he spent his eccentric adult life under Communism. His biography sheds light on his anachronistic style of willful introspection: following a World War I injury his right arm was amputated.

In 1922 he enrolled in the School of Graphic Arts in the Czech capital and received an old-fashioned training in photography. To uphold "straight," unmanipulated camera work, he and the other rebels—including Jaromir Funke, Jaroslav Rössler, and Frantisek Drtikol—founded the Czech Photographic Society in 1924.

During the Nazi occupation of Czechoslovakia he began the series "From the Window of My Atelier," 1940-54, which would include his best-known photographs. In 1940 he also started contact printing to ensure maximum control over the details and subtle gray scale framed by a new motif: the window—a window etched with rain or snow, looking over a deserted garden in Prague's old quarter. In the early 1950s he found an 1894 Kodak panoramic camera, and in 1959 he published a series of Prague cityscapes. In the 1960s he began his "Labyrinths" series, of his lifetime accumulations of papers and memorabilia.

Hiroshi Sugimoto (Japanese, b. 1948) Aspects of theater and Conceptual art unite the elegant, visually disparate black-and-white series by this Tokyo-born artist, who came to New York in 1973. His best-known works include his antique movie theater interiors (begun 1978), for which he exposed his film for exactly the length of the film on view (turning the screen white and depopulating the theater); and his seascapes (from 1980), which depict particular seas around the world but show only horizon lines, recalling Mark Rothko's last, Zen-like abstractions. Sugimoto's most recent series, on old mathematics models, questions the relations between science and art, just as his earlier work overturned expectations about time and truth in photographs.

Shoji Ueda (Japanese, 1913—2000) Children and nudes in "the theater of dunes" of his birthplace, Tottori prefecture, populate his best-known work, of 1945-51. Over a 70-year career, he blended European modernist traits with Japanese pictorial traditions, and was honored in Japan from the 1930s and active in photographers' associations there. He began to win recognition in Europe in the late 1970s.

Jerry Uelsmann (American, b. 1934) As early as 1959 he fought the dominant Stieglitz-Weston tradition with his combination prints, which seamlessly united contradictory realities for poetic and humorous effect. His crystalline images of levitating trees and libraries with cloud ceilings were "post-visualizations," he said, creations of "in-process discovery" in the darkroom. A longtime professor at the University of Florida and a founding member of the Society for Photographic Education, 1962, he was first recognized for the white magic of his work in 1967.

Roman Vishniac (American, b. Russia, 1897-1990) To help fundraising efforts for poor Jews, he photographed with a concealed camera in ghettos in Poland, Hungary, Russia, and Romania in 1935-38, making some 5,000 pictures. His often intimate images revealed the lifestyles and hierarchies of Orthodox families and their ancient quarters just before the Holocaust. In 1940, he escaped to New York and made microphotographs as a second career, drawing on his training in Moscow in the biological sciences.

Carrie Mae Weems (American, b. 1953), is best known for confronting racism, sexism, and class differences in America through her camera work, photographs she appropriates, and her combinations of them with provocative texts she adds. She received her undergraduate degree from CalArts (the California Institute of Arts, Valencia); her M.F.A. from the University of California, San Diego; and for three years studied folklore at the University of California, Berkeley. Though first a "street" photographer in the spirit of Winogrand, she began using various Postmodern strategies in the 1980s to make her points. In the 1980s she photographed at Sea Island, Georgia, home of a colony of runaway slaves; and in the early '90s she juxtaposed her copies of 1850s ethnological photographs of American blacks with mournful abolitionist texts of that period.

Joel-Peter Witkin (American, b. 1939) was one of the most-dis"cussed art photographers of the '80s for his distressed prints picturing amputees, sideshow performers, severed body parts, transsexuals, and so on, which he composed with Old Master monumentality. In this glamour-obsessed decade, he contemplated the primal realities of abnormality and death, and since then has staged museum painting using a cast of dwarfs and other Others, addressing the transformations possible to the camera and the brush.

PHOTOGRAPHY CREDITS

Pg. 4-5: Magnum Photos; **Pg. 6-7:** Courtesy Matthew Marks Gallery, New York and Gallery Monika Sprueth, Philomene Magers, Cologne/ARS, NY/VG Bild-Kunst, Bonn; **Pg. 8-9:** Art Department; **Pg. 10-11:** National Geographic Image Collection; **Pg. 12-13:** VII Photo Agency; **Pg. 14-15:** Reza/Webistan; **Pg. 16-17:** National Geographic Image Collection; **Pg. 18-19:** Art + Commerce; **Pg. 21:** Martin Parr/Magnum Photos; **Pg. 22:** Steve McCurry/Magnum Photos; **Pg. 24:** National Geographic Image Collection; **Pg. 26:** Courtesy Bonni Benrubi Gallery, NYC; **Pg 27. & 28:** National Museum of Photography, Film & Television/ Science & Society Picture Library; **Pg. 30:** National Museum of Photography, Film & Television/Science & Society Picture Library (top), Harry Ransom Humanities Research Center/The University of Texas at Austin (bottom); **Pg. 31:** George Eastman House; **Pg. 32:** George Eastman House; **Pg. 35:** R.M.N/ Art Resource; **Pg. 37:** © Museum Associates/Los Angeles County Museum of Art; **Pg. 38:** The J. Paul Getty Museum, Los Angeles; **Pg. 40:** Courtesy of Andrew Smith Gallery; **Pg. 43:** The J. Paul Getty Museum, Los Angeles; **Pg. 44-5:** Courtesy of Scheinbaum & Russek; **P. 47:** Commerce Graphics Ltd., NYC; **Pg. 49:** © Esto Photographics Inc.; **Pg. 50:** © The Solomon R. Guggenheim Foundation, New York; **Pg. 52-3:** Courtesy Matthew Marks Gallery, New York and Gallery Monika Sprueth, Philomene Magers, Cologne/ARS, NY/VG Bild-Kunst, Bonn; **Pg. 55:** Robert Polidori; **Pg. 56-7:** Jan Staller; **Pg. 59:** Canadian Centre for Architecture, Montreal; **Pg. 60:** Courtesy of Fraenkel Gallery, San Francisco; **Pg. 61:** Spencer Collection, The New York Pubic Library, Astor, Lenox and Tilden Foundations; **Pg. 62:** Courtesy of Pace MacGill Gallery, New York; **Pg. 64:** V&A Images/The Victoria & Albert Museum, London; **Pg. 67:** George Eastman House; **Pg. 68:** Hill & Adamson Collection, University of Glasgow Library; **Pg. 70:** George Eastman House; **Pg. 73:** Brady-Handy Photograph Collection/Library of Congress; **Pg. 75:** Musee D'Orsay/R.M.N./Art Resource; **Pg. 76:** The J. Paul Getty Museum, Los Angeles; **Pg. 79:** George Eastman House; **Pg. 80:** Photographie J.H. Lartigue/© Ministere de la Culture-France/AAJHL; **Pg. 81** Library of Congress; **Pg. 82:** © Hurrellphotos.com; **Pg. 85** " Die Photographische Sammlung/SK Stiftung Kultur- August Sander Archiv, Cologne; ARS,NY, 2005; **Pg. 87**: Camera Press, London; **Pg. 89:** Magnum Photos; **Pg. 90:** ©1991 The Richard Avedon Foundation; **Pg. 92:** Stephen Frank; **Pg. 93:** The Polaroid Collection with permission from Pace MacGill Gallery, New York; **Pg. 94:** George Eastman House with permission from Pace MacGill Gallery, New York; **Pg. 96-97:** Courtesy Fraenkel Gallery, San Francisco; **Pg. 98-99:** Contact Press Images; **Pg. 101** © The Solomon R. Guggenheim Foundation, New York , fractional Gift, Nina and Frank Moore, 1999; **Pg. 102:** Harry Ransom Humanities Research Center/The University of Texas at Austin; **Pg. 103:** National Geographic Image Collection; **Pg. 104-5:** (2) Library of Congress, Prints and Photographs Division; **Pg. 106:** National Geographic Image Collection; **Pg. 108:** © Sterling and Francine Clark Art Institute, Williamstown, Mass.; **Pg. 109:** Abbot-Charnay Collection/American Philosophical Society; **Pg. 110:** Courtesy of the Royal Photographic Society Collection at the National Museum of Photography, Film & Television/ Science & Society Picture Library; **Pg. 112-3:** Wm. B. Becker Collection/ American Museum of Photography; **Pg. 115:** The J. Paul Getty Museum, Los Angeles; **Pg. 116:** National Geographic Image Collection; **Pg. 118-9:** Library of Congress, Prints and Photographs Division, LC-USZ62-51649; **Pg. 121:** Miriam and Ira D. Wallach Division of Art/ New York Public Library; **Pg. 123:** © The Rephotographic Survey: (Top) Library of Congress, (middle) Rephotographic Survey Project, (bottom) Third View Project; **Pg. 124-5:** National Geographic Image Collection; **Pg. 127:** George Eastman House; **Pg. 129:** Paul Caponigro; **Pg. 131:** © Ansel Adams Publishing Rights Trust/Corbis; **Pg. 132-3:** © Carol Beckwith and Angela Fisher; **Pg. 135:** Courtesy of Joel Sternfeld and Luhring Augustine Gallery, NYC; **Pg.137:** © Richard Misrach; **Pg. 138-9:** National Geographic Image Collection; **Pg.140:** © James D. Balog; **Pg. 141** National Geographic Image Collection; **Pg. 142:** Library of Congress, Prints and Photographs Division, LC-DIG-stereo-ls00455; **Pg. 143:** Library of Congress, Prints and Photographs Division, LC-USZ62-121713; **Pg. 144:** © Estate Brassai/R.M.N./Art Resource; **Pg. 147:** Library of Congress, Prints and Photographs Division, LC-USZ62-99204; **Pg. 148-9:** Magnum Photos; **Pg. 151:** Library of Congress, Prints and Photographs Division, LC-USZC4-9340; **Pg. 153:** The J. Paul Getty Museum, Los Angeles; **Pg. 154** Brady Civil War Photograph Collection/ Library of Congress, Prints and Photographs Division, LC-Dig-cwpb-01085; **Pg. 156:** George Eastman House; **Pg. 158:** Penny de los Santos/National Geographic Image Collection; **Pg. 159:** National Museum of Photography, Film & Television/ Science & Society Picture Library; **Pg. 161:** Wellcome Library, London; **Pg. 162:** Museum of the City of New York; **Pg. 164-5:** Library of Congress, Prints and Photographs Division, LC-DIG-nclc-00980; **Pg. 167:** Library of Congress, Prints and Photographs Division, LC-USZ62-120664; **Pg. 168:** Library of Congress, Prints and Photographs Division, LC-DIG-ppmsca-08167; **Pg. 172-3:** © Estate of Andre Kertesz, Collection J. Paul Getty Museum, Los Angeles; **Pg. 175:** Magnum Photos; **Pg. 177:** Magnum Photos; **Pg. 178:** Magnum Photos; **Pg. 180:** International Center of Photography/Getty Images; **Pg. 181:** Office of War Information Photograph Collection/Library of Congress, Prints and Photographs Division, LC-USF34-T01-039623-D; **Pg. 182:** Courtesy Kathy Ryan; **Pg. 183:** Time & Life Pictures/Getty Images; **Pg. 184:** Office of War Information Photograph Collection/Library of Congress, Prints and Photographs Division, LC-USF34-T01-009097-C; **Pg. 186:** The J. Paul Getty Museum, Los Angeles; **Pg. 188:** Time & Life Pictures/Getty Images; **Pg 190-91:** Getty Images; **Pg. 193:** Anna Khaldei/George Eastman House; **Pg. 194-5:** © Michael P. Mattis Collection; **Pg. 197:** Magnum Photos; **Pg. 198:** Harry Ransom Humanities Research Center/The University of Texas at Austin; **Pg. 199:** Center for Creative Photography/ Black Star; **Pg. 201:** Office of War Information, Photograph Collection/Library of Congress, Prints and Photographs Division, LC-USF34-T01-013407-C; **Pg. 202:** Magnum Photos; **Pg. 203:** Courtesy Larry Clark and Luhring Augustine Gallery, NYC; **Pg. 204:** AP/Wide World Photos; **Pg. 206:** Magnum Photos; **Pg. 208:** Time & Life Pictures/Getty Images; **Pg. 210:** Contact Press Images; **Pg. 211:** Magnum Photos; **Pg. 212:** VII Photo Agency; **Pg. 213:** Magnum Photos; **Pg. 215:** Contact Press Images; **Pg. 216:** Polaris; **Pg. 218-9:** GerdLudwig; **Pg. 220:** Magnum Photos; **Pg. 222-3:** Contact Press Images; **Pg. 224:** Magnum Photos; **Pg. 225:** Mary Ellen Mark; **Pg. 226-7:** National Geographic Image Collection; **Pg. 228:** © Diana Walker; **Pg. 229:** National Geographic Image Collection; **Pg. 231:** National Geographic Image Collection; **Pg. 232:** George Eastman House; **Pg. 235:** Courtesy of the

Royal Photographic Society Collection at the National Museum of Photography, Film & Television/Science & Society Picture Library; **Pg. 236:** George Eastman House; **Pg. 238-9:** George Eastman House; **Pg. 241:** The Metropolitan Museum of Art, Gilman Collection, Purchase, The Annenberg Foundation Gift, 2005 (2005.100.370). Photograph © 1993 The Metropolitan Museum of Art; **Pg. 242:** Courtesy of the Royal Photographic Society Collection at the National Museum of Photography, Film & Television/ Science & Society Picture Library; **Pg. 243:** Library of Congress, Prints and Photographs Division, LC-USZ62-67659; **Pg. 245:** Library of Congress, Prints and Photographs Division, LC-USZC4-4635; **Pg. 247:** Courtesy of the Royal Photographic Society Collection at the National Museum of Photography, Film & Television/ Science & Society Picture Library; **Pg. 249:** Courtesy of the Royal Photographic Society Collection at the National Museum of Photography, Film & Television/ Science & Society Picture Library; **Pg. 250-1:** Library of Congress, Prints and Photographs Division; **Pg. 252-3:** Libnrary ofCongressLC-DIG-ppmsc-04838; **Pg. 254:** The J. Paul Getty Museum, Los Angeles; **Pg. 257:** George Eastman House; **Pg. 258:** Courtesy of the Royal Photographic Society Collection at the National Museum of Photography, Film & Television/ Science & Society Picture Library; **Pg. 259:** Courtesy of Alain Scheibli; **Pg. 260:** © 2005 Artists Rights Society, NY/VG Bild-Kunst, Bonn/The J. Paul Getty Museum, Los Angeles; **Pg. 263:** San Francisco Museum of Modern Art/© Aperture Foundation, Inc. Paul Strand Archive; **Pg. 265:** ©The Lane Collection/Courtesy Museum of Fine Arts, Boston; **Pg. 266:** © 1981 Arizona Board of Regents/Center for Creative Photography/The J. Paul Getty Museum, Los Angeles; **Pg. 268-9:** © The Imogen Cunningham Trust; **Pg. 271:** © 2005 Artists Rights Society, New York/VG Bild-Kunst, Bonn/ Art Resource; **Pg. 272:** © Estate of George Grosz/Licensed by VAGA/New York, Digital Image ©The Museum of Modern Art/Licensed by SCALA/Art Resource, New York; **Pg: 273:** George Eastman House; **Pg: 275:** The Metropolitan Museum of Art, Gilman Collection, Purchase, Ann Tenenbaum and Thomas H. Lee Gift, 2005(2005.100.147); **Pg. 276:** © 2005 Karl Blossfeldt Archiv/Ann u. Jurgen Wilde, Cologne/Artists Rights Society, NY; **Pg.278:** © 2005 Artist Rights Society, New York/VG Bild-Kunst, Bonn/ George Eastman House; **Pg. 279:** Collection of Alexander Kaplen, Courtesy of Ubu Gallery, New York; **Pg. 281:** Rodchenko & Stepanova Archives/Schickler Fine Arts; **Pg. 283:** ©2005 Artist Rights Society, New York/VG Bild-Kunst, Bonn/ Victoria & Albert Museum, London; **Pg. 284:** Bill Brandt Archive Ltd., London; **Pg. 286-7:** © Man Ray Trust/ARS/ADAGP/The J. Paul Getty Museum, Los Angeles; **Pg. 289:** George Eastman House; **Pg. 291:** Magnum Photos; **Pg. 293:** Nickolas Muray Photo Archives/George Eastman House; **Pg. 294:** Tepper Takayama Fine Arts, Boston; **Pg. 298:** Thomas Hoepker/Magnum Photos; **Pg. 300-01:** © 1984 The Estate of Garry Winogrand/ The J. Paul Getty Museum, Los Angeles; **Pg. 303:** Courtesy of Fraenkel Gallery, San Francisco; **Pg. 305:** © William Klein/Courtesy Howard Greenberg Gallery/NYC; **Pg. 307:** Tepper Takayama Fine Arts, Boston; **Pg. 309:** © Henri Dauman/DaumanPictures.com; **Pg. 310:** © William Wegman; **Pg. 312-3:** © 1994 John Baldessari & Gemini G.E.L.; **Pg. 315:** © Marie Cosindas/Courtesy Robert Klein Gallery; **Pg. 316:** © 2005 Eggleston Artistic Trust/Courtesy Cheim & Read Gallery, New York; **Pg. 320-1:** © The Cocktail Party/Sandy Skoglund; **Pg. 322:** © Stephen Shore/Courtesy of 303 Gallery, NYC; **Pg. 323:** © Cindy Sherman/Gift of Jeffrey Fraenkel/San Francisco Museum of Modern Art; **Pg. 325:** Courtesy of Mary Boone Gallery, New York/George Eastman House; **Pg. 326:** Ted Thai/Time Life Pictures/Getty Images; **Pg. 327:** Allan Tannenbaum/ Polaris; **Pg. 329:** © Duane Michals; **Pg. 330:** Solomon R. Guggenheim Museum, New York Gift, Robert Mapplethorpe Foundation, 1993; **Pg. 333:** Courtesy of Edwynn Houk Gallery, New York; **Pg. 334-5:** © Nan Goldin/San Francisco Museum of Modern Art/ Gift of Collectors Forum, Pam and Dick Kramlich. Norah and Norman Stone; **Pg. 337:** Solomon R. Guggenheim Museum, Purchased with funds contributed by the Harriet Ames Charitable Trust and by the International Director's Council; **Pg. 338-9:** Art Department; **Pg. 341:** Courtesy of Pace MacGill Gallery, New York; **Pg. 342:** Courtesy International Center of Photography; **Pg. 343:** Courtesy Janet Borden Inc., New York; **Pg. 344-5:** © Jeff Wall; **Pg. 347:** Courtesy Fraenkel Gallery, San Francisco; **Pg. 348-9:** © Doug & Mike Starn/Artist Rights Society, NYC/Courtesy Powerhouse Books; **Pg. 351:** Courtesy The Polaroid Corporation with permission by the Ansel Adams Publishing Rights Trust; **Pg. 352:** Courtesy of the artist; **Pg. 354:** Gift of Alden Scott Boyer/George Eastman House; **Pg. 355:** Library of Congress, Prints and Photographs Division, LC-USZC2-6029; **Pg. 358-9, 361, 362:** Condé Nast Archive/Corbis; **Pg. 364:** Courtesy G. Ray Hawkins and Christie's, New York; **Pg. 366:** Courtesy Herbert Matter Archive/Stanford University; **Pg: 368-9:** Sotheby's, London; **Pg. 370:** Art +Commerce; **Pg. 371:** Courtesy of Kent Gallery/Artist Rights Society, NYC; **Pg. 373:** Courtesy Howard Greenberg Gallery, NYC; **Pg. 374:** Courtesy Staley Wise Gallery, New York; **Pg. 377:** © Melvin Sokolsky/Harper's Bazaar; **Pg. 379:** ©1957 Richard Avedon Foundation; **Pg. 380:** Courtesy of Irving Penn and Condé Nast Archives/Advance Magazine Group; **Pg. 382:** Courtesy the Terence Donovan Archive, London; **Pg. 384:** © BertStern; **Pg. 385:** © The Helmut Newton Estate/Maconochie Photography; **Pg. 386:** Art + Commerce; **Pg. 388-9:** Courtesy Staley Wise Gallery; **Pg. 391:** Courtesy Little Bear Inc.; **Pg. 393:** Courtesy Herb Ritts Foundation, Los Angeles; **Pg. 394:** Art + Commerce; **Pg. 395:** Courtesy of Visionaire Magazine; **Pg. 396-7:** © Raymond Meier; **Pg. 398:** Art + Commerce; **Pg. 399:** Courtesy Andrea Rosen Gallery, New York; **Pg. 400:** Brendan McDermid/EPA/Sipa Press; **Pg. 402:** Harold & Esther Edgerton Foundation, 2005, Courtesy of Palm Press Inc.; **Pg. 404-5:** Bill Frakes and David Callow/Sports Illustrated; **Pg. 407:** The J. Paul Getty Museum, Los Angeles; **Pg. 408:** Pennsylvania Academy of the Fine Arts; **Pg. 409-10:** © Gary Schneider; **Pg. 412:** © Karen Kasmauski **Pg. 415:** © David Scharf; **Pg. 416-7:** Undersea Images Inc.; **Pg. 418:** National Geographic Image Collection; **Pg. 421, 422-3:** NASA; **Pg. 424:** National Museum of Photography, Film & Television/ Science & Society Picture Library; **Pg. 425:** © Albert C. Koetsier; **Pg. 426:** Tom Grill/Corbis; **Pg. 427:** Library of Congress; **Pg. 428:** Henry Groskinsky/Time Life Pictures/Getty Images; **Pg. 429:** Bernard Hoffman/Time Life Pictures/Getty Images; **Pg. 430:** Toshifumi Kitamura/AFP/Getty Images. Camera Icons provided by Getty Images and George Eastman House.

The Publishers have made every effort to trace copyright holders. We apologize for any omissions that may have occurred.

BIBLIOGRAPHY

THIS TEXT IS ESPECIALLY INDEBTED TO THE FOLLOWING SOURCES, WHICH CAN BE STRONGLY RECOMMENDED FOR FURTHER READING:

Davis, Keith F. *An American Century of Photography, from Dry-Plate to Digital,* 2nd ed. rev'd. Kansas City, MO: Hallmark Cards, 1999.

Goldberg, Vicki, ed. *Photography in Print: Writings from 1816 to the Present.* New York: Simon & Schuster, 1981.

Johnson, Brooks, ed. *Photography Speaks: 150 Photographers on Their Art.* Norfolk, VA: Chrysler Museum of Art/Aperture Foundation, 2004.

Marien, Mary Warner. *Photography: A Cultural History.* London: Laurence King, 2002.

Rosenblum, Naomi. *A World History of Photography,* rev'd. New York: Abbeville, 1997.

OTHER HELPFUL SURVEYS ARE:

Baldwin, Gordon. *Looking at Photographs: A Guide to Technical Terms.* Los Angeles, CA: J. Paul Getty Museum, 1991.

Green, Jonathan. *American Photography: A Critical History 1945 to the Present.* New York: Abrams, 1984.

Greenough, Sarah, et al. *On the Art of Fixing a Shadow: One Hundred and Fifty Years of Photography.* Washington, D.C.: National Gallery of Art, 1989.

Hambourg, Maria Morris, et al. *The Waking Dream: Photography's First Century.* New York: Metropolitan Museum of Art/Abrams, 1993.

Jeffrey, Ian. *The Photography Book.* London: Phaidon, 2000.

Rosenblum, Naomi. *A History of Women Photographers,* rev'd. New York: Abbeville, 1994.

Newhall, Beaumont. *The History of Photography from 1839 to the Present,* rev'd. New York: Museum of Modern Art, 1982.

Wells, Liz. *A Photography Reader.* London/New York: Routledge, 2003.

TEXTS THAT INFORM CHAPTERS 1-3 INCLUDE:

Castleberry, May, et al. *Perpetual Mirage: Photographic Narratives of the Desert West.* New York: Whitney Museum of American Art, 1996.

Edwards, Elizabeth, ed. *Anthropology and Photography, 1860-1920.* New Haven, CT: Yale University Press, 1992.

Hales, Peter Bacon. *Silver Cities: The Photography of American Urbanization, 1834-1915.* Philadelphia, PA: Temple University Press, 1983.

Haworth-Booth, Mark, ed. and intro. *The Golden Age of British Photography, 1839-1900.* New York: Aperture, 1984.

Howe, Kathleen S., and Carla Williams. *First Seen: Portraits of the World's Peoples, 1840-1870.* Santa Barbara: Santa Barbara Museum of Art, 2004.

Jussim, Estelle, and Elizabeth Lindquist-Cock. *Landscape as Photograph.* New Haven/London: Yale University Press, 1985.

Naef, Weston J., and James N. Wood. *Era of Exploration: The Rise of Landscape Photography in the American West, 1860-85.* Buffalo/New York: Albright Knox/Metropolitan Museum, 1975.

Pare, Richard. *Photography and Architecture, 1839-1939.* Montreal: Canadian Centre for Architecture, 1982.

Robinson, Corvin, and Joel Herschman. *Architecture Transformed.* MIT Press, 1987.

Ryan, James R. *Picturing Empire: Photography and the Visualization of the British Empire.* Chicago: University of Chicago Press, 1997.

Sandweiss, Martha A., ed. *Photography in Nineteenth-Century America.* New York: Abrams/Amon Carter Museum, 1991.

Scharf, Aaron. Pioneers of Photography. New York: Abrams for BBC, 1976.

FOR PHOTOJOURNALISM, CHAPTER 4, SEE FOR FURTHER INFORMATION:

Daniel, Pete, et al. *Official Images: New Deal Photographs.* Washington, D.C.: Smithsonian Institution Press, 1987.

Fralin, Frances. *The Indelible Image: Photographs of War— 1846 to the Present,* ed. Jane Livingston. Washington, D.C.: Corcoran Gallery of Art/Abrams, 1985.

Fulton, Marianne. *Eyes of Time: Photojournalism in America.* Boston, MA: New York Graphic Society/Little, Brown, 1988.

Goldberg, Vicki. *The Power of Photography: How Photographs Changed Our Lives.* New York: Abbeville, 1991.

Knightley, Phillip. *The First Casualty: From the Crimea to Vietnam—The War Correspondent as Hero, Propagandist, and Myth Maker,* rev'd. New York: Harcourt Brace Jovanovich, 2004.

Manchester, William. *In Our Times: The World as Seen by Magnum Photographers.* New York: American Federation of Arts/W.W. Norton, 1989.

Moeller, Susan D. *Shooting War: Photography and the American Experience of Combat.* New York: Basic Books, 1989.

Stott, William. *Documentary Expression and Thirties America.* New York: Oxford University Press, 1973.

Taylor, John. *Body Horror: Photojournalism, Catastrophe, and War.* New York: New York University Press, 1998.

Trachtenberg, Alan. *Reading American Photographs: Images as History, Mathew Brady to Walter Evans.* New York: Hill and Wang, 1989.

FOR PHOTOGRAPHY AS ART, CHAPTERS 5-7, SEE:

Ades, Dawn. *Photomontage,* rev'd. London: Thames & Hudson, 1986.

Burgin, Victor, ed. *Thinking Photography.* London: Macmillan, 1982.

Coleman, A.D. *Light Readings: A Photography Critic's Writings 1968-1978*. New York: Oxford University Press, 1979.

Foster, Hal, ed. *The Anti-Aesthetic: Essays on Postmodern Culture*. Port Townsend, WA: Bay Press, 1983.

Hambourg, Maria Morris, with Christopher Phillips. *The New Vision: Photography Between the World Wars*. New York: Metropolitan Museum/Abrams, 1989.

Jammes, André, and Eugenia Parry Janis. *The Art of the French Calotype*. Princeton, NJ: Princeton University Press, 1983.

Krauss, Rosalind, and Jane Livingston, eds. *L'Amour fou: Photography and Surrealism*. Washington, D.C.: Corcoran Gallery, 1985.

Livingston, Jane. *The New York School: Photographs 1936-1963*. New York: Stewart, Tabori & Chang, 1992.

Metropolitan Museum and Berger-Levrault. *After Daguerre. Masterworks of French Photography (1848-1900) from the Bibliothèque Nationale*. New York and Paris, 1981.

Wallis, Brian, ed. Art *After Modernism: Rethinking Representation*. Boston: David R. Godine, 1984.

Westerbeck, Colin, and Joel Meyerowitz. *Bystander: A History of Street Photography*. London: Thames & Hudson, 1994.

FOR FASHION AND ADVERTISING, CHAPTER 8, SEE:

Berger, Warren. *Advertising Today*. London/New York: Phaidon, 2001.

Hall-Duncan, Nancy. *The History of Fashion Photography*. Rochester, NY: International Museum of Photography/ Chanticleer Press, 1977.

Harrison, Martin. *Appearances: Fashion Photography Since 1945*. New York: Rizzoli, 1991.

Sobieszek, Robert. *The Art of Persuasion: A History of Advertising Photography*. New York: Abrams, 1988.

Williams, Val, ed. *Look at Me: Fashion and Photography in Britain 1960 to the Present*. London: British Council, 1998.

FOR SCIENCE, CHAPTER 9, SEE:

Burns, Stanley B., M.D. *A Morning's Work: Medical Photographs from the Burns Archive and Collection, 1843-1939*. Santa Fe, NM: Twin Palms, 1998.

Ewing, William A. *Inside Information: Imaging the Human Body*. London: Thames & Hudson, 1996.

Kevles, Bettyann Holtzmann. *Naked to the Bone: Medical Imaging in the Twentieth Century*. New Brunswick, NJ: Rutgers University Press, 1997.

Thomas, Ann. *Beauty of Another Order: Photography in Science*. New Haven/London: Yale University Press/National Gallery of Canada, Ottawa, 1997.

CONTRIBUTORS

Peggy Archambault is an art director for the National Geographic Society. Her work has been recognized by the New York Art Director's Club, *Communication Arts*, *Print Magazine*, *Graphis*, and the Society of Publication Designers.

Leah Bendavid-Val directs the National Geographic photography book program and is a writer and curator specializing in Russian photography. She has curated exhibitions at the Corcoran Gallery of Art, Washington, DC, and the Pushkin Museum of Fine Arts, Moscow. She is the author of five books on photography, including *Propaganda & Dreams* and *Stories on Paper & Glass*. She is also co-author of *Sam Abell: The Photographic Life*.

Susan Blair has edited photography for several National Geographic books including *From the Front*, *Africana Woman*, *The Encyclopedia of Space*, and most recently *Wide Angle: National Geographic Greatest Places*.

Jim Enzinna has contributed to books as a writer, editor, researcher, and indexer for over 20 years. He has also worked on magazines, television, and the Internet.

Russell Hart, executive editor of *American Photo* magazine and editor of *American Photo On Campus*, has written about photography for the *New York Times*, *Men's Journal*, and *Us*. His books include *William Albert Allard: The Photographic Essay*, and *Photography For Dummies*. His photographs are in the permanent collections of several major museums. He has taught photography at Tufts University and the School of the Museum of Fine Arts, Boston.

Anne H. Hoy is a former curator for the International Center for Photography. An art historian and author, she teaches the history of 19th- and 20th-century photography at New York University and in the City University of New York system. Hoy also writes and edits books and magazines.

Bronwen Latimer has produced and edited photography for *Time* magazine, *Sports Illustrated*, National Geographic *Adventure*, and *US News & World Report*. She is currently developing *The Ultimate Photo Field Guide* for National Geographic.

Rebecca Lescaze is a senior editor in the National Geographic Society's Book Division. She has edited more than 30 books, including *Eyewitness to the 20th Century*, *Milestones of Science*, and the *Photography Field Guide*.

Paul Martin is the executive editor of *National Geographic Traveler* magazine. His articles for *Traveler* have taken him around the world, and he has also written three books, including the memoir *Land of the Ascending Dragon: Rediscovering Vietnam*.

Walton Rawls is the author of several books in American cultural history, including *The Great Book of Currier & Ives' America* and *Wake Up, America!: World War I and the American Poster*. He was a contributor to the *Oxford Companion to American Military History* and the *Penguin Dictionary of American Folklore* and the editor of a great many books, among them Rosenblum: *A World History of Photography*.

THE BOOK OF PHOTOGRAPHY

TEXT BY ANNE H. HOY
FOREWORD BY LEAH BENDAVID-VAL
TECHNICAL SIDEBARS BY PAUL MARTIN
PICTURE CAPTIONS BY BRONWEN LATIMER
TIMELINE BY SUSAN BLAIR

PUBLISHED BY THE NATIONAL GEOGRAPHIC SOCIETY
John M. Fahey, Jr., President and Chief Executive Officer
Gilbert M. Grosvenor, Chairman of the Board
Nina D. Hoffman, Executive Vice President

PREPARED BY THE BOOK DIVISION
Kevin Mulroy, Senior Vice President and Publisher
Kristin Hanneman, Illustrations Director
Marianne R. Koszorus, Design Director
Rebecca E. Hinds, Managing Editor
Leah Bendavid-Val, Director, Photography Books

STAFF FOR THIS BOOK
Leah Bendavid-Val, Editor
Bronwen Latimer, Illustrations Editor
Peggy Archambault, Art Director
Walton Rawls, Text Editor
James B. Enzinna, Researcher
Rebecca Lescaze, Contributing Editor
Susan Blair, Assistant Editor
R. Gary Colbert, Production Director
Michael Horenstein, Production Project Manager
Meredith Wilcox, Illustrations Specialist
Cataldo Perrone, Design Assistant

CONSULTANT
Russell Hart, Executive Editor *American Photo* magazine

MANUFACTURING AND QUALITY CONTROL
Christopher A. Liedel, Chief Financial Officer
Phillip L. Schlosser, Managing Director
John T. Dunn, Technical Director
Chris Brown, Manager

Founded in 1888, the National Geographic Society is one of the world's largest nonprofit scientific and educational organizations. Its mission is to increase and diffuse geographic knowledge while promoting conservation of the world's cultural and natural resources. National Geographic reflects the world through its five magazines, television programs, films, radio, books, videos, maps, interactive media and merchandise. National Geographic magazine, the Society's official journal, published in English and 27 local-language editions, is read by 40 million people each month in every country in the world. The National Geographic Channel reaches more than 260 million households in 27 languages in 160 countries. Nationalgeographic.com averages around 60 million page views per month. National Geographic has funded more than 8,000 scientific research projects and supports an education program combating geography illiteracy.

For more information,
log on to nationalgeographic.com;
AOL Keyword: NatGeo.

NATIONAL GEOGRAPHIC SOCIETY
1145 17th Street N.W.
Washington, D.C. 20036-4688 U.S.A.
Visit the Society's Web site at
www.nationalgeographic.com.

Library of Congress Cataloging-in-Publication Data

Hoy, Anne H.
 The Book of Photography : the history, the technique, the art,
the future / text by Anne H. Hoy.
 p. cm.
 ISBN 0-7922-3693-9
 1. Photography. I. Title

TR146.H82 2005
770—dc22

2005050868

Printed in the U.S.A.